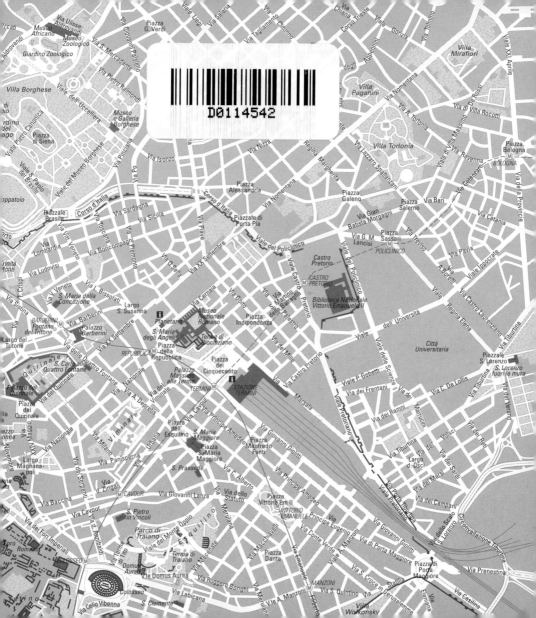

Rome

and the

Vatican City

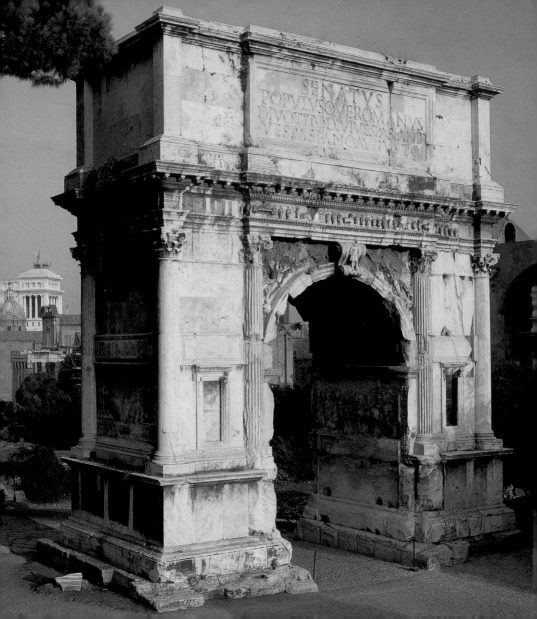

ART & ARCHITECTURE

ROME

and the

VATICAN CITY

Brigitte Hintzen-Bohlen
With contributions by Jürgen Sorges

KÖNEMANN

Frontispiece:
The Arch of Titus and the Forum Romanum

Note:
Information regarding the location of works in museums and churches as well as
concerning opening times are subject to change.

© 2005 Tandem Verlag GmbH
KÖNEMANN is a trademark and an imprint of Tandem Verlag GmbH

Original Title: *Kunst & Architektur. Rom*
ISBN 3-8331-1304-9

Art Direction: Peter Feierabend
Project Management: Ute Edda Hammer, Kerstin Ludolph
Editing: Uta Büxel, Daniela Müller, Jutta Allekotte, Frank Zimmer
Layout and Typesetting: Holger Crump
Picture Research: Monika Bergmann, Astrid Schünemann

© 2005 for the English edition: Tandem Verlag GmbH
KÖNEMANN is a trademark and an imprint of Tandem Verlag GmbH

Translation from German: Peter Barton, Anthea Bell and Eileen Martin in association with
Cambridge Publishing Management
Editing: Chris Murray in association with Cambridge Publishing Management
Typesetting: Cambridge Publishing Management
Project Management: Sheila Hardie and Anna James for Cambridge Publishing Management
Project Coordination: Tammi Reichel

Printed in China

ISBN 3-8331-1484-3

10 9 8 7 6 5 4 3 2
X IX VIII VII VI V IV III II

Table of Contents

View of Rome from the Gianicolo

View of Rome with the
Monumento Nazionale
a Vittorio Emanuele II

Vatican City and St. Peter's:
aerial view

Tivoli, the Villa Hadriana,
Canopus Valley

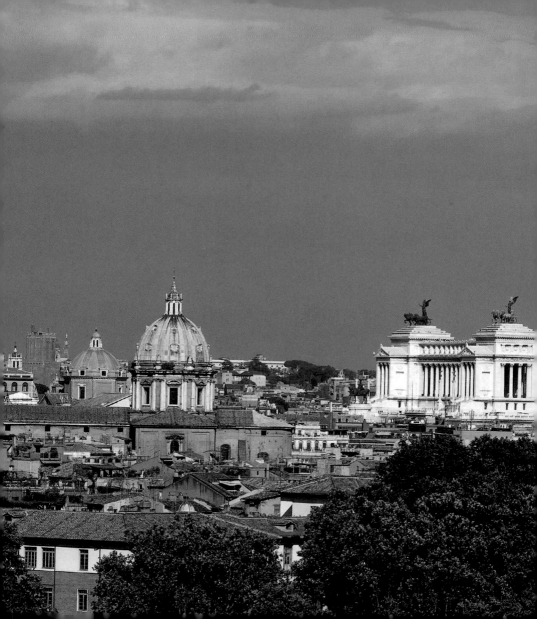

Roma Aeterna – the Eternal City

"There is almost nothing beautiful in the world other than Rome."
(Johann Joachim Winckelmann, 1756)

Rome – the navel of the world, the Eternal City, the center of Western Christianity: epithets like these have long been used to try to define the unique nature of the Italian capital. Three thousand eventful years have fashioned the character of this remarkable city, creating an historical synthesis found nowhere else in the world. In every century the masters of Rome – the generals and emperors of classical times, and then popes and princes later – stamped their own personalities on the city. They summoned famous architects and artists to create the buildings, sculptures and paintings that lend the capital the appearance that still constitutes its fascination today. Past and present, the pagan and the Christian, art and everyday life – all are inextricably combined. Again and again through its long history, the city has given crucial political and artistic stimulus to the cultural and intellectual history of Europe. Latin, the language of the classical empire, has many modern Western descendants.

View from the Gianicolo of the Piazza Venezia, with the Monumento Nazionale a Vittorio Emanuele II

The governmental and judicial systems of ancient Rome became the model for a number of modern states and their legal codes. It was in Rome that the imperialist ideas of the Middle Ages originated, molded by Christianity; it was here that papal power established itself in the age of the Renaissance, while the papal court became the center of humanist culture. In classical antiquity and modern times alike, Roman architecture, painting and sculpture have regularly inspired the whole of the Western world. Notwithstanding all the changes the Eternal City has seen, it has preserved an immense variety of art treasures that from time immemorial have attracted and delighted millions of cultured visitors. So great is Rome's magnetic attraction that many who were planning only a short visit have felt impelled to stay on longer, for months or even years. The list of the city's famous visitors is a long one, and many of them have tried to sum up their overwhelming impressions in words. Perhaps the best-known comment was made by Johann Wolfgang von Goethe: "I can say that only in Rome have I understood what a human being really is. I never again reached those heights or knew those joyful sensations; by comparison with what I felt in Rome, I have never really been happy again."

The Eternal City: its Origins in Legend and History

As with all cities whose origins are shrouded in obscurity, many myths have grown up around the founding of Rome. Aeneas, who fled with his father Anchises and his son Ascanius from the burning city of Troy to the coast of Latium, where he married the king's daughter, was revered as the ancestor of the Romans. One of his descendants was Numitor, king of Alba Longa, whose daughter Rhea Silvia was impregnated by Mars the god of war and bore him the twins Romulus and Remus. Her uncle Amulius, who claimed the throne for himself, set the twins adrift in a basket on the Tiber after their birth, but Providence saved them. A she-wolf suckled the brothers until they were rescued by the herdsman Faustulus. As young men they avenged their deposed grandfather and, fulfilling the prophecy of an oracle, founded a city on the Palatine Hill – the city of Rome. They quarreled because Remus ignored the sacred boundary or *pomerium* drawn around the city by his brother, and sacrilegiously crossed it; Romulus killed him for this transgression. A settlement grew up, but now the Romans needed women to give them children and so they abducted the Sabine women, daughters of a neighboring tribe in the nearby mountains; the Sabines declared war on them. Through the treachery of Tarpeia, daughter of the Roman officer commanding the citadel, the Sabines managed to take the stronghold. The war was brought to a happy conclusion only by the courageous intervention of the Sabine women, who flung themselves between the combatants – their husbands on one side, their fathers and brothers on the other. In resolution of the conflict, the Sabines settled on the Quirinal Hill, the two tribes were united, and

Johann Heinrich Wilhelm Tischbein, Goethe in the Campagna, 1787, oil on canvas, 164 × 206 cm, Städelsches Kunstinstitut, Frankfurt

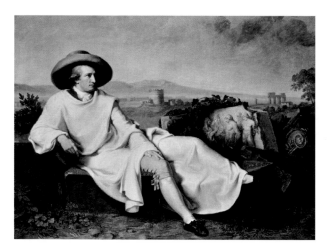

from then on they ruled together. The legend says that Romulus was later carried up into heaven, although a piece of black marble in the Forum, the Lapis Niger, was venerated as his tomb.

Unlike the Roman historians, who gave the date of the foundation of the city as April 21, 753 B.C. – the day with which the Roman reckoning of time began, *ab urbe condita* – archaeological finds below the Capitol and on the Palatine show that the first settlements there were as early as the 10th century B.C. It is likely that shepherds and farmers sought refuge from the regular flooding of the Tiber and from enemy attack by settling on the Palatine, Esquiline, and Quirinal Hills. As these settlements spread, they joined together in the 8th century B.C. to form a single larger community, with the Capitol as its political and religious center. Under the rule of the Etruscans, who immigrated from the north, this community became a city between the 7th and the 6th centuries B.C. Legendary tradition held that Romulus was followed by seven Etruscan kings; the last, Tarquinius Superbus, was expelled in 510 B.C. and was replaced by a republican state. Etruscan influence is reflected in the

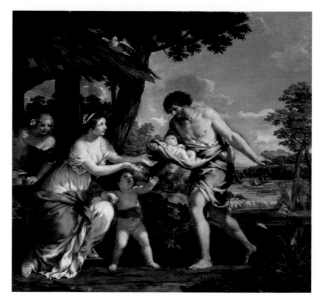

Pietro da Cortona, Faustulus finding Romulus and Remus, 1643, oil on canvas, 251 × 265 cm, Musée du Louvre, Paris

division of the city into its main administrative districts and the distribution of its citizens between social classes. During the Etruscan period building of the great drainage project of the Cloaca Maxima began, the Forum was paved, the temple of Jupiter on the Capitol was built, and the city was surrounded by the Servian Wall, named after the man who was thought to have built it, Servius Tullius, the sixth king of Rome.

Emerging as a World Power: the Roman Republic

After the fall of the monarchy at the end of the 6th century B.C. the nobility, known as patricians, assumed political and religious leadership, and the age of the Roman Republic began. While Rome had to defend itself in the 5th and 4th centuries B.C. against the Etruscan city of Veii, the Celts, the Latins, and the Samnites, there were fierce power struggles raging at home between the patricians and the common people, the plebeians. These issues were settled only when the plebeians themselves became politically organized and had access to the offices of state, and when legal principles had been drawn up in the Twelve Tables of the Law. Internal peace went hand in hand with a shrewd policy of alliances which enabled Rome to defeat the Etruscans in the north, the Samnites in central Italy, and finally, at the beginning of the 3rd century B.C., the Greeks in southern Italy.

Reconstruction of the Forum Romanum, 19th cen., watercolor, Soprintendenza alle Antichità, Rome

Rome was now the strongest power in the land, and a struggle for domination of the whole Mediterranean area began. In 146 B.C., at the end of the three Punic Wars, Rome's mighty rival Carthage was defeated and the coast of North Africa, with large parts of Spain, western Sicily, Sardinia, and Corsica, came under Roman rule. There were no limits to the Roman urge for conquest, and by the late 1st century B.C. the eastern Mediterranean from Greece to Asia Minor, the whole of Spain, and Upper Italy were all under Roman dominion. Rome had risen to the rank of a world power. But in the last century before the Christian era it suffered severe crises at home that gradually undermined the fabric of the republic. Slave revolts, conspiracies, and civil wars shook the state, culminating in the assassination of Julius Caesar in 44 B.C.

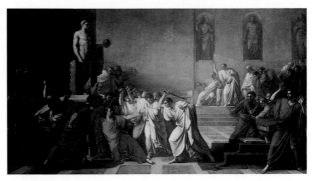

Vincenzo Camuccini (1773–1884), The Assassination of Julius Caesar, Museo di Capodimonte, Naples

The city had expanded during the centuries of republican rule, and now covered the Seven Hills – the Capitol, Palatine, Aventine, Caelian, Esquiline, Viminal, and Quirinal. Immigrants from all over Italy flocked in, and the population grew to almost half a million. However, the city itself did not look at all like the capital of an international empire, and was unable to compete with either the cities of the Greek east or those of Campania and Latium. The Romans had certainly extended the road network, constructed aqueducts to ensure a water supply, and erected other utilitarian buildings, but they had few magnificent temples or imposing squares. Most notably of all, the layout of the city reflected the stark contrast between the rich and the poor: the luxurious villas of the nobility stood outside the walls, while Rome itself was crowded with tall tenement blocks in dark, narrow streets where the poor lived, with only a few great urban palaces rising among them. As yet, moreover, the Romans had not developed an artistic style of their own, although they had absorbed many elements of Hellenistic art and culture from immigrant Greek artists and from the Greek sculptures brought back to Rome as the spoils of war.

The Imperium Romanum

The young Octavian, a nephew of Julius Caesar, inherited this difficult situation, and after seventeen years of civil war he finally restored peace at home. He also formally reinstated the Roman Republic, but in practice, as *princeps* ("the first"), he held all power in his own hands. During the forty-one years (27 B.C.–A.D. 14) under his official title of Augustus ("Sublime"), he laid the foundations for the government of the capital and its empire over the next three centuries. The imperial Roman period began with Augustus, whose contemporaries saw his reign as the beginning of a golden age, an idea celebrated in the reliefs on the altar of peace, the Ara Pacis. Augustus conquered the Alpine tribes, secured his borders, brought peace to the provinces, and introduced essential administrative reforms. He was also responsible for initiating major building projects in the empire, dividing Rome into fourteen districts, and implementing a wide-ranging architectural policy that not only added new luster to the city but also, through various specific objectives, lent prestige to the new ruler and his family. In addition, he embarked on a program of religious reform, reconstituting the old forms of worship, bringing the religious code up to date, and restoring old temples. The visual arts flourished under Augustus, and so did scholarship and literature – we need only think of the works of Ovid, Virgil, and Horace. A new pictorial language

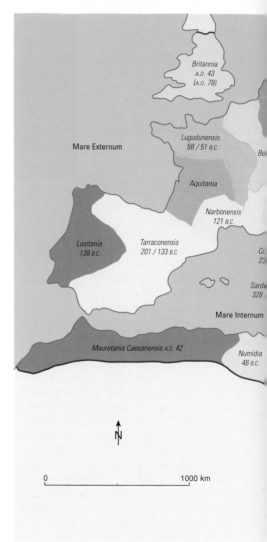

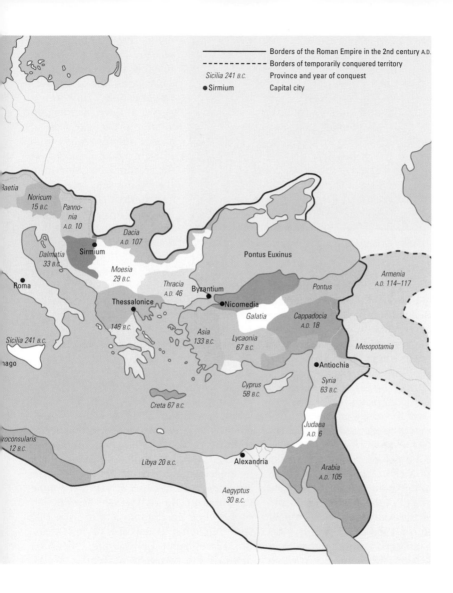

Borders of the Roman Empire in the 2nd century A.D.
Borders of temporarily conquered territory
Sicilia 241 B.C. Province and year of conquest
● Sirmium Capital city

Raetia
Noricum 15 B.C.
Panno-nia A.D. 10
Dacia A.D. 107
Dalmatia 33 B.C.
●Sirmium
Moesia 29 B.C.
● Roma
Thracia A.D. 46
Byzantium
Pontus Euxinus
Armenia A.D. 114–117
Pontus
Thessalonice
●Nicomedia
Galatia
Cappadocia A.D. 18
146 B.C.
Sicilia 241 B.C.
Asia 133 B.C.
Lycaonia 67 B.C.
Mesopotamia
nago
Cyprus 58 B.C.
●Antiochia
Syria 63 B.C.
Creta 67 B.C.
roconsularis
12 B.C.
Judaea A.D. 6
Libya 20 B.C.
● Alexandria
Arabia A.D. 105
Aegyptus 30 B.C.

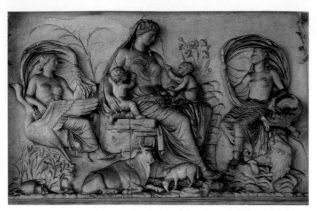

Detail of the Ara Pacis Augustae: Pax (the personification of peace), dedicated 9 B.C., marble relief, Rome

developed, locating its ideals in classical Greek art and rejecting the opulent extravagance of Hellenistic forms.

The Senate deified Augustus after his death, and the imperial cult was adopted by Italy and the provinces. It formed a link between them and the remainder of the empire, expressing their loyalty to a dynasty that guaranteed the peace of the imperial territories. Over the course of the next two centuries, under the successors of Emperor Augustus, the territorial area of Roman rule expanded and was consolidated, eventually covering large parts of Europe, North Africa, and Asia Minor. Rome became the *caput mundi*, the "head of the world." Trade and taxes from all the Roman provinces brought great wealth to the capital, which was extensively adorned with magnificent buildings as successive emperors tried to outdo each other. Most of the ancient Roman remains still extant today date from the first two centuries A.D. This was a period of town planning on a large scale, the era of Nero's Domus Aurea, the Flavian palace complex on the Palatine, the Colosseum, the Forum and Markets of Trajan, Hadrian's Pantheon, the Villa Adriana in Tivoli, the triumphal arch of Septimius Severus in the Forum with its three archways, and the impressive Baths of Caracalla and Baths of Diocletian. A final great work of architecture was the city wall, dating from the mid-3rd century A.D., eighteen kilometers (11 miles) in length, and defending a city that had spread far beyond its original confines. By now, stronger fortifications were necessary once again, for the great period of the *imperium* (empire) was long since past. Economic crises, revolts, and military setbacks were characteristic features of the turbulent 3rd century, and the Emperor Diocletian (reigned 284–305) sought to counter them by implementing a comprehensive reorganization of the empire, at the same time decentralizing the civil service. The division of the whole empire into four areas of rule (the Tetrarchy) lasted only a few years. In 312, Emperor Constantine (306–337) defeated his co-regent Maxentius at the

Battle of the Milvian Bridge, and it was then that he declared himself to be the sole ruler of the West Roman Empire. Later, in 324, he became the sole ruler of both the East and West Roman Empires. In 330 he moved his seat of government east, away from Rome to Constantinople, and it was this move that initiated the final decline of the former world empire.

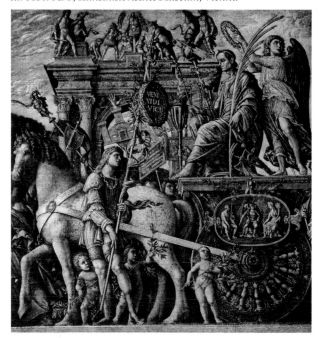

After Andrea Mantegna, Julius Caesar in his Triumphal Chariot, ca. 1480/1495, Kunsthistorisches Museum, Vienna

Early Christian Rome

When the apostles Peter and Paul came to Rome in the 1st century A.D. they found a small Christian community already in existence. Over the following centuries, and despite constant persecution, it steadily increased both in size and strength. By the terms of an edict of tolerance issued in 313, all churches, private houses, goods, and landed property that had been confiscated from Christians were returned to them, and it was two years later that Emperor Constantine recognized Christianity as the official religion of Rome in the Edict of Milan. The emperor, who was himself converted to the Christian faith on his deathbed, founded the church of S. Giovanni in Laterano, and donated the Lateran palace, which stood in its precincts, to the successor of St. Peter. In subsequent centuries, independent churches such as S. Agnese fuori le mura, S. Maria Maggiore, SS. Cosma e Damiano, and S. Lorenzo were built on the sites of what had originally for the most part been modest private houses, and these churches were magnificently ornamented with

mosaics. The formal style of grand imperial architecture was adopted and modified for the new Christian buildings; for instance, the Roman basilica was used as the model for St. Peter's and for S. Paolo fuori le mura, and the mausoleum for S. Constanza.

The fall of the *imperium Romanum* was accompanied by the rise and dissemination of the Christian faith, and after the death of Emperor Theodosius in 395 his sons divided the territory into an Eastern and a Western Roman Empire. Western Rome fell to the onslaught of the barbarians – the Visigoths plundered Rome in 410, and the Vandals attacked in 455 – and its fate was sealed in 476 with the deposition of the last emperor, Romulus Augustulus. It is true that in the course of reconstruction fine new churches such as S. Sabina and S. Stefano Rotondo were built, but the ancient buildings became increasingly dilapidated and were exploited as stone quarries or sources of lime. The Visigoths were now the rulers of Italy, with Ravenna as their new center; Rome became unimportant.

Toward the Holy Roman Empire

No sooner had the situation in Rome become calmer after the war between the Ostrogoths and Byzantium (535–552) than a Lombard invasion threatened (568). More and more of the inhabitants left the ruined and looted city. In the 6th century it had a population of only 50,000 (there had been over a million during the imperial period), and in the 8th and 9th centuries there were fewer than 25,000. The only ruler of the city was the bishop of Rome, the head of Christendom – soon generally called the pope (father) – and he was the sole hope of its population. Pope Gregory I (pontificate 590–604) was one of the great church leaders of the early Middle Ages, and laid the foundations of secular papal rule in Rome with his far-sighted policies. At the end of the plague, commemorated by the statue of the archangel Michael on the Castel Sant'Angelo, he embarked on a great missionary project in northern Europe. Subsequently, throngs of pilgrims streamed into the city, which only now began to experience a revival. The influence of foreign rulers steadily declined, but the popes did not have sufficient military strength to protect themselves against enemies in the long term. When the Lombards again threatened Rome in 753, Pope Stephen III (pontificate 752–757) sought an ally in the Frankish King Pepin. After they had defeated the aggressors, Pepin, in the Pepin Donation of 754, guaranteed the church its rule over Rome and large parts of northern Italy, thus creating the foundations for the later ecclesiastical state. In return, the pope anointed the Frankish leader the first "king by the grace of God." This alliance was consolidated under Charlemagne, who granted further territory to the church, and was solemnly crowned emperor in St. Peter's on December 25, 800 by Leo III (pontificate 795–816). This was the beginning of the

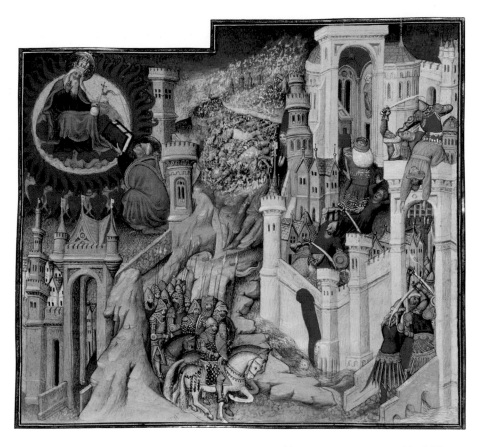

French master, manuscript "De civitate dei," The Goths Attacking Rome, 1469–1473, 5.25 × 3.70 cm, Bibliothèque Nationale, Paris

eventful history of what later became known as the Holy Roman Empire, which had its spiritual center in Rome, although its real power base lay north of the Alps.

Conflict was inevitable: while the emperors demanded a say in papal elections, the popes claimed the privilege of celebrating imperial coronations, and sole rights to the

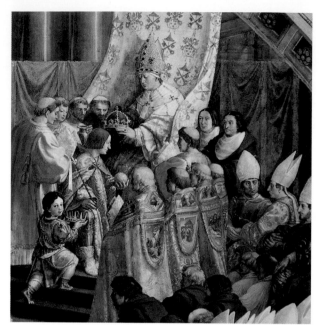

Raphael, The Coronation of Charlemagne (detail), ca. 1516/17, fresco, Stanza dell'Incendio di Borgo, Musei Vaticani, Rome

Rome in the Middle Ages: the Struggle for Power

The medieval centuries are dismal chapters in the history of Rome. The city suffered from conflicts between the popes and the emperors, was delivered up defenceless to invasions and attacks by peoples including the Saracens (846) and the Normans (1084), and was cast into anarchy by the mighty clans of the nobility who struggled for power with each other and with the pope. Unlike the northern Italian cities of Florence, Milan, Venice, Pisa, and Genoa, Rome lay outside the great trading and seafaring routes, and could not profit from the general economic boom that prevailed elsewhere. In the 12th century the citizens, under Arnold of Brescia, rebelled against the secular rule of the popes and set up a short-lived democratic republican government (1143–1144), which lasted no longer than the republic that was founded two centuries later by Cola di Rienzo.

The proclamation of the first Holy Year in 1300 brought the city a brief revival of its fortunes, but soon the power struggle among the noble families for occupation of appointment of bishops. This struggle between the papacy and the empire was to determine the course of events in the following centuries.

In the 8th and 9th centuries, when the Frankish kings had ensured a stable basis for papal rule, Rome enjoyed a brief period of prosperity, which is still in evidence today in the richly ornamented churches of S. Giorgio in Velabro, S. Prassede, S. Marco, S. Cecilia in Trastevere, and S. Maria in Dominica.

the papal chair or for appointments as cardinals was once again determining the course of events. There was conflict with France too, and it was one fraught with profound consequences: when the quarrel about the pope's supremacy over secular rulers reached its peak under Boniface VIII (pontificate 1294–1303), the king of France deposed him, and the first French pope was installed as Clement V (pontificate 1305–1314). In 1309 Clement moved the papal residence to Avignon, where it remained for 70 years. During the "Babylonian captivity" of the papacy – so called because it lasted longer than the captivity of the Jews in Babylon – Rome sank to its lowest depth. The return of Gregory XI (pontificate 1370–1378) in 1377 made little difference, for until 1417 Christendom was split by the Great Western Schism, when several popes claimed the holy chair of St. Peter at the same time. Eventually a solution was found at the Council of Constance (1414–1418), which ended the schism in 1417 by electing

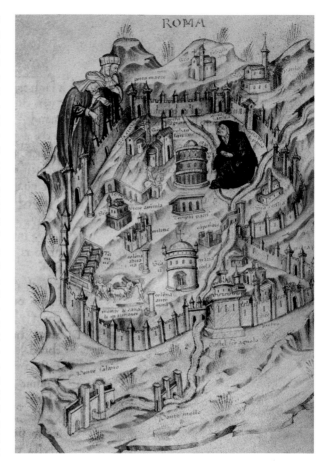

Italian codex, 15th century, Bibliothèque Nationale, Paris

Pope Martin V, a member of the Colonna family. This pope (pontificate 1417–1431) helped Rome to rise from the ruins, and ushered in the age of humanism and the

Renaissance. The defensive appearance of the city at this time, with its fortified residences and the towers belonging to the various contending families, reflected these never-ending conflicts. Yet in the centuries of the Middle Ages, which had been so disastrous in general for the city, an increasing number of major works of art had been created, including Cosmati mosaics and the paintings of Giotto di Bondone and Petro Cavallini. It was the 14th century, with the exile of the popes to Avignon, which brought all this artistic activity to an end. The churches, palaces, streets, and squares of Rome were deserted as a consequence of the drastic reduction in the number of its inhabitants.

The Renaissance

The necessary conditions for spiritual and political revival in the Church were created under Martin V and his successors in the chair of St. Peter. During the 15th century, despite a number of conflicts, the popes at last succeeded in giving the papal territorial state the full secular powers that had existed in name only since the time of Charlemagne. The prerequisites were now in place for the reconstruction of the city; its new brilliance was to give visible expression to its status as the spiritual center of Christianity. Rome was governed by a complex administrative body, the Curia, with the pope and the cardinals at its head. Popes preferred to give key positions in the Curia to members of their families (the attitude known as nepotism, from the word for "nephew"). With such a broad power base to support them, the princes of the church competed to adorn their city. They summoned the finest architects, sculptors and painters, who vied with one another in the attempt to make Rome a center of art and architecture that would be able to stand comparison with other European cities. Soon Rome had ousted Florence from the leading position it had occupied in the 15th century, and became the center of the High Renaissance. The rebuilding of St. Peter's was entrusted to Bramante, the painting of the *stanze* (large rooms) and loggias of the papal apartments in the Vatican to Raphael, and the ceiling frescoes of the Sistine Chapel to Michelangelo Buonarroti. Even the *Sacco di Roma* in 1527 – the Sack of Rome by the troops of Charles V, who did appalling damage – interrupted the papal building program for only a short period of time. As both secular princes and men of the church, the popes were less interested in theological questions than in art and architecture, their own prestige, and the power and wealth of their families. All these projects were financed by taxation and the huge sums obtained from the sale of indulgences, which finally led to the Protestant Reformation and to schism.

Ignazio Danti (1536–1586), Map of Rome, fresco, Galleria delle Carte Geografiche Vaticana, Musei Vaticani, Rome

ROMA
PER SACRAM B. PETRI SEDEM CAPVT ORBIS EFFECTA. S.LEO

The Age of the Counter-Reformation

Pope Paul III (pontificate 1534–1549) convened the Council of Trent (1545–1563) to draw a clear line between Roman Catholic doctrine and the aspirations of the Reformation, and to safeguard the unity of the faith and the Church. The Council was the point of departure for the Counter-Reformation, in which the Jesuit order was particularly prominent. The rules of the order became an important instrument in the struggle against both heretics and reformers, and the Jesuits played a crucial part in converting the New World to Christianity. The Counter-Reformation demanded its sacrifices in Rome itself: among the most famous was the Dominican monk and philosopher Giordano Bruno, who was burned at the stake in the Campo dei Fiori in 1600.

Rome profited by the new movement. Its population increased again, and endeavors to proclaim the theological and inner renewal of the Catholic Church in words and images set off an architectural and artistic boom of hitherto unknown proportions. The popes remained undisputed princes of the ecclesiastical state until the end of the 17th century, ruling in harmony with the higher ranks of the clergy and the secular nobility. They commissioned more and more new works of art, which brought even greater glory to the *caput mundi*, giving it a structure still visible today. Under Paul III, Michelangelo Buonarroti painted the *Last Judgement* in the Sistine Chapel, and as the newly appointed supervisor of work on the rebuilding of St. Peter's began designing the dome that dominates the cathedral. Vignola and Giovanni della Porta left their stamp on the new sacred architecture of the Counter-Reformation with the church of Il Gesù, built specifically for the recently founded Jesuit order. New churches and noblemen's palaces enhanced the appearance of the city, and under Sixtus V (pontificate 1585–1590) and his architect Domenico Fontana it saw a period of urban planning

View of Rome, from an engraving by Antoine Aveline (1

Ansicht von Rom, nach einem Kupferstich von Antoine Aveline (1691-1743)

on a huge scale. The strict classical forms of the Renaissance were now superseded by the powerful flowing lines of the Baroque, and in the 17th century, under Popes Urban VIII, Innocent X, and Alexander VII, the rival masters Bernini and Borromini left their own mark on the city. Bernini expressed the church's claim to power in the new design of St. Peter's Square and the colonnades surrounding it, added new touches to the interior of St. Peter's with the bronze baldacchino and the Cathedra Petri, and gave the Piazza Navona a new focal point in the monumental Fontana dei Fiume. Borromini's rhythmically curving line enlivened the city's architecture with buildings like S. Agnese in Agone, S. Carlo alle Quattro Fontane, and S. Ivo alla Sapienza, and Carlo Maderno completed the rebuilding of St. Peter's. New inspiration entered painting around 1600 in the artistic work of Caravaggio, Annibale Carracci,

), print by Broscheles & Co., Hamburg

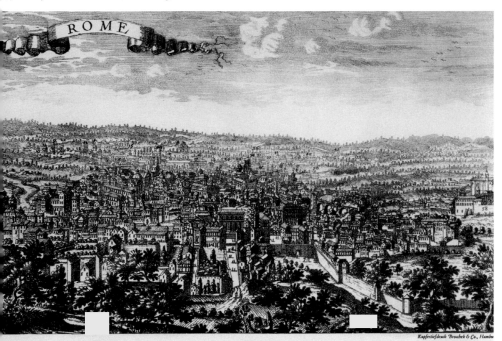

ROME

Kupfertiefdruck Broschek & Co., Hambu

Domenichino, and Guido Reni, and after the mid-19th century the illusionist ceiling frescoes of Petro da Cortona, Andrea Pozzo, and Baciccia were very influential.

Italy against the Pope

The Baroque city and its countless artistic treasures brought many people to visit Rome in the 18th century – pilgrims, artists, and art lovers, as well as young men completing their education through foreign travel. Outstanding scholars such as Johann Joachim Winckelmann spent long periods in the city and devoted themselves to the study of Roman antiquities. Their work led to the founding of the first museums. Although individual projects such as the Spanish Steps and the Fontana di Trevi (Trevi Fountain) show that architecture continued to develop in Rome, papal power

Rome Transformed, original drawing by H. Effenberger, from Die Illustrierte Zeitung, no. 2547, 23.4.1892, pp. 444 – 445

had begun to decline. The ecclesiastical state played a merely subordinate role in a Europe that was now changing. Even Rome was affected by the French Revolution. Napoleonic troops entered the city in 1798, proclaimed a Roman republic, and removed the pope from his position as head of state. It is true that the powers of the papacy were restored by the Congress of Vienna in 1814, but it soon came under pressure from the movement for national unity known as the Risorgimento. With French aid, Pius IX (pontificate 1846–1878) defended himself successfully against the revolutionary troops of Mazzini and Garibaldi. Pius IX responded to the demands of Camillo Cavour and King Vittorio Emanuele II to have Rome declared the capital of the kingdom of Italy (proclaimed in 1861) by defending his powers with the dogma of papal infallibility. However, when the Franco-Prussian war forced the French troops to withdraw, it was only a matter of weeks before the pope was obliged to renounce his claims to secular power. In a symbolic assault on the Porta Pia, Italian troops took the city on September 20, 1870, and the people of Rome voted to become part of a united Italy. Rome became the capital of the kingdom in 1871. The pope, however, withdrew behind the walls of the Vatican in protest.

The period of the Napoleonic wars and the Risorgimento brought few changes in the urban architecture of Rome, apart from the designing of the Pincio park and the Piazza del Popolo by Giuseppe Valadier.

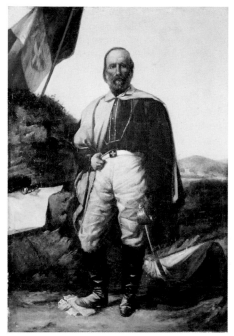

Filippo Palizzi (1818–1899), Portrait of Giuseppe Garibaldi, Museo del Risorgimento, Rome

However, the unification of Italy ushered in great innovations. As yet the country had no base from which to exercise power; now ministerial buildings such as the Palazzo Giustizia were erected for the civil service, and whole areas of the city were rebuilt to accommodate the rapidly rising population. Imposing streets such as the Via Veneto, the Via Nazionale, and the Corso Vittorio Emanuele gave the capital a new structure.

From Mussolini to the Present Day

The "captivity" of the pope was ended only by Mussolini, who recognized the sovereignty of the ecclesiastical state in the Lateran Treaties concluded in 1929 with Pope Pius XI (pontificate 1939–1958). After his celebrated "march on Rome," Mussolini, who was *Duce* (leader) of the Fascist movement, forced King Vittorio Emanuele III to abdicate. Mussolini's dream was to restore the old *imperium*, and he planned to realize that dream by embarking upon a huge building program. Mussolini built a highway, which today is known as the Via dei Fori, right across the ancient imperial forums, and he also had the old Borgo quarter torn down to build the Via della Conciliazione as a link with St. Peter's Square. A magnificent stadium, the Foro Italico, was laid out in the north of the city, and the EUR quarter in the south was created for a planned world exhibition in 1942. Foreign policies that were part of the Duce's imperial dream included participation in the Spanish Civil War, the invasion of North Africa, an alliance with Hitler, and Italy's entry into the Second World War. The last of these projects was to be responsible for his downfall: when the Allies attacked Rome in July 1943 Mussolini was taken prisoner, and although he was liberated again by the Germans he was finally executed by partisans in 1945.

In 1946 the Italian people abolished the monarchy in a referendum, and on 18 June the Republic was proclaimed. Rome has been its capital ever since. Important events such as the signing of the Treaties of Rome founding the European Community (1957), the Olympic Games (1960), the Second Vatican Council (1962–1965), and the World Soccer Championship (1990) have consistently made the city the focus of world attention. However, the city has been unable to hold its own on the economic level with the cities of northern Italy and also lacks any real system of town planning. Today the *borgate* (shacks) which were built in the suburbs by the throngs of post-war immigrants from the south have been demolished, only to be replaced by bleak residential estates of tower blocks. Although Rome now has a peripheral motorway system, two airports, an international railway station, and two subway lines, the main problem of this city of three million inhabitants, as in the past, is its chaotic traffic. One consequence of this traffic problem is the high levels of air pollution that it causes. Every day this pollution inflicts new damage on the entire city and, in particular, damages its architectural and artistic monuments.

However, to celebrate the Holy Year at the turn of the millennium, the city, the Pope, and the Italian Ministry of Culture have embarked on a gigantic restoration program, that will bring new luster to the old buildings and works of art. In addition, several areas of ancient Rome have been excavated for the very first time, including the imperial forums on the Via dei Fori Imperiali. The Domus Aurea (a palace complex which

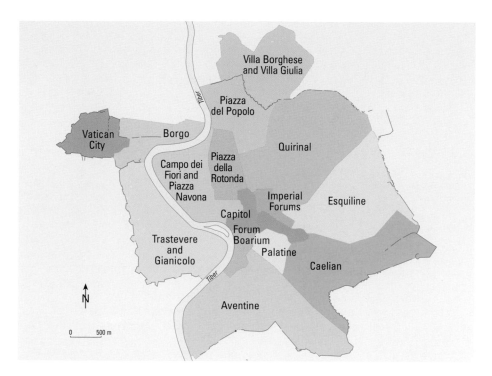

Villa Borghese
and Villa Giulia

Tiber

Piazza
del Popolo

Vatican
City

Borgo

Quirinal

Piazza
della
Rotonda

Campo dei
Fiori and
Piazza
Navona

Imperial
Forums

Esquiline

Capitol

Forum
Boarium

Trastevere
and
Gianicolo

Palatine

Caelian

Tiber

N

0 500 m

Aventine

was built by Nero) has been opened to visitors once again, collections have been put into good order, and museums re-opened. But the depredations of the past cannot be eradicated everywhere, and they clearly illustrate the insoluble problem Rome faces at the beginning of the third millennium: how to reconcile the needs of its current inhabitants with the preservation of its myriad treasures from centuries past without either destroying the past or detracting from the quality of the future.

Visiting the Eternal City: a Word of Advice

To visit Rome is not sufficient to know it. In fact, a person can spend many years in the Eternal City without coming to understand it in all its aspects. When someone commented to the Danish sculptor Thorvaldsen that he must know Rome very well, the artist replied: "I am just beginning to understand it, but then I've only lived here thirty years."

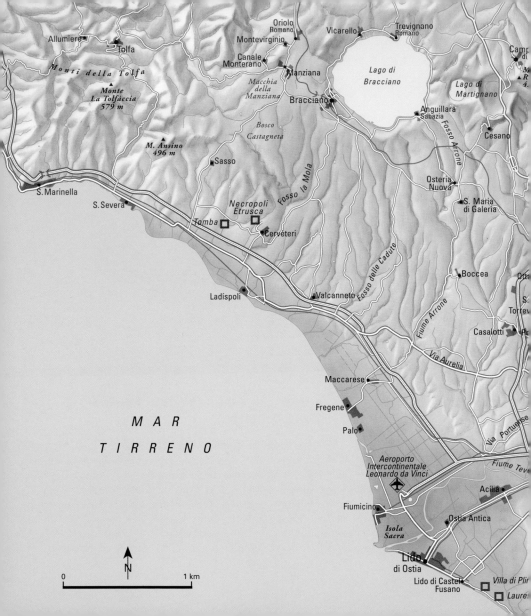

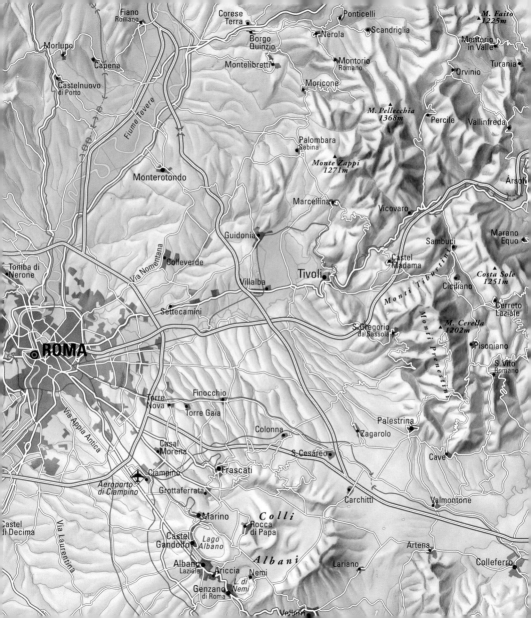

Rome and the Vatican in a Nutshell

Location

- Capital of the Republic of Italy and the Comune di Roma province
- Situated in central Italy, on the plain of the Campagna Romana, and at the foot of the volcanic hills of the Latium region
- Height above sea level: 13 m (43 feet) at the bend of the Tiber – 138 m (453 feet) at Monte Mario
- Built on both sides of the Tiber, which flows into the Tyrrhenian Sea at Ostia some 20 km (12.4 m) away

Area

- City of Rome: 209 km^2
- Comune di Roma, with 35 outer city quarters and six suburbs: 1508 km^2

Climate and best time to travel

- Mediterranean climate with mild winters and hot summers
- Ideal time to travel: early summer and October, when the days are sunny but not too hot
- Particularly crowded at Easter
- August is the traditional vacation month in Italy, very hot with many stores and restaurants closed

Population

- Number of inhabitants in 1991: 2.77 million
- Strong demographic growth since Rome became the capital of Italy, particularly because of immigration from the southern provinces
- 1951 the number of inhabitants in the historic city center has dropped from 424,400 to 150,000

Local government

- Civic administration: a mayor with a residence in the Palazzo dei Senatori on the Capitol, an upper house of 14 city councillors, a town council of 80 members

State officials

- State president, with a residence in the Palazzo Quirinale
- Parliament of deputies (sitting in the Palazzo Montecitorio)
- Senate (sitting in the Palazzo Madama)

Economy

- The service sector (tourism, radio, television, publicity, and fashion) employs 1.1 million workers, i.e. nearly 80%
- 250,000 are employed in administration and management, with banks, stock brokers, and insurance companies steadily growing in importance
- Only about one-fifth of the population is employed in industry, though new companies are increasingly setting up in the outer

districts (electronics, telecommunications, information technology, and the pharmaceuticals industry)

The Vatican

- Area of the Vatican City: 0.5 km^2; exterritorial areas comprise the great pilgrim churches, the Lateran, the Cancelleria and the papal summer residence of Castel Gandolfo
- Local government: subject to the pope
- Number of inhabitants: 1,200, of which some 700 have citizenship of the Vatican
- Vatican citizens enjoy freedom from taxation
- The Vatican has its own postal system, currency, radio station, and daily newspaper, *l'Osservatore Romano*

Useful addresses for travelers

- ENIT Rome:
 Via Marghera 2, tel. + 39-0649711, fax + 39-064463379

- APT Rome:
 Via Parigi 11, tel. + 39-06488991, fax + 39-064819316

- ENIT USA:
 630, Fifth Avenue, Suite 1565, New York tel. + 1-212-2454822, fax + 1-212-5869249

 500, North Michigan Avenue, Suite 2240, Chicago, tel. + 1-312-6440996, fax + 1-312-6443019

 12400, Wilshire Blvd., Suite 550, Los Angeles tel. + 1-310-8201898, fax + 1-310-8206357

- ENIT UK:
 1, Princes Street, London tel. + 44-20-74081254, fax + 44-20-74936695

Rome on the Internet

- www.roma2000.it
- www.inforoma.it
- www.roma-online.uk
- www.roma-antiqua.uk
- www.romaturismo.it
- www.venere.it
- www.vatican.va
- www.romeguide.it/Eng
- www.itwg.com
- www.enit.it

Climate

Average temp in °F (°C)	Jan	Feb	March	April	May	June	July	Aug	Sept	Oct	Nov	Dec
Day	51.8 (11)	55.4 (13)	59 (15)	66.2 (19)	75.4 (23)	82.4 (28)	86 (30)	86 (30)	78.8 (26)	71.6 (22)	60.8 (16)	55.4 (13)
Night	39.2 (4)	40.1 (4.5)	44.6 (7)	50 (10)	55.4 (13)	62.6 (17)	68 (20)	68 (20)	62.6 (17)	55.4 (13)	48.2 (9)	41 (5)
Sunshine hrs/days	4	4	5	7	8	10	11	10	7	6	5	4
Rainy days	8	9	8	8	7	4	2	2	5	8	10	10

Opening times (not guaranteed accurate)

Ara Pacis Augustae: closed to the public at present.

Catacombe di Callisto, di Domitilla, di S. Sebastiano, di Priscilla: Thurs.–Tues. 8.30 am–12 pm/2.30 pm–5 pm (March–Oct. until 5.30 pm). Closed Wed., S. Sebastiano Sun., Priscilla Mon.

Circo di Massenzio: 9 am–1 pm.

Colosseum: 9 am until 1 hour before sunset.

Domus Aurea: Wed.–Mon. 9 am–7.45 pm, closed Tues. Phone bookings recommended (+39-0639749907).

Foro Romano and Palatino: 9 am until 1 hour before sunset.

Galleria Borghese: Tues.–Sun. 8.30 am–7 pm, closed Mon., Christmas Day and New Year's Day.

Galleria Doria Pamphilj: Fri.–Wed. 10 am–5 pm. Closed Thurs.

Galleria Nazionale d'Arte Antica, Palazzo Barberini: Tues.–Sun. 8.30 am–7.30 pm, closed Mon.

Galleria Nazionale d'Arte Antica, Palazzo Corsini: Tues.–Sun. 8.30 am–1.30 pm, closed Mon.

Il Gesù: 6 am–12.30 pm, 4.30 pm–7.15 pm. (March–Oct.), 4 pm–7.15 pm (Nov.–Feb.).

Mausoleo di Augusto: admission only by previous permission given in writing.

Mercati Traianei: Tues.–Sun. 9 am–6.30 pm (Nov.–Feb. until 4 pm). Closed Mon.

Musei Capitolini: Tues.–Sun. 9 am–7 pm. Closed Mon.

Musei Vaticani (Vatican Museum): Apr.–Oct. Mon.–Fri. 8.45 am–4.45 pm. Nov.–March 8.45 am–4.45 pm. Closed Sat ., Sun., religious holidays and May 1.

Museo Barracco: Tues.–Sun. 9 am–7 pm, closed Mon.

Museo della Civiltà Romana: Tues.–Sat. 9am–7 pm, Sun. 9 am–2 pm, closed Mon.

Museo delle Terme: 9 am–7.45 pm.

Museo di Palazzo Venezia: Tues.–Sun. 9 am–1.30 pm, closed Mon.

Museo Nazionale di Castel Sant'Angelo: Tues.–Sun. 9 am–7 pm, closed Mon.

Museo Nazionale di Villa Giulia: Tues.–Sun. 9 am–7.30 pm, closed Mon.

Oratorio dei Filippini: usually open in the morning

Palazzo Altemps: 9 am–7.45 pm Tues.–Sun. Closed Mon.

Palazzo Braschi: closed to the public at present.

Palazzo and Galleria Colonna: Sat. 9 am–1 pm.

Palazzo della Cancelleria: Mon.–Sat. 4 pm–8 pm, by arrangement only.

Palazzo del Quirinale: second and fourth Sun. each month.

Palazzo di Montecitorio: not open to the public.

Palazzo Farnese: not open to the public, but guided tours available at regular intervals, for information call +39-06975413.

Palazzo Massimo alle Terme: 9 am–7.45 pm Tues.–Sun. Closed Mon.

Palazzo Massimo alle Colonne: only on 16 March, 7 am–1 pm.

Palazzo Pamphilj: not open to the public

Palazzo Spada: Tues.–Sat. 9 am–7 pm, Sun. 9 am–1 pm, closed Mon.

Pantheon: Mon.–Sat. 9 am–7.30 pm, Sun. 9 am–6 pm.

Parco Archeologico di Via Appia Antica: 9.30 am–6 pm.

Planetario (Aula Ottagona): Sun. and holidays 9 pm–1 am.

S. Agnese fuori le mura: 8 am–12 noon, 4 pm–6 pm.

S. Agnese in Agone: Mon.–Sat. 5 pm–6.30 pm,
 Sun. 10 am–1 pm.

S. Andrea della Valle: 8 am–12.30 pm,
 4.30 pm–7.30 pm.

S. Carlo ai Catinari: 7 am–12.00 noon, 4 pm–8 pm.

S. Carlo alle Quattro Fontane: Mon.–Sat. 9 am–
 1 pm, Mon.–Fri. 4 pm–6 pm, Sun. no access
 for the general public.

S. Cecilia in Trastevere: 10 am–12 noon, 4 pm–6 pm.

S. Clemente: Mon.–Sat. 9 am–12.30 pm, 3 pm–
 6 pm., Sun. 10 am–12.30 pm, 3 pm–6 pm.

S. Costanza: Mon., Wed.–Sat. 9 am–12 noon,
 4 pm–6 pm, Sun. 4 pm–6 pm, closed Tues.

S. Croce in Gerusalemme: 6.30 am–12.30 pm,
 3.30 pm–7 pm.

S. Giovanni in Laterano: 7 am–6.30 pm.

S. Ignazio di Loyola: 7.30 am–12.30 pm,
 4 pm–7.15 pm.

S. Ivo alla Sapienza: Sun. 10 am–12.00 noon.

S. Lorenzo fuori le Mura: 7 am–12.30 pm,
 3.30 pm–6.30 pm (Nov.–Feb), 4 pm–7.30 pm
 (March–Oct.).

S. Maria dei Angeli: 10.30 am–12 noon, 4 pm–7 pm.

S. Maria della Pace: 8 am–12 noon, 4 pm–7 pm.

S. Maria del Popolo: 7 am–12 noon, 4 pm–7 pm.

S. Maria in Aracoeli: 6.30 am–6.30 pm.

S. Maria in Cosmedin: 10 am–1 pm, 3 pm–6 pm
 (Nov.–Feb.), 9 am–1 pm, 3 pm–7 pm
 (March–Oct.).

S. Maria in Trastevere: 7.30 am–1 pm, 3.30 pm–7 pm

S. Maria in Vallicella (Chiesa Nuova): 8 am–
 12 noon, 4.30 pm–7 pm.

S. Maria Maggiore: 7 am–6.50 pm.

S. Maria sopra Minerva: 7 am–12 noon, 4 pm–7 pm.

S. Paolo fuori le Mura: 7 am–6.45 pm.

S. Pietro in Montorio: 9 am–12 noon, 4 pm–6 pm.

S. Pietro in Vaticano: 7 am–6 pm (Nov.–Feb.),
 7 am–7 pm (March–Oct.).

S. Pietro in Vincoli: 7 am–12.30 pm, 3.30 pm–6 pm
 (Nov.–Feb.), 3.30 pm–7 pm (March–Oct.).

S. Prassede: 7.30 am–12 noon, 4 pm–6.30 pm.

S. Saba: 7 am–12 noon, 4.30 pm–7 pm.

S. Sabina: 6.30 am–12.30 pm, 4 pm–7 pm.

S. Stefano Rotondo: 9 am–12 noon.

SS. Quattro Coronati: Mon.–Sat. 6.10 am–
 12.35 pm, 3.15 pm–6 pm, Sun. 6.40 am–12.35 pm,
 3.30 pm–7.30 pm; Oratorio di S. Silvestro:
 Mon.–Sat. 9.30 am–12 noon, 4.30 pm–6 pm,
 Sun. 9.30 am–10.30 pm, 4.30 pm–6 pm.

Scala Santa and Sancta Sanctuorum:
 March–Oct. 6 am–12 noon, 2.30 pm–6.30 pm,
 Nov.–Feb. 6 am–12.30 pm, 3 pm–7 pm.

Scavi di Ostia: Tues.–Sun. 9 am–4 pm (March–Oct.
 until 6 pm), closed Mon.

Tempietto: 9 am–12 noon, 4 pm–6 pm.

Terme di Caracalla: Tues.–Sun. 9 am until 1 hour
 before sunset.

Tivoli, Villa d'Este: 9 am–7.45 pm. Closed Mon.

Tivoli, Villa Hadriana: 9 am–5 pm (May–Aug. until
 7.30 pm).

Tomba di Cecilia Metella: Mon.–Fri. 9 am–4 pm.
 (March–Oct. until 6 pm), Sat.–Sun 9 am–1 pm.

Villa Chigi (La Farnesina): Mon.–Sat. 9 am–1 pm,
 closed Sun.

Villa Medici: inquire by telephone for opening
 times (tel. +39-067611 or 06798381).

*Extensive excavations at present being carried
out in Rome cannot be covered in this volume,
since the findings have not yet been published in
full. Information on the location of works in
museums and churches, and on opening times,
may be subject to modification.*

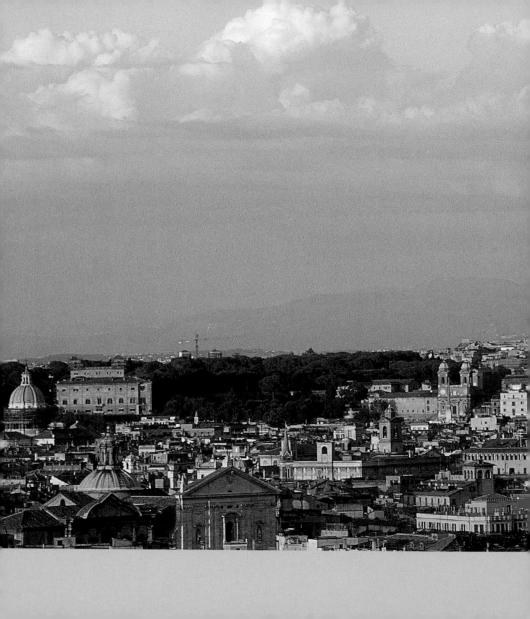

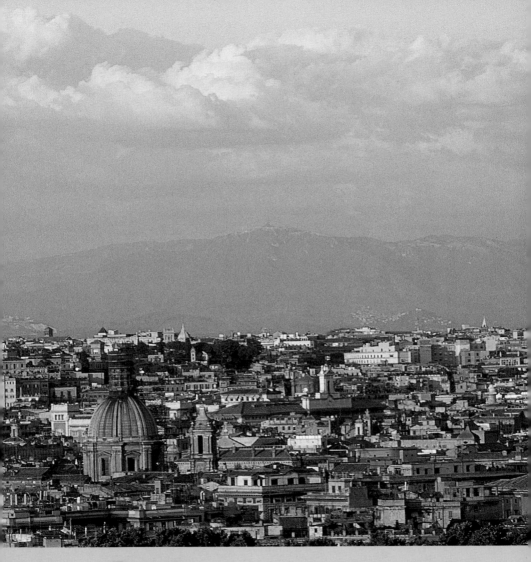

Rome

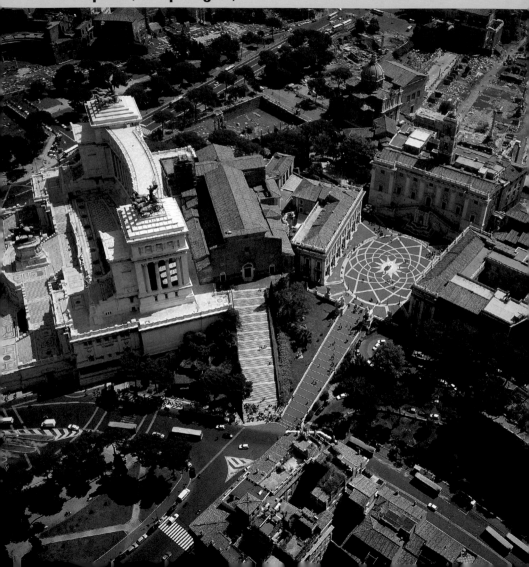

The Capitol (Campidoglio)

Although it is the lowest of the seven hills of Rome, the Capitol, which has two rounded summits divided by a shallow depression, was already the political and religious center of the city in classical antiquity. Since it was surrounded by inaccessible rock slopes except on the side facing the Quirinal, it was particularly suitable for a fortress. According to legend, the Sabines were able to take the hill only because Tarpeia, daughter of the officer commanding the guard, opened the gates to them. The Tarpeian Rock, from which criminals were thrown in later periods, is named after her. In classical times, the Capitol was aligned with the Forum Romanum: the temple of Jupiter, Juno, and Minerva, the supreme gods of the state, was built on the southern summit, the Capitolium; and from the 4th century B.C. the temple of Juno Moneta stood on the northern summit, the Arx, on the present site of S. Maria in Aracoeli. In the shallow valley between them, now occupied by the Piazza del Campidoglio, lay the Asylum, a sanctuary which according to legend dated back to Romulus and offered refuge to hunted men. On the eastern side stood the Tabularium, the Roman state archive. At the foot of Capitol Hill, the present site of the church of Giuseppe dei Falegnami, was the Mamertine prison, in

Reconstruction of the Capitol complex

which the Apostles Peter and Paul were probably held captive.

The Capitol has remained the center of the city down the centuries. Pope Paul III intended to emphasize its significance when he commissioned Michelangelo Buonarroti to redesign the square in 1536. Michelangelo's concept of this piazza, with its palaces and the impressive sloping ramp of its steps, provided the Capitol with a worthy setting befitting its importance as a symbol of the *caput mundi*. Today, two of the most important Roman museums stand in the square, and the Capitol still plays a significant part in politics. The Treaty of Rome was signed here in 1957 when the European Economic Community was founded, and the Palazzo dei Senatori is the official seat of the mayor of Rome.

View of the Capitoline Hill

Previous pages: view over Rome from the Gianicolo

The Capitol

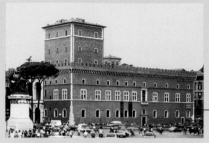

Palazzo Venezia, access to the Viale del Plebiscito 118, p. 43

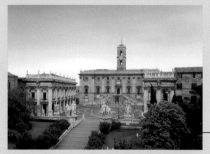

Piazza del Campidoglio, with the Palazzo Nuovo and Palazzo dei Conservatori, p. 50

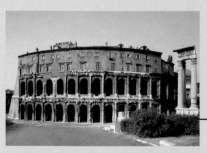

Theater of Marcellus, Via del Teatro di Marcello, p. 47

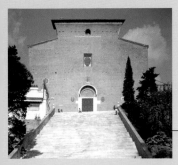

S. Maria in Aracoeli, Piazza d'Aracoeli, p. 48

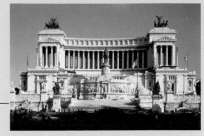

Monumento Nazionale a Vittorio Emanuele II,
Piazza Venezia, p. 42

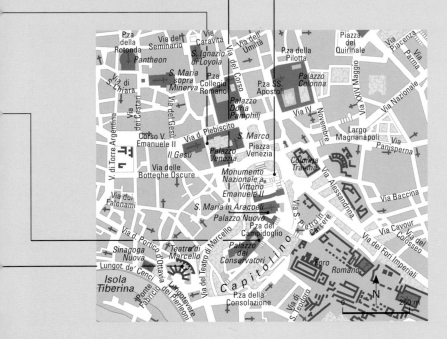

Piazza Venezia with the Monumento Nazionale a Vittorio Emanuele II

The Piazza Venezia is one of the major traffic junctions of the city; the Via del Corso, the Via dei Fori Imperiali, and the Via del Teatro di Marcello are among the thoroughfares that converge there. In its present form the square dates back to the late 19th century, and is dominated by the gigantic monument to Vittorio Emanuele II, built in dazzling white Brescian marble and disrespectfully nicknamed "the wedding cake" or "the typewriter." It was built between 1885 and 1911 to commemorate the unification of Italy under King Vittorio Emanuele II of Savoy. His equestrian statue in gilded bronze stands in front of the high pillared hall, and is the focal point of this memorial to the victory of the first king of Italy. The monument is richly adorned with sculptures. Halfway up the majestic flight of steps stand the Altar of the Fatherland and the Tomb of the Unknown Soldier; a visit to these important memorials is always an integral part of a city tour for foreign state visitors.

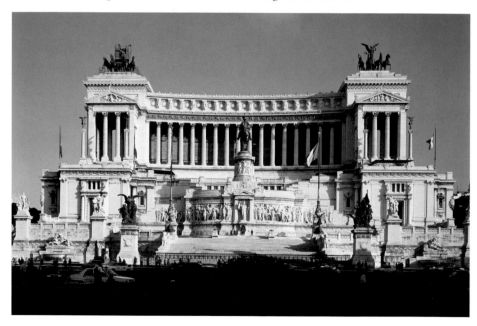

Palazzo Venezia

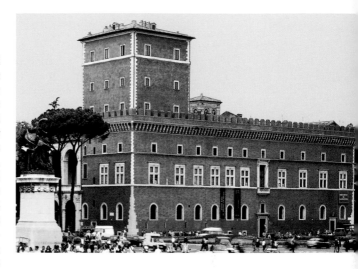

The Venetian Cardinal Pietro Barbo had the Palazzo Venezia, one of the first secular Renaissance buildings in Rome, erected in the grounds of his titular church of S. Marco, to plans by Francesco del Borgo. Work began in 1455, and when he succeeded to the papacy as Paul II in 1464 Barbo used the palace as his residence. Later the building served as the Venetian embassy, and it passed into Austrian hands in 1797, before becoming state property in 1916. The architecture displays the typical characteristics of a Roman cardinal's palace of the second half of the 15th century. The defensive appearance given to the building by the tall ground-floor story, the angle tower, and the ring of battlements, the asymmetry of the façade, and the emphasis on horizontal rather than vertical elements clearly distinguish the Roman palazzo from the palaces of Florence, which aim to achieve a balance between horizontal and vertical features. The marble cross-barred window frames on the upper floor are typical of early Renaissance architecture in Rome, and are found in many palaces and houses. A museum is now housed in the large and imposing halls of the interior, some of which are decorated with frescoes, and it contains many valuable exhibits from the field of applied art as well as sculptures, paintings, and tapestries.

To the south of the palazzo stands S. Marco, one of the earliest titular churches in Rome, and later the church of the Venetian community in the city. Paul II (pontificate 1464–1471) added a two-story portico to it to serve as a loggia from which the benediction could be pronounced. Also to the south is the Palazzo Venezia, which was demolished when the national monument was built and re-erected in its present location. It was once the setting for a botanical garden, and today, with its two-story arcades and octagonal columns, surrounds an interior courtyard reminiscent of Florentine cloisters.

Vittorio Emanuele II – a King for Italy

by Jürgen Sorges

Torta nuziale ("wedding cake") and *dentiera* ("dentures") were the irreverent names with which the Romans dubbed the huge memorial to King Vittorio Emanuele II in the Piazza Venezia when the "Vittoriano" was opened, still unfinished, in 1911. This marble monster, designed by Giuseppe Sacconi in 1885 and built by Pio Piacentini, Manfredo Manfredi, and Gaetano Koch, was not finally completed until 1927, and by that time Italy was ruled by Il Duce, Benito Mussolini. As the *altare della patria* ("altar of the fatherland"), it has divided rather than united opinions in Rome and indeed Italy ever since, and not just over its artistic merits, for this colossal piece of urban architecture entirely blocks the view of the Forum Romanum. In front of it stands the largest equestrian statue of the 19th century: Vittorio Emanuele II and his horse ride here on parade for all eternity, twelve meters (39 feet) tall and weighing fifty tons. Also, the brilliant white limestone (from the Brescia region) doesn't sit happily with the Travertine marble so predominant in Rome.

A glance at the history of the 19th century will help illuminate the polarization of opinions on this monument: *Fare un quarantotto* ("to do a 48") refers not to some Roman card game or lottery, but to the chaotic state of internal politics in Italy during the Year of Revolutions, 1848. The Appenine peninsula at the time was a political patchwork, with the Bourbons ruling the south, an ecclesiastical state in the center, and independent principalities and duchies in the north. In addition, Field Marshal Radetsky had taken and occupied Venice for Austria. Only the royal house of Piedmont-Savoy in the northwest asserted itself and its political will to unify Italy – with the support of France and Napoleon III. In 1849 Vittorio Emanuele II took over the affairs of state from his father Carlo Alberto of Savoy. Ten thousand liberals, democrats, and social revolutionaries thereupon flocked to Turin to join him as the new standard-bearer of their hopes, for Piedmont, which had economic aspirations as well, was guaranteeing the new values of 1848: freedom of thought, speech, and political activity.

At the time Italy's cultural achievements were at a very low ebb. The major exception was the composer Giuseppe Verdi, who has stood ever since as a synonym for the period of the Risorgimento, the resurgence of Italy. The libretti of his operas, expressing social criticism and strongly influenced by late Romanticism, were loudly acclaimed, and so above all were his scores. The moving chorus of the Hebrew slaves in Verdi's *Nabucco* reflected the general mood of the population. In the intervals of performances the Italian opera-goers toasted each other with the fashionable drink of the season, the *coppa Bellini*, and whispered the maestro's name – for ingenious minds had taken the composer's surname as the ideal symbol of the unification of Italy: "V.E.R.D.I.": the letters stood as a

secret cipher for the initials of "Vittorio Emanuele Re d'Italia" – Vittorio Emanuele, king of Italy. Once made, the link between musician and monarch stuck.

Several fervently desired near-miracles helped to bring about the envisioned unification: Garibaldi's legendary march of the *mille*, "the thousand," set out from Marsala in Sicily, and in 1860 joined southern Italy with Piedmont.

Anita Garibaldi, who was the general's wife, took part in the march herself, carrying a pistol, or so at least her equestrian statue on the Gianicolo Hill in Rome would have us to believe. Another supporter of the cause, Vittorio Emanuele's prime minister, Count Camillo Benso di Cavour, was skilfully pulling the political strings in Turin at this time.

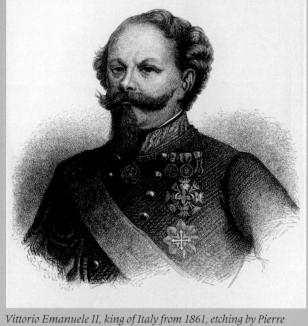

Vittorio Emanuele II, king of Italy from 1861, etching by Pierre Guillaume Metzmacher, 1859

In 1865 Florence became the capital, replacing Turin, and a year later Venice was "returned" to the new royal house of Italy. On September 20, 1870, finally, Rome too gave way, and Pope Pius IX withdrew into the Vatican with bad grace. The gates of the Quirinal Palace, the pope's private summer residence, were opened only by a massive assault on them by rifle butts. The new master of the house, Vittorio Emanuele II, took up residence on New Year's Eve 1870, and he declared Rome the new capital of Italy that night. Dynastic reasons induced him to retain his royal title as it was: the first king of Italy in modern times has therefore entered the history books as *Secondo*, "the Second."

The cultural life of Rome was now enormously enriched: the king's son and successor, Umberto I (died 1900), and Umberto's wife, Margherita (died 1926), held grand balls in the Quirinal Palace on Wednesdays, and on Thursdays the court listened to dramatic readings at a literary salon. For no sooner had the proud fanfares died away

than sobering realization dawned: the king ruled a country where sixty percent of the annual revenues went to service its debts and pay military expenses. Italy lagged far behind the rest of Europe in industrialization. The new parliament was unhappy to find that a whole two percent of the population, just 500,000 citizens, had turned out to vote its members in. There were no votes of any kind for women, the right to vote was strictly imposed by census in the north, and all illiterates were rigorously excluded from the vote in the rural south of the "boot" of Italy: almost four-fifths of all Italian men could not read, and were thus not represented in parliament. Garibaldi withdrew into private life, and many disillusioned democrats with him; he died in 1882.

Against this background, the present-day Roman nickname for the outsized Monumento a Vittorio Emanuele II seems very appropriate. Termed the *macchina da scrivere*, "typewriter," it is a fitting symbol in stone for Italy's first large-scale modern campaign to encourage literacy: compulsory free education for child-ren between the ages of six and nine was introduced in 1878. The death of Vittorio Emanuele II also occurred in this eventful year, as well as the first great wave of immigration to the capital by the rural population of Italy. Many impoverished people sought better living conditions near the center of power. Even more Italians left Italy to live in places such as America, Argentina, and Australia seeing these as utopian countries with a bright future which could promise them a good lifestyle. For many who stayed at home, the new wealth of their "American sons and uncles" soon began to hold a greater power of attraction than the royal house of Savoy.

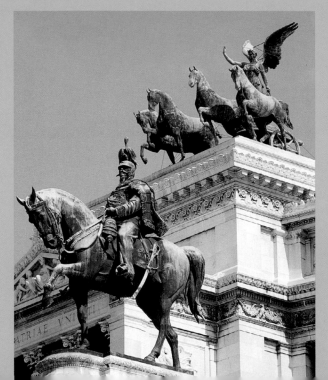

Equestrian statue of King Vittorio Emanuele II outside the "Vittoriano" on the Piazza Venezia

The Theater of Marcellus
(Teatro di Marcello)

Around 13 B.C. the Emperor Augustus completed the theater begun under Julius Caesar. It was dedicated to his nephew, son-in-law, and designated successor Marcellus, who had died young. The semi-circular travertine building was not built on the slope of a hill, like a Greek theater, but was entirely free-standing. At an original height of thirty-three meters (108 feet), it could accommodate some 15,000 specta-tors. Its two arcaded stories and the attic story were divided by Doric, Ionic, and Corinthian half-columns. Today, only the two lower stories have been preserved. In the 13th century the theater was used as a fortress by the Savelli family, and in the 16th century Baldassare Peruzzi erected a palace on the ruins of the building. It came into the hands of the Orsini family in 1712. Three columns from the temple of Apollo, with their entablature, still stand in front of the theater; this temple was restored in 34 B.C. by the consul C. Sosius, and was furnished with magnificent works of art.

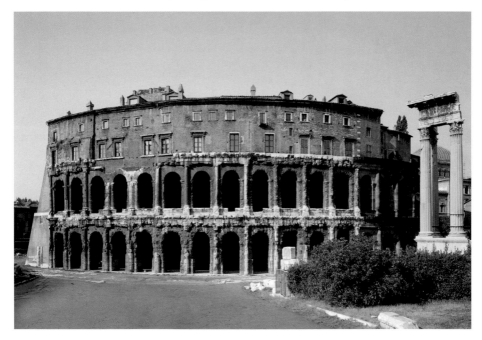

S. Maria in Aracoeli

A majestic white marble stairway with one hundred and twenty-four steps set close together, donated by the people of Rome to Our Lady of Aracoeli in 1348 in gratitude for their deliverance from the plague, leads to the plain brick façade of the basilica, which is divided by columns into a nave and two aisles. According to legend, it is built on the place where the Tiburtine Sibyl prophesied the advent of Christ to Emperor Augustus shortly before his death. Thereupon Augustus dedicated an altar to the Son of God, the *Ara coeli* (Latin: altar of heaven). Later, St. Helena, the mother of Constantine the Great, was buried above this place. Her bones are said to rest in a marble tomb beneath the octagonal dome of the aedicule built on the site of the altar in the left transept in 1602. As early as the 6th century, a monastery complex was built on the foundations of the Roman temple of Juno Moneta, and Innocent IV gave it to the Franciscans in 1250. In the late 13th century they began work on the new building which became the center of political life in the medieval city as the "church of the senators and people of Rome." The Roman parliament met here, and it was the setting for civic ceremonies.

The Interior

Inside, S. Maria in Aracoeli is an example of the traditional churches of the mendicant religious orders, being bounded to the east by a straight, self-contained choir, with subsidiary side choirs. Twenty-two ancient

columns, originally from classical buildings in the Forum and the Palatine, support the clerestory above, which is lined with rectangular windows. The coffered ceiling of the central nave is carved with symbols of sea battles, and was donated by Marcantonio Colonna to commemorate the naval victory of Venice over the Turks at Lepanto in 1571. The Cappella Bufalini, at the opening of the right-hand side aisle, is decorated with frescoes showing scenes from the life and death of St. Bernardino of Siena (1380–1444), a famous preacher greatly venerated by the Franciscans who often visited this church. They were painted by the Umbrian artist Pinturicchio around 1485, and are among his major works. A chapel near the sacristy contains a statue known as the Santo Bambino, the miracle-working Christ-Child of Aracoeli, according to legend carved from the wood of an olive tree from the Garden of Gethsemane. The original figure was stolen in 1994, and has now been replaced by a replica. Miraculous healing powers are attributed to the Bambino, and he is even carried to the bedsides of the sick. At Christmas the 60-cm (24-inch) tall statue is set up in the middle of a large crib, and Roman children preach their own sermons in front of it.

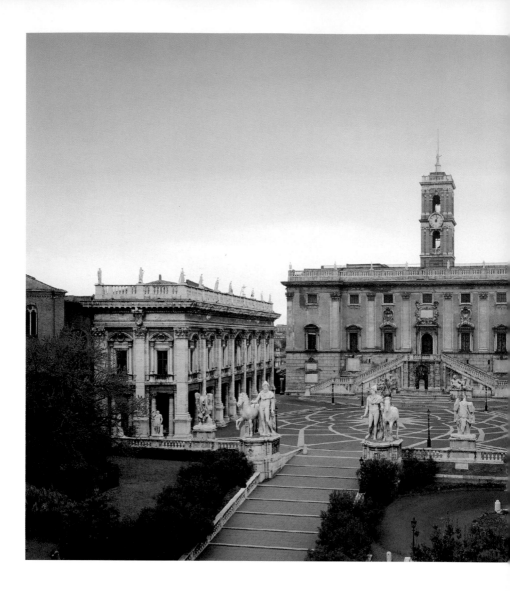

Piazza del Campidoglio

In 1536, when Michelangelo Buonarroti was commissioned by Pope Paul III to design an imposing square on the Capitol for the visit of Emperor Charles V, he had to include in his plans the senatorial palace built in the 12th century on the foundations of the Tabularium, and the mid-14th century guildhall on the south side. After their construction the main view from the Capitol was no longer of the Forum, as it had been in antiquity, but of the city opposite. Michelangelo's design made the equestrian monument of the Emperor Marcus Aurelius, transferred to the Capitol in 1538, the dominating feature at the center of the square. He designed a stepped oval ring for the trapezoid area created by the existing buildings, placing a star-shaped ornament inside the oval with the plinth of the statue at its center. Modifications were made to the existing architecture: Michelangelo planned to renovate the façades of the two palaces already present, and to build a third, the Palazzo Nuovo, as a counterpart to the Palazzo dei Conservatori. As the sides of these two buildings do not directly adjoin the long façade of the Palazzo Senatorio, but have space between them, Michelangelo created an open square looking west to St. Peter's, the Christian counterpart of the Capitol. Access to the square is by way of a broad ramp, the *Cordonata*. Its balustrades are adorned with ancient sculptures, including the massive statues of the Dioscuri (the mythical Castor and Pollux). Construction of the piazza progressed only very slowly, and in the end it was left to other, later architects to execute Michelangelo's concept. The piazza was not finally completed until the 17th century.

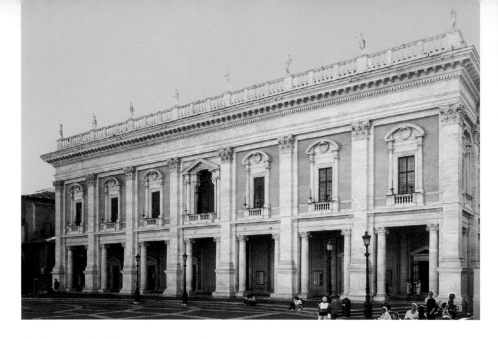

Palazzo dei Conservatori

The Roman *scholae* (guilds) had their official and judicial guildhall on the lower floor of the old 14th-century palace on the right-hand side of the Piazza del Campidoglio, while the "conservators" had their official rooms on the upper floor. As a result of the growing importance of this supervisory architectural body and its care of monuments in the 15th century, the palace, which was converted around 1520, adopted as its name the Palazzo dei Conservatori, a reference to the Conservators. Michelangelo Buonarroti intended to renovate the front wing of this building, and the work was carried out to his plans by Giacomo della Porta in 1564–1568. The façade is impressive with its colossal Corinthian design, a form seen here for the first time in a secular Roman Renaissance building. Corinthian pilasters link the two floors of the façade. On the ground floor of the building, it opens into a portico with a flat entablature resting on Ionic columns, which echo the half-columns on the back wall. The upper floor is divided up by windows, which are framed by columns and surmounted by a segmented gable. A balustrade runs around the high entablature, with ancient statues in each of the axes of the colossal pilasters.

The building differs from the original design in only one point: Giacomo della Porta emphasized the central axis, which Michelangelo had envisaged on a smaller scale, by designing a single larger window.

The fine collection of the Musei Capitolini is exhibited in the buildings of the Palazzo Nuovo and the Palazzo dei Conservatori; its nucleus was the art collection that was begun in 1471 by Pope Sixtus IV. As well as classical sculptures and carvings, frescoes dating from the 15th to 17th centuries and many paintings are on public view.

balanced composition and realistic representation suggest Hellenistic models of the 2nd century B.C. This work was much admired both in classical antiquity and in the Renaissance, as many copies and references in painting and sculpture show.

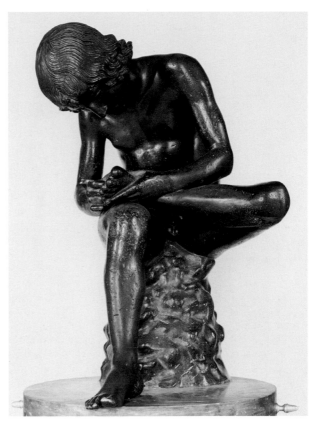

Boy Removing a Thorn (Spinario), 2nd Century B.C.
Bronze, h 73 cm

This Roman bronze sculpture, which is difficult to date because of its eclectic features, is among the finest genre figures of classical antiquity. It shows a boy sitting on a rock, with his left ankle resting on his right thigh while he pulls a thorn out of his foot. The boy's head is reminiscent of works of the Austere Style of Greek sculpture from the 5th century B.C., the

Palazzo dei Conservatori

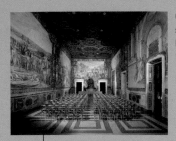

Cycle of pictures showing scenes of the early history of Rome, by Cavaliere d'Arpino, 1595–1612

Boy Removing a Thorn, p. 53

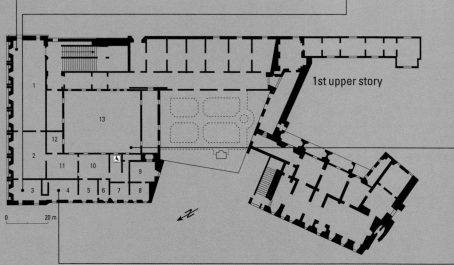

1st upper story

0 20 m

1 Sala degli Orazi e Curiazi		
2 Sala dei Capitani	6 Sala delle Aquile	10 Sala degli Arazzi
3 Sala dei Trionfi	7 Sala Arcaica	11 Sala di Annibale
4 Sala della Lupa	8 Sala Arcaica	12 Chapel
5 Sala delle Oche	9 Sala dei Magistrati	13 Interior courtyard

Head and hand of Constantine the Great. Fragments of a seated statue, presumed to have been 10 m tall, from the west apse of the Basilica of Maxentius, A.D. 306–312.

Guercino, The Burial of St. Petronilla. Altarpiece, created for Pope Gregory XV in 1623, hung in St. Peter's until 1730, and was then moved to the Quirinal.

2nd upper story

0 20 m

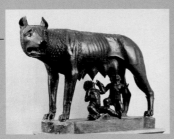

The Capitoline she-wolf, p. 110

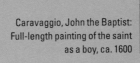

Caravaggio, John the Baptist: Full-length painting of the saint as a boy, ca. 1600

Palazzo dei Conservatori **55**

Palazzo Nuovo

To provide the Capitol's square with a balanced layout, Michelangelo planned another building, the "new" palace, as an exact counterpart of the Palazzo dei Conservatori opposite. It was begun in 1603, but was not completed (by Girolamo and Carlo Rainaldi) until between 1644 and 1654, under Pope Innocent X. They followed Giacomo della Porta's stronger emphasis on the middle of the façade, which had departed from Michelangelo's original design. The new building at first housed some of the ancient statues that had previously been kept in the Palazzo dei Conservatori. It was not until Pope Clement XII decreed in 1734 that Rome's collection of ancient works of art should be displayed in its rooms, and the public should have admission, that the Capitoline Museum was itself founded; it was in effect the first public museum in the world.

Equestrian Statue of Marcus Aurelius,
A.D. 176–177
Gilded bronze, h 424 cm

Michelangelo had chosen as the dominating central point of the redesigned Piazza del Campidoglio the famous classical equestrian statue of Emperor Marcus Aurelius, which was transferred to the Capitol in 1538 from its place outside the Lateran basilica. The bronze statue, originally gilded, and regarded in medieval times as the most important symbol of justice in Rome, had stood there since the 10th century. The monument owed its symbolic value to a false identification, which at the same time preserved it from destruction, unlike most other ancient bronzes. It was venerated as *caballus Constantini*, since the horseman was thought to represent the first Christian emperor, Constantine the Great. The pre-medieval history of the statue is

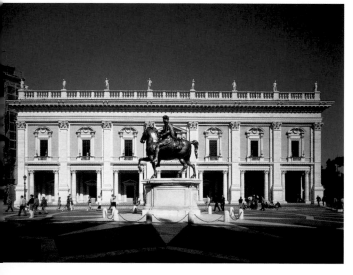

obscure: it is not known why it was cast, nor where it stood in classical antiquity.

This statue is highly esteemed in Western art history, and may be regarded as the prototype of all later equestrian statues. It represents the philosopher Emperor Marcus Aurelius (reigned 161–180), who was famous for both his commitment to the state and his virtue and wisdom. He is seen dressed in a tunic and *paludamentum* (general's cloak), and his right hand is raised in greeting to his troops. It is possible that the monument was erected to commemorate a military victory, for at one time the statue of a defeated king with bound hands lay beneath the raised right front hoof of the horse.

There are two enduring legends that have grown up around this monument. According to one of these, the Day of Judgement will dawn when all the gilding has finally disappeared from the bronze, while the other claims that when the horse and its rider are once again entirely covered with gold, Rome will return to being the master of the world. Regardless of such legends, the equestrian statue was removed from its

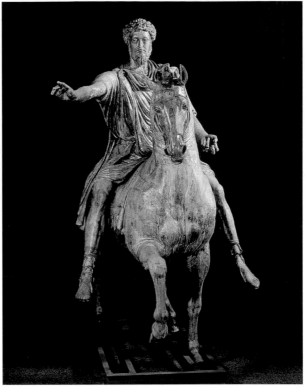

place in 1981 and was subjected to modern restoration and an investigation of its material. Since that time it has been situated in the courtyard of the Palazzo Nuovo because of the severe damage it had previously suffered from weathering, and for this reason has been replaced by a bronze replica which has stood in the Capitol square since 1997.

Palazzo Nuovo

Equestrian statue of
Marcus Aurelius, p. 56

The Marforio, fountain
statue of a river god from
the 1st century A.D.

Ground floor

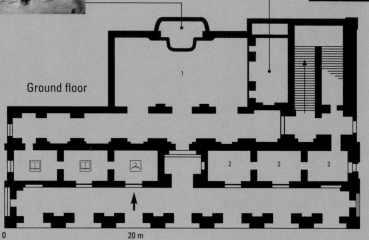

0 20 m

Discobolus: the torso is a copy of the
athlete of Myron (ca. 450 B.C.)

1 Cortile

2 Stanzette terrene

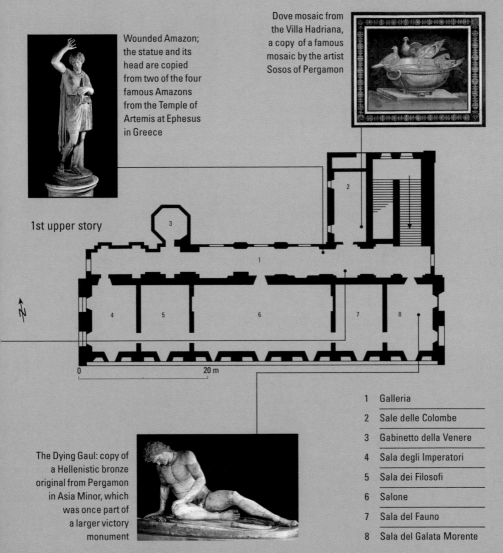

Wounded Amazon; the statue and its head are copied from two of the four famous Amazons from the Temple of Artemis at Ephesus in Greece

Dove mosaic from the Villa Hadriana, a copy of a famous mosaic by the artist Sosos of Pergamon

1st upper story

0 20 m

The Dying Gaul: copy of a Hellenistic bronze original from Pergamon in Asia Minor, which was once part of a larger victory monument

1 Galleria

2 Sale delle Colombe

3 Gabinetto della Venere

4 Sala degli Imperatori

5 Sala dei Filosofi

6 Salone

7 Sala del Fauno

8 Sala del Galata Morente

Palazzo Nuovo **59**

Julio-Claudian Emperors

Augustus (27 B.C.–A.D. 14)

Tiberius (14–37)
Caligula (37–41)
Claudius (41–54)

Nero (54–68)

Year of the Four Emperors; the Flav...
Galba, Otho, Vitellius (69)

Vespasian (69–79)
Titus (79–81)
Domitian (81–96)

The Roman Emperors and Their Times

0	25	50	75

29 B.C. Curia Julia, Mausoleum of Augustus

27 B.C. Temple of Apollo on the Palatine

9 B.C. Ara Pacis

2 B.C. Forum of Augustus

45 Harbor of Ostia
52 Aqua Claudia

52 Porta Maggiore

After 54 Domus Transitoria

64 Domus Aurea

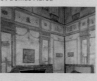

71–75 Templum Pacis
80 Colosseum

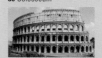

80 Temple of Jupiter on the Capitol
81 Arch of Titus
81–92 Domus Flavia and Domus Augusta...

31 B.C. Victory of Octavian over Mark Antony at the Battle of Actium

20 B.C. Return of the eagles of the legions taken by the Parthians from Crassus

16–9 B.C. Incorporation of Gaul, Panonia, and Germania into the Roman Empire

14–16 Tiberius' Campaign against the German tribes

17 Province of Cappadocia founded

43 Claudius conquers southern Britain

46 Province of Thrace founded

62 Nero begins his tyrannical reign after murdering his mother Agrippina and his wife Octavia

70 Conquest of Jerusalem

78–84 Province of Britain exten... to Scotland

85–89 Battles against the Dacia...

27 B.C. Restoration of the Republic: Octavian is given the honorific title of Augustus

17 B.C. Centenary celebrations of the city of Rome

2 B.C. Augustus receives the honorific title of *pater patriae* (Father of the Fatherland)

A.D. 4 Adoption of Tiberius

14 Deification of Augustus after his death

64 The fire of Rome; persecution of Christians

65 Pisonian conspiracy

68 Suicide of Nero after his condemnation by the Senate

69 Year of the Four Emperors

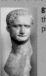

81 Domitian becomes the third Roman emperor from plebeian family, the Flavia...

79 Eruption of Vesu...

96 Domitian assassin... after he claims the *dominus et deus* and or... sacrifices to his st...

Agrippa (63–12 B.C.), son-in-law of Augustus

Horace (65–8 B.C.), poet

Livy (59 B.C.–A.D. 17), historian

Virgil (70–19 B.C.), poet

Thrasyllos (d. 36), astrologer

Ovid (43 B.C.–A.D. 18), poet

Livia (58 B.C.–A.D. 29), wife of Augustus and mother of Tiberius

Agrippina the younger (15/16–59), wife of Claudius and mother of Nero

Seneca (3 B.C.–65), philosopher and tutor of Nero

Lucan (39–65), poet

Petronius (d. 66), writer

Severus and Celer, architects

Pliny the Elder (24–79), writer

Quintilian (35–95), teacher of rhetoric

Flavius Josephus (37–97), Jewish historian and general

Martial (41–100), epigrammatist, writer

Emperors

doptive Emperors

Hadrian (117–138)

Antonines
Antoninus Pius (138–161)

Marcus Aurelius (161–180)

Lucius Verus (161–169)
Commodus (180–192)

Severans
Pertinax (193)
Didius Iulianus (193)
Pescennius Niger (193–195)

Septimius Severus (193–211)
Clodius Albinus (195–197)

erva (96–98)
ajan (98–117)

100 125 150 200

Art and Architecture

97 Forum of Nerva

107–113 Forum, Column and Markets of Trajan

09 Baths of Trajan

3 Restoration of the Forum of aesar, harbor in Ostia

118–125 Pantheon

121 onward Temple of Venus and Roma

134 Mausoleum of Hadrian (Castel Sant'Angelo)

117–138 Villa Hadriana in Tivoli

Athenaeum (first university-like institution in Rome)

141 Temple of Antoninus Pius and Faustina

145 Temple of Hadrian

ca. 161 Plinth of the Column of Antoninus Pius

180 Column of Marcus Aurelius

193 onward Domus Severiana

203 Arch of Septimius Severus

204 Argentarian Arch

ca. 300 Temple of Mithras in San Clemente

Military Campaigns

01–102, 105 Campaigns against the acians. Under Trajan, the Roman mpire reaches its largest extent ith the addition of the provinces of acia, Arabia (106), Armenia, Assy-a, and Meso-otamia 14–117)

132–135 Revolt of the Jews under Bar Kochba; conquest of Jerusalem

The empire pacified by the building of fortresses

The Roman Empire enjoys its most peaceful period under Antoninus Pius

162–165 Parthian War
167–175, 178–180 Marcomanni Wars

195–198 Parthian Wars

208–211 British campaign; Septimi-us Severus dies accompanied by his sons Caracal-la and Geta

Historical Events

6 Nerva chosen as *princeps* by the Senate; dopts the Spaniard Trajan, the first Roman mperor of provincial origin

112 Legal restric-tions imposed on persecution of Christians

Persecution of the Christians (right)

121–125, 126–129 Exten-sive journeys through the empire to inspect its administration

Formation of a legally trained professional civil service in Rome (replac-ing elected officials)

164–180 Plague epidemic in the empire

Septimius Severus, born in North African city of Leptis Magna, founds his claim to rule on his fictitious adopti-on by Marcus Aurelius

176 Commodus becomes co-regent, thus restoring the dynastic succession

Contemporaries

lutarch (46–120), historian, philosopher nd writer

liny the Younger (62–113), writer

ion Chrysostomos ca. 98–120), orator and hilosher

pollodorus of Damascus, rajan's architect

Tacitus (50–116), historian

Juvenal (65–ca. 128), poet

Suetonius (70–130), writer

Epictetus (d. 138), philospher

Lucian (120–180), Greek writer

Apuleius (125–180), writer and traveling orator

Aelius Aristeides (117–180), writer

Galen (129–199), physician to Marcus Aurelius

Dio Cassius (154–229), Greek historian in Rome

Philostratos (b. ca. 170), Greek philosopher

The Roman Emperors and Their Times

Caracalla (211–217)
Geta (211)
Macrinus (217–218)

Elagabalus (218–222)

Severus Alexander (222–235)

Soldier Emperors

Maximinus Thrax (235–238)
Gordianus I (238)
Gordianus II (238)
Balbinus (238)
Pupienus (238)
Gordianus III (238–244)
Philip the Arabian (244–249)
Decius (249–251)

Trebonius Gallus (251–253)
Aemilianus (253)
Valerianus (253–260)
Gallienus (253–268)
Postumus (260–268)

Claudius II Gothicus (268–27
Quintillus (270)
Aurelian (270–275)
Tacitus (275–276)
Florianus (276)
Probus (276–282)
Carus (282–283)
Carinus (283–285)
Numerianus (283–284)

| 225 | 250 | 260 | 280 |

216 Baths of Caracalla

after 218 Temple of the Sun on the Palatine

Catacombs of St. Calixtus

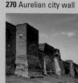

270 Aurelian city wall

270 onward Porta San Sebastiano

212 Caracalla has his brother and co-regent Geta murdered

213, 234–235 Wars with the Germanic tribes

216–217 Parthian War

231–233 Victory over the new Persian kingdom of the Sassanids, who subsequently became Rome's most dangerous enemies

235–236 Germanic campaign

237 Sassanid attack on Mesopotamia

243 Victory over the Sassanids at the battle of Resaina; Antioch regained

246–247 War with the Dacians and Germans

254–256 Frontiers of the empire under threat from attack by the Goths, Quadi, Sarmatae, Parthians, Franks, Alamanni, and Mauretanian tribes

260 Victory over the Alamanni at Milan

268 Victory over the Goths

268, 271 Victories over the Alama

269 Victory over the Goths at the Battle of Naissus

272 Overthrow of the separatist Gallic Empire; restoration of imp al unity

274 Aurelian assumes the title *dominus et deus* and introduces worship of the *sol invictus* and t. imperial cult as the state religior

212 Constitutio Antoniniana: rights of Roman citizenship granted to all free inhabitants of the provinces

220 Elagabalus proclaims the worship of the Syrian sun god

Period of "soldier emperors" crowned by their troops, but usually soon murdered, and constantly involved in struggles to secure the boundaries of the empire

248 The Roman millenium celebrated

249–251, 257–258 Persecution of Christians under Decius and Valerianus

258 onward Financial crisis and increasing devaluation of the coinage in the Roman Empire

260 Edict of tolerance toward Christians

269 onward Army reforms

Claudius Aelianus (175–235), writer

Pontianus (230–235), first Pope; sound evidence exists for the date of his abdication

Plotinus (205–270), Egyptian philosopher in Rome

Diogenes Laertius (300–350), writer of a history of philosophy

Constantine and his Successors

Constantine I, the Great (306–337)

Constantine II (337–340)
Constans I (337–350)
Constantius II (337–361)
Magnentius (350–353)
Julian the Apostate (361–363)

Valentinian and his Successors

ocletian (284–305)
aximian (285–310)
onstantius I Chlorus
93–306)
alerius (293–311)
everus II (305–307)

Maxentius (306–312) Licinius (308–324)
Maximinus II Daia (305–313)

Jovian (363–364)

Valentinian I (364–375)
Valens (364–378)
Gratianus (367–383)
Valentinian II (375–392)
Theodosius I (379–395)

Emperors

300	325	350	375

298–306
Baths of
Diocletian

3 Decennial Plinth

306–310 Basilica of
Maxentius

312 Arch of Constantine

312 1st Lateran basilica

319 1st St. Peter's basilica Mausoleum of Helena

Arch of Janus

3rd quarter of 4th century Mosaics in
S. Costanza

ca. 385 Mosaic in the apse of
S. Pudenziana

422–432 Wooden door of S. Sabina

432–440 Mosaics
in the nave of
S. Maria Maggiore

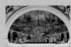

Art and Architecture

troduction of the Tetrarchy:
overnment by two Augusti and
vo Caesares

3 Comprehensive reform of
e empire

7 The empire divided into 12
oceses and 101 provinces

evolutions at home suppres-
d, frontiers of the empire
cured and extended

312 Victory of
Constantine
over Maxenti-
us at the Milvi-
an Bridge

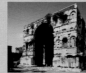

324 Victory of Constantine over Licinius at
Adrianopolis; he becomes sole ruler

Constantine divides the
empire between his
three sons, who fight
each other

330 Byzantium, rena-
med Constantinople,
becomes capital of the
Christian Empire.

ca. 375 Beginning of tribal migrations
from eastern Europe

394 Theodosius reunifies the Roman
Empire

395 After his death it is divided into
Western and Eastern Roman Empires
by his sons; end of the unified empire

476 End of Western Roman Empire after
the deposition of Romulus Augustulus
(475–476)

Military Campaigns

e Roman Empire becomes
absolute monarchy on the
iental model, with god-emper-
s whose subjects are Roman
izens

3–311 Savage persecution of
ristians under Diocletian

The system of the tetrarchy fails
because of the dynastic claims of
the individual rulers

313 Edict of Tolerance of Milan,
giving Christians full religious
freedom and equal rights

337 Constantine converts to
Christianity on his deathbed

Julian, known as "the
Apostate" because of
his secret preference
for pagan worship,
tries to introduce Mit-
hraism as a religion

354 Closure of all
heathen temples

391 Christianity becomes
the state religion

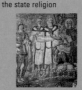

Historical Events

Eusebios (260–340),
author of the first church history

Athanasius (295–373),
Greek Church Father,
Bishop of Alexandria

Cyril of Jerusalem (315–386), Church Father

Ausonius (311–393), poet

Ammianus Marcellinus (ca. 300–ca. 400),
historian

Ambrose (340–397), ecclesiastical teacher
in Milan

Augustine (354–430), Church Father

Contemporaries

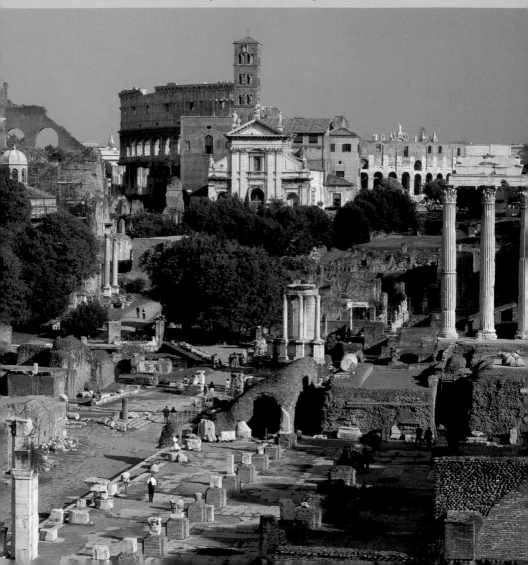

The Forum Romanum (Foro Romano)

The Via Sacra (Sacred Way), which was used for religious and triumphal processions, led to the Forum Romanum, the center of political, religious, commercial, and judicial life in ancient Rome. Originally a marshy valley of no economic use in which the dead were buried, its central position made it the natural focal point of the city when the surrounding hills had been settled. Its early history coincides with the rule of the Tarquins; the fifth king, Tarquinius Priscus, is said to have erected several public buildings in this valley, and most crucial of all installed an extensive drainage system to draw off the water. From then on, the area below the capital began to be divided into two parts with precisely defined functions. The northern area contained the Comitium (place of assembly), where political meetings were held and great popular festivals celebrated. The Curia, where senators met, and the Rostra, the platform from which orators spoke, were built beside it in the 5th century B.C., in the early days of the republic. Further south was the actual market where farmers and tradesmen sold their wares and money-changers offered their services. The Forum

Forum Romanum, view of the ruins

was a place where the gods were worshiped: the earliest temples included the temples of Saturn, the Dioscuri, and Concordia. Other sacred places were the temple of Vesta on the outskirts of the old Forum, the house for her priestesses the Vestal Virgins, and the Regia, the residence of the *pontifex maximus* (high priest).

However, urban architecture in the Forum really began to flourish only in the 2nd century B.C, after the Punic Wars and the conquest of the eastern Mediterranean area, when Rome rose to become the leading world power. Within the space of a few years the face of the city center was fundamentally changed: imposing basilicas were built as markets and law courts, lending the Forum a unified appearance. The building in the early 1st century B.C. of

Giovanni Battista Piranesi, Forum Romanum, 1775, etching

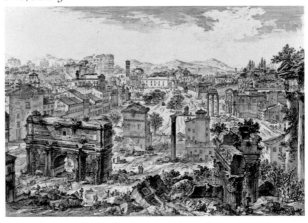

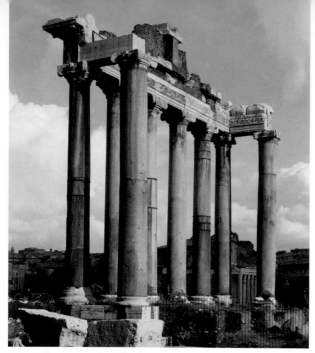

Forum Romanum, Temple of Saturn

moving the Curia and Rostra and rebuilding them on new sites. The building of the Basilica Julia and the reconstruction of the Basilica Aemilia completely transformed the long sides of the Forum. Under Augustus, it was used as a tool of imperial propaganda: the shorter eastern side now included the temple of the deified Julius, with a triumphal arch in honor of Augustus on one side of it and another for the grandson who was his intended successor on the other. Over the centuries the Forum remained what the first emperors had made it: an instrument of dynastic prestige. Most of the later buildings – temples of deified emperors or triumphal arches – made only slight modifications to the structure of the square. Only when the Roman Empire, until then ruled in theory by the partnership of the Senate and the emperor, had legally become a monarchy were radical new building measures undertaken. They included the addition of columns along the southern side, monuments to commemorate the ten-yearly celebration of the introduction of the tetrarchy, and the equestrian statue of Constantine in the middle of the square. With the Column of Phocas, erected

the Tabularium, the Roman state archive, gave the Forum a worthy and magnificent background. Conditions had been created for an organic new design, completed by Caesar and Augustus. However, the political changes under those two statesmen, which turned Rome from a republic into a principality, resulted in a shift both of political functions and of the market area itself. As early as 54 B.C, Julius Caesar had begun extending the Forum northward by building the Forum Julium on the site of the Comitium, a process which involved

in 608 in honor of the Byzantine emperor of that name, the history of the ancient Forum comes to an end.

The Forum then lapsed into oblivion for centuries, but during the Renaissance interest in the ancient classical site revived. However, there were devastating consequences for the old buildings. Previously, they had been protected by a deep layer of soil and thick plant growth, but now intensive exploitation of ancient monuments began both in the Forum and in other parts of the city. The move of the papacy from Avignon back to Rome set off frantic building activity, and there was a demand for all kinds of materials. The Forum was transformed into a stone quarry. Not until the end of the 17th century and the advent of scientific archaeology was there a change of attitude. In 1788 the first excavation of the Forum took place, and at the beginning of the 19th century archaeologists began systematically uncovering the ruins, a program of excavation that is still in progress today.

Reconstruction of the Forum Romanum, watercolor, Soprintendenza alle Antichità, Rome

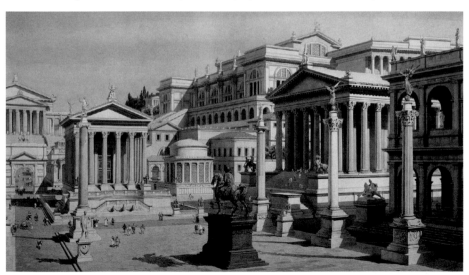

SPQR – the Roman State from the Kings to the Imperial Period

by Jürgen Sorges

The foundations of the Roman state were laid during the legendary period of rule by the seven kings of Rome (said to date from 21 April 753 B.C.). Farmers and landowners who had settled in the area lived side by side with shepherds and craftsmen. Cattle, *pecus*, were the means of exchange used in bartering goods and produce; *pecunia*, the Latin word for money, refers to this historical tradition. After the mid-3rd century B.C. a monetary system displaced the butchers' shops which had dominated the Forum Romanum. The new money-changing booths on the Via Sacra were a clear symbol of the striking changes in the city's economy, which were of course accompanied by political upheavals on a large scale.

Even when the city was first founded the political concept of clan rule (*gens*: clan, group of families) had become less important. It was replaced on the one hand by strong family ties, while on the other the *populus*, the body of citizens from which soldiers were raised, took over the role of the clan. Subsequently, this concentration on military aims played a considerable part in determining the structure of the Roman state. The king (*rex*), appointed with the blessing of the gods, united in himself all state powers in the form of the *imperium*, the power of command, and the *auspicium*, interpretation of the divine will through omens, particularly the flight of birds (hence the word "auspicious"). The King was the supreme army commander, high priest, and judge. His advisers were the assembly of elders (*senatus*) and the clan chieftains (*senes*), who would later become the senators. The people themselves were organized into thirty *curiae* (Latin *curia*, *coviria*: "community of men"),

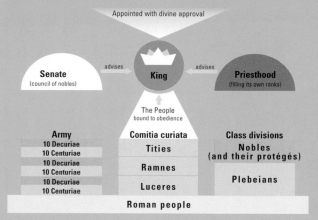

Appointed with divine approval

Senate
(council of nobles)

advises

King

advises

Priesthood
(filling its own ranks)

The People
bound to obedience

Army	Comitia curiata	Class divisions
10 Decuriae / 10 Centuriae	Tities	Nobles (and their protégés)
10 Decuriae / 10 Centuriae	Ramnes	
10 Decuriae / 10 Centuriae	Luceres	Plebeians

Roman people

The head of state during the period of the kings in Rome was the rex, who also held the office of high priest, pontifex maximus. He was advised by the priesthood and the Senate (the council of nobles). The strict separation between the nobility and the plebeians was reflected in the army and the comitiae of the curiae.

divided spatially into three districts or "tribes" (Tities, Ramnes, and Luceres), each of them being subdivided into ten of the *curiae*. This formed the basis of the Roman army: at first each district was obliged to provide one hundred cavalrymen and one thousand infantrymen. Taxation was also based on the same system.

The end of the royal period, generally dated at around 509 B.C., ushered in far-reaching changes: the extended city area was now organized into twenty-one tribes and later into thirty-five. Spatial division of the city rather than a system based on clans finally came in. The assembly of tribes gave rise to the composition of the army, divided up strictly according to five classes of property ownership. In all it consisted of one hundred and ninety-three "centuries" (*centuriae*): they comprised eighteen cavalry units manned by the nobility, eighty heavily armed centuries of hoplites, made up of rich landowners; ninety lightly armed centuries, four hundred engineers and musicians, and one hundred landless men. Only *iuniores* (men up to the age of forty-six) went to war, while their elders, the *seniores*, stayed behind to guard homes, farms, and the city walls. Decisions on

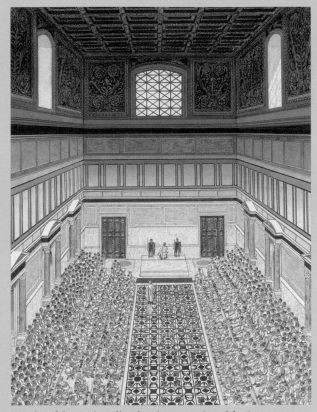

Interior of the Curia Julia, showing a meeting of the Senate, illustration by Peter Connolly, 1998

war or peace were made by the army assembly, which also elected the highest administrative officials, passed laws, and sat in judgement on the citizens of Rome. If the hoplites and the cavalry were in agreement, they automatically had a majority.

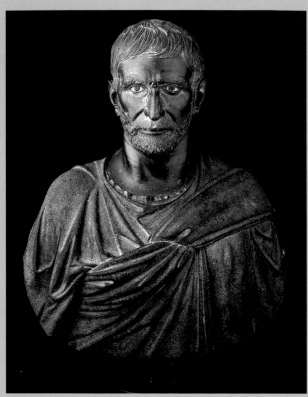

Statue known as the Brutus Capitolinus, date disputed: 4th century
B.C., bronze, h 69 cm, Museo Capitolino, Rome; the only extant
portrait of a Roman from the middle of the republican period

former consuls, and later on plebeians were represented. The Senate initially advised and later instructed the magistrate or supreme head of the city. The magistrate, in his own turn, was elected by the people's assemblies (*comitiae*) of the *curiae*, tribes, and centuries. A special set of rules applied to the plebeian assembly, which elected plebeian *aediles* and tribunes to represent their interests. All holders of the magistrature were elected for one year only, to prevent the return of autocratic rule and despotism. The consuls were in charge of civic finances, the conduct of war, and the judicial system. The *praetors* (judges), subordinate to them and responsible for jurisdiction among Roman citizens, also had unlimited authority. After 247 B.C. they were joined by the *praetor peregrinus*, whose task it was to settle disputes between Romans and foreigners. The censors, who were usually former consuls, and were responsible for the supervision of strict Roman morals and the valuation of property (which determined membership of social classes), were an exception for they were elected for five years. The *aediles* were responsible for the markets, the organization of games and state funerals, main-

At the head of the Roman Republic were the consuls (*consules*), who held the *imperium*, the power to command, for a year. They were assisted by the Senate (of three hundred members), in which the heads of great families,

taining the temples, and policing the city. Finally, the *quaestors* supervised the never-ending flow of money into the state coffers.

Later on the fate of the city was determined by protracted conflicts between patricians and plebeians. Time and again these class struggles brought the *status quo* to a breaking point, and as a result there were modifications to the power of the state. Ultimately, Roman legislation was strengthened: as early as five years after the first version of the famous Twelve Tables of the Law (ca. 450 B.C.), for instance, it was found necessary to lift the ban on inter-class marriages. The introduction of the right to opposition within the magistrature, and above all the institution of the *provocatio*, appeal proceedings conducted in front of the whole citizenry, reinforced the rights of the individual against state autocracy.

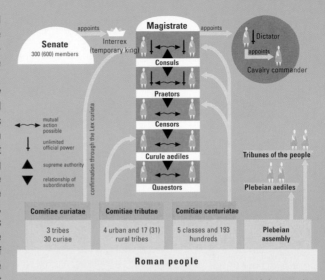

The nobility of Rome, as represented by the Senate, and the people represented by aediles and tribunes, were the foundations on which the Roman republic was based. Comitiae centuriatae (from the army) and comitiae tributae (from the urban districts) were chosen by the people, and elected the administration: the Roman magistrature consisting of quaestors, aediles, censors, praetors, and consuls. The senate confirmed decisions of the consuls, who held office for a limited period, and in times of crisis granted them full dictatorial powers (also for a limited period) or took them itself

Matters such as the remission of debts and restrictions on land ownership (to 135 hectares in 366 B.C.) also called for regular review. In line with the Licinian-Sextian laws, the reform movement of the Gracchi (133–121 B.C.) in particular supported the rights of plebeians. Gifts of provisions and grants of land to the poor, and the restriction of land ownership to 250 hectares, were intended both to guarantee peace and to extend rights of citizenship to the peoples of Italy outside Rome.

During the reign of Julius Caesar there were radical changes in the state: benefit for the poor was restricted to 150,000 (male) citizens, and community constitutions were set up in Italy. The Senate seized state powers only briefly, following the assassination of Caesar (it subsequently defied him).

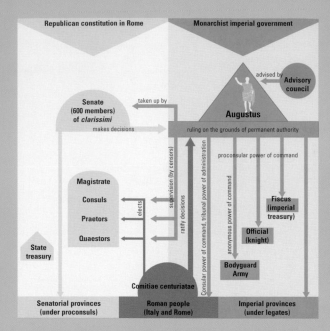

Republican constitution in Rome | Monarchist imperial government

advised by Advisory council

Augustus

ruling on the grounds of permanent authority

Senate (600 members) of *clarissimi* — taken up by

makes decisions

supervision (by censors)

ratify decisions

proconsular power of command

Consular power of command, tribunal power of administration

anonymous power of command

Magistrate

Consuls

elects

Praetors

Quaestors

Fiscus (imperial treasury)

Official (knight)

State treasury

Bodyguard Army

Comitiae centuriatae

Senatorial provinces (under proconsuls) | Roman people (Italy and Rome) | Imperial provinces (under legates)

A distinctive feature of the early imperial period is the coexistence of monarchical power with the remains of the republican constitution as represented by the Senate. While the latter (now enlarged to six hundred members) retained control over the state treasury, the Roman magistrature, and the senatorial provinces, imperial power extended to the army, the newly conquered imperial provinces, and the general levying of taxes. The people had no influence except over the army assembly and the plebiscite (publicly announced demands of the plebeians)

The imperial period began in 12 B.C. with the principate of Augustus. While a monarchical imperial structure with the emperor as ruler (holding the *imperium* for life) developed in the conquered provinces, Rome itself retained its republican constitution. There was constant friction between the emperor and the Senate, which was now enlarged to six hundred members and had to confirm the imperial authority. The emperor held tribunal and consular power for life, but did not regularly perform the functions of those offices.

The supply of grain and the building of roads were exclusively the domain of the emperor, and so was the office of *pontifex maximus*, the high priest of Rome. Under Caligula and Nero the emperors began being deified in their lifetime (prayers were offered to the *genius Augusti*). This development had far-reaching consequences, since it came into force for the swearing in of new recruits, who were thus directly subordinate to the emperor, a state of affairs binding on everyone. The constitution of Diocletian and Constantine of around A.D. 300 finally established the absolutist imperial state. State power was shared by three authorities: the emperor, the court, and the imperial council, which consisted of ministers (the *comitas*) and to which the court administrators were subject. The army of seventy-five legions, with 900,000 men in all, was led by army

commanders (*magistri militum*), while four prefects administered the Roman provinces. The Roman Senate was downgraded to the status of a parliament for the urban community, and the Christian bishop of Rome, as the new *pontifex maximus*, was at first only a local religious dignitary.

This imperial reform, which was aimed to strengthen the empire and negated every republican tradition, and the "emancipation" of the god-emperor mentioned above, formed the basis for all the theories of the divine right of kings held in the medieval European world. It was only the year 1918 that would finally put an end to them.

SPQR (Senatus Populusque Romanus) "The Senate and People of the City of Rome." Traditional inscription over the entrance to the Centrale Montemartini (Via Ostiense), Rome's oldest electricity station (which is now a museum). The street lamps imitate the papal miter.

Forum Romanum

Temple of Antoninus Pius and Faustina, p. 90

Arch of Septimius Severus, p. 82

House of the Vestal Virgins, p. 89

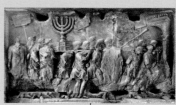

Arch of Titus, p. 94

Basilica Aemilia
(with detail)

The few remains of the magnificent building regarded by the Roman writer Pliny as one of the greatest wonders of the ancient world was an example of the basilica (Greek: "royal hall"), a type of structure that gradually spread from the Hellenistic East to Italy in the 2nd century B.C., and became characteristic of the design of Italian forum. The basilica served as both a market and a law court, and always followed the same pattern: a broad, roofed area was divided into several aisles by rows of columns; the central area was taller than the side aisles, and had large windows in its clerestory. Although it was rebuilt on a number of occasions, the Basilica Aemilia always retained this pattern. Erected in 179 B.C., it was restored several times by the Aemilian family with whose name the building has remained linked down the centuries. However, the renovations of 55–34 B.C. and 14 B.C. were financed mainly by Julius Caesar and Augustus. After the basilica had been severely damaged by fire in the 3rd century A.D. it was rebuilt in its old form, but it finally burned down at the beginning of the 5th century.

Reconstruction

The building, 102 m (335 feet) in length, formerly opened on a two-story Doric portico looking out on to the Forum, with a row of small trading booths known as *tabernae* behind it. A flight of

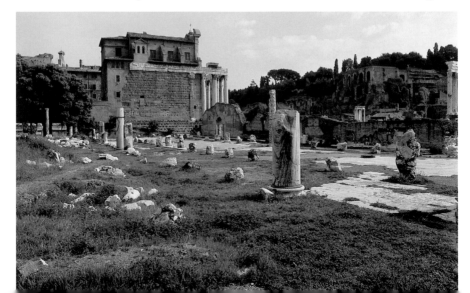

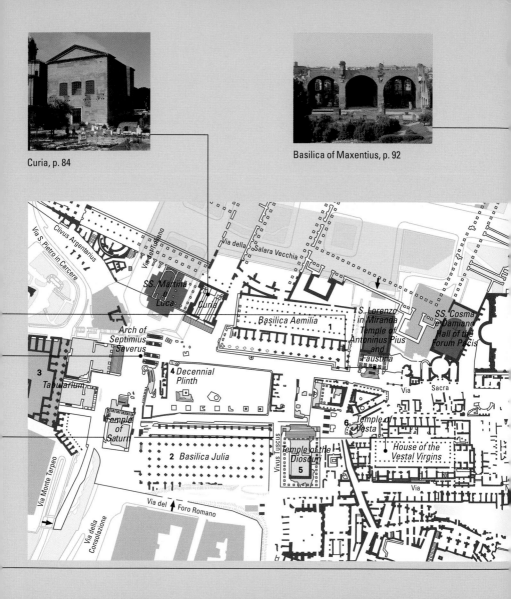

Curia, p. 84

Basilica of Maxentius, p. 92

Via S. Pietro in Carcere

Clivus Argentarius

Via dei Fori Imperiali

Via della Salara Vecchia

SS. Martina e Luca

Curia

Basilica Aemilia 1

S. Lorenzo in Miranda
Temple of Antoninus Pius and Faustina

SS. Cosma e Damiano
Hall of the Forum Pacis

Arch of Septimius Severus

3

Tabularium

4 Decennial Plinth

Via Sacra

Temple of Saturn

Vivus Tuscus

2 Basilica Julia

Temple of the Dioscuri

5

6 Temple of Vesta

House of the Vestal Virgins

Via

Via Monte Tarpeo

Via della Consolazione

Via del ↑ Foro Romano

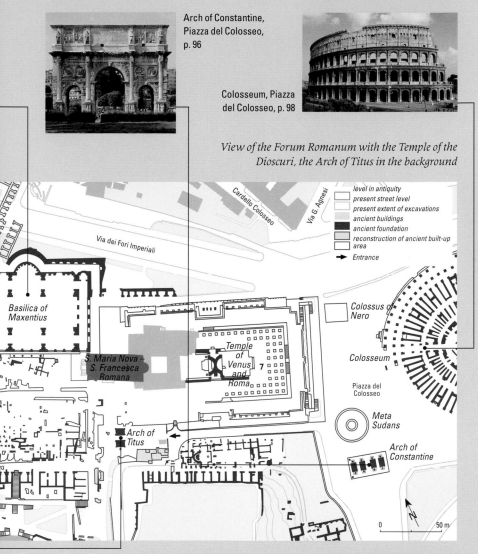

Arch of Constantine, Piazza del Colosseo, p. 96

Colosseum, Piazza del Colosseo, p. 98

View of the Forum Romanum with the Temple of the Dioscuri, the Arch of Titus in the background

Cardello Colosseo

Via G. Agnesi

Via dei Fori Imperiali

level in antiquity
present street level
present extent of excavations
ancient buildings
ancient foundation
reconstruction of ancient built-up area
➤ Entrance

Basilica of Maxentius

S. Maria Nova – S. Francesca Romana

Temple of Venus and Roma

7

Colossus of Nero

Colosseum

Piazza del Colosseo

Meta Sudans

Arch of Titus

Arch of Constantine

0 50 m

N

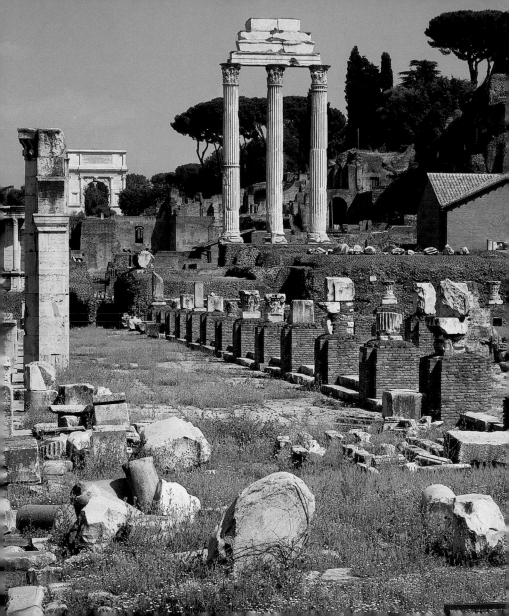

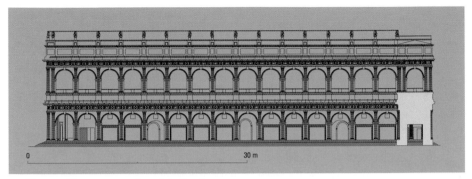

Basilica Aemilia, reconstruction of the façade

steps led to the upper floor at each end. Between the tabernae there were three passageways leading to the four-aisled hall beyond. The central story was surrounded by a gallery. The parts of the building still extant give some idea of its former glory: the floor, the rows of columns, and the interior wall paneling were made of marble in various colors, the architectural compo-nents bore fine ornamentation, and a frieze showing scenes from the early history of Rome adorned the entablature of the three-story central section. Forty statues of oriental figures made the basilica a kind of hall of fame of the Roman people.

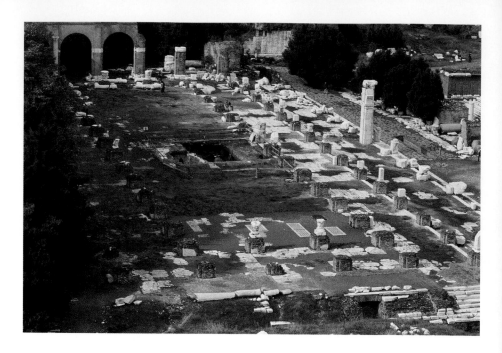

The Basilica Julia

The building to the southeast of the Temple of Saturn, of which only the foundations and the stumps of the columns remain today, was of the same type as the Basilica Aemilia. Julius Caesar had begun building the great basilica, which is named after his family, in 54 B.C., on the site of the old Basilica Sempronia. Augustus completed the building, but it was entirely burned down a few years later. The new building, which he dedicated to his grandsons and to his adoptive sons Gaius and Lucius Caesar, was restored in the 3rd century by Diocletian after another fire. 101 m (331 feet) long and 49 m (160 feet) wide, the building was laid out with four side aisles, and consisted of a large three-story central hall surrounded by two porticoes on all four sides. As in the Basilica Aemilia, it contained *tabernae*, but they were located at the back of the building. The Basilica Julia was a court of law in which the tribunal of the *centumviri* ("hundred men") sat to adjudicate on cases of property ownership and issues of inheritance.

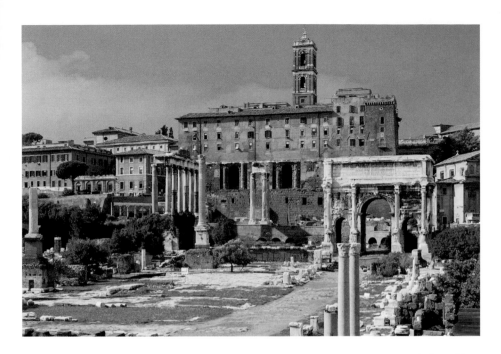

The Tabularium and Temple

The tall substructure and remains of the arcaded gallery of the Tabularium, the ground floor of the senatorial palace since the Middle Ages, rise at the back of the Forum, looking toward the Capitol. Built in 78 B.C., the Tabularium held the state archives of Rome, and its mighty façade towered above the whole northern part of the Forum. A few columns of the temple that used to stand in front of it are still extant: the eight Ionic columns beside the Basilica Julia are from one of the oldest Roman temples, built in honor of Saturn, which used to contain the state treasury (*aerarium*). The remains of the colonnade belong to the portico of the Dei Consentes, dedicated to the council of the twelve highest gods of Rome and restored in A.D. 367. The foundations and the three Corinthian marble columns next to them are from the temple in honor of the deified emperors Vespasian and Titus.

The Arch of Septimius Severus
(Arco di Settimio Severo)

The mighty triumphal arch with three archways, 20.88 m (68 feet) high and 23.27 m (76 feet) wide, is among the best-preserved

monuments in the Forum. According to the dedicatory inscription on the attic story, it was erected by the "Senate and people of Rome" (as indicated by the abbreviation SPQR: Senatus Populusque Romanus) to celebrate the tenth anniversary of the accession of Emperor Septimius Severus and his son Caracalla in A.D. 203. Originally the inscription also mentioned Geta, the second son of Septimius Severus, but his brother Caracalla murdered him after their father's death and had his name removed from all state monuments, a procedure called the *damnatio memoriae*. The arch is faced with marble and bears profuse relief decoration, now badly weathered, celebrating the emperor's victory over the Parthians and Arabs. Beside large statues of Roman soldiers, with Parthian prisoners shown on the plinths, scenes from the two campaigns are depicted on the reliefs above the side archways. The frieze shows the imperial triumph. We know from images on coins that the arch was once surmounted by a bronze quadriga (a four-horse chariot) with the statues of the two mighty emperors.

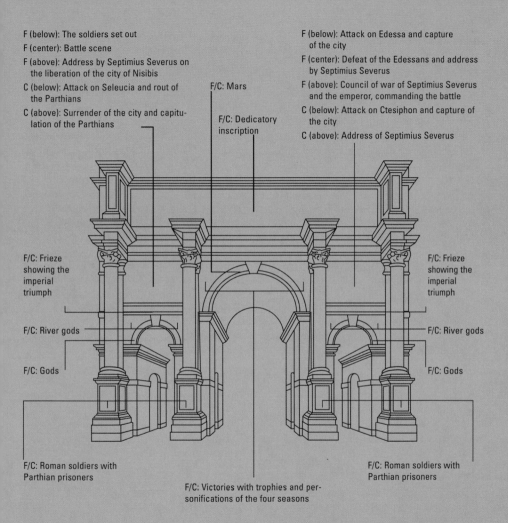

F (below): The soldiers set out

F (center): Battle scene

F (above): Address by Septimius Severus on the liberation of the city of Nisibis

C (below): Attack on Seleucia and rout of the Parthians

C (above): Surrender of the city and capitulation of the Parthians

F (below): Attack on Edessa and capture of the city

F (center): Defeat of the Edessans and address by Septimius Severus

F (above): Council of war of Septimius Severus and the emperor, commanding the battle

C (below): Attack on Ctesiphon and capture of the city

C (above): Address of Septimius Severus

F/C: Mars

F/C: Dedicatory inscription

F/C: Frieze showing the imperial triumph

F/C: Frieze showing the imperial triumph

F/C: River gods

F/C: River gods

F/C: Gods

F/C: Gods

F/C: Roman soldiers with Parthian prisoners

F/C: Roman soldiers with Parthian prisoners

F/C: Victories with trophies and personifications of the four seasons

F: Forum side C: Capitol side
(source see p. 621)

The Curia

The Curia was the meeting house of the Senate, politically the most important organ of the Roman Republic; it exercised rights of supervision over all that went on in the state. Caesar had a new building erected directly beside his own forum to replace the old Curia Hostilia, which was burnt to the ground in 52 B.C. However, the present large brick building dates from its reconstruction under Diocletian, after the great fire in A.D. 283, which devastated the whole quarter between the Forum Julium and the Basilica Julia. Thanks to extensive restoration in the 1930s, the building, which became the church of

S. Adriano in the 7th century, has been returned to its former condition. Originally the lower part of the outer walls was faced with marble slabs, and the upper part with stucco imitating marble. A bronze door leads to the unusually high interior; its original wings were moved to the main portal of S. Giovanni in Laterano in the 17th century. The marble floor of *opus sectile* work and the architectural structure of the walls, with niches for statues framed by columns, date from the time of Diocletian. The senators' seats once stood on the stepped platforms on both sides of the central gangway, and accommodated some three hundred senators voting *per sessionem*, that is to say, those in favor of a motion sat on one side, while those against it sat on the other. There was a large rostrum for the consuls, the highest officers of state, on the narrow side at the back between the two doors, with a statue of Victory donated by Augustus.

The Plutei or Anaglypha Traiani, Early 2nd Century
Marble, h 1.68 m
Relief showing the granting of *alimenta*: 5.26 m
Relief showing the burning of notes of indebtedness: 4.34 m

The Curia contains two large reliefs from the period of Trajan or Hadrian. There is controversy about their original location; they may have been the breastwork of an orator's platform, or a balustrade. Extremely valuable as a contemporary depiction of the Forum,

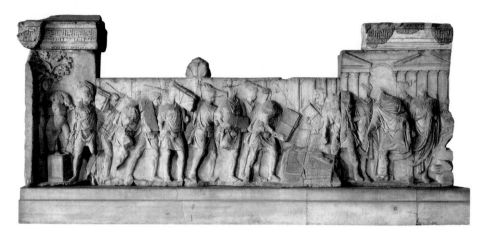

they show official business being transacted: on the relief shown above, taxes are being imposed on the citizens and notes of indebtedness burnt in the presence of the emperor. The relief below shows the granting of *alimenta*, there were loans at a low rate of interest for agriculture, the proceeds of which went to support children who were in need. The back of the relief shows the kinds of animals that were sacrificed at the great Roman festivals: pigs, sheep, and bulls (the *suovetaurilia*).

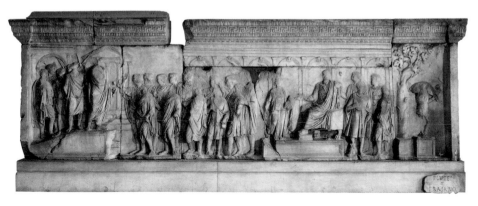

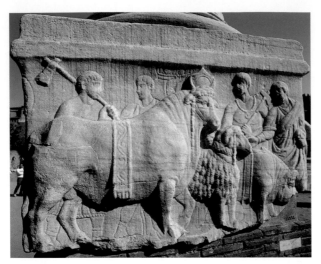

The Decennial Plinth

The Decennial Plinth stands near the Arch of Septimius Severus. It is the marble base of a triumphal column with the figures of two Victories on the front, holding a shield with the dedicatory inscription. According to this inscription, the monument was set up to celebrate the tenth anniversary (decennial) of the tetrarchy – the rule of Rome by four emperors: two Caesares and two Augusti – in the year A.D. 303. A relief on the Arch of Constantine shows us the original setting of the monument: it was one of five monumental columns placed behind the *rostra* and bearing statues. The central column bore a statue of Jupiter, and there were two imperial portraits on each side. The plinth with the dedicatory inscription is also adorned with reliefs on the other sides, depicting sacrifices. A scene of the *suovetauralia* (the sacrifice of a bull, a sheep, and a pig) is followed by one showing Emperor Diocletian offering a libation to Mars, the god of war. The emperor, who is being crowned by the goddess of victory, is accompanied by the *flamen martialis* (priest of Mars), a boy with a box of incense, and a musician with a wind instrument. The figure wearing a toga on the right is the symbol of the Senate (*genius*

Arch of Constantine (detail)

Senatus), and on the left, behind the emperor, are the seated goddess of the city, Roma, and the head of the sun god Sol with his characteristic sunburst of rays. The procession of senators is shown on the third side.

Temple of the Dioscuri
(Tempio dei Dioscuri)

The only remaining parts of the *peripteros*, a temple with a columned hall set on a tall podium, are the 12-m (39-foot) high Corinthian columns beside the Basilica Julia, known popularly as the "Three Sisters." The cult of the twins Castor and Pollux, native to Greece, spread to Rome at the beginning of the 5th century B.C. According to legend, during the battle of Lake Regillus (499 B.C.), when the Romans were fighting the Latins, two mysterious horsemen appeared and helped the Romans to gain victory. Soon after the battle the couple were seen watering their horses at the Spring of Juturna in the Forum; they announced news of the victory to the city, and then disappeared. The people recognized them as the Dioscuri, and

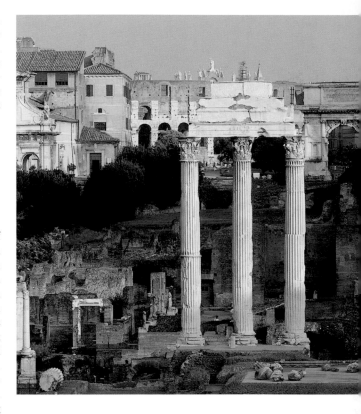

the grateful dictator Aulus Postumius Albinus vowed to build them a temple, which was dedicated by his son in 484 B.C. The monumental remains still visible today are from a later building, of the time of Tiberius (A.D. 14–37). The temple was the headquarters of the office of trading standards, where the official weights and measures of the city of Rome were kept.

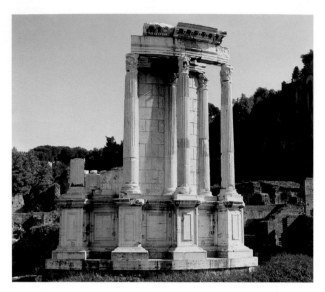

The Temple of Vesta
(Tempio della Vesta)

Opposite the Regia, the residence of the high priest, stood the temple of the goddess Vesta; together with the house of the goddess' priestesses, it formed the Atrium Vestae. Inside the *cella*, the inner sanctuary of the temple, the sacred fire burned as a symbol of the fire in the hearth of the royal palace, the ideological center of the state. Every New Year's Day in Rome, the Romans brought the fire back to their homes, which they had freshly cleaned in anticipation. The sacred fire was originally tended by the king's daughters; this task was trans-ferred to six priestesses in the republican period. The Vestal Virgins, the daughters of distinguished patrician families, entered the service of the goddess when they were between the ages of six and ten. They had to remain in the priesthood for thirty years, and during this time were vowed to chastity. If a Vestal Virgin broke her oath, the punishment was death. On the other hand, the priestesses were granted great privileges: they were no longer under the authority of their fathers, they had considerable financial means, and they enjoyed great respect.

As well as the sacred fire, the temple contained the items that (according to legend) Aeneas had saved from Troy and that were supposed to guarantee the eternal existence of Rome. They included the *palladium*, the ancient idol of Minerva. The small round marble temple set on a high platform, which was once surrounded by twenty Corinthian columns on plinths, dates from a restoration initiated by Julia Domna, the wife of Emperor Septimius Severus, after the fire of A.D. 191. Since it was particularly vulnerable to fire, being the location of the sacred flame itself, there must have been an opening to let smoke out in the middle of the conical roof.

House of the Vestal Virgins
(Casa delle Vestali)

The House of the Vestal Virgins (the only female priesthood in Rome) stands beside the temple of Vesta; its remains also date back to the reconstruction under Emperor Septimius Severus. It consisted of a rectangular courtyard with three pools of water at the center, surrounded by a two-story columned hall. At the sides of the courtyard there were buildings on several floors containing the rooms where the priestesses lived and the domestic offices. Statues of the chief Vestals stood in the porticoes of the courtyard; some of the sculptures and their plinths are still in existence today. On the right of the entrance is a small aedicule, which according to the inscription on the frieze was erected by order of the Senate. The Atrium Vestae continued in existence until the emperor Theodosius officially banned heathen worship in A.D. 391; after that time it was used by imperial and then later by papal civil servants.

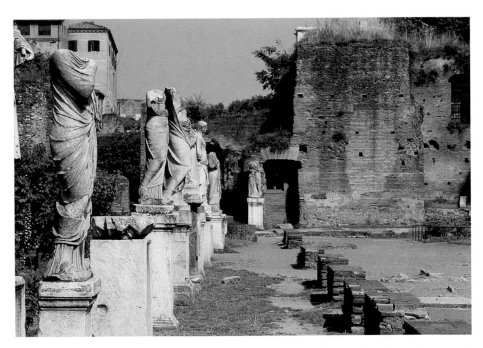

Temple of Antoninus Pius and Faustina
(Tempio di Antonino Pio e Faustina)

North of the Regia, which was the official residence of the high priest, is a large and well preserved temple, whose name is confirmed by the dedication inscribed on the architrave. This temple was erected by Emperor Antoninus Pius in honor of his deceased and deified wife Faustina in A.D. 141. After his death in A.D. 161, the temple was dedicated to him as well. Modifications to the exterior and interior structure go back to the conversion of the building into the church of S. Lorenzo in Miranda (1150). The masonry between the columns, however, was removed again for the visit of Emperor Charles V to Rome in 1536. The Baroque façade dates from 1602. A broad flight of steps leads from the Via Sacra up to the tall podium. There are six columns 17 m (56 feet) high along the façade, with shafts of *cipollino* (Euboean marble) and Corinthian capitals of white marble, and

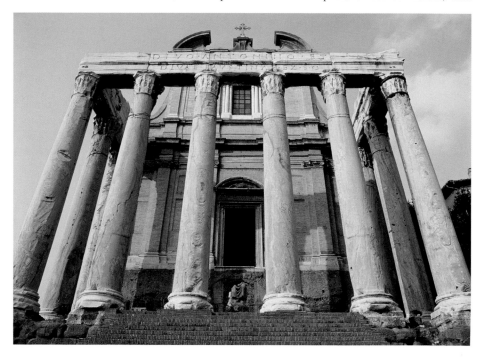

two more columns on the long sides. The frieze of winged griffins, candelabras, and vegetative motifs that adorns the entablature is considered to be one of the outstanding works of Roman decorative art.

Temple of Venus and Roma
(Tempio di Venere e Roma)

Emperor Hadrian commissioned his architect Apollodorus to begin building this temple on the site of the atrium of Nero's Domus Aurea in A.D. 121. It lay within an area contained

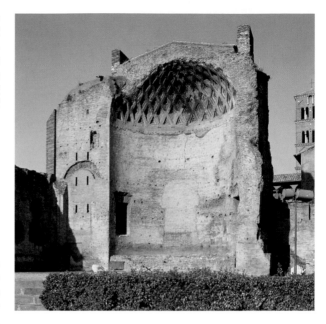

on its long sides by a double row of columns, and rose on a tall podium as an example of the Corinthian *peripteros*, a temple surrounded by a hall with ten columns in front and twenty on the long sides. Inside the hall there were two *cellae*, set back to back, and originally with a flat ceiling. The building acquired its present form, with apses and barrel vaulting, when it was restored by Maxentius in A.D. 307. Large porphyry columns divided up the structure of the walls and contained the apses: small niches for statues framed by columns set on consoles. A floor of colored marble and panels adorned with stucco

work on the ceiling completed the magnificent furnishing of the temple interior. It was dedicated to the tutelary goddess of the city, Roma, and to Venus as patron of the imperial house. In the western *cella* facing the Forum (later incorporated into the convent of S. Francesca Romana, which today houses the Antiquarium Forense) stood the statue of Roma, while the statue of Venus in the eastern *cella* looked toward the Colosseum.

The Basilica of Maxentius
(Basilica di Massenzio)

Three huge barrel-vaulted areas are the only remains of the Basilica of Maxentius, one of the finest buildings in imperial Rome. Visitors to the Forum in antiquity could see it shining from afar, for its roof was once covered with gilded tiles. However, they were removed in the 7th century and re-used in the building of Old St. Peter's. Maxentius begun work on the basilica between A.D. 306 and 310, on the site of a large Flavian complex with store-rooms and other utilitarian buildings. It was completed later, under his adversary Constantine, who made considerable modifications to the original plan by turning the main axis 90 degrees and moving the entrance from the eastern to the southern side. The measurements of the two-aisled basilica illustrate its imposing extent: the central section alone was 80 m long, 25 m wide and 35 m high (262 feet × 82 feet × 115 feet).

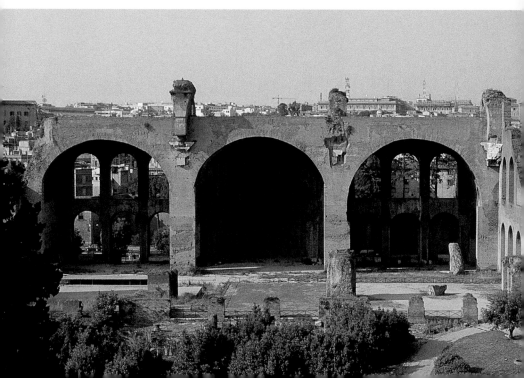

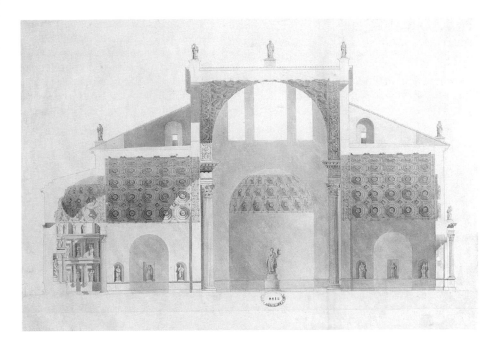

Reconstruction

On its western side, the central area of the Basilica of Maxentius opened into an apse where the remains of a colossal seated statue of Constantine were found; they are now in the courtyard of the Palazzo dei Conservatori. Its size and the principle of its construction, with its mighty groined vaulting, derive from the architecture of the Baths, the central areas of which were also described as basilicas. The magnificent vaulting rested on eight Corinthian marble columns, 14.5 m (48 feet) high, only one of which has been preserved. Pope Paul V had it erected in the square in front of S. Maria Maggiore in 1613. The side aisles were lower, and each was divided into three sections, with barrel vaulting ornamented by panels. On its northern side, the central area ended in an apse with niches for statues in the walls. The apse was marked off by a barrier consisting of columns and grilles, and was used as a law court. Opposite, on the southern side, the entrance built under Constantine led from the Via Sacra up a flight of steps to a portico with four porphyry columns.

The Arch of Titus
(Arco di Tito)

Over the highest point of the Via Sacra rises the oldest extant triumphal arch in Rome. It probably owes its good state of preserva- tion to the fact that it was incorporated into the medieval fortifications built by the Frangipani family. In 1822, when Valadier began restoring it to its former condition for Pope Pius VII, he had to dismantle it first. When he rebuilt it, he replaced any missing material with darker travertine limestone.

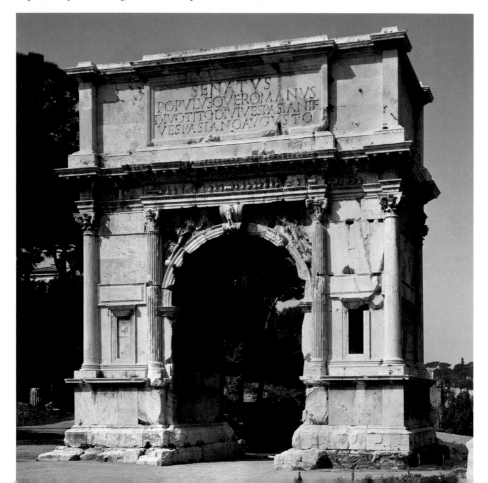

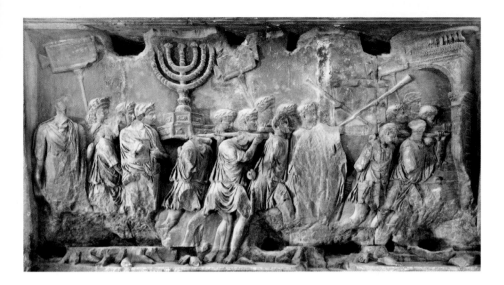

According to the dedicatory inscription on the attic story, the structure, which has a single archway, was built by Emperor Domitian after A.D. 81 in honor of his deified brother and predecessor Titus. It celebrates the suppression of the Jewish revolt in Palestine and the occupation of Jerusalem by Titus and his father Vespasian in A.D. 71. The decorative relief also refers to this event: the outer side of the frieze depicted the triumph of both rulers – only the relief on the eastern side is preserved today – and the spandrels of the arch contained goddesses of victory bearing standards.

Relief Over the Southern Side of the Archway, after A.D. 81
Marble, 240 x 385 cm

Two incidents from this triumph over the Jews are shown in the large areas of relief work above the archway: the southern side shows the start of the triumphal procession. Roman legionaries are carrying valuable items of loot, including the seven-branched candlestick and the silver trumpets from the Temple in Jerusalem. The most important moment of the triumph itself is depicted opposite: Titus, accompanied by his official servants the lictors, stands in the quadriga led by the city goddess Roma; he is crowned with a laurel wreath by Victoria, the goddess of victory.

The Arch of Constantine
(Arco di Costantino)

In gratitude for the victory of Constantine over his co-emperor Maxentius in the Battle of the Milvian Bridge in A.D. 312, the Roman Senate and people erected a triumphal arch in the valley between the Caelian Hill and the Palatine. It lies on the Via Triumphalis, the road along which the triumphal procession passed. With a height of 25.7 m (84 feet) and a depth of 7.4 m (24 feet), it is the largest and best preserved of Roman war memorials. It adopts the triple archway model of the Arch of Septimius Severus, with its structure divided in front by columns, and is very colorful in appearance because of the use of polychrome varieties of marble. Unlike earlier buildings of the kind, however, the Arch of Constantine is not an entirely new creation. Most of its reliefs are taken from older buildings, of the period of Trajan, Hadrian, and Marcus Aurelius. In the process, their imperial portraits were usually replaced by the portrait of Constantine, and sometimes by that of his co-emperor Licinius, updating what were now historical events of the past. The reason for such a procedure lies in Rome's loss of power when its old position as capital of the empire was ceded to Constantinople. A consequence of this political development was the closure of the great sculptors' studios, which had depended mainly on court commissions. When there were not enough sculptors available to work on large public projects, older monuments were demolished and their materials re-used.

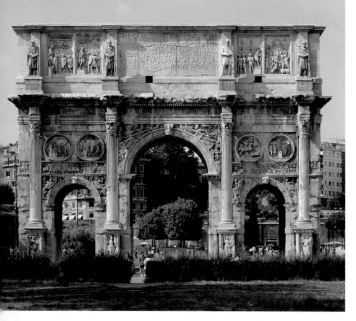

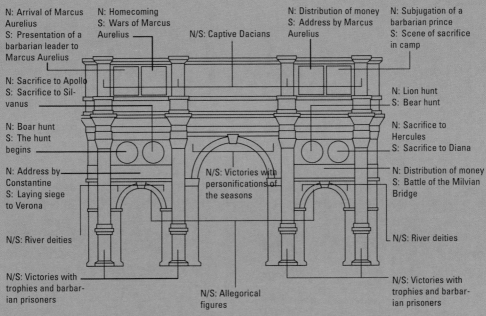

N: Arrival of Marcus Aurelius
S: Presentation of a barbarian leader to Marcus Aurelius

N: Homecoming
S: Wars of Marcus Aurelius

N/S: Captive Dacians

N: Distribution of money
S: Address by Marcus Aurelius

N: Subjugation of a barbarian prince
S: Scene of sacrifice in camp

N: Sacrifice to Apollo
S: Sacrifice to Silvanus

N: Lion hunt
S: Bear hunt

N: Boar hunt
S: The hunt begins

N: Sacrifice to Hercules
S: Sacrifice to Diana

N: Address by Constantine
S: Laying siege to Verona

N/S: Victories with personifications of the seasons

N: Distribution of money
S: Battle of the Milvian Bridge

N/S: River deities

N/S: River deities

N/S: Victories with trophies and barbarian prisoners

N/S: Allegorical figures

N/S: Victories with trophies and barbarian prisoners

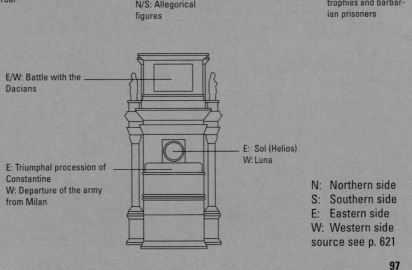

E/W: Battle with the Dacians

E: Triumphal procession of Constantine
W: Departure of the army from Milan

E: Sol (Helios)
W: Luna

N: Northern side
S: Southern side
E: Eastern side
W: Western side
source see p. 621

The Colosseum
(Colosseo)

The Colosseum, in the valley between the Palatine, Esquiline, and Caelian Hills, is now the emblem of Rome. Despite much damage by fires, earthquakes, and looting, it has survived the centuries, and is still impressive today for its literally colossal measurements. It could accommodate over 70,000 spectators to watch gladiatorial contests, animal hunts, and *naumachiae* (mock naval battles). The Amphiteatrum Flavium did not acquire the name Colosseo until the Middle Ages, probably because it was situated close to the colossal statue of Nero, which was 20 m (66 feet) high. Vespasian began building the largest amphitheater in the Roman world in A.D. 72, on the site of an artificial lake that had been in the grounds of the Domus Aurea, Nero's imperial palace. When the Colosseum was inaugurated by his son and successor Titus in A.D. 80, the occasion was marked by festive games lasting one hundred days in which 5,000 animals were killed. The elliptical building measures 188 m (617 feet) along its lengthwise axis and

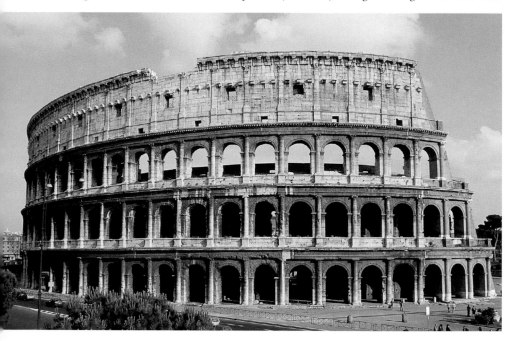

156 m (512 feet) along the transverse axis. Only about two-thirds of the exterior encircling structure (height 50 m (164 feet)), built entirely of travertine, is still extant. The building has four stories, and each of the three lower floors consists of 80 arcades, with half-columns of different orders in front of them – Doric on the first floor, Ionic on the second, and Corinthian on the third. The fourth floor has the structure of an attic story divided up by Corinthian pilasters, with a rectangular window in every alternate section of the wall. Poles to hold the awning that could be stretched over the Colosseum when necessary were once placed in the holes above the consoles.

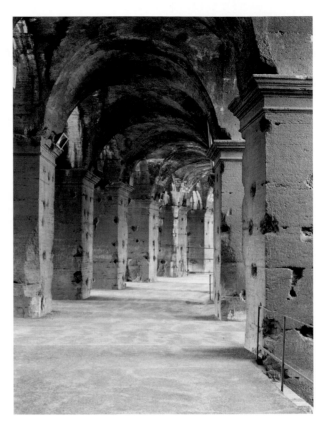

The Interior

Access to the Colosseum was regulated by a well-planned system. Except for the four entrances on the main axes, which were reserved exclusively for privileged persons, all the archways of the arcades on the ground floor were numbered. These numbers matched those on the spectators' entrance tokens (*tesserae*), so that they could easily find their seats, and the auditorium could be rapidly cleared in an emergency. A cleverly devised system of barrel-vaulted passages running around the building, with flights of steps and ramps radiating from them, made quick access possible to any level and to the correct row of seats on it.

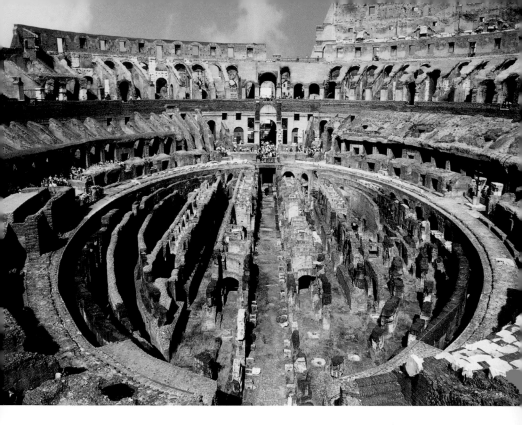

The Auditorium and Arena (with Reconstruction)

The auditorium was divided into five circles, one above another. Entrance to the auditorium was free, but the levels were allotted to distinct groups of the population in accordance with the class structure of ancient Rome. Members of the senatorial class sat directly in front of the arena, with seats of honor at the axes for the emperor and his family, officers of state, Vestal Virgins, and priests. The second level was for knights, and the third and fourth levels for other classes. The top level was reserved for the women spectators. The seats in the first four levels were all constructed of stone, whereas those in the top level were made of wood.

The basement below the arena, which measured 78 by 46 m (256 × 151 feet), was

covered with wooden planks and contained all the equipment necessary for the games: dressing rooms, stage machinery, cages used for housing the wild beasts, and weapons. The thirty niches in the underground enclosure wall had small tackle blocks fitted in them to winch wild beasts and gladiators up to the arena. With the aid of a system of pulleys and counterweights, all kinds of scenery could be lifted up into the arena over sloping ramps, so that a landscape setting of hills or woods could be created for animal hunts.

The Roman people were able to satisfy their hunger for *panem et circenses* (bread and circuses) in the arena until the year A.D. 523. The last known games were held under the reign of the Ostrogoth king Theodoric (A.D. 473–526). The Colosseum lay abandoned during the Middle Ages, and only an apocalyptic prophecy by the Anglo-Saxon monk Bede recalled its former importance: "Rome will stand as long as the Colosseum stands; if the Colosseum falls, Rome will fall, and if Rome perishes the world will end." In the Middle Ages, the noble Roman family of the Frangipani were responsible for converting the Colosseum into a fortress, and later, like many other ancient buildings, it was principally used as a stone quarry. It was only when the monumental building was made into a memorial to Christian martyrs in 1744, and a bronze cross erected in the arena, that it was preserved from further depredations. In the near future the underground passages of the arena will, however, no longer be exposed, but will be covered by a wooden floor as they were in classical antiquity.

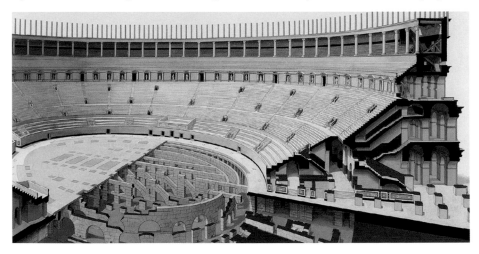

The Colosseum – Gladiatorial Combat and the Persecution of Christians

by Jürgen Sorges

Habet! Hoc habet! – "He has it! Now he has it!" Feelings run high in the Flavian amphitheater. The *lanista*, the referee in the arena, quickly parts the combatants with his long staff. A trumpet call halts the single combat as a severely wounded gladiator falls to the ground. Showing no emotion, the defeated man makes a ritual gesture, asking the *editor*, the man who is holding the games and sits in the grandstand, to grant him his life, the *missio*. The *editor* immediately encourages the enthusiastic fans of the games in the audience to decide on the loser's fate themselves, by turning their thumbs up or down. Today they do not grant mercy, for the young gladiator has not yet made himself a name with the public. The principal referee, known as Charon after the underworld ferryman of Greek mythology, then takes a hot branding-iron and presses it on the man's lifeless body. The fight to the death is over. Impaled on a hook, the corpse is dragged out of the Colosseum through the *porta libitina*, the Gate of Executions. The spectators, satisfied, stream out through the *vomitoria* (ways up to the auditorium) to one of the seventy-six exits, which are colorfully painted and have stucco decoration.

This would have been a standard day in the Colosseum. In the morning there were animal fights or hunts, the *venationes*; it took great logistical skill to keep the whole affair running smoothly. The basement floor was built on the

Rome mosaic showing gladiators and a man fighting a leopard, 4th century A.D., Galleria Borghese, Rome

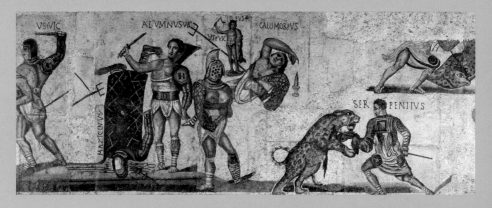

foot-thick concrete foundations of the Colosseum, which covered the site of an artificial lake in Nero's Domus Aurea; this basement was 6 m (20 feet) deep, 75 m (246 feet) long, and 44 m (144 feet) wide, and resembled an underground Noah's Ark. In the central passage there were wooden ramps that could be folded down to provide the beasts of prey with access to the arena. Winches opened up cages in the five narrow lateral corridors. Gangplanks and elevator shafts led to sixty-two mechanically operated trapdoors let into the wooden floor of the arena, each measuring 1.5 by 0.6 m (5 x 2 feet), so that leopards and young bears could appear in the ring as if by magic. Mechanical lifting platforms brought many a gladiator and *deus ex machina* up to the sand of the arena instantly.

Ludi, ludi, ludi – games, games, games! This section of a calendar shows the importance of games to the Roman festivals, ca. A.D. 25, marble, Museo Cincio, L'Aquila

Public executions took place at noon, when the sun was at its highest. At this time of day the sun blazed straight down through the oval opening in the awning, which provided shade. One thousand marines hoisted and reefed this vast awning (which weighed 24.4 tons) above the 70,000 spectators, over 50 m (164 feet) up in the air. They also sprinkled water and perfumed essences over the crowd, who had been guided to their numbered seats on the four levels of the auditorium by a cleverly devised system of entrances, passage ways, and stairs.

The executions usually took the form of the *damnatio ad bestias*. The act of throwing human beings to wild beasts to be eaten was not regarded as uncivilized, but was staged as a cynical "theater of reality:" scenery referring to classical myths and legends provided relevant settings.

The afternoon was the time for the *munera*, the gladiatorial combats. The fighting men left the *ludus magnus*, the barrack-like gladiatorial school only sixty paces away from the Colosseum, passing through a tunnel to what, after the pyramids, was the second largest building in the ancient world: the oval marble structure was 188 m (617 feet) long and 156 m

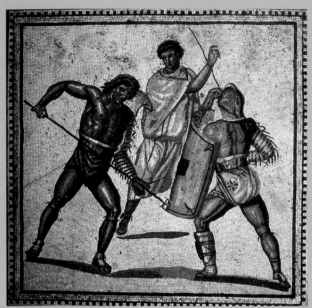

One-on-one combat between gladiators: right a secutor, left a retiarius, with a lanista (referee) in the middle holding his sign of office, a long staff. Mosaic from the Roman villa at Nennig, 3rd century A.D.

(512 feet) wide. The gladiators made their ceremonial entrance through two gates reserved solely for them, and addressed the occupant of the imperial box: *Ave Caesar! Morituri te salutant!* After those prepared to die had thus greeted their emperor – who, like Julius Caesar (100–44 B.C.) or Marcus Aurelius (A.D. 121–180), might well be leafing through state papers and feeling bored – the show began with the *prolusio,* mock fighting with blunted weapons to put the audience, who were seated strictly according to social class, in the right mood. A trumpeter signalled the beginning of the real fights, which often took place to the accompaniment of music on the water organ.

Up to twenty different kinds of gladiators fought, either in groups or in single combat. Some were *essedarii,* warriors of the British type in small chariots. Archaeological finds of equipment have made the Samnites the best known category today; the Samnite wore a mighty helmet with a crest and visor, and carried the short sword (*gladius*) of the Roman legionary, and a long rectangular shield. Men armed like Gauls carried large convex shields and slashing swords with long blades. They fought helmeted "Thracians," who carried square shields and fought with curved swords. The *retiarius* (net fighter) used a net and trident, the insignia of the fisherman's craft. The *secutor* carried a *gladius* and *scutum,* the short sword and shield of the Roman legionaries, and wore a *manica* (arm guard) and a helmet.

Between the beginning of the gladiatorial games in 264 B.C., and their final banning in A.D. 404 (though in fact there were later games) thousands, including many Christian martyrs, lost their lives in the Colosseum. Before their inauguration in A.D. 80, these deadly "games" had been held in other arenas, including the Circus

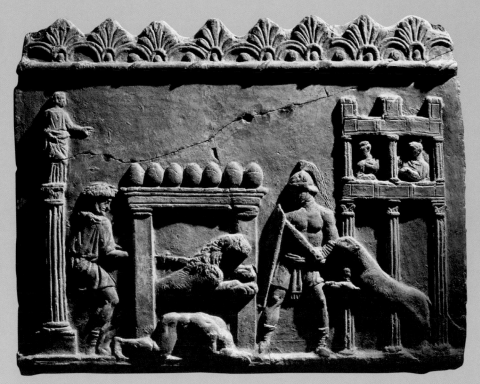

The beginning of an animal fight. A lion is let into the arena, where a heavily armed gladiator is waiting. Some of the audience watched the show from boxes (above right). Roman relief, 1st century B.C.– 1st century A.D., Museo Nazionale Romano, Rome

Maximus. During the period of the Roman Republic politicians used them as a method of contesting elections: the people voted for whoever laid on the best show and the most famous gladiators. According to the historian Livy (59 B.C.–A.D. 17) the *munus*, originally a religious funeral rite for noblemen, soon became a popular entertainment. During the imperial period gladiatorial combats degenerated into mass spectacles, attracting enthusiastic audiences in over 170 arenas throughout the empire. The satirist Juvenal (ca. A.D. 65–ca. 128) summed up these *ludi* or games: the provision of *panem et circenses* ("bread and circuses," the basics of life and mass entertainment) was a cynical way of keeping the populace happy and the empire intact.

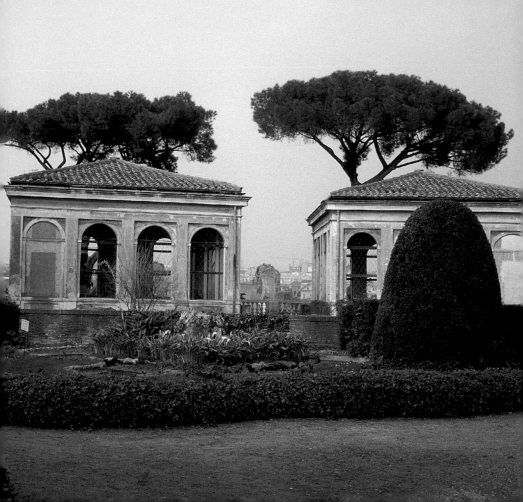

The Palatine (Palatino)

The ancient road of the Clivus Palatinus leads from the Arch of Titus to the Palatine, which had enjoyed special status from time immemorial because of its central position among the seven hills of Rome. According to legend, Greeks from Arcadia settled here at an early date, led by Evander and his son Pallas. Romulus, wrote the poet Virgil, met them when he too settled on the Palatine and so founded the city of Rome. Here legend and history are in agreement: the remains of an Iron Age house on the southwest side of the hill confirm the tradition of the Casa Romuli, which was believed to be the home of the city's founder, and was rebuilt again and again. A sacred cave below the Palatine was venerated as the Lupercal, the place where Romulus and Remus were said to have been suckled by a she-wolf. Other deities and their cults were later introduced to the Palatine: Cybele (a goddess of Asia Minor), Vesta, and the Greek god Apollo. During the republican period, the hill became the favorite residence of the Roman upper classes, as the remains of imposing dwellings such as the Casa dei Grifi still show today. Emperor Augustus brought radical changes to the appearance and importance of the Palatine, where he built a temple linked to his own palace in honor of his patron the god Apollo. Subsequently, the Palatine became the imperial residence: in succession, it saw the building of the palaces of Tiberius, Nero, the Flavians, and Septimius Severus. They finally merged into a great complex of buildings that looked like a single imperial palace. (The term "palace" itself is derived from the name Palatine.) Even today, the ruins convey a vivid impression of the former magnificence of the complex, although it is very difficult to distinguish between the various different levels of construction because of the frequent conversions and rebuilding in later periods. Besides churches and monasteries, the Roman family of the Frangipani built a fortress here in the Middle Ages, and in the late Renaissance the nobility favored it for its extensive gardens and vineyards, of which the Farnese Gardens, the *orti farnesiani*, are still impressive evidence today.

Giovanni Battista Falda, View of the terraces in the garden of the Prince of Parma on the Palatine, 17th century, etching

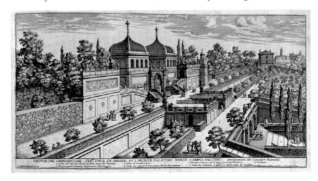

View of the Palatine

The Palatine

Domus Flavia, p. 123

House of Livia, p. 114

House of Augustus, p. 116

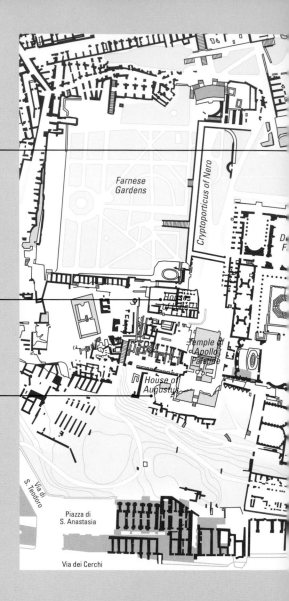

Farnese Gardens

Cryptoporticus of Nero

D F

House

Temple of Apollo Palatine

House of Augustus

Via di S. Teodoro

Piazza di S. Anastasia

Via dei Cerchi

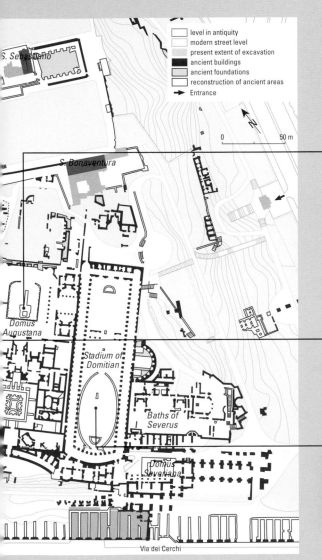

S. Sebastiano

S. Bonaventura

0 50 m

Domus
Augustana

Stadium of
Domitian

Baths of
Severus

Domus
Severiana

Via dei Cerchi

Domus Augustana, p. 125

Museo Palatino, p. 117

Stadium of Domitian, p. 125

Ab Urbe Condita – the Mythological Origins of Rome

by Jürgen Sorges

Rome, as the proverb says, was not built in a day, and there are many legends about the origins of the Eternal City. The latest version has been put forward by Roman feminists linking the emblem of the city of Rome, the Capitoline She-Wolf, with another *lupa*, a she-wolf of a very specific kind in antiquity: this was the term applied by the people of ancient Rome to the city's many prostitutes. The places where they worked, called *lupanari* (she-wolves' caves), were distributed all over the city. During the

imperial period the basements of stadiums and amphitheaters were particularly popular for this purpose. Of course this interpretation of the maternal animal said to have suckled the twin founders Romulus and Remus is meant to be a provocative hypothesis, but it cannot be dismissed out of hand any more than it can be definitely proved.

Attitudes towards the myths on the founding of Rome were always influenced by strong emotion, for the answers to some very explosive questions were connected with these legends. For instance, the rulers of Rome from Augustus onward made the oracular pronouncements of the Sibyls the basis of their policy. These ancient divine oracles were venerated by the Roman people, and were thus an effective method of enlisting religion in support of political decisions.

By the time of the historian Livy (59 B.C.–A.D. 17), one of the most important of the Roman historians, it had become difficult to reconstruct the early period. This was because the fire after the plundering of Rome by the Gauls in 390 B.C. had destroyed a large part of

The Capitoline She-Wolf, 5th century B.C., bronze, 75 × 114 cm, Museo Capitolino, Rome. The figures of Romulus and Remus were added in the 15th century by the sculptor Antonio Pollaiuolo

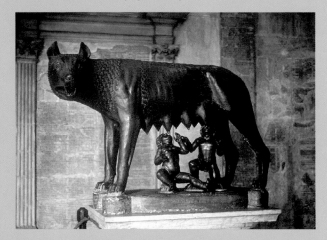

the archives. Oral tradition and the annals, the chronicles for every year recorded by the *pontifex maximus* (high priest), formed the basis of Roman history. But as Livy himself pointed out, most of the annals had been written in retrospect, over three centuries after the event. Using these unreliable sources as evidence, however, the strong "annalists" faction dated the founding of Rome to April 21 753 B.C.

In classical antiquity the Roman people believed every word of the traditional legends, and they found plenty of concrete evidence to support the tale of the twin brothers Romulus and Remus. The she-wolf's cave, the Lupercal, was identified as a site between the Palatine and the Circus Maximus, and was venerated at regular intervals. According to popular tradition, a swampy area (*velabrum*) along the Tiber, near the present church of San Giorgio in Velabro, was the place where the twins, exposed in a basket, had been washed up. The "House of Romulus" on the Palatine was a sacred place, and is today thought to be the remains of an Iron Age settlement of the 9th to 8th century B.C. It was frequently rebuilt and improved in classical antiquity. The traditions of the annalists are still with us today: when the holes to contain the piles supporting three tiny huts were found in 1948 on the Germal, a foothill of the Palatine, scholars were quick to connect them with the story of the shepherd Faustulus who, with his wife, was supposed to have brought up the twins. The Romans venerated the "tomb of Romulus" thought to lie beneath the Lapis Niger in the Forum Romanum, and were correct in so far as recent studies actually do identify this area as a graveyard, outside the gates of the nucleus from

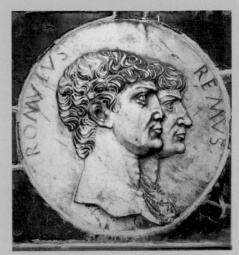

An artistic fantasy of classical antiquity: double portrait of the twins Romulus and Remus. Marble relief dates from the imperial Roman period

which Rome would grow, then only a settlement surrounded by a palisade on the Palatine. Evidence has even been found to corroborate the legendary Rape of the Sabine Women: Lake Curtius in the Forum was identified as the abyss into which Curtius, a Sabine warrior, disappeared with his horse during a battle against the Romans; the Tarpeian Rock, Rome's most famous place of execution, was called after the girl Tarpeia who undertook to betray Rome to the Sabines; and Antemnae, one of the three Sabine villages which lost their women, really was only ten kilometers (6.2 miles) from the Palatine. Around 1985 archaeologists found the remains of the settlement on the Via Salaria, below the military complex on Monte Antenne.

Matthias Merian the Elder: Romulus and Remus Determining the Site of the City from the Oracle of the Flight of Birds, 1630, engraving, Sammlung Archiv für Kunst & Geschichte, Berlin

truth in it. Julius Caesar claimed that he was descended from Julus, the eldest son of Aeneas, who was better known by the name of Ascanius. And Augustus made clever use of the prophesies of the Cumaean Sibyl, which had led Aeneas to Latium: the wanderings of Aeneas, and the connection thus established between Troy, Carthage, and Rome, provided an ideal justification for Roman hegemony in the Mediterranean area. Fulfilment of these divine oracles ultimately made the rulers of Rome to be gods themselves.

Another body of opinion, even in the time of Livy, promoted Aeneas as the founder of Rome. Who wanted to be descended from Romulus, an illiterate cattle thief, when other nations could boast of poets like Homer and countless warrior heroes? The general trend to Hellenization demanded myths going further back into the past to provide documentation of Rome's superiority even at an early date. Nothing was more natural than to make the cultivated Trojans, in legend the great enemies of Greece, into the ancestors of the Romans. The neighboring Etruscans had already emphasized their own origins in the eastern Mediterranean. The *Aeneid* of Virgil (70–19 B.C.) is therefore only the culmination of a hypothesis cultivated by historians over the centuries, and even the most sceptical critics eventually accepted that there was a grain of

An archaeological find only 24 cm (9.4 inches) high, made in 1877 near the Etruscan city of Caere (now Cerveteri), takes us back to the early history of Rome: the Tragliatella Pitcher is now exhibited in the Sala del Camino of the Capitoline Museums. This locally made vessel, which has been dated to around 620 B.C., depicts a social custom for which there is evidence in inscriptions dating from the 3rd century B.C. at the latest, and which Virgil describes in detail: the *troiae lusus*, the "Troy Game." This "dance," performed on foot and horseback, was not confined to funeral rites. Since the time of Augustus the ritual equestrian game performed annually by boys approaching manhood had been part of the celebrations of the founding of the city of Rome. The Latin word *truia*, however, meant an arena or battle ground, and had nothing to do with the

ancient city of Troy. Two steps forward, one step back: this dance of initiation for young men dates from very ancient times, but Aeneas is unlikely to have known it.

Modern archaeologists have found traces of settlements in Rome dating from as early as the 12th century B.C. The first were on the Palatine, the Esquiline, and the Caelian Hills, and there is evidence for settlement on the Quirinal too in the 8th to 7th centuries B.C. If there ever was a historical Romulus, he lived around 650 B.C., at the time when the various nuclei that became Rome merged. And it is possible that the founding of the city was as violent as it appears in the account given by Plutarch (ca. A.D. 46–120):

Romulus, according to Plutarch, plowed a furrow that formed a trench marking out the boundary of the new settlement. The soil thrown up and piled inside the boundary formed the foundation for a wall of palisades. Romulus marked the position of the city gates by raising the plow when he reached that spot. According to ancient custom, a new community had now been created, surrounded by a *pomerium*, a sacred boundary, which now formed the dividing line between town and country, culture and nature, peace and war, intellectual pursuits and the trades of agriculture and stockbreeding. Carrying weapons inside the *pomerium* was forbidden. But Remus, making light of the ban, jumped the wall, thus desecrating the divinely ordained ritual of the founding of the city. Thereupon Romulus in a fit of anger struck down his brother, and in doing so he became the sole ruler of the new settlement.

The coexistence of the Roman people was thus based on two violent acts: a fratricide (represented by the murder of neighboring settlers) accompanied by the breaking of a sacred treaty. For the famous Rape of the Sabine Women, in historical terms, in fact denotes the forcible seizure of the salt trade from the Sabines who were living on the Via Salaria – and that trade was the real source of Rome's power.

Nicolas Poussin, The Rape of the Sabine Women, before 1665, oil on canvas, 157 × 203 cm, Musée du Louvre, Paris

The House of Livia
(Casa di Livia)

The southern end of the Cryptoporticus of Nero, with its artistic stucco relief ornamentation, once adjoined a group of republican houses, one of them known as the House of Livia because a lead pipe bearing the name of the wife of Augustus was found there. A rectangular courtyard surrounded by pillars is extant, as well as three rooms which are well worth seeing for their fine frescoes in the Second Pompeian style (ca. 30 B.C.). The right-hand wall of the central *tablinium* (sitting and dining room) is the best preserved. Its structure suggests a stage set: Corinthian columns divide the wall surface into three areas. The white columns on their tall plinths seem to be standing in front of the dark red wall and supporting the coffered ceiling, which is depicted in convincing perspective. Small genre pictures, depictions of griffins, and winged deities are painted above projecting cornices half way up the walls. Openings painted in the side sections show architectural scenes (in perspective) containing figures, while the central area depicts a mythological scene: Io, the lover of Zeus, seated under a column bearing the statue of a goddess, is being watched by Argus on behalf of the jealous Hera, Zeus' wife. The messenger of the gods, Hermes, is approaching from the left to rescue Io. The middle of the narrower wall is adorned with a depiction of Polyphemus and Galatea, unfortunately badly damaged. A small Cupid is holding the mighty Cyclops by his reins, so that he can only cast a longing glance at the fair Galatea, who mocks him from the back of her seahorse. The walls of Room E on the right are divided into simple geometrical areas by representations of columns at the front, with garlands of foliage and fruits hanging from them. Above them is a narrow frieze on a yellow ground (*fregio giallo*), with Egyptian scenes in an impressionistic style, in accordance with the taste of the times.

House of Livia, wall of Room E with the "fregio giallo," ca. 30 B.C.

House of Livia, the "tablinium," fresco showing Io, Argus, and Mercury, ca. 30 B.C.

The House of Augustus
(Casa di Augusto)

To the south of the House of Livia, excavations have uncovered the remains of other republican houses, as well as a large complex of buildings with small living rooms on the western side and an imposing reception area to the east, known as the House of Augustus. It is now thought that if, as Suetonius says, Augustus bought further plots of land and buildings after acquiring this complex, then the whole district, including the House of Livia, must have been in the emperor's hands.

Room of the Masks (*Ambiente delle Maschere*), ca. 30 B.C. (Detail)

The illusionistic frescoes of the period around 30 B.C. have been preserved in two of the small rooms in the west wing. The walls of the room, which is known as the *Ambiente delle maschere* (the room of the masks), have frescoes on three sides showing architecture, resembling complex stage sets with theatrical masks half way up. Instead of the central door, which is usual on stage, each wall has a picture showing a rustic temple. In the next room a mural on the upper part of one wall shows a court with a columned hall.

The Museo Palatino

The convent of the Suore della Visitazione was built in the 19th century on part of the ground on which the Palazzo dei Flavi was situated. The Museo Palatino occupies the building today, and here many murals, sculptures, and other archaeological finds from the Palatine are on display.

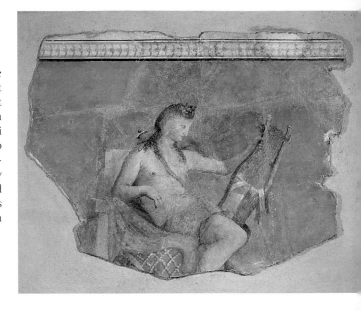

Fresco of Apollo, Late 1st Century B.C.–Early 1st Century A.D.
Fresco, h. 56 cm, w. 69 cm, 27 B.C. – A.D. 14

One of the exhibits in the Museo Palatino is a fragment of a mural on a blue ground, showing Apollo, which may be regarded as a typical example of the classicism of Augustan art. The god sits bare-chested on a throne, holding his cithara in his left hand. Before him stands the Omphalos of Delphi, covered with a network of lines and symbolizing the navel of the world. Apollo was the patron deity of Augustus, who thought he owed his victory over Mark Antony at the Battle of Actium in 31 B.C. to the god. The emperor built a magnificent temple in honor of Apollo next to his own house between 36 and 28 B.C., and it is likely that that the fresco was originally in this temple. Augustus wished the Palatine to become a religious center equal in importance to the Capitol, and therefore had the Sibylline books, so important in Roman religion, moved from the temple of Jupiter Capitolinus to the temple of Apollo. In addition, he erected a shrine to Vesta in his house, since as the newly elected *pontifex maximus* (high priest) he had to reside near the sacred fire. This was a principal part of the cult of Vesta and symbolized the center of the state.

The Museo Palatino

Painted terracotta slab from the temple of Apollo: Apollo and Hercules disputing possession of the Delphic tripod, 27 B.C.–A.D. 14, Augustan period

Reconstruction of an archaic house

Ground floor

Painted terracotta vessel from the gable of the temple of Victory, 3rd Century B.C.

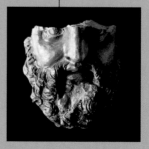

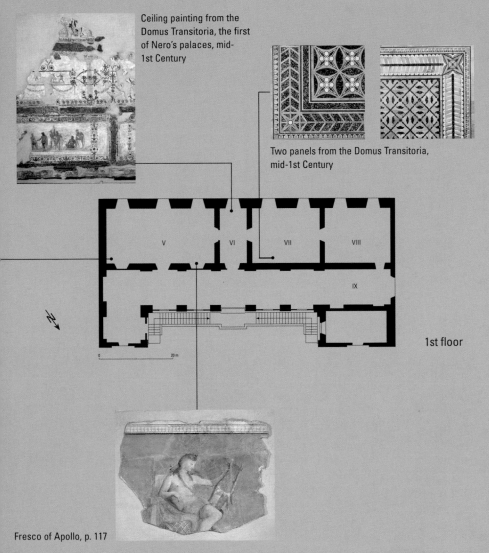

Ceiling painting from the Domus Transitoria, the first of Nero's palaces, mid-1st Century

Two panels from the Domus Transitoria, mid-1st Century

V

VI

VII

VIII

IX

0 20 m

1st floor

Fresco of Apollo, p. 117

Ancient Wall Coverings – the Forms and Techniques of Roman Murals

The Romans imitated the Greek custom of plastering and then painting walls. Even today, the specimens of Roman mural painting that have been preserved in the towns of Pompeii and Herculaneum, near Mount Vesuvius, give the visitor some idea of the wealth of color that once distinguished the houses, palaces, and villas of antiquity. To the modern viewer, their use of color and their technique are equally impressive, for the paintings lost little of their former brightness during the period of nearly 2,000 years before they were rediscovered and excavations were begun in the mid-18th century. Only oxidation, weathering, and modern environmental influences have gradually caused them to fade.

The walls are dominated by the basic colors of ocher, blue, black, and Pompeian red, which were mixed to produce other shades. Scholars are still not quite sure how the characteristic Pompeian red pigment was made. However, Roman authors of the imperial period, such as the architect Vitruvius and the writer Pliny, provide detailed information on various painting techniques. Before a wall could be painted it had to be perfectly smooth, without cracks or other flaws. To achieve this effect, increasingly fine layers of plaster – at least three of fine sand plaster and three of marble plaster – were applied to the

Fresco in the First Style, Casa dei Grifi, Antiquarium Palatino, Rome

Style

Second Style

Third Style

Fourth Style

background as it dried, and the surface was then finished with hard, durable marble stucco (made from pulverized marble). Before the painting could be executed, in watercolors, the support surface had to be moistened, as in later fresco techniques. Vitruvius describes the method: "If the colors are applied when the plaster is still wet, they will not flake, but will last well, since after the moisture has been boiled out of the lime in the kiln, and porosity has rendered it powerless, its thirst forces it to absorb everything with which it happens to come into contact." The pigments were made from mineral and animal substances, mixed with water and bound with glue, milk, egg, or gum. Finally, the painters burnished their completed work well with Punic wax.

The paintings thus preserved, which always imitate architecture, have different decorative forms that were classified in the late 19th century as belonging to four styles, on the basis of the many finds from Pompeii. Today, archaeologists regard this division less as a firm chronological framework than as an aid to description, since several systems of decoration could co-exist. The colorful mural painting of the First Style (2nd century B.C.–80 B.C.), also called the panel style, uses plaster, stucco, and pigments to imitate a marble wall of rectangular blocks rising above a base course, sometimes with columns painted in front of it. The key feature of the Second Style is its attempt to enlarge a room by illusionistic means. The wall surface seems to retreat behind three-dimensionally painted columns or pilasters on a cornice above the base course, then to open up to architectural views. The Third Style came in at the end of the 1st century B.C., enhancing the architectural illusionism of the Second Style with architectural and landscape views resembling paintings, and replacing the earlier naturalistic depictions of architecture by ornamental embellishments of form. Columns and cornices become slender, unreal structures, candelabras and swags are reduced in size, and the walls are divided up into small areas and strips. In the

Fourth Style, the beginning of which is dated by archaeologists to the Pompeian earthquake of A.D. 63, the walls appear to have been melted away as the boundaries of the room, and are merely neutral background areas divided into three horizontal zones, allowing the imagination to play freely. They may show flat surfaces, architectural subjects in perspective, and ornamental or figurative themes.

With the fall of Pompeii after the eruption of Vesuvius in A.D. 79, these archaeological distinctions of style come to an end, but Roman murals do not: fewer are preserved after this date, but there are still many examples of murals from the houses, tombs, and catacombs of the capital and the provinces.

Fresco in the Fourth Style, Domus Aurea, Sala 114, Rome

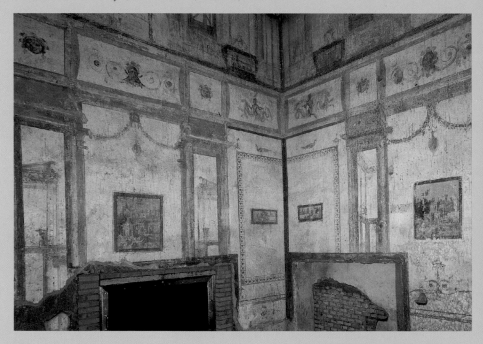

The Domus Flavia

A flight of steps leads from the Cryptoporticus of Nero to the Flavian palace. It was built under the emperor Domitian by his architect Rabirius, above the remains of Nero's palace and of some republican houses – the best known is the Casa dei Griffi (House of Griffins), so called from its stucco decoration – and it covered the entire central area of the Palatine. It remained the emperor's residence until the late imperial period. The complex was therefore restored and extended, but never replaced by a new building. The Flavian building was a type of royal palace previously unknown in Roman architectural history. It is also evidence of changes in the political conditions, for under the rule of Domitian the Augustan principate had finally become an absolute monarchy. The elevated public position of the emperor now had to be visibly expressed in architecture, and so the public and private areas were kept strictly separate in the Flavian palace complex. The palace is in three parts, and comprises the state apartments (the Domus Flavia), the living area (the Domus Augustana), and the stadium. The ground plan and the ruins that are still in existence convey an impression of the vast extent and magnificent furnishing of this palace, which was often extravagantly praised.

Reconstruction (after P. Connolly)

The center of the complex was a large marble peristyle containing an octagonal fountain structure, with the other rooms laid out around it. There was a vast hall, the *aula regia* (throne room), in the middle of the northern side. Its walls were decorated with panels of marble and with polychrome columns, and contained niches holding colossal black basalt statues. This was where imperial audiences were held, with the emperor enthroned like a god in the apse. To the west there was a smaller area with a central section flanked by two aisles and with an apse, which was probably used as an *auditorium* for meetings of the imperial council. It is more difficult to be sure of the function of the entrance hall in the east – arbitrarily known as the *lararium*, or chapel for the household gods known as the Lares – but it is possible that the bodyguard was accommodated here. To the south, the peristyle ended in a large room with an apse, described in the sources as the *coenatio iovis*; this was the emperor's magnificent banqueting hall. Considerable parts of the polychrome marble floor in *opus sectile* work, and the remnants of underfloor heating, bear witness to the room's former glories. The hall had two large windows, opening out on both sides on two symmetrically designed nymphaea.

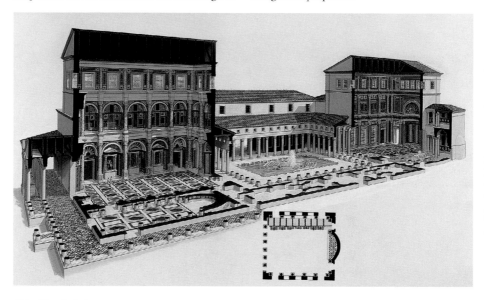

Stadium of Domitian (Stadio di Domiziano)

The hippodrome or stadium, so called because of its shape, resembled a Roman circus in being an oblong with semicircular ends, and lay along the eastern side of the Domus Augustana. It had two-story porticoes on all sides. This third part of the complex was probably a pleasure ground of the kind traditional in villa architecture, where the emperor could watch entertainments from his grandstand. In the 2nd century A.D. Emperor Septimius Severus extended the complex southward to the Circus Maximus by adding further rooms (the Domus Severiana) and a large complex of baths.

Domus Augustana

The private part of the palace adjoined the rooms reserved for state occasions, and was built on two levels, suiting the lie of the land. The northern rooms were set around a courtyard surrounded by columns, with an area of water that had a small temple in honor of the goddess Minerva at its center. In the southern part, built on a lower level, the rooms were also grouped around a peristyle, which was structured by four semicircular pools that were facing each other. The main entrance was on the side of the palace with the state apartments, leading to the Circus Maximus, conceived as a large exedra with a columned hall in front of it.

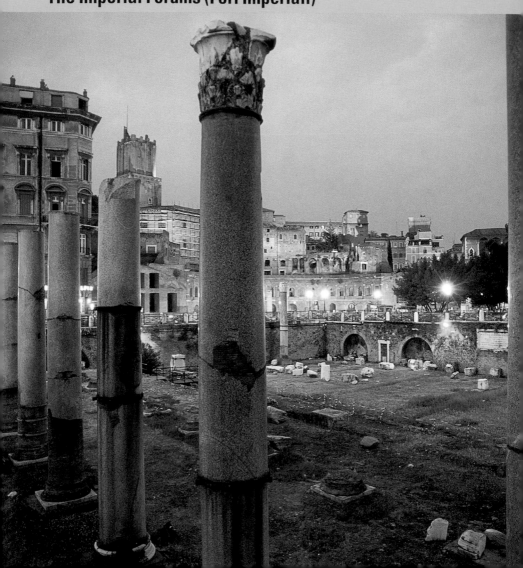

The Imperial Forums (Fori Imperiali)

Toward the end of the republican period, when Rome had become the dominant power in the Mediterranean region, the old Forum Romanum was no longer large enough for the increasingly complex and varied requirements of state occasions and administrative tasks. As early as 54 B.C. Julius Caesar began building an annex, which was initially planned and laid out as an extension of the original forum. However, there were also ideological and propaganda aims involved. Not only did the Forum of Caesar mark the development of a strictly axial architectural pattern, imitated in the later imperial forums, but the imposing statement it made also set certain standards. The following decades saw the building of the Forum of Augustus, the Forum of Nerva (which is also known as the Forum Transitorium), and the largest of them all, the Forum of Trajan. Vespasian was responsible for the building of the Templum Pacis (Temple of Peace) east of these forums. The ultimate result was a mighty complex of public buildings which provided accommodation for the central political, administrative, judicial, and economic power of the city.

After the fall of Rome these imperial forums suffered centuries of neglect. It was not until Mussolini demolished the medieval quarter to make way for the building of the Via dell' Imperio, which is now the Via dei Fori, that the ancient remains came to the light of day again. The

March of the Fascist youth organizations, photograph

new boulevard, which provided a direct link between the Piazza Venezia and the Colosseum, was used by the Fascists as the scene of their great marches. Since the time allowed for excavations was only brief, large parts of the imperial forums were buried under the wide street, and the few surrounding ruins did not allow visitors to form any very realistic idea of their appearance in antiquity. Restoration of the ancient buildings and extensive excavations on both sides of this main traffic artery began in 1995, and previously accepted theories of the ground plans of the imperial forums may have to be revised in the light of their findings. The area is then to be converted into an archaeological park with a large exhibition center.

View of the Forum of Trajan

Imperial Forums

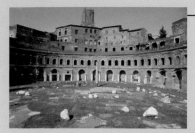

Markets of Trajan, Via IV November/Via Biberatica, p. 142

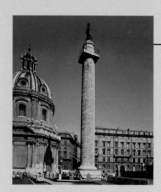

Trajan's Column, Via dei Fori Imperiali, p. 140

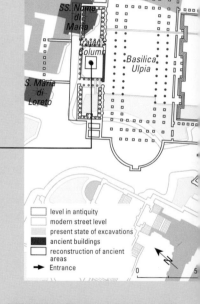

level in antiquity
modern street level
present state of excavations
ancient buildings
reconstruction of ancient areas
→ Entrance

Forum of Trajan, Via dei Fori Imperiali, p. 138

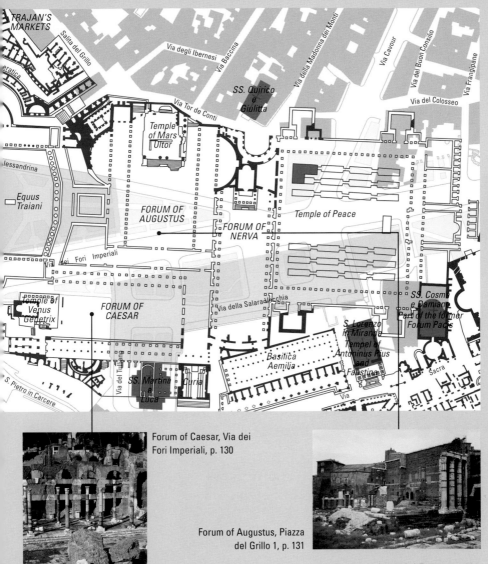

TRAJAN'S MARKETS

Salita del Grillo

Via degli Ibernesi

Via Baccina

Via della Madonna dei Monti

Via Cavour

Via del Buon Consiglio

Via Frangipane

eratica

Via Tor de' Conti

SS. Quirico e Giulitta

Via del Colosseo

lessandrina

Temple of Mars Ultor

Equus Traiani

FORUM OF AUGUSTUS

Temple of Peace

FORUM OF NERVA

dei Fori Imperiali

Temple of Venus Genetrix

FORUM OF CAESAR

Via della Salara Vecchia

SS. Cosmo e Damiano

Part of the former Forum Pacis

S. Lorenzo in Miranda Tempel of Antoninus Pius and Faustina

Basilica Aemilia

Via del Tulliano

SS. Martina e Luca

Curia

Sacra

S. Pietro in Carcere

Via

Forum of Caesar, Via dei Fori Imperiali, p. 130

Forum of Augustus, Piazza del Grillo 1, p. 131

The Forum of Caesar
(Foro Iulio)

Julius Caesar's plans provided for his new forum to lie directly next to the old one, which entailed moving the Curia and Comitium. At the Battle of Pharsalus (48 B.C.), when the war against Pompey was decided in Julius Caesar's favor, he had vowed to build a temple in honor of Venus Genetrix. It was consecrated at the same time as the inauguration of the forum, although the building was not completed until the reign of Augustus. The new forum, measuring 160 m (525 feet) by 5 m (16 feet), had a double row of columns on three sides, and there were barrel-vaulted *tabernae* (shops) on the southern side. The back of the forum was dominated by the temple of Venus, built on a high podium (the three Corinthian columns now re-erected date from its restoration under Trajan). The devotional image of the goddess stood in the apse of the *cella*, which was richly ornamented and contained many works of art. The ideological function of this building was obvious: it was intended to celebrate Venus Genetrix, ancestress of the Julian *gens* (clan) to which Caesar belonged, and thus the dictator himself; his equestrian statue stood in the exact middle of the forum, in front of the temple. Under Trajan, the Basilica Argentaria, where financial exchange would have been carried out, was added at the northwest end.

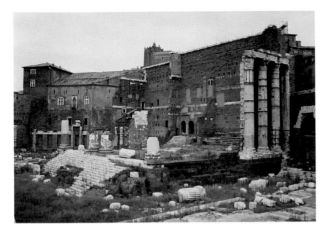

The Forum of Augustus
(Foro di Augusto)

At the Battle of Philippi in 42 B.C., in which Brutus and Cassius, the murderers of Augustus' adoptive father Julius Caesar, were killed, Emperor Augustus vowed to build a new forum in honor of the god Mars Ultor (the Avenger). It was not consecrated until 2 B.C., a period of some forty years after he had made this promise. The purpose of this area was to provide a new location for the holding of trials, and was also an imposing center glorifying the emperor as a victorious military commander.

The Forum of Augustus, like the Forum of Caesar, was conceived as a square surrounded by a columned hall of several stories, with additional wide exedrae adjoining it; the temple on its podium stood at the back of the area. The main focal point of the forum was the statue of Emperor Augustus in his triumphal chariot. There was a high anti-fire wall which divided the precinct from the densely inhabited quarter beyond it. In its time this forum was a magnificent and colorful spectacle: all the buildings were made of precious polychrome marble, richly ornamented, and furnished with countless statues, in accordance with a carefully planned pictorial program in honor of the emperor.

The Gods of the Roman Pantheon

by Jürgen Sorges

The ancient Roman gods derived from several sources. The oldest of the deities, greatly honored by the families of Rome, were their ancestral and household gods, the Lares and Penates. Until the late imperial period, as tutelary gods of the family, these family deities regularly received offerings on domestic altars and in niches on the external walls. In addition there were mythical protective deities and supernatural figures such as the founder of the city, Romulus; in his deified form, as Quirinus, he had a temple dedicated to him on the Quirinal. There was also the goddess of the city, Roma. Jupiter, Juno, and Minerva enjoyed special veneration as the founding deities of Rome, and were worshiped as the Capitoline triad on the lowest but most central of the seven hills of Rome. Juno and Minerva were originally among those ancient Italian and Etruscan divinities who had great influence on the Roman pantheon. A curious case is that of Janus, the two-faced god of gates and thresholds, who originally divided interior from exterior, the pure from the impure, the

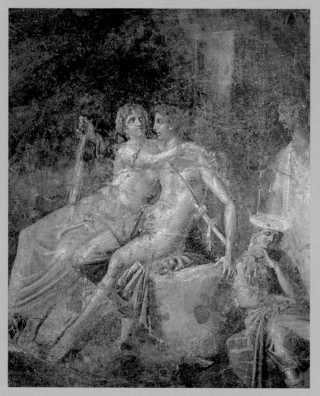

Mars and Venus, Roman mural from the Casa del Citarista, Pompeii, 1st century A.D., 253 × 150 cm, Museo Nazionale Archeologico, Naples

good from evil, and ultimately the sacred from the profane. As the god who gave his name to the Roman month of January, he also represented the transition from the old year to the new. Ancient Rome had several gods personifying human qualities, for instance Fides (loyalty), Honos (honor), Spes (hope), and Concordia (harmony). A large temple was dedicated to Concordia as the symbol of political unanimity between patricians and plebeians. Finally, the private deities included many minor gods who were invoked for everyday purposes, and whose function is comparable to that of the Christian patron saints of later times. The Greek pantheon had

Triumph of Neptune, Roman floor mosaic, 3rd century A.D., 119 x 180 cm, Musée Archéologique, Sousse

a strong influence on the religion of Rome, sometimes through the Etruscans, but its members were also introduced to Rome directly by the Greeks. Originally the portrayal of gods in human form was forbidden in Rome, but this changed as Greek culture increasingly permeated Roman society from the south of the Italian peninsula, particularly after the conquest of Greece in the year 2 B.C. However, even in the late republican period the ban on depicting gods in human form was founded on a belief in the superiority of Roman gods over their Greek equivalents.

Attempts to combat Greek religious influence ended in the imperial period. Instead, the aim now was to incorporate the Hellenistic divinities

into the Roman canon as smoothly as possible. The *Metamorphoses* of the Roman poet Ovid (43 B.C.–ca. A.D. 17), a verse epic describing some two hundred and fifty stories of metamorphoses from Greek and Roman mythology, is from this phase of development.

Increasingly, there were contributions to the Roman pantheon from the mystery cults, most of them from the eastern Mediterranean. The women of Rome in particular joined the mystery cults of the Magna Mater, Isis, and other deities originally from the religions of Anatolia, Syria, Lebanon, and Egypt. Secret monotheistic cults and sects made an appearance; Christianity and Judaism were originally

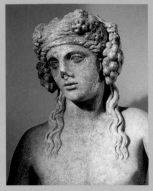

Aesculapius, Roman copy of an original of the 5th century B.C., marble, h 58 cm, Museo Nazionale Romano, Rome

Apollo, 2nd century, marble bust, h 26 cm, Museo Nazionale Romano, Rome

Head of a statue of Bacchus, Roman copy of a Hellenistic original, Museo Nazionale Romano, Rome

classified with them, along with the cult of Mithras. A special Roman development was the deification of mortal human beings – the emperors of Rome and many of their wives and mistresses.

The Major Roman Divinities

Aesculapius, the Roman god of medicine, corresponded to the Greek Asklepios. The oldest temple to Aesculapius in Rome was built on the island in the Tiber in 293 B.C., in obedience to an oracular pronouncement, and the site made it an ideal quarantine station when disease and epidemics threatened. This tradition continued into the Christian era; there is still a hospital on the island.

Apollo, the handsome son of Jupiter and Latona, twin brother of Diana (originally an Italian nature goddess) was regarded variously as the god of prophecy, leader of the nine Muses, the god of light, and the sun god. He was the personal patron of Augustus.

Bacchus, the god of wine and dissipation, corresponded to the Greek Dionysos. From time to time orgiastic excesses and alleged conspiracies (for his worship often took place in private houses) led to the persecution and banning of the cult of Bacchus in ancient Rome.

Castor and Pollux, the twin sons of Jupiter, banished from heaven, helped the Romans to gain victory in many battles (including the Battle of Lake Regillus in 496 B.C.). The largest of the ancient monuments to the two divine

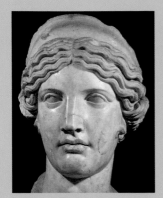

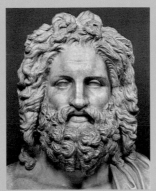

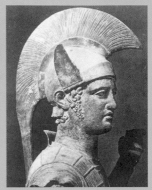

Juno with a diadem, 1st century, marble, Museo Nazionale Romano, Rome

Jupiter (Jupiter of Otreuli), 1st century A.D., marble bust, h 58 cm, replica of the ancient statue of the Jupiter Capitolinus, Musei Vaticani, Rome

Mars (known as the Mars of Todi), 6th century B.C., bronze, Musei Vaticani, Rome

heroes, worshiped in Greece as Kastor and Polydeukes, still stands today on the Quirinal.

Ceres, like the Greek Demeter, was popular as the goddess of the earth, foodstuffs, and fertility. From the 6th century B.C. she was also the equivalent of Demeter as goddess of marriage and the dead.

Cupido, the son of Venus, whose task it was to arouse desire and love. His arrows were as sure to hit their mark as those of his Greek equivalent Eros.

Diana, the ancient Roman counterpart to the Greek Artemis, was later regarded as the goddess of hunting.

Di(e)s Pater, god of the underworld, who rules over the dead with his wife Proserpina.

Faunus, together with the Etruscan and Italian god Silvanus (Latin *silva*, "wood"), was god of the woods and forests, and was associated with the Greek shepherd god Pan.

Juno, the wife of Jupiter (Greek: Hera), was the patron goddess of young women (Latin *iuventa*, "youth") and one of the three deities in the Capitoline triad. As Juno Moneta she later presided over the first mint in Rome and the city treasury.

Jupiter, the ancient Indo-European sky god, was the supreme deity of the Romans. His Greek counterpart is Zeus. He was also god of the weather (commanding thunder, lightning, and rain), he maintained justice, and was the god of oaths ("By Jupiter!") and of custom. His many love affairs reduced his wife Juno to despair.

Liber, like Bacchus, was a god of intoxication and wine. He corresponds to Dionysos (Latin *libertas*, "freedom").

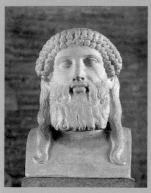

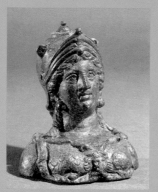

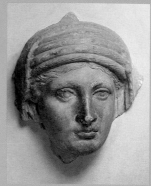

Mercury, Roman copy of an original of the 5th century B.C., marble bust, h 24 cm, Museo Nazionale Romano, Rome

Minerva (weight in the form of a bust of Minerva), bronze or lead, h 9.4 cm, Musée Guimet, Paris

Vestal Virgin, priestess of Vesta, 1st half of 2nd century, marble, h 21 cm, Museo Palatino, Rome

Magna Mater, the great mother goddess, counterpart of the goddess Cybele. As she originated in Asia Minor, around the area of Troy, the mythical city of origin of Aeneas, founder of Alba Longa, she was highly honored; her worship was brought to Rome in 204 B.C. in fulfilment of an oath. There was less tolerance of her sometimes orgiastic cult and its eunuch priesthood, which Roman citizens were forbidden to join. However, as with all the other gods, a Roman always had to be in charge of her temple.

Mars, the very popular Roman god of war (who was also known as Mars Ultor) and in myth the father of Romulus and Remus. His Greek counterpart was Ares.

Mercury, god of tradesmen, merchants, and messengers, was modeled on the Greek messenger of the gods Hermes.

Minerva, the ancient Etruscan goddess of crafts, was originally equated with Artemis. Later, as goddess of wisdom, she became the counterpart of the Greek Athene.

Neptune, the principal god of the sea, was the counterpart of the Hellenistic Poseidon.

Saturn was regarded as the supreme god in mythical times, before he was ousted by Jupiter. As god of the sowing of seed and agriculture, he was of ancient significance. Kronos fulfilled the same functions in Greece.

Tellus, also known as Terra Mater, Earth Mother, was the counterpart of the Greek earth goddess

Gaia. In the imperial period she and Oceanus, the great ocean surrounding the earth, symbolized the extent of the *imperium Romanum*.

Victoria, the goddess of victory, took her attributes of the wreath and the palm branch from her Greek equivalent Nike.

Venus, the goddess of love, corresponded to the Greek goddess Aphrodite, born of the foam of the sea. Venus was the tutelary goddess of the Roman *gens Julia*, to which Gaius Julius Caesar belonged.

Vesta, the deeply venerated Roman goddess of the hearth and the domestic flame. Her worship in her round temple on the Forum Romanum was the task of her priestesses, the Vestal Virgins. Vestals had direct access to the emperor, and the principal Vestal (*virgo maxima*) was on a par with the high priest (*pontifex maximus*). Transgression of the Vestals' vow of chastity was punished by burial alive. The Greek counterpart of Vesta was Hestia.

Vulcanus, the ancient god of fire, had very old Italian origins as the divinity of volcanoes. He was also the god of the blacksmith's craft, and thus identical with the Greek god Hephaistos.

Aphrodite, Roman copy of a Hellenistic original, marble, h 180 cm, Museo Nazionale Romano, Rome

The Forum of Trajan
(Foro di Traiano)

Trajan built the last and most magnificent of all the imperial forums with the spoils of war taken in his campaigns against the Dacians between A.D. 107 and A.D. 113. The Forum of Trajan covered an area of 300 m by 185 m (984 feet by 607 feet). Huge quantities of soil, and the entire saddle of land between the Quirinal and the Capitol, had to be removed to make way for this mighty complex, which was designed by the architect Apollodorus of Damascus and was much admired in antiquity.

Louis Noguet, Reconstruction of the Forum of Trajan, 1869
Watercolor

A triumphal arch on one side of the Forum of Augustus led to a large square with the bronze equestrian statue of Trajan at its center. The longer sides of the square, flanked by columned halls, opened out into large exedrae with apses. The Basilica Ulpia, which consisted of a hall flanked by double aisles, and which was used as a law court and market, shut off the back of the square. Behind it, the buildings of two libraries, for Latin and Greek literature, flanked the column of Trajan. It was long assumed that there had been a square surrounded by columned halls west of the forum, with a temple for the deified Trajan and his wife Plotina. Modern excavations have not so far confirmed this theory, but the final outcome is not yet known. The ground plan may seem surprising by comparison with the other imperial forums. It derives from military architecture: a basilica closed off the area, as in the *principia*, the main squares of military camps, while the libraries occupied the space reserved for military archives, and Trajan's Column took the place of the camp shrine with the army standard. The significance of

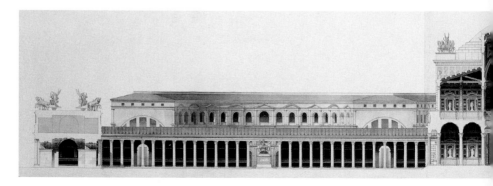

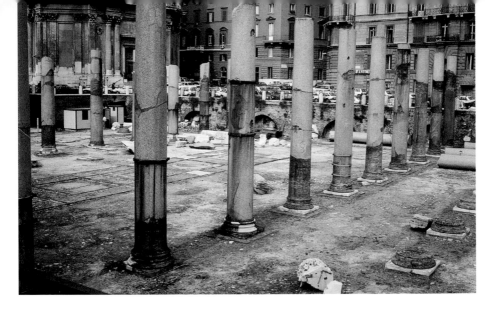

such a plan was obvious: it was intended to celebrate the deeds of an emperor who had come to power through his military career, and under whom the *imperium Romanum* had reached its widest extent. The lavish sculptural decoration included, among other subjects, statues of captive Dacians, a six-horse triumphal chariot with the statue of Trajan, and a large frieze with battle scenes (today on the Arch of Constantine).

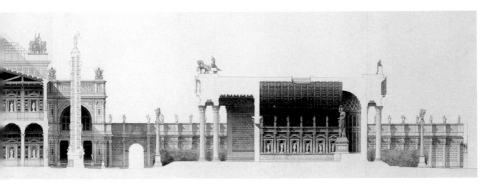

Trajan's Column
(Colonna Traiana)

The Trajan's Column, almost 40 m (131 feet) in height, is the only monument in the Forum that is still almost intact today. It rises on a cubic plinth, consists of seventeen drum-shaped marble sections, and can be climbed by a spiral staircase inside the column. It was once surmounted

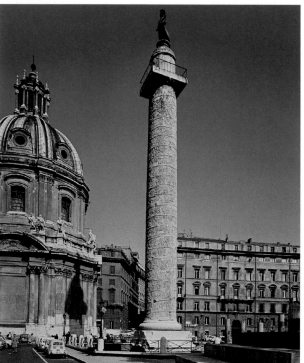

by a gilded bronze statue of Trajan, for which Pope Sixtus V (pontificate 1585–1590) substituted a statue of St. Peter in 1588. The inscription held up by two goddesses of victory over the doorway in the plinth speaks of the function of this monument: the column was intended to show "the height of the mountain that was removed with so much labor." It was both a victory monument and a funerary memorial; the golden urn containing the emperor's ashes was kept inside the plinth, which has relief decoration.

Frieze (Detail)

The observer in antiquity had a good view from the surrounding buildings of the shaft of the column, which is 29.78 m (98 feet) high and bears a relief frieze 200 m (658 feet) long that rises in a spiral. Like a chronicle, *Trajan's* describes the major events in two wars against the Dacians, shown with the figure of a goddess of victory recording them in writing. The frieze seems to translate Trajan's own account of the campaigns in his *Commentarii* into pictures. The various scenes merge

without transition, in the narrative manner of Roman historians, and are separated from each other only occasionally by architectural features. The pictorial areas are densely filled with figures, and leave little room for depictions of architecture and landscape. Although the reliefs are very shallow, the different parts of the background are subtly graded, so that the elements furthest to the back are only lightly incised, as if they were drawings. The realistic depiction of both scenes and figures is impressive, sometimes showing individuals with the terrors of war very expressively reflected in their faces. The wealth of detail, however, not only makes the Trajan's Column an impressive sculptural masterpiece and a valuable historical source, but also serves as a unique document for our knowledge of ancient weapons and costume.

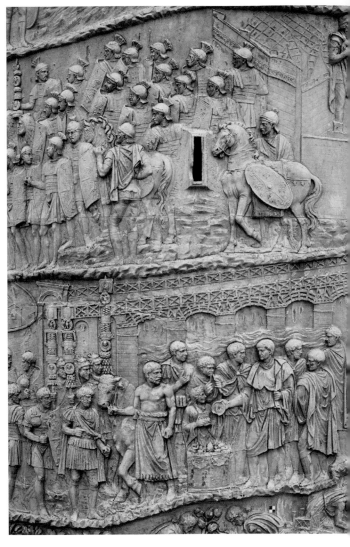

The Markets of Trajan
(Mercati Traiani)

The architect Apollodorus of Damascus built an impressive complex of buildings consisting of market halls and shopping streets on the slope of the Quirinal. All kinds of goods were bought and sold here: fruit and vegetables, grain, spices, fish, oil, and wine. The market complex also contained the state storehouses, which provided food for the poor at moderate prices or even free.

The semicircular brick building is laid out on six terraced floors, and contains over one hundred and fifty *tabernae* (shops). Its façade, with a large, semicircular hall at each side, rises beyond the eastern exedra of the Forum. There are eleven shops on the ground floor, quite shallow in depth, with almost square doorways and semicircular transoms above them. The arched windows flanked by pilasters in the upper part of the building admitted light to a passage above the rooms of the ground floor, with another ten *tabernae* coming off it.

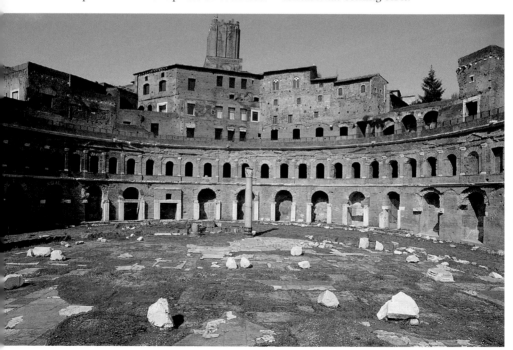

The Market Hall

From here, a steep stairway led to a huge market hall containing several shops, which must have formed the focal point of the complex. It was over two stories high, and roofed with a boldly designed structure of six groined vaults. The south side gave access to a row of rooms on two floors that probably served as offices for the management of the complex.

The Via Biberatica

The entrances to the barrel-vaulted storerooms and shops on the third floor were on a street that is still well preserved, the Via Biberatica. Its name probably derives from the late Latin word *biber* (drink), which suggests the function of some of the shops on this street.

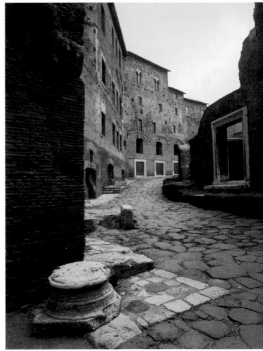

The Legacy of Rome – Antiquity in the Modern World

by Jürgen Sorges

The world of ancient Rome is still with us in many ways now that we have entered the third millennium of the Christian era. First and most importantly, Latin records the thinking of antiquity, and lives on in the tradition of the Romance languages, which include Italian and French. In addition, at least every fourth foreign word that has come into such Germanic languages as English and German is borrowed or adopted from Latin.

Among the most important legacies of Roman antiquity is the concept of the *res publica*, "public affairs." This synonym for the state, giving its name to the word "republic," still determines the principles of public affairs in many modern governments.

The tradition of Roman law (*ius* and *lex*) is also very much alive today: as a form of state jurisdiction, it laid the foundation for international and national agreements and their legality in national and international courts of law. As a legal system of civic rights, in a modified form it still governs the relationship of the individual to the community and the private to the public sector.

Money rules! The Capitoline goddess Juno Moneta ("she who reminds") presided over Rome's first mint and the state treasury. The goddess lives on among us in the words "money" and "monetarism." The heavy Roman copper coin called an *as* is not forgotten today either. The term originally meant "the one" or "unity," and

An "aes grave," the heavy copper coin of the Roman Republic, after 211 B.C.

was later used to determine standard Roman weights and measures. When card games were invented in the 15th century, it became that valuable card the "ace," found up many a poker player's sleeve. The influence of Rome on military life is obvious (Latin *militia*: obligatory army service). Generals have studied Roman strategy and tactics into recent times, and the efficient military logistics of antiquity have been much imitated. The polenta carried with them by the Roman legionaries, originally made from millet (Latin *milium*), is regarded by military historians as one of the great trump cards of Roman military policy, for it enabled the army to move fast and be prepared for battle at any time.

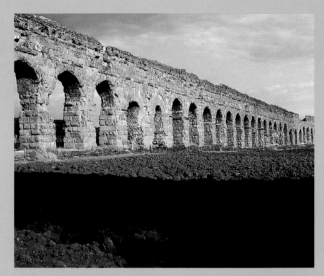

Aqueduct from the time of Emperor Claudius (reigned 41–54), Rome

In the field of culture (Latin *cultura*) at least three of the great stylistic movements of European art – the Romanesque, Renaissance, and Neo-classical movements – owed their existence to Roman antiquity, and we may add Classicism and Romanticism.

Modern architects still study the principles laid down by the Roman Vitruvius in his work in ten books *De architectura*, of around 25 B.C. and dedicated to Emperor Augustus. The Palatine, one of the seven hills of Rome, has even given its name to an architectural form: the imperial residences on the *palatium* served as models for later palaces. The world also has the engi-

neers and masons of Rome to thank for the first large multi-story tenement buildings, as well as the first functional urban sewerage and drainage system, in the form of the Cloaca Maxima, the sewers of Rome, with canals and hundreds of springs, and aqueducts providing the first properly planned communal water supply.

The building of early paved roads, with substructures, embankments, and curbs, probably goes back to the legionaries of Rome who first built such a "flat wall" over rough ground as the Via Appia in 312 B.C. The first "Pony Express" of international history was introduced on this route, the queen of the consular Roman roads: the postal service

Reconstructed restaurant in Ostia Antica, on the Via di Diana

between Rome and the Calabrian military port of Brundisium (now Brindisi) took a maximum of fourteen days. At the end of the imperial period Rome had 372 paved long-distance roads with a total length of 53,000 Roman miles (1 mile = 1,478 meters or 4,848 feet). Rome also left to posterity 3,000 stone bridges, enabling travelers to cross such rivers as the Ebro, the Danube, and the Po dry-footed.

Good building materials were also developed in Rome: how would the modern world manage without cement as hard as concrete? Various construction tools such as the first lifting crane in history were also Roman inventions. The factories (*fabricae*) of Rome worked on an

industrial scale, but were organized to manufacture not single items but groups of products – for instance, fireproof tiles and mass-produced amphoras were made under the same roof.

Ancient Rome has also left a lasting mark on cookery. Ingenious innkeepers and cooks developed the first ketchup-like seasoning in history in the form of *garum*, made from fermented sardines. And what is thought to be a 20th-century innovation, the snack bar, was known in the taverns (*tabernae*) of Rome 2,000 years ago. Guests spooned food out of hollows sunk into stone tables. When Aeneas was wandering the Mediterranean area, he was told that he should settle "where they eat their tables." In the house of King Latinus, the ruler of Latium, food was served not in bowls and dishes but on trenchers of bread which were eaten at the end of the meal, and the Trojan hero knew he had reached his journey's end. The stone-baked pizza, made beside the Tiber since time immemorial, is another Roman speciality.

At least in quantitative terms, the Romans are world leaders in the making of pasta: Roman cookbooks of the 1st century A.D. mention over 200 separate noodle dishes.

Today the Italian cuisine of Rome has a worldwide reputation for its nourishing, varied, and digestible dishes.

However, certain practices thought to descend from ancient Roman times date, in fact, from even earlier models, for instance the Latin "plebiscite," the basic democratic form of election. Rome did vote democratically in its army assembly, but Athens can claim to have been the first state to adopt the principle of "one man, one vote," at least for its free male citizens.

"Bikini-clad" girls with palm branch mosaic (detail), 4th century A.D., Villa Casale in the Piazza Armerina, Sicily

The Campo dei Fiori and Piazza Navona

The ancient Field of Mars, the Campus Martius, lies northwest of the Capitol on the broad plain between the Via Flaminia (now the Via del Corso) and the great bend in the Tiber. The papal Old Town was built here in the late Middle Ages, with its two central markets on the Piazza Navona and the Campo dei Fiori. The legends said that the Field of Mars, originally a marshy area often flooded by the Tiber, had been a royal possession of the Tarquins. After their expulsion from Rome it passed into the hands of the state and was dedicated to Mars, the god of war. Since it lay outside the *pomerium*, the sacred city boundary within which no weapons were permitted to be carried, it served during the republican period as the scene of military exercises and political events. The area known as the Area Sacra di Largo Argentina dates from this phase; four temples, one round and three rectangular, were built on it between the early 3rd and 2nd centuries B.C. After the late republican period, and above all during the imperial period when in practice the people had almost no political power left to influence decisions, the whole of the Field of Mars was fundamentally reorganized. As well as theaters, amphitheaters, and baths to entertain the population of the city, buildings were erected in honor of the emperor and his family, and they merged together to form a magnificent urban architectural complex. During the Middle Ages the area was largely deserted, but after the late 15th century, when the architectural renovation of Rome began with the return of the popes from Avignon, new streets and squares were laid out and many new buildings constructed. The Campo dei Fiori, "field of flowers," called (like the market place itself) after the flowery meadows that

Giacomo della Porta and Taddeo Landini, Fontana delle Tartarughe, 1585, tortoises dating from 1658

View of the Campo dei Fiori

had covered the site before it was built up, was among the liveliest of the Roman squares of the Middle Ages. As the Pilgrim's Way (Via del Pellegrino) led to St. Peter's by way of the Campo, it was surrounded by pilgrim guesthouses. At the beginning of the 16th century, Pope Julius II had the winding streets between the Capitol and the Vatican replaced by a broad avenue designed by Bramante. This avenue was called the Via Giulia named after the pope who had commissioned it. This became one of the main axes of Rome and was lined with churches and noblemen's palaces. A bronze statue of the philosopher Giordano Bruno in the middle of the Campo dei Fiori recalls the darker pages of the past, for this was where public executions were carried out under the Inquisition.

The Area Sacra di Largo Argentina: a complex with the remains of four temples of the republican period. A large podium made of blocks of tuff (a volcanic rock) still stands behind them. It was part of the famous Curia of Pompey, where Caesar was assassinated on March 15, 44 B.C.

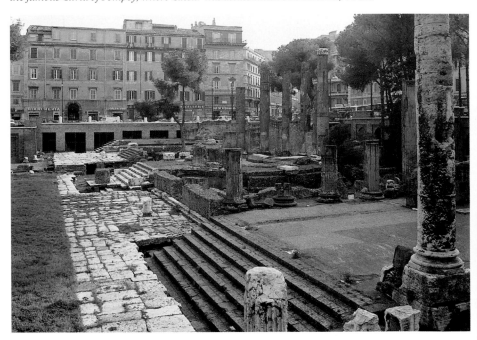

The Palazzo della Cancellaria

Building began on this palace in 1483 to provide a residence for Cardinal Raffaele Riario, nephew of Pope Sixtus IV. It was part of an ambitious redevelopment program, with which the pope sought to restore the past glories of Rome. The architect may have been Baccio Pontelli, who had participated in other projects for Riario. With its clarity of structure and well-proportioned forms, the palazzo is an outstanding example of Roman palace architecture of the Quattrocento. The three-story façade, divided on the upper floors by delicate pilasters, is made of travertine taken from various sources, including the Colosseum. It is the first consistently classical façade of the Roman Renaissance. The main portal was designed in 1589 by Domenico Fontana. The interior courtyard, in the style of Bramante, is surrounded by two double-storied arcades in the Tuscan style, and an upper story with pilasters that have composite capitals. It was not long before the cardinal lost the palace to the Curia because of his part in a conspiracy against Pope Leo X, and the Curia used it to house the papal chancellery which gives its name to the building – cancellaria.

The Campo dei Fiori and Piazza Navona

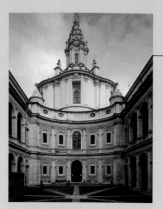

S. Ivo alla Sapienza, Corso del
Rinascimento 40, p. 179

Pasquino, Piazza di Pasquino, p. 180

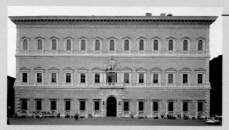

The Palazzo Farnese, Piazza Farnese, p. 159

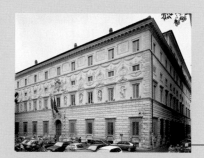

The Palazzo Spada, Piazza Capo di Ferro 13, p. 162

S. Andrea della Valle

Well known as the setting for the first act of Puccini's opera *Tosca*, this church is among the famous Baroque buildings of Rome. Francesco Grimaldi and Giacomo della Porta began building it in 1591 for the Theatine Order, which had made the implementation of Catholic reform its special concern. By 1622 Carlo Maderno had added the dome, the second largest in Rome after the dome of St. Peter's. It is the dominating center of the church, which like the Jesuit churches has a broad nave offering nothing to distract the eyes of the faithful. Instead of aisles, small areas open into the nave like

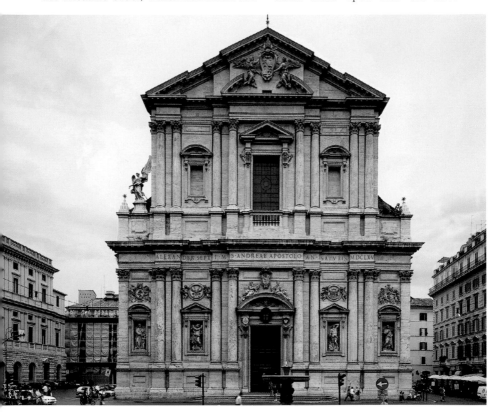

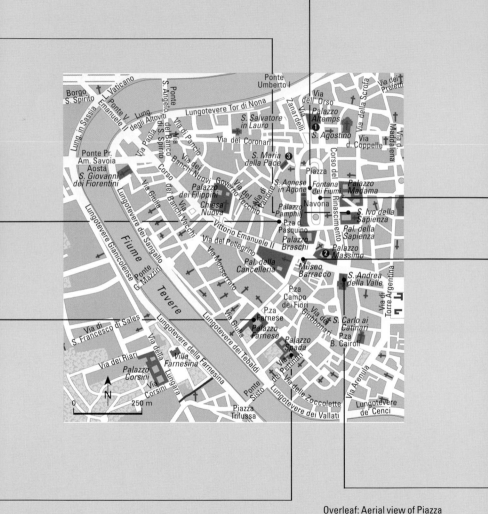

Overleaf: Aerial view of Piazza
Navona and surroundings

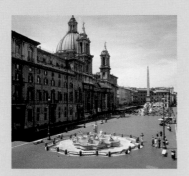

Piazza Navona with S. Agnese in Agone and the Palazzo Pamphilj, Piazza Navona, p. 174

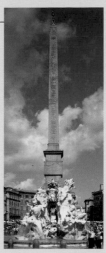

Fountain of the Four Rivers, Piazza Navona, p. 178

The Piccola Farnesina, or Farnesina ai Baullari (Museo Barracco), Corso Vittorio Emanuele II 166, p. 158

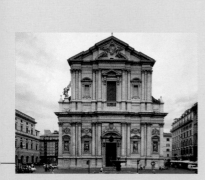

S. Andrea della Valle, Piazza S. Andrea della Valle, p. 156

Other sights:

1 Palazzo Altemps, Via di S. Apollinare 8, p. 170

2 Palazzo Massimo alle Colonne, Corso Vittorio Emanuele II 141, p. 181

3 S. Maria della Pace, Vicolo dell' Arco della Pace 5, p. 168

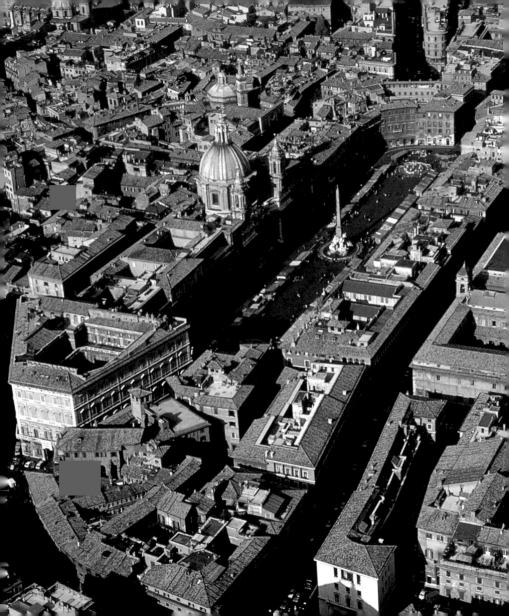

chapels where anyone could have a mass said, or even have a tomb built. Carlo Rainaldi designed the façade, which was completed in 1655/65, as an architectural form with increasing gradations of emphasis: to create a strong concentration of effect on the center, the five sections of wall are not only progressively broader and more lavishly decorated as they move inward, but the wall surface itself projects out to produce a terraced effect. Rainaldi's structural design, with its monumental double columns, emphasis on the window frames, and strongly accentuated cornices, gives the façade the three-dimensionality and the dramatic effects of light and shadow typical of Baroque architecture.

View of the Inside of the Dome

The fresco in the dome, executed by Giovanni Lanfranco in 1621–1625, represents the glories of paradise – a subject particularly suitable for a dome symbolizing heaven and divine rule. With its foreshortened figures, and the massed effects of the painted firmament, which seems to open up the dome to the sky itself, it is the first example of *trompe l'œil* painting in Rome, and set the standard for the painting of other domes in the high Baroque period.

In 1624–1628 Domenichino (Domenico Zampieri) painted the pendentives with frescoes of the four Evangelists, and decorated the apse with scenes from the life of St. Andrew. The pictorial narrative is conveyed by only a few figures, harmoniously set against wide landscape or architectural backgrounds. The frescoes are generally regarded as his most important work in Rome.

The Piccola Farnesina, or Farnesina ai Baullari (Museo Barracco)

This small palace derives its name from the lilies on the cornice, which were erroneously interpreted as part of the coat of arms of the Farnese family. In fact they represent the lily of France, and the French diplomat Thomas Leroy who commissioned the palace is responsible for their appearance here. Antonio da Sangallo the Younger built him this three-story rectangular building, which looks out at the back on a courtyard flanked by two projecting wings. The building was restored and given a new façade at the end of the 19th century. The Palazzo today houses the Museo Barracco, and here the collection of Assyrian, Egyptian, Greek, Etruscan, and Roman sculptures donated to the city of Rome in 1902 by Baron Giovanni Barracco can be seen.

Injured Dog, 2nd Century
Pentelic marble,
h 44 cm, l 69 cm

This slender bitch turning her head as she half-lies on one side to lick her injured thigh is considered to be one of the finest animal sculptures in the art of classical antiquity. Twisting her body as she supports herself on her splayed front paws, back legs drawn together and crossing each other, she gives the impression of life and swift movement. The marble strut supporting her leg with its hind paw held in the air suggests that the sculpture derives from a bronze original of the 4th century B.C. She may be identical to the bronze dog licking its injury which was praised by Pliny in his *Naturalis Historia* for its natural appearance. She originally stood in the *cella* of Juno in the temple of Capitoline Jupiter until the Capitol was plundered in A.D. 69 by the troops of Vitellius.

Palazzo Farnese

On the Piazza Farnese, once the scene of many great festivities, is one of the most magnificent and architecturally important of the family palaces of Rome, the Palazzo Farnese. This was to provide the model for many other princely residences in the city. Antonio da Sangallo began building a town house in 1514 for Alessandro Farnese, later to be Pope Paul III (pontificate 1534–1549). After the architect's death Michelangelo took on the role of supervising the work. He completed the exterior walls and the roof cornice, as well as the upper story of the interior courtyard. All that is left today of Michelangelo's plan to build a bridge

over the Tiber linking the gardens of the Palazzo Farnese to the Villa Farnesina, which was another of the family's properties in Trastevere, is the arch of a bridge across the Via Giulia. The last of three famous architects employed on the building, Giacomo della Porta completed the rear façade and brought the work to a conclusion in 1589. The palace descended by inheritance to the Bourbons, and later came into the hands of the French state. Today the building provides accommodation for both the French Embassy and the Ecole Française de Rome. However, the incomparable art collection of the Farnese family, part of which was kept in this building until the middle of the 18th century, was moved to Naples in 1787.

This "king of palaces" is designed as a large rectangle with four wings around a square interior courtyard. The three-story façade, 46 m (151 feet) in length, with its entrance on the Piazza Farnese is articulated only by the different design of its rows of windows and the slightly projecting rusticated porch. It incorporates the Renaissance principle of composition, according to which the harmony of all parts is achieved when nothing can be changed, added, or omitted without detracting from the perfection of the whole. Since the free-standing main building required fully formed walls all the way around, the sides repeat the structure of the main façade, while the back, which has a view looking out over the Tiber, is designed as a garden façade. The structure of the large interior courtyard with its rhythmic succession of arcades and windows, rising from the Doric through the Ionic to the Corinthian order, owes much to the legacy of antiquity as expressed in the Colosseum.

The Galleria, Annibale Carracci, ca. 1597
Fresco

The frescoes in the vaulted ceiling of the Galleria in the upper story of the back wing – created for Cardinal Odoardo Farnese around 1597 by Annibale Carracci with the assistance of his brother Agostino and his pupils Domenichino and Albani – are among the masterpieces of Roman Baroque painting. The room, 20 m (66 feet) long and 6 m (20 feet) wide, is barrel-vaulted, with *cavetti* forming the transition from the vault to the walls. Carracci divided the vault into three zones along its length. The framework of the five mythological pictures which can be seen in the central zone consists of atlantes and herms painted in grisaille on the lateral zones, with naked youths crouching at their feet. Beside them are pink *putti* and green-hued medallions imitating the patina of bronze reliefs. They are partly concealed by smaller mythological scenes, while personified virtues appear in the corners, and the large pictures at the two ends of the vault tell the story of the legend of Perseus. The pictorial program as a whole takes love stories from classical mythology as its subject, and the central idea is the transformation of the human soul by the power of divine love. The central fresco shows the triumphal procession of Bacchus and Ariadne, illustrating the mythological story very naturally and faithfully. There are real and painted architectural and three-dimensional elements such as garlands, cartouches, medallions, and *tondi* all over the ceiling, and these blur the boundary between architecture and picture. Fulfilling the function of a gallery, the ceiling fresco presents the viewer with several different works of art, and in making the painting imitate sculptures and reliefs it contributes to discussion of the *paragone*, the dispute about which was the more important art, painting or sculpture, a very topical subject at the time.

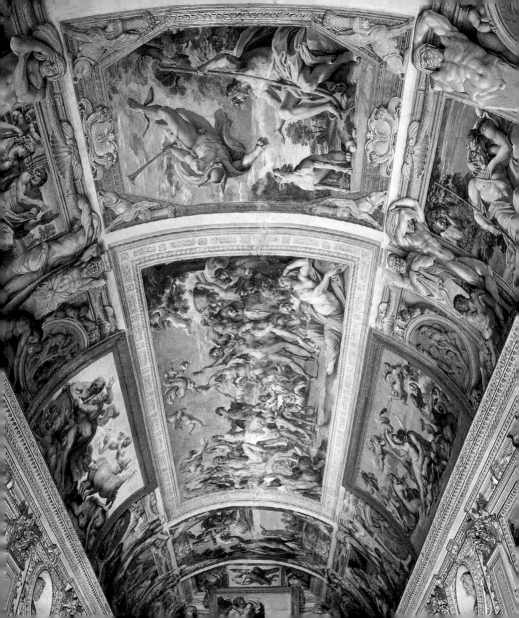

The Palazzo Spada

Built by Giulio Merisi da Caravaggio for Cardinal Girolamo Capodiferro in 1550, in time for the Holy Year celebrations, the Palazzo Spada stands in the narrow alleys behind the Piazza Farnese. It passed into the hands of Cardinal Bernardino Spada in 1632, and was rebuilt by Borromini. It has been the seat of the Italian Council of State since 1927.

The Palazzo Spada is an example of Mannerism in Roman architecture. The façade and interior courtyard contain a wealth of stucco and sculptural decoration, the work of Giulio Mazzoni in 1556–1560. Statues of famous figures in Roman history stand in the niches of the façade of the *piano nobile* (left to right: Trajan, Pompey, Fabius Maximus, Romulus, Numa, Marcellus, Julius Caesar, and Augustus), with inscriptions relating to them between the windows of the upper floor. The *cortile* (interior courtyard) is surrounded by pillared arcades on three sides of the ground floor. There are two friezes below the windows, representing a battle with centaurs and a maritime scene in the manner of ancient reliefs. Statues of classical gods and geniuses stand between them. On the main façade of the building, figures of naked youths hold the coats of arms of Pope Julius III (pontificate 1550–1555) and the king of France, whose court the cardinal had frequently visited as ambassador. Bernardino Spada had a gallery built on the first floor to take the valuable collection of paintings and sculptures made by the cardinal during his time as papal envoy in Bologna (1627–1631). The Galleria Spada is an illustration of the cardinal's discriminating taste as well as his connections with the most famous artists of the city; it contains works

by Guido Reni, Guercino, Domenichino, Andrea del Sarto, Mattia Preti, Bruegel, and Rubens.

The Colonnade

It was in 1635 that Francesco Borromini built a colonnade on the left side wing at the back of the building using the "false perspective" method. It appears to be a long gallery with columns leading to another large courtyard at the far end. In fact the corridor, flanked by double Tuscan columns and roofed by a coffered barrel vault, is only 9 meters (30 feet) long. It has the appearance of being four times that length because as the columns recede they become shorter and narrower, while the floor rises and the passage becomes narrower. The statue, which is the focal point at the end of the perspective, is therefore smaller than life size.

Chiesa Nuova (S. Maria in Vallicella)

S. Maria in Vallicella, which is one of the great Baroque churches of Rome, stands in the piazza on the Corso Vittorio Emanuele II. In 1575, with the support of Pope Gregory XIII (pontificate 1572–1585), the religious leader Filippo Neri commissioned Matteo da Città di Castello, and later Martino Longhi the Elder, to begin the construction of a new church – the "Chiesa Nuova" – on the site of an older building. Neri, founder of the Congregation of the Oratory, was one of the leading figures of his time. He strove for the renewal of the Catholic Church and the spread of new pastoral methods, including new forms of sermons, pilgrimages, and hymns. The Chiesa Nuova thus became the symbol of his reforming aspirations. It was consecrated in 1599, although the two-story façade, divided up by pilasters and large cornices, with a portal by Fausto Rughesi framed by columns, was not completed until 1605. The building is designed as a cruciform basilica with two aisles; a particular feature is the mighty dome above the crossing, which is visible from afar. While the interior was originally a plain devotional space, in line with Neri's ideas of reform, it acquired a wealth of Baroque decoration after 1640.

**Peter Paul Rubens,
Sts. Domitilla, Nereus,
and Achilleus, 1608**
Oil on slate, 425 × 250 cm

Three pictures painted on slate by the young Rubens adorn the high altar of the church: at the center is the *Madonna with Angels*, on the right *Sts. Domitilla, Nereus, and Achilleus*, and on the left *Sts. Gregory, Maurus, and Papas*. The paintings reflect the many influences absorbed by the artist during the eight years that he stayed in Italy. The treatment of light is reminiscent of Tintoretto and Caravaggio, while the spatial composition and the stance of the individual figures owe something to Mannerism. It is not surprising to find this Rubens altarpiece in the Chiesa Nuova, which was one of the first churches built in the spirit of the Counter-Reformation; the work shows St. Domitilla with her two servants Nereus and Achilleus, whom she converted shortly before her death and who are holding palm branches as a sign of their redemption.

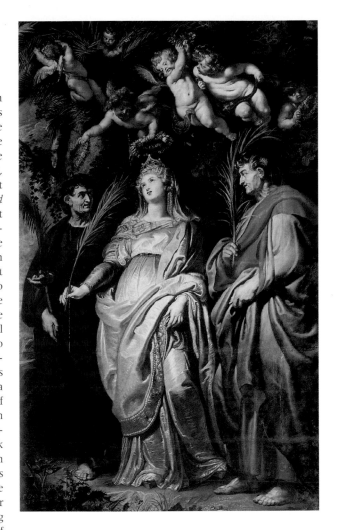

Pietro da Cortona, Fresco Above the Nave and Aisles, The Vision of St. Filippo Neri, 1648–1651
Fresco, 27 × 13 m

The apse, dome, nave and aisles of the monumental interior of the Chiesa Nuova, decorated mainly in white and gold, are ornamented with frescoes executed by Pietro da Cortona. The Accademia di San Luca had honored the Tuscan painter with the title of "prince" after he had painted his magnificent ceiling frescoes in the Palazzo Barberini, and he was considered to be one of the leading Baroque painters in Rome. The characteristics of his style are dynamic compositions full of active figures, luxuriant color, impasto brushwork, and light hues. In 1648–1651 he painted the dome with a depiction of the saints in heaven, while the four prophets announce the Last Judgement in the pendentives. Inside the dome is God the Father, with Christ displaying the instruments of His Passion, indicating the suffering that awaits Him in order to persuade God the Father to show mercy to mankind. There is a fresco of the Assumption of the Virgin above the apse; she is shown as an intercessor for humanity. The fresco above the nave depicts a vision seen by Filippo Neri during the building of the church, in which a beam had come loose and had to be replaced: the vision is to be understood as a symbol of the plans for reform projected by the founder of the Order, and of the building of the Chiesa Nuova itself.

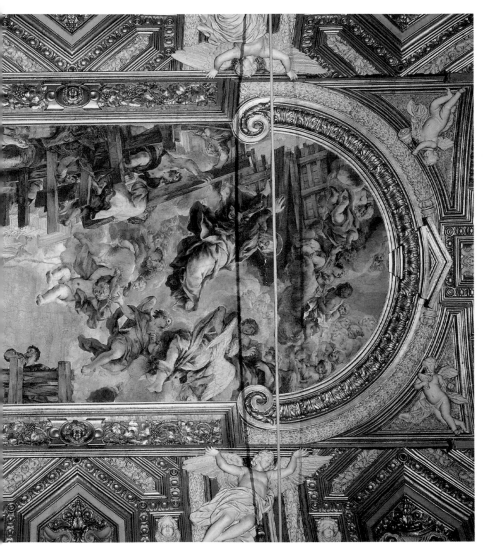

S. Maria della Pace

In 1482 Pope Sixtus IV (pontificate 1471–1484) began building a church in honor of S. Maria della Pace (St Mary of Peace) in gratitude for the peace treaty concluded with Milan and other Italian states. It is thought that the first architect was Baccio Pontelli, and that the single nave with chapels on both sides was his work. In the early 16th century Bramante built the cloister for Cardinal Oliviero Carafa – his first Roman commission – and he was probably also responsible for the octagonal dome. Pietro da Cortona was commissioned by Alexander VII (pontificate 1655–1667) to restore the church in the middle of the 17th century, and the Baroque façade dates from this time. Cortona, who also designed the surrounding facades in the Piazza della Pace, emphasized the center of this one by adding a prominent semicircular porch with Doric columns on the ground floor. The façade of the upper floor, divided up by Corinthian columns and pilasters, recedes behind it. The central window is a segmented arch surmounted by a pediment with several frames. The diversity of forms, varying between rectangular, triangular, semicircular, and curves both convex and concave, creates the taut dynamic which is typical of a Baroque display wall.

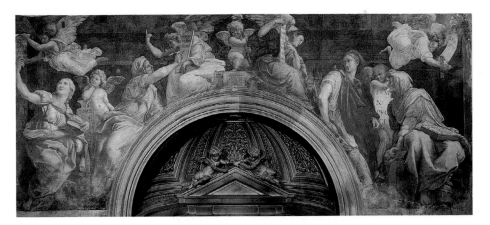

The Cappella Chigi, Raphael, Four Sibyls, 1514
Fresco

In 1514 Raphael was commissioned by his friend, the Sienese banker Agostino Chigi, to paint his famous fresco of the *Four Sibyls* on the right-hand side of the altar wall of the first chapel, in which there is a niche. To the side of the window in the upper part of the wall, the four Old Testament prophets (probably by Raphael's pupil Timoteo Viti) face the prophetesses of classical antiquity who foretold the birth of Christ. In contrast to the Sistine frescoes of Michelangelo, the sibyls are not shown deep in thought or poring over prophetic books, but join with winged geniuses in a rhythmically constructed group of communicating figures. The geniuses are bringing the sibyls scrolls on which the viewer can read fragments from the Book of Revelation and the Gospels. The Cumaean Sibyl sits on the left, with a genius handing her a scroll bearing the inscription "The Resurrection of the Dead." The Persican Sibyl is shown leaning on the arch of the niche, writing: "His fate shall be death." Behind the Phrygian Sibyl, who is supporting herself on the arch, a genius points to the words: "Heaven surrounds the vessel of clay." A genius bearing the inscription, "A new generation," stands behind the Tiburtine Sibyl, the only one of the four shown as a wise old woman, while an angel hovers above them with a scroll entitled: "I will open the tomb and rise again." On the apex of the archway of the apse, a small winged being is holding the Eleusinian torch, the symbol of initiation into the mysteries of the spiritual world. No doubt the fresco was intended to emphasize the theme of the Resurrection, which Raphael had originally planned to paint as an altarpiece.

The Palazzo Altemps (Museo Nazionale Romano)

Work on the Palazzo Altemps, which with its fine Renaissance façade occupies a large site on the Via di S. Apollinare, was begun in 1477 for Girolamo Riario, the nephew of Pope Sixtus IV (pontificate 1471–1484). After 1568 it passed into the hands of Cardinal Marco Sittico Altemps (Altemps was the Italian version of the German surname of Hohenems). Martino Longhi the Elder was commissioned by the cardinal to build the watchtower and the two-story interior courtyard surrounded by Ionic arcades. In the 16th century the palazzo was among the most magnificent noblemen's residences in Rome, for the Altemps family were avid collectors and loved luxury. They had the *cortile* and all the rooms furnished with paintings and classical statues, and assembled an extensive library, which is now in the Vatican. Later, some of their antiquities passed into the Ludovisi Collection founded by Ludovico Ludovisi, the nephew of Gregory XV (pontificate 1621–1623). His heirs sold it to the Italian state in 1901, and it now forms an important part of the stocks of the Museo Nazionale Romano. Several of the antiquities from the Altemps Collection have been returned to their original places of exhibition. Since its complete renovatio, the Palazzo Altemps has been part of the Museo Nazionale Romano, and now contains the Ludovisi Collection.

**Ludovisi Group of Gauls,
Roman Copy of a Greek
Original of the 3rd Century B.C.**
Marble, h 211 cm

This is a Roman copy in marble of a bronze group which, together with the *Dying Gaul* in the Palazzo Nuovo on the Capitol, was part of a large triumphal monument erected by King Attalos I of Pergamon in the temple of Athene in that city around 230/220 B.C. The group with the Gallic prince killing his wife and then himself is an example of the dramatic style of the high Hellenistic period. The prince, striding out powerfully, looks back at his pursuers as he thrusts his sword into his chest. His left hand holds the arm of his wife, who has already fallen dead to the ground. The details are vividly shown: the blood spurting from the Gaul's breast as the point of his sword enters, the mortal wound under his wife's left armpit, her closing eyes, her facial expression showing her recent death agony. Unlike other memorials to victories, this monument refrained from depicting the triumphant forces of

Pergamon, and it does not show a battle, but instead presents the suicide of the defeated as a final act of free will.

The Ludovisi Ares, Roman Copy of a Greek Original of the 4th Century B.C.
Marble, h 156 cm

Here a Roman sculptor has produced a replica, with a few modifications, of a late classical bronze of the period around 330 B.C. – a statue of Ares, the god of war.

Head turned to one side, right leg outstretched, left leg drawn up, hands clasped around his knee and cloak draped over his hips, he sits apparently at his ease. But his body is tensed, and his attitude betrays alertness. The god is ready for battle, as the sword in his left hand suggests, although it is still sheathed. The other weapons – shield, helmet, and greaves – were undoubtedly added by the Roman copyist, who also adds a small Cupid at the god's feet in reference to his affair with the goddess Venus (Aphrodite). By creating this new composition, the Roman copyist has in effect reinterpreted the statue, so that it now shows Ares laying down his arms for the goddess of love.

The Ludovisi Throne, Mid-5th Century B.C.
Marble, h 107 cm, l 143 cm

The work known as the Ludovisi Throne was found in Sallust's gardens, where it was probably part of an altar. For a long time there was controversy over the nature of this work because of its form, but it is now regarded as an original

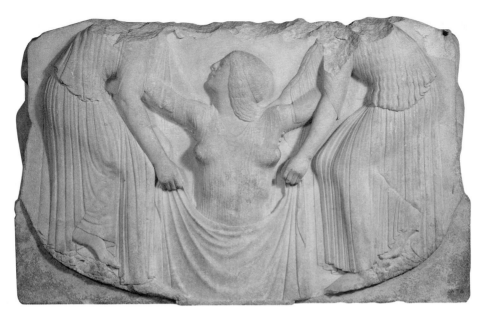

from the middle of the 5th century B.C.; its original location used to be identified as a temple of Aphrodite in Locri in southern Italy. The main side shows a goddess who is just emerging from the water, judging by her wet garment and the beach shown at the sides. She is supported by two female figures holding a cloth in front of her and taking her under the arms to help her out. The goddess, whose face is seen in profile in the usual pre-classical manner, is looking up. Although there have been many interpretations of this scene, it probably shows the birth of Aphrodite, who according to Greek mythology rose from the sea at Paphos on Cyprus and was received by the Horae (goddesses of the seasons). The reliefs on the sides would also support such an interpretation: they obviously portray sacred and profane elements in the worship of the goddess, with a naked girl flute-player, no doubt a *hierodule* (temple servant), on one side, and on the other a veiled priestess making an offering of incense before a *thymiaterion* (censer).

Piazza Navona

The Piazza Navona is probably Rome's most famous example of continuity in town planning. Its long ground plan, with a curving narrow side to the north, retains the form of the stadium (240 by 65 m or 787 by 213 feet) built by the emperor Domitian (A.D. 81–96) for games and sporting competitions, later to include animal fights and gladiatorial combats. The buildings around the square stand on the terraces of the old *cavea*, which could seat

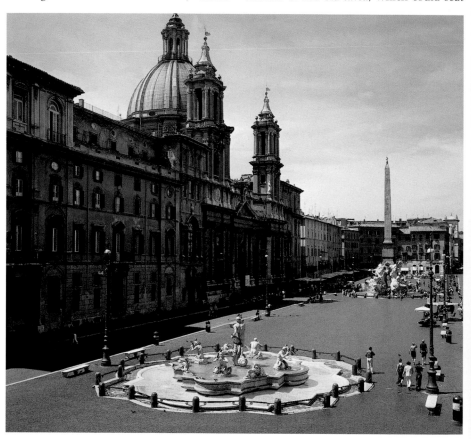

30,000 spectators. The name also still indicates the purpose for which the piazza was originally used, for Navona is said to derive from *in agone* (on the place of combat). However, if popular tradition is to be believed, the name comes instead from *navis* (ship), because the shape of the square, with its rounded end, resembles a boat. As the largest square in one of the most densely populated quarters of Rome, it featured prominently in the plans for renovation work undertaken during the Renaissance. Pope Sixtus IV

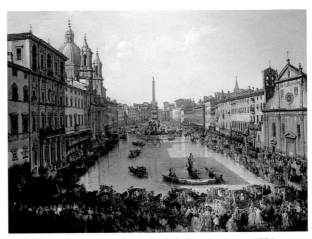

Giovanni Paolo Pannini, *The Flooded Piazza Navona, 1756, oil on canvas, 96 × 136 cm, Niedersächsisches Landesmuseum, Hanover*

(pontificate 1471–1484) had the market moved here from the Capitol in 1477, and the construction of several noblemen's palaces (such as the Palazzo Massimo alle Colonne and the Palazzo Madama) made the Piazza Navona a favorite residential area for the upper classes of Rome. Its architectural development culminated under Pope Innocent X (pontificate 1644–1655), who began rebuilding here, after his election, in 1645. He had his family palace and the church of S. Agnese in Agone renovated, the two fountains placed outside by Gregory XIII (pontificate 1572–1585) restored, and he erected the huge Fontana dei Fiume (Fountain of the Four Rivers) in the middle of the square. Through the centuries, the

piazza was the scene of magnificent tournaments and festive processions. Water festivals took place here until the 19th century, and the square was flooded to a certain level for them in August. Prosperous citizens drove through the water in their carriages, while ordinary people paddled around in it. To this day the Piazza Navona is one of the liveliest squares in the city of Rome, with street traders and performers offering entertainment until late into the night. As the Roman author Giuseppe Gioacchino Belli wrote in the early 19th century: "Ah, the Piazza Navona! It cares not a whit for the Piazza di Spagna or St. Peter's Square. It is not a square but the great outdoors, a festival, a stage, and wonderful fun."

The Palazzo Pamphilj

Together with the church of S. Agnese in Agone, the palace built for Pope Innocent X (pontificate 1644–1655) of the Pamphilj family dominates one of the longer sides of the Piazza Navona. The architect of the building, constructed between 1644 and 1650, was Girolamo Rainaldi, who combined several buildings, bought for addition to the original palace, into a single complex, incorporating S. Agnese as the family church and palace chapel. Borromini, whose rival designs were not accepted, was commissioned to design only the great hall and build the gallery that would be painted by Pietro da Cortona. Cortona's frescoes show scenes from Virgil's national epic, the *Aeneid*, in iconographic reference to the mythological descent of the Pamphilj from Aeneas himself. Later, the pope gave the palace to his sister-in-law, Olimpia Maidalchini, who was given the nickname *olim pia* (formerly pious) by the *statua parlando* (speaking statue) of Pasquino (see page 180). Today the building is used to accommodate the Brazilian Embassy.

S. Agnese in Agone

This church rises on the remains of the foundations of Emperor Domitian's circus (they are built into the crypt), as the name *in agone* (on the place of combat) indicates. According to legend, it occupies the site where St. Agnes was martyred. When she was stripped naked before the crowd, her hair suddenly and miraculously covered her, preserving her modesty. In 1652 Pope Innocent X commissioned Girolamo Rainaldi to begin building

S. Agnese as the palace church of the adjoining Palazzo Pamphilj. Later Borromini took over work on the building, and he was succeeded in 1657–1672 by Carlo Rainaldi. Borromini was responsible for most of the Baroque façade: the concave line typical of his style is flanked by two bell towers set wide apart, designed in the form of baldacchini and with a high attic story. The tall lantern, surmounted by a dome, rises behind the attic story. The church was conceived on the ground plan of a Greek cross, a centrally planned structure with arms of equal length and deep niches. The tall dome is the focal element of the interior. It rises on eight columns, with a projecting entablature, and was painted with frescoes by Ciro Ferri and his school; the allegorical figures of the virtues in the spandrels are by Il Baciccia.

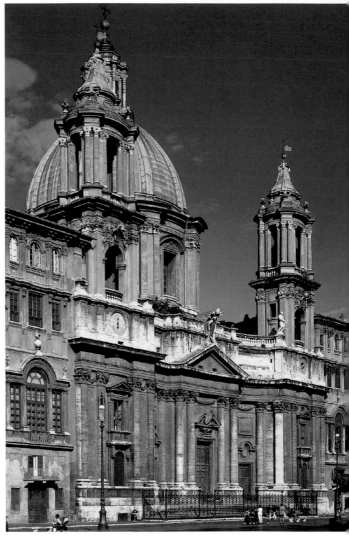

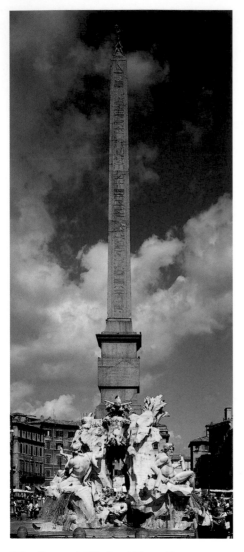

Fountain of the Four Rivers
(Fontana dei Fiume)

Pope Innocent X planned to make a large fountain, crowned with an obelisk from the Circus Maxentius, the focal point of the Piazza Navona. Bernini's magnificent Fountain of the Four Rivers, which was commissioned in 1647, is masterly in its presentation of a complex iconographic concept, and is regarded as one of the great achievements of Baroque sculpture. The pictorial program pays tribute to the pope for bringing new glory to the square, originally laid out by a Roman emperor. The center of the mighty basin is an artificial rock with personifications of four great rivers at its four corners: the Nile, the Ganges, the Danube, and the Rio de la Plata. They symbolize the known continents of the time which were under the influence of papal power, and they are surrounded by such specimens of the flora and fauna of their respective parts of the world as the lion, horse, dragon, snake, and palm tree. In reference to the papal donor, his coat of arms – a dove carrying an olive branch – appears on the rock and on the top of the obelisk in the middle of the fountain. It also alludes to the ancient Roman founder of the square, for according to the inscription it is not, like the other famous obelisks of Rome, an Egyptian artefact, but a Roman monument originally erected by Domitian in the temple of Isis on the Field of Mars.

The Palazzo della Sapienza and S. Ivo alla Sapienza

The façades and courtyard of the Palazzo della Sapienza, which until 1935 was the seat of the old University of Rome and now accommodates the archives of the city and the ecclesiastical state, were built in the 16th century by Pirro Ligorio and Giacomo della Porta. However, the heart of the papal complex is the chapel, which was designed by Francesco Borromini in 1642–1660, consisting of two equilateral triangles – symbols of the Trinity – placed together to form the shape of a star. The lower part of the church façade, which continues the line of the double arcades of the interior courtyard, is surmounted by an attic story with oval windows set on their longer sides. Ornamental turrets stand at the corners, three-dimensional imitations of the heraldic *monti* (mountains) in the coat of arms of Pope Alexander VII Chigi. A trifoliate drum rises above the turrets. The cross, the symbol of divine

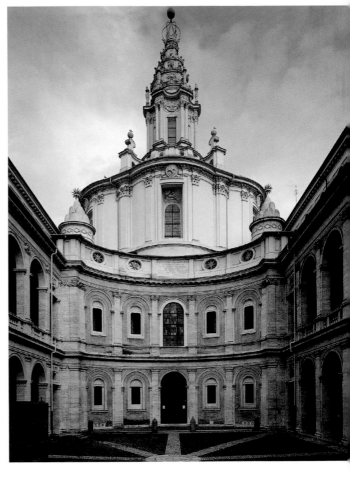

wisdom (*sapienza*), stands on the spiral upper part of the lantern, which has concave sides; the structure is reminiscent of Baroque depictions of the Tower of Babel.

Pasquino

Roman Copy of a Hellenistic Original of the 3rd Century B.C., Marble, h 192 cm

One of the most famous of the *statue parlanti* (speaking statues) of Rome, this is really a fragment of an ancient group showing the Greek hero Menelaos with the dead Patroclus. It became famous under the name of "Pasquino" because in the early 16th century it stood beside the workshop of a tailor of that name, and people attached scurrilous writings to it. In a time when there was no freedom of speech, and all criticism of political events was forbidden, the discontented citizens of Rome would secretly place notes with satirical verses on the statue as a public expression of their dissatisfaction. Pasquino soon started to enter into conversation with other *statue parlanti*, including the Marforio, the 1st-century fountain statue of a river god on the Capitol, and Madama Lucrezia, a female bust from antiquity in the Piazza San Marco, nicknamed for the mistress of King Alfonso of Aragón. It was a tradition that would continue into the 19th century. When Pope Innocent X (pontificate 1644–1655) unveiled the Fountain of the Four Rivers in the Piazza Navona, the people did not like the high burden of taxation that enabled the pope to commission works of art, and they announced, through the stone lips of Pasquino: "We don't want obelisks and fountains; we want bread, bread, and more bread."

The Palazzo Massimo alle Colonne

Some years after the destruction of the houses of the Massimo family in the Sacco di Roma of 1527, Baldassare Peruzzi was commissioned by Pietro Massimo to rebuild them. The palace rises above the stadium of Domitian, and its gently curving façade follows the convex line of the auditorium of antiquity. The smooth rusticated façade, broken only by windows on the upper floors, opens out on the ground floor into a Doric portico with six columns, to which the phrase "alle Colonne" in the name of the palace refers.

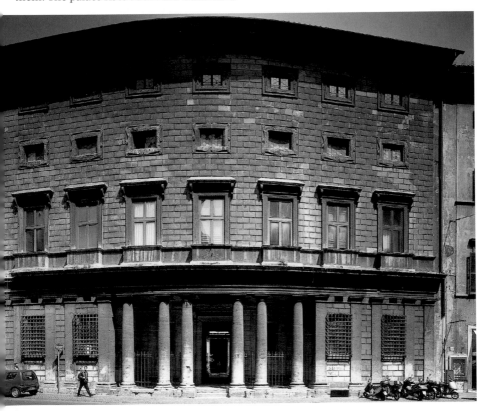

The Sacco di Roma – the Sack of Rome in 1527

by Jürgen Sorges

GEORGIVS A IRVNTSPERG IMPERATORVM DECRETIS EXERCITVE GERMANICI DVX PER TIRO- LIM ET VICINAS ALPES DEFECTIONEM COLONORVM COMPRESSIT. PER LIGVRIAM ET REGIONEM TRANSPADANAM ITALIAE VRBES POPVLOS REBELLES PERDOMVIT. AD PALVDES VENETAS VICTOR AC- CESSIT. EXERCITVMQVE AD LOCA IN QVA DELAPSVM OBSIDIONE QR·ET QN·LIBERAVIT.VICIES PLVS MINVS SIGNIS COLLATIS PVGNAVIT. AD EVM MODVM ARMATVS PRELIVM CONCIVIT ANTE PAPIAM GALLOS CECIDIT. CAETRA CAEPIT OBSESSOS EXTREMAQVE METVENTES SERVAVIT. VIXIT ANNOS·LIIII·MENX·DIES·XXVII·OBIIT AND CRISTIAO·M D X X VIII·MENSE AVG·DIE XX

*Georg von Frundsberg, Imperial Army
Commander; contemporary painting of
unknown provenance*

Contemporaries compared the Sacco di Roma in 1527 with the plundering of Rome by Alaric's Visigoths in A.D. 410, and the destruction of the city by Geiserich's Vandals in A.D. 455. "On the 6th day of May we took Rome by storm, killed over 6,000 men, plundered the whole city, took what we found in all the churches and scattered on the ground, and burned down a good part of it," stated Sebastian Schertlin von Burtenbach (1496–1577), one of the leaders of the German lansquenets. At the end of 1526 Georg von Frundsberg (1473–1528), captain of the county of the Tyrol and a charismatic army commander, had led a troop of 12,000 footsoldiers across the Alps, without any cavalry or artillery reinforcements, to relieve the imperial army in Milan. The veteran commander had no uniforms or boots, provisions or wages for his troops, who were recruited from the south German and Habsburg territories. Loyal to the emperor, they were motivated by bitter hatred for the pope, who had poured scorn on them from a distance as "Luterani," followers of Martin Luther. The army wanted no less than the deposition of the pope – and plunder, for after Venice and Genoa, Rome was considered the third richest city in Italy. The fortunes of battle and the hesitant tactics of Pope Clement VII (pontificate 1523–1534) had brought the strategically inferior imperial army to the gates of Rome, robbing and murdering as it went like an apocalyptic avalanche. There could be no going back: the army, now numbering 40,000 unpaid men, was driven on by hunger. Behind them, the Duke of Urbino was approaching with the papal army reserves.

Trastevere, May 6, 1527, the headquarters of Sant'Onorio at dawn: one more day, and the army had stormed the Leonine Wall of the Vatican, which was considered impregnable, at the Porta San Pancrazio and the present Torre Cavalleggeri. Nor could its supreme commander, Charles de Bourbon, constable of France, do anything to prevent the events of the coming night, the most appalling in the modern history of Rome, for he had been shot in the belly. The pope fled from the Vatican at the last minute with 3,000 loyal men, making his way down the 800 meters (2,624 feet) of the corridor of the Borgo to the Castel Sant'Angelo, while the mercenaries inflicted bloody slaughter on the Swiss Guard as they shielded the pope's retreat in St. Peter's Square. The lansquenets pitched camp in the Campo dei Fiori, while their allies stationed an impenetrable force of besiegers around the Ponte Sant'Angelo below the Castel Sant'Angelo. On June 5 the pope was forced to surrender, and two days later the papal forces which had been occupying the Castel Sant'Angelo left. Imperial mercenaries, including two hundred of Schertlin's lansquenets, moved in and became the pope's jailers. "There was great lamentation among them, they wept a great deal, and we all grew rich," noted Schertlin in his journal, for the benefit of posterity.

The pope remained imprisoned in the Castel Sant'Angelo for seven months. It was not until December that Clement managed to flee to Orvieto. Two months later, in February 1528, the mercenaries left Rome too, taking their loot with them. However, the dizzy heights to which food prices rose, the money the mercenaries had spent on prostitutes, their addiction to gaming and drinking, and the ravages of disease brought a large part of the stolen valuables and works of art back into Roman hands within a few months. But the Sack of Rome was a crucial watershed in the artistic life of the city: most of the artists' workshops had been abandoned, and scarcely any pupils of the master Raphael ever returned to the Tiber.

Matthias Merian the Elder, Charles de Bourbon, Constable of France, giving the order to plunder the city (Sacco di Roma May 6, 1527). Engraving (colored later)

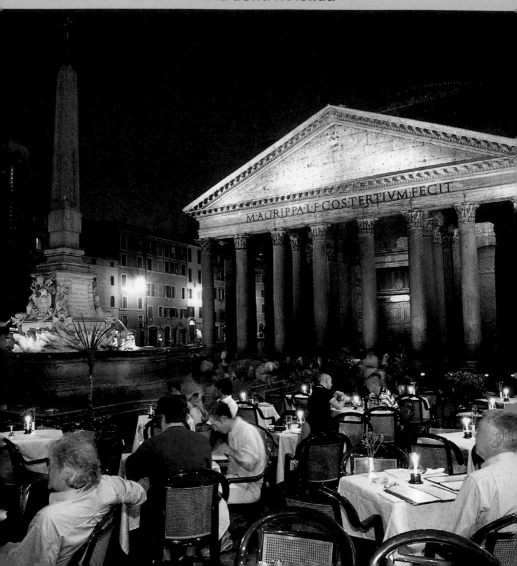

Only the tangle of narrow streets and alleyways shows that this was once a mainly working class quarter of Rome. Today, the presence of the Borsa and the head offices of many banks makes it the financial center of the city. Moreover, the Italian parliament sits in the historic Palazzo di Montecitorio, and many branches of the civil service have their headquarters in the neighboring buildings. The focal point of the quarter is the famous Piazza della Rotonda in front of the Pantheon, simply called "the round thing" (*rotonda*) in the Middle Ages. At its center lies a marble fountain erected by Giacomo della Porta in 1575, on which Pope Clement XI had an obelisk from the temple of Isis placed in 1711. There are magnificent buildings and unusual monuments to be found in the maze of narrow streets around the piazza: for instance, the huge foot of an ancient colossal statue, and the Fontanella del Facchino (porter), one of the *statue parlanti*, beside the Banco di Roma.

In antiquity this quarter was part of the Field of Mars. During the renovation of the city under Augustus, the buildings erected here included the forerunner of the Pantheon; the Baths of Agrippa, set in spacious gardens with an artificial lake; the Saepta Julia, an open area laid out on a monumental scale for public entertainments; and columned halls with famous works of art. Today scarcely anything is left of all these buildings.

A devastating fire in A.D. 80 destroyed large parts of the quarter, and when later emperors began reconstruction work, the built-up area was extended to the north. The Pantheon, probably the most famous building in European architectural history, was built under Hadrian. Antoninus Pius built the temple to the deified Hadrian, and Marcus Aurelius was honored after his death with a column in the Piazza Colonna. This monument marks the end of the ancient history of the quarter, which was quite sparsely inhabited until the Middle Ages.

The Gothic invasions and Lombard sieges of the city in the 6th century led to reorganization within its boundaries, and subsequently the Field of Mars was more densely populated again. This development continued throughout the Middle Ages, when new residential areas inhabited by the lower social classes grew up around such recently founded churches as S. Maria sopra Minerva. While the urban developments carried out by the popes of the Renaissance only touched the outskirts of this part of the Field of Mars, its fortunes saw a spectacular revival during the Baroque era. The churches of Il Gesù, S. Ignazio, and La Maddalena, and palaces such as the Palazzo Montecitorio, the Palazzo Doria Pamphilj, and the Palazzo Borghese are evidence of the extensive building activity that went on here during the 17th and 18th centuries.

View of the Piazza della Rotonda

In and around the Piazza della Rotonda

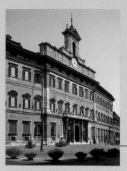

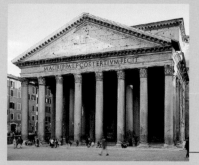

Palazzo di Montecitorio, Piazza di Montecitorio, p. 212

Pantheon, Piazza della Rotonda, p. 188

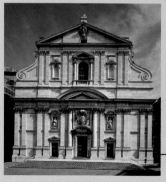

S. Maria sopra Minerva with Obelisk, Piazza della Minerva 42, p. 196

Il Gesù, Piazza del Gesù, p. 201

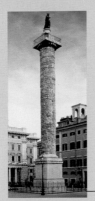

Column of Marcus Aurelius,
Piazza Colonna, p. 213

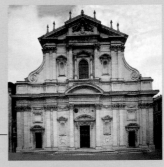

S. Ignazio di Loyola, Piazza di
S. Ignazio, p. 210.

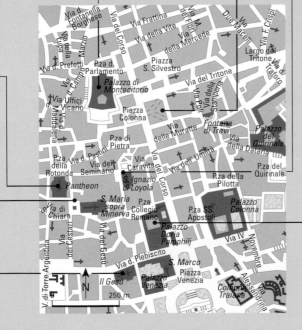

Palazzo Doria Pamphilj, Via del
Corso, entrance in the Piazza
del Collegio Romano 1 a, p. 208

The Pantheon

The Pantheon, one of the best preserved and most fascinating buildings of ancient Rome, stands on the Piazza della Rotonda. The inscription on the architrave reminds us that the man who first built on this site, Agrippa, was son-in-law to the emperor Augustus. He erected a rectangular temple here in 27 B.C., in honor of the ruling family, but according to tradition Augustus refused to have it consecrated to himself and, modestly, merely had his statue placed in the porch. The building was therefore named the Pantheon, although the precise significance of calling it a temple of "all the gods" is not clear. It was probably first dedicated to the planetary gods, particularly Mars and Venus, the tutelary deities of the Julio-Claudian *gens*, as the symbolism of the dome would suggest; it is constructed to resemble the vault of the firmament with a circular opening for the sun at the center. After the fire of A.D. 80, Emperor Hadrian had a new building erected between A.D. 118–125, the Pantheon as it still stands today. This architectural masterpiece was a severe test of the technical abilities of the architects of Rome, and later it served as a model to Renaissance artists such as Bramante and Michelangelo. In fact the Pantheon was preserved from destruction only because in 609 Emperor Phocas of Byzantium gave it to Pope Boniface IV (pontificate 608–615), who converted it into the church of S. Maria ad Martyres a year later, on November 1. Earthquakes, floods, and demolition did the building considerable damage over the centuries, but it was always restored again. In 663, for instance, Emperor Constans II had the gilded bronze roof tiles taken to Constantinople, and Pope Urban VIII Barberini melted down the bronze ceiling of the porch to provide material for Bernini's baldacchino in St. Peter's and cannons for the Castel Sant'Angelo.

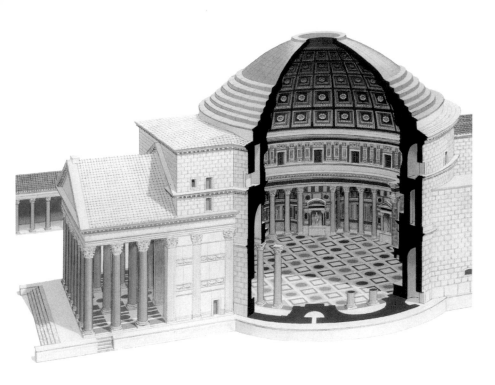

Reconstruction

The Pantheon was designed as a round building with a colonnaded porch. In antiquity, when the street level was a good deal lower than it is today, a long area framed by porticoes led up a flight of steps to this three-aisled porch, which has eight monolithic granite columns with Corinthian marble capitals along its front. A mighty bronze door gives access to the circular interior, which is 43.20 m (142 feet) in diameter and as high as it is wide. If the line of the dome were continued to form a globe, it would fit exactly into the cylindrical drum of the lower part of the building. The round building consists of a brick masonry wall 6.20 m (20 feet) thick, with relieving arches and cavities built into it, and the shallow calotte is constructed of concrete. The exterior of the building was originally faced with blocks of plaster, and the dome was covered with gilded bronze tiles.

The Interior

On entering the Pantheon, visitors are often impressed by the monumental simplicity of the interior and the perfect harmony of its proportions: the distance from the floor to the dome is exactly the same as the diameter. The floor is made of square and circular marble slabs, using the same varieties of marble as the rest of the architectonic decoration. The walls in the lower zone open alternately into niches, each with two pillars in front, and aedicules surmounted by trian-gular or segmented pediments. The niche opposite the entrance is marked out by its size and the different line of its cornice. Above it is the attic zone, its former structure visible today only in a small part that has been reconstructed; the rest has 18th-century stucco ornamentation. In antiquity, the decoration consisted of slender Corinthian pilasters with square blind windows fitted between them. The statues of ancient gods that originally stood in the niches and aedicules were replaced over the centuries by Christian altars and tombs.

Pope Pius VII's secretary Cardinal Ercole Consalvi (1757–1824), who was a prominent figure of his time, is buried here under a monument created by Thorvaldsen in 1824 (third niche on the left), and the kings of Italy were laid to rest in the Pantheon at the end of the 19th century (second niche on the right and second niche on the left). However, one of the tombs in the church to which visitors are most attracted must be that of the Renaissance artist Raphael (under the third aedicule on the left). His bones rest in an ancient sarcophagus above which stands the *Madonna del Sasso*, created in 1520–1524, in accordance

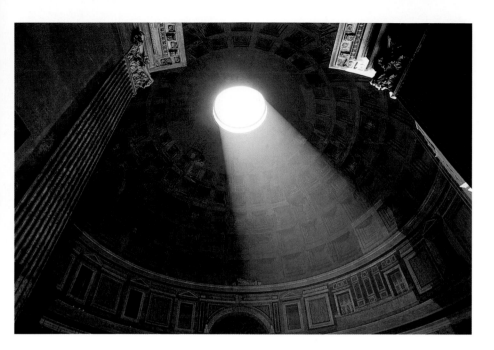

with the terms of his will, by Raphael's pupil Lorenzetto. The inscription on the tomb, composed by Raphael's friend Cardinal Pietro Bembo, runs: *Ille hic ist Raphael, timuit quo sospite vinci, rerum magna parens et moriente mori* (Here lies Raphael; our great Mother Nature feared to be conquered by him in his lifetime, and to perish herself on his death).

A View of the Dome

The mighty hemisphere of the great vault of the dome as it rises above the walls appears to imitate the firmament itself. Made entirely of concrete, it was until the 20th century the largest dome ever built. The interior is ornamented with five concentric circles, each consisting of twenty-eight coffers once faced with gilded bronze, and diminishing in size as they rise to the apex of the vault. Light falls evenly into the space below through the round opening in the middle of the dome, which is 9 m (30 feet) wide.

Johann Joachim Winckelmann and Antiquity

by Jürgen Sorges

Anton Maron, Portrait of J.J. Winckelmann, 1768, oil on canvas, 135 × 100 cm, Staatliche Galerie Moritzburg, Halle an der Saale

In 1779, when Landgrave Friedrich II of Hesse-Kassel founded his Société des Antiques (Antiquarian Society), he remembered, regretfully, a man whom he would have been more than delighted to appoint president of that exclusive circle of art lovers: Johann Joachim Winckelmann, the most famous art theoretician of his time, who had died eleven years earlier. By 1785 the stocks of the library in the Museum Fridericianum in Kassel numbered 33,965 books. Casts of famous statues of antiquity were collected, and studied in the light of the knowledge won from the natural sciences: Winckelmann's theoretical writings had been very influential. Art and science were the two poles of his thinking, and this new imperative, expressed in the concept of all-round culture, also dominated other European museums at the time. The humanist scholar in the service of the nobility had been replaced by a new ideal: the man of wide culture and education.

It was by no means obvious that Winckelmann was destined to become the leading European expert on the art of antiquity: he was born on December 9, 1717 in Stendal (now Saxony-Anhalt), the son of a cobbler. His schooldays were spent in Berlin and Salzwedel in the Altmark. Winckelmann studied theology in Halle in 1738–1740, also attending lectures on philosophy and aesthetics. After a year being employed as a private tutor, he went to Jena University in 1741 to study medicine and mathematics, but soon interrupted his studies and returned to employment as a private tutor. In April 1743 he took up the position of assistant head of the Latin School at Seehausen in the Altmark.

The great turning point in the life of Johann Joachim Winckelmann came in September 1748, when he took up an appointment as "historical assistant" and librarian to Count Heinrich von Bünau in Nöthnitz near Dresden. At the age of thirty-one, he had at last found in the cultivated artistic circles of that city, sometimes called "the Florence of the Elbe," an atmosphere in which he could immerse himself further in his studies of art and literature in several languages. From October 1754 he devoted himself to these studies, and a stipend granted to him the next year by the Crown Prince of Saxony made it possible for him to visit Rome as an independent scholar. He was immediately successful with a publication setting out the program for his subsequent work, *Thoughts on the Imitation of Greek Works in the Art of Painting and Sculpture*, which went into a second edition as early as 1756. In 1757 the outbreak of the Seven Years' War caused Winckelmann financial difficulties, but he found the solution by taking a position in the household of the Roman Cardinal Archinto. It was through him that he was able to gain access to the most important scholarly circles in the city. Winckelmann acquired a reputation outside the bounds of Rome itself with the publication of his *On the Old Herculanean Writings* of 1758 and his *On the Famous Museo Stosch in*

Bernardo Bellotto, View of the Tiber with the Castel Sant'Angelo in Winckelmann's time, ca. 1769, private collection

Florence of 1759; he had studied this museum's unique collection of engraved gems the previous winter. His *Remarks on the Architecture of the Ancient Temples at Girgenti in Sicily* of 1759, and in particular his *Remarks on the Architecture of the Ancients* of 1762, pointed the way ahead for subsequent generations of scholars who would follow in his footsteps, and anticipated the philosophical and literary writings of Hegel, Schiller, and Herder. German classicism would have been unthinkable without the new ideal of beauty propagated by Winckelmann in his works: henceforth "noble simplicity and serene grandeur" was an artistic maxim that ruled Europe. Winckelmann's new "divine Arcadia" inspired by Greek art also had enormous influence on Johann Wolfgang von Goethe (1749–1832) and the travelers who followed him to Italy on the classical Grand Tour, the tour of southern Europe that was incumbent on young noblemen as part of their education. In 1765–1768 the young Goethe took many drawing lessons in Leipzig from Adam "Friedrich" Oeser, who also taught him etching and engraving. Oeser was one of the closest friends of Winckelmann, who had now become an acknowledged art theoretician.

In June 1759 Winckelmann entered the circle of Cardinal Albani, who was the most important collector of antiquities in Rome at this time. He now worked at the Villa Albani, which had been built by the architect Carlo Marchionni in 1743–1763 to accommodate the cardinal's extensive collection of sculptures. This early neo-classical villa on the Via Salaria is regarded today as an outstanding example of the new 18th-century taste in art and architecture, developed under the influence of Winckelmann himself. It has belonged to the aristocratic Roman banking family of Torlonia since 1865.

In April 1763, through the good offices of his mentor Cardinal Albani, Winckelmann obtained the highest position to which a Roman scholar could aspire: he was appointed

Villa Albani (built 1743–1763, architect Carlo Marchionni) on the Via Salaria, Rome, photograph ca. 1880

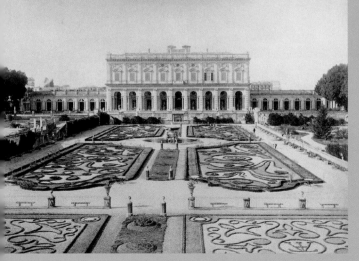

supervisor of all the antiquities in Rome. He employed the following years in writing his main work, the *History of the Art of Antiquity* (1764–1768), which was a comprehensive account of the ancient works of art. And his voice was heard: he protested energetically against the chaotic and unorthodox methods of contemporary excavation in Herculaneum and Pompeii, setting off the "Pompeii mania" that has pervaded Europe ever since. But Winckelmann's views persuaded the director of excavations of that time, the Swiss engineer Karl Weber, to work systematically, not at random and on the principle of chance. Winckelmann may rightly be regarded as the founding father of classical archaeology.

In 1768, a long-planned journey to Germany where he intended to stay in several places finally took Winckelmann only to Regensburg, from where he traveled back to Italy by way of Vienna. Unfortunately fate struck him down, completely unexpectedly, in Trieste on June 8, 1768: Winckelmann's "Life for Apollo," his fight for beauty and its interpretation, ended in an act of violence when he was robbed and murdered for the valuables he was carrying.

The works of art placed by Winckelmann in the rooms of the Villa Albani did not remain there long either: in 1798 Napoleon Bonaparte had part of the collection taken to Paris as the spoils of war. The Congress of Vienna decided in 1815 that they should be returned to Rome, but the cost of transport was too high, and Prince Albani, who was in financial difficulties, decided to sell most of his collection. In this way some forty statues arrived a little later at the Glyptothek in

Johann Joachim Winckelmann, Geschichte der Kunst des Alterthums (History of the Art of Antiquity), title page of first edition (Part 1), 1764, Waltherische Hof-Buchhandlung, Dresden

Munich, where they are kept to this day, and other works were acquired by museums in Vienna and Paris. The antiquities since collected for the Villa Albani by the Torlonia family, very much in the spirit of Winckelmann himself, are considered one of the finest private collections in the world. However, they have not been on display to the public since the end of the Second World War.

The Piazza della Minerva and the Obelisk

The piazza in front of S. Maria sopra Minerva is dominated by an unusual monument consisting of a marble elephant with an obelisk on top of it. An Egyptian obelisk from the temple of Isis in Egypt was found in the garden of the monastery of S. Maria sopra Minerva in 1665, and the monks wished to place it in the square in front of the church. The base of the obelisk consists of an elephant with a heavy saddle on its back, designed by Bernini and executed by Ercole Ferrata in 1667. The elephant, an ancient symbol of strength, wisdom, and piety, was intended to symbolize those virtues that support true Christian doctrine, as the inscription on the plinth explains: "… documentum intellige robustae mentis esse solidam sapientiam sustinere" (it takes a strong mind to bear the burden of wisdom).

S. Maria sopra Minerva

The first and only Gothic church in Rome, on which building began in 1280, stands on the site of an ancient temple of Isis which was erroneously identified as a temple of Minerva, hence the nickname *sopra Minerva* (above the temple of Minerva). The building of the church of S. Maria, in accordance with plans by an unknown architect, continued with many interruptions until

1453, when the Gothic groined vaulting was placed over the nave. Also unknown is the designer of the plain Renaissance façade, on which the marks showing the height of the flooding of the Tiber from the 16th to the 19th centuries can be seen to this day.

The church has always belonged to the Dominican order, which had its Generelate – the headquarters of its central Roman administrative body – in the neighboring building on the left. This building also accommodated the authorities of the Inquisition in the 17th century, in the time of Galileo Galilei. Located in the middle of the city as it was, and in the care of a preaching order, S. Maria sopra Minerva was very popular among the Roman people. A number of side chapels were added to the two aisles of the pillared basilica in the 16th and 17th centuries, and there are many tombs here; those buried in the church included several popes; the painter Fra Angelico, himself a member of the order; and St. Catherine of Siena. The building of the chapels changed the spatial design of the interior, and in the 19th century the church underwent a thorough restoration to reinstate its Gothic appearance.

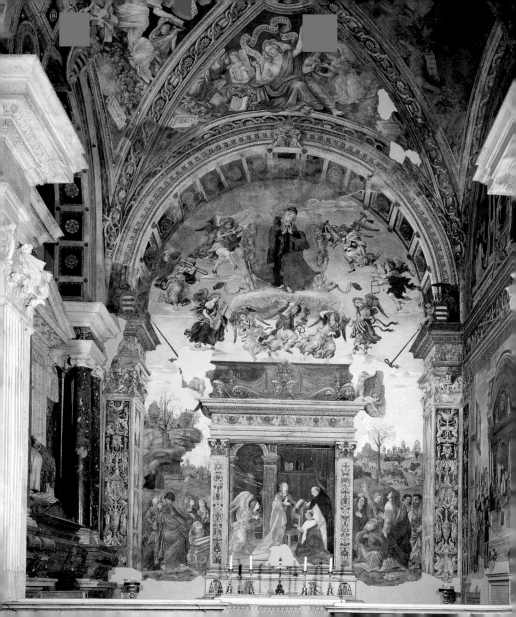

The Carafa Chapel, Filippino Lippi (1457–1504), 1488–1493, with Detail: Equestrian Monument of Marcus Aurelius
Fresco

An arch resting on fluted Corinthian pilasters with a soaring entablature forms the entrance to the best-known funerary chapel in the church. This chapel, which is located at the end of the right-hand transept, was built for Cardinal Oliviero Carafa and was consecrated in 1493. Its fame derives from the frescoes of Filippino Lippi, who worked on the interior decoration from 1488–1493. They are among the most outstanding chapel decorations in Rome. Lippi painted the frescoes in honor of the Virgin Mary and St. Thomas Aquinas, the famous medieval doctor of the church and a Dominican himself. The wall behind the altarpiece, on which St. Thomas is shown recommending Cardinal Carafa to the good offices of St. Mary, shows the Assumption of the Virgin. The right-hand wall contains scenes from the life and apotheosis of the saint. It includes a view of the Lateran palace, with the equestrian monument to Marcus Aurelius that once stood there constituting a notable topographical detail left of the throne. The depiction of the virtues and vices originally on the left wall had to give way to the tomb of Paul IV (pontificate 1555–1559), who was a nephew of Cardinal Carafa, and whose name is linked with the Counter-Reformation and the Inquisition. Through his use of architectural details, some painted and some real, Filippino Lippi created the impression of spatial illusion. The wall behind the altarpiece appears to open into a spiritual world. The naturalistic depiction of space and landscape, and the subtly differentiated bearing and gestures of the individual characters, relate directly to the viewer and are typical of early Renaissance painting. The pilasters framing the chapel are decorated with grotesques, an early reaction to the Roman wall paintings which were discovered in the Domus Aurea in the 1480s.

Michelangelo Buonarroti (1475–1564), The Risen Christ, 1519–1521
Marble, h 205 cm

The statue of Christ to the left of the high altar is one of the artistic treasures of the church. When it was unveiled on December 27, 1521, the sculptor thought it so bad that he even offered to provide a substitute. Michelangelo had begun work on the statue of Christ as soon as he received the commission in 1514, but he left it uncompleted when a vein of black marble appeared in the face. He entrusted the completion of the second version, which he had begun in 1519, to his assistant Pietro Urbano, who damaged the statue so badly in some parts that even the master himself could not rectify matters. However, in the 16th century it was one of Michelangelo's most admired works. The painter Sebastiano del Piombo was so impressed by it that he said the knees of Christ were worth more than all Rome put together. The combination of the Christian subject with the idealized image of a hero of antiquity is unusual: Christ is shown standing, entirely naked (the bronze loincloth is a Baroque addition), without wounds and in a strong *contrapposto* attitude, turning his head. He clasps the cross and the instruments of martyrdom in both hands, in a gesture expressing the voluntary nature of his death on the Cross.

Il Gesù

The Spanish nobleman Ignatius of Loyola (1491–1556), who turned to the religious life at the age of thirty, was the founder of the Society of Jesus, usually known as the Jesuits, recognized by Pope Paul III (pontificate 1534–1549) as a priestly order in 1540. The rules of the order included lifelong chastity, poverty, and a readiness to serve the pope anywhere. The community soon spread out from Rome and Italy to the Catholic countries of Europe, and at the request of the Catholic kings of Spain and Portugal founded the first missionary stations in the East Indies, Brazil, the Congo, and Ethiopia. In Europe, the Jesuits were influential supporters of the Counter-Reformation, their principal aim being to reform the Catholic Church from within.

A decision was made in 1550 to build a new church to replace the small structure next to the building where the order lived and worked, which is still an international Jesuit college today. In 1568 Giacomo Vignola was commissioned by Cardinal Alessandro Farnese to begin work on the principal church of the Jesuit order. It is among those buildings that may be said to have set new trends in Western architecture. Vignola's novel idea of merging the nave of the medieval basilica with the design of centrally planned High Renaissance

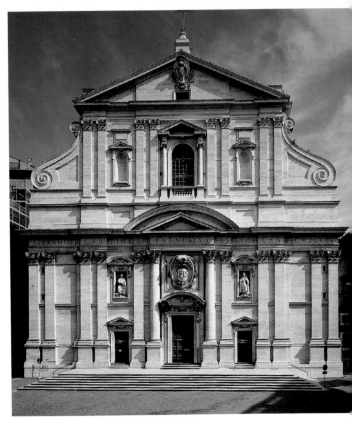

buildings, creating a structure with a dome over the crossing, became the model for many Baroque churches. After the architect's death, the members of the order completed the building, and it was consecrated in 1584. The façade (1575/76), which brings together elements of Renaissance and Baroque architecture, is the work of Giacomo della Porta. The division of the structure by pilasters reflects the basilical cross-section of the interior. Lavishly designed volutes lead from the sides to the taller, narrower central section, which is also emphasized by the main porch and central window of the upper story. The way in which the architectural order rises toward the center is enhanced by the powerful relief of the wall surfaces, with openings, protruding pilasters, columns, and cornices. A dome with its windows surmounted by pediments rises above the intersection of the transept, which is aligned with the walls of the side aisles.

Cappella di S. Francesco Borgia, with frescoes by Andrea Pozzo, ca. 1588

Il Baciccia, Triumph of the Name of Jesus, p. 206

1	Cappella di S. Andrea
2	Cappella della Passione
3	Cappella degli Angeli
4	Cappella di S. Francesco Borgia
5	Cappella della Sacra Famiglia
6	Cappella della SS. Trinità
7	Cappellla di S. Maria della Strada
8	Cappella del Sacro Cuore

Altar of St. Ignatius, p. 205

Memorial to St. Roberto, with a bust by Gianlorenzo Bernini, 1622

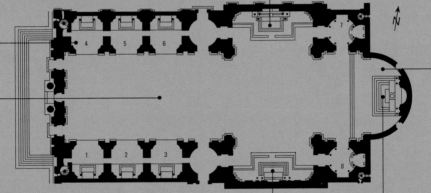

Pietro da Cortona, altar of St. Francis Xavier, 1674–1678

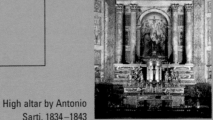
High altar by Antonio Sarti, 1834–1843

The Interior

Preaching and the intensive pastoral care of individual believers through confession, spiritual exercise, and communal divine service, were among the main tasks of members of the order. The architect Vignola did justice to both requirements with his design for a cruciform interior, at the same time creating the prototypical interior plan of Roman churches. The spatial emphasis lies in the nave, which can accommodate a large number of worshipers. With the intersection and the apse, it creates the impression of a single unified area; the side chapels for private prayer, for confession, or for the remembrance of the dead have a subsidiary function. The altar is visible from anywhere in the church, so that all the faithful can follow the mass. The Baroque ornamentation, with its interplay of variegated marble, stucco work, gilding, frescoes, and sculptures, conveys little idea of the original spatial effect of the plain Cinquecento decoration. The walls of the nave are divided by pillar-like structures, with the barrel vault resting on their entablature and illuminated by lunettes containing windows. Arcades between the pilasters give access to the side chapels. The arches of the intersection support the cylindrical drum of the dome, which concludes in a hemispherical calotte.

**Andrea Pozzo (1642–1709),
Altar of St. Ignatius, 1696–1700**
Marble, bronze, silver, lapis
lazuli, and gilding

The altar, which was erected by Andrea Pozzo in 1696–1700 above the tomb of Ignatius of Loyola in the left transept, is one of the artistic masterpieces of the church. The boundaries between painting and sculpture, reality and illusion appear to dissolve in this work. The altar shows the group of the Trinity as a vision experienced by the saint. The colossal silver statue of St. Ignatius, which was executed by Pierre Legros, stands between four great lapis lazuli columns, but it is only a copy; Pope Pius VI (pontificate 1775–1799) was obliged to have the original melted down to pay war reparations to Napoleon after the Treaty of Tolentino. The group which is by Pierre Legros to the left of the altar, showing the triumph of Faith over Heresy, is probably among the most expressive ensembles of Baroque art. During the Counter-Reformation, the Church saw the overcoming of Heresy as an essential prerequisite for the triumph of good over evil. The victor is the personification of Faith on the right of the group (by Giovanni Théodon), casting Heresy into the depths. The small *putto* pointing to an open book is indicating the True Doctrine.

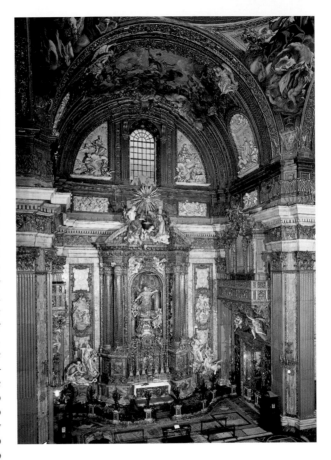

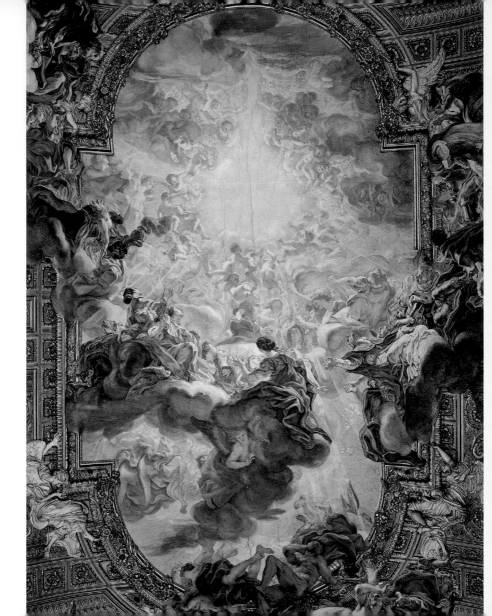

Il Baciccia, Triumph of the Name of Jesus (with detail), 1676–1679
Fresco

At the request of the Jesuit superior, Father Olivia, the interior was refurbished in the second half of the 17th century. He wanted an effect that would impress believers and familiarize them with the glories of heaven through contemplation of the history of salvation. He gave the commission for the painting of the dome, the barrel-vaulted nave, and the vault of the apse to Giovanni Battista Gaulli, known as Il Baciccia, who showed virtuoso skill in translating the basic ideas of the Baroque, the constant presence in this world of the world beyond, into his painting.

The lively frescoes – scenes of the *Adoration of the Lamb* in the apse, the *Triumph of the Name of Jesus* in the nave, and the cycle of angels in the dome (1676– 1679) – are notable for their skillful illusionism. A *trompe-l'œil* effect makes the four prophets in the pendentives beneath the dome seem to be hovering on clouds, giving a real impression of the metaphysical presence of the saints. The fresco located in the nave appears to be fixed to the ceiling by the heavy frames borne by white stucco angels. The monogram of Christ, IHS, appears at the center of the bright sky, surrounded by *putti*. The fresco also shows a number of redeemed souls who will enter into eternal life, while the damned fall into the pit. The figures moving into the picture from outside or falling out of it, with painting and stucco alternating fluently, make viewers feel that the vault is about to split and open up to give a view of the sky above: they find themselves in the role of an audience watching a divine spectacle in the heavens.

The Palazzo and Galleria Doria Pamphilj

This large complex of buildings, set on a square of streets, has an architectural history covering four centuries and closely connected with the complex fabric of relationships between the great noble families.

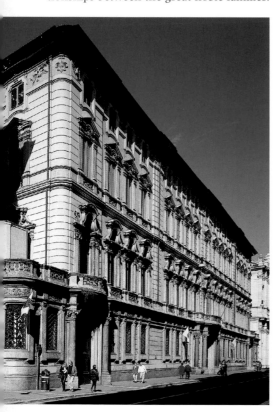

The nucleus of the building dates from the 15th century; it later entered the possession of the Della Rovere family, and in 1601 into that of Cardinal Pietro Aldobrandini. Through Aldobrandini's heiress, Donna Olimpia Aldobrandini, who married Camillo Pamphilj, nephew of Pope Innocent X, it finally came into the hands of the Pamphilj family. Donna Olimpia also brought a considerable art collection to the marriage, and this collection was enriched in the late 17th century by the union of the house of Pamphilj with the Doria family of Genoa. It formed the basis of the collection in the Galleria Doria Pamphilj (entrance on the Piazza del Collegio Romano), which contains over four hundred paintings of the 15th to the 18th centuries.

The palace has six monumental entrances arranged around five inner courtyards. What is really the principal façade, containing the main porch and a handsome vestibule with a wide staircase, was built by Antonio del Grande around 1660, and looks out on the Piazza del Collegio Romano. The most impressive, however, is the façade on the Corso, created by Gabriele Valvassori in the decorative *barocchetto* (late Baroque) style between 1731 and 1735. A swelling, fluid line is created by the organization of the columns, the narrow windows with lavish decoration above them, and the curving balconies and galleries on all floors. Valvassori was also commissioned to close off the upper, open loggia on the courtyard side, to make room for the gallery.

Galleria Doria Pamphilj

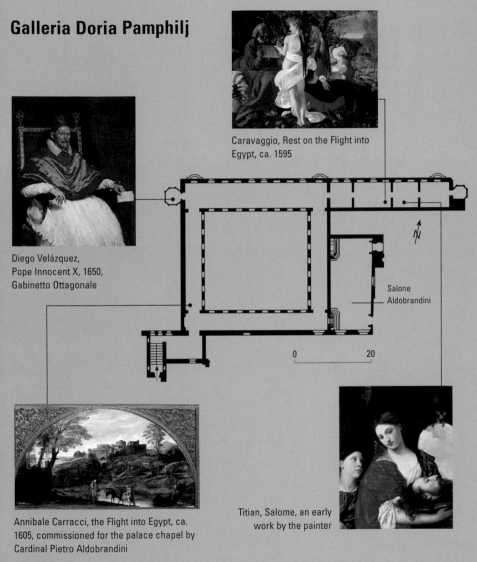

Caravaggio, Rest on the Flight into Egypt, ca. 1595

Diego Velázquez,
Pope Innocent X, 1650,
Gabinetto Ottagonale

Salone
Aldobrandini

0 20

Annibale Carracci, the Flight into Egypt, ca.
1605, commissioned for the palace chapel by
Cardinal Pietro Aldobrandini

Titian, Salome, an early
work by the painter

S. Ignazio di Loyola

Under the auspices of Cardinal Ludovico Ludovisi, building began in 1626 on the second great church in honor of the founder of the Jesuit order, four years after the canonization of Ignatius of Loyola. In accordance with the desire of the Jesuits to promote the Catholic faith through the arts and sciences, major artists were commissioned to work on its construction. Orazio Grassi was responsible for the plans, while Andrea Pozzo was responsible for painting the interior. Since the intersection was not surmounted by a dome, he constructed an artificial work of architecture in *trompe l'œil* painting.

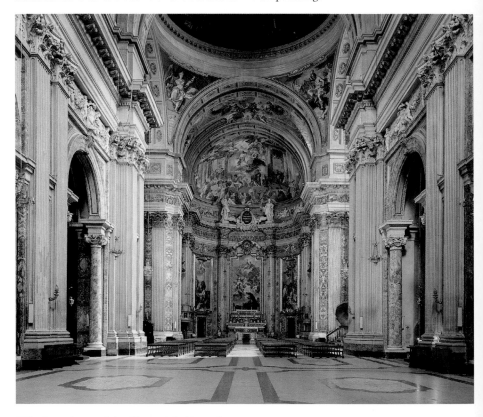

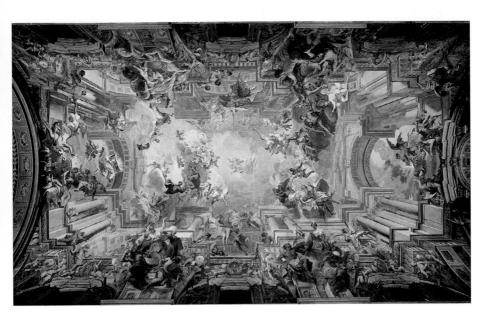

Andrea Pozzo (1642–1709),
Apotheosis of St. Ignatius, 1691–1694
Ceiling fresco, 17 × 36 m

To the Jesuit mind, sending out preachers to all nations was essential to ensure the conversion of the heathen and ultimate triumph of the church. Andrea Pozzo's ceiling fresco, which uses the methods of illusionist painting to create a dome apparently flooded with light, reflects this idea: the observer looks up to heaven, where St. Ignatius of Loyola is receiving the Light of the Word of God as it proceeds from Christ, and conveying it to the four quarters of the earth, shown as personifications in the attic story of the *trompe l'œil* architecture. They are turning to the saint in rapture, for they owe their liberation from heresy and idolatry entirely to the missionary work of the Jesuit order. Other saints of the order also populate heaven, along with many praying figures. By building a round tile into the floor, Pozzo has indicated the place from which viewers can best follow the perspective construction of the simulated architecture, in which the boundaries between real and painted building blur and are merged.

The Palazzo di Montecitorio

In antiquity, emperors were cremated on the spot where the Italian parliament meets today. Remnants of *ustrina* (funeral pyres) have been found during excavations, as well as the plinth of the Column of Antoninus Pius (now in the Vatican Museum), from the remnants of which the obelisk in the Piazza di Montecitorio was re-erected in 1792. Emperor Augustus had brought the obelisk of Pharaoh Psamtik (Psammetichus) II (594–589 B.C.) from Heliopolis; it originally stood on the Field of Mars west of the Ara Pacis, and acted like the pointer of a sundial.

Bernini began work on the palazzo, commissioned by Pope Innocent X (pontificate 1644–1655) in 1650, but it was not completed (by Carlo Fontana) until 1694, after a long interruption. Bernini had designed the large building with a curving convex façade, its twenty-five window axes being divided into five sections. The central part projects forward, with a columned porch on the ground floor and an attic story surmounted by a clock tower. Bernini lent a strong accent to the central story with the pediments of its windows, which are alternately triangles and segmented arches. Originally planned as the residence of the Ludovisi family, the palace later assumed the function of *curia innocenziana*, the papal law court. When it became the parliamentary chamber in 1871 a large extension was built on at the back by Ernesto Basile.

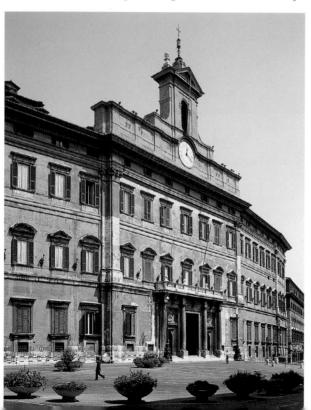

The Column of Marcus Aurelius

(Colonna di Marco Aurelio)

After the death of Marcus Aurelius in A.D. 180, the senate dedicated a column almost 30 m (98 feet) in height to him; it was completed in 193, and presumably was connected with a temple, in honor of the deified emperor, lying behind it. A spiral staircase inside the column leads up to the platform at the top. Like the Column of Trajan, it has relief decoration running around it in a spiral band, depicting Marcus Aurelius's two campaigns on the Danube frontier against the Marcomanni and the Sarmations (A.D. 172–175), separated from each other by a goddess of victory. The style is quite different from that of Trajan's Column: deep indentations break the surface up into strong contrasts of light and shadow, and the figures are more markedly distinct from each other, emerging from the surface with greater volume. The separate episodes, shown in a simplified and schematic manner, seem to form a consecutive narrative. The Renaissance artist Domenico Fontana restored the column in 1589, creating a new marble base from the material of the demolished *Septicodium*, a building erected as a display façade for the palaces of Septimius Severus on the Palatine. He also replaced the statue of the emperor on top of the column with a bronze statue of the Apostle Paul holding a sword. A staircase of 190 steps leads up to it inside the column.

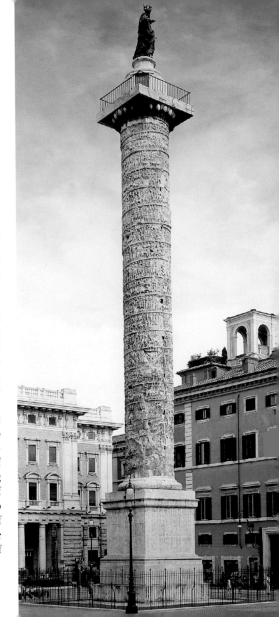

The northern part of the ancient Field of Mars, where Emperor Augustus built the great Ara Pacis (altar of peace) and his own mausoleum, today consists of two large squares and the buildings around them. To the north is the Porta del Popolo, the gate through which, for centuries, travelers coming from the north down the Via Flaminia entered the city. It opens into the Piazza del Popolo, which the popes began to develop in the 16th century. They had new roads built and existing roads extended to handle the ever-increasing influx of pilgrims and other visitors. Examples are the three streets fanning out from the piazza, popularly known as the *Tridente* (trident). On the right is the Via di Ripetta, leading to the banks of the Tiber. In the middle the Via del Corso, 1.6 km (1 mile) long and following the course of the ancient Via Flaminia, leads to the Piazza Venezia. On the left the Via del Babuino, which owes its name – "baboon" – to the statue of an ungainly Silenus, leads to the most famous square in the city of Rome, the Piazza di Spagna. In the 17th century the two most powerful countries in Europe, Spain and France, shared occupation of the streets around this piazza between them and embellished them with imposing buildings. The Spaniards built their Vatican embassy in the Palazzo di Spagna, while the French constructed a monumental flight of steps leading from the piazza to their church of SS. Trinità dei Monti and other French institutions on the Pincio. In the 18th century the square was largely populated by Englishmen who came to Rome on the Grand Tour of Europe, and stayed in one of the many hotels in the area. The district was also popular with artists and intellectuals from all over the world right into the 19th century. Goethe stayed here, and so did the English poets Keats and Shelley; the houses where they lived are now memorials to them. Even today the visitor is reminded of those days by the famous Caffè Greco in the Via Condotti, where international celebrities used to met, and Babington's Tea Room in the Piazza di Spagna. Since then the Piazza di Spagna has become the favorite rendezvous for tourists who are visiting Rome. From the square, they can walk to see the sights – the famous monuments of antiquity, the Renaissance, and the Baroque period – or simply wander down the most elegant shopping street in Rome, the Via Condotti, or the Via del Babuino with its many art galleries and antiques shops. Passing the Villa Medici, the visitor reaches the attractive parks on the Monte Pincio, and can then climb onward and upward to the spacious grounds of the Villa Borghese. This park also contains the Villa Giulia, accommodating the Galleria d'Arte Moderna in a building erected for the fiftieth anniversary of the unification of Italy, and the Giardino Zoologico.

View of the Piazza del Popolo from the Pincio

In and around the Piazza del Popolo

S. Maria del Popolo, Piazza del Popolo 12, p. 230

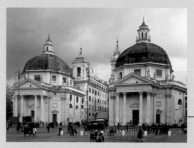

The Piazza del Popolo, with S. Maria dei Miracoli
and S. Maria in Montesanto, pp. 228

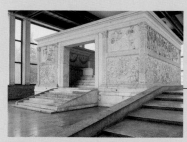

The Ara Pacis Augustae, Via di Ripetta,
p. 218

Mausoleum of Augustus, Piazza Augusto
Imperatore, p. 219

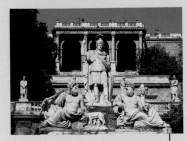

The Pincio, p. 227

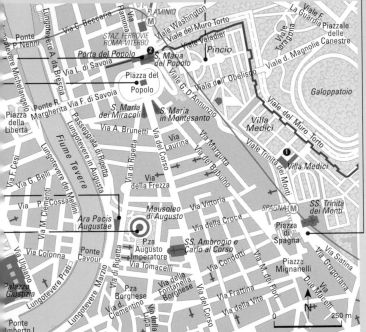

The Piazza di Spagna, the Spanish Steps, and SS. Trinità dei Monti, p. 224

Other sights:

1 Villa Medici, Viale della Trinità dei Monti 1, p. 226

2 Porta del Popolo, between Piazza del Popolo and Piazzale Flaminio, p. 229

Ara Pacis Augustae

The Altar of Peace, reconstructed in the 1930s for the 2000th anniversary celebrations in honor of Emperor Augustus, was originally dedicated in 9 B.C. after the emperor's victories over Spain and Gaul. Two entrances in the longer sides of the rectangular enclosure wall lead to the altar itself, which stands on a stepped base. The marble enclosure wall has relief decoration both inside and outside, with scenes of mythological and allegorical subjects near the entrance doors, while the reliefs on the two narrow sides show the imperial family in solemn procession. The Ara Pacis is a significant political monument of the Augustan epoch, and was propagandist in its aims. Myth, history, and religion symbolized the age of peace that had dawned, after centuries of conflict, with the policies introduced by the new imperial autocracy.

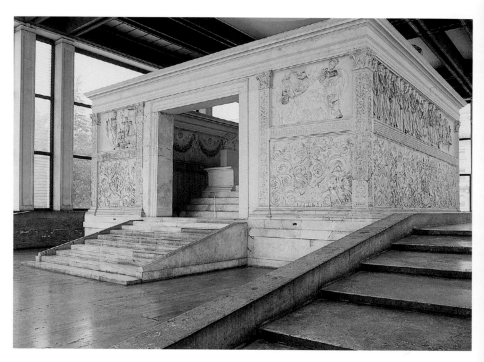

The Mausoleum of Augustus
(Mausoleo di Augusti)

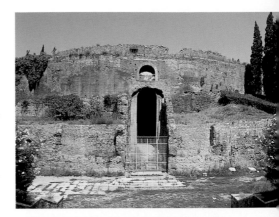

After his victory over Antony and Cleopatra and the conquest of Egypt, Augustus returned from Alexandria in 29 B.C. and began building a great tomb for himself and his family in the Field of Mars. It imitated a famous model, the mausoleum of Alexander the Great in Alexandria, but with its earthen tumulus it was also reminiscent of Etruscan funerary structures, and so had links with Italian traditions. In the Middle Ages the mausoleum was turned into a fortress by the Colonna family, and later, when it fell into ruin, its site was used as a garden, amphitheater, and concert venue, until the Roman remains were excavated and the mausoleum restored in 1936.

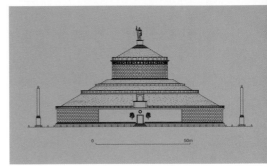

Reconstruction (after H. von Hesberg)

Ancient sources enable us to reconstruct the building precisely: a mound of earth planted with evergreen trees – cypress or oak – rose above a high enclosure wall. Beneath this mound stood a round structure with a diameter of 87 m (278 feet), consisting of five concentric circular walls around a central area, where a circular passage containing three funerary niches surrounded the round *cella*. The emperor was laid to rest here, and his bronze statue was placed on top of the monument.

Two obelisks stood at the entrance, in the manner of the Pharaonic tombs of Egypt. In later centuries they were moved to the Piazza del Quirinale and the Piazza dell'Esquilino. Originally bronze tablets inscribed with Augustus's achievements, were mounted on them.

Entering a New Millennium – From a City of Bricks to a City of Marble

"Aware that the city was architecturally unworthy of her position as capital of the Roman Empire, besides being vulnerable to fire and river floods, Augustus so improved her appearance that he could justifiably boast: 'I found Rome built of sun-dried bricks; I leave her clothed in marble,'" writes Suetonius in his biography of Augustus. Indeed, at no other period did the outward appearance of Rome undergo such fundamental change as in the forty-five years of his rule. Step by step, Augustus carried out a vast amount of building work, unique even in antiquity, as part of his comprehensive program for the political reform of the state. Redevelopment of the residential quarters and sanitary improvements went together with the building of marble temples and large leisure complexes for popular entertainment, which entirely changed the face of Rome and everywhere provided visible signs of the new political system.

View of the temple of Apollo and house of Augustus on the Palatine, model, Museo della Civiltà Romana, Rome

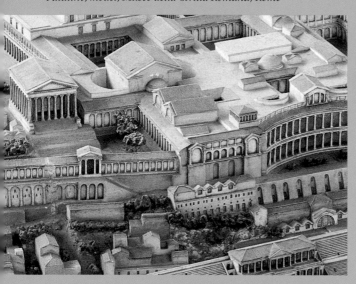

When Octavian, who did not acquire his title of Augustus, "the Sublime," until 27 B.C., came to power at the end of a crisis-ridden decade of civil war, he found a city whose appearance reflected the decline in the state and its political order. The magistrates had neglected the infrastructure and any kind of well thought out town planning ever since the first great period of political turmoil at the end of the 2nd century B.C., hardly even carrying out the restoration work necessary or erecting any new buildings. Victorious commanders did occasionally enhance the appearance

of the city with magnificent buildings comme-morating their triumphs, but they did so solely for reasons of personal prestige and power, not for the common good. By the end of the 1st century B.C. Rome was capital of a world empire, but that position was not reflected in the architectural condition of the city.

A Program for the Reform of the State

Octavian, who had played a leading part in the civil wars himself, could not, and knew he must not, continue this tradition. If he wished to establish himself as ruler and to usher in a new age of peace, he had to break with his predecessors' methods and move in another direction. His contemporaries had blamed neglect of the gods and an exaggerated cult of the individual for the decline of the state and morality. To counter this situation, the *princeps* introduced a comprehensive program for the revival of religion (*pietas*), morality (*mores*), virtue (*virtus*), and the dignity of the Roman people, accompanied by the development of a new style in the visual arts and the construction of many public buildings. In this he took his guidelines principally from the clear, austere formal vocabulary of classical Greek art and its pictorial subjects. This program was not in fact devised and planned in advance, but developed gradually during the reign of Augustus, depending on political circumstances. In the first years of his rule after the death of Caesar, when Octavian still had to share power with two

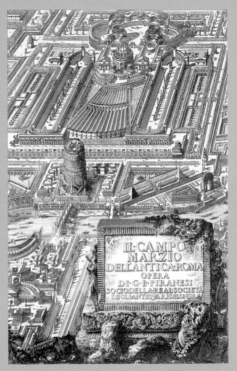

Giovanni Battista Piranesi (1720–1778), Campo Marzio, Gabinetto dei Disegni e delle Stampe, Florence

co-regents in the "triumvirate" (44–29 B.C.), his first concern was to secure his own position of primacy and place himself at the center of events. The erection of the temple in honor of his personal tutelary deity Apollo on the Palatine falls into this period. The temple precinct is reminiscent of Hellenistic royal residences with its impressive situation, high

above the much-frequented Circus Maximus, its direct link with the modest dwelling of Octavian himself, and its proximity to the mythical home of Romulus, founder of the city. The Forum acquired a new look too; the marble façades of the Curia and the temple in honor of the deified Julius Caesar – Octavian's adoptive father – were far more striking and magnificent than the old temples built of tuff and travertine. It was also on the Field of Mars that Augustus built his mausoleum, which reflected his own stature and power even in its outward proportions, and dominated the area with its marble façade.

When Octavian had defeated his opponent Antony at the Battle of Actium (31 B.C.) and integrated Egypt into the empire, all power was in his hands, for he had saved the state from disaster. His prime task now was to establish the new form of rule securely and durably, for himself and for his successors. In architecture, this aim was expressed by the spectacular renovation of all the temples in 28 B.C., an operation which affected eighty-two buildings and was also part of the program of religious reform. The appearance of the city was fundamentally changed: façades of white Carrara marble shone on all the hills of Rome, most of them adorned with lavish ornamentation, often gilded, and fitted out with a carefully devised iconographic program in mind. The paving of the Forum, the erection by the Senate of an arch celebrating the triumph of Augustus over the Parthians, and the temples of the Dioscuri and Concordia renovated by Tiberius, made the former center of the republic into the showcase of the Julian imperial house,

with buildings which overshadowed the old republican monuments. However, the greatest change to the appearance of the city lay in the Forum of Augustus, with the temple of Mars Ultor, dedicated in 2 B.C., and this forum became the new center of Rome. Surrounded by high walls, it was notable for its fine ornamentation, leaning chiefly on models in the Greek classical style, and a cleverly organized pictorial program centering on the person of the *princeps* and the new values promoted by the state. At the same time the city was redivided into fourteen (instead of seven) *regiones* (regions) and two hundred and sixty-five *vici* (urban districts), and the road network and ground sites were also redeveloped, giving the city the appearance it would retain for the next few centuries.

Not only did Augustus build temples and lay out squares, his care for the good of his people and the improvement of their living conditions in general was an important part of his program of reform. With the assistance of Agrippa, who was appointed to the office of aedile in 33 B.C., existing aqueducts were repaired and new aqueducts and storehouses built, and fire walls and barracks were erected for the fire service, which was recruited from among the ranks of slaves. These measures ensured that the population could be supplied with provisions and live in safety. From the outside, such buildings were visible signs of the internal security of the new state. In addition, the people now had access to the kind of luxury that had been reserved for the rich alone in the republic, through the policy of *publica magnificentia* (public splendor).

Augustus had the city palace of the rich knight Vedius Pollio in the middle of the densely populated area on the Esquiline ostentatiously torn down and replaced by the Porticus Liviae, erected for the people and consisting of a complex of halls with gardens, fountains, vine arbors, and works of art. Agrippa was particularly supportive of the *princeps* in realizing the idea of *publica magnificentia*. He transformed the entire Field of Mars into a huge leisure complex for the benefit of the population of Rome. At its heart lay the Pantheon, devoted to the cult of the ruling house and its patron deities, and surrounded by parks, porticoes, baths, and theaters richly adorned with works of art. The Ara Pacis in the northern part of the Field of Mars, near the mausoleum, was consecrated as an altar with pictorial decoration which programmatically celebrated the new age of peace ushered in by Augustus.

More than any other ruler before or after him, Augustus succeeded in transforming Rome architecturally into the worthy capital of a world empire, thus setting new standards which became the model for the structure of other imperial cities, and remained so for centuries to come. The appearance of the city at the end of his reign reflects the great achievements of the *princeps* who ushered in a period of peace and prosperity marked by national reconciliation and moral revival, after the dark decades of civil war. It shows that Augustus could rightly be celebrated as the new founder of the city in architectural, social, and cultural respects alike.

Gemma Augustea, ca. 10 B.C., sardonyx, 19 x 23 cm, Kunsthistorisches Museum, Vienna

223

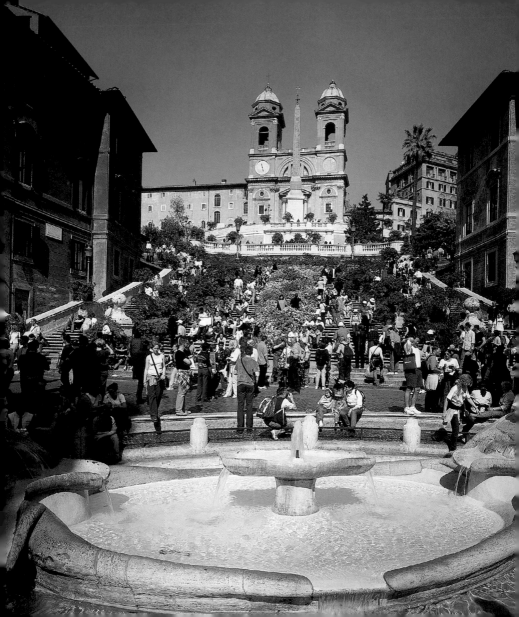

Piazza di Spagna, the Spanish Steps, and SS. Trinità dei Monti

The piazza is among the most striking sights of Rome, not least for the famous Spanish Steps, still a meeting place by day and night for both native Romans and visitors to the city. This monumental stairway, in three sections, begins with a broad ascent of three flights of steps, followed in the central section by further flights curving in and out, and leading to the broad ascent to the church of SS. Trinità dei Monti at the top. The building of the Spanish Steps, to a design by the architect Francesco de Sanctis that was realized in 1723–1726, was financed by the French ambassador, Étienne Gueffier. The church of the Trinity, dominating the Spanish Steps with the double towers of its façade, was founded by King Charles VIII of France. Building began in 1502, and the church was finished in 1587 by Domenico Fontana, who completed the double flight of steps, adorned with ancient capitals and reliefs showing figures of saints. The fountain in the center of the square, in the shape of an old, half-capsized ship and known affectionately to the Romans as *La Barcaccia* (rotten old tub), was designed by either Gianlorenzo Bernini or his father Pietro in 1627–1629, when the Tiber burst its banks and the flood waters washed a boat up here.

Daniele da Volterra (1509–1566), Deposition from the Cross, 1541
Fresco on canvas, transferred to canvas, 400 × 280 cm

One of the most famous frescoes in Rome can be seen inside SS. Trinità dei Monti. The *Deposition from the Cross*, which lost some of its strength of coloring when it was transferred to canvas, is by Daniele da Volterra. The influence of his master Michelangelo is clearly perceptible in the muscular bodies of the male figures.

The Villa Medici

This beautiful villa on the Pincio above the Piazza di Spagna was built in the 16th century, when the rich and powerful Cardinal Giovanni Ricci di Montepulciano commissioned the architect Annibale Lippi to undertake the thorough conversion of a small property here. After his death the building passed into the hands of Cardinal Federico de' Medici, from whom it gets its name. Federico, who had competed with other noble families to assemble an extensive collection of antiques, had Bartolomeo Ammanati build a long gallery, and the garden was magnificently laid out. Under his successors, the villa gradually fell into neglect: Cosimo III moved the paintings to the Palazzo Pitti in the 17th century, and

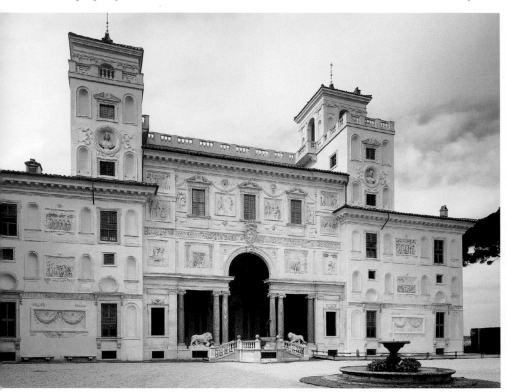

the archaeological collection was taken to Florence in 1770 (it is now in the Uffizi Galleries). The villa, which had passed into the possession of the house of Lorraine after the Medici family died out, saw a new period of prosperity only when Napoleon moved the Académie de France to this site in 1803. The presence of the Académie, which awarded the Prix de Rome enabling young artists to study the antiquities of the city, meant that the villa was renovated, and also became, as it still is, a center for the encouragement of art, very much in the Renaissance spirit.

Unlike the austere, plain façade, the garden side, designed by Annibale Lippi and consisting of a central structure with a Serlian loggia and wings surmounted by small towers, has a complex and richly structured façade. It is lavishly ornamented with ancient reliefs – including some of garlands taken from the Ara Pacis – and with busts and commemorative stones which remind the visitor of Cardinal Ricci's passion for antiquity. Two marble lions, with their front paws resting on a globe, stand beside the stairway to the loggia.

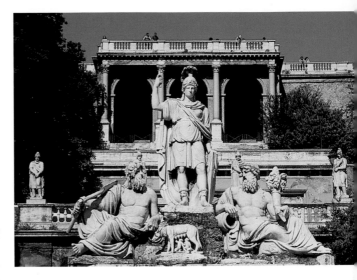

The Pincio

A neo-classical landscape garden designed by Giuseppe Valadier at the beginning of the 19th century lies above the Piazza del Popolo. The gardens of old Roman families, including the Pinci family who give the place its name, once occupied this site. The Pincio, with its broad avenues lined by shady pines, palms, and evergreen shrubs, has always been a popular place to walk. The visitor can stroll down the paths past portrait busts and monuments to famous Italians and great patriots, or enjoy what is perhaps the finest view of the city from the viewing terrace.

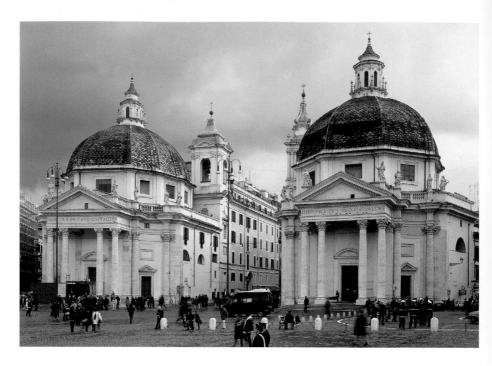

The Piazza del Popolo, S. Maria dei Miracoli, and S. Maria in Montesanto

The large oval Piazza del Popolo has undergone many modifications over the centuries, but now presents the picture of a unified whole. It was built in the 16th century beside the old parish church of S. Maria del Popolo; in 1589 Sixtus V (pontificate 1585–1590) had two more streets built beside the central axis of the Corso, and an Egyptian obelisk was re-erected in the middle of the square. In 1658 Alexander VII (pontificate 1655–1667) commissioned Carlo Renaldo to build the twin churches of S. Maria dei Miracoli and S. Maria in Montesanto on the south side of the square, flanking the Corso like a symmetrical gateway. Giuseppe Valadier completed the building of the square in 1816–1820 by adding semicircular walls, making it the only neo-classical square in the city.

The Porta del Popolo

Even in antiquity visitors to the city entered through the Porta Flaminia. In the middle of the 16th century, Pope Pius IV commissioned Nanni di Baccio Bigio to provide a new exterior façade for the old Porta, now renamed after the neighboring church of S. Maria del Popolo. The design of the gate imitates a Roman triumphal arch with a single archway. It is adorned on the side facing away from the city with ancient columns and statues of St. Peter and St. Paul. A century later, when one of the most famous of all pilgrims to Rome, Queen Christina of Sweden, came to the city, Pope Alexander VII commissioned Gianlorenzo Bernini to design a façade for the side of the gateway facing the piazza. Crowned with the papal coat of arms, the inscription on the attic story wishes the queen a fortunate and salutary stay in Rome. The gate was originally flanked by two towers, but they were demolished in 1879 when the two side passages were built.

S. Maria del Popolo

S. Maria del Popolo, one of the oldest parish churches in Rome, stands above the tomb of Emperor Nero, whose damned soul, according to a medieval legend, inhabited a walnut tree on the site. In 1099, to put an end to the haunting, Pope Paschal II had the tree felled, its ashes thrown into the Tiber, and a chapel built to the Virgin Mary on the place where the tree had stood. Gregory IX (pontificate 1227–1241) replaced this chapel in 1227 by a large parish church for the people (*popolo*). In 1472 Sixtus IV (pontificate 1471–1484) had work begun on a new building in the Renaissance style, and in 1505 Bramante added the choir for the Augustinian monks who had now moved in. Martin Luther, once a member of the order himself, probably stayed here with his fellow Augustinians when he came to Rome in 1512. The Baroque conversion which was carried out by Bernini dates from the 17th century.

Conceived as a pillared basilica (with a central hall and two aisles) on a cruciform ground plan with lateral chapels, the church has a plain, tripartite travertine façade, and is a fine example of the architecture of the early Renaissance in Rome. S. Maria del Popolo is famous, among other things, for its chapels, which were magnificently furnished by leading Roman families. An octagonal dome rises above the crossing, and is probably the oldest of the Roman church domes that can be seen from the exterior. During the 15th century, it also represented a new symbol of supremacy, marking out the domain of papal rule.

The Cappella Chigi

Between 1511 and 1516, and at the request of his friend the banker Agostino Chigi, the artist Raphael converted the third chapel in the left-hand aisle into a funerary chapel for the Chigi family. He designed both the architecture – a central area

supported by four pillars, with a coffered and gilded dome – and the mosaic in the lantern, which shows God the Father creating the firmament, surrounded by the symbols of the sun and the seven planets in their positions at the time of the birth of Jesus Christ. He also designed the pyramidal tombs for Agostino and his brother Sigismondo on the side walls, the marble sculptures in the niches, and an altarpiece, but these were executed by other artists. The frescoes on the walls between the windows are by Francesco Salviati. The overall concept uses perspective effects executed in valuable materials, so that the funerary chapel has the appearance of being much larger and more magnificent than it actually is. The individual elements of this "total art work" are also coherent in their thematic program, as expressed in the inscription on the floor: *Mors ad coelos [iter]* (Death is the way to heaven). When the artist and his patron both died in 1520, however, the chapel was not completed, and it remained in an unfinished state until Pope Alexander VII (pontificate

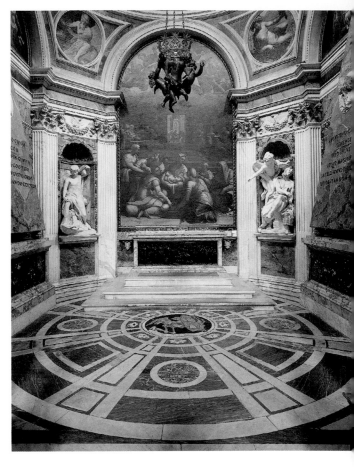

1655–1667), who himself was a member of the Chigi family, commissioned Bernini to provide the statues of the prophets Daniel and Habakkuk for the niches, and new portrait medallions.

Defying Convention – the Life and Art of Caravaggio

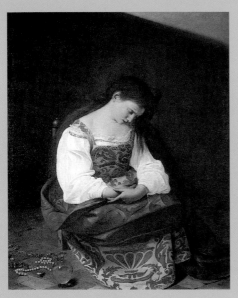

The Penitent Mary Magdalene,
ca. 1595, oil on canvas, 122.5 × 98.5 cm,
Galleria Doria Pamphilj, Rome

Few painters can have infringed the artistic and social conventions of their own time as much as Michelangelo Merisi (1571–1610), called after his home town of Caravaggio in northern Italy. His life story reads like a police report, for he was known for his quick-tempered and quarrelsome nature, and was often in trouble with the law. Hardly less spectacular

was his art, which established entirely new criteria for European painting. Unlike the Carracci, who took their guidelines from the ideals of antiquity and the High Renaissance, Caravaggio had no particular models. He did employ certain traditional elements (particularly from north Italian painting) such as chiaroscuro and the use of highlights and heavy shadow, but he heightened such effects to create an entirely new artistic style. His stark realism, use of color, and dramatic treatment of light set new standards, distinguishing his painting fundamentally from the other artistic trends of the time. Caravaggio cared nothing for conventional pictorial genres, or for their traditional ranking according to precedence. The Dutch art historian Carel van Mander wrote: "There is nothing better than to follow nature, said Caravaggio, and he obeyed that maxim in his own painting." It is true that since the writings of Leon Battista Alberti (1404–1472) the imitation of nature had been an accepted principle in manuals of painting, but Caravaggio applied it to new subject matter. He was not solely concerned to depict anatomically correct body proportions and movement, but worked from living models whom he brought into his studio from the street. His subjects were people, usually in contemporary dress, whose daily lives he observed precisely and recorded in his compositions.

He broke away from the conventional depiction of traditional pictorial subjects quite early in his career: "He painted a girl sitting on a chair, her hands in her lap, drying her hair. He portrayed her sitting in a room, and by placing a salt cellar adorned with precious stones on the floor, he made a Magdalene of her," wrote his contemporary Giovanni Pietro Bellori of the painting of that saint in the Galleria Doria Pamphilj. Similar arrangements are typical of the painting of Caravaggio, who often expressed the deeper meaning of a picture through such unpretentious details. The red ribbon on the girl's dress, for instance, is a symbol of venality, and reminds the viewer of the saint's earlier life as a prostitute. The penitent's attitude is another innovation; she is shown sitting on a chair in the dark, sunk in melancholy, with tears of repentance for her earlier life in her eyes.

Caravaggio also startles the viewer of his biblical narratives with new pictorial ideas, elucidating his subjects through the use of genre scenes. For instance, the *Calling of St. Matthew* in S. Luigi dei Francesi is set in the everyday scene of a counting-house (or inn), which Christ and Peter have entered from the right. He concentrated on figural depiction in his paintings, showing little interest in landscape, and using plants at the most as scenery. He would often even leave the viewer at a loss to identify the setting of a scene, merely painting the figures against a dark, indefinable background.

The treatment of color and of light and shade were particularly important to him, and he and his successors, called the Caravaggisti, were famous for these effects: the contrast between the brightly lit, smooth parts of a painting, and dark, shadowed areas of color is the dominating feature of his style. He used a palette of earth colors, relieved only by bright white and a

The Calling of St. Matthew, 1599/1600, oil on canvas, 322 × 340 cm, S. Luigi dei Francesi, Cappella Contarelli, Rome

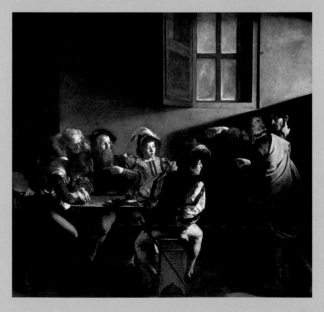

strong red. In the *Conversion of St. Paul* in S. Maria del Popolo, bright light falling into the picture guides the viewer's eye to the youthful army officer, depicted with bold foreshortening in the grip of physical ecstasy, whereas traditional Christian painting expressed divine light by showing rays. The same light falls on the horse, whose rump and back occupy large parts of the area of the picture.

Equally unusual is the composition of the *Crucifixion of St. Peter* on the opposite side wall of the chapel, created as a companion piece, with a figure seen from behind in the foreground: one of the three executioners raising the cross has turned his buttocks to the viewer. Peter, as the main character, is placed at the center of the narrative by means of the lighting. In contrast, Caravaggio has concealed the faces of two of the executioners, thereby emphasizing their subordinate role. What is important is brightly lit; the unimportant disappears into darkness. The precision with which the nails in the hands and feet are portrayed, and other realistic details, like the soldiers' dirty feet, bring the subject very close to the viewer.

This stark, unadorned realism was entirely alien to Caravaggio's contemporaries, and he was often sharply criticized as offending against "decorum." It is in this context that we should appraise the withering comment of the French painter Nicolas Poussin, who voiced the

The Conversion of St. Paul, 1601, oil on canvas, 230 × 175 cm, S. Maria del Popolo, Cappella Cerasi, Rome

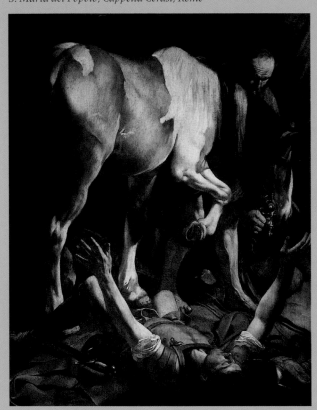

opinion that Caravaggio had come into the world only to ruin painting.

Caravaggio's pictures suggest a fundamentally new form of devotion. Instead of showing enraptured figures and supernatural incidents, Caravaggio gave his saints the faces of ordinary people, presenting the history of salvation as part of everyday life, affecting everyone. He even painted Christ and the Virgin from live models, something that had been strictly forbidden since the Council of Trent (1545–1563).

The patrons who commissioned work from Caravaggio were not always pleased with the unconventional results. For instance, when he represented the death of the Virgin as the last agonies of a mortal woman in a painting for the church of S. Mariain Scala in Trastevere, the order of Discalced Carmelites rejected it. Nonetheless, even if few of his contemporaries understood or appreciated Caravaggio's radical innovations, his use of new artistic methods guided the development of painting into new paths.

The Crucifixion of St. Peter, 1600–1601, oil on canvas, 230 × 175 cm, S. Maria del Popolo, Cappella Cerasi, Rome

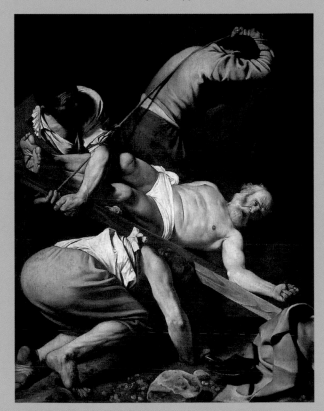

The Villa Borghese and Villa Giulia

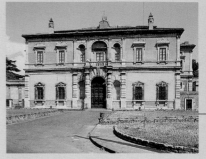

Villa Giulia, Piazzale di Villa Giulia 9, p. 238

Grounds of the Villa Borghese, Tempio di Esculapio,
p. 245

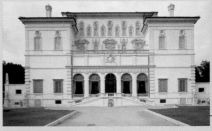

Villa Borghese, Piazzale Scipione Borghese 5,
p. 244

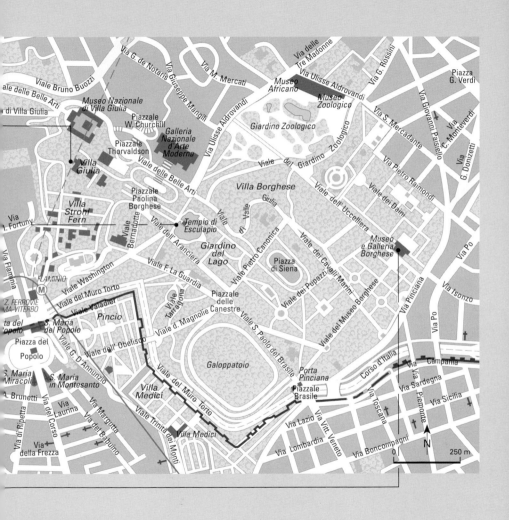

Viale Bruno Buozzi
Viale delle Belle Arti
di Villa Giulia
Via G. de Notaris
Via Giuseppe Mangili
Via M. Mercati
Via delle Tre Madonne
Via Ulisse Aldrovandi
Via G. Rossini
Piazza G. Verdi

Museo Nazionale di Villa Giulia
Piazzale W. Churchill
Museo Africano
Museo Zoologico
Via S. Mercadante
Via Giovanni Paisiello
Via C. Monteverdi
Via G. Donizetti

Galleria Nazionale d'Arte Moderna
Giardino Zoologico
Via Ulisse Aldrovandi

Piazzale Thorvaldson
Viale delle Belle Arti
Villa Giulia

Villa Borghese
Viale del Giardino Zoologico
Via Pietro Raimondi
Viale dei Daini

Piazzale Paolina Borghese
Villa Strohl Fern
Via I. Fortuny
Viale Bernadotte
Viale dell'Aranciera
Tempio di Esculapio
Viale del Uccelliera

Via Flaminia
Giardino del Lago
Viale Pietro Canonica
Viale di Valle
Viale Giulia

Piazza di Siena
Museo e Galleria Borghese
Via Po
Via Isonzo

FLAMINIO
Viale Washington
Viale F. La Guardia
Viale dei Cavalli Marini
Viale dei Pupazzi
Viale del Museo Borghese
Via Pinciana

Z. FERROVIE MA-VITERBO
Viale del Muro Torto
Viale Valadier
Pincio
Viale Tarragona
Piazzale delle Canestre

ta del popolo
S. Maria del Popolo
Viale G. D'Annunzio
Viale d. Magnolie
Viale S. Paolo del Brasile
Porta Pinciana
Corso d'Italia
Via Campania

Piazza del Popolo
Viale dell'Obelisco
Galoppatoio
Piazzale Brasile
Via Toscana
Via Sardegna
Via Sicilia

S. Maria Miracoli
S. Maria in Montesanto
Viale del Muro Torto
Villa Medici
Piazzale Brasile
Via Piemonte

A. Brunetti
Via del Corso
Via Laurina
Via Margutta
Via del Babuino
Viale Trinità dei Monti
Villa Medici
Via Lazio
Via Vitt. Veneto
Via Lombardia
Via Boncompagni

Via di Ripetta
Via della Frezza

N
0 250 m

The Villa Giulia

A year after his election to the papacy in 1550, Pope Julius III planned to build a summer residence outside the gates of the city. He commissioned its design from the architects Vasari, Vignola, and Bartolomeo Ammannati, with Michelangelo to advise them. Within five years they had created a magnificent Mannerist building in which architecture, nature, fountains, and works of art were harmoniously combined. The pope, an enthusiastic lover of antiquity, supervised the furnishing of the villa in person, bought antiques, and sought out plants and fruit trees. Although the history of the building of the villa is not entirely clear because of many modifications to the designs, and because several different architects were involved, it is certain that Vignola became Julius III's favorite archi-

tect. He began by designing an exterior of very austere appearance, following the precepts of the Council of Trent, but the rooms of the interior had rich and imaginative furnishings and could stand comparison with the glories of the past. Left vulnerable to looters after the death of Julius III, the Villa Giulia served for centuries as a storeroom for agricultural implements. Since 1889 it has been the location of the Museo Nazionale Etrusco, which has a major collection of Etruscan finds from Latium, Umbria, and Tuscany.

Behind the façade, with its forbiddingly defensive appearance, and beyond an entrance in the shape of a triumphal arch, two interior courtyards are laid out to a ground plan combining a rectangle with a semicircle. A light loggia, enclosed by wings on two floors, frames the first courtyard in a semicircle almost like a theatrical set, and leads to the second courtyard, with the lower-lying Nymphaeum designed by Ammannati. The semicircle of the first courtyard creates an original spatial effect in the main part of the villa, which had painted decoration entirely executed by the brothers Federico and Taddeo Zuccari.

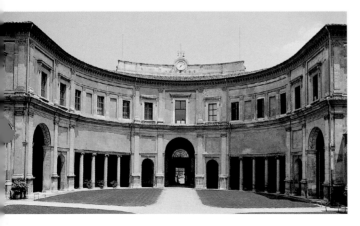

The Nymphaeum

The entrance to the famous Nymphaeum, which is built on two floors around a sunken inner courtyard, is through a columned hall. Many statues once stood in the niches, but only those of the recumbent river deities of the Arno and the Tiber now remain. A balustrade surrounds the lower-lying Nymphaeum, with its loggia supported by caryatids. The loggia is fitted out with grottoes and a *fontana segreta* (secret fountain); Julius III had the aqueduct known as the Aqua Vergine specially extended to supply this fountain. Although the villa has been robbed of much of its former lavish decoration of finely chased metal, gold, stucco, and ancient statues, it is still an impressive sight for visitors today.

The Courtyard Loggia

Among the glories of the old decoration, now largely faded, the ceiling paintings by Pietro Venale in the loggia of the first interior courtyard are a particularly fine example. Green tendrils can be seen covering the whole of the barrel vault, with *putti* and birds playing among them, so that the loggia seems to be turned into a garden arbor. The walls are ornamented by rectangular areas marked off by pilasters, containing grotesques and mythological figures.

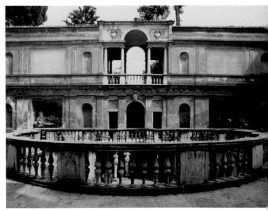

The Villa Giulia

Terracotta portrait bust of
a man from Cerveti,
1st century B.C.

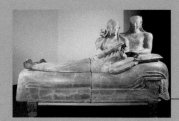

Etruscan sarcophagus of married couple, p. 242

Apollo of Veii, from the roof
ridge of a temple in Veii,
early 6th century B.C.

Courtyard loggia, p. 239

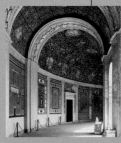

Other works on the first floor:

Cista Ficorini, ca. 300 B.C.: bronze lidded box from Praeneste

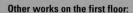

The Chigi Pitcher, p. 243

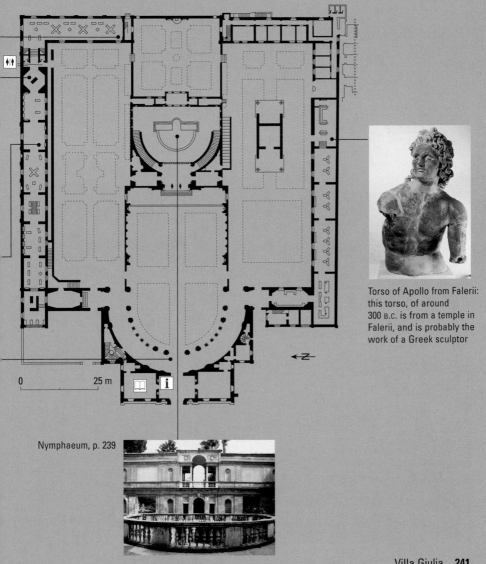

0

25 m

Torso of Apollo from Falerii: this torso, of around 300 B.C. is from a temple in Falerii, and is probably the work of a Greek sculptor

Nymphaeum, p. 239

**Etruscan Sarcophagus of Married Couple,
Late 6th Century B.C.**
Terracotta, 141 × 220 cm

This terracotta sarcophagus from Cerveteri, which has been reassembled from over four hundred fragments, is among the masterpieces in the Museo Nazionale Etrusco. Its size shows that it must have been made for a powerful and prosperous citizen of the town and his wife. It shows a man and woman reclining on a couch with a high mattress draped with a covering, their upper bodies erect as they lean on their left arms. They are closely related in attitude and gesture, and seem to be deep in conversation. With their plump bodies, rounded limbs, narrow eyes, and the ironic smiles around mouth and cheeks, as well as the stylized way their draperies fall, the figures are reminiscent of Greek works in the Ionic style of the late 6th century B.C., but unlike them, the forms appear exaggerated. In addition, the lower parts of the couple's bodies and their legs are displayed on a flat plane, and their backs are only superficially worked, showing that the master who executed the piece was Etruscan. The sarcophagus, formerly painted, was fired in four large

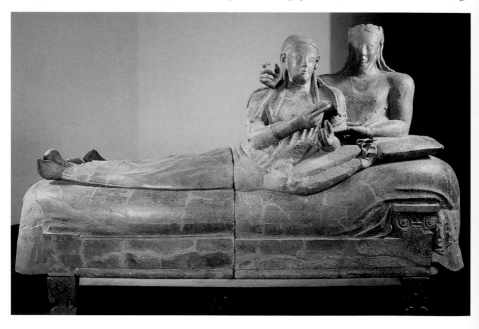

sections: the two halves of the chest and the two halves of the lid. It is in fact an urn on a monumental scale, with a removable lid to take the ashes of the dead.

The Chigi Pitcher, 7th Century B.C.
Earthenware, h 26 cm

This *oinochoe* (wine pitcher) of the third quarter of the 7th century B.C., once in the Chigi collection, is an import from Corinth found near Veii in Etruria. With its wealth of pictorial decoration of high quality, it is among the most important extant specimens of proto-Corinthian ceramic ware. The largest picture, which also contains the greatest number of figures,

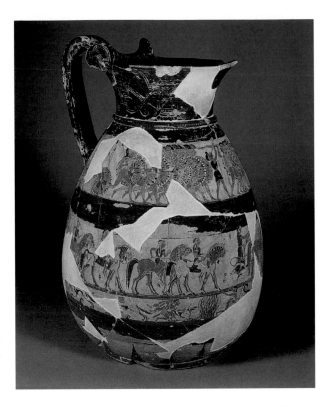

is painted on the shoulder, and shows a battle scene. The young flute player behind the first rank of men on the left, playing a battle song with his head thrown back and his instrument raised high, is among the finest figures on the frieze. A broad band of varnish divides it from the second figurative frieze, which shows three scenes:

a group of four horsemen and a four-horse chariot with its driver; a lion hunt; and the Judgement of Paris. Hermes is leading Hera, Athene and Aphrodite to Paris, who will judge which of the goddesses is most beautiful. Finally, the narrow frieze below is ornamented with scenes of hare and fox hunting.

The Villa Borghese (Museo Borghese)

Scipione Caffarelli Borghese, Pope Paul V's megalomaniac nephew, had a villa built in 1613–1616 in his family vineyards outside the Porta Pinciana. It had a spacious Baroque pleasure garden, now joined to the Pincio, which was divided into three sections: first, a garden traversed by avenues, with fountains, tombstones, and architectural fragments, and leading to the Casino, which had ancient statues in front of it and *giardini segreti* (secret gardens) to its sides. Beyond this first section was a garden of antiquities planted with six hundred durmast oaks, and with ancient statues of seated figures and herms lining its avenues. In the final section, there was a large natural park which was equipped with animal enclosures.

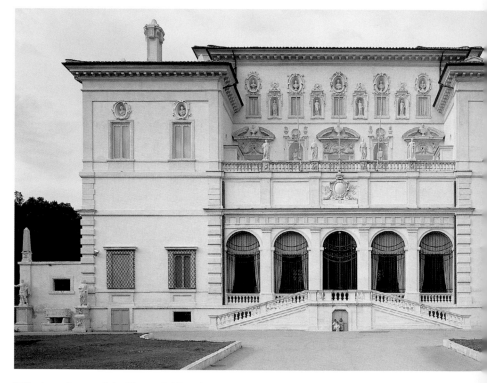

Flaminio Ponzio was commissioned to design the Casino, and after his death Giovanni Vasanzio (Jan van Santen) took over the supervision of the building. He followed the example of the Villa Medici in furnishing the exterior with rich ornamentation taken from archaeological finds, so that any visitor could identify the building as a private museum. It contained Scipione Borghese's fabulous collection of paintings and antiquities, to which he constantly and enthusiastically added.

Basic changes were made to the interior decoration under the supervision of Antonio Asprucci at the end of the 18th century, when the villa passed into the possession of Marcantonio IV Borghese. Every hall had its own theme, with its decorative painting to some extent reflecting the works of art displayed in it. In 1902 the entire grounds and all the works of art were acquired by King Umberto I of Italy, and donated to the city of Rome. As a result this very rich private collection became a public museum, which is world-famous today as the Galleria and Museo Borghese.

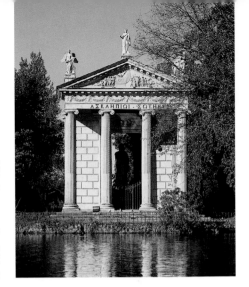

Park, Antonio Asprucci, Tempio di Esculapio

At the request of Prince Marcantonio Borghese, Christoph Unterberger transformed the Baroque grounds into an English landscape garden in the late 18th century. Joined to the Pincio, it is now the largest park in the city. In accordance with the taste of the time, buildings in the antique style were distributed around the park. They included the Tempio di Faustina (the wife of Emperor Antoninus Pius), the round Tempietto di Diana, and the Ionic Tempio di Esculapio (temple of Aesculapius), designed by the architect Antonio Asprucci, in the middle of an artificial lake. A number of different installations have been accommodated in the area since the park became state property in 1902.

Museo Borghese

Roman marble copy of Hermaphroditus, the son of Hermes and Aphrodite, from the bronze Greek original of the mid-2nd century B.C.

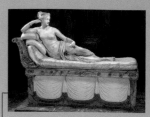

Antonio Canova, Paolina Borghese as Venus, 1804–1808

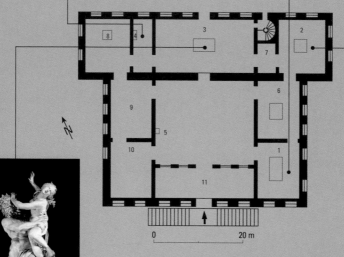

ground floor

Gianlorenzo Bernini, The Rape of Proserpina by Pluto, 1621

1 Sala della Paolina	6 Sala del Davide
2 Sala dell' Apollo e Dafne	7 Chapel
3 Galleria degli Imperatori	8 Sala dell' Enea e Anchise
4 Sala dell' Ermafrodito	9 Sala Egizia
5 Entrance hall	10 Sala del Fauno Danzante
	11 Portico

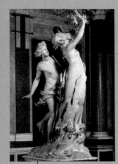

Gianlorenzo Bernini,
Apollo and Daphne,
p. 248

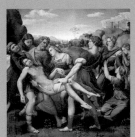

Raphael, the Ent-
ombment of Christ,
1507, commissio-
ned by Atlanta
Baglioni in
memory of her
murdered son Gri-
fonetto

1st floor

Titian, Divine and Earthly Love, 1514,
for Nicolò Aurelio, secretary to the
Council of Ten in Venice

The Man who Breathed Life into Marble – Gianlorenzo Bernini

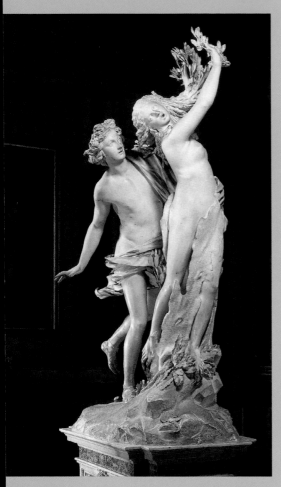

The Baroque style in Rome is intimately linked to the name of the man said to have carved amazing works of art from relatively small blocks of marble even in his youth, in the workshop of his sculptor father Pietro Bernini. He was Gianlorenzo Bernini (1598–1680). His career began its precipitous rise in his early years, and he was artistic curator to several popes over a period of decades. He had a large studio of sculptors, stucco artists, and bronze-casters working for him, and his fame spread far beyond Italy. Always competing with his great rival Francesco Borromini (1599–1667), he created churches and palaces, squares and fountains, and brought to Rome the Baroque style which still marks the appearance of the city today. His friends had expected him to be "the Michelangelo of his century" – and the artist was equal to that claim, for Bernini was more than merely an architect and sculptor. He designed whole interiors, combining different artistic genres into impressive and significant total art works. He was a skilful painter and draftsman, and was one of the early practitioners of caricature, not sparing even his august patrons. In addition he turned his mind to town planning, created stage sets and festive decorations, and even wrote and produced plays. Gifted with such

Apollo and Daphne, 1622–1625,
Villa Borghese, Rome

versatility, he was a new incarnation of the ideal to which the Renaissance had aspired, the *uomo universale*, a man educated and talented in every field.

"From my youth I devoured marble, never striking a false blow"

This was Bernini's comment on the time – a mere seven months – it took him to create the figure of David, whose face he is said to have modeled on his own. This sculpture was the last of a series of commissions for Cardinal Scipione Borghese that marked the advent of an entirely new style: Roman Baroque. The harmonious combination of the methods of sculpture and painting so characteristic of Bernini's work is already perceptible here, and it made him one of the great figures in the history of European art. With incomparable bravura, he created lively compositions in which opposites are harmonized, skilfully employing the lighting effects of concave and convex surfaces. He diversified surface structures by polishing, boring, and roughening them so effectively that they gave the impression of different colors. No sculpture illustrates this ability better than the lifesize marble group of *Apollo and Daphne*, in which the smoothly polished areas of the naked bodies contrast with the god's smooth but unpolished fabric cloak, and the rough bark of the tree, while Apollo's tousled mane of curls is in contrast to the fine strands of the nymph's hair. This work was also an achievement unprecedented in large sculptures: the depiction of something described in literary terms as a continuous process. Inspired by the verse of Ovid's *Metamorphoses*, Bernini had chosen to show the moment in which the nymph, fleeing the clutches of the god who desires her, begins to change into a laurel tree.

Bust of Pedro de Foix Montoya, ca. 1622, S. Maria in Monserrato, Rome

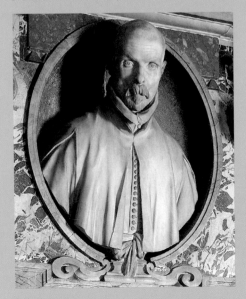

"A speaking likeness"

Bernini's ability to suggest the shades of color in a face when translating it into marble is most evident in his portraits, which were said to show "a speaking likeness." The portrait bust of Pedro de Foix Montoya in S. Maria in Monserrato is convincing in the impressive contrast between the sparse hair on the sitter's head, the shaved stubble on his hollow cheeks, and the stiff bristles of his moustache. But Bernini considered that: "A mere likeness is not enough. One must express what is going on inside the head of one's hero." For this reason, his portraits were not created during tedious sittings; he used to watch his models at their daily occupations, making many sketches, so that he could familiarize himself with their features and characteristic movements. In the figure of Montoya, for instance, the high, slightly wrinkled forehead and the slight turn of the eyes to the right suggest the subject's intellectual qualities.

A Total Art Work

"There is a widely held opinion that Bernini is the first to have tried to unite architecture, sculpture, and painting so that they come together to form a beautiful whole," wrote Filippo Baldinucci in 1682. This is particularly true of Bernini's

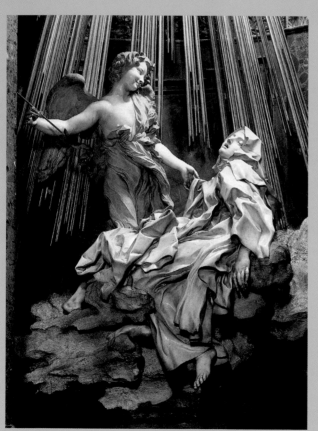

Altar of St. Teresa of Ávila, 1646, S. Maria della Vittoria, Cappella Cornaro, Rome

later works, mostly on religious subjects. Among the most impressive examples of his skill in merging different artistic means of expression is the Cappella Cornaro, the funerary chapel of the Cornaro family in S. Maria della Vittoria. Its walls are covered with slabs of marble of different colors, and members of the family are seated on balconies along the side walls, as if in boxes at the theater, apparently deep in animated conversation. However, the focal point of the chapel is the tabernacle, in which a white marble group stands against a background of great golden rays. It represents St. Teresa of Ávila, mystic and writer, who re-founded the order of Carmelite nuns. She hovers on a cloud in visionary rapture, penetrated by the divine love symbolically expressed in the angel's arrow. The saint herself described her experience of a heavenly vision in her autobiography. Bernini translated her words into marble, staging the event as a theatrical spectacle, in particular by the clever use of what might almost be stage lighting. In the same way, the surrounding architecture, sculptures, and paintings in the Cappella Altieri in S. Francesco a Ripa are designed to set off the recumbent figure of the Blessed Ludovica Albertini, one of Bernini's late masterpieces. The swirling folds of Ludovica's garments, the variegated marble, and the use of lighting effects emphasize the drama of the moment when she is overcome on her deathbed by the passionate experience of religious visions.

The Blessed Lucovica Albertoni, 1674, marble and jaspis, length 188 cm, S. Francesco a Ripa, Rome

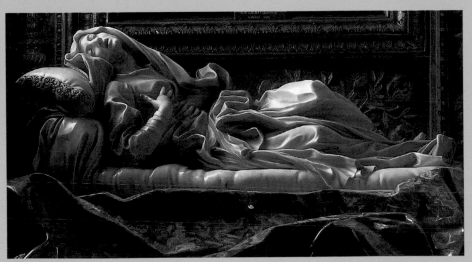

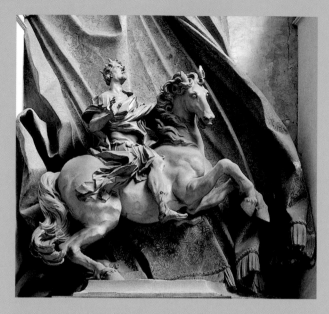

visitors while leading them to St. Peter's itself. In the interior, the Cathedra Petri, the sacramental altar, and the papal tombs depict the transformation from earthly death into the spiritual life of eternity for the observer.

More than any other artist, Bernini left his personal stamp on the building, and from now on his activity as architect of St. Peter's was an even more important part of his work. He often chose to construct a centrally planned building, believing that such a design was the best way to achieve harmonious unity between the spatial area, its sculptural ornamentation, its interior decoration, and its furnishings. A characteristic example is the church of S. Andrea al Quirinale, built on a long oval ground plan surrounded by oval and rectangular chapels. Here the design of the interior is oriented entirely towards the altar area, which is framed by aedicules with Corinthian columns. The central theme is the martyrdom of St. Andrew: the altarpiece, the *Crucifixion of St. Andrew* by Borgognone (1621–1676), looks as if it is being carried down from heaven by stucco angels. Gilded clusters of rays direct the eye up to the broken pediment of the aedicule, where the saint seems to

Chief Architect of St. Peter's

Bernini's pre-eminent position in Baroque Rome becomes fully comprehensible only when we remember that he was chief architect of St. Peter's for 50 years, and thus had a leading part in working to promote the faith (*propaganda fides*) by means of the visual arts. His masterly creations gave the basilica its final, incomparable form. Even on the bridge known as the Ponte Sant'Angelo, the angels carrying the instruments of Christ's Passion accompany pilgrims on their symbolic Way of the Cross, leading them to the colonnades of St. Peter's Square, which symbolize the Catholic world as they open out to embrace

be rising to the sky through the opening in the dome, surrounded by cherubim. Bernini made use of the way the light falls from the dome to cast apparently heavenly radiance on the face of St. Andrew.

At the end of his long life, criticism of Bernini by his adversaries became louder, and it was often said that it was time to retire the "Cavalier Bernini, who persuades the popes into useless expenditure in these difficult times." Such comments were not a matter of indifference to him, and he tried to compensate by exaggerated piety.

When Gianlorenzo Bernini died at the great age of 82 on November 20, 1680, he was solemnly interred in the church of S. Maria Maggiore, and had thus come back to the place where, as a child in his father's workshop, he began breathing life into marble. A simple slab is the memorial to a man "who was not merely great but extraordinary in the arts of painting, sculpture, and architecture." (Filippo Baldinucci, *Vita del. Car. G.L. Bernini*, 1682)

S. Andrea al Quirinale, Rome

The Quirinal (Quirinale)

The Via Veneto leads away from the spacious grounds of the Villa Borghese. Unlike most of the streets and squares of Rome, it owes its international renown not to any outstanding monuments but to the film director Federico Fellini. His celebrated film *La dolce vita*, released in 1961, is a memorial to this boulevard noted for its luxury hotels and *Belle Époque* street cafés. It was built in 1879 during the period of great architectural activity that followed the founding of the kingdom of Italy. However, the "sweet life" of the 1960s, when famous movie stars frequented the cafés and restaurants of the Via Veneto, is now a thing of the past.

The Via Veneto traces a wide arc on its way to the Piazza Barberini. A favorite residential area for prosperous Romans in antiquity, the site fell largely into decline after the 5th century A.D., and did not see a new and brilliant revival of its fortunes until Pope Urban VIII Barberini had his family's town palazzo built in one of the vineyards located there. The Piazza Barberini gives access to the Quirinal, the highest of the seven hills of Rome, which takes its name from the temple of Quirinus, the god of war. In the 4th century two great complexes of thermal baths were built here in the middle of a large residential area: the Baths of Diocletian and the smaller Baths of Constantine. After the fall of the Roman Empire, the Quirinal, like the other hills, lapsed into oblivion, but this

Film poster for La dolce vita

quarter of the city revived again in the 16th century, when wide streets were built along which great families erected their palazzi. The most important building, however, is the Palazzo del Quirinale on the summit of the hill, once a papal summer residence, on which work began in 1574. After the end of papal supremacy in 1870, it was used as a residence for the kings of Italy, and has been the official residence of the Italian presidents since the proclamation of the republic.

Palazzo del Quirinale

The Quirinal

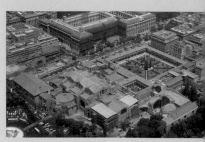

Piazza della Repubblica with the Baths of Diocle
and S. Maria degli Angeli, p. 270

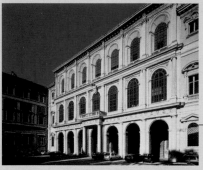

Palazzo Barberini, Via delle Quattro Fontane 13, p. 258

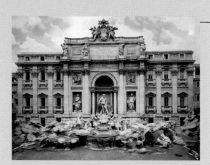

Fontana di Trevi, Piazza di Trevi, p. 285

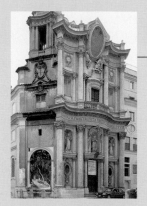

S. Carlo alle Quattro Fontane,
Via del Quirinale 23, p. 282

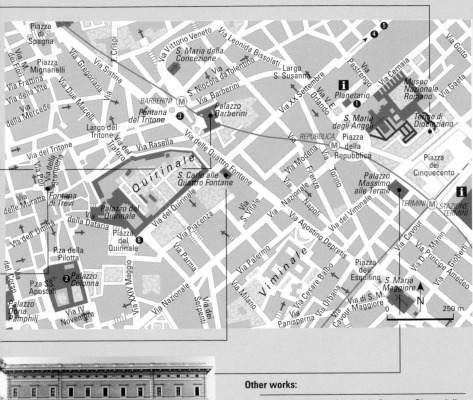

Palazzo Massimo alle Terme (Museo Nazionale Romano), Piazza dei Cinquecento, p. 274

Other works:

1 Planetario, Museo Nazionale Romano, Piazza della Repubblica, p. 280

2 Palazzo Colonna, Via della Pilotta 17, p. 292

3 Fontana del Tritone, Piazza Barberini, p. 258

4 S. Costanza, Via Nomentana 349, p. 262

5 S. Agnese fuori le mura, Via Nomentana 389, p. 264

6 Piazza del Quirinale, p. 284

Fontana del Tritone

Shortly after the completion of the Palazzo Barberini, Bernini created the Fontana del Tritone (Triton Fountain) for Urban VIII on the Piazza Barberini in 1642. Four dolphins standing on their heads, with the family coat of arms visible between them, form the base of the monument, which has no other architectural structure. Their tails support an enormous scallop shell in which Triton, a sea god with a human torso and a fish's tail, is seated. He is holding a conch shell in his raised hands, blowing it to send a jet of water high into the air.

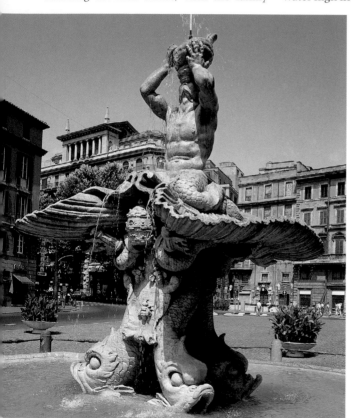

The Palazzo Barberini

Pope Urban VIII (pontificate 1623–1644), who was one of the most enthusiastic builders in Baroque Rome and employed the two leading architects of the day, Borromini and Bernini, acquired a palace with a *vigna* (vineyard) from Duke Alessandro Sforza in 1625. Carlo Maderno began converting this palazzo into a residence for the Barberini family, and after his death Bernini took over supervision of the work with the collaboration of Borromini (until 1633). The plans as a whole are ascribed mainly to Maderno, who chose an unusual ground plan because of the building's situation and the large

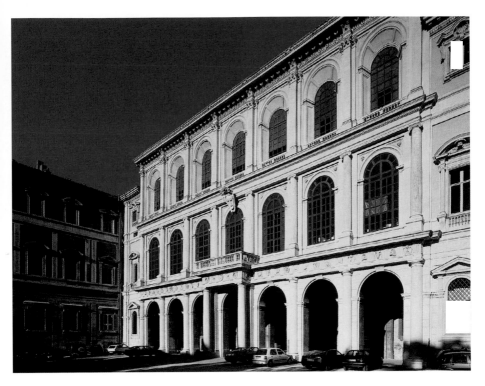

garden surrounding it. Unlike earlier Roman palaces, which were designed as buildings of four wings with an internal courtyard, or strictly as squares, Maderno added two narrow wings extending past the long rectangle of the main area to both front and back. The result is an H-shaped building. His innovations also affected the façade, which is constructed in the form of an arcade on all three floors. These arcades imitate the Colosseum in following the three classical orders of architecture: there are Doric columns in front of the pillars of the arcades on the ground floor, Ionic columns on the central floor, and Corinthian pilasters on the top floor.

The Italian state acquired the palazzo in 1949, and used the left wing of the building to accommodate the Galleria Nazionale d'Arte Antica; the museum contains works by many of the major European painters of the 13th–18th centuries.

The Stairway

Among the special features of the interior is the spiral staircase in the right-hand wing, designed by Borromini on an oval ground plan, and already showing a Baroque departure from the usual type designed by Bramante and Vignola. Light falls from above on the flight of steps, which is supported by double columns, and the play of light and shade create attractive alternating perspectives.

Raphael, La Fornarina, ca. 1518–1519
Oil on panel, 85 × 60 cm

This unusual portrait shows a half-naked woman modestly holding one hand in front of her bare breasts, like the *Venus pudica*. It is signed RAPHAEL URBINAS on the ribbon she wears on her upper arm. In the past, she was often thought to be Raphael's mistress Margherita, who was a baker's daughter ("fornarina"), but controversy still surrounds the real significance of the painting and indeed the real identity of the artist.

**Pietro da Cortona (1596–1669),
The Triumph of Divine
Providence, 1633–1639**
Ceiling fresco, 15 × 25 m

The imposing center of the suite of rooms is the *gran salone* (large salon) which occupies two floors, and was used by the Barberini for festivities, banquets, and theatrical performances. Between 1633 and 1639 Pietro da Cortona ornamented the ceiling with a fresco. Like the furnishings of the palace as a whole, the fresco was created with the aim of celebrating the power of the Barberini pope. At the center of the ceiling, divine providence is triumphing over time, sending out immortality to crown the emblem of the Barberini with a wreath of stars. The scenes at the side illustrate the many virtues of Urban VIII – wisdom, piety, dominion, and statesmanship – and the achievements of his pontificate. In this masterpiece, Pietro da Cortona successfully set out a complex iconographic program, combining a religious theme with glorification of the house of Barberini in an extremely ambitious and dynamic manner that blurs the boundaries between architecture and painting.

S. Constanza

In A.D. 330 Constantia, daughter of the Emperor Constantine, erected a basilica with a circular ambulatory near the grave of St. Agnes; remains of the enclosure wall are the only parts to have been preserved. The basilica was combined with a mausoleum built by Constantia for herself and her sister Helena. Before the 6th century, this mausoleum was converted into a baptistery called Santa Costanza. From outside, the church is a round building consisting of three super-imposed cylindrical sections of different sizes and heights. Originally the enclosure wall was surrounded by a columned ambulatory, which like the biapsidal porch, has since been destroyed.

The Interior

The interior of the church is impressive for its sense of spatial harmony, the result of the complex interrelationships between the separate elements of the building. Twelve double columns of granite with Corinthian capitals form a circular arcade

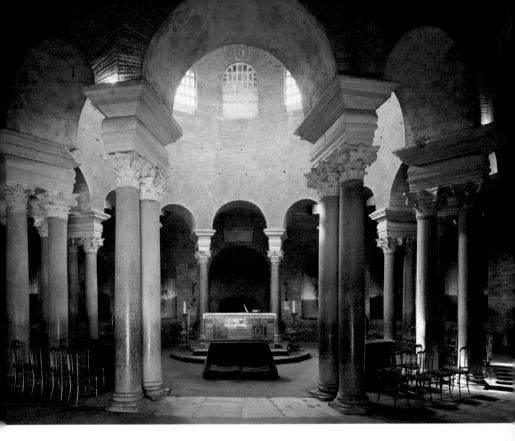

and support the drum, whose twelve windows allow light to suffuse the interior. There is a lower, barrel-vaulted ambulatory around the pairs of columns, bounded on the exterior by an encircling wall with alternate semicircular and rectangular niches. These niches open out at the four main axes into small chapels, suggesting the shape of a Greek cross. The four archways of the arcade are higher at these points, so that the viewer's eye is guided in certain directions. The interior, once entirely covered with marble and ornamented with mosaics, is among the finest examples of the architecture of late antiquity in Rome.

S. Agnese fuori le Mura

Constantia founded this church in A.D. 342 in memory of St. Agnes, whose burial place in the catacombs on the Via Nomentana had become a popular place of pilgrimage in the 4th century. According to legend, Agnes, the daughter of a noble family, refused to marry the heathen son of the city prefect and as a result suffered martyrdom. Only a few remains of the original basilica are preserved, near the church of S. Costanza. When the Constantine building began to fall into decay, Pope Honorius (pontificate 625–638) had a smaller church built beside it, with two aisles like its predecessor and with its altar placed directly above the tomb of St. Agnes. The interior is divided up by sixteen ancient columns. In spite of some modifications and extensions, the early medieval structures are still clearly perceptible, particularly in the typical galleries along the front and side walls. Early in the 17th century the choir was redesigned, side chapels were added, and a Baroque baldacchino was built for the altar; the decoration of the triumphal arch was not carried out until the middle of the 19th century. Notable features are the richly ornamented wooden ceiling of the unusually tall and narrow central nave, dating from 1606; the 7th-century stone episcopal throne in the apse; and the marble candelabrum beside the 13th-century ciborium.

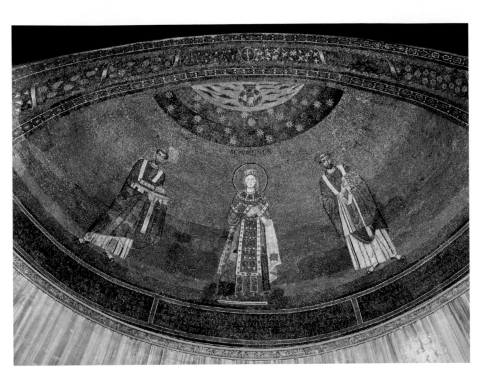

The Apsidal Mosaic

The semi-dome of the apse contains a 7th-century mosaic. St. Agnes, a slender columnar figure, stands in the middle of the wide pictorial area, adorned with jewels like a Byzantine empress and wearing a violet dress and golden stola. Fire and a sword, the instruments of her torture, lie at her feet. The saint is flanked by popes Honorius and Symmachus, offering her a model of the church. Above St. Agnes, at the apex of the semi-dome, the heavens appear to open up, showing the hand of God. The lamb carried by the martyr refers to the legend that a week after her death she appeared to her parents, surrounded by other young martyrs and holding a lamb. From then on, two lambs were blessed on the altar of the church annually on January 21, and their wool was used to weave a *pallium* (stola), the vestment given by the pope to every newly appointed archbishop.

From Servant to Knight –
Slaves and Freedmen in Imperial Rome

by Jürgen Sorges

The history of the *imperium romanum* (Roman Empire) is also the story of its slave revolts. The best known, and the most dangerous to Rome, were the rebellions of starving slaves on the estates of Sicily, Rome's oldest granary, in the periods 136–131 and 104–101 B.C. Any surviving rebels were crucified around Mount Etna, like the followers of Spartacus after his uprising a little later, when wooden crosses were erected every fifty paces along the Via Appia. Up to 50,000 condemned men died on them, usually of suffocation, and their bodies were left hanging there for years as a warning to all enemies of Rome. None the less, Spartacus has gone down in history as a symbol of the desire for freedom and the fight against slavery. He himself had been sold into the gladiatorial trade, where he had to fight for his life every day. The arbitrary power of the masters over their slaves was modified by the *lex petronia* of 19 B.C., which stipulated that they could be condemned to fight wild beasts only with state approval.

However, slave revolts were not the only uprisings in the history of Rome. Freeborn citizens rebelled with equal regularity, particularly in the chaotic metropolis itself, for sometimes the living conditions of the free were worse than those of slaves and foreigners from the east, who were legally of lower social rank. These people, who could be identified by the Greek sound of their names, were often the victims of popular anger because they were better clothed and cared for. In ordinary life, the legal distinction between those who were free and those who were not was blurred, for slaves could often participate

Matthias Merian the Elder, The Romans Fighting Spartacus. Final battle between Crassus and Spartacus in 71 B.C. in Lucania. Engraving from J.L. Gottfried, 1630, Historische Chronica, Frankfurt am Main

in public life, and most important of all they could make a career for themselves. However, they did not have equal opportunities in their various activities: prospects were poor for the oarsmen chained to the galleys of Rome; for men laboring in the stone quarries of North Africa; and for the slave laborers, some 3,000 of them who, although they were well fed, had to spend their lives working in the underground passages of the imperial Villa Hadriana, with no hope of ever seeing the light of day.

Educated slaves in Roman households, however, could achieve unusually high social status. Such slaves commanded high prices in the slave markets, and were valuable economic assets requiring careful treatment, for they were investments: their diet, care, and clothing were those of free men in private households. The differences showed in the subtly graduated granting of social privileges, for instance their exclusion from family banquets. In public, slaves walked behind their masters; but on the other hand they had access to all public temples, to the Colosseum, and to the baths.

Slaves (servi) *were at the bottom of the social ladder in ancient Rome. Through buying their freedom or through liberation, they could rise to the ranks of freedmen* (liberti) *among the Roman citizenry* (cives romani), *or they might be classed as foreigners* (peregrini), *in which case they had no rights to citizenship. Roman citizens could become* decuriones *(officials holding a mandate) by election. An army career enabled a man to become an officer, the class from which the rank of cavalry officer or knight* (equites) *developed. Senatorial office was acquired by birth or by military success. Beside the emperor* (caesar), *only senators* (senatores) *could be Roman governors or commanders of legions*

Slaves had to obey their *patronus* and *patrona* (the master and mistress of the household) in everything, but there were limits to arbitrary treatment. The patron could adjudicate only in family matters; in the case of serious crimes

punishable by mutilation or even death, the *pater familias* was subject to the control of the Roman state. His duties toward his slaves were meticulously regulated, and the state quite often punished cruel slave owners severely. The legal canon of rights protecting slaves steadily improved: Emperor Claudius (reigned 41–54) made it incumbent on an owner to take responsibility for the health of his slave, and if he neglected to do so, the slave was considered free. Killing old or sick slaves was punished as murder, and if slaves were turned out they could claim state support. Emperor Domitian (reigned 81–96) banned the castration of slaves, and Hadrian (reigned 117–138) abolished the death penalty for slaves who had committed criminal offenses and their imprisonment in private dungeons.

Many slaves wore a small plaque, the *bulla*, around their necks, often engraved with their master's address and the amount of reward if they ran away and were recaptured. None the less, they could rise to high-ranking professional positions. Many acted as tutors, and entrepreneurial abilities were desirable and highly valued. Slaves worked as bankers, estate managers, and manufacturers. The regulations applying to the life of a slave even allowed them

Kitchen Scene, ca. A.D. 250, relief from the Igel Column (funerary monument of the Secundinians), Rheinisches Landesmuseum, Trier

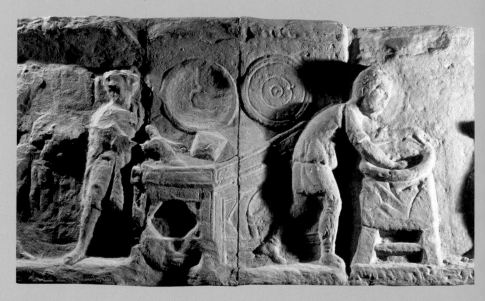

to acquire property: they could use this *peculium* either to buy back his freedom, by repayment of their purchase price, or to build their own career. Most slaves were freed when they were around thirty, and often remained devoted to their masters, bearing their names all their lives. Such people were particularly well represented in the service of the state and the emperor, since they were regarded as men who would be especially loyal and would not mix with the Roman upper classes. Consequently, slaves and freedmen often rose to high political office in the imperial period, and acquired great wealth. In the 1st century A.D., for instance, there were times when the distinction of being the richest man in Rome was disputed between the senator Gnaius Cornelius Lentulus and the imperial freedman Narcissus. Both of these men were said to have fortunes of four hundred million sesterces, riches enough to maintain whole legions of soldiers.

Claims in literature of the existence of millions of household slaves must be discounted as inaccurate. The highest number of slaves one patron ever owned was just above four thousand. At most, five hundred slaves worked on a landed estate. In Rome, the number of slaves in an ordinary household was normally under ten, and in a nobleman's establishment between thirty-one and a hundred.

Sons of freedmen could rise in the social scale. The next generation could aspire to the rank of knights, and the generation after that to senatorial rank. The personal physician of Emperor Augustus (reigned 27 B.C.–A.D. 14) succeeded in rising from slavery to become a knight within only a few years. Freed slaves

Crouching African Boy, 2nd century A.D., bronze, height 14.2 cm, Musée du Louvre, Paris

could sometimes afford extravagant tombs, thus announcing their social success to posterity. While only a minority of the free Roman population had funerary inscriptions recorded, a disproportionate number of freedmen appear on such monuments.

After the 3rd century, as a result of this contrast between Romans who were free but poor and those who were slaves and freedmen, a number of free but impoverished Roman citizens sold their children to ensure that they had a good education and prospects of advancement in the households of the nobility. Some sold themselves too, as it was their only chance of a career holding imperial office.

S. Maria degli Angeli and the Baths of Diocletian
(Terme di Diocletiano)

To satisfy the demands of the ever-growing population of this part of the city, Emperor Maximian who shared imperial power with Diocletian, built a complex of baths between 298 and 306 on his return from Africa. It covered an area of 376 by 361 m (1,233 by 1,184 feet) and could accommodate three thousand people. An inscription praises the size and equipment of this mighty building, which outdid all other baths in extent and magnificence. When in 537 the Goths destroyed the Aqua Marcia,

which supplied the baths with water, they fell into decay and were used as barns, granaries, stables, or as a source of stone. In the modern period the ruins were integrated into other buildings from which, even today, give the visitor some idea of their extent in antiquity.

Ground Plan (after E. Paulin, 1880)

The ground plan follows the typical pattern of the thermal baths of antiquity: a central axis divides the complex into two symmetrical halves. In the center is a large basilica with the cold water pool (*frigidarium*), leading on one side to the *natatio*,

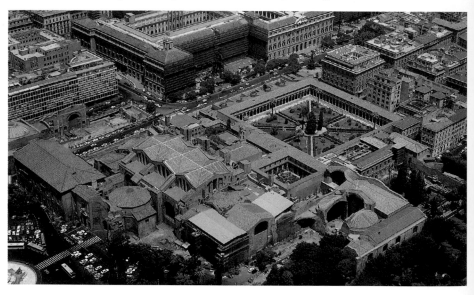

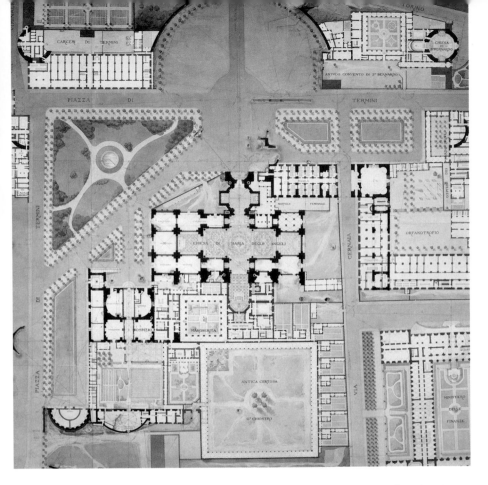

an open-air swimming pool, and on the other to the warm water pool (*tepidarium*) and the hot water pool (*calidarium*). Located to the sides were the sports grounds (*palaestrae*) and changing rooms (*apodyteria*). The rooms along the enclosing wall contained libraries and auditoriums, and the wall itself opened out to the north into a large exedra.

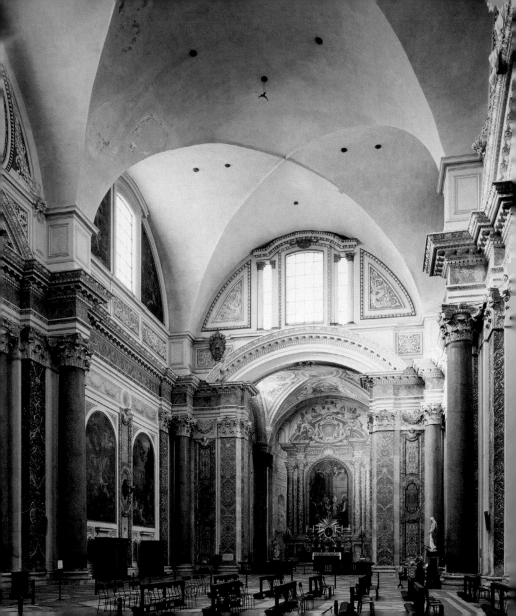

The Interior

When Pius IV (pontificate 1559–1565) gave the site to the monks of S. Croce in Gerusalemme, Michelangelo converted the central hall of the baths into the church of S. Maria degli Angeli. Work began on the conversion in 1563. The two axes of the ground plan, in the shape of a Greek cross with four side chapels, relate to the old basilica, the *caldarium*, and the *tepidarium*. The floor level had to be raised by two meters (six and a half feet) to keep the interior dry. The ancient plinths of the columns therefore disappeared beneath the floor, and were replaced by new structures. Various restorations, and the extensive renovation carried out in 1749 by Vanvitelli when he turned the main hall into a transept, have made it difficult to see Michelangelo's original concept today. However, the monolithic columns of red granite and the mighty groined vaulting in the present transept give some idea of the appearance of the baths in antiquity.

In 1576 Gregory XIII (pontificate 1572–1585) built granaries, which were later extended, in the northwest part of the main complex of the baths. The round church of S. Bernado alle Terme was built at the end of the 16th century in one of the four corners of the enclosure wall.

Piazza della Repubblica

In 1887, when Rome had just become the capital of Italy, the architect Gaetano Koch converted the site of the great exedra – formerly called the Piazza Esedra – into a magnificent square, with the Fontana delle Naiadi by Alessandro Guerrieri (1885) at its center. Koch echoed the form of the ancient exedra in the semicircular neo-classical colonnades of the two palaces, which once housed elegant shops. The Piazza della Repubblica, at the end of the Via Nazionale, which was built in 1867 as a major traffic artery, symbolizes the transition from ancient to modern Rome, for the first ministerial buildings in the new capital were erected in its immediate vicinity.

Palazzo Massimo alle Terme (Museo Nazionale Romano)

The Museo Nazionale Romano was founded in 1889 to accommodate the antiquities that had been found in and around Rome, or came from older private collections such as those made by the churches and the Ludovisi Collection. The southern part of the Baths of Diocletian and the cloisters of the Carthusian monastery built on the site were used as exhibition rooms, and consequently the museum is also known simply as the Museo delle Terme (Baths Museum). However, the space soon proved inadequate for the museum's collection, which was constantly increasing because of many new finds and acquisitions. In 1995, after a period of more than thirty years of uninterrupted restoration work, the Palazzo Massimo alle Terme on the Piazza dei Cinquecento was opened, and it now houses a large part of the museum's art treasures. The old rooms of the baths are presently undergoing restoration and conversion. With the Palazzo Altemps and the Planetario, the Palazzo Massimo alle Terme has now become an exhibition area of the Museo Nazionale Romano, which is second only to the Musei Vaticani in its stock of antiquities. Among the outstanding exhibits there are Greek, Hellenistic, and Roman sculptures, fine examples of Roman mural painting, and sarcophaguses dating from the Christian and pre-Christian periods.

Girl of Antium
(Fanciulla d'Anzio), ca. 250 B.C.
Parian marble, h 174 cm

The girl stands before us, one foot far out to her side, her head bent to look at the sacrificial platter she is holding. This still contains a rolled-up fillet, a sprig of laurel, and the remains of a *thymiaterion* (censer) – a foot in the shape of a lion's claw, showing that the girl has been performing a sacrificial ritual. Her hair is casually pinned up and wound into a knot above her forehead. She wears a loose-fitting garment that has slipped off her lowered shoulder, its hem sweeping the ground. The appeal of this statue lies in the girl's mixture of piety and natural charm. Unlike figures of the classical period, it expresses lively movement in the turn and attitude of her head, a feature indicating that it dates from around 250 B.C.

Art for Sale – the Studios of Roman Copyists

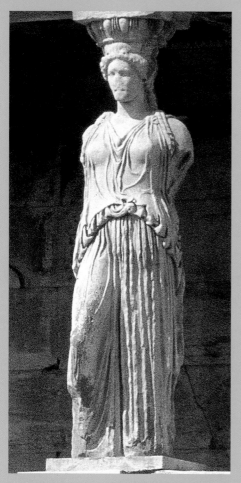

Caryatid, ca. 420/410 B.C., Erechtheion, Athens

When the German art historian Johann Joachim Winckelmann spoke of the "noble simplicity and serene grandeur" of works of Greek art, he did not know that in many cases he was describing Roman copies of lost Greek originals. For while only a small number of the latter have been preserved – most of them reliefs, and a few large bronzes – there are a great many later reproductions of Greek works, generally in marble, and more or less true to the originals. Such copies or replicas are very important to archaeologists, since analysis of them has made it possible to reconstruct the appearance of the original work to a high degree. In view of the scarcity of genuine originals, moreover, they are of incalculable value for our overall knowledge of Greek sculpture in general and its chronological development.

The majority of Roman copies were made for historical reasons, for since the conquest of Greece and the Greek east in and after the 2nd century B.C. the art and culture of the Hellenic world had exerted an increasingly strong influence on Roman society. Greek works of art were brought back to Rome as the spoils of war after military campaigns, and were publicly exhibited in triumphal processions or as votive offerings. It soon became fashionable for the upper classes, who were usually very familiar with

Greek culture, to possess such works of art themselves and display them in their villas and country houses. An art market soon developed for the sale of originals and the ordering of copies. When it became obligatory during the imperial period to furnish all public buildings with statues, the number of businesses producing copies rose rapidly.

Finds made in a sculptor's studio in the southern Italian city of Baiae show the kind of work that went on in such a workshop. The copyists of antiquity used methods similar to modern techniques, making plaster casts of the originals to provide themselves with models which they then copied in stone. Using measuring points, and recording measurements with callipers, they could transfer the scale and proportions of the original from the plaster cast to the block of marble. The parts in between were then modeled free-hand. The closer together the measuring points, the more the copies would resemble the original. In bronze copies, which were much less common, negative molds were cast and then filled with the molten metal, while the smoothing and finishing of the surface was left to the sculptor. These procedures enabled copies to be made anywhere, since the casts could be sent all over the Roman Empire. However, making such plaster casts was very time-consuming, and they were expensive to buy, so that most copyists' studios could offer only a certain standard repertory of the most famous Greek masterpieces, a state of affairs reflected in the stocks of modern museums.

Caryatid, Villa Hadriana, Canopus, Tivoli

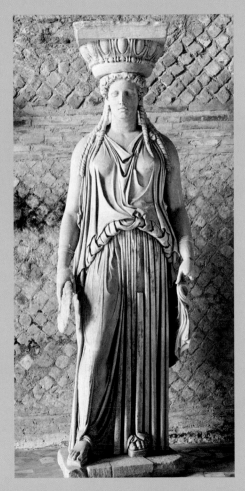

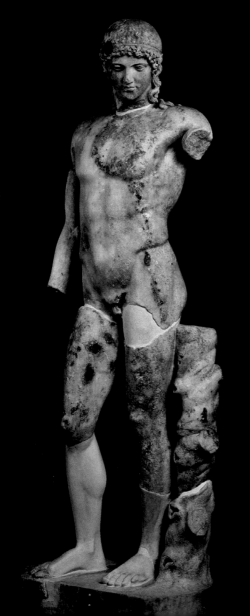

**The Tiber Apollo
(Apollo del Tevere), Roman
Copy after a Greek Original
from the Middle of the
5th Century B.C.**
Parian marble, h 204 cm

This marble statue, named
after the place where it was
found, shows the youthful
god Apollo with one leg set
casually in front of the
other, his head with its long
locks of hair bending to-
ward his left shoulder. He
has raised his left hand and
is probably grasping the
branches of a laurel tree,
which would have occupied
the position of the Roman
marble support in the copy.
His right hand hangs down
and was once holding his
bow. The *contraposto* attitude
and the thorough study of
musculature indicate that
the bronze original dated
from the middle of the 5th
century B.C.

**Augustus of the Via Labicana,
Late 1st Century B.C.**
Marble, h 217 cm

This marble statue from the
late 1st century B.C., larger

than life size and named after the site where it was found, shows Emperor Augustus clad in a toga and offering a sacrifice. In line with traditional devout practice, he has covered his head as a sign of humility. Judging by the remains of color, the toga was originally painted Tyrian purple, and the statue was probably holding a sacrificial dish in its outstretched hand. The simplicity of Augustus's bearing shows that he is depicted doing his religious duties as *pontifex maximus* (chief priest), and emphasizes his *pietas* (piety). *Pietas* was one of the four virtues with which the emperor liked to identify. The head of the statue corresponds to an Augustan type familiar in many versions. Individual characterization, and certainly any signs of ageing, were rejected in favor of idealization. The structure of the features and the hair are reminiscent of the heads of idealized Greek statues of the late classical period: the clasp in the hair over the middle of the forehead, however, is a characteristic touch in portraits of the Emperor Augustus.

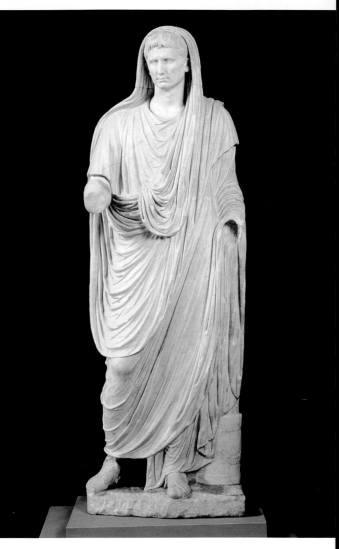

Planetario (Museo Nazionale Romano)

The Octagonal Hall in the western corner of the Baths of Diocletian, which was integrated with the museum a few years ago, was used as a school in the late 19th century and then as a movie theater. It was converted into a planetarium in 1928. The metal canopy beneath which the major finds from the great baths of ancient Rome are displayed bears evidence of the building's former use.

Hellenistic Ruler (Ruler of the Baths), 2nd Century B.C.
Bronze, h 237 cm

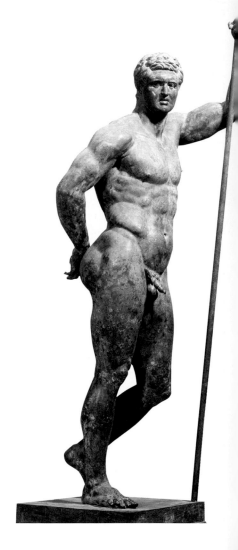

This bronze statue of a naked man, which probably derives its pose from the famous *Alexander Carrying a Lance* by Lysippus, is a Hellenistic work of the second quarter of the 2nd century B.C. The attitude and nudity, which are also typical of representations of divine figures, invite comparison with the statues of Hellenistic rulers, but unlike them it does not wear a royal fillet. The identity of the subject of the portrait is therefore still a matter of controversy. While some have seen him as a king (and the features do suggest portraiture), others think that the statue depicts a Roman army commander, perhaps one of those who defeated the kings of Macedonia.

Seated Boxer, Mid-1st Century B.C.
Bronze, h 128 cm

Body leaning forward, arms on his thighs, the boxer sits on a block of stone, glancing back over his right shoulder. He is marked by the traces of a fight: his right eye is puffy, his ears are swollen, and some of his teeth are missing, and there are scratches and drops of blood on his muscular body. The artist reproduced every detail of the straps of the boxing gloves worn on his stiffly outstretched hands; as usual with figures of athletes, his penis is bound up. A number of references to sculptural forms of the past are present but unrelated in this figure, and do not form a new, unified style. This eclecticism suggests that the statue dates from the late Hellenistic period: the broad face seems to have frozen into rigidity, and the bunched muscles of the body are set side by side in blocks. According to the remains of a signature on a strap on the left boxing glove, this bronze, was the work of an artist called Apollonios.

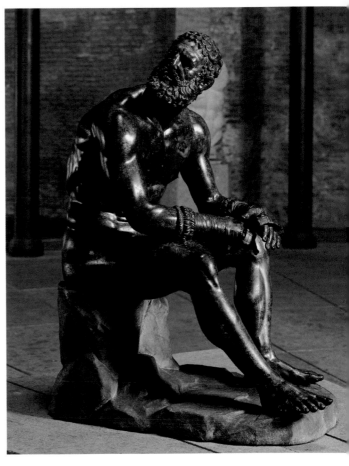

S. Carlo alle Quattro Fontane (S. Carlino)

In 1634 the Trinitarians commissioned Borromini to build a church in honor of the founder of their order, St. Carlo Borromeo, at the intersection of the Via del Quirinale and Via delle Quattro Fontane (named after the four fountains at its corners). It was consecrated in 1646, but Borromini designed the façade only shortly before his death in 1667. The façade and interior of this little church, its entire area no larger than that of one of the piers at the crossing of St. Peter's, are notable for the interplay of their curving lines. The design of the façade, characterized by a typical Baroque synthesis of architecture and sculpture, divides into two layers of wall construction: the stories of the front section are structured by columns, while the second section behind it consists of alternating concave and convex curves. Niches with figures of saints adorn the bays. In the central bay of the upper floor, a huge medallion with the portrait of St. Carlo Borromeo is supported by angels, so that the broken cornice resembles volutes as it surrounds the relief.

View of the Dome

The interior of the little church is dominated by the interplay of concave and convex wall surfaces typical of Borromini. Concealing the shape of the ground plan, they provide constant surprises. The transition between them is marked by half-columns supporting the oval dome. The coffers in the dome, some of them cruciform and some polygonal, diminish in size toward the center, reinforcing the impression of perspective and therefore of height. Light falls into the church, which is ornamented almost entirely in white stucco, through the lantern and some windows set in the coffers.

The Piazza del Quirinale

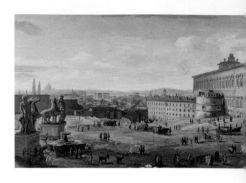

The Palazzo Quirinale was begun in the late 16th century as a papal summer palace. The history of its construction was complex, however, and it was not completed until the time of Pope Clement XII (pontificate 1730–1740). It became a royal residence after 1870 and has been the official residence of the president of the state of Italy since 1947. The public square in front of it is one of the most impressive in Rome, with a view over the entire city center as far as St. Peter's. The Piazza del Quirinale, designed by Domenico Fontana, was part of the town planning program of Pope Sixtus V (pontificate 1585–1590), who had the two 5.60 m-high (18 feet-high) statues of the Dioscuri taming horses moved from the Baths of Constantine to the middle of the piazza.

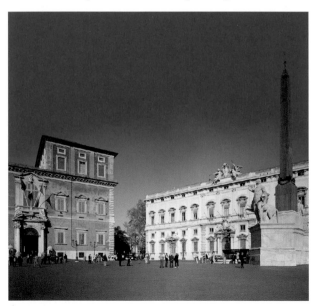

These horses gave the hill its name of Monte Cavallo (horse hill). The appearance of the square has changed over several centuries: in the early 17th century, it was leveled and enlarged under the supervision of Carlo Maderno; in 1783 the obelisk from the Mausoleum of Augustus was placed between the two statues; and the fountain, with a basin from the Forum near the temple of the Dioscuri, was set in front of this ensemble in 1813. The great balustrade between the square and the city was constructed at the end of the 19th century.

The Fontana di Trevi

The Fontana di Trevi, Rome's largest and most famous fountain, is located in front of the Palazzo Poli. It is into this fountain – so the legend goes – that you must throw a coin if you want to come back to Rome again. The Baroque display wall of the fountain is 20 m (66 feet) wide and 26 m (85 feet) high, and was built by Nicola Salvi in the period between 1732 and 1762 in the form of a triumphal arch with three archways and a mighty attic story. In the central niche, behind the artificial rocks, stands the mighty figure of Oceanus, the god of the ocean, on a shell-shaped chariot drawn by seahorses, and surrounded by shells and tritons. The side niches contain statues of Abundance (on the left) and Healing (on the right), by Filippo Valle, and the reliefs above show Agrippa agreeing to the building of the Aqua Virgo, and the story of its creation.

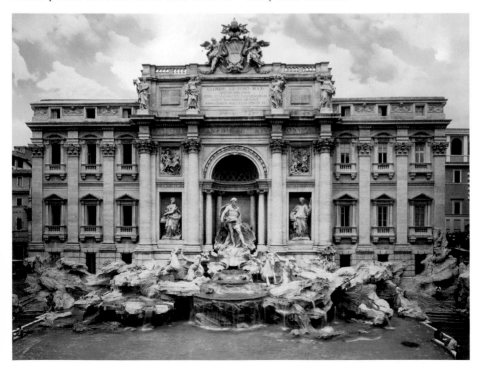

The Renaissance and the Rebuilding of Rome under Nicholas V

Eighteen cardinals had assembled for the papal conclave of March 4–6, 1447 which, unusually, took place in the sacristy of S. Maria sopra Minerva. Strange things were going on outside the church on the site of the ancient temple to the Egyptian goddess Isis. One of the official guards at the gates of the conclave, Silvio Piccolomini – who later became pope himself (as Pius II, pontificate 1458–1464) – was an eyewitness, and denounced the jettisoning of old traditions. For instance, odd-looking crates known as *cornute*, painted with the cardinals' coats of arms, were being driven, rumbling and clattering, through the narrow streets of Rome. Whole processions of the various cardinals' supporters, the *famiglia* who had to be provided for, followed these supposed coffins, which were really only containers bringing provisions for the cardinals into the conclave daily (and no doubt secret messages as well). Something had to be done to put a stop to this ridiculous spectacle! Then

NICOLAVS QVINTVS.

NICOLAVS PAPA V LIGVR.

Portrait of Pope Nicholas V, unattributed engraving, from G. Pinadello, Invicti Quinarii, 1589, Rome

sensational news came: the papal tiara had gone not to a man who would have maintained tradition, the powerful noble Roman favorite Cardinal Prospero Colonna, but to an unknown, gray church mouse, a small, thin, pale cleric with no personal fortune. The people of Rome were not particularly pleased with this choice, in view of the fact that they considered it their traditional and natural right to ransack the winner's private property there and then. The *popolo romano* therefore made the bearer of the "bad news" pay, and Prospero lost twice over, for all the Colonna properties in Rome passed into the hands of the mob.

Nicholas V (pontificate 1447–1455) – not to be confused with Nicholas V the anti-pope (pontificate 1328–1330) – had been born Tommaso Parentucelli, son of a surgeon in the little Italian town of Sarzana. He began his career as a schoolmaster, then became a private tutor, entered the service of the Church, and rose to become archbishop of Bologna and Roman titular cardinal of S. Susanna. In 1439 he had taken part in the famous Council of Florence, which the Medici had contrived to have held on the Arno, thanks to the depth of their coffers: no one else could afford to stage the extravagant ceremony of welcome for Emperor John VIII Palaeologus of Byzantium (reigned 1425–1448) or provide for his retinue of a thousand followers. Such a lavish show, the pope believed, was necessary as a sign that Rome took precedence over Byzantium. While the official delegations spent months wrangling over Church dogma, a small sensation took place among those participants who had intellectual interests. Scholars on both sides eagerly exchanged books and manuscripts,

Justus of Ghent, Portrait of John Bessarion for the Palazzo Ducale in Urbino, ca. 1475, on wood, 116 x 56 cm, Musée du Louvre, Paris

forgetting other hostilities in discussion of their common inheritance from Plato (ca. 428–ca. 347 B.C.), Aristotle (384–322 B.C.), and other great minds of Greek antiquity. The future Nicholas V was conspicuous among those who felt particular enthusiasm for *studia humanitas*, humanist studies. He was not a genius, but he had a lively mind trained in rhetoric and a phenomenal memory. "What he does not know is not knowledge," said Piccolomini. No one guessed that the magnificent secularization of the papacy would begin with this man, a "pillar of literature."

It was in fact a bookseller, a Florentine called Vespasiano da Bisticci, who became the pope's closest adviser. The bibliophile Nicholas hoped to emulate his scholarly Byzantine models, Plethon, and particularly Cardinal Bessarion (1403–1472), venerated by all as a polymath: both men had stayed on in Italy after the Council of Florence, and could help with the transference to the West of knowledge – for knowledge is power. And the West, in the pope's view, must also have access to the extraordinary wealth of books available in Byzantium. The Biblioteca di S. Marco was

N.J.B. de Polly, La Galerie Nouvelle de la Bibliothèque Vaticane à Rome (The New Gallery of the Vatican Library in Rome), peepshow print, ca. 1780, engraving, colored, Paris

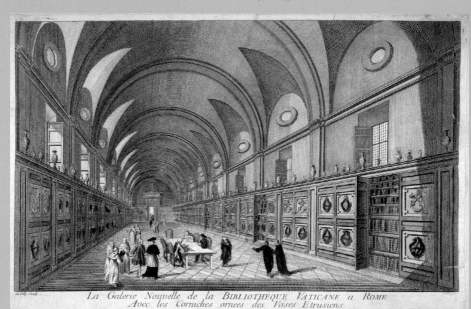

La Galerie Nouvelle de la BIBLIOTHEQUE VATICANE a ROME
Avec les Corniches ornees des Vases Etrusiens.
Paris, chez N. J.B. de Poilly, rue St Jacques a l'Esperance

founded in Florence, with the private library of Boccaccio (1313–1375) as its basic stock, and the Biblioteca Marciana in Venice was built on the foundations of the great private collection of Cardinal Bessarion and the library of Petrarch (1304–1374). Nicholas V acquired for Rome the Biblioteca Apostolica Vaticana, which became internationally famous as the Vatican Library. By the end of his papacy, he had collected 1,200 codices alone.

A pope now became a patron: ordinary backroom scholars quickly rose to well-paid professorial positions and high offices in the church. Even a man previously ostracized, the Neapolitan Lorenzo Valla (1407–1457) who in 1440 had exposed the Donation of

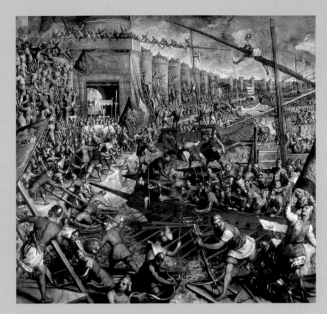

Domenico Tintoretto, The Capture of Constantinople, 1578–1585, oil on canvas the Doge's Palace, Venice

Constantine as a brilliant forgery, thus showing how hollow was the claim of the Roman papacy to be the legitimate heir to the Western Roman Empire of antiquity, was able to pursue his career again. A permanent revolution was under way.

One of these new humanists, a certain Johann Müller from Königsberg in Franconia, became known to later generations as Regiomontanus (1436–1476). As assistant to Cardinal Bessarion and student of his arcane interests, he zealously selected and translated the writings of antiquity on the natural sciences, although the more spiritually inclined Bessarion

would not accept their value. In this way Regiomontanus promoted a revolution in mathematics, physics, ship-building, architecture, and not least, astronomy.

Meanwhile, Nicholas V provided the requisite framework conditions. During his first two years as pope, he induced all the warring parties in Italy to agree on an armistice. The holy year of 1450 followed – a year of peace, and one that brought money flooding into Rome again, after a long lean period. The Vatican register licensed over one thousand hostelries in the Old Town district alone, the highest number of inns that

was ever recorded there. But Nicholas V did not forget the poorer pilgrims: he arranged for an open-air market to be set up near the Arco di Gallieno on the Esquiline, to supply the faithful with provisions at a low price as they made their way to S. Maria Maggiore and the obligatory forty-eight-hour pilgrimage to the other titular churches of Rome.

Rome itself was rebuilt: Nicholas V restored to working order the Aqua Virgo aqueduct of 19 B.C., which was built by the Roman statesman Agrippa (63–12 B.C.) near the Pantheon to supply his baths. The plans were by Leon Battista Alberti (1404–1427), and the aqueduct was extended along the Via Trinitatis, the present Via Condotti. At the end of the aqueduct, Alberti installed a fountain in 1453 to spurt water into the air, and Nicola Salvi converted it into the world-famous Fontana di Trevi in 1732–1751 (the work was finally completed in 1762). Also in 1453, one of the oldest and finest churches in Rome, S. Stefano Rotondo, was restored and reduced in size under the auspices of Nicholas. He provided for the defense of the city, among other measures, by building the mighty tower on the Milvian Bridge, later extended by Valadier in 1805 to form a triumphal arch. The Capitol had a new tower, which was built in 1453. The Castel Sant'Angelo acquired a wall crowned with battlements, with first three and then four round towers consecrated to the Evangelists, the fourth being added under Pope Alexander VI (pontificate 1492–1503). The marble angel, which had been erected on the Castel Sant'Angelo in 1379, was replaced in 1453 by a bronze statue of the archangel Michael. The extension of the Vatican palaces around the Cortile dei Pappagalli began in the Grand style in 1450: three of the six rooms to be seen today in the Appartamenti Borgia are on the first floor of this extension. The four *stanze* (rooms) which were painted by Raphael in the years 1508 to 1520 were also built in the period after 1450. The first frescoes to be painted in these rooms (nothing is left of them now) were by Piero della Francesca (ca. 1420–1492); and Fra Angelico (ca. 1400–1455) was responsible for painting the Cappella Niccolina.

Nicholas also crowned the last Holy Roman emperor of the German Nation in Rome. This state ceremony for the Habsburg emperor Frederick III on March 19, 1452 became a spectacle on a large scale. After the proclamation of Frederick as Augustus, with his crown, scepter, and imperial orb, there was a long and exhausting ceremony on the Ponte Sant'Angelo. The emperor himself dubbed three hundred noblemen knights, in what was merely a theatrical show of chivalry. The imperial diamond sword, supposed to be worth a fortune, was nothing but a cheap theatrical prop. *Tempora mutantur* – the times were changing.

The year 1453 began badly. On January 9 Stefano Porcari, a Roman nobleman with an inquiring mind, an enthusiastic humanist who had been appointed rector of the Campania and the Marittima by Nicholas V in 1448, was hanged in the Castel Sant'Angelo with his fellow conspirators. Humanism was one thing; a new Roman Republic complete with a democratic system such as Porcari had demanded was quite another. His feelings deeply wounded, Nicholas V, who saw himself as the most liberal pope in history and therefore expected his subjects' goodwill, withdrew into retirement.

The final catastrophe came on May 28 and 29, 1453, when Constantinople at last fell to the Ottoman sultan Mehmed II (1432–1481). A Hungarian engineer and gun founder called Urban had already offered his services to Emperor John VIII Palaeologus of Byzantium in 1452, purely with business interests in mind. However, John's treasury was empty, and Urban went on to Adrianople, 200 kilometers (124 miles) away and the residence of Sultan Mehmed II. There he found an audience that was ready to listen to him and he built an early kind of Big Bertha, measuring 8 m (26 feet) long, with walls 20 cm (8 inches) thick, and 75 cm (30 inches) in diameter. It took a total of sixty oxen to pull the cannon to Constantinople, and its balls smashed through the triple walls around the city. The capital of the Byzantine Empire, which was previously believed to be impregnable, collapsed in rubble and ashes. However, some of its knowledge had been secured for Rome, and even greater efforts would follow in the future.

Pope Nicholas V departed this world on March 24, 1455. Before doing so, however, he made a speech for the benefit of posterity, another innovation. Now it was for the popes who came after him to continue his work.

Regiomontanus (Johann Müller), Epytoma in Almagestum Ptolemaei, title page of the 1496 edition of the book, published in Venice

The Palazzo Colonna

This spacious complex, still in the possession of the old and distinguished Roman Colonna family and covering an entire square of four streets, is a magnificent town palazzo that has grown through the centuries. In 1424 Martin V Colonna (pontificate 1417–1431) had an old tower combined with several buildings to form a single complex, thus elevating it to the dignity of a papal residence. Other buildings were erected in the area during the 16th century, and in 1654 Lorenzo Onofrio Colonna commissioned the architect Antonio del Grande to make all these buildings into a coherent whole. He designed a façade looking out on the inner courtyard, ornamented with arcades (which have now been filled in), and aligned the building with its central section. The gardens were linked to the palace by four bridges. The conversion of the building continued in 1730, when Niccolò Michetti built the façade to look out on the Piazza dei SS. Apostoli. The work on the side of the Via della Pilota, was performed by Paolo Posi, and was concluded in the year 1760.

In the course of more than three centuries an extensive complex had thus been created, with several wings laid out around a large courtyard.

The Galleria Colonna

The halls of the Galleria Colonna, decorated with designs by Antonio del Grande and Girolamo Fontana (1654–1671), and displaying the family's impressive collection of paintings, are among the most magnificent Baroque rooms in Rome. In a play on the name of "Colonna" – column – the rooms are divided by two arcades supported on large columns of yellowish marble. Fine frescoes adorn the vaulted ceilings, celebrating the famous deeds of the Colonna family. The ceiling fresco by Sebastiano Ricci located in the Sala dei Paesaggi, for instance, glorifies the victory of the legendary Marcantonio Colonna over the Turks in the naval Battle of Lepanto in 1571. Benedetto Luti

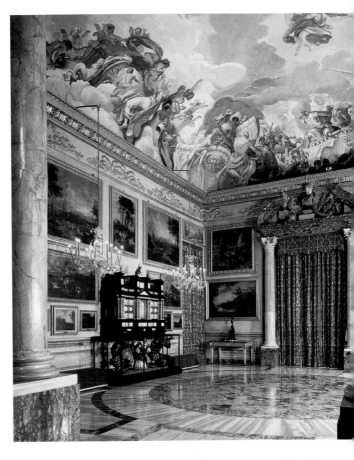

depicted the apotheosis of the Colonna pope on the ceiling of the Sala dell'Apoteosi di Martino V. The Sala del Trono was reserved for papal receptions, while the Sala di Maria Mancini was dedicated to Cardinal Mazarin's niece, who was the wife of

Lorenzo Onofrio Colonna. Huge painted mirrors on the walls, Venetian chandeliers, and gilded stucco work contribute to the expensive splendor of the furnishings, which is further enhanced by the display of ancient statues and valuable paintings.

The Esquiline (Esquilino)

The character of this densely populated residential area, which is divided from the Viminal by the Via Cavour, is determined today by the ruins of such great buildings of antiquity as the Domus Aurea and the Baths of Trajan, and venerable churches such as S. Maria Maggiore, S. Pudenziana, and S. Prassede. In antiquity the Esquiline, the most extensive of the seven hills, was one of the most crowded quarters of the city. It was settled at a very early period, and tradition says that it was incorporated into the city by the Etruscan king Servius Tullius in the middle of the 6th century B.C. During the republican and imperial periods, the heights of the seven hills became popular residential districts for the Roman nobility, while the poorer classes lived on the slopes and in the unhealthy atmosphere of the valleys. The gardens of Maecenas, a friend of the Emperor Augustus and a famous patron of literature, were on the Esquiline. They later became part of what is probably the most famous palace complex of antiquity, Emperor Nero's Domus Aurea. Although the domestic chapels of the Christians had become the first churches of Rome in the early Christian period, the residential areas of the Esquiline, like those of the other hills, fell into decline in the course of the Middle Ages. It was Pope Sixtus V (pontificate 1585–1590) who included the hill in the large-scale town planning project which, he hoped, would result in these

View of the Piazza dell'Esquilino

areas being resettled. His principal aim was to integrate the religious centers of these half-deserted areas – S. Maria Maggiore was one of the seven pilgrimage churches – into the city as a whole. He therefore had major roads built in the vicinity of the churches, to give pilgrims access to those churches that lay outside the city walls. Until the 1850s, when building began on the new main train station – known as the

Stazione Termini, the first train station 1867

Stazione Termini because of its proximity to the Baths of Diocletian – little had changed in this quarter. Only after 1870 were new housing plans drawn up, providing for the development of the space between the station and the Piazza Vittorio Emanuele II as a residential area. It was at this period that the apartment blocks on several floors were built, with the standard ocher façades that are so typical of the area to this day.

The Esquiline

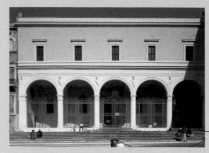

S. Pietro in Vincoli, Piazza di S. Pietro in Vincoli 4A, p. 311

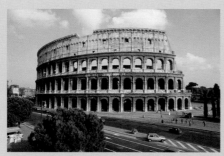

Colosseum, Piazza del Colosseo, p. 98

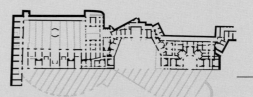

Domus Aurea, Via Labicana 136, p. 314

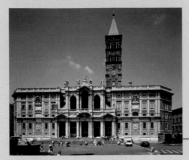

S. Maria Maggiore, Piazza S. Maria
Maggiore, p. 298

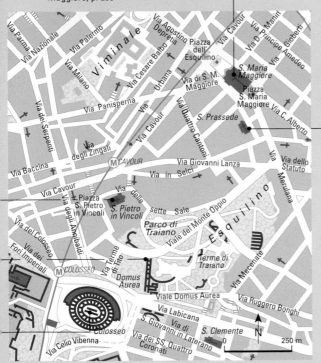

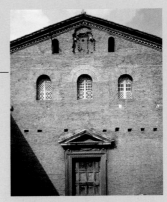

S. Prassede, Via S. Prassede 9A,
p. 308

S. Maria Maggiore

Not only is S. Maria Maggiore one of the seven pilgrimage churches and also one of the four patri-archal basilicas of Rome, it is the largest and most important shrine to the Virgin Mary in the city. Its history goes back to an earlier and smaller building erected by Pope Liberius (pontificate 352–366) after he had a vision of the Virgin Mary. The Mother of God

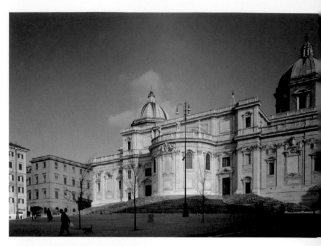

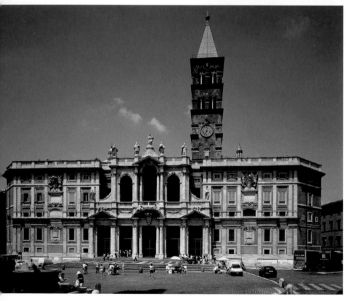

told him to build her a church on the spot where snow would lie next day (this was in the month of August). Snow fell on the highest point of the Esquiline. After the Council of Ephesus in 431, which confirmed the earthly and divine nature of Christ and thus of Mary as *theotokos* – she who had given birth to God – Pope Sixtus III (pontificate 432–440) had a basilica built in her honor near the old church. Although its architectural history lasted for over a millennium and a half, this church, which has become the center of the

veneration of Mary in the city, and is an essential place to visit on any pilgrimage to Rome, presents a unified picture. The apse and transepts were built during a conversion process at the end of the 13th century; a *campanile* (bell tower) was added in 1377, the tallest in Rome at a height of 75 meters (246 feet); and several chapels were built on to the aisles in the course of the 16th century. In 1587 Sixtus V moved the obelisk from the Mausoleum of Augustus to the square in front of the façade of the choir. Paul V had the *cipollino* marble column from the Basilica of Maxentius placed in front of the main façade, and crowned with a statue of Mary. In 1673 Carlo Rainaldi designed the apse façade as a Baroque display wall in two stories with a wide flight of steps in front of it; and in 1743–1750 Ferdinando Fuga designed the western entrance façade with the loggia for the pronunciation of the benediction, which contains a 13th-century mosaic depicting the "miracle of the snow."

out by Ferdinando Fuga in 1750. Forty Ionic columns separate the wide nave from the narrow, windowless aisles. At the end of the 15th century Giuliano da Sangallo was commissioned by Pope Alexander VI (pontificate 1492–1503) to create the fine coffered ceiling, which was gilded with the first gold from America sent to Rome by the king of Spain. S. Maria Maggiore is particularly notable, among other features, for its 5th-century mosaic ornamentation. The body of the church is adorned by pictorial areas divided by pilasters and showing Old Testament scenes: the story of the patriarchs Abraham, Isaac, and Jacob on the left, and of Moses and Joshua on the right.

The Interior

In essence, the spatial impression of the interior of this early Christian basilica has been preserved in spite of the restoration carried

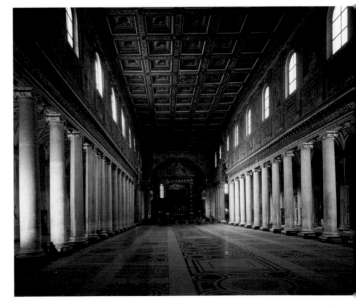

S. Maria Maggiore

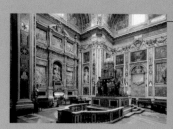

Cappella Sistina, p. 306

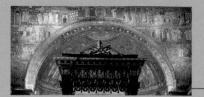

Triumphal arch, p. 302

Apsidal mosaic (detail), p. 302

Cappella Paolina, p. 307

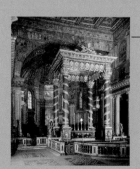

Baldacchino over the high
altar, by Ferdinando Fuga

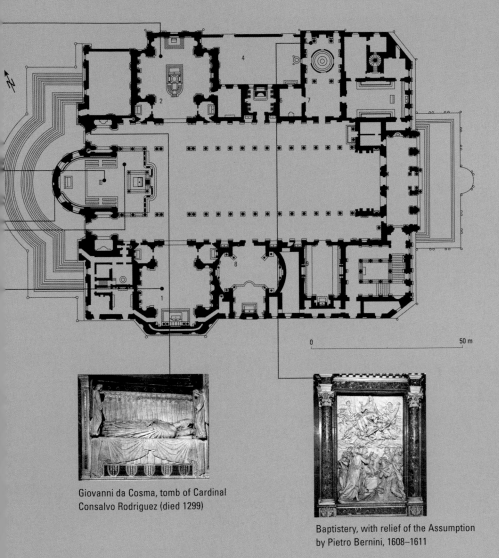

4

2

6 7

8

1

0 50 m

Giovanni da Cosma, tomb of Cardinal
Consalvo Rodriguez (died 1299)

Baptistery, with relief of the Assumption
by Pietro Bernini, 1608–1611

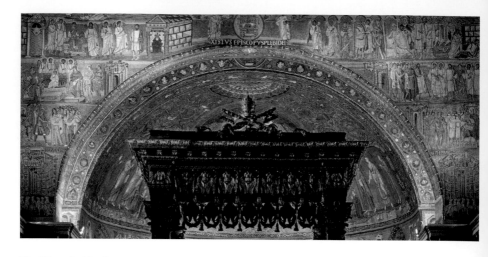

The Triumphal Arch

The mosaics which can be seen on the triumphal arch in the church of S. Maria Maggiore tell the story of Jesus. Laid out in strips, they are devoted to the accounts of the childhood of Christ in the Gospels. On the left are the Annunciation, the Adoration of the Magi, the Massacre of the Holy Innocents, and a depiction of the heavenly city of Jerusalem; on the right there are scenes of the Presentation of Christ in the temple, the Flight into Egypt, the Three Kings with Herod, and the town of Bethlehem. Above the apex of the arch is the empty throne of the Savior. The fundamental idea behind the mosaics as a whole is to illustrate the continuity of the history of salvation from the Old Testament to its fulfilment in the New Testament.

The Apsidal Mosaic (Detail)

The mosaics found in the apse, which are devoted to the Virgin Mary, were created by the mosaicist Jacopo Toritti after the rebuilding of the church in the period 1292 to 1295. He brought Roman mosaic art to its last fine flowering in this masterpiece. Surrounded by twining tendrils on a golden ground, with birds nesting, animals crawling, and flowers in bloom among the arabesques of vegetation, the center of the semi-dome is occupied by a medallion showing the Coronation of Mary against a blue background sprinkled with stars. St. Peter, St. Paul, and St. Francis are approaching from the left, with the figure of the donor Pope Nicholas IV (pontificate 1288–1292) shown on a smaller scale kneeling in front of them.

Annunciation, Pseudo Matt. 9, 2	Joseph's doubts dispelled Matt. 1, 18–24	The Apocalyptic Throne Rev. 4–5	Presentation of Christ in the Temple Luke 2, 22–38	Joseph told to flee Matt. 2, 13
Adoration of the Magi Matt. 2, 9–11				Aphrodisius goes to meet Christ, Pseudo-Matt., 20–24 (?)
Massacre of the Holy Innocents Matt. 2, 16				The Magi and the scribes with Herod Matt. 2, 1–8
Jerusalem Rev. 21, 10–21				Bethlehem Rev. 21, 10–21

S. Maria Maggiore, arrangement of mosaics on the triumphal arch

On the right is the kneeling figure of the second donor, Cardinal Jacopo Colonna, in front of John the Baptist, St. James, and St. Anthony. Below the vault of the dome, five scenes from the life of Mary are shown in the strips between the windows, while the heads of the twenty-four elders appear on the frieze marking off the front of the semi-dome.

In the scene of the Coronation of the Virgin, Jacopo Torriti depicted a subject that originated in the iconographic repertory of Gothic sculpture, and is frequently found on the tympanums of French cathedrals. In addition, it emphasizes the direct ascent of Mary to heaven, both body and soul, in reference to a theological tenet that was the subject of much discussion, particularly in the 13th century.

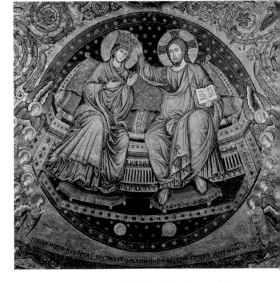

Pictures in Colored Stones – Mosaics

The colorful mosaics seen in Early Christian and medieval churches are among the most impressive works of art in Rome. In terms of art history these two epochs are considered the golden age of mosaic art, although the technique had been in use for centuries. The method of putting together regularly or irregularly formed small tiles to make ornaments and figures, fixed in place with mortar, was already known in the ancient Orient and in Greece. The little stones or tiles, known as tesserae, were placed on the mortar background while it was still damp and they were then pressed into it, following a sketch that had been previously drawn on the surface (the direct setting method). When the art of mosaic came to Rome from the Greek east in the 2nd century B.C., it was the well-to-do who first equipped their houses with this colorful (and expensive) form of ornamentation.

Many early mosaics were often modeled on paintings, as we can see in the fine gradations of color used, and the construction of the figures and objects to produce highlights and heavy shadows. Only in the 1st century B.C., according to Roman writer Pliny the Elder in his *Naturalis Historiae*, did walls begin to be decorated with mosaics – in this case glass mosaics, consisting of tesserae made of glass paste (smalts), and colored with metal oxides. These magnificent mosaics made ordinary citizens want decoration of the same kind for themselves. Black and white mosaics, with tesserae of basalt and white marble or limestone, of which many examples from the 1st–3rd centuries have been preserved in Rome and Ostia, were an inexpensive alternative. However, the opportunities for picturesque expression were obviously fewer when the stones were in only two colors. Instead of an effect of spatial depth with background nuances, the background surface was light, with black figures and objects on it, their curves and the turn of bodies expressed by graphic white lines. Multicolored mosaics had become less usual at this time. It was not until the period of Hadrian (reigned 117–138) that sporadic instances reappeared in Rome, and the art was revived, especially in the Roman provinces.

Ritual Sacrifice of a Bull, 2nd century, mosaic, Caserna dei Vigili, Ostia antica

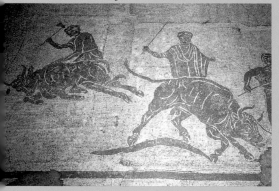

When the first great churches were built in the 4th century, the Christians took over this ancient manner of decorating the walls and ceilings of buildings. Figural floor mosaics could hardly be reconciled with their religious principles, since they would have entailed "treading Christian symbols underfoot." At first the stylistic elements of the mosaics of antiquity were retained, as in the church of S. Costanza, where there are only a few symbols of the Christian faith among the ancient motifs on a white background. Soon, however, Christian mosaics were serving not purely for decoration, as in antiquity, but as religious propaganda. The functions of a spatial area and its decoration were now combined, and complemented each other. At the same time the materials used changed. Smalts in all possible shades of color, some of them gold-plated, were mingled with the colored natural stones, intensifying the effect of radiance and creating strong reflections, especially on curved surfaces. Under the influence of Byzantine art, a gold background before which the monumental figures face the viewer frontally became the rule. Church interiors now became a representation of the Christian cosmos, and the arrangement often followed what to a great extent was an established pattern: the middle of the apse is occupied by Christus Pantocrator among the Apostles, with saints or figures of donors beside him, and surrounded by the symbolic forms of the four Evangelists, the twelve Apostolic Sheep, the river of Jordan, and the walls of Bethlehem and Jerusalem. Important incidents in the history of salvation are shown on the triumphal arch, and scenes from the Old and

Crossing of the Red Sea, mosaic, 432–440, S. Maria Maggiore, mosaic on the right wall of the nave

New Testaments are represented on the walls of the main body of the church. Fine examples of mosaic art were created in Rome throughout almost the whole of the Middle Ages. In the Carolingian period, and at the beginning of the 12th century, new inspiration came into mosaic art when the ancient formal repertoire was taken up again. Mosaic art in ecclesiastical architecture of the late 13th and early 14th centuries is considered to have had a final glorious flowering with the mosaicists Jacopo Torriti and Pietro Cavallini, before painting finally superseded the genre at the beginning of the Renaissance.

The Cappella Sistina

Pope Sixtus V (pontificate 1585–1590) had a chapel built by Domenico Fontana in the right-hand side aisle in the form of a Greek cross, with an octagonal dome over the crossing. It is called the Cappella Sistina after him. The relics of the crib of Bethlehem, the medieval crib chapel by Arnolfo di Cambio (ca. 1289), and a 16th-century Madonna are kept in a small underground chapel. Above it stands the sacramental altar, with a gilded bronze tabernacle that is supported by four bronze angels. The angels refer to the iconography of the Ark of the Covenant, representing Christ as the incarnation of the New Testament, replacing the Old Testament, and His law replacing the law of Moses, whose tables of the law were kept in the ark. The shrine is built in the form of a church, since the New Testament is made manifest in the church, and the "cradle" of the church is the crib of Bethlehem. The chapel was also the last resting place of Pope Pius V (pontificate 1566–1572). His tomb has a display wall on two stories, adorned with columns, showing the pope enthroned as a teacher of church doctrine in the center. Pope Sixtus V himself, builder of the chapel, preferred to emphasize his piety: Fontana shows him bare-headed and kneeling, deep in prayer as he turns toward the shrine and the crib.

The Cappella Paolina

Pope Paul V Borghese had a chapel designed by Flaminio Ponzio built from 1611 onward for the members of his family, as a companion piece to the Cappella Sistina. The tombs of Paul V and his predecessor Clement VIII, also designed by Flaminio Ponzio and with reliefs showing important events in their pontificates, stand in the Cappella Paolina, which is richly furnished with frescoes and stucco work. The most lavish item is the altar with the picture of the Madonna known as the *Salus Populi Romani* (Salvation of the Roman People), its gilded frame supported by angels. It was said to have been painted by St. Luke himself. A relief depicts the miracle of the snow of S. Maria Maggiore in front of a lapiz lazuli background.

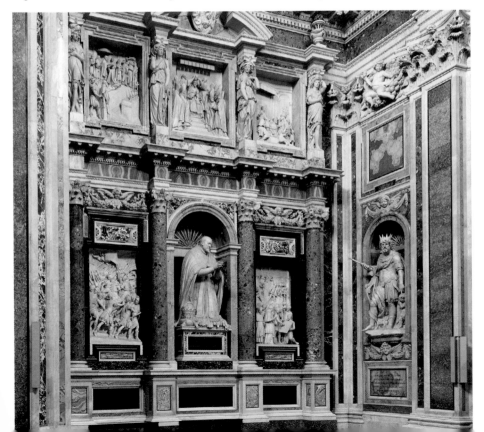

S. Prassede

There was a church dedicated to St. Praxedis as early as the 5th century, and under Pope Paschal I (pontificate 817–824) it was extended to form a basilica with a nave and two aisles. It came into the possession of the Benedictines in 1198. In following centuries, the church was rebuilt and restored several times without losing its basilical character. In the interior, sets of two granite columns bearing a horizontal architrave alternate with massive pillars, and divide the broad nave from the side aisles. Arches were added in the 13th century, running across the church from pillar to pillar. Like other churches of the time, S. Prassede was ornamented with a wealth of mosaics. The Heavenly City of Jerusalem appears above the triumphal arch, and the Apocalyptic Lamb, the Book with Seven Seals, the Seven Candlesticks, the Four Archangels, and the symbols of the Evangelists are shown on the apsidal arch. On both sides of this arch, the elders of the apocalypse are bringing golden wreaths to the Lamb of God, and the dome of the apse shows the sisters Pudentiana and Praxedis being led into heaven. The pictorial depictions had several aims: to glorify God and his saints, and at the same time to instruct the faithful in the Christian doctrine.

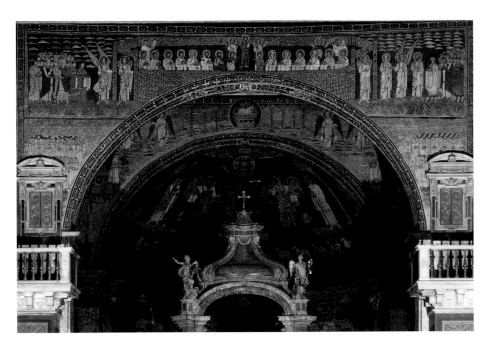

The Apsidal Mosaic

The 9th-century Carolingian mosaic depicts the legend of the two saints Pudentiana and Praxedis, who were said to have taken the apostle Peter into their house. In gratitude, Peter and Paul received them in heaven and presented them to Christ. The sisters have crowns of eternal life, which they are holding with awe in their veiled hands. To the left, the builder of the basilica, Pope Paschal I, appears with a model of the church, which he is about to give to Christ. On the other side stands St. Zeno, in whose honor Paschal had a chapel built next to the right-hand aisle. The reception of the two sisters into heaven takes place on a green strip of ground overgrown with flowers, with the Jordan flowing into it, and Jerusalem and Bethlehem standing one at each end. This subject is continued into the lower frieze, which shows the Lamb of God and twelve sheep, symbols of the Apostles.

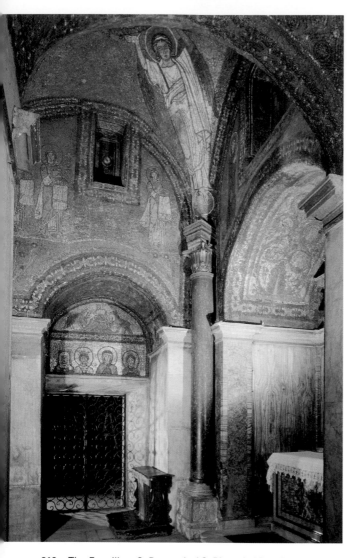

The Cappella di S. Zenone

Pope Paschal I had a chapel, dedicated in honor of St. Zeno, added to the right-hand aisle of the church, and this was designed to follow the ground plan of a Greek cross. It was also to contain the tomb of his mother, Theodora. This chapel is among the few completely vaulted medieval buildings to be found in Rome. The entrance consists of two porphyry columns with Carolingian capitals, supporting an ancient entablature. The vault and walls are covered with colored mosaics on a gold ground, depicting subjects relating to the relics of martyrs in the church. There is a head-and-shoulders image of Christ in a round aureole at the apex of the vault, and this is borne up by four angels who seem to be growing out of the columns supporting the vault. The Apostles John, Andrew, and James are shown in the right-hand round arch, and Christ appears in the niche between St. Paschal I and St. Valentinian.

S. Pietro in Vincoli

This church, on which building began in A.D. 431, was dedicated to St. Peter and St. Paul when it was consecrated by Pope Sixtus III (pontificate 432–440). However, when the empress Eudoxia gave his successor Leo the Great (pontificate 440–461) the chains said to have been worn by the apostle Peter in prison, he became the sole patron of the church, the name of which means "St. Peter in chains." Large parts of the 5th-century building have been preserved. It is a basilica with a broad nave and two narrow aisles, with the addition of a transept, a remarkable innovation at the time. In the interior,

the Doric columns, probably re-used from a building of the Roman imperial period, belong to the original building. Several extensions and conversions were carried out between the 8th and the 13th centuries: around 1475 Sixtus IV (pontificate 1471–1484) had the cloister built, and a single-story porch opening into pillared arcades. Other alterations were carried out by Giuliano della Rovere, the future Pope Julius II (pontificate 1503–1513). S. Pietro was his titular church as cardinal (1471–1503). It was restored in the first half of the 18th century, and the ceiling fresco in the nave dates from this time.

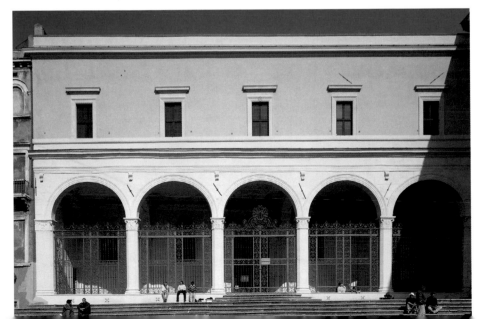

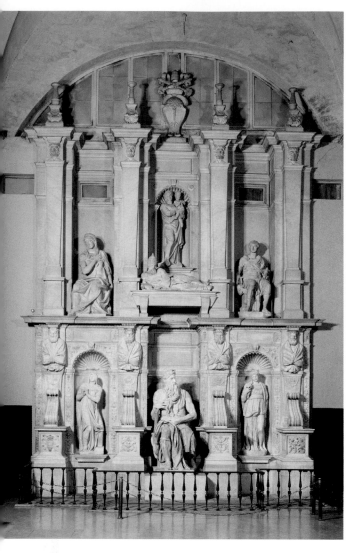

The church owes its fame primarily to the tomb by Michelangelo in the right-hand aisle. The history of this monument, commissioned from Michelangelo by Pope Julius II in 1505, covers forty years. The lack of steady interest shown by Julius himself, and commissions from his papal successors who recruited the artist into their service, slowed the project down. Originally, it was planned as a free-standing tomb on the model of the mausoleums of antiquity. Of hitherto unparalleled proportions, with almost forty statues, it was to have stood in the choir of the new St. Peter's. Finally, after six changes to the contract, it was designed in a much reduced form as a wall tomb, and installed in S. Pietro in Vincoli in 1545. The last contract, of 1541, stipulated that Michelangelo, who had already completed the figure of Moses in 1515, had

to deliver only two more statues, those of Leah and Rachel, while the other sculptures – the recumbent figure of the pope, the Virgin Mary, and the two flanking figures of the prophet and the sibyl – were to be done by assistants according to his designs.

Michelangelo Buonarroti, Moses (Detail From the Tomb of Pope Julius II)

The central figure, which gives some idea of the size of the tomb as it was originally planned, is the colossal seated statue of Moses, the biblical hero who led the children of Israel out of their captivity in Egypt. Originally conceived as a statue for one corner of the tomb, its proportions are distorted by its present position, which seem to cramp the massive figure. Moses is depicted as an old man, but his muscular arms still show the power that had been granted to him. With the Ten Commandments under his right arm, his fingers playing with the hair of his beard, he has turned his head to the left, eyes opened wide: his left hand is clutching at his body. His head is surmounted by horns; they were the result of a misunderstanding by a translator of the Bible, but became a symbol of the hero's divine enlightenment. By comparison with his swelling physical form, the ornamental construction of his beard and hair, and his draped garment, the two religious allegories represent the calmer, late style of the master, then nearly eighty years old, in which

all movement is turned inward. At the same time they show that the tomb in its final execution was confined to purely Christian subject matter. The Biblical female figures of Leah ("active love")

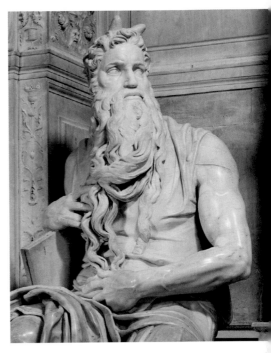

and Rachel ("faith"), one on each side of Moses, symbolize the active life (*vita activa*) and the contemplative life (*vita contemplativa*).

The Domus Aurea

The Emperor Nero built the Domus Transitoria (House of Transition) to link the imperial possessions on the Palatine with those on the Esquiline and make them into a single palace complex, but it was almost entirely burned down in the fire of A.D. 64. The sources dispute whether the fire was an accident, or the result of arson by the emperor himself. In any case, he had a new and huge complex of villas erected in its place by the architects Severus and Celer. Completed in A.D. 68, it seemed more like a town than a home, and went by the name of the Domus Aurea (Golden House). Nero had appropriated so many sites that the Romans said, jokingly, they had better move to Veii, since Rome had become a single house.

In his biography of Nero, the Roman historian Suetonius gives an account of the appearance of the complex: "A huge statue of himself, 120 feet high, stood in the entrance hall; and the pillared arcade ran for a whole mile. An enormous pool, more like a sea than a pool, was surrounded by buildings made to resemble cities, and by a landscape garden consisting of plowed fields, vineyards, pastures, and woodlands – where every variety of domestic and wild animal roamed about. Parts of the house were overlaid with gold and studded with precious stones and nacre. All the dining rooms had ceilings of fretted ivory, the panels of which could slide back and let a rain of flowers, or of perfume from hidden sprinklers, shower upon his guests. The main dining room was circular, and its roof revolved slowly, day and night, in time with the sky. Sea water, or sulphur water,

Domus Aurea, ground plan

was always on tap in the baths. When the palace had been completely decorated in this lavish style, Nero dedicated it, and condescended to remark: 'Good, now I can at last begin to live like a human being'."

Little remains today of this mighty complex, since Nero's successors returned the site to the Roman people, and it was soon built over. Vespasian, for instance, had the famous Colosseum built on the site of Nero's artificial lake, Hadrian erected the temple of Venus and Roma over the vestibule, and Trajan constructed his baths on the site of the main building. The area was closed for many years, but since 1999 some of the rooms have been open to the public again for viewing.

The Octagonal Domed Hall

At the end of the 15th century the halls of the residential wing of the palace, which had over time filled up with rubble, were rediscovered and were described simply as "grottoes." Several rooms came to light, including a nymphaeum and the octagonal domed hall, partly ornamented with fine murals consisting of arabesques and mythological figures which acted as models for the artists of the Renaissance (hence the stylistic term "grotesque"). The famous Laocoön group, now in the Musei Vaticani and only one example of what was once a wealth of sculptural decoration, was also found in the Domus Aurea.

Power and Excess – the Megalomania of the Roman Emperors

As we see it today, only a few of the Roman emperors were rulers who came up to the standard that Augustus had set. His own unpopular successor Emperor Tiberius (reigned A.D. 14–37) certainly did not: after years of sexual dissipation he fell into a coma at his villa in Capri, and although he did come round again, he was strangled in his bed by his own successor's servant.

Of the megalomaniacs, egotists, paranoiacs, and psychopaths who followed him on the Roman throne, the Emperor Nero is the best known, because of the rumor that he himself set the city of Rome on fire in A.D. 64. However, although the Roman people credited him with arson at the time, modern historians doubt that he was in fact responsible. On the other hand, they agree in their verdict on Gaius Caesar

Nero (Lucius Domitius Ahenobarbus), reigned 54 – 68, marble bust, h 31 cm, Museo Nazionale Romano, Rome

Agrippina the Younger, wife of the emperor Claudius and mother of Nero, 54 – 68, marble bust, Museo Nazionale Archeologico, Naples

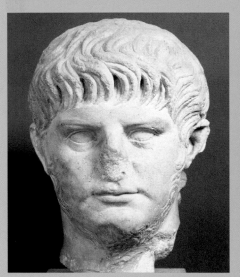

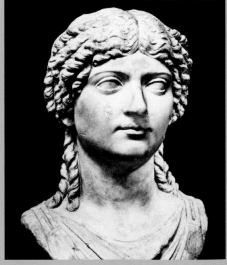

Augustus Germanicus (reigned A.D. 37–41), known to everyone only by his childish nickname of Caligula ("Little Boot"). He was given this nickname because he spent his youth with the troops of his father, the military commander Germanicus, and so grew up wearing the *caligae*, the boot-like sandals of the Roman legionaries. Germanicus' brother Tiberius saw to it that the boy's parents and brothers were either assassinated or starved to death. Tiberius did not see his nephew Caligula as a potential adversary: he is said to have remarked that there could be "no better a slave and no worse a master than Caligula."

Lack of attention to the boy led him into scandal even in his youth: Caligula was caught in the act of incest with his favorite sister Drusilla when he was fifteen. He inherited responsibility without any preparation for his task, and in spite of the first decrees he passed, indicating an attitude of goodwill to the people and promising a good reign, within only three years and ten months he had become the most cruel despot ever to sit on the throne of Rome. In fact Caligula contracted a severe disorder in October of A.D. 37, which from its symptoms, suggestive of schizophrenia, has been diagnosed by modern doctors as meningitis. Even more serious was a hereditary affliction of the Julio-Claudian imperial house: Caligula suffered badly from epilepsy. His reign was marked by violence, cruelty, autocracy, and his evil temper. The concept of the divine emperor formed a sinister union with his own narcissism: although his portraits show him with a full head of hair, Caligula's hair was in fact sparse, and when he walked the streets of Rome no one was allowed

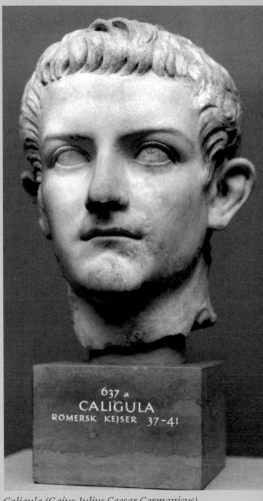

Caligula (Gaius Julius Caesar Germanicus), reigned 37–41, marble bust, h 28 cm, Ny Carlsberg Glyptotek, Copenhagen

317

to look down on his bald patch. Uttering the word "hair" in the emperor's presence could mean the death penalty. He had galleys lashed together for a length of three Roman sea miles in the waters off the most fashionable seaside resort of antiquity, Baiae in the Bay of Naples, so that he could pass over the water like Neptune with his one great love, his horse Incitatus. When he even tried to make the horse a senator, Cassius Chaerea, tribune of the Praetorian Guard, put an end to these imperial whims. Caligula's fourth wife also fell victim to the generally applauded murder of her tyrannical husband, and his little daughter's brains were dashed out against a wall.

Biographies of the matricide Nero (reigned 54–68) fill library shelves all over the world. Born Lucius Domitius Ahenobarbus on December 15, A.D. 37, he has gone down in history as a megalomaniac, and the worst actor and lyre player of all time. His great-grandfather had been the right-hand man of Caesar's great adversary Mark Antony; his grandmother Antonia was the daughter of Mark Antony and Cleopatra. Educated by the best tutors of his day, Burrus and the philosopher Seneca, Nero consolidated the finances of the Roman state in the early years of his reign better than any ruler after him except Domitian, and intended to put Rome on the path to prosperity. However, his power-hungry mother Agrippina the Younger was a fateful influence on him. Seneca could teach his pupil everything but the philosophy of

Caracalla (Lucius Septimius Bassianus), reigned 211–217, marble bust, h 52 cm, Musée du Louvre, Paris

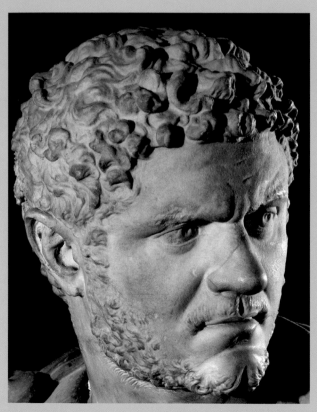

moderation, something that a prospective *imperator* hardly seemed to need. It was his cunning mother who had him renamed Tiberius Claudius Nero Caesar when he was twelve, and contrived to place him on the throne at the age of 18: Agrippina induced her new husband, the Emperor Claudius, to adopt him. When Britannicus, Claudius' own son, suddenly died in mysterious circumstances, the way was open to Nero.

He was undoubtedly clever, and struggled all his life to achieve success in his emotional life: a dangerous endeavor that brought him up against many people, including his manipulative mother. His one great love, the freedwoman Acte, was not his equal in rank, but was protected by his power from the intrigues and even the sexual enticements of his forty-five year old mother. Poppaea Sabina, a woman who has gone down in history as a kind of "Black

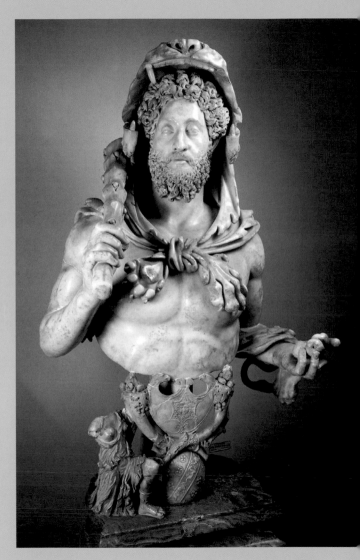

Commodus (Marcus Aurelius Commodus Antoninus) as Hercules, reigned 180–192, marble bust, h 133 cm, Musei Capitolini, Rome

Widow," then made successful advances to the emperor. Husband after husband had become entangled in the wiles of this intelligent and dominant lady, who was generous with her favors. Many biographers believe that the death of her daughter Augusta by Nero in A.D. 62, when the child was only four months old, destroyed the emperor's last hold on reality. The unfortunate life of Nero, a total narcissist and the first persecutor of Christians in Rome, ended on June 9, A.D. 68 with his dying words: "What an artist dies in me!" Fleeing from a revolt, he fell on his own sword.

From a modern viewpoint, the character of the Emperor Domitian (reigned A.D. 81–96) appears ambivalent. His contemporaries unrelentingly consigned this great patron of building – who among other works had the stadium on the site of the present Piazza Navona constructed, to the fate of *damnatio memoriae* – obliteration from public memory. The strictly conservative Domitian, who intended his reign to be free of depravity, banned homosexual practices, and wished to return Roman society to its roots, owed this condemnation, the worst imaginable for an emperor, to the Roman Senate: Domitian, a loner who aimed to be the best and most virtuous of all Roman emperors, had twelve leading senators executed. Tales have come down to us of his unbridled virility and his weakness for dwarfs and for women, whom he allowed to appear as gladiators in the Colosseum for the first time, although he went too far with what might appear an act of emancipation when he made them fight each other.

Domitian had the walls of his rooms faced with white marble, hoping that the reflections it cast would protect him from assassins lurking behind his back. His hair was scanty, although his statues all show him with luxuriant locks. All his life, he had the nervous habit of killing flies with the point of a quill wherever he happened to be. It was Domitian's lack of the social communication skills and his unapproachability that brought him to his end. Those few advisers whom he did allow near him, his *amici*, killed him in a palace coup. One of them, Nerva, became emperor, and with him the age of the adoptive emperors began.

Even after the wise reigns of Hadrian and Marcus Aurelius, Rome had to endure autocratic and immoral rulers: the best known of them were two emperors who bore the same imperial name, Marcus Aurelius Antoninus.

The first was born Lucius Septimius Bassianus (reigned 211–217), son of the emperor Septimius Severus, and is known today by his nickname of Caracalla. He acquired it in his early years as co-ruler because of his liking for a new fashion of the time, a wide cape with no fastenings, under which all kinds of things could be hidden. Caracalla has gone down in history as the murderer of his own brother and co-ruler Geta, eleven months his junior. The murder, at the end of December 211, was followed by a fourteen-day massacre in Rome in which over 20,000 suspected supporters of Geta perished. Nonetheless, modern scholars do not see the career of Caracalla solely in terms of this violent deed, but regard him principally as the emperor who gave Roman citizenship to the entire population of the empire when he approved the *constitutio antoniniana*. In fact other reforms and cultural projects

were also introduced by this potentate, who is best remembered for initiating the building of the largest baths in Rome. His great enthusiasm, besides his admiration of Alexander the Great, was for a variety of different gods. He visited both the temples of the Celtic god Grannus and the shrine of Asklepios in Pergamon, where he slept in the temple and performed other meditative rituals. For dynastic reasons, his successor also received the name of Marcus Aurelius Antoninus, but he is better known as Elagabalus (reigned 218–222). A transvestite and high priest of the cult of Baal, this youth thought he could bring eternal peace to the empire through forcibly marrying the Chief Vestal Virgin of Rome. This outrageous project, which shook Rome to the very foundations of its religion and morality, was brought to a rapid end by the assassination of Elagabalus.

Simeon Solomon, Elagabalus, High Priest of the Sun, 1866, watercolor, 46.4 × 29.2 cm, The Forbes Magazine Collection, New York

The Caelian Hill (Celio)

The Caelian Hill, now known as Monte Celio, rises like a long foothill from the plain to the south of the Colosseum. Writers in antiquity believed the name derived from the Etruscan general Caelius Vibenna, who brought his army to the aid of Servius Tullius, sixth king of Rome; as a reward he was given the hill for his residence. The Caelian Hill became an elegant residential district in the late republic and under the emperors, but after the fire in A.D. 64, which destroyed large sections of the area, Nero incorporated part of the district into his vast Domus Aurea, while tenement housing (*insulae*) was built on the slopes towards the Esquiline Hill and the Colosseum. But it was the huge temple dedicated to the divine Emperor Claudius that dominated the quarter and that was visible from afar. Military barracks were also a feature of the hill. The fifth cohort of the *vigiles* (the fire guard) was stationed near the church of S. Maria in Domenica, where the two barracks for the *equites singulares* (the imperial cavalry guard) were also located, while the *castra peregrina* was at S. Stefano Rotondo; this housed the soldiers of the provincial armies when they had special duties to perform in Rome. At the end of antiquity the appearance of Monte Celio changed completely. The Lateran became the new focus, and for nearly a thousand years, from the time of Constantine to the early 14th century, it was the papal residence. As well as the

church of S. Giovanni in Laterano and the first Lateran palace, so many buildings were erected here in the course of the centuries that the Lateran grew into what was virtually a small town. By 1377, when the popes finally returned from their exile in Avignon, the district, including the palace and the church, had been badly damaged by fire (in 1308 and then 1361) and the palace was no longer suitable as a residence; the Vatican thus became the papal residence and the Caelian Hill continued its inexorable decline. The Lateran basilica and S. Croce in Gerusalemme were still major pilgrimage churches, but the district remained run-down until new housing was built in the late 19th century.

The garden of the Villa Celimontana

Piazza di S. Giovanni in Laterano

The Caelian Hill

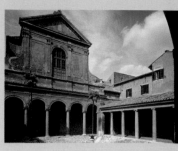

S. Clemente, Via di S. Giovanni in Laterano, p. 326

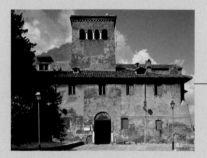

SS. Quattro Coronati, Via dei SS. Quattro Coronati 20, p. 336

S. Stefano Rotondo, Via di S. Stefano 7, p. 338

Other works:

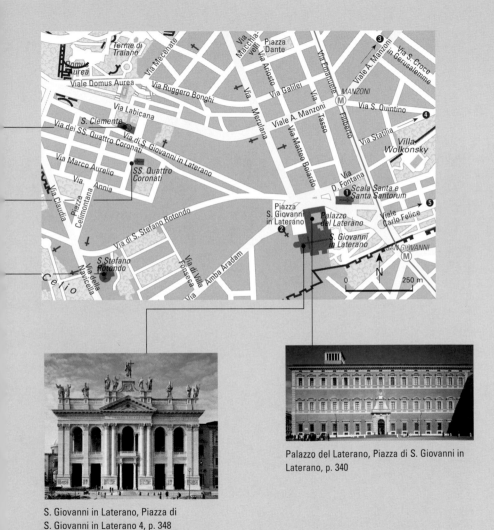

Terme di
Traiano

Domus
Aurea

Viale Domus Aurea

Via Ruggero Bonghi

Via Labicana

S. Clemente

Via dei SS. Quattro Coronati

Via di S. Giovanni in Laterano

Via Marco Aurelio

SS. Quattro
Coronati

Via Annia

Via Claudia

Piazza
Celimontana

Via di S. Stefano Rotondo

S. Stefano
Rotondo

Celio

Via della
Navicella

Via di Villa Fonseca

Via di Villa

Amba Aradam

Via Mecenate

Via Macchia-
velli

Piazza
Dante

Via Ariosto

Via Galilei

Via Merulana

Viale A. Manzoni

Via Emanuele Filiberto

Viale A. Manzoni

Via Tasso

Via Matteo Boiardo

Piazza
S. Giovanni
in Laterano

MANZONI

Via S. Manzoni

Via S. Croce
in Gerusalemme

Via S. Quintino

Via Statilia

Villa
Wolkonsky

Via
D. Fontana

Scala Santa e
Santa Santorum

Palazzo
del Laterano

S. Giovanni
in Laterano

Viale
Carlo Felice

SAN GIOVANNI

N

0 250 m

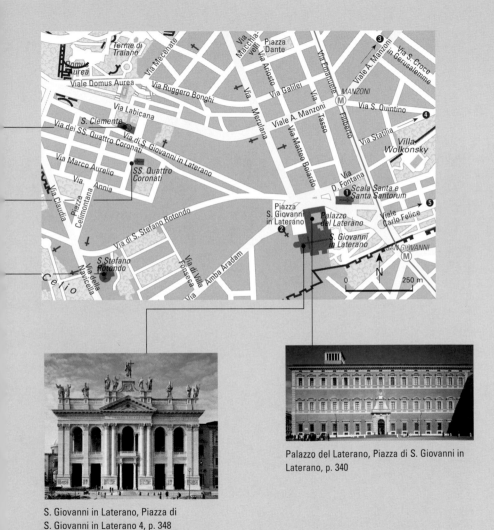

Palazzo del Laterano, Piazza di S. Giovanni in
Laterano, p. 340

S. Giovanni in Laterano, Piazza di
S. Giovanni in Laterano 4, p. 348

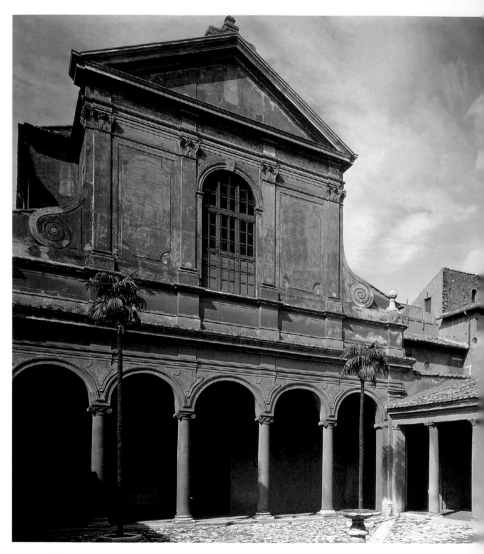

S. Clemente

S. Clemente is one of the eighteen titular churches in Rome that are known to have existed as early as the 3rd century A.D. Under Pope Siricius (pontificate 384–399) a basilica was erected over a Roman dwelling; dedicated to St. Clement (presumed pontificate 88–97), the third Roman bishop after St. Peter, it was destroyed during the Norman invasion in 1084. The remains can now be seen in the lower church, which was uncovered in the mid-19th century. A few years after the church was destroyed a new building was started under Pope Paschal II (pontificate 1099–1118) on ground raised to a higher level; known as the Upper Church, it has a mosaic in the apse and costly marble inlays on the floor by Cosmati artists. The choir screen, which dates from the 6th century, was rescued from the earlier building, and antique ruins were pillaged for the church's columns. The two-aisled basilica has a forecourt with a fountain; it is surrounded on three sides by a portico with antique Ionic columns. The upper section and ceiling of the interior of the church were designed in the late Baroque style by Carlo Fontana in 1713–1719 under Pope Clement XI. Fontana also built the façade on the Via di S. Giovanni in Laterano; the bell tower, which is also Baroque, rises above a left voluted gable.

S. Clemente is of special importance among the churches of Rome, for it is a unique example of a building that illustrates the sequence of epochs: visitors can see example of Roman architecture on three levels, from classical antiquity (the dwelling and Mithraeum), through the early Christian era (the Lower Church), to the late Middle Ages (the Upper Church).

The Mithraeum

A staircase leads from the left aisle of the Lower Church into the Roman dwelling, which is the oldest part of the site. In the late 2nd or early 3rd century A.D., a shrine to Mithras was erected here. The Mithras cult came originally from Central Asia and in the 3rd century it was one of the most important cults in Rome. In the center of a long, barrel-vaulted room with benches down the sides stands an altar, with a relief showing the sun god slaying the primeval bull – a sacrifice that was repeated by the god's followers as a ritual act. Mithras is thrusting his dagger into the bull, under which a dog and a snake are licking up the blood as it flows out, while a scorpion is biting the animal's genitals. The god has turned his head to look at the raven that has brought him the order from the sun god Helius-Sol to sacrifice the bull. His head appears in the left upper corner, while on the right we see the moon goddess Selene-Luna. Two protective divinities, Cautes and Cautopathes, are shown on the sides; one is holding up a torch and the other is lowering one, these are symbols of the sun rising in the morning and setting in the evening.

Lower Church, The Body of St. Clement Being Taken to the Church of St. Clement, 11th Century
Fresco

To provide a foundation for the Upper Church, the rows of columns in the Lower Church were supported with masonry and up to two-thirds of the space was filled in. Although additional walls had to be inserted during the excavations in 1862, the old structure can still be recognized. The basilica has a great round apse and a narthex with four columns connecting the central nave

and the atrium. The church is a treasure trove of Romanesque wall painting which, with its vivid narrative style and naturalistic depictions, constitutes a turning point in Roman painting. Two frescoes in the vestibule date from the 11th century; one is *The Body of St. Clement Being Taken from the Vatican to the Church of St. Clement* and the other *The Miracle by the Tomb of St. Clement*. According to legend, Pope Clement was thrown into the Black Sea with an anchor tied to his feet; believers flocked to the spot every year. A tondo represents the saint with the patrons who donated the frescoes, Beno da Rapiza and Maria Macellaria, together with their children. Other paintings are to be found in the nave, depicting among other things the Ascension (painted in the 9th century A.D.) and scenes from the legend of St. Alexius. Another cycle from the 11th century shows the legend of the persecution of St. Clement by the heathen prefect Sisinnius. The men pursuing the pope were blinded by God and seized a column instead of the saint. When attempting to take it away with them, they

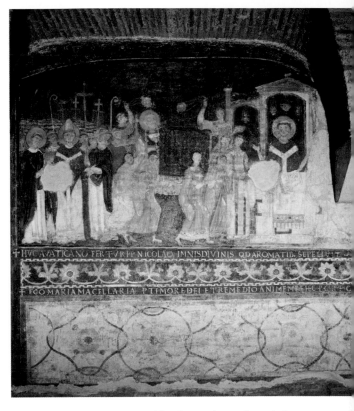

were stopped by the prefect, who cried out: *Fili dele pute, traite* ("Sons of whores, get you gone!"). The inscription is one of the earliest surviving examples of the Italian language (*volgare*).

Sacrificial Bull and Starry Skies – the Cult of Mithras

by Jürgen Sorges

The highly influential Mithras cult emerged at almost the same time as Christianity and was one of the most successful mystery religions of antiquity. It began with worship of the ancient Iranian god Mithra. Centuries later an arcane cult, that changed in character in the course of time, developed and became very influential, particularly on Rome's army officers and legionaries. Customs officers, tax officials, and merchants also joined and worshipped Mithras, and this helps to explain the enormous geographical spread of the cult throughout the Roman empire. In addition to its presence in Rome, it flourished particularly along the Roman frontiers – at Hadrian's Wall in northern Britain and in cities of North Africa, along the far-flung border posts in Germany and down to the Danube delta, along the Atlantic coast of Portugal and into the Levant, leaving hundreds of specially erected sites (known as Mithraea) that are like subterranean caves. There is architectural and archaeological evidence that after the decline of the Mithras cult from the 4th century A.D. many Christian churches were built over their sites, and in the last 150 years scholars have uncovered numerous finds that provide new insight into the cult. Despite this evidence, the Mithras "puzzle" – what exactly the followers believed – is hard to unravel and it has not finally been solved even now.

It is known that the Mithraism communities were organized into numerous small groups like secret societies; they were in fact like men's clubs. To some extent they were egalitarian, and surprisingly not only soldiers but also slaves were allowed to be members. Women, however, were excluded.

But little knowledge has survived of their beliefs, or of the rites they practiced and their religious ideas of life on earth and beyond. Like all the mystery cults of classical antiquity, Mithraism left very few written traces.

Most of the scant sources we have are writings by critics and opponents of the cult. Religious scholars, including many early Christians, viewed the cult mainly as "competition," for the Mithras cult was extremely successful. Some modern scholars, like the 19th-century French historian Ernest Renan, actually held the opinion that "had Christianity fallen victim to a deadly disease soon after its birth, the world would now worship Mithras."

In the 2nd and 3rd centuries A.D. Rome was the main locus of the controversies that raged between the followers of the two religions. At that time, the Mithras cult was at least equal in strength to Christianity, and both sects competed with Rome's many traditional divinities. To obtain influence with and protection from the Roman emperors, both sects resorted to denunciation, accusing each other of blasphemy and of imitating sacred ceremonies. The recriminations went on for decades until finally, in ignorance of their real

rites, its opponents accused the Mithras cultists of ritual child murder. The spiritual conflict threatened to turn into armed conflict, and it was only when Emperor Constantine (who was the sole ruler in the Western Roman Empire from A.D. 312) declared Christianity to be the state religion, so inaugurating the transformation of Rome, that the rivalry was decided in favor of Christianity.

Nevertheless, the ideology of the Mithras cult never entirely disappeared. Quite a number of scholars today assume that some of the elements of the antique Mediterranean cultural heritage, including the Mithras cult, flowed into the "melting pot of Christianity."

Rome is particularly rich in examples of this. One that is known for certain is the subterranean part of the basilica of S. Clemente on the Via S. Giovanni in Laterano. Here a Mithraeum has been completely uncovered and is now open to the public after fifteen years of restoration work. The descent from the imposing Christian Upper Church is like a spectacular journey through time. The visitors "land" in the middle of the ruins of houses that were reduced to rubble by the legendary

Mithras Killing the Bull, Roman relief, marble with paint and gilding, Palazzo Massimo alle Terme, Museo Nazionale Romano, Rome

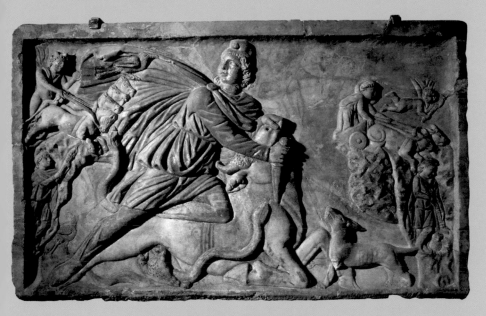

fire in the city in Nero's time (A.D. 64). Mithraea have also been found under S. Stefano Rotondo and particularly under S. Prisca on the Aventine Hill. Other important Mithras shrines in Rome were located under the Circus Maximus, under the Palazzo Barberini, and in the Baths of Caracalla. The most important, most informative, and best preserved Mithras cult sites, however, are in the ancient coastal town of Ostia Antica (which contains the Mithraeum of the Seven Gates, the Mithraeum of the Seven Spheres, and so on). Frescoes, mosaics and sculptural remains found there have provided important information on the cult.

In these sites, which the early Christian church writer Origen called "images of heaven," scholars believe they have found the key to decipher the cult. In the center of all the cave temples stood the *tauroctonia*, on a structure resembling an altar. It was the central religious motif of the cult. Here the god Mithras kills a bull with a knife by cutting its throat. The sacred act of killing the bull also involves a number of other animals and objects that puzzled scholars for decades. A dog, a snake, a raven, a scorpion, lions, and a chalice were apparently present at the bloody event but took no part in it and appeared to have no obvious connection with it. But individual sites have revealed more secrets. Wall paintings were found in the Mithraeum in S. Prisca showing a procession in honor of Mithras and finally actually depicting the initiation ceremony to the cult. The initiation consisted of seven degrees or levels: *corax* (the raven), *nymphus* (the nymph), *miles* (the soldier), *leo* (the lion), *parses* (the Persian), *heliodromus* (the courier of the sun), and *pater* (the father). The symbols and even schematic depictions of these initiation stages are also to be found on mosaics in the site at Ostia. Finally, the early Christian writers Origen and Jerome provided crucial information in their writings; we

Banquet for Mithras and the Sun, 2nd–3rd century A.D., relief from Fiano Romano, Musée du Louvre, Paris

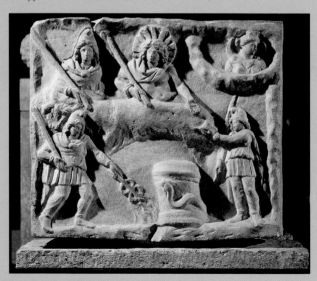

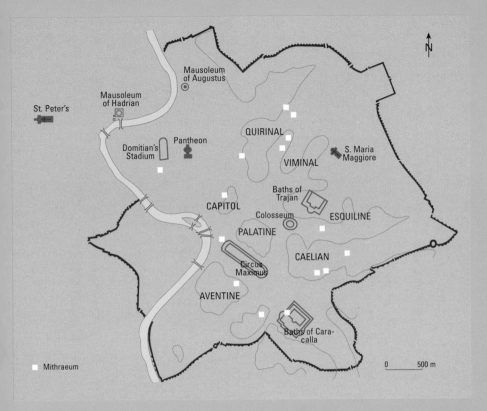

The distribution of Mithras cult sites and monuments in Rome (from F. Coarelli)

know, for example, that the stone vault of a Mithras site was frequently decorated with a colored firmament. Numerous depictions of the signs of the Zodiac have survived and in some cases, like those in Ostia's Mithraeum of the Seven Gates, the documentation has also survived.

The German scholar, K.B. Stark, was the first to interpret the Mithras religion as an astral cult worshipping the stars in the firmament in 1869. Research, particularly that carried out during the last three decades of the 20th century, finally succeeded in confirming this cosmological interpretation.

The Upper Church, Schola Cantorum

The choir screens in front of the 12th century apse were constructed using boards from the Pope John II choir in the Lower Church. Colored inlay work was added in basketwork patterns or wreathed circles on blank fields. This ensured the almost complete preservation of the only example of a 6th-century choir. Together with the large Easter candlestick, the ambos, and the fine mosaic floor they are among the masterpieces of Cosmati art.

The Chapel of St. Catherine in the Upper Church, The Legend of St. Catherine, by Masolino da Panicale (1383–1440)
Fresco, 420 × 310 cm, before 1431

The small rectangular chapel at the front of the left aisle was donated by Branda da Castiglione, who was titular cardinal of S. Clemente from 1425 to 1431. The frescoes, by the Florentine artist Masolino da Panicale, in cooperation with Masaccio, are among the most outstanding works of the early Renaissance. The chapel of St. Catherine is the earliest important chapel decoration in Rome after the return of the popes and it marks the introduction of Florentine Renaissance painting in Rome. This is evident, among other things, in the use of central perspective and in the complex narrative structures. On the side walls scenes on two levels illustrate the legend of St. Catherine of Alexandria and St. Ambrosius, while the altar wall bears a monumental crucifixion. The *sinopie* (preliminary drawings) found during the most recent restoration are on the wall of the aisle outside the chapel.

SS. Quattro Coronati

Dedicated to four martyrs, this church dates back to the 4th century. The martyrs are known as "the holy four crowned men" because they were martyred by being crowned with a wreath of sharp iron spikes that were forced into their skulls. A large building erected under Pope Leo IV (pontificate 847–855) was destroyed during the Norman invasion in 1084. Then around 1111 Pope Paschal II had a two-aisled, galleried basilica built on the site, incorporating parts of the nave and the apse of the older building. The new structure had alternating supports, and part of the old nave was made the forecourt of the new church. In the 13th century the monastery was extended to make a strong fortification for the protection of the neighboring Lateran. The fortress-like façade with the bell tower built into the gateway is a reminder of this function.

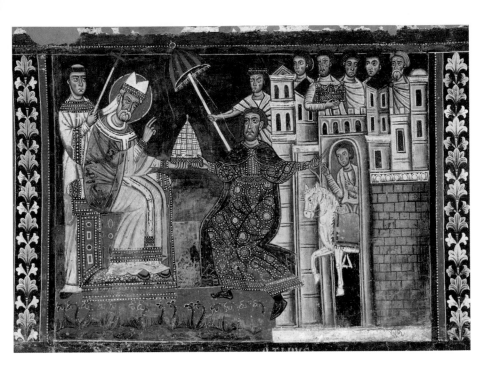

**The Oratory of S. Silvestro, Roman School,
St. Sylvester Receiving the Papal Insignia,
Tiara, and Parasol from Constantine; 1248**
Fresco

The oratory of S. Silvestro, built in 1246, contains a cycle of frescoes in honor of St. Sylvester that are of great political significance, depicting the conversion of Emperor Constantine by Pope Sylvester. Constantine is shown as a sick man, to whom St. Peter and St. Paul appear in a dream, advising him to find the pope, who is living as a hermit on Monte Soratte. The pope tells the emperor to honor the portraits of the two Apostles and heals him through baptism. Thereupon Constantine allows the pontiff to rule over Rome. He leads his horse to the Lateran on foot, and, kneeling gives the pontiff a tiara as a sign that the papacy has precedence over all secular power. This painting can be seen as a warning to the Hohenstaufen Emperor Frederick II (reigned 1215–1250), who was attempting to contest the recent reassertion of this claim by Pope Innocent IV.

S. Stefano Rotondo

This church, which is dedicated to St. Stephen, is located on the site of a Roman barracks. It has had an eventful history. It was built by the Emperor Valentinian III (reigned 425–455) or Pope Sixtus III (pontificate 432–440) and was dedicated under Pope Simplicius (468–483). The rotunda consists of three concentric circles (measuring 64 m or 210 feet in diameter) within which is inscribed a Greek cross with chapels in its arms, so integrating two basic types of church architecture into a unique synthesis. The building was probably intended to resemble the rotunda in the Church of the Holy Sepulchre in Jerusalem, for the dimensions are to a large extent the same. Possibly the intention was to transplant the most sacred Christian shrine symbolically on to Roman soil.

The Interior

In the 8th century Pope Hadrian I (pontificate 772–795) had the central space secured with an arch that spanned the entire room. After the destruction during the Norman invasion in 1084, the outer ring was removed during the time of Pope Innocent II (pontificate 1130–1143); the spaces between the next ring of columns were walled up and a portico built before the eastern transept. As a result of this reduction the marble panels and the mosaics dating from the 6th century were lost. However, the twenty-two Ionic columns that bear the upper section of the central structure on horizontal architraves are still impressive today. A further restoration program was carried out under Nicholas V (pontificate 1447–1455) around 1453, during which parts of the fine double portal were constructed.

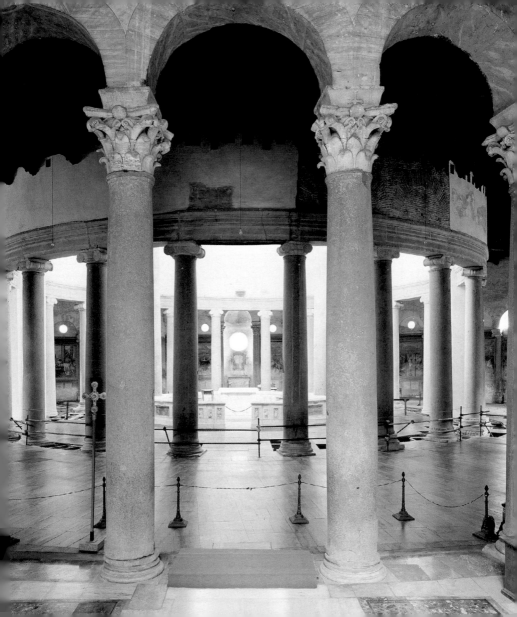

Palazzo del Laterano

The Lateran is one of the richest historical sites in Rome. The popes resided here for centuries until the papal residence was moved to the Vatican after their return from exile in Avignon in 1377, after which the Lateran quickly lost its importance. Today the Lateran Palace, which, like the church, is outside the Vatican territory but is in the ownership of the Vatican State, houses the administration of the Roman bishopric. Originally the property belonged to the Laterani family; later it passed to the emperor. After his victory at the Ponte Milvio in A.D. 312, which he believed he owed to the Christian God, Constantine gave the site to Pope Miltiades (pontificate 311–314) to build a church and Patriarchium; this was the predecessor of the Lateran Palace and remained the official residence of the popes until 1377. However, the Patriarchium gradually fell into decay, as a consequence of the fires in 1308 and 1361 and the long papal exile, and after the decision to move the papal residence to the Vatican it was never fully restored. It was rebuilt in the 16th century under Pope Sixtus V (pontificate 1585–1590) as part of his extensive program of restoration in Rome. He commissioned the architect Domenico Fontana, who had the old Patriarchium demolished and built a U-shaped palace around a large inner court beside the long northern wall of the basilica. Long rows of windows subdivide the palace frontage.

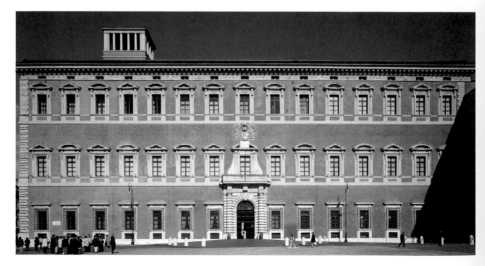

On the Piazza di S. Giovanni in Laterano, Fontana set an obelisk 47 m (154 feet) high to replace the equestrian statue of Marcus Aurelius that had been moved to the Capitol. The obelisk had originally been set before the temple of Ammon in Thebes in the 15th century B.C. by Pharaoh Thutmoses III. In A.D. 357 it was brought to Rome by Constantine's son, Constantius, and set upon the *spina* (the wall separating racing tracks) in the Circus Maximus.

The Scala Santa

The Scala Santa, or Holy Stairway, which Sixtus V had moved here from the old papal palace, leads to the former private chapel of the popes, S. Lorenzo in Palatio. It owes its additional name *Sancta Sanctorum* to the

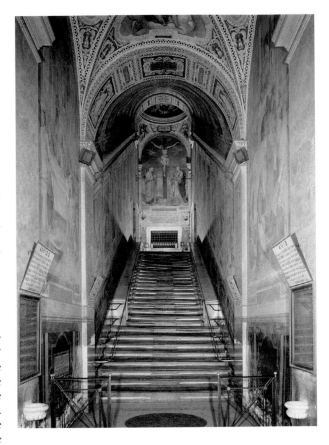

precious trove of relics once kept there, including a portrait of Christ that, according to legend, was an *acheiropoeton*, a work not made by human hand. The stairway consists of twenty-eight white marble steps and (again according to legend) is said to have come from Pilate's Palace in Jerusalem and to have been climbed by Christ before His death; St. Helena, the mother of Constantine, is reported to have brought them to Rome. No one was allowed to set foot on the steps, which were covered with wood, and even now pilgrims mount the steps on their knees in memory of the sufferings of Jesus.

Holy Year 1500

by Jürgen Sorges

"I open and none shall close; I close and none shall open!" With these words Pope Alexander VI (pontificate 1492–1503) concluded the past year and opened the new century on Christmas Eve in 1499 by symbolically passing through the Porta Santa (Sacred Doorway) in St. Peter's.

Traditionally, the new year began for the Catholic Church not on January 1, but on Christmas Day, the feast to mark the Savior's birth. And while the Pope energetically struck the masonry with his ceremonial silver hammer, workmen were busy on the other side of the Porta Santa, removing plaster and stones inside St. Peter's, in what was then the largest building site in Europe, to enable Christ's representative on earth to make his difficult symbolic entry. The year 1500 was the eighth regular celebratory year since Pope Boniface VIII had inaugurated the first Holy Year in 1300. However, the model for this event, which had aroused a response beyond anything that had been hoped for, was a Jewish religious custom celebrated every fifty years.

Rodrigo Borgia, as Pope Alexander VI was originally called, appeared to have made

Bernardino di Pinturicchio, Portrait of the Pope Alexander VI, detail of the fresco The Resurrection, 1492–1495, Borgia Apartments, Vatican, Rome

the best possible arrangements for the great event. With one stroke of the pen he had divided the New World discovered by Christopher Columbus into Spanish and Portuguese spheres of influence; he had also issued a papal bull stating that the question of the Immaculate Conception, which had long been the subject of heated debate in Christian dogma, particularly between the Franciscans and the Dominican monks, was finally settled – anyone who still believed Mary was stained with Original Sin was now committing heresy. The French king Charles VIII had also been mollified. Only a few years before he had stood with his army *ante portas*, before the gates of Rome. Only the outbreak of plague and the surrender of a high-ranking hostage had induced him to withdraw. Of all possible choices, Cesare Borgia, the hot-headed son of the pope (who officially was meant to be celibate), had to be delivered up to the enemy. But the king had withdrawn for the Holy Year and was busy on his own affairs, notably his divorce from his deformed queen. Pope Alexander VI had not hesitated for a moment: in return for a considerable sum he declared the indissoluble sacrament of marriage null and void. Cesare Borgia had acquired the resplendent title of Duke of Valentinois as part of the bargain; and in an instant he had discarded the cardinal's robe he had received at the age of eighteen.

A young artist who was then still unknown, a certain Michelangelo Buonarrotti from Florence, had also profited indirectly from these diplomatic agreements. In the chapel of St. Petronilla in St. Peter's a very special sculpture was displayed in this celebratory year of 1500. It had been

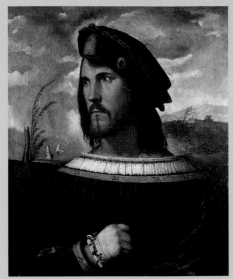

Altobello Meloni, Portrait of an Italian Condottiere (presumed to be Cesare Borgia), ca. 1520, painting on wood, 56 × 47 cm, Galleria dell'Accademia Garrara, Bergamo

commissioned by the ambassador of Charles VIII to the Holy See: Michelangelo's first Pietà. Many visitors to St. Peter's thought this grieving Madonna holding Jesus' body on her lap after the deposition from the Cross had been placed too high; others thought the suffering Mother of God was too young. But all were agreed on the inimitable sheen of the marble, the superb hand-ling of the drapery, and the sensitive and poig-nant expressions of the two figures. It was an acknowledged masterpiece, more successful than the works of antiquity, proof of the superior creativity of the modern age, a victory of the new

over the seemingly overwhelming heritage of antiquity. The artist was not modest; his name was proclaimed right down the ribbon over the Virgin's breast: "Michael Angelus Buonarotus of Florence made this!"

Many answered the Pope's call to Rome, and at Easter in the year 1500 more than 200,000 believers from all over the Christian world knelt in St. Peter's Square. Some pilgrims had even come from Iceland, although in official Church doctrine the Antichrist dwelt on the south coast of that island, and the entrance to hell itself was reputedly near the Hekla volcano. All these pilgrims "saw the brilliance and heard of the crimes of the Borgias," as Ferdinand Gregorovius said in his emotional report on the year 1500. The pilgrims

Lafréry, The Seven Churches of Rome, ca. 1575, engraving,
Kunstbibliothek, Staatliche Museen zu Berlin Preussischer Kulturbesitz

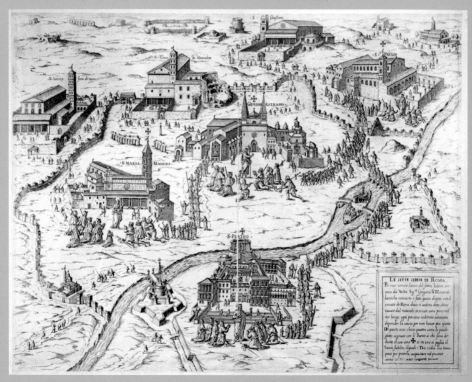

saw the courtesans coming from the Vatican palaces, notably the famous Vanozza and Giulia Farnese, whose intrigues and love affairs would soon bring the Farnese family noble titles and even papal rank. And they saw Lucrezia Borgia, the beautiful daughter of the pope, conceived in an incestuous relationship, when she rode in festive robes accompanied by one hundred ladies-in-waiting through Rome. But Cesare Borgia, son of the pope, outshone them all. Under a black mask, the murderer of his own brother, Gandia, entered Rome on February 26, 1500 dressed entirely in black velvet and accompanied by a retinue of one hundred men, also dressed all in black. Cesare had a very good reason to hide his face. In 1495 a new disease had appeared for the first time among the French troops besieging Naples and had since been spreading through Europe; it was known as the "French disease"; Cesare's face was hideous with second degree syphilis.

For the pilgrims in Rome the year developed into a nightmarish conflict between devotion and bacchanalia. They had all donated to the pope at least that weekly wage that the Church claimed was the minimum cost of absolution from lesser sins. Moreover, letters of indulgence were circulating throughout Europe proclaiming that they would smooth the way to paradise for those who had remained at home as well. Rome itself was well prepared for the masses; the route the pilgrims had to take to be given full indulgence for their sins was efficiently organized. The Holy Year of 1300 had brought an innovation to the European transport system that the poet Dante Alighieri had praised in the *Divine Comedy*: it was the *senso unico*, the one-

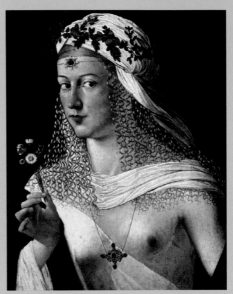

Bartolomeo da Venezia, Portrait of Lucrezia Borgia, painting on wood, 43.5 × 34.3 cm, Städelsches Kunstinstitut, Frankfurt am Main

way street, and it was invented to control the stream of pilgrims who were flooding eagerly into the city and so prevent the streets from being blocked. For it was not only the graves of the Apostles in St. Peter's and S. Paolo fuori le Mura that had to be visited: S. Maria Maggiore on the Esquiline had been an essential part of the pilgrimage since the papal bull of 1439, and then there were the martyrs' catacombs of S. Sebastiano on the Via Appia. A new axial street had also been constructed through the city for the magnificent processions organized by the pope and the hosts of pilgrims. Critics

objected that the grave of Romulus had been destroyed to make way for it, but it was the only way the pilgrims could perform their duties, with all the prescribed prayers and confessions, within the stipulated time set of forty-eight hours. Those who wanted to be quite certain of absolution were required to repeat the pilgrimage a total of fifteen times, as was the case in the year 1300; and residents of Rome had to perform thirty of these processions within the year. Rome offered spectacles as well at this time; indeed, there were so many that the year 1500 became one of the most eventful in the history of the Eternal City. In honor of Cesare Borgia, Alexander VI made the carnival that year an unforgettable experience, and on the Piazza Navona the son of the Borgias flaunted a triumphal procession of eleven wagons. The people were very deeply impressed; they cheered and flattered him. But into the midst of the festivities there burst the news that on February 24, the new heir to the throne of the Holy Roman Empire had been born. The German national church in Rome, S. Maria dell'Anima, put on festive robes to welcome the new baby boy who was to rule as the Emperor Charles V from 1519 to 1556. Cesare's limelight had been stolen.

Even stranger things were to happen and they could only be explained by a pact with the devil. As the pilgrims were hastening back to their lodgings over the Sant'Angelo bridge in the spring of 1500 after visiting St. Peter's, they saw dozens of corpses of hanged men dangling in the wind. One was a doctor from the Lateran hospital who had attacked and killed passers-by in the early morning hours with bow and arrow and had poisoned rich patients in their beds. Only a short time later, on the feast of St. John with its garlands of flowers, Cesare organized a bloody bullfight in an enclosure on St. Peter's Square. He is said to have killed bulls with his own hands, using spears and a single blow of his sword.

Only a few days later, on June 29, a storm broke over the papal suite. As a result, the chimney fell down through the roof of the building, killing a papal adviser. "The pope is dead," cried the people in relief, while many Borgia supporters fled the city. Only when cannon were fired from Sant'Angelo did people stop plundering and calm down, as they learned that the head of the Holy Mother Church had survived. On July 15, the young Prince of Bisceglie, who was the husband of Lucrezia Borgia, was seriously wounded by would-be assassins with daggers on the steps of St. Peter's and was taken under heavy guard into Sant'Angelo to recover. But on August 18, Cesare Borgia hastened to his sickbed and strangled the prince with his own hands. Lucrezia fled Rome in panic accompanied by six hundred servants. The seventy-year old pope appointed twelve new cardinals on September 28, bringing "120,000 ducats per hat" into a war chest that would be empty again by October.

Many pilgrims returned home happy after a mad, turbulent Holy Year, for during the long winter months ahead of them they would have had incredible stories to narrate about their time in Rome. On April 22, 1500 the Terra do Brasil had been discovered by the Portuguese navigator Pedro Álvares Cabral and his men. A holy beggar monk, a certain Savonarola, had been

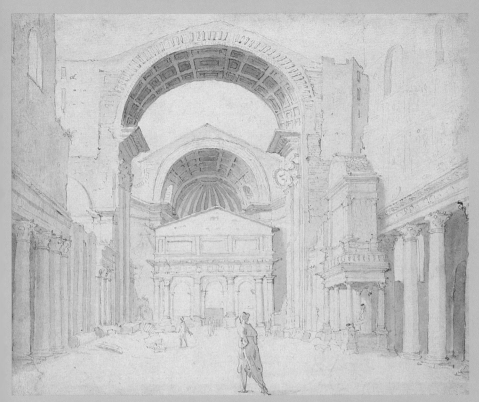

Marten van Heemskerck, Interior of St. Peter's during the rebuilding 1534–1536, drawing,
Kupferstichkabinett, Staatliche Museen zu Berlin Preussischer Kulturbesitz

burned at the stake two years before in Florence, and Tomás de Torquemada, Spain's feared Grand Inquisitor, was now dead. They could now talk of bigoted believers, fanatical heretics, and new intellectual heroes called "humanists." They could talk of legendary and exotic treasures, and even of a distant land called Cathay, or China, never heard of before, where, as rumor had it, a new utensil, the toothbrush, had been invented. For the first time since antiquity the world in Europe was global again. It might even – as a certain heathen named Ptolemy had written in his book *Almagest* – be round.

S. Giovanni in Laterano

The papal bishops' church – MATER ET CAPUT OMNIUM ECCLESIARUM URBIS ET ORBIS ("Mother and head of all churches in the city and on earth") – one of the seven pilgrimage churches in Rome, was dedicated to the Savior (Basilica Salvatoris) in A.D. 313, immediately after the Edict of Milan (which granted religious toleration). So it is the earliest Roman church building. With a length of 100 m (328 feet) and a width of 56 m (184 feet), it was larger than the Maxentius basilica. Its present name dates only from the 7th century, when Pope Gregory I, The Great (pontificate 590–604) placed it under the protection of John the Baptist. Of the medieval basilica, the important cloister dating from the 13th-century has survived, with some features inside the church. The major redesign came in the Holy Year 1650 under the direction of Pope Innocent X (pontificate 1644–1655). The architect was Francesco Borromini, who transformed the four-aisled basilica into a Baroque church. During the period 1733 to 1736 Alessandro Galilei added the monumental main façade; and then in 1886 Pope Leo XIII pontificate (1878–1903) was responsible for having the choir enlarged.

Galilei erected the façade above the vestibule with a design that marks the highpoint of the Baroque façade in Rome. Huge pilasters and columns divide the wall into five sections, the central one of which projects. A balustrade adorns the attic, bearing statues of saints, while the projection is gabled. Behind the main frontage is a second wall in the form of a two-story colonnade. This projects forward only above the main entrance, to create the balcony of the loggia from which the pope would give his blessing.

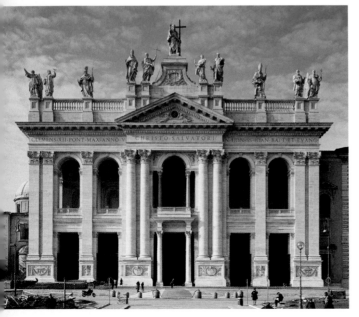

Simone di Giovanni Ghini (1406/7–1491), tomb of
Martin V. (1432)

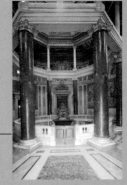

Baptistery, p. 353

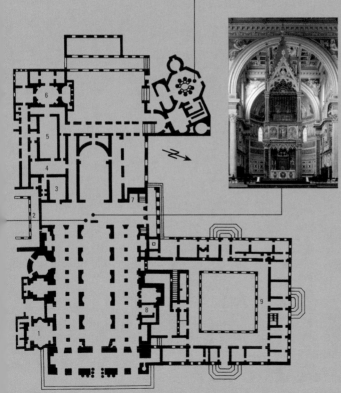

Papal Altar, p. 352

1	Cappella Corsini
2	Cloisters
3	Cappella Colonna
4	Old sacristy
5	Sala Clementine
6	New sacristy
7	Cappella del Crocifisso
8	Cappella Torlonia
9	Palazzo del Laterano

0 100 m

The North Façade with the Benediction Loggia

The architect Domenico Fontana had already set a vestibule before the northern transept on the Piazza di S. Giovanni in Laterano as early as 1586–1589; it was commissioned by Pope Sixtus V and consists of a two-story arcade with paintings inside. The pope would give his traditional blessing on Ascension Day from the loggia. Inside the vestibule is a bronze statue of Henry IV of France by Nicolas Cordier, made in 1608. Because Henry made generous donations to the chapter, all the heads of state of France have been made honorary canons of the basilica ever since.

Filipo Gagliardi (Died 1659), Interior of the Old Lateran Basilica, S. Martino ai Monti
Fresco

Emperor Constantine adorned the first monumental Christian church in Rome with gold, silver, and mosaics. It was a four-aisled columned basilica with transepts and apse. Along the entire width of the nave was an almost square atrium, to serve as a place of meditation and purification. Fifteen columns of Numidian marble separated the broad central nave from the narrower side aisles, and each of the broad arches had to span a gap of 4 m (13 feet). A triumphal arch on high pillars marked the border between the nave and the transept with the altar in the center. In the apse behind this the pope's chair stood on a raised dais. The nave and aisles were not vaulted, and the roof timbers were uncovered, as is evident from the fresco in S. Martino ai Monti, which has an illustration of the old church building.

with the delicately profiled wall structures of the high Baroque, which are almost all in white stucco, the wooden ceiling executed under Pope Pius IV (pontificate 1559–1565), which had to be retained on the order of Pope Innocent X, seems massive and heavy. Borromini also added chapels to the side aisles and, in contrast to the strong longitudinal accent of the old basilica, gave the building a wider structure.

The Interior

When redesigning the church in 1650, Borromini was instructed by the pope to create a modern church interior while keeping as faithfully as possible to the old ground plan and retaining the structure of Constantine's building. Borromini reduced the fourteen arcades of the central nave to five, placing these between huge pillars framed by colossal pilasters and setting windows above them. In the walls between the pillars he set niches framed with columns, and thanks to generous patrons large statues of the twelve Apostles were placed here between 1703 and 1719. The niches are crowned with stucco reliefs showing scenes from the Old and New Testaments, and painted medallions with portraits of the prophets. Compared

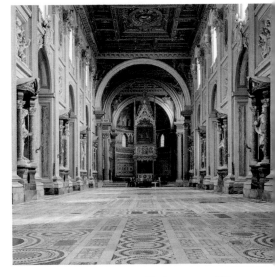

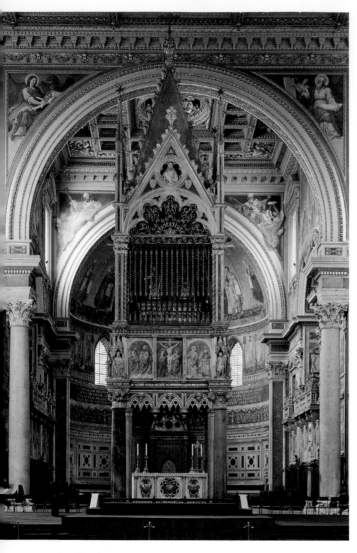

One of the most important
works of sculpture in the
church is the Papal Altar, at
which only the pope may
celebrate the Eucharist. It
contains the wooden altar
table on which, according to
legend, the first Roman
bishops celebrated mass.
Above it rises the taber-
nacle, adorned with frescoes
and sculptures; it may have
been designed by Giovanni
di Stefano of Sienna in
1367–1370, but it was
greatly restored in 1851. The
lilies in the coat-of-arms in
the decoration are a refer-
ence to the patron, Charles
V of France. In the upper
part are busts of St. Peter
and St. Paul in silver gilt; in
the Middle Ages it was
believed that they contained
the heads of the two
Apostles. In the *confessio*
below the altar is the tomb
of Pope Martin V (pontifi-
cate 1417–1431) by Simone
di Giovanni Ghini of around
1443: it was in this church
in 1417 that Martin V ended
the Great Schism.

The Baptistery of S. Giovanni in Fonte

A baptistery dedicated to St. John the Baptist stands at the southern end of the Lateran basilica. It was built by Emperor Constantine in the form of a rotunda over a nympheum of the Laterani Palace, which dates from antiquity. The octagonal form with the font in the center was created in 432, when Pope Sixtus III replaced Constantine's building with a new structure. In this form the baptistery became a model for countless others all over Italy. The upper section rests on an architrave supported by pillars of porphyry and bearing an elaborate inscription praising baptism. In the 16th century a ring of small pillars was set on the architrave and the gallery was raised. The present interior is largely the result of a Baroque redesign which was carried out in the 17th century, when Andrea Sacchi and his pupils decorated the walls with frescoes showing scenes of the life of Constantine, while the lantern is decorated with scenes from the life of St. John the Baptist. The font of green basalt, which dates from classical antiquity, was provided with a gilded bronze lid by Ciro Ferri in 1677/78. The side chapels, which are dedicated to St. Rufina, St. Venantius, and the two St. Johns, date from the 5th to 7th centuries. The Cappella del Battista still has the bronze door dating from late antiquity. The ceiling in the Cappella di S. Giovanni

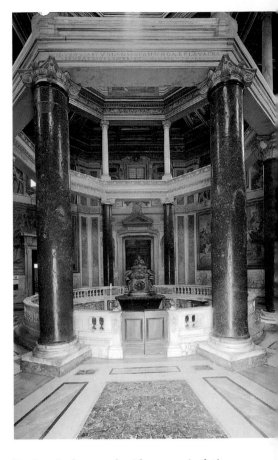

Battista is decorated with a mosaic dating from the 5th century: in the center stands the Lamb of God, enclosed in a wreath showing the seasons, with ears of corn, roses, lilies, olives, and vine leaves; around this are flower vases between pairs of birds.

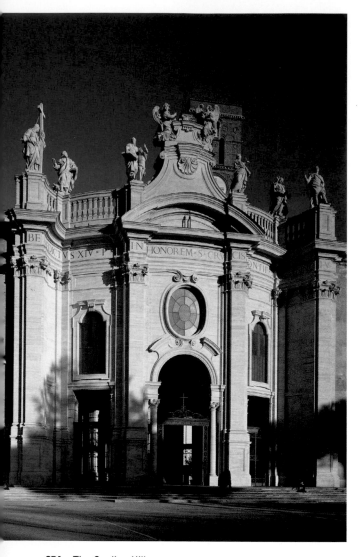

S. Croce in Gerusalemme

This church is believed to contain the relics of St. Helena, who was the mother of Emperor Constantine, and is said to have discovered parts of the Cross of Christ on a pilgrimage to the Holy Land. Around A.D. 350 the emperor had a church built in Helena's palace to house the relics and since then it has been one of the seven pilgrimage churches of Rome. Recently excavations under the church have revealed the remains of a baptistery which, dating from the time of Emperor Constantine, is the oldest building of its kind in Rome. The church was changed into a two-aisled basilica in the 12th century under Pope Lucius II, and its campanile was incorporated in the late Baroque conversion in the 18th century. Domenico Gregorini created the curved façade with a portico in 1743–1750. The balustrade is adorned with statues and culminates in the center in the Apotheosis of the Cross.

The Porta Maggiore and the Tomb of Eurysaces

The Porta Maggiore was built in A.D. 52 by Emperor Claudius and incorporated into the Aurelian city wall under Emperor Aurelian. Originally it was not a city gate; it took the Aqua Claudia and Anio Novus aqueducts across the Via Labicana and the Via Prenestina. The name is presumably derived from the fact that it lies on the way to S. Maria Maggiore. The gate consists of a large travertine arch with two openings. The two side sections have windows that are framed with Corinthian half-columns and gables. On the high attic behind which ran the troughs of the two aqueducts, three inscriptions have been chiseled. They date from the emperor who built the arch, Claudius, and the emperors who restored it, Vespasian and Titus. Below the arch, huge blocks of basalt that once paved the ancient road are still to be seen.

Immediately before the gate, outside the city wall, stands the tomb of the baker Eurysaces and his wife Atistia. It dates from around 30 B.C. and, owing to the lack of space, it has a unique trape-zoid ground plan. On the façade are cylindrical elements arranged in vertical and horizontal rows, presumably representing the vessels that were used to knead dough. Above runs a frieze showing bread being made, weighed, and delivered. Between the zones with the cylindrical elements the same inscription is repeated on all three sides: *Est hoc monimentum Marcei Vergilei Eurysacis pistoris, redemptoris, apparet* ("This is the tomb of the baker Marcus Vergilius Eurysaces, who was a businessman and junior official").

S. Lorenzo fuori le Mura

Immediately outside the city wall, beside the largest cemetery in Rome, the Campo Verano, stands one of the seven pilgrimage churches, dedicated to the memory of the martyr St. Lawrence. Refusing to hand over the church treasure, that Pope Sixtus II entrusted to him, to the Emperor Valerian (reigned 253–260), Lawrence instead gave it to individual Christians (it was therefore beyond the reach of the emperor's officials) and to the poor. As a punishment he was beaten with lumps of lead, burned on a grill, and then buried in the catacomb of St. Ciriaca on the Campo Verano. Constantine built a sanctuary over his grave as early as 330; further south, on the present cemetery land, he built a church, the *basilica major*. However, none of this is now recognizable. The basilica, which was particularly richly adorned with *spolia*, was built by Pope Pelagius II (pontificate 579–590) over the martyr's grave. It has served as the choir for the new church since the great reconstruction in the 13th century under Pope Honorius III (pontificate 1216–1227),

who had the old apse removed and added a nave with a portico which, like parts of the interior, is ascribed to the Vassalletti marble workshop. Over the architrave of the vestibule runs a frieze decorated with porphyry discs topped by a cornice with palmettes and gargoyles in the form of lions' heads. On the walls are the remains of a cycle of frescoes showing scenes from the life of St. Stephen and St. Lawrence; inside stands a 3rd century A.D. Attic sarcophagus adorned with cupids. During the Second World War S. Lorenzo was the only monument in Rome to be badly damaged; large parts were repaired and the sections rebuilt by 1949.

The Choir

The triumphal arch with a mosaic showing Christ resplendent in the center marks the transition to the old Pelagius church. The choir dates from this earlier building, as is evident in the arrangement of two aisles and nave, with galleries divided by ten *spolia* columns with Corinthian capitals. Two of the columns have rare antique composite capitals showing trophies of victory and captured weapons. In the center, over the relics of St. Lawrence and St. Stephen, stands an altar ciborium from the 12th century; a three-tiered columnar structure, it is one of the finest ciboriums in Rome. Cosmati work in complicated geometric patterns of black, white, and red porphyry decorates the floor. The choir screens, which like the bishop's throne are richly inlaid, date from the 13th century.

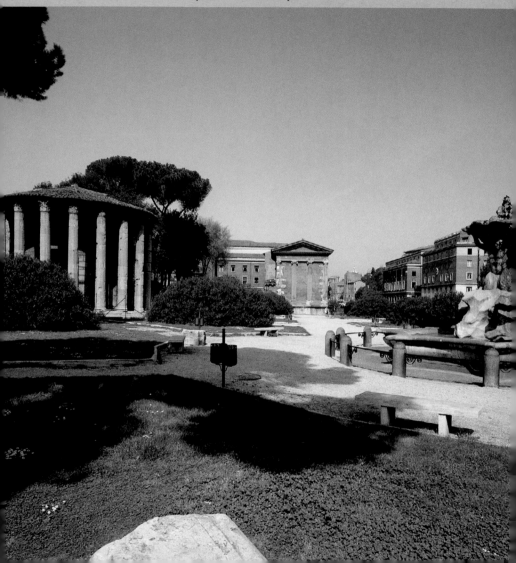

The Forum Boarium (Foro Boario)

The plain between the Capitol, the Palatine, and the Aventine on the one side, and the Tiber on the other, has been of crucial importance ever since Rome was founded. This is where the most important transport routes of central Italy crossed: the Tiber, which was then navigable from its mouth up to Orte, and the north-south land route from Etruria to Campania. Between the Forum Holitorium (the vegetable market, near what is now S. Nicola in Carcere) and the Forum Boarium (the cattle market) lay the Portus Tiberinus, the harbor for merchant vessels, and the temple of Portunus, the god who protected the harbor. Whereas the district was a market place even in early times for the local people and Greek merchants, the commercial quarter outside the city walls began to be built up under the Etruscan kings. More building went on in the 3rd and 2nd centuries B.C., when Rome was rising to become the major power through her conquests in and around the Mediterranean. The two temples on the Forum Boarium were built at this time, as was the Pons Aemilius, the present Ponte Rotto. The Forum Boarium was one of the oldest and most important market places of ancient Rome. It lay directly beside the Tiber, where

Gaspare Vanvitelli, Il Tevere a Ponte Rotto, 1681, tempera on parchment, 23.5 × 43.5 cm, Galleria Nazionale d'Arte Antica, Rome

the Cloaca Maxima, the central sewer of the Roman system, flowed into the river. After Claudius and Trajan had built new harbors in Ostia, the market gradually declined as a trading center. But in the 3rd century A.D. bankers and cattle traders built an arch in honor of the Emperor Septimius Severus and his family (Arco degli Argentarii), and in the 4th century a rectangular marble arch, the Ianus Quadrifrons, was constructed over the street crossing at the Forum. The Piazza della Bocca della Verità now stands in the place where the Forum Boarium once stood. It lies at the center of this quiet district, where Greeks from Byzantium had settled in the 6th century A.D. and erected some of the early Christian buildings, notably S. Giorgio in Velabro and S. Maria in Cosmedin. The streets along the Tiber still bear vivid witness to both ancient and early Christian Rome.

View of the Forum Boarium

The Forum Boarium

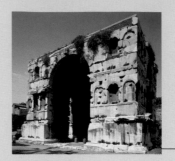

Ianus Quadrifrons, Via del Velabro, p. 370

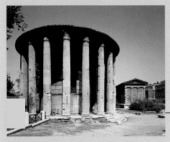

Temple of Hercules Victor, Piazza della
Bocca della Verità, p. 365

Bocca della Verità,
Vestibule of S. Maria in Cos-
medin, p. 364

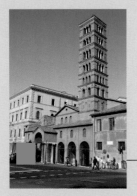

S. Maria in Cosmedin, Piazza della
Bocca della Verità 18, p. 362

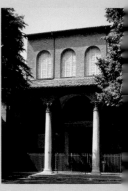

S. Sabina, Piazza Pietro d' Illiria 1, p.

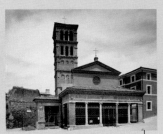

S. Giorgio in Velabro,
Via del Velabro 19, p. 375

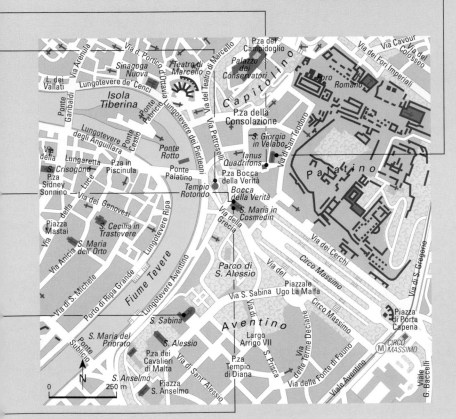

Via d. Portico d'Ottavia
Via Arenula
Lungotevere de' Cenci
L. dei Vallati
Sinagoga Nuova
Teatro di Marcello
Via del Teatro di Marcello
P.za del Campidoglio
Palazzo dei Conservatori
Via dei Fori Imperiali
Via Cavour
Via del Colosseo
Foro Romano
Isola Tiberina
Ponte Garibaldi
Ponte Fabricio
Lungotevere dei Pierleoni
C a p i t o l i n o
Ponte Cestio
Lungotevere degli Anguillara
P.za della Consolazione
Via Petroselli
S. Giorgio in Velabro
Via di San Teodoro
Via della
Lungaretta
S. Crisogono
P.za Sidney Sonnino
Via della Luce
P.za in Piscinula
Ponte Rotto
Ponte Palatino
Ianus Quadrifrons
Tempio Rotondo
P.za Bocca della Verità
Bocca della Verità
P a l a t i n o
Via dei Genovesi
S. Maria in Cosmedin
Via della Grecia
Piazza Mastai
S. Cecilia in Trastevere
S. Maria dell'Orto
Via Anicia
Lungotevere Ripa
Via di S. Michele
Porto di Ripa Grande
Lungotevere Aventino
Fiume Tevere
Via dei Cerchi
Circo Massimo
Via dei
Va di S. Gregorio
Parco di S. Alessio
Via S. Sabina
Piazzale Ugo La Malfa
Circo Massimo
Ponte Sublicio
S. Maria del Priorato
S. Sabina
A v e n t i n o
Via S. Sabina
Via delle Terme Deciane
Largo Arrigo VII
S. Prisca
Via della Fonte di Fauno
Piazza di Porta Capena
CIRCO MASSIMO
N
0 250 m
S. Anselmo
Piazza S. Anselmo
P.za dei Cavalieri di Malta
S. Alessio
Via di Sant'Alessio
P.za Tempio di Diana
Viale Aventino
Viale G. Baccelli

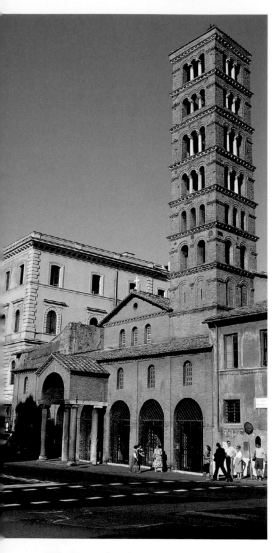

S. Maria in Cosmedin

What was once the Forum Boarium, one of the oldest market places in ancient Rome, is now the Piazza della Bocca della Verità. In the 6th century the church of S. Maria in Cosmedin was founded over the remains of an ancient building. In the late 8th century, when the Eastern Church banned the depiction of Christ, the Virgin Mary, and the saints – a movement known as iconoclasm – Pope Adrian I handed the church over to the Greeks who had fled the East Roman empire. At that early date the basilica was enlarged with an apse at the end of each of the two aisles and the nave – a type of building that appears here for the first time in Western architecture. The bishop's throne, decorated with lions, also dates from this time. A further conversion followed under Pope Callistus II (pontificate 1119–1124), which created the vestibule and the campanile, and extremely elaborate Cosmati work in the interior. As all the fittings are extremely costly the name "in Cosmedin" can be a reference to a square in Constantinople and hence to the Greek word *kosmos* (jewelry, adornment). The rebuilding undertaken in the Baroque era was removed in the late 19th century and the 12th century conditions restored. From the outside S. Maria in Cosmedin is a simple brick tile structure with a two-story vestibule to which the powerful vertical of the high campanile provides a strong contrast.

The Interior

The interior of S. Maria in Cosmedin, with its alternating sequence of columns and rectangular pillars, points towards Ottonian architecture in the 10th century. With its flat wooden ceilings, each of the aisles and the nave give the impression of a box-like space defined by the smooth wall surfaces. The columns are antique *spolia*, but they do not appear to have a supporting function; they look more like decorative items added later. Originally the entire interior of the church was painted with frescoes that blended harmoniously with the colored marble inlays on the floor. The presbytery, which is reserved for the clergy, is kept separate from the nave by transparent filigree marble screens. The unique liturgical ensemble has survived from the time of Pope Callistus II (pontificate 1119–1124); it consists of the *schola cantorum* (chancel for the choir) with ambos at the sides, an Easter candlestick, and an altar ciborium with a 13th-century Gothic superstructure.

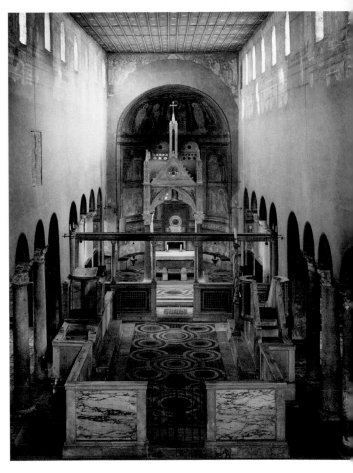

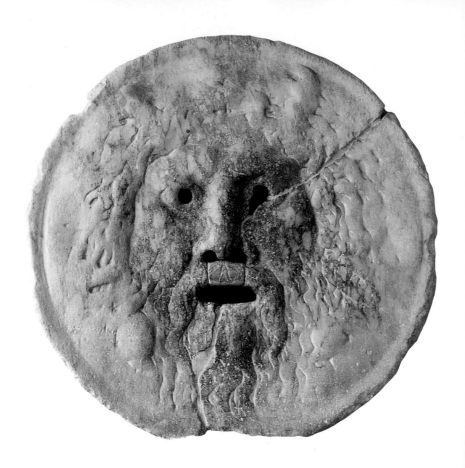

Bocca della Verità
Marble, dia 166 cm

Located in the left wall of the vestibule is the celebrated Bocca della Verità, the "Mouth of Truth." According to the medieval local lore anyone who was accused of a crime, or anyone who had given an oath, had to put their hand into the open mouth of this ancient Triton mask. If the person had not told the truth their fingers would be bitten off.

The Temple of Hercules Victor
(Tempio Rotondo)

The Temple of Portunus

On the Forum Boarium, beside what is now the Ponte Rotto, there stands two antique temples which, thanks to the later church buildings, are still well preserved today. The round temple is the oldest building in Rome made entirely of marble. It used to be called the temple of Vesta owing to its similarity to the temple of the same name located on the Forum Romanum. It is surrounded by twenty Corinthian columns and was built at the end of the 2nd century B.C. by a Greek architect. According to the inscription, it was dedicated to Hercules Victor by the Roman merchant Marcus Octavius Herrenus. This patron was presumably one of the *olearii*, the Association of Oil Dealers, who worshipped Hercules as their tutelary divinity.

North of the temple of Hercules Victor, on the lower level of the ancient street, is the only almost completely preserved ancient temple in Rome. A rectangular building dating from the 1st century A.D., with four columns on its front, it is known as the temple of Fortuna Virilis. But presumably it is the temple of Portunus, for it is known from ancient sources that the harbor divinity had a shrine on the old harbor, directly beside the Pons Aemilius. The temple does not have a colonnaded ambulatory around the *cella* as the Greek-inspired buildings do, and instead of the free-standing columns there are half-columns attached to the walls. The building is constructed of tuff and travertine and was once entirely covered in stucco.

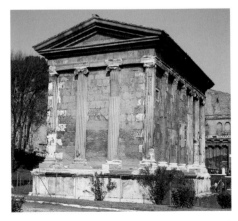

Women in Ancient Rome

by Jürgen Sorges

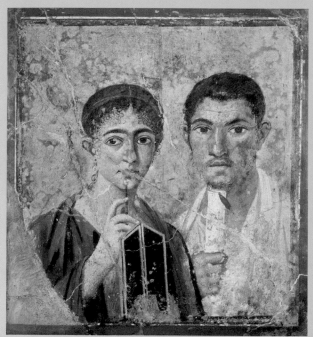

Double Portrait of Paquius Proculus and his Wife (holding a scroll and writing implements), 1st century A.D., fresco from Pompeii, 65 × 58 cm, Museo Nazionale Archeologico, Naples

south were particularly strong influences. These different sources gave rise to pronounced contrasts, particularly with regard to the role of women in society. The ladies of the Etruscan upper class are described as sexually liberated and naturally played a part in public life; they bore their own names and were welcome guests at banquets, while the Greek ideal banished women from public view to hearth and home. Major differences also emerged with regard to the upbringing of children. The Etruscan women had their children brought up in groups outside the home, whereas in Greek families the wives were largely responsible for bringing up the children. There were also differences regarding the freedom to divorce and inheritance laws. These sources played an important part in the

The attitude to women in ancient Rome derived historically from three main sources. Beside the old Italic–Latin roots, markedly agrarian in character, Rome's Etruscan neighbors to the north and the Greek colonies that were settling in the lives of the Roman patricians, especially because they also created patterns for the *plebs* who imitated the patricians. However, rigorous barriers to marriage between the nobility and the lower classes were laid down in

law, and these ensured that many of the rights and freedoms that the Roman patrician women had always enjoyed were not passed on to society as a whole.

While the old influences from the time of the kings, with their strong Etruscan elements, lived on for a long time in the nobility, an image of woman formed in the ensuing first phase of the Roman republic that persisted right into the modern age in Christian thought. The period that entered the Roman collective memory as the "difficult years of construction" brought not only the basic principle of monogamy in the *familia* but also, most importantly, a strict division of work between husband and wife as the economically most successful mode of the partnership. A code of behavior evolved that was sanctioned and controlled by society; it governed the upbringing of children of both sexes through an extensive catalog of *virtues*. And although the *non plus ultra* of Roman womanly virtue may seem ludicrous to us today, at the time Lucretia was considered to be the supreme heroine, by women as well as men. The daughter of Lucretius Tricipitinus, and wife of Lucius Tarquinius Collatinus, Lucretia was raped by Sextus, the eldest son of the Roman king Tarquinius Superbus (reigned 534–510 B.C.). After confiding in her father and husband, she took her own life. This crime (committed around 510 B.C.) brought down the royal dynasty, according to the legend, and caused a republic to be proclaimed; indirectly it was also an expression of the unassailable rights and virtues of the Roman wife.

As the Roman constitution was based on a military assembly of all male members, any political influence women might exercise was limited to individual members of noble families

The Girl with a Stylus (presumed to be the poetess Sappho), Roman wall painting from Pompeii, 1st century A.D., Museo Nazionale Archeologico, Naples

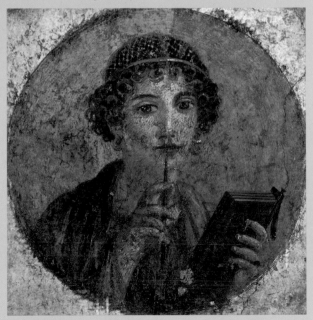

and the emperor's family. Livia, who was the wife of Augustus, Agrippina the Elder (ca. 13 B.C.–A.D. 33) and Agrippina the Younger (A.D. 15–59), Messalina (ca. A.D. 25–48), the "Syrian" empresses, and the Empress Helena (ca. A.D. 248–ca. 328) can all be cited as examples. Women did not have the vote and the prestigious office of priestess was only open to women in a

Portrait head of Livia, Roman, basalt, height 32 cm, Musée du Louvre, Paris

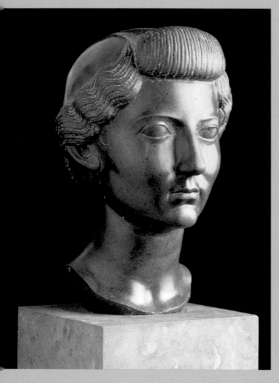

few specific cults that were feminine in their orientation (e.g. Demeter and Isis) and the cult of Vesta, which remained extremely powerful right to the end of Imperial Rome.

Within the family, the husband was the almost unrestricted ruler; he was the *patron*, a role that had survived from the family clans of early times. His wife, the *patrona*, on the other hand, was responsible for the household almost independently. In her role as *matrona* she was also responsible for supervising the upbringing of the children. Attendance at elementary school, which was obligatory under the emperors, was also open to girls, but further schooling was available only to the children of wealthy families. Under the emperors, Roman women were expected to be fertile mothers. They were married early and were expected to "give" the state, rather than their husbands, at least three children. From the time of Augustus, the state and private foundations paid child allowances, but only as long as the conditions of Roman civil law were fulfilled.

For most Romans a life-long monogamy was the ideal, though the upper classes often had quite different norms. Divorce and remarriage were not uncommon among noble women, although they had to submit to certain restrictions. Even at the end of the 2nd century A.D. they were still forbidden to marry below their station. Pope Callistus I (pontificate 217–222) allowed the wealthy patrician women to live as if in wedlock without a marriage certificate – indeed he sanctioned the practice, for it was presumably a great incentive to them to convert to Christianity and support the Church. This aroused vehement protests within the Roman

curia, which in the end finally resulted in the appearance of the antipope Hippolytus (pontificate 217–235).

Innumerable accounts have survived of widows in Rome who seized the opportunity of a gap in the law and did not remarry after the death of their husbands. For the inheritance laws gave them sole right to all his goods and businesses – but only until a new husband entered the house or the role of *patron* passed to the eldest son. So many Roman widows preferred to take a lover, a fact that was generally severely criticized by contemporary writers, but often accepted with an understanding grin as well.

Life and work were very different for female slaves and freed women. Modern scholars estimate that far more than half the heavy labor that was carried out in the fields was performed by women. However, female slaves in the country were also able to rise to the position of estate managers, although their master retained the right of signature in financial matters. Most of these women were employed as midwives, nurses, governesses, and doctors. In the acting profession, which was regarded as somewhat dubious, women could make a

career as actresses, singers, and even as gladiators. Work in catering was also considered to be of low social status. In manufacturing, the women mainly worked in textiles. Finally, many women earned their living as prostitutes – and with little or no attempt at concealment, for their profession was tolerated.

Ladies Having Their Hair Dressed by a Female Slave, Roman wall painting from Herculaneum, 1st century A.D., Museo Nazionale Archeologico, Naples

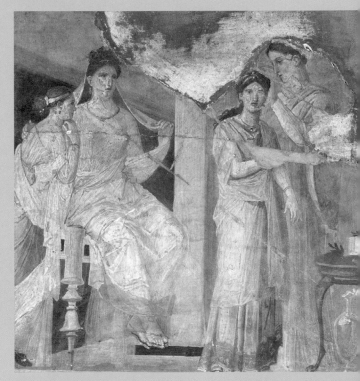

refs to the four fronts of the arch.

In all likelihood, the arch served as a roofed street crossing in the midst of the lively commercial quarter, providing a meeting point for the traders on the Forum Boarium. It is listed in the antique regional directories as *arcus constantini*, which suggests that it may have been built in the first half of the 4th century A.D. Fragments of a dedicatory inscription in the walls of the façade and the interior of the neighboring church, S. Giorgio in Velabro, are thought to have once been part of this building. The arch is faced in marble and it is subdivided on the exterior by two rows of shell-shaped niches framed by delicately profiled columns that probably once held statues. The tops of the four arches have reliefs of Roma and Juno seated, and Minerva and Ceres standing. The brick attic was removed in 1830 when the remains of the medieval tower were removed. This tower had been added onto the ancient monument in the 13th century by the Frangiani family.

Ianus Quadrifrons

On the Via del Velabro, a name that recalls the marshy river bank (*velabrum*) of the Tiber river, where the legendary she-wolf is said to have found Romulus and Remus, a great arch rises above an arm of the Cloaca Maxima. It has passages on all four sides, but was not dedicated to the god Janus, as one might suppose from the name *Ianus Quadrifrons*. *Ianus* in Latin simply means "passage," and *quadrifrons*

S. Sabina

According to legend, the house of a rich Roman lady named Sabina once stood on this spot; another account says that the mortal remains of a saint from Umbria were kept here. St. Sabina is said to have been run through with a sword during the reign of Emperor Hadrian and so received the palm of martyrdom. The name of the man who commissioned the church is known for certain through an inscription: he was an Illyrian priest named Petrus, who erected a two-aisled basilica using his own fortune during the time of Pope Celestine I (pontificate 422–432), just after the invasion of the Goths. Under Pope Eugenius II (pontificate 824–827) the interior was given an elaborate marble facing of which only fragments have survived. The ancient Corinthian columns and the frieze of *opus sectile* with inlays of porphyry and serpentine above the arcades of the central nave are particularly fine. In 1219 Pope Honorius III (pontificate 1216–1227) gave the church to the Dominican order and had cloisters built. After the Council of Trent, twenty of the twenty-six windows were walled up, for it was thought that too bright a light distracted the soul from meditation. More changes to the early Baroque style were made in 1587 by Domenico Fontana, who was the architect of Pope Sixtus V (pontificate 1585–1590). However, today the two-aisled basilica is seen largely in its original condition, due to a restoration program which was carried out in the early 20th century. It is one of the best preserved early Christian basilicas in Rome.

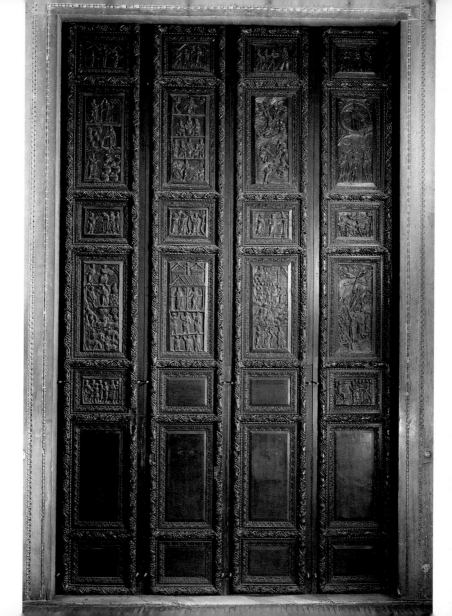

Central Portal, 5th Century
Wood, 530 × 312 cm

The double doors of cypress wood in the vestibule of the church of S. Sabina, which were carved by an unknown master in the 5th century, are among the oldest and finest wood reliefs that have survived from early Christian times. There are reliefs on both sides: those on the inside feature plants and geometric patterns, while those on the outside depict episodes from the Old and New Testaments. We see, for example, the Adoration of the Magi, events from the life of Moses, the miracles performed by Christ, and scenes from the Passion. It is assumed that the models for the depictions were painted miniatures in codices and scrolls. Originally the wooden door had a total of twenty-eight relief panels, each being framed in vine leaves, but only eighteen have survived. Moreover, they are no longer arranged in the order in which they were originally placed.

Crucifixion	The Women at the Tomb		Adoration of the Magi	Christ with Peter and Paul
Miracles of Christ	Miracles of Moses		Ascension of Christ	Christ in Judgment
Christ Appears to His Disciples	Christ Appears to the Women		Peter Denies Christ	Habakkuk
The Summoning of Moses	The Acclamation		Moses and the Flight out of Egypt	Ascension of Elijah
Christ before Pilate				Jesus before Caiaphas

S. Sabina, Central portal, Plan

Crucifixion of Christ, Detail of the Central Portal

Historically, the most important relief panel in the doors of S. Sabina is the one showing the Crucifixion of Christ, for it is one of the very earliest representations of the subject. Christ and the two thieves stand as symbolic figures, their arms outstretched, before a stone wall with three gables. The crucifixion is only apparent from the nails in the palms of the hands and bars of wood behind the heads, feet, and hands. The figures are of different size, in keeping with their rank and importance: Jesus towers above the two criminals, and the repentant sinner is bigger than the thief who is still filled with wrath. As in all the other early Christian artifacts, here too Christ is shown with his eyes open and without an expression of pain. Subjects from the Passion or the martyrdom of saints were not depicted until the late 4th century.

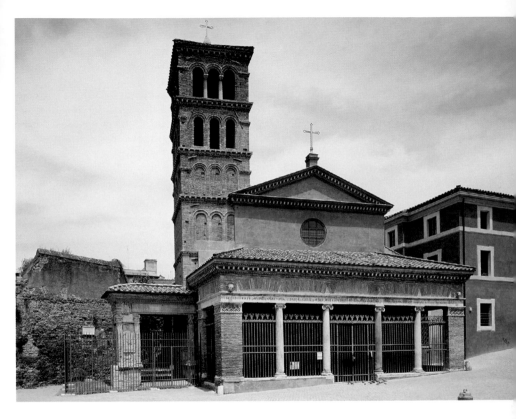

S. Giorgio in Velabro

Dedicated to St. George, this basilica dates from the time of Pope Gregory IV (pontificate 827–844). In the 12th century a portico and a campanile were added; this involved building over parts of the Arco degli Argentarii, which was erected in A.D. 204 by Rome's bankers and cattle traders in honor of Septimius Severus and his family. Reliefs on the arch, which are visible in the entrance to the church, show sacrificial rites involving the emperor's family; those on the outside depict Roman soldiers with barbarian prisoners. The door under the portico was destroyed in 1992 in a Mafia attack; the frame is made of fragments of antique buildings.

Victory at any Price – Chariot Racing in the Circus Maximus

by Jürgen Sorges

The famous chariot races in imperial Rome were as bloody in reality as they are in the classic film *Ben Hur*. Quite often the chariots of up to twelve competitors were overturned, trapping their drivers and often causing fatalities. The *murcia*, later known as the Curve of Titus, was notorious for these accidents, many of which were the result of deliberate obstruction or collusion between the four rival stables. These were the Reds, the Blues, the Greens, and the Whites; they were known as *factiones* and each strove for the favor of the crowd, where excitement would rise to fever pitch as the spectators were overcome with *furor circensis*, the frenzy of the games.

The original form of the Circus Maximus is still recognizable today, the huge tuff and travertine remains from the time of Julius Caesar (1st century B.C.) surviving. Under Emperor Trajan (reigned A.D. 98–117) the great stone arena, which was 650 m (2,132 feet) long and 125 m (410 feet) wide, was entirely faced in marble; the seating could hold, if not the legendary 385,000, certainly up to 250,000 spectators. Twelve starting stalls adorned with herms and known as *carceras* were built into the straight front end of the circus, the *officium*. This is where the drivers waited for the start signal from

The colors of the four main racing stables are to be seen in the mosaics from a villa of ca. A.D. 200 on the Via Cassias. They are now in the Museo Nazionale Romano delle Terme in Rome

the *editor*, the organizer of the event, who to start a race would drop a handkerchief, the *mappa*. At that moment a sophisticated mechanical device unbolted and opened the iron gates.

From the time of Emperor Augustus (reigned 63 B.C.–A.D. 14) a *spina* (wall) ran down the center of the arena. It was 2 m (7 feet) high, 6 m (20 feet) wide and 214 m (702 feet) long, creating a track that was 85 m (279 feet) wide; drivers had to go around the track seven times. At each end of the *spina* were counters to record the number of rounds ridden, consisting of seven metal dolphins that could be clapped down; they were dedicated to the sea god Neptune, who was also the god of horses. Augustus had an obelisk of Ramses II (reigned 1279–1212 B.C.) that had been brought from Heliopolis in Egypt erected on the *spina*, and since 1589 it has stood on the Piazza del Popolo. In A.D. 357 the obelisk of Thutmosis III (reigned 1479–1425 B.C.) from Thebes was added, and in 1588 it was placed on the Piazza S. Giovanni in Laterano. Other images of divinities, including one of Cybele, adorned the axis. On the opposite straight lay the *pulvinar*, the emperor's box built under Trajan in the form

Chariot racing in the Circus Maximus, woodcut, anonymous, ca. 1890

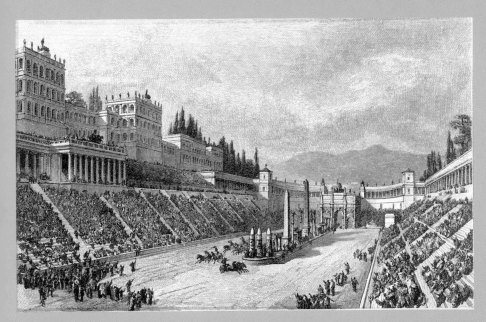

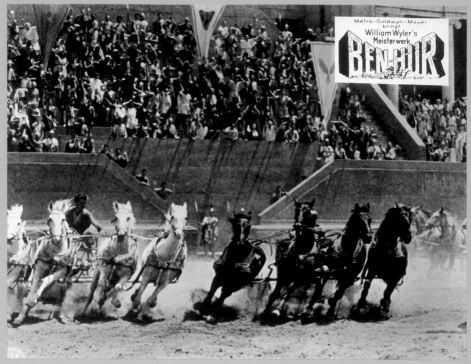

*The director William Wyler created movie history with the chariot race sequence in his classic film
Ben Hur in 1959*

of a temple. It was set on the same level as the winning line, which was on a raised and tented structure on the other side of the track.

As well as smaller awards the victors received large sums in prize money: 50,000 sesterces were paid out per race. The most successful professional drivers, the "Formula I" of antiquity, became multimillionaires; superstar C. Appuleius Diocles is said to have accumulated a fortune

of 35 million sesterces. But the most favored of all the drivers was almost certainly the Emperor Nero (reigned A.D. 54–68). Like his fellow emperors Caligula (37–41), Domitian (81–96) and Commodus (180–192), he was in the Green stable, the *prasini*, who engaged in fierce duels with the *veneti*, the Blues. At the Olympic Games in A.D. 67, Nero is said to have won 1,800 titles, including the first prize in chariot racing. It is a

classical case of preventive "emperor duping," for Nero, who was highly excitable, was thrown from his chariot and never in fact reached the winning post.

If they did not have the skill of the charioteers, many in the crowd at least tried to become as wealthy, for dozens of betting businesses were run in the lower story of the Circus. Countless fast-food sellers catered to physical needs, and often wine flowed in plenty as well, not infrequently causing bloody fights on the stands. Numberless fatalities are documented during these battles between rival fans, and in Pompeii thousands once lost their lives this way. Crowd surges and mass panic also caused major disasters. On one occasion a column collapsed, killing a thousand; on another the rear wall of a stand fell, causing 13,000 deaths.

Nevertheless, as in the Colosseum the people became more and more demanding. Towards the end of the Roman Republic only seventeen *ludi circensis* (circus games with ten to twelve chariot races a day) were held. At the end of the imperial age there were sixty racing days, each of which had, since Nero's time, lasted until sundown. A barbarian finally put an end to the bloody history of chariot racing, when King Totila of the Eastern Goths (reigned 541–552) banned the tradition that had lasted 1150 years.

The Circus Maximus in 1999

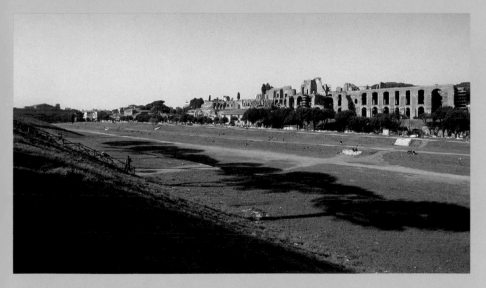

The Aventine Hill (Aventino)

The most southerly of Rome's seven hills was integrated into the city only under Emperor Claudius (reigned 41–54). In early times its special position, directly on the Tiber and near the commercial harbor, made it a lively business quarter where many foreigners came to trade. Indeed, only foreigners were allowed to trade outside the *pomerium*, the sacred city boundary. Many temples stood on the Aventine, including the temple of Diana, which King Servius Tullius had erected in the 6th century B.C. as a shrine for the Latins. In the 5th century B.C. the area was settled by the *plebs* – ordinary people, peasants, small traders, and craftsmen. The *plebs* had absolutely no political rights compared with the propertied class (the patricians), and they were not admitted to the highest offices of state. This caused long years of class war until finally they succeeded in obtaining political rights, which were laid down in the Twelve Tables in 451 B.C. During the republic, the Aventine was densely populated with plebeian housing and business premises, but under the emperors it became an elegant residential district for the Roman nobility, while the lower classes moved onto the plain by the new harbor, or to Trastevere on the right bank of the river. When the Goths attacked Rome in the early 5th century A.D., it was mainly the luxurious villas on the Aventine that they plundered and destroyed.

View from the Aventine Hill to the Vatican

Hence apart from the remnants of Servius' city wall no ancient buildings have survived on the hill. Only Monte Testaccio ("Rubble Hill"), remains to bear witness to the old harbor with its huge warehouses and store sheds. From here come the countless broken amphoras that were once used to transport goods, particularly wine and oil, and which were dumped here, growing in the course of time to an artificial mound 36 m (118 feet) high. Today the quarter is full of lively streets lined with shops and restaurants, while early Christian and medieval churches and public parks are characteristic of the appearance of the elegant residential district on the Aventine. From the top of the hill one has a fine view over the river to St. Peter's.

Monte Testaccio, "Rubble Hill"

The Aventine Hill

S. Saba, Via di S. Saba, p. 386

The Protestant cemetery, Via Caio Cestio, p. 384

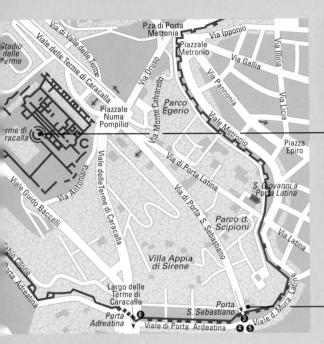

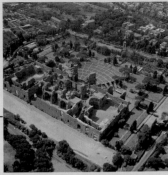

The Baths of Caracalla, Viale delle Terme di Caracalla 52, p. 388

The Cestius Pyramid, Piazzale Ostiense, p. 384

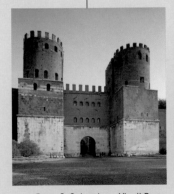

Porta S. Sebastiano, Via di Porta S. Sebastiano 18, p. 394

The Aventine Hill **383**

The Cestius Pyramid
(Piramide di Cestio)

To the south of the Aventine stands a very unusual structure. It is linked to the Aurelian city wall and was evidently inspired by Egyptian models. Caius Cestius, who died in 12 B.C., had a pyramid erected here, 27 m (89 feet) high and faced in white marble. It was to be his tomb. Two

inscriptions, both with the same wording, confirm this: *C(aius) Cestius L(uci) f(ilius) Pob(lilia tribu) praetor, tribunus plebis, (septem) vir epulonum* – "For Caius Cestius, son of Lucius, of the Tribus Publilia, Praetor, tribune of the people and member of a college of priests." According to his testament, which can be read in the small inscription on the eastern side, the monument had to be completed in only three hundred and thirty days. The little door in the west side leads to the burial chamber, which is decorated with paintings in the Third Pompeian style. The design of the tomb as a pyramid is characteristic of the Egyptian forms and motifs which became fashionable under Emperor Augustus; it can also to be seen, for example, in the construction of obelisks.

The Protestant Cemetery
(Cimitero acattolico)

Beside the Cestius Pyramid, in the shadow of the city wall, lies the famous cemetery where non-Catholic foreigners are buried. The oldest grave dates from 1738. It was initially a meadow where sheep and goats grazed, until the pope permitted the Protestants to use it as a burial ground. The dead could be buried there only at night, and gravestones were forbidden. This was to change only when Wilhelm von Humboldt, who was Prussian Ambassador to the Holy See from 1802 to 1808, lost two of his sons in Rome

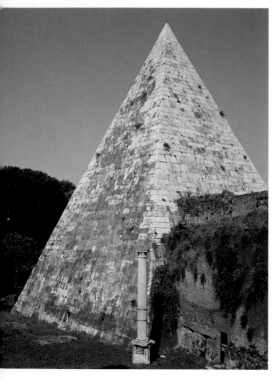

and wanted a grave fittingly marked and protected. He obtained permission to buy a piece of the land and fence it for use as a family vault. Two upright marble columns still mark the place today. About twenty years later other Protestants were also permitted by the papal authorities to fence in the graveyard. If one walks through the cemetery one finds the graves of famous visitors to Italy under the pines and cypresses – painters, poets, scholars, diplomats and emigrants who came to Rome and died there. They include the English Romantic poet John Keats and his fellow poet Percy Bysshe Shelley,

Goethe's illegitimate son August, and other famous figures like the architect Gottfried Semper, the painter Hans von Marées, and Henriette Hertz, who founded the Bibliotheca Hertziana. Cyrillic inscriptions with the orthodox Russian cross remind visitors of Tolstoy, Prince Gagarin, and Prince Yussupov. The grave of Antonio Gramsci, co-founder of the Italian Communist Party, is also to be found there.

S. Saba

In the 7th century A.D, Oriental monks erected a small church over the house and oratory of St. Silvia, the mother of Pope Gregory the Great (pontificate 590–604). It was dedicated to St. Saba (who died in 532), one of the great founders of an order in the Eastern Church who founded the monastery of Mar Saba near Bethlehem. In the mid-12th century a basilica was built which was restored in the 15th century and again in the 20th. Passing through a Romanesque doorway, one enters a quiet court that reveals a view of the façade with the campanile. In the vestibule, ancient Roman and early Christian finds are displayed.

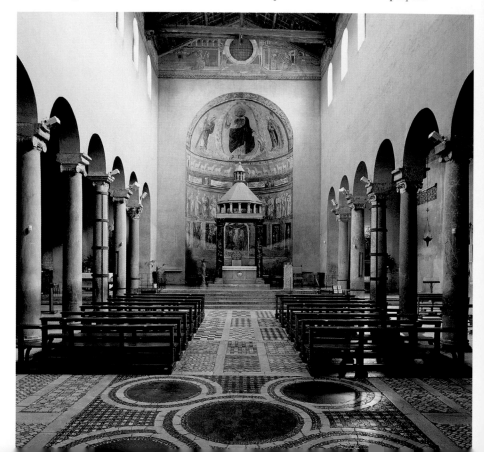

The Art of the Cosmati

In the early 12th century an entirely new form of mosaic decoration evolved, which is known as Cosmati work. This is intricate inlay work executed in white and colored marble, gold and multicolored glass flux, and it rapidly became an essential decorative element found in almost all the Roman churches. Combined to form geometric and abstract patterns, the mosaic tiles wind around discs of red porphyry or rectangular fields of green serpentine. The mosaic decorations were initially limited to the floors of the churches, but they quickly spread on to beams and columns in cloisters and porticos, choir screens and ambos, and even candelabra, ciboriums, Easter candlesticks, and bishops' thrones.

The artisans who created these works, the Cosmati, lived and worked in central Italy as mosaic setters, marble sculptors, and architects until the 14th century. They came from various artists' families, of which the Vassalletti and the Torriti were the best known. The name "Cosmati" comes from the forename Cosmas, which is found in many inscriptions. The artists proudly called themselves *magistri doctissimi romani* ("supreme Roman masters"), and marked their works with confident signatures in the tradition of antique artisans. They took classical and early Christian art as their primary models, carefully studying the floor mosaics and almost literally copying capitals and friezes on ancient temples; they also incorporated antique parts of buildings as *spolia* in their own work.

Parallel to the revival of mosaic art in apse decoration and partly under the influence of Byzantine art, the Cosmati gave the Roman churches an entirely new appearance in the 12th and 13th centuries. It was to provide essential stimulus to ensuing generations of artists, including the painter Pietro Cavallini.

Altar decorated with Cosmati work, Sacre Grotte, Vatican, Rome

The Baths of Caracalla
(Terme di Caracalla)

In imperial Rome the public baths ceased to be exclusively used for physical hygiene and sports and increasingly became a place of social intercourse. This necessitated the extension of the existing facilities and the construction of new baths. Emperor Caracalla met this demand when he opened a huge complex in A.D. 217, covering a square site of 11 hectares that could fit about sixteen hundred people in the bath house alone. On walking through the ruins, which are well preserved, one can still gain a vivid impression of the layout and the huge dimensions of the halls. The monumental bath house lay in the central part and had the traditional ground plan with the main rooms on the central axis and arranged around them, symmetrically with the axis, the changing rooms (*apodyteria*), smaller rooms for massage and medical examinations, and the sports areas (*palaestrae*). The sequence of rooms was impressive, not only for the wide variety of ground plans and types of vaulting but also for the luxury of the fittings. Where today we see only simple brickwork were once pilasters and niches, while the walls were covered with mosaics, frescoes and marble. The architecture and painting were enriched with many fine sculptures, of which only the Farnese Bull and the famous Farnese Hercules in Naples need be mentioned. The main technical facilities for the baths were in the cellars, which

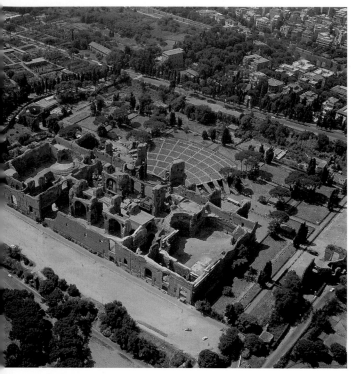

formed a regular network of subterranean streets. The water for the baths was collected in huge cisterns that could hold 8,000 m³ (2,100,000 U.S. gallons) of water; they were concealed behind the flat exedrae on the south-west side of the enclosing wall. Those who had finished bathing could find plenty to do outside the actual bath complex. They could stroll in the gardens that surrounded the central section or wander through the colonnades of the enclosing walls, which also contained concert and lecture rooms,

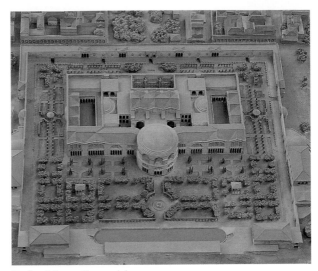

Baths of Caracalla, model

libraries, shops, offices, inns, and even a subterranean shrine to Mithras. So the baths were in fact a gigantic leisure complex providing for what the Roman poet Juvenal called *mens sana in corpore sano* (a healthy mind in a healthy body), with a comprehensive supply of sports and cultural facilities. The baths could be used until sundown and were free of charge. Only starting in the year 537, when the Goths cut off the supply of water, did the baths begin to decay. Then in 847 an earthquake brought down some parts of the building. But the baths suffered their worst damage through Pope Paul III Farnese (pontificate 1534–1549), who released them as a quarry for the rebuilding of St.

Peter's. It was in this way that many of the sculptures came into the possession of the papal family. The basins of the two fountains before the Palazzo Farnese, for example, also came from the Baths of Caracalla. Most recently the baths have been used for open air opera performances, but these had to be stopped in 1998 because the huge number of visitors that they attracted was threatening to damage the building.

Balnae and Thermal Baths –
the Bath Culture of Ancient Rome

by Jürgen Sorges

Balnae vina Venus corrumpunt corpora nostra; sed vitam faciunt; balneae vina Venus – "Baths, wine and love ruin our bodies but they make life worth living; baths, wine and love." In this inscription on his grave a Roman left for posterity his personal eulogy of the bath culture in ancient Rome. The enthusiastic author of these lines could indeed have fulfilled all these needs at once in the biggest thermal facilities ever built in antiquity. Caterers and traveling tradesmen supplied the guests, while prostitutes and rent boys were ready for customers. After there were numerous scandalous occurrences, the Emperor Hadrian (reigned 117–136) decided to forbid men and women from bathing together at the same time. A hundred years later this rigorous law had to be reinforced, as men and women always bathed naked.

The biggest leisure temples of antiquity all had a gymnasium or lyceum attached to provide

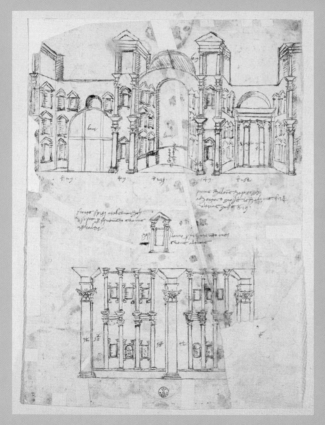

Antonio da Sangallo the Elder (1455–1534), The Baths of Diocletian, Gabinetto dei Disegni e delle Stampe, Florence

fitness and sports facilities; and to refresh the mind they also had large libraries, lecture rooms, and exquisite works of art.

The bath culture of Rome had a long tradition. Accounts as early as the 3rd and 2nd centuries B.C. have survived that indicate that at least on market days (every ninth or tenth day) the country folk streamed into Rome to have a bath. So a regular culture of privately owned, rented bath houses called *balneae* developed. A bath house run by a leaseholder was an extremely profitable investment, for the general level of hygiene in Rome's private dwellings was not of a particularly high standard. By 33 B.C. Rome had 170 *balneae*, enticing customers with welcoming warmth, refreshing cold plunges, and saunas.

The entrance charge for the private baths was low, on average only the easily affordable *quadrans*. The price was virtually symbolic and almost everyone could afford it. This low cost was a result of the competition from the public baths, which started when Agrippa opened his *thermae* (from the Greek *therme*, warmth, heat) on the Field of Mars in 19 B.C. Agrippa instructed in his will that these baths, which were then the largest baths in Rome, must continue to operate free of charge, thus setting standards of liberality for all the emperor builders who came after him.

After Nero's gigantic structure (A.D. 62) imperial baths were gradually built in every part of the city. They opened mainly in the afternoons, and everyone, including slaves, visitors to Rome, and children, were allowed to use them. The basic facilities in all the *thermae* included a changing room (*epodyterium*), a cold bath (*frigidarium*), a

View into the Baths of Caracalla

basin with luke warm water (*tepidarium*), and a hot bath (*caldarium*). Then there were the steam baths (*laconica, sudatoria*), and the leisure and recreation facilities. Often musicians played in the luxurious rooms. In fact the Baths of Caracalla, which were built in the early 3rd century A.D., must be imagined as an amusement palace as they offered pleasures, that were otherwise reserved for the head of state, to all who came every day. Two subterranean levels, with stores and equipment and wide corridors in which ox carts could transport goods of every

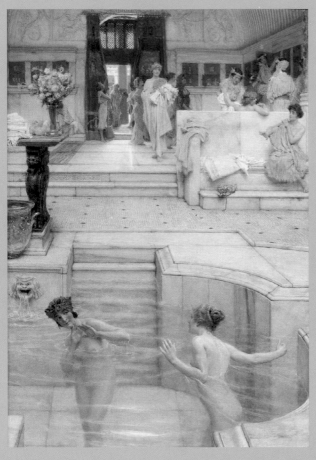

Caracalla, which covered an area of just under twelve hectares, actually exceeded the total area covered by all of the imperial forums (9 hectares/22 acres).

Throughout the imperial age new baths were constantly being built. Nero's magnificent building was followed by the Baths of Titus on the Collo Oppio (around A.D. 80), built by the architect Apollodorus of Damascus, who used part of Nero's celebrated Domus Aurea. Only a short time later Trajan had these overbuilt with the baths that bear his name (A.D. 104–109). Nearly one hundred years were to pass before Emperor Commodus (reigned 180–192) had the Baths of Commodus erected to the south of where the Baths of Caracalla would later stand.

kind, hid all physical labor from view, and a sophisticated subterranean heating system ensured that the temperature remained at an even and pleasant level all day. The staggering size of just one of these sites, the Baths of Today no trace of these is left, nor of the baths built by Septimius Severus (reigned 193–211). The water tanks that fed the Baths of Caracalla had a capacity of 8,000 m³ (over 2,000,000 gallons), but these baths were only

finished in 225, during the reign of Alexander Severus (222–235). The interior measured 220 m by 114 m (722 feet by 374 feet), the outside 337 m by 328 m (1,105 feet by 1,076 feet). To provide access to the site, the Via Nova, which at 30 m (98 feet) was the widest avenue in Rome at the time, was extended from the Circus Maximus to the baths and lined with shop openings. Alexander Severus, on the other hand, favored a decentered concept of urban planning and had smaller baths constructed in every district. By levying a new trade tax he was able to raise enough funds to hold "oil lamp soirées" in the baths, so that those who worked during the day were at last able to enjoy the facilities at night. Emperor Decius (reigned 249–251) built magnificent baths on the Aventine, the remains of which were discovered by that great architect of the late Renaissance, Andrea Palladio (1508–1580).

The baths remained the Romans' favorite place for social exchange and public meetings until the end of the imperial age. Within their walls, pools and chambers probably millions of business transactions took place, hundreds of thousands of marriages were arranged, and many a conspiracy, even popular uprisings, were hatched.

E. Paulin, The Baths of Diocletian, ca. 1880, watercolor, École Nationale Supérieure des Beaux Arts, Paris

The Aurelian City Wall

One of the most impressive monuments of ancient Rome is the Aurelian city wall, an encircling ring which is still largely intact. It was built under Emperor Aurelian in A.D. 270 – 272 to protect the city against attacks by barbarians and was finished by Emperor Probus (reigned 276 –282). It is almost 19 km (12 miles) long and it enclosed the entire Roman *urbs* of the 3rd century. It was 6 m (20 feet) high, and in some places was as high as 10 m (33 feet). A total of three hundred and eighty-three towers projected from the wall at intervals of about 30 m (98 feet), and eighteen gates gave access into the city. The coats of arms of numerous popes recall renovation work that was carried out over the following centuries. The city wall fulfilled its function as fortification until September 20, 1870, when the troops of the Kingdom of Italy broke through northwest of the Porta Pia, using modern artillery, and took Rome.

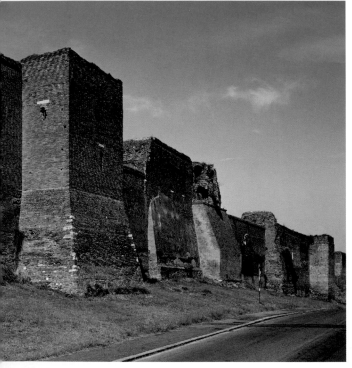

Porta S. Sebastiano

The most important and best preserved city gate of Rome is the three-story Porta S. Sebastiano. It is a great arched entrance, the present appearance of which dates from a rebuilding program carried out under Emperor Honorius (reigned 395 – 408) in the 5th century. The round-arched gate was once secured with a double door and a portcullis and flanked on both sides by crenellated

towers set on square bases. The gate takes its name from the little church of S. Sebastiano ad Catacumbas near the Via Appia, while the earlier structure, a two-gated arrangement with low round towers, was named the Porta Appia, after the main exit road from Rome. A figure of the archangel Michael and an inscription recall the battle on September 29, 1327 in which the Romans secured a victory over Robert of Anjou, King of Naples. Before the gate on the city side stands the Arch of Drusus, on which the Aqua Marcia, an aqueduct supplying the Baths of Caracalla, among other things, was taken across the Via Appia.

Parco Archeologico di Via Appia Antica
(See the next double page)

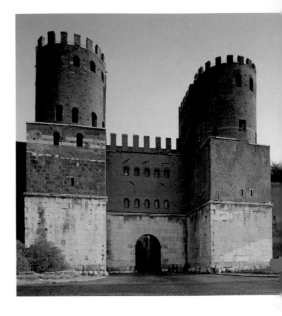

The Via Appia is one of the most important and best preserved streets of the ancient Roman network. Laid out by the Censor Appius Claudius in 312 B.C., it starts at the Porta Capena directly behind the Circus Maximus and linking Rome with Brindisi in Apulia via Benevento. From the harbor at Brindisi goods could be transported to Athens and the East. Like all the roads leading out of Rome, the Via Appia was paved with huge blocks of basalt, its surface was markedly curved to allow the rainwater to drain away, and it was lined on both sides with pavements in stamped clay. Its width corresponded to the antique standard measurement for roads, 4.10 m (13.4 feet). Every fourteen to sixteen kilometers (nine to ten miles) were rest stations where travelers could stop and change horses. Outside the Porta S. Sebastiano the Via Appia, which had always been the most elegant location for Roman burials, was lined with monuments of various kinds. Because the Romans practiced both burial and cremation in the same area there were subterranean vaults like the Columbaria, tombs placed above ground in the form of little temples or houses and great mausoleums like that of Cecilia Metella.

Parco Archeologico di Via Appia Antica

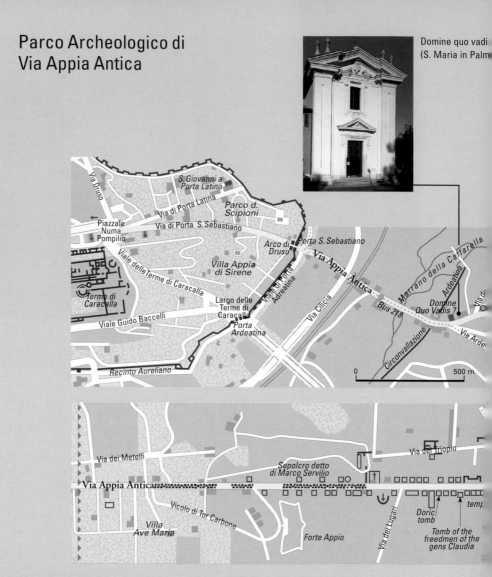

Domine quo vadi
(S. Maria in Palm

S. Giovanni a
Porta Latina

Via di Porta Latina

Parco d.
Scipioni

Via di Porta S. Sebastiano

Via Druso

Piazzale
Numa
Pompilio

Arco di
Druso

Porta S. Sebastiano

Via Appia Antica

Marrano della Caffarella

Ardeatina

Via de

Viale delle Terme di Caracalla

Villa Appia
di Sirene

Viale di Porta Ardeatina

Via Cilicia

Bus 218

Domine
Quo Vadis ?

Terme di
Caracalla

Largo delle
Terme di
Caracalla

Via Arde

Viale Guido Baccelli

Porta
Ardeatina

Circonvallazione

Recinto Aureliano

0 500 m

Via dei Metelli

Via del Triopio

Sepolcro detto
di Marco Servilio

Via Appia Antica

Vicolo di Tor Carbone

Villa
Ave Maria

Forte Appio

Via dei Lugar

Doric
tomb

temp

Tomb of the
freedmen of the
gens Claudia

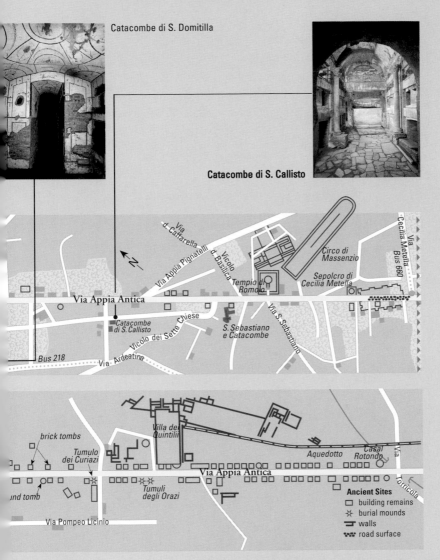

Catacombe di S. Domitilla

Catacombe di S. Callisto

Via d. Caffarella
Via Appia Pignatelli
Vicolo d. Basilica
Via Appia Antica
Catacombe di S. Callisto
Vicolo dei Sette Chiese
Via Ardeatina
Bus 218
Tempio di Romolo
Circo di Massenzio
Sepolcro di Cecilia Metella
Via Cecilia Metella
Bus 660
S. Sebastiano e Catacombe
Via S. Sebastiano

brick tombs
Tumulo dei Curiazi
Villa dei Quintili
Via Appia Antica
Aquedotto
Casal Rotondo
Via Torricola
...und tomb
Tumuli degli Orazi
Via Pompeo Licinio

Ancient Sites
☐ building remains
✳ burial mounds
⊤ walls
〰 road surface

Early Christianity

by Jürgen Sorges

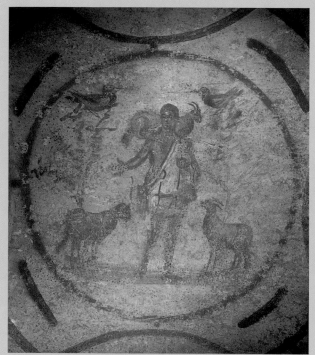

Christ the Good Shepherd, early Christian wall painting, 3rd century A.D., Catacombe di Priscilla, Rome

The earliest traces of a Christian community in Rome date from the reign of the Emperor Claudius (reigned 41–54). At that time the first Christians in Rome were very probably only a splinter group within the Jewish community.

Claudius certainly made no distinction between them: both were forbidden to hold meetings and Christians and Jews alike were frequently banished. Both groups operated outside the Roman state religion, so they were classified as *religio illicita*, sects forbidden by law. These "Jewish Christians" had been brought up in the Jewish faith and probably spoke Hebrew; at the latest by the time of Nero (reigned 54–68) they had been joined by the "heathen Christians," members of the Christian faith from outside the Jewish culture, most of whom had a Hellenistic upbringing and education. They had been converted by the missionaries, including St. Paul, and were called Hellenic Christians because of their different cultural roots. The tensions between the groups were to be resolved by the Council of Apostles in Jerusalem (A.D. 48/49) which gave the two groups equal standing.

Both Jews and Christians belonged to the lowest levels of Roman society, and most of them

were slaves or freedmen and women. The most important source of the early history of the Church is the Epistle to the Romans by the missionary St. Paul (ca. 58). The presence of the Apostles Peter and Paul in Rome almost certainly stimulated community life for these early Christians, who may have numbered about a thousand.

Originally the Christians lived on the outskirts of the city, in Trastevere and on the Aventine. This is confirmed by the cemeteries laid out near these residential districts. The oldest of

Titular churches, Constantine churches and other new secular buildings in Rome ca. A.D. 500 (from Richard Krautheimer, 1980)

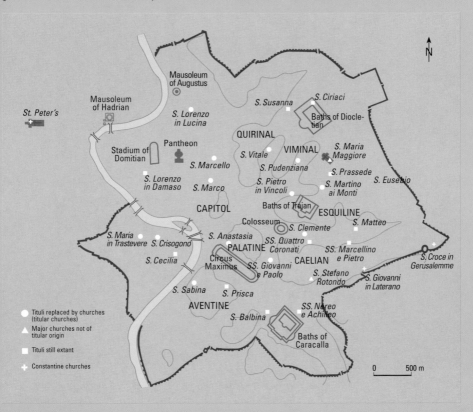

Matthias Merian the Elder, Persecution of the Christians by Nero after the Fire in Rome in A.D. 64. Martyrs were put to death by being sewn into animal skins or burnt alive; copper engraving from J.L. Gottfried, Historische Chronica, 1630, Frankfurt am Main

forgotten, until Pope Nicholas V (pontificate 1447–1455) and the new Accademia Romana rediscovered these ancient burial places.

Early imperial Rome had only very small Christian communities and even at the end of the 2nd century they had neither prayer houses nor public meeting rooms. As was the Jewish custom, private houses were used as meeting places, where the life of Jesus was remembered at meals with invited guests. A total of twenty-eight of these private *tituli*, the origin of Rome's later titular churches, have so far been discovered by archaeologists. At a very early date the sermon, together with the "mystery of the Eucharist," formed part of these meals, but it was only the Old Testament and the arrival of the Messiah that were read out. The language of the liturgy was Greek; and it was only much later that the gospels on the life of Christ also formed part of the reading.

Each titulus community operated independently and was directed by a *presbyter* who also functioned as supervisor or *episkopos*; from this evolved the office of *episcopus* or bishop. He was assisted by the deacon, who was responsible for charitable concerns. In his Epistle to the Romans, St. Paul criticized the strong rivalry between the communities, especially over questions of faith, calling

the burial places, known as catacombs, are those of S. Sebastiano on the Via Appia Antica. In fact the Latinized name *catacumbas* derives from the Greek *kata kumbas*, which translates as "near the bottom of the valley," so it was originally a geographical designation indicating the location of the graves.

The great age of the Christian catacombs began in the 2nd century, but only in the 4th century were they marked as places of particular reverence with basilicas built over them. Their reputation as the resting places of saints brought a constant stream of visitors right up until the 11th century, not only to revere the dead but primarily to purchase the relics of saints. In the following five centuries the catacombs were gradually

upon them to unite. Nevertheless, different interpretations of the Bible evolved even at an early date and seemingly the office of a supreme presbyter as arbitrator was not yet known. Decisions were made by a college of bishops. Another textual source is the first Letter of Clement, from the time of the fourth bishop of Rome, St. Clement (88–97). Early traces of Christianity are documented in the lower story of the basilica of S. Clemente, where foundations blackened with soot have been uncovered beneath a Mithras cult site dating from the second century. They are the foundations of houses that were burned in the fire in Nero's time (A.D. 64). Some modern scholars think it possible that the legendary fire was actually started by Christians. The general air of revolt in Palestine at the time and the visionary and apocalyptic mood among the original Christian communities could possibly have been the cause. But Nero's first persecution of the Christians is definitely confirmed, as is the lowly social status of his victims – under Roman law the form of execution suffered by many of the early martyrs was crucifixion, and this was a punishment that was usually reserved for slaves.

From the papacy of Pius I (pontificate 140–155), the Church took on an institutional character. There were already five Church offices and Latin was introduced for the celebration of the Eucharist. By the year 160, about 15,000 Christians were living in Rome. By the middle of the 3rd century, the Church in Rome

Jules Eugène Lenepveu, Martyrs in the Catacombs, 1855, oil on canvas, 170 × 336 cm, Musée d'Orsay, Paris

already had a hundred and fifty-five Church officials and 30,000 believers. For ever since the decrees issued by Emperor Septimius Severus (reigned 193–211), the Christian Church had become an increasingly powerful force in the city; it was allowed to exist but was watched distrustfully. The distrust deepened as the Church's power grew, and between the years 240 and 270 the pagan Roman Empire went on the offensive again. Under Pope Fabian (pontifi-cate 236–250) the Emperor Decius (reigned 249–251) unleashed a campaign of bloody persecution, calling for all the Church property to be confiscated. This was during the lifetime of St. Lawrence, who suffered a cruel martyrdom. As deacon he was directly involved in the confiscations ordered by Decius. In order to protect the Church's assets, he had them legally transferred to private individuals and gave some away to the poor. The furious emperor took his

Gianlorenzo Bernini, St. Lawrence, marble, 1617, 66 × 108 cm, Collezione Contini-Bonacossi, Florence

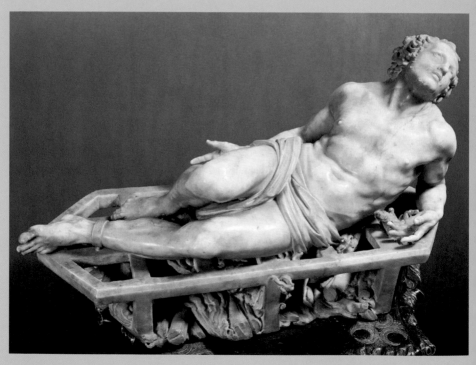

The Three Youths in Purgatorial Fire, early Christian fresco, 3rd century A.D., *Catacombe di Priscilla, Rome*

revenge on St. Lawrence by ordering him to be burned alive on a grill.

What is reputed to be the instrument of his torture is kept in the church of S. Lorenzo in Lucina on the Via del Corso, together with the iron chains that bound the saint during his imprisonment. Pope Sixtus II also died a martyr's death; he was killed on August 6, 254 in the catacombs of S. Callisto by assassins sent at the behest of the Emperor Valerian; legend has it that Sixtus II was struck down while he was preaching.

The Emperor Valerian achieved the goal of confiscating Church property around 260, but his successor Gallienus (reigned 253–268) restored it.

Not until October 28, 312, the date of the battle at the Milvio Bridge, which began with a cavalry skirmish in Saxa Rubra north of Rome, did the period of bans and persecution end for the Roman Christians. The *Pax Christi* sign that miraculously appeared on the banners and shields of Constantine's army marked the start of a new epoch and the reign of *Christus triumphans*, Christ triumphant, began.

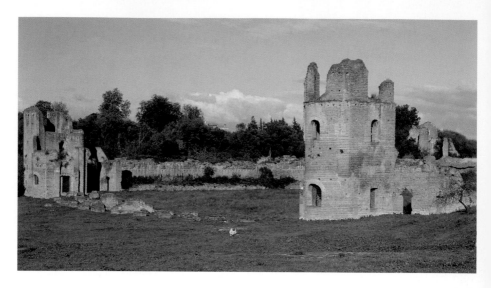

The Circus Maxentius
(Circo di Massenzio)

This *circus* (race track) is part of a great palace complex built by the Emperor Maxentius (reigned 306–312) on the Via Appia by greatly extending and rebuilding an older villa. It is one of the best preserved examples of this type of architecture. It is laid out similarly to the Circus Maximus, and could hold nearly 10,000 spectators. The arena is around 513 m (1,683 feet) long and about 78 m (259 feet) wide, and is divided in two by a low wall (*spina*) that the chariots had to circle a total of seven times. The Domitian obelisk once stood in the center of the richly decorated *spina* before

Pope Innocent X (pontificate 1644–1655) had it moved to the Piazza Navona in 1650 to crown the Fountain of the Four Rivers (Fontana dei Quattro Fiumi). At the western end of the arena were the starting stalls (*carceres*) between two high towers, with the main entrance in the middle. The emperor could reach the raised dais at the winning post directly from his palace down a long corridor. Immediately beside the Circus Maxentius and the imperial residence lay a monumental burial ground, which Maxentius had constructed in honor of his son Romulus, who died in A.D. 309 and was deified. The mausoleum is a round structure with a dome 33 m (108 feet) in diameter. The whole edifice rises above a broad colonnaded court.

The Tomb of Cecilia Metella

Probably the best known burial construction on the Via Appia is the Mausoleum of Cecilia Metella. As the inscription states, she came from a Roman patrician family around the turn of the millenium and was the daughter of Consul Quintus Metellus Creticus, who conquered the island of Crete in 69 B.C., and she married the younger Crassus, whose father was a member of the triumvirate with Caesar and Pompey. The tomb is built like the Mausoleum of Augustus. A rotunda faced with travertine rises from a square base. It is 11 m (36 feet) high and has a diameter of 29.5 m (97 feet), with a frieze of bulls' skulls, garlands, and trophies below the cornice. Locally, it is still called Capo di Bove (the bulls' skull). Inside is a vaulted burial chamber; the sarcophagus it once contained is now displayed in the Palazzo Farnese. The crenellated walls recall the medieval history of the mausoleum, for the Caetani family incorporated it as the main tower in their fortifications in 1302.

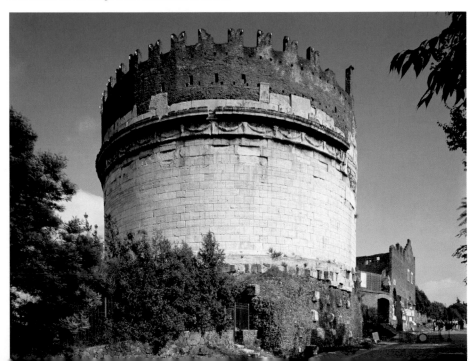

S. Paolo fuori le Mura

Outside the city, about two kilometers (1.2 miles) beyond the antique Porta Ostiense, lies S. Paolo, one of the four patriarchal basilicas and one of the seven pilgrimage churches owned by the Vatican. Originally a small church stood here that had been built in the time of Constantine over the grave of the Apostle Paul on the Via Ostiense. Theodosius (reigned 379–395) and his fellow emperors replaced it at the end of the 4th century A.D. with a columned basilica with a nave, four aisles and transepts. The church was completed under Honorius (reigned 395–423). The ground plan and dimensions were exactly those of the Basilica Ulpia at the Trajan Forum, and until the rebuilding of St. Peter's in the 16th century it was the biggest Christian church in the world. But even in the Middle Ages fires and earthquakes necessitated extensive restoration work. In the 5th century, for instance, a rich mosaic decoration was added, and at the end of the 13th century the wall paintings in the central nave were renewed by Pietro Cavallini. But in 1823 a fire destroyed almost the entire building. The reconstruction aimed to retain the dimensions and forms of the 4th century basilica and only the Romanesque tower was replaced with a new structure in the Neo-classical style. Around

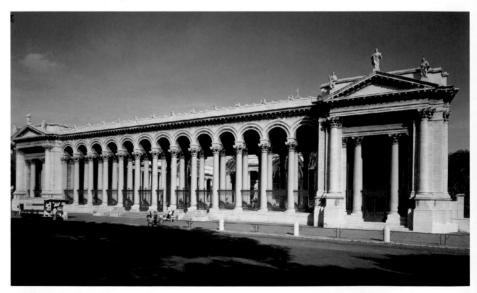

1900 a forecourt was created in front of the façade, around which a roofed colonnade was built. Outside the church was redesigned in the historicist taste of the 19th century, using original parts of the building in some places. The gable on the façade was decorated with mosaics: against a golden background, Christ, flanked by St. Peter and St. Paul, raises His hand in blessing.

Porta Santa, Staurachios of Chios, The Martyrdom of St. Peter, ca. 1070

The bronze portals are 20th century. To the right of the church is the Porta Santa, opened only in holy years. On its inside are remains of the wings of the main portal of the preceding building, work of the Greek architect Staurachios of Chios in Constantinople around 1070. The doors have fifty-four panels showing scenes from the New Testament and from the lives of the saints; their outlines are inlaid with silver to give them greater relief.

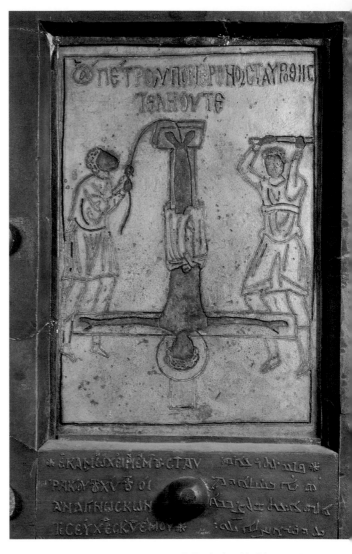

Bartolomeo Pinelli (1781–1835),
S. Paolo fuori le Mura after the Fire of 1823
Drawing

Using old engravings is the only way we can reconstruct the interior of S. Paolo fuori le mura before the devastating fire of 1823. Fluted columns down the nave carried the upper wall on round arches, with a row of round-arched windows opening below the unfaced roof timbers. The aisles, which were flanked with smooth piers, were illuminated by windows that were situated above the arcades; their lightly polished alabaster gave the interior a warm light. Behind the triumphal arch stretched the transept, which had no supports but extended only a short way beyond the outside walls of the side aisles, directing the visitor's gaze towards the mighty semicircle of the apse.

The Interior

After the fire, which occurred in 1823, eighty massive granite pillars were erected down the nave and the unfaced roof was

replaced with a richly gilded stucco ceiling. Moreover, the height of the inner aisles was reduced by the clerestory, making these very much darker today and creating a strong contrast between the vast light nave and the dark, narrow side aisles. Below the 19th century frescoes in the nave, there is a frieze of mosaics running right round the interior. It now has two hundred and sixty-five medallions showing the portraits of all the popes. The frieze has taken the place of a painted gallery of portraits of the popes that had been continued from antiquity to the 19th century but was destroyed in the fire in 1823.

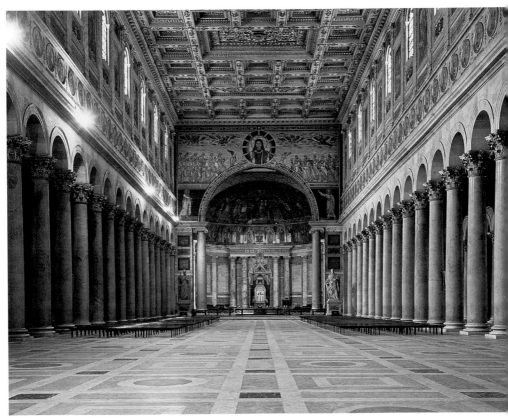

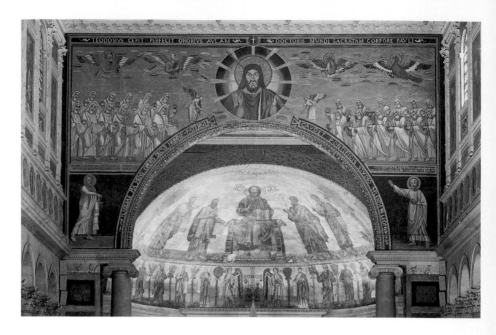

The Mosaic on the Triumphal Arch

The mosaic on the triumphal arch has largely survived from the old basilica. Restorers were able to take it off the old wall and attach it to the new, making only a few changes. It dates from the 5th century and, as the inscription at the foot of the arch tells us, it was created under Pope Leo I (pontificate 440–461) and paid for by the Empress Galla Placidia: PLACIDIAE PIA MENS OPERIS DECUS HOMNE. PATERNI GAUDET. PONTIFICIS STUDIO SPLENDERE LEONIS ("Placidia the Pious is delighted with the brilliant decoration with which the devout Pope Leo has crowned her father's work"). The upper inscription praises the builders of the basilica, Theodosius and Honorius. The mosaic depicts in a slightly changed form the Apocalypse, from the Revelation of St. John. Christ's head and shoulders are shown in a nimbus of the sun with the twenty-four Patriarchs approaching from both sides; above them float the symbols of the evangelists. To right and left at the foot of the arch stand St. Peter and St. Paul. St. Peter is pointing to Christ with his right arm while St. Paul is pointing down, presumably to the tomb.

The Cloister

South of the transept of the basilica lies one of the finest cloisters of the Middle Ages. It has double rows of columns in varying designs, some smooth, others with fluted shafts twisted like ropes to suggest the weaving of two thick strands. The cloister was built between 1205 and 1241 by the Vassalletti, when a Benedictine monastery was added to the church. An antique stone located above the central arch on the north side bears the name of the architects, who were among the most celebrated sculptors and mosaic artists in Rome. Mosaic inlays of gold and colored glass adorn the columns, architraves, and cornices, intensifying the three-dimensional effect of the marble.

Fragments of the old basilica that was destroyed are displayed in the cloisters, as are antique sarcophaguses, one of which has scenes from the story of Apollo. In the 12th century it served as the tombstone for Pietro de Leone.

EUR

The EUR, the Esposizione Universale Romana (World Exhibition in Rome) is a suburb in the south of Rome built originally for a world exhibition that was to be held in 1942. Owing to the outbreak of the Second World War the great exhibition never took place. Mussolini wanted to erect a great new district here, an *urbs magna* which would take up the tradition of antique imperial Rome and compete with papal Rome and its old palace buildings. So under the direction of Marcello Piacentini the architects did not design temporary pavilions, as had been the case with earlier world exhibition sites; they erected buildings with a complete infrastructure in a style that was intended to satisfy the desire for exaggerated monumentality on the part of the Fascist rulers. The district was completed in the 1950s, and with its functional street network and broad green areas it became a model of modern urban planning and developed into a residential and administrative quarter. The huge marble structures now accommodate official bodies and museums, including the Museo della Civiltà Romana, which offers vivid displays of life in ancient Rome using models and reconstructions, including a model of the ancient city at the time of Constantine, and plaster casts taken from the reliefs on the Trajan Column.

Palazzo della Civiltà del Lavoro

One of the best known buildings in this district is the Palazzo della Civiltà del Lavoro, which was started on a square ground plan in 1938 by the architects Giovanni Guerrini, Ernesto Bruno La Padula, and Mario Romano. It recalls the *pittura metafisica*

(metaphysical painting) of the 20th-century artist Giorgio de Chirico. Because of its huge, regularly spaced round windows it is known locally as "the square Colosseum." The first row of arcades contains numerous statues symbolizing the various crafts. The Palazzo dei Congressi has earned a place in architectural history for the novelty of its design as a domed hollowed block of stone.

Palazzo dello Sport

On the other side of the artificial lake, which is edged with thousands of Japanese cherry trees, lies another remarkable building that has played an influential part in modern architectural history. It is the Palazzo dello Sport that was designed by Pier Nuigi Nervi for the Olympic Games held in Rome in 1960. It is crowned by a semi-circular concrete dome with a diameter of 100 m (328 feet) that rises from a glass cylinder 20 m (66 feet) high. Inside, the dome is coffered with concrete ribs.

Trastevere and Gianicolo

On the left bank of the Tiber there are two very different districts. In no other part of Rome is the atmosphere of a traditional old quarter so alive as in Trastevere, although there are some signs now that it is degenerating into a drug district. Even in antiquity the Trastevere district – the name comes from the Latin *trans tiberim* ("on the other side of the Tiber") – was a poor quarter with few monuments of any significance. But the wall paintings and stucco ceilings that have been excavated around the Farnesina are from a Roman villa (they are now in the Museo Nazionale Romano) and they prove that some wealthy people lived in the area between the Tiber and Gianicolo, building magnificent villas and laying out fine gardens.

Later, in the 3rd and 4th centuries, many Christians settled here and founded the first titular churches. In the Middle Ages the quarter flourished and the dense network of narrow alleys and twisting streets with little squares that now make Trastevere so picturesque grew up. The park on Gianicolo and the Botanical Gardens are an oasis of peace and quiet after the busy turmoil in the streets, and from the

top of the hill one has one of the best views of the Tiber and over the city right to the surrounding hills. The hill named after the God Janus (Latin *iani collis*, Italian *giani collo*) is, like the Vatican, not one of the classical seven hills of Rome, and it was only fully incorporated within the city boundary in 1642 under Pope Urban VIII (pontificate 1623–1644). But it played an important part in Rome's history, for this is where the partisans of the Roman Republic under Garibaldi defended themselves against the French troops whom Pope Pius IX (pontificate 1846–1878) had summoned to his aid.

The Botanical Gardens

View of a street in Trastevere

Trastevere and Gianicolo

S. Maria in Trastevere,
Piazza di S. Maria in
Trastevere, p. 425

Tempietto in the inner court of S. Pietro in
Montorio, Via Garibaldi 33, p. 430

S. Pietro in Montorio, Piazza S. Pietro in
Montorio 2, p. 428

S. Cecilia in Trastevere, Piazza di S. Cecilia, p. 422

Other sights:

1 Villa Doria Pamphilj, Via di S. Pancrazio, p. 443

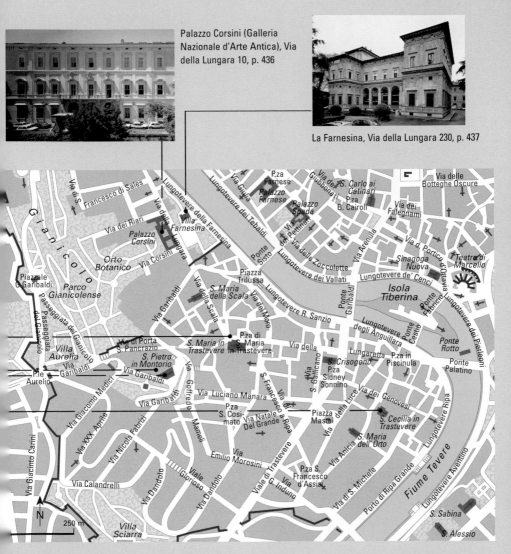

Palazzo Corsini (Galleria Nazionale d'Arte Antica), Via della Lungara 10, p. 436

La Farnesina, Via della Lungara 230, p. 437

Among Rabbis and Imams –
Jews and Muslims in Rome

by Jürgen Sorges

Towards the end of the republican era, ancient Rome could claim to be the most important multi-religious center in the Mediterranean. For two thousand years ago nearly every religion of the region had its cult site inside the city walls. Modern reconstructions of the street plan of the *urbs* of antiquity show hundreds of shrines, temples, and burial sites that bear witness to a tradition of tolerance. Only with the victory of Christianity, the beginning of which historians now date on October 28, A.D. 312, the day of the battle at the Ponte Milvio, was the attitude of Roman men and women to outside cultures to change fundamentally. Only one other religious community survived the ensuing storms of the passing of time on the Tiber, and can actually look back on a longer tradition there than the Christians: it is Rome's Jewish community. The first contacts with the Roman Senate are documented as early as 139 B.C., when the first Jews came to Ostia and settled in Trastevere in Rome, the district that was then assigned to simple soldiers, craftsmen, and foreigners who did not have Roman citizenship. In fact, archaeologists have found here the oldest traces of the Jewish community, which is said to have numbered as many as 8,000 in the post-Augustan age. The façade of a house on Vicolo dell'Atleta concealed one of the oldest synagogues in the city. One of the first patrons of Jewish culture in Rome was no less a man than Julius Caesar. He allowed the Jews their own jurisdiction and granted them

extensive civil and trade rights. But the relationship between Romans and Jews deteriorated with the uprisings in the Roman province of Judaea and the conquest of Jerusalem in A.D. 70 – the reliefs on the Arch of Titus on the Forum Romanum depict the triumphal display of the treasures captured as booty, which include the celebrated seven-branched candlestick from the temple in Jerusalem. At times Jews and Christians alike were subject to persecution.

The hostility between Jews and Christians began under Pope Leo I (pontificate 440–461), as laws against the Jewish community increasingly limited the professions and occupations open to its members. Access to public office was forbidden them, and the situation greatly worsened under Gregory VII (pontificate 1073–1085) and then during the crusades.

Throughout the 14th century more and more Jews moved from Trastevere across the Tiber into the area around the ruins of the Circus Flaminius. It was desolate but they were relatively safe there from hostility and attacks. After 1555 the rest of the Jewish community, which numbered about 9,000, were forced to follow them, when Pope Paul IV Carafa (pontificate 1555–1559) followed the model of Venice and issued a bull *Cum nimis absurdum*, not only ordering a Jewish ghetto to be established in Rome but also ordering all Jews regularly to attend sermons by Catholic missionary priests. The Jews suffered occupational discrimination,

they were reduced to working as refuse collectors, the maximum interest Jewish businessmen were allowed to charge was fixed at twelve percent, and they were forced to repurchase their residence permit every year. The Jews were not permitted to leave the residential quarter assigned to them between sunset and sunrise. The ghetto, which was finished by 1566, lay between the Theater of Marcellus, the Piazza Mattei, and the Tiber; it was walled and the main entrance was on the Piazza delle Cinque Scuole (The Square of the Five [Talmud] Schools). It never measured more than three hectares, and, now called Sant'Angelo, it is still the smallest district of Rome. The present name comes from the church of Sant'Angelo in Pascheria that was founded in A.D. 775. It was one of the four churches that was engaged in missionary work with the Jews in the following centuries. It is said that Rome's Jews stuffed candle wax into their ears to avoid hearing the Christian services that were performed every week.

There are countless stories that have grown up around the Seraglio degli Ebrei, the "Hebrews' Seraglio," the colorful nickname that was coined for the ghetto by the local Romans. In fact the restricted life in the ghetto, which lacked sufficient wells and was therefore unhygienic and plagued with disease, must have been very much less picturesque than legend would have us believe.

Noah (his arms raised in prayer) Leaving the Ark, incision in a stone on a marble sarcophagus, 4th century A.D., Catacombe di Priscilla, Rome

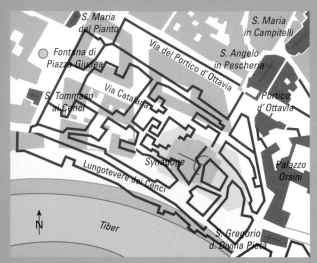

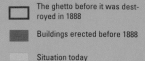
Map of the old Jewish ghetto (outlined in bold) on Lungotevere Cenci when it was opened up in 1888, superimposed on a plan of the buildings and street lay-out today

King Vittorio Emanuele III (reigned 1900–1946) used to say, "will never betray us." For many Italian Jews loyal to the throne, including the Turin scientist and writer Primo Levi (1919–1987), who saw themselves as an integral part of Italian society, with a common tradition going back for more than 2,000 years, the passive attitude taken by the Italian monarchy and the pope was devastating. A total of two thousand and ninety-one Roman Jews were transported to Dachau, Auschwitz, and Bergen-Belsen; and of that number only fifteen came back to the Tiber.

The ghetto disappeared only with the liberation of Rome in 1870 and the abolition of the Church State. Rome's Jews had lent strong support to Italy's struggle to become a unified nation in the 19th century, being seen as "the faithful Swiss Guard of the future royal house of Savoy," and so they were granted full rights of citizenship. At the time, the appointment of General Count Guiseppe Ottolenghi, a Jew, as Italian Minister of Defense was an act unique throughout all of Europe.

All the more tragic were the consequences of Mussolini's seizure of power, and especially the adoption of the notorious Nuremberg race laws of 1935 by the Italian Government. "The Jews,"

The decisive step towards reconciliation between Christians and Jews in Rome was taken on April 13, 1986 by Pope John Paul II when he traversed the distance from the Vatican Palace, over the Tiber, to Lungotevere Cenci. In the Great Synagogue he was received by Rabbi Elio Toaff, who had been the head of the city's Jewish community, which had grown to 16,000 members, for forty years. They embraced to symbolize the historic reconciliation. Pope John Paul II renewed the reconciliation in the Holy Year 2000, when for the first time a

pope called upon believers to visit the titular churches in Rome and also to visit the Holy Land. (Israel, Nazareth, Jerusalem, and Bethlehem are regarded as places of pilgrimage of equal importance.)

Muslims also form an important religious community in Rome; they currently number about 50,000. Previously condemned by popes and by Luther, and actually thrust into hell for evermore by Italy's great poet Dante Alighieri (1265–1321) in his *Divine Comedy*, Islam had difficulty gaining a foothold in the center of Catholic Christianity at the end of the 20th century. When an Islamic center was built on Monte Antenne in the Roman district of Parioli, including the biggest mosque in Europe, there was a great deal of criticism and many misunderstandings that only came to an end in 1993 when the construction work was completed. Since then, dialog between the two most populous religions on earth has moved into calmer territory in Rome.

The Dean of the Faculty of Architecture at Rome University, Paolo Portoghesi, was persuaded to design the great mosque in 1975. He took as his models, among others, the Roman Pantheon, Borromini's church Sant'Ivo alla Sapienza, the Spanish Steps, the mosques at Kairouan in Tunis and Cordoba in Spain, and the cathedral of Monreale north of

Palermo in Sicily. In accordance with the 24th Sura of the Koran, he chose light as the leitmotif for the religious structure, which is designed in the postmodern style. The complex, located on the Via Anna Magnani/Via della Moschea, is crowned by thirteen domes and has capacity for 2,500 believers. But it has not found favor with all the critics. The columns inside the building, which faces Mecca, have been called "hands praying and thrusting upwards," while many people have remarked that the 42-m (138-foot) minaret looks rather squat in proportion to the rest of the mosque. Sheikh Mahmud Mohamed Hammadi, an Egyptian in his late fifties who held office for more than eight years in England, is now the Imam of the mosque in Rome.

Osvaldo Armanni and Vincenzo Costa, The Great Synagogue on Lungotevere dei Cenci, 1899–1904

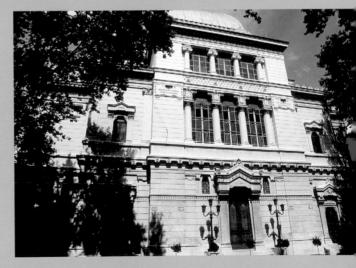

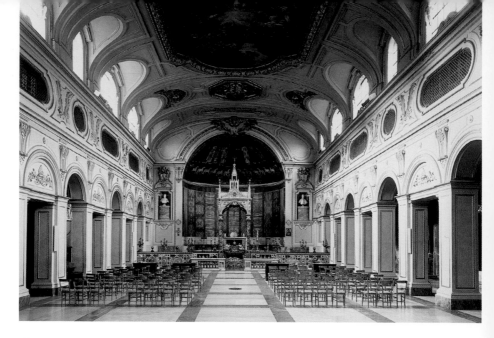

S. Cecilia in Trastevere

S. Cecilia in Trastevere was built in the 5th century, according to legend over the dwelling of Valerianus and his wife Cecilia, who was a Christian and suffered martyrdom under Emperor Marcus Aurelius (reigned 161–180). In the 9th century Pope Paschal I (pontificate 817–824) renovated the building, had the mortal remains of the saint deposited there, and had the mosaics in the apse executed. The portico and the five-story campanile were added in the 12th century. In 1725 Cardinal Francesco Aquaviva undertook to fundamentally redesign the

building; the architect Ferdinando Fuga, designed the entrancing inner court with its decorative flowerbeds and an antique kantharos vase in the center, and also the façade with the cardinal's coat of arms in the gable. The 12th-century portico has been preserved, with its fine architrave bearing a mosaic and antique Ionic columns in pink granite. The interior is in the form of a basilica with a low roof and an apse. The original character was entirely lost in the Baroque conversion, in the course of which the medieval columns were enclosed in pillars. The crypt contains the entrance to the remains of a Roman dwelling that extends under the whole of the church.

Stefano Maderno (1576–1636),
St. Cecilia, ca. 1600
Marble, l 102 cm

Pietro Cavallini (1273– ca. 1321),
The Last Judgment (Detail), End 13th Century
Fresco (following page)

In the *confessio* under the altar lies the marble statue of St. Cecilia that was carved around 1600 by Stefano Maderno. This celebrated masterpiece shows the saint in the position in which she was found when her tomb in the Callistus Catacombs had been opened a year before. Maderno has rendered a cruelly realistic depiction of the pain-ridden body of a woman who had been tortured to death. After she was captured, Cecilia was sentenced to be drowned in a bath of boiling water, but she survived this torture and was finally beheaded. Her martyrdom is depicted in 17th-century frescoes in the former *caldarium* of the ancient dwelling.

At the end of the 13th century Cardinal Cholet of France commissioned the painter Pietro Cavallini to decorate the inside entrance wall and parts of the walls of the nave with frescoes. When the nuns' gallery was inserted in the 16th century, however, the frescoes were moved and some parts were destroyed. The general impression was greatly reduced. Today the frescoes, which are regarded as among the finest surviving works of medieval painting, can be viewed only with special permission. Scenes from the Old and New Testaments appear on the walls of the nave, and the entrance wall bears the fresco of the Last Judgment. Christ is shown enthroned in the center as

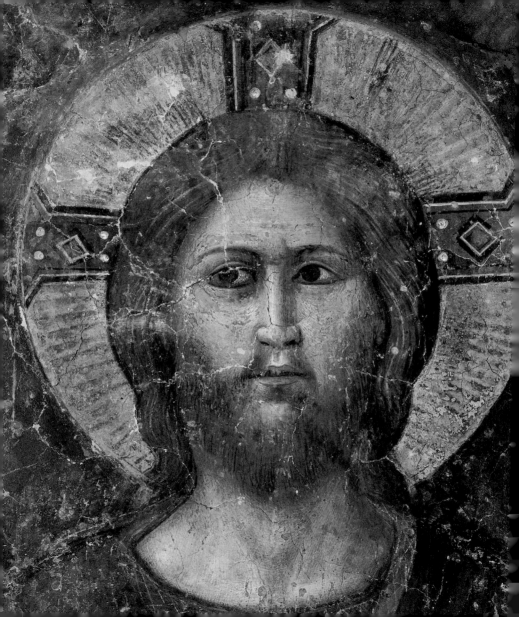

the Judge of the World, against a crimson mandorla, surrounded by the heavenly host. The frontal view of Christ recalls the stern Byzantine tradition, but here Christ is no longer only the severe Judge of the World; the visible wounds of his crucifixion on hands and breast symbolize the sufferings of the Man of Sorrows. Mary, John the Baptist, and the Apostles are seated at the Judgment. Beneath, angels are blowing trumpets and directing the righteous to heaven and the sinners to hell. Among Cavallini's great innovations are his experimentation with perspective, for instance to depict the throne of Christ and the choir of Apostles, together with an expressive use of warm colors and a three-dimensional play of shadows.

S. Maria in Trastevere

The oldest church that is dedicated to the Virgin Mary in Rome is S. Maria in Trastevere. It is a basilica with a Romanesque campanile that Innocent II (pontificate 1130–1143) built to replace an earlier building dating from the 3rd/4th century. It stood on the spot where in 38 B.C. oil was said to have sprung up out of the ground, this miraculous

phenomenon was interpreted as a sign of the coming of the Savior. The medieval façade is adorned with a mosaic frieze dating from the 12th century and depicts the Virgin Mary surrounded by ten holy virgins bearing lighted oil lamps as a sign of their virginity. It was redesigned in 1702 by Carlo Fontana, who added a porch, the balustrade of which is crowned with the figures of saints making sweeping gestures. Inside, twenty-two antique Ionic columns divide the nave from the aisles, rising from bases of differing heights necessitated by their new location. As in the early Christian building that preceded this one, the columns support an architrave and an entablature of antique *spolia*.

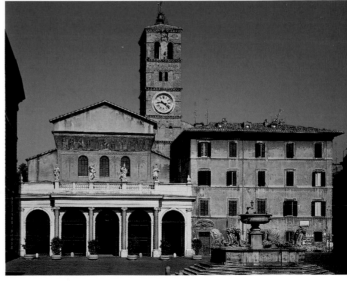

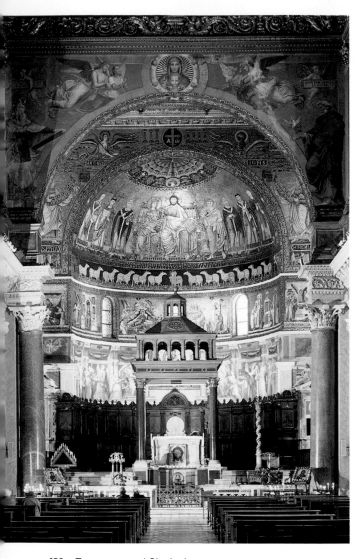

The Mosaics in the Arch and Half-Dome of the Apse

S. Maria in Trastevere owes its fame to the mosaics in the apse. The oldest date from the time of the new building and they cover the arch and half-dome in the apse. They are distinguished by a shimmering gold and a brilliance of color intended to convey the glory of heaven. At the peak of the triumphal arch is a medallion bearing the Greek letters Alpha and Omega to symbolize divine eternity. It is flanked by the seven candlesticks and the Four Beasts of the Apocalypse, identified with the Evangelists in inscriptions. Beneath these are the two prophets Jeremiah and Isaiah. In the half-dome of the apse Mary appears for the first time in Christian art beside Christ on the heavenly throne; she is shown wearing a crown and the magnificent robes of a queen. This was the first monumental depiction of her, and an innovation that reflects changes in belief and devotion; it gave

rise to a new ideal type of Mary as the Queen of Heaven. On the right are depicted the saints Peter, Cornelius, Julius, and Calepodius, on the left are the saints Callixtus, Lawrence, and Pope Innocent II is seen holding a model of the church. The lower frieze of lambs symbolizes the people of God moving towards the Lamb of God. The architectural images at the ends of the frieze are of Jerusalem and Bethlehem, from which the first supporters of Christ were derived.

Pietro Cavallini (1273–ca. 1321),
The Death of Mary,
End 13th Century
Mosaic

The mosaics located in the central field of the apse were created at the end of the 13th century by Pietro Cavallini; and they were commissioned by Cardinal Bertoldo Stefaneschi. They show scenes from the life of Mary. The cycle begins on the triumphal arch with her birth; this is followed by the Annunciation, the Nativity, the Worship of the Magi, the Presentation of Jesus in the Temple, and the Death of Mary. In the center, Mary appears with the Apostles Peter and Paul, while the

patron of the church, Bertoldo Stefaneschi, kneels at her feet with his coat of arms and an inscription giving reference to his donation. The difference from the older mosaics is apparent in the handling of the volumes of the bodies and the natural movement of the figures, for the older mosaics were executed in the rather formal Byzantine tradition. Another new feature is the manner in which space itself has been handled, the figures are no longer set against the foil of a gold ground but they stand in landscapes or inside buildings, and perspective has been used to give some idea of space and distance.

S. Pietro in Montorio

As early as the 9th century a church was founded on the spot where, at least according to legend, St. Peter was crucified. The addition *in Montorio* (on the Golden Mount) to the name came from the golden brown soil on the hill, which in Latin was *Mons aureus*. In the late 15th century the church was given to the Franciscans, and with the support of the Spanish monarchs Ferdinand of Aragón and Isabella of Castile a new building was erected; this had to be restored after fighting in 1849. The architect of the building, which is in the early Renaissance style with a nave flanked by side chapels, was Baccio Pontelli. He also inserted a transept consisting of two great semi circular exedrae before the long choir.

**Capella Borgherini,
Sebastiano del Piombo
(1485–1547),
The Flagellation of Christ, 1518**
Fresco, 515 x 300 cm

As well as the Cappella
Raymondi (second from
left), that was built between
1638 and 1648 to designs
by Gianlorenzo Bernini, the
interior of the church holds
another artistic masterpiece.
In the Cappella Borgherini,
which is the first chapel
on the right, there is an
altarpiece showing *The
Flagellation of Christ* by
Sebastiano del Piombo, who
was one of the great painters
of the High Renaissance
in Rome. After training
in Venice, he was brought
to Rome by the banker
Agostino Chigi to paint fres-
coes in the Villa Farnesina,
where he came to play a
major role as mediator
between the joyous coloring
in Venetian painting and the

powerful expression of Roman art. This
altarpiece – which, like *The Transfiguration
of Christ* in the lunette, was painted for
Cardinal Pier Francesco Borgherini – arrests
the viewer with the boldness of its com-
position, which balances a rich columnar
architecture and powerful depictions of

Christ and the tormentors. Their muscular
bodies recall the works of Michelangelo,
with whom Sebastiano del Piombo was
closely associated.

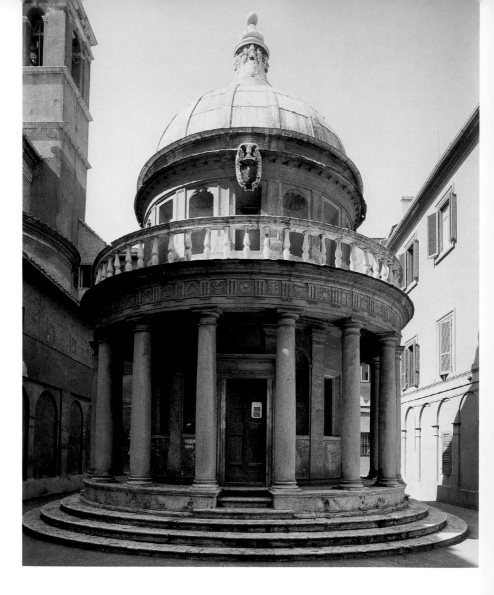

The Tempietto

In 1502 in the court of the monastery of S. Pietro in Montorio, the architect Bramante built an oratory in memory of the martyrdom of the Apostle Peter, whose cross is said to have stood exactly on this spot. This tempietto, one of the pioneering (and much-copied) buildings of the High Renaissance, is distinguished by a truly classical formal vocabulary. Its proportions are balanced and oriented entirely to the human scale, while the clarity of the architectural design lends it a special dignity and monumentality. The model was the round temple of antiquity, and so the leitmotif is the circle, which is regarded as the symbol of cosmic perfection. The building consists of a cylindrical, two-story core crowned by a semicircular dome. The central core is enclosed in a ring of Doric granite columns that rise to the height of the first story. The upper story is set back behind the balustrade, with windows between alternating semicircular and rectangular niches. These light the interior, as does the light that enters through an opening in the dome. Bramante's designs for the enclosing wall were not executed, and today the tempietto stands rather incongruously in a narrow inner court.

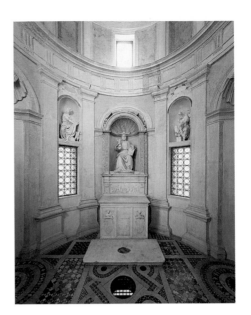

The Interior

Unlike the usual practice in Roman and Christian church architecture, Bramante concentrated entirely on the exterior and refrained from decorating the interior. In his concept the building is purely monumental; it is a Christian memorial in classical form. The tiny interior is white, and in the niches, which are placed exactly between those on the outside, are statues from the school of Bernini. There is access to a subterranean chapel that was built in 1586 by Pope Paul III (pontificate 1534–1549) and marks the place where St. Peter is supposed to have been martyred.

Preservation Rather than Destruction –
the First Antique Collections in Rome

by Jürgen Sorges

For centuries the people of Rome unashamedly pillaged the inexhaustible supply of stones in the antique buildings all around them for their own buildings. In the early 15th century some of these ruins were actually used as dwellings: people lived in the lower stories of the Circus Maximus, the tiers in the Theater of Marcellus, the portico of the Octavia, and the spectators'

The model for the first Renaissance palaces in Rome was modeled on the Colosseum (here the inner court of the Palazzo Venezia, entered from the Viale del Plebiscito)

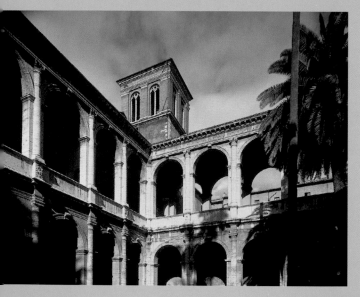

rows in the Stadium of Domitian (on the Piazza Navona). Dozens of limestone grinders turned busily by the Colosseum and on the Forum Romanum, supplying seemingly endless quantities of the urgently needed building material. Surprisingly, most was plundered under Pope Nicholas V. The most intellectual of all the successors to St. Peter, the great patron of humanism, and the most important initiator of the reconstruction of Rome was also the man who destroyed most of the city's ancient heritage. The reason was simple: it was financial. As owners of the land that held most of the ancient buildings, the popes leased it out unhesitatingly for use as stone quarries. The leases actually cost two-third less than the cost of labor and transportation needed for traditional quarries. Nicholas V had 2,300 wagon loads of travertine and marble blocks removed from the Colosseum in a single year; he also plundered the Circus Maximus and the temple of Venus and Roma on the Forum Romanum, and by pulling down the Servian city wall that stood between

the Palentine and the Aventine he eliminated the oldest surviving monument in the Eternal City.

Grinders were still turning all round the Palentine even in Raphael's day. The marble Rome of the Augustan age that had survived above the ground was mercilessly pulverized. Heated to make lime, it entered the substance of new Renaissance palaces and churches as tiles, plaster, and mortar.

One representative of the Holy See and of the Holy Roman Emperor, Enea Silvio Piccolomini from Siena, anticipated the change that was already apparent and wrote:

"O Rome, the contemplation of thy ruins always elevates my mind. Thy past glory shines from the ruins. But thy people are breaking off the marble from the old walls, they are burning the lime out of the costly stone for an inferior purpose. If this criminal activity continues for another three hundred years, not a trace will be left of the most noble things here."

Pope Pius II (pontificate 1458–1464), Piccolomini issued a bull on April 28, 1462 that marked the real beginning of antiquarian scholarship – the preservation of historical monuments, and the work of building up antique collections. For the first time scholarship was not left to chance: people searched out and excavated antique remnants systematically and under direction.

But they were often driven not only by aesthetic passion – works of art had a high market value. Quite a number of cardinals' households in Rome cleared their debts with

Johann Gottlieb Matthäi, Wall with Antique Busts, ca. 1810, etching (colored), Antikensammlung, Dresden

433

The Boy Extracting a Thorn from his Foot (p. 53). The head and hand of the Emperor Constantine and parts of the huge statue of Emperor Nero, which was then wrongly thought to be of Domitian, were placed in the inner court.

There was intense excitement when on April 14, 1585 the sculpture of a girl was discovered almost intact in an antique sarcophagus on the Via Appia. The beautiful girl was quickly named "Cicero's daughter" and a huge crowd surged to the Conservatori Palace where the pagan girl was displayed. Pope Innocent VII quickly realized that this intense interest could encourage non-Christian leanings, and the sculpture was secretly buried again at the Porta Pinciana.

In the next few years the demand for antiquities far exceeded the supply, and towards the end of the 15th century this "antiquities crisis" actually gave rise to new professions – copyists and forgers now ran lucrative businesses. One of the most serious cases came in 1499, when an enterprising Roman invented seventeen entirely unknown antique authors, producing writings for them in Latin and ancient Greek and selling them at high prices.

The waves of emotion settled only when an archaeological sensation occurred towards the end of the century. In Antium south of Rome (now Anzio), a great giant was dug out of the earth. Displayed in the Vatican, the Apollo Belvedere, as the find came to be known, was from then on

antique finds that were turned up in particularly large quantities along the Via Appia and in Ostia. Pope Sixtus IV speedily repealed Pius II's decree protecting these finds and Rome's antique treasures again fell victim to the passion for building palaces and private homes. The work on St. Peter's profited as well.

But in 1471 Rome was also endowed with the first museum of the modern age when finds from all over the city were assembled in the Conservatori Palace on the Capitol. They included the *Capitoline She-Wolf* that had been in the Lateran Palace for centuries (p. 110), and

regarded as the supreme example of antique sculpture. Cardinal Giuliano delle Rovere, the future Pope Julius II bought the statue and later added it to the Vatican collection. The passion for collecting, and the understanding and patronage shown by the pope, were to give scholarship on antiquity its real breakthrough and finally establish the importance of antiquities collections. Then, in January 1506, a group sculpture was found in the ruins of the Baths of Titus; it was remarkable because it was mentioned by the ancient Roman writer Pliny. Under the eyes of Michelangelo, as Ferdinand Gregorovius reports, the work that has been regarded ever since as the most important example of classical art to be found was unearthed, examined, and taken to the Vatican. It was the Laocoön group. The Greek sculptor who carved it is thought to be Agesander, Polydoros or Athenodoros, and on that winter day in Rome he handed his great achievement straight to Michelangelo. Antiquity was reborn!

Carl Becker, Pope Julius II Inspecting the Apollo Belvedere after its Recovery, woodcut from a painting, 1887, Sammlung Archiv für Kunst und Geschichte, Berlin

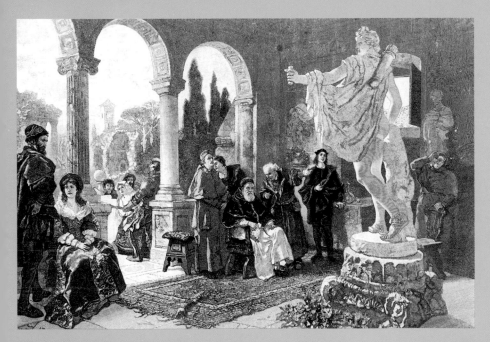

Palazzo Corsini (Galleria Nazionale d'Arte Antica)

At the end of the 15th century, on the slope between Gianicolo and the Tiber, Cardinal Raphael Riario had a palace erected. It has accommodated many famous guests over the centuries, including Queen Christina of Sweden, under whose aegis the palace enjoyed its finest years, and has been endowed with many remarkable works of art and other costly items. In 1736 the property was sold to Cardinal Neri Corsini, who wished to display the extensive library and the collection of paintings that were owned by his family. He commissioned the architect Ferdinando Fuga to renovate the palace completely, giving it its present appearance with a severe façade subdivided by three rows of windows. Since 1883 the Palazzo Corsini has been the property of the state and it now houses the Accademia dei Lincei. The first floor holds parts of the Galleria d'Arte Antica, a collection that was formed in 1895 by combining the collections of the Princes Corsini and Torlonia. The main part consists of 17th and 18th century European painting.

La Farnesina

Outside the gates of Rome, on the bank of the Tiber and opposite the banking quarter, Agostino Chigi, a prosperous banker who was the financier of Pope Julius II and Pope Leo X, had a villa built by the Sienese architect Baldassare Peruzzi between 1507 and 1511. It was inspired by descriptions of villas in antique poetry. Chigi, who was one of the wealthiest and most cultured personalities in Rome, wanted a refuge where he could devote himself to leisure pursuits and literary discussion. He was an expert on Greek literature, a writer himself, and also a generous patron of the arts; he set up his own printing works to publish texts by classical Greek writers. In his villa he hosted humanist discussions, festive banquets and theatrical performances, numbering great scholars and famous artists among his guests. He commissioned the leading artists of his time to decorate the villa, among them the young Raphael and Sebastiano del Piombo. After his death in 1520, however, the property remained empty and it was plundered when Rome was attacked in 1527. Today it bears the name of the man who acquired it in 1580, "La Farnesina," the little palace of Alessandro Farnese.

In 1927 it became the property of the state and since 1944 it has belonged to the Accademia dei Lincei, an academy of science founded in 1603; it houses a collection of prints and drawings. The U-shaped building with its clearly defined sections stands in direct relation to the surrounding terraces and gardens, which are geometric in design, and from which one could once see the ruins of Rome and the more recent buildings in the city. However, the present appearance of the palace, with the exterior plastered, is very unlike its original appearance, for Peruzzi covered the two-story façade with vermiculation and painted it in a monochrome hue with telamones (columnar supports in the form of a man's figure) and plant motifs.

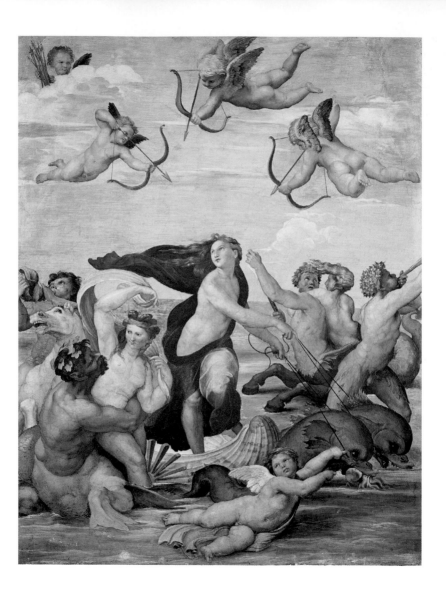

**Sala di Galatea,
Raphael (1483–1520),
The Triumph of Galatea, 1513**
Fresco, 295 × 225 cm

Beside the loggia stands the room that is known by the name of Raphael's fresco, *The Triumph of Galatea*. The fresco is one of the highpoints of Renaissance classicism and, according to the artist himself, was not painted from a model but according to his notion of ideal beauty. The composition is a play of diagonals, with the center dominated by the beautiful sea nymph Galatea and her red cloak. She is surging through the waves in a vessel drawn by dolphins and surrounded by figures rising and twirling in exuberant movement while above cupids shoot arrows. But Galatea has eyes only for the Amor of platonic love, who has left his arrows in their sheath. Her virtue is praised because she preferred spiritual love to physical love and rejected the wooing of the one-eyed Cyclops Polyphemus, with his huge nose and shaggy temples shaded by acorns.

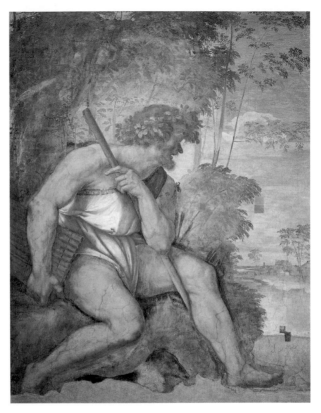

**Sala di Galatea, Sebastiano del Piombo
(1485–1547), Polyphemus, 1512**
Fresco

The grotesque figure of the giant serenading Galatea with his reed flute had been executed a year before Raphael's scene by the Venetian painter Sebastiano del Piombo. This fresco stands next to Raphael's.

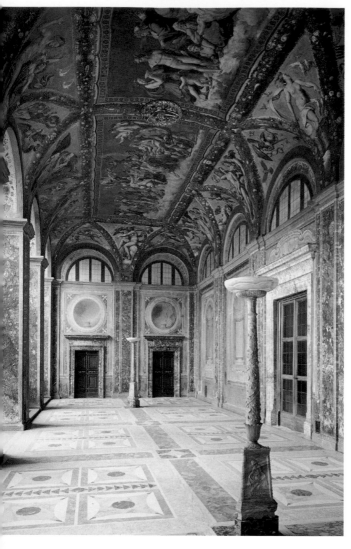

**Loggia, Raphael (1483–1520),
Cupid and Psyche, 1517**
Fresco, 19.3 × 7.5 m

At the request of Chigi the great entrance loggia to La Farnesina was decorated by Raphael and his best pupils with episodes from the myth of Cupid and Psyche. Raphael conceived the room in the form of an open pergola, and this was encased in rich garlands of fruit and flowers by his assistant Giovanni da Udine. The ceiling contains two *trompe l'oeil* frescoes that were painted to have the appearance of tapestries; they depict the deliberations of the gods on the subject of whether they should admit Psyche to Olympus and the ensuing nuptials of Cupid and Psyche. Other scenes from the myth are to be seen in the domes and pendentives. Presumably the subject was chosen in reference to Chigi's forthcoming wedding to his mistress Francesca Ordeaschi; as they already had four children, they were being urged to marry by Pope Leo X.

Baldassare Peruzzi (1481–1536), Salone delle Prospettive, Trompe l'Œil Wall Painting showing a Landscape, 1515–1516
Fresco, 905 × 763 cm

On the upper floor of La Farnesina is the Salone delle Prospettive, the place where the wedding of Agostino Chigi and his mistress was celebrated. Baldassare Peruzzi, who was famous for his stage sets and theater decoration, created a perfect spatial illusion in the room, giving the impression that it opens outward. The walls dissolve into a deceptively realistic monumental colonnade giving a view of the countryside around Rome and the most famous buildings in the city, but the whole is a painted illusion. Even the pattern on the real floor is continued in the painted loggia. Above the columns runs a frieze that is divided by herms into individual fields in these there are scenes from Ovid's *Metamorphoses*. For the fresco above the fireplace Peruzzi chose the appropriate subject of *The Forge of Vulcan*.

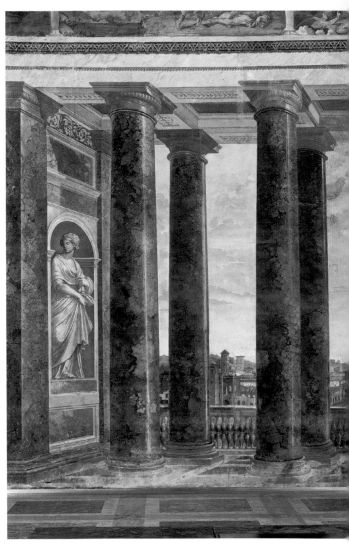

Sala delle Nozze, Sodoma (1477–1549)
The Nuptials of Alexander and Roxana,
1511/1516–1518
Fresco, 460 × 670 cm

The adjoining room is the bedroom of Agostino Chigi, which the Sienese artist Giovanni Antonio Bazzi, known as Sodoma, was commissioned to decorate. Using descriptions of antique paintings by the Roman writer Lucian, Sodoma painted scenes from the life of Alexander the Great. Probably the finest of the frescoes is that on the rear wall showing *The Nuptials of* *Alexander and Roxana*. We see a bedroom opening between columns on to a landscape. In the center stands the mighty Alexander, turning to the virgin Roxana, the most beautiful of the daughters of Darius, the king of Persian. On the right-hand wall Sodoma depicted *The Meeting between Alexander and the Family of Darius*, while to the left of the entrance we see Alexander in his youth, taming his horse Bucephalos. Again the choice of subjects reflects Chigi's passion for the golden age of antiquity, and his desire to recreate it in his villa.

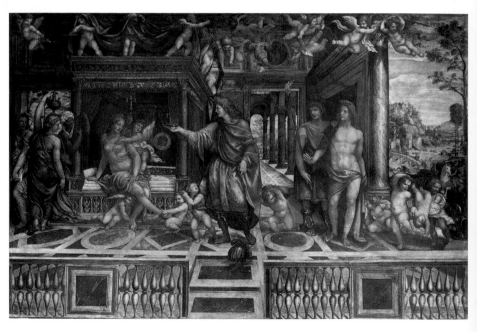

Villa Doria Pamphilj

On a site acquired in 1630 and later extended with further purchases, Cardinal Camillo Pamphilj, nephew of Pope Innocent X, had a villa laid out and built under the direction of Alessandro Algardi, a sculptor and restorer of antiquities. Unlike similar villas of the time, it was not intended as a museum for a collection of antiquities that already existed; once the villa was built, Camillo bought specific antique statues, reliefs and smaller artifacts to adorn it. The centerpiece of the architecture is the block-like Casino del Bel Respiro, which was inspired by the classical architecture of Palladio (1508 –1580). It stands on a high base and towers over the surrounding garden, which is laid out in geometric forms and contains statues and ancient sarcophaguses. The outside walls are covered with antique statues and busts, ancient reliefs and contemporary reliefs in the antique style, on the model of other Roman palaces and villas. After the death of the last male Pamphilj in 1760 the name and assets were merged with those of the Doria family, who sold the gardens to the City of Rome in 1963 and the Casino to the Italian State.

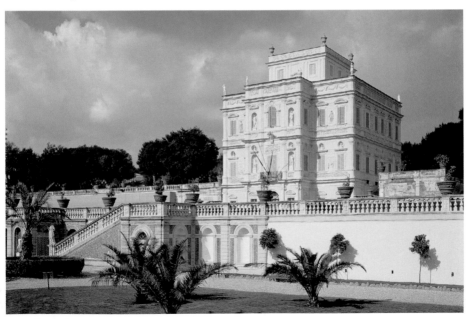

The Borgo

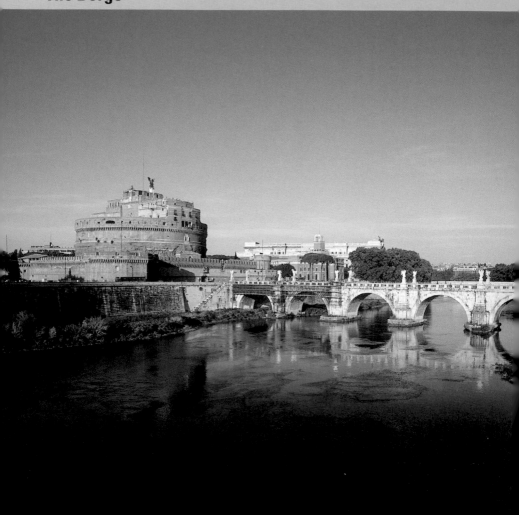

Before 1936, visitors to St. Peter's had to wind their way through the dark, narrow alleys in the medieval district of the Borgo before unexpectedly emerging onto the vast, light-filled square in front of the cathedral. Earlier visitors to Rome described this walk as one of the most impressive experiences they encountered in the city.

Under the protection of the Castel Sant'Angelo, the district had gradually become a center of pilgrimmage since the early construction of Old St. Peter's. From the 8th century onwards, northern Europeans—particularly the Saxons, the Langobards, and the Franks—had set up hospices for pilgrims. In 847, during the papacy of Leo IV, the district was devastated by a terrible fire that was only brought under control through a miracle, brought about by the pope giving his blessing from the loggia of St. Peter's. Afterwards he had a fortification built and the district cleaned up. It was eventually named after him, Città Leonina.

After being incorporated in the municipal administration in 1586 it finally received the name Borgo, a derivation of the Latin *burgus*, meaning castle. Thanks to its proximity to St. Peter's, this area had enjoyed a

steady improvement long before that point, but this was brought to an abrupt end during the Sack of Rome in 1527. Although the devastation wrought by the German soldiers caused the area to decline, its underlying appealing character survived until it was destroyed by a wave of "urban renewal" between 1936 and 1950. To create a wide access road to St. Peter's, Mussolini

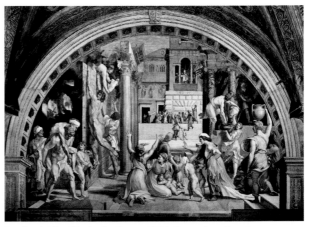

Raphael, The Fire in the Borgo, 1514, fresco, length at base ca. 670 cm, Stanza dell'Incendio di Borgo, Musei Vaticani, Rome

had large areas of the old quarter demolished. The broad boulevard with the Via della Conciliazione (Street of Reconciliation) was intended to be a symbol of the reconciliation between the Holy See and the Italian State that was sealed in the Lateran Treaties of 1929.

View of the Castel Sant'Angelo and Bridge

The Borgo

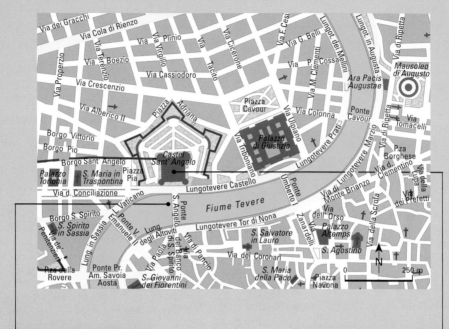

Ponte Sant'Angelo, p. 447

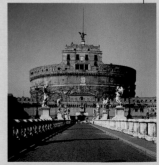

Castel Sant'Angelo, p. 447

Ponte Sant'Angelo and Castel Sant'Angelo
(illustration on the following page)

With its great swinging arches, of which the three in the center are original, while the bridgeheads at the sides had to be replaced in the 19th century, the Ponte Sant'Angelo is regarded as one of the finest ancient bridges in Rome. Built by Emperor Hadrian in A.D. 134 to give triumphal access to his mausoleum, the bridge was initially named after his family, Pons Aelius. Only when the Baroque sculptor Bernini and his associates adorned it with a new balustrade and ten figures of angels for Pope Clement IX (pontificate 1667–1669) did it become the Ponte Sant'Angelo, the Bridge of Angels, in name and in fact. The stone angels bear the instruments of the suffering of Christ and were intended to line a symbolical Way of the Cross leading the pilgrims to their goal, St. Peter's. All the angels have their backs to the river and so face the pilgrim; their robes seem to be blown about by the wind, and the instruments of Christ's Passion are presented with all the intense emotion of the late Baroque. The two sculptures by Bernini's own hand (the angel with the crown of thorns and the angel with the inscription on the Cross) pleased the pope so much that he had them replaced with copies; the originals are now in S. Andrea della Fratte. By 1534 the statues of the Apostles Peter and Paul had been placed at the southern end of the bridge, symbolic guards watching over the bridge after the Sack of Rome. The inscriptions on the bases of these two statues welcome arrivals and warn against presumption, with St. Paul adding impressive emphasis to this with his raised sword.

Across the Ponte Sant'Angelo the route leads to the castle. It has played an important part in the history of Rome in every age and its architecture consists of layers from the different periods that are characteristic of the city's building history. Originally having been built as a mausoleum for the Emperor Hadrian, it was transformed into a fortified castle in the Middle Ages and later still converted into a residence for the popes in the Renaissance. But it owes its name to a miracle. When in A.D. 590 the city was devastated by a terrible plague that threatened to wipe out the population, the Archangel Michael appeared to Pope Gregory the Great (pontificate 590–604) during a penitential procession. The Archangel sheathed his bloody sword as a sign that the anger of God was appeased and that the plague had run its course. In gratitude Pope Gregory had the castle crowned with the figure of an angel to recall the miracle. Today a bronze angel by Peter van Verschaffelt, executed in 1752, stands on the upper terrace; his wings are outstretched and he is sheathing his sword in accordance with the legend. This figure replaced the older marble angel by Raffaello da Montelupo which was executed in 1544, and is now displayed in the Cortile dell'Angelo.

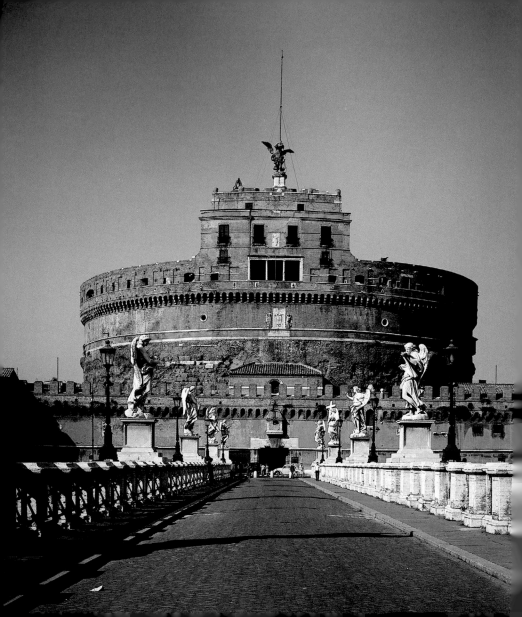

The Castel Sant'Angelo (detail below right)

Owing to its long history, the Castel Sant'Angelo is an extremely complex structure with strong contrasts in its architecture, sculpture, and painting. From the outside it looks like a massive fortress, surrounded by a square wall with battlements and bastions at the corners. The cylindrical structure that rises above this has in its core the mausoleum built by Hadrian for himself and his future generations. Originally a cylindrical structure 21 m (69 feet) in height and with a diameter of 65 m (213 feet) it rose from a high square base of tuff and travertine blocks with sides 86 m (282 feet) long. This cylindrical structure probably held statues and enclosed the burial chamber. The structure culminated in a round temple crowned by a bronze quadriga (four-horse chariot) with the statue of the emperor. Inside, a spiral ramp that can still be used today, led to the burial chamber. Just under two centuries later the mausoleum was incorporated in the Aurelian city wall and it was strengthened to become a fortress. In the 6th century it fell into the hands of the Goths, and in the Middle Ages served as a citadel and a prison; in dangerous times it was a refuge for the popes who could reach the castle from St. Peter's down a roofed passage called the *passetto*. Between the 10th and 14th centuries the Castel Sant'Angelo was the only fortress in Rome and it practically dominated the city, with the most powerful princes fighting for control of it. The popes demanded the return of the castle as one of the conditions for their return from Avignon and it finally passed into the hands of the Holy See in 1379. After the last uprising against the papacy, conversion work was started under Nicholas V (pontificate 1447–1455) and his successors, who modernized the fortress to make it, as the papal residence, both safer and more comfortable. The castle was enclosed in a wall of fortifications with four bastions at the corners; a moat was dug and the *passetto* was fortified. A brick superstructure was added to the cylindrical building in several phases to house the magnificent papal apartments. Today these are used as a museum to display sculptures, paintings, and weapons.

The Apollo Room, Perin del Vaga (1501–1547), 16th Century

Fresco

Following the vaulted passage leading to the inner core of the Castel Sant'Angelo, we reach the Cortile dell'Angelo, a court named after the statue of an angel by Raffaello da Montelupo that once crowned the building. Opposite the entrance lies the chapel of Leo X (pontificate 1513–1521), the façade of which is said to have been designed by Michelangelo Buonarroti. The door on the left leads to the Apollo Room, which Perin del Vaga and others decorated with frescoes in the 16th century. Based on models found in Emperor Nero's Domus Aurea, a vast palace complex, they depict the gods of Olympus with putti, strange creatures, flowers and fruit. There are plant and figural ornaments and landscape, the whole blending into an ensemble in the antique style. From here we reach the Sala della Giustizia (Chamber of Justice), which is named after the fresco of the Archangel Michael by Domenico Zaga (1545–1549). The Archangel is shown holding the symbols of justice. The route continues into the residential apartments of Pope Clement VII, who took refuge in the castle for six months during the Sack of Rome in 1527 and was thus able to withstand Charles V's siege.

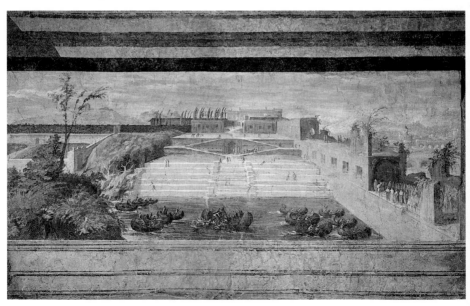

Sala Paolina

One of the finest rooms in the Castel Sant'Angelo is the one on the upper floor named after Pope Paul III (pontificate 1534–1549), the Sala Paolina; this is also known as the Sala del Consiglio, the Council Chamber. It was transformed into an opulent ensemble with magnificent frescoes and painted *trompe l'oeil* architecture by Perin del Vaga and Pellegrino Tibaldi. In two great cycles of paintings on the ceiling and the long walls, Vaga sang the praises of the policy pursued by his client, praising his virtues by – in reference to the pope's two names – drawing parallels with the lives of St. Paul and Alexander the Great, who were held to symbolize wisdom and justice. Depicted on the narrow walls are the two "proprietors" of the castle, Emperor Hadrian and the Archangel Michael. While Hadrian, the founder of the monument, is shown handing over his realm to Paul III in his open left hand, the Archangel is storming into the room as the guardian of justice. Below the cornice golden letters read: "Everything in this fortress that was once derelict, inaccessible

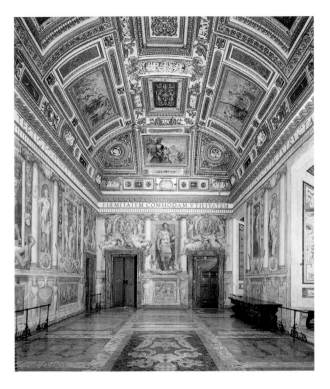

and falling into ruin has been renovated and restored thanks to Pope Paul III; it has been decorated in the endeavor to achieve stability and soundness, comfort, function, and easy elegance." A Greek inscription on the ceiling also proclaims: "Paul III, Pontifex Maximus, transformed the upper section of the tomb of the Divine Hadrian into a wonderful princely palace."

Operation Rome 2000

by Jürgen Sorges

The fundamental changes brought about by the fall of the Berlin Wall on November 9, 1989 rapidly affected Rome's politicians, urban planners, and cultural authorities. For after a glance at the building boom this gave rise to in Berlin (and also developments in London and Paris), and in view of the expected European Union, Rome's city councilors felt impelled to take immediate action if Rome was not to miss out. The planners were helped by four factors that contributed to the success of the Operazione Roma 2000 – Operation Rome 2000. Firstly, Rome was the home of the Treaty of Rome of 1957, which laid the basis for European integration; this gave it a particular historical significance and helped to open the coffers in Brussels. Secondly, the Italian parliament had passed a law on urban planning in the early 1990s giving preference to building projects in Rome over other Italian cities. Although the "capital city law" aroused much ill-feeling and harsh criticism, the decision in favor of Rome did have very positive effects, enabling investment totaling at least three billion Euros to be undertaken.

Thirdly, the coming Holy Year 2000 also opened the coffers of the European Community, and also of numerous countries and churches. The Palazzo Farnese, home of the French embassy, for instance, underwent elaborate renovation, and from 1999 was open to the general public on certain days. The gardens and the Villa Medici near the Spanish Steps, the home of the French Academy, the oldest art academy in Rome, have held exhibitions regularly since then, opening doors that were once firmly closed. America, Germany, Spain, and the United Kingdom have made important

The symbolic opening of the Porta Santa (Holy Door) in St. Peter's at the beginning of Holy Year 2000

contributions. Fourthly, there was a new mayor. Initially dismissed as an "ineffectual green," Francesco Rutelli was a fortunate choice, for Rome now had a young and energetic mayor who was strongly committed to environmentalism and yet, as a native of Rome and a trained town planner and architect, was keenly aware of the practical and economic needs the capital faced.

Everyone is profiting from Rutelli's programs, such as Roma Verde (Green Rome), which improved and extended the city's green lungs. Cycling tracks and paths for joggers have been laid out, park benches installed, and even rickshaw drivers are now offering their services in the park of the Villa Borghese. The public transport system, long despised, now has new underground stations (like the convenient Cipro/Vatican Museums stop), and the trains run on time. Moreover, the city has treated itself to a brand new fleet of very comfortable trams and buses. Even the telephone system, for decades the Achilles' heels of Rome's infrastructure, is working beautifully. With their Cento Piazze program to revive one hundred public places in the historical center and the inner periphery, Rutelli's team has won the support of Romans and tourists alike. Not only has the original paving on the Piazza before the Pantheon been restored (allowing spectacular archaeological finds to be uncovered), but also street crossings that used to be choked with traffic, like the Piazza Ungheria and the Piazza Regina Margherita, have been transformed into pleasant meeting places,

greatly improving the quality of city life. That the main project — a tunnel under the Castel Sant'Angelo to ease the flow of Rome's road traffic — could not be finished in time for the Holy Year owing to the many conditions imposed by the need to protect historical buildings and

Pope John Paul II opens the Holy Year 2000 on Christmas Eve 1999

archaeological sites, hardly surprises those who know Rome. The plan is that the traffic will run through a tunnel here, taking much of the strain off the inner city.

The second celebrated project, a combined concert hall and congress center designed by Renzo Piano in the northern district of Parioli, has been open to all visitors to Rome since the end of 2001. The Chiesa del Giubileo, the Jubilee church in the otherwise unremarkable district of Tor Tre Teste, which was designed by internationally renowned architect Richard Meyer, was finished in 2000. The use of sand blasting has not only given the façade of St. Peter's a face lift for the Holy Year, but has also brought to light again the original colors used by Carlo Maderno in 1614. The ancient Porta Maggiore and the

façades of the Capitoline Museums are also bright and shining, and the latter have actually been given a new and spectacular exhibition space on the Via Ostiense in the oldest power station in Rome, which has been renovated for the purpose. There is now a six-story car park with a shopping mall built on the fringe of the Vatican city, and even the corridor from the Vatican to the Castel Sant'Angelo, which for centuries served the popes as a means of escape, was opened to the public in 2000 after fourteen years of restoration work.

Altogether, ancient Rome has profited greatly from the building boom. Music lovers were delighted by plans for the summer opera concerts, which had to be moved to Rome's 1960 stadium for a time, to be returned to the Baths of Caracalla. Millions were spent restoring this venue with its elegant marbling, and it would have been the ideal place to listen to Luciano Pavarotti and company on a warm summer night under an open sky. Unfortunately, serious structural damage to the baths was discovered during the restoration and they can no longer be used for concerts.

Giovanni Ascarelli, Maurizio Maciocchi and Danilo Parisis, New Underground Station at the Vatican Museums

Rome's ancient harbor in Ostia, the docks built by Emperor Claudius (reigned 41–54) and Emperor Hadrian (reigned 117–138) have been excavated at huge cost and now stand as an archaeological park, the Porto dei Porti

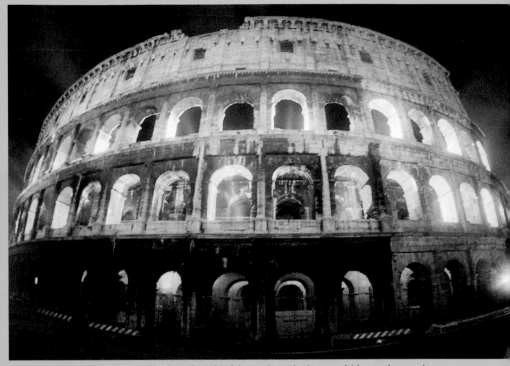

At the beginning of the third millenium the role of the ancient Flavian amphitheater has again changed. The Colosseum now serves as a monument to the preservation of human rights, for on the initiative of the United Nations, it is bathed in golden light for 48 hours whenever a person condemned to death is pardoned, anywhere on earth.

(Harbor of Harbors), for the public to see. The whole area around the garden of the Villa Borghese entices visitors as the Parco dei Musei (Museum Park), offering the delight of incomparable art treasures, especially in the Galleria Borghese, which has been renovated at great expense: "Only those who know that our restorers and many of us here have worked through ten winters with no heating and sometimes without electricity, indeed that many of us spent the night here for weeks on end, to complete the renovation work on time, will fully appreciate the justifiable pride of the Romans in this gigantic work of reconstruction."

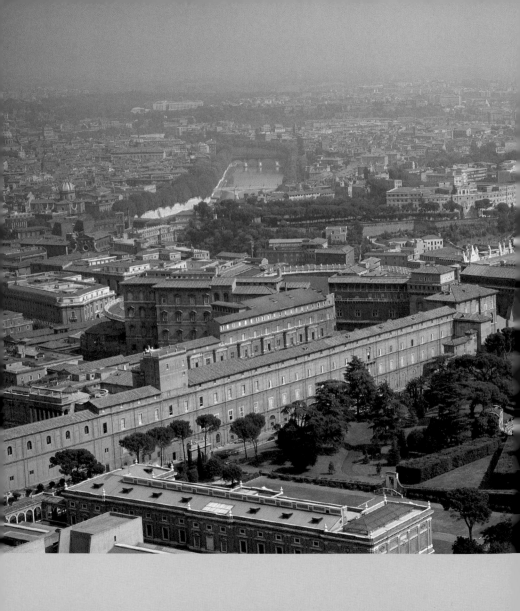

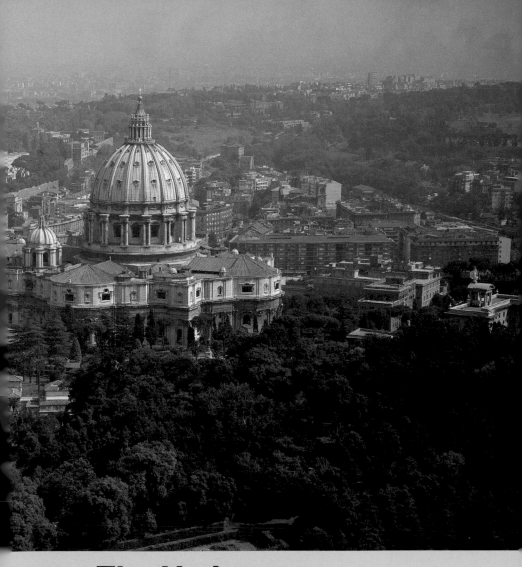

The Vatican

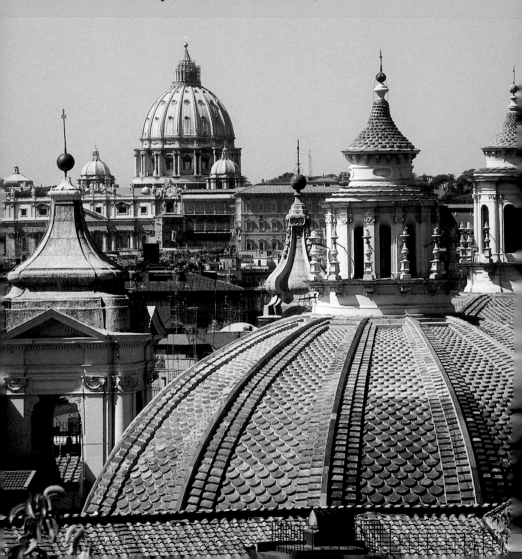

The Vatican City (Città del Vaticano)

Historically, the Vatican – the name derives from the hill of the same name on the right bank of the Tiber – is part of the Borgo district. The tall obelisk on St. Peter's Square still recalls the Circus of Nero to the south of the Vatican Hill, that has gone down in history as the location of countless gory spectacles. Many Christian martyrs died a cruel death there, including, according to tradition, the Apostle Peter, who is said to have been buried in the immediate vicinity. This gave the area a new significance in the Christian era and after his conversion to Christianity the Emperor Constantine had a church built over what was believed to be St. Peter's grave; that church was demolished in the early 16th century to make way for a grandiose new building, which in time would become the St. Peter's we know today, the Mother Church for all Roman Catholics.

In time the Vatican became the seat of the popes, for the official papal residence was moved from the Lateran to the Vatican in the 14th century after the papacy had returned from Avignon (1377). In order to accommodate the papal court and the Curia, the

View from Pincio to the Vatican

Previous double page: the Vatican City and St. Peter's from the air

small fortress built by Nicholas III (pontificate 1277–1280) had to be enlarged and through many extensions, renovations and adaptations, which went on until the 19th century, one of the largest and most complex set of palace buildings in the world evolved. From here the popes ruled the once extensive Church State, which came to an end only with the unification of Italy in 1870. Not until February 11, 1929 were Church and state in Italy reconciled, when the present borders of the Vatican were laid down in the Lateran Treaties. The Vatican is subject to the sovereignty of the pope. At less than half a square kilometer (0.2 square miles), it is the smallest state in existence. Parts of the papal palace now house the Vatican Museums, which hold what is probably the greatest art collection in the world.

Giovanni Paolo Panini, Cardinal Melchior of Polignac Visiting St. Peter's in Rome, 18th century, Musée du Louvre, Paris

Behind the Leonine Wall – the Vatican State

by Jürgen Sorges

Giovanni Battista Piranesi, View of the Vatican Basilica with the Wide Portico and the Adjacent Piazza, etching, 1775, later colored, sheet 120 of the Vedute di Roma *series*

The *Ager Vaticanus* (Vatican district) was named after an Etruscan deity to whom it was once dedicated. For a long time it lay unnoticed outside the gates of ancient Rome. But with the martyrdom of St. Peter, who was crucified and buried here, the area became the focus of interest for the Bishops of Rome; the first church of St. Peter was built on this spot from about A.D. 319; it was dedicated in 326. It may be assumed that a palace stood here by around 800, as Charlemagne slept here during his coronation as Holy Roman Emperor. After the popes' return from their "Babylonian exile" in Avignon in 1377, Pope Gregory IX gave up the oldest papal residence, the Lateran Palace, which had become uninhabitable, and moved to the new Vatican Palace near the cathedral of St. Peter. Popes Nicholas V, Julius II, Leo X and finally Paul III all made their contributions to the palace, making it the monumental residence it still is today. The building was also used for secular purposes, namely the government of the Church State. After the conquest of Rome in 1870, Pope Pius IX (pontificate 1846–1878) went into voluntary exile in the Vatican Palace and was never to leave it again.

The territory within the forbidding Leonine Wall measures a scant 44 hectares; it is only 1,025 by 850 m (3,362 by 2,788 feet). But the Vatican also owns property outside the Vatican, including the seat of the *Ufficio Propaganda Fide*; diplomatic representations and nunciatures all over the world; the summer residence of the popes in Castel Gandolfo south of Rome; and the site of the new Vatican television transmitter on Via della Conciliazione, within sight of St. Peter's. Activities within the fourteen hundred rooms in the Vatican

Palace have always been shrouded in mystery. The veil is lifted only on special occasions, such as during the election of a pope, when once again black or white smoke can be seen to issue from the chimney of the Sistine Chapel, thus signifying a successful or unsuccessful round of voting for the next Bishop of Rome. The entrances to the little state – there are only three – are closely watched by the Swiss Guard. People are allowed to enter only if they are attending an audience with the pope in the audience chamber designed by the 20th-century architect Pier Luigi Nervi and named after Pope Paul VI. *Permessi* (special permits) are needed to enter the wings of the Palace that are not part of the Vatican Museums. So it is not surprising that even now, at the beginning of a new millenium, many Romans turn to take a closer look if a car goes past with the characteristic SCV number plate, for it will be one of the official fleet of vehicles of the Stato della Città del Vaticano (the State of the Vatican City). If the letters are followed by the number 1, the pope himself could be sweeping past in his *macchina blindata* (armored car).

Conclave after the Death of Pius IX (7 February 1878) and the Election of Leo XIII (20 February 1878), contemporary woodcut, colored later

The citizens and staff of the Vatican have traditionally enjoyed special status in Rome. They are envied both for their safe and privileged jobs, and also for their reputation, acquired through generations, for being the most efficient bureaucrats in the world. The Holy Father needs a staff of only 3,000 to administer 300,000 parishes worldwide. In fact, however, Christ's representative on earth has, beside the cardinals, a multitude of bishops, priests, monks and nuns who are not included in the official statistics. Beside his representational duties, the pope and his staff have to deal with numerous questions of faith as well as everyday problems. As Bishop of Rome, Pope John Paul II had to deal with the annual water bills or the problems of access to the Vatican multi-story car park (called mockingly by the Romans "God's Parking Lot"), which have to be settled with the municipal authorities in Rome. Time is short. Encyclicals have to be composed, printed and bound (in the Tipografia Poliglotta, the biggest printing works in the world); appointments made and resignations accepted; and questions of faith clarified. A whole host of journalists follow every statement, however minor, by the pope, for if he should express his deep regret at an unfortunate development in the world, you may be sure that the international media will be aware of it within minutes. One of the biggest problems in recent decades has been the training of young priests, for only one-third of all the parish posts is currently filled.

Another important field of activity is that of communication. The periodical *Osservatore Romano* is obligatory reading for all correspondents in Rome, and Vatican Radio and the new Vatican TV channel, whose programs can be received worldwide, are of no less importance.

The Vatican was also quick to see the enormous potential of the Internet and to take advantage of this rapid means of communication and news presentation. In the early 1990s the Vatican was one of the very first institutions to be officially represented on the World Wide Web, with an elegant homepage. Finally the Vatican Library, founded around 1450 by Pope Nicholas V, must be mentioned. Although the Borgia popes, often in need of money, sold a large part of the first collection – and therefore

Burning the Ballot Papers During the Conclave to Elect Leo XIII (February 20, 1878), contemporary woodcut

unwittingly helped to spread the new knowledge and ideas of the Renaissance throughout Europe – only a century later the library had regained its unique status worldwide. In 1611 the Vatican Archive, which is still celebrated today, evolved from it. Extremely valuable parchment manuscripts are stored in this archive, and probably many secret or "poison pen publications," as well – in his bestselling novel *The Name of the Rose* Umberto Eco, the Italian Professor of Semiotics, imagined a lost second volume on poetics by Aristotle to be such a work. The bibliophile treasures are stored, secure from nuclear attack, in the cellars of the Vatican Palace, where they fill fifty-four kilometers (28 miles) of shelves. In the year 2000 John Paul II decreed that scholars may now have access to all the records in the archive up to the end of the pontificate of Pius X (who died in 1914), and since then the rush to peruse its historical documents has never ceased. So we may soon expect some spectacular reassessments of historical issues that were long thought to be settled. And there may be many a "news item," many centuries old, from the rich store of private records, going back almost 2000 years, on the inner workings of the governing institutions of the Catholic Church; withheld

Pope John Paul II will go down in history as "the traveling pope." No pope before him had visited so many of the faithful all over the world. On June 23, 1996 Wojtyla, seen here in his "pope-mobile," celebrated mass in the Olympic Stadium in Berlin.

from public scrutiny for far too long, many of these documents may provide a fascinating, even startling insight not only into the Church itself but also into Western history.

The Vatican City

The Vatican Museums, p. 492

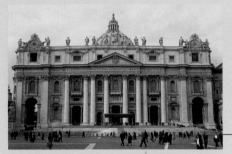

St. Peter's, p. 468

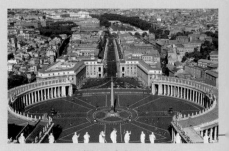

St. Peter's Square (Piazza S. Pietro), p. 466

The Vatican Palace p. 488

Via della · Melloria · Via Cipro · Via Angelo Emo · Via d. Ammiragli · Viale · Via Vaticano · Viale Vaticano · Via Aurelia · Via Nicolò V · Via · Via Villa Alberici · Viale · Gregorio VII · Crocifisso · Aurelia · Via del · Via di Porta · Cavalleggeri · Cavalleggeri

(M) CIPRO · Piazza S. Maria Via Candia delle Grazie · Via Tunisi · Via Vaticano · Viale · Bastioni di Michelangelo · Viale di Michelangelo

Pinacoteca Vaticana · Pontificia Accademia d. Sienze · Musei Vaticani · Via Pio X · Cortile del Belvedere · Via del Belvedere

Palazzo del Governatorato · Cappella Sistina · Collegio Etiopico · Radio Vaticana · Stazione Ferroviaria · Tribunale · Sagrestia · Basilica di S. Pietro · Piazza S. Pietro · Aula d. Udienze · Pal. d. S. Uffizio · Largo Porta Cavalleggeri · Galleria Principe Amadeo Savoia Aosta · Via delle Fornaci · Viale delle Mura Aurelia · Piazza di S. Maria alle Fornaci

Via Germanico · Via Ottaviano · Via dei Gracchi · Via Cola di Rienzo · Via Boezio · Piazza del Risorgimento · Via Crescenzio · Via Properzio · Via Alberico II · P.za A. Capponi · Via di Porta Angelica · Via D. Mascherino · Borgo Vittorio · Borgo Pio · Via dei Corridori · Borgo Sant' Angelo · Palazzo Torlonia · Piazza Pio XII · Via d. Conciliazione · Via Paolo VI · Borgo S. Spirito · S. Spirito in Sassia · Via de' Penitenzieri · Lung. in Sassia · P.za della Rovere · Salita di S. Onofrio · Via del Gianicolo

0 250 m N

St. Peter's Square
(Piazza S. Pietro)

Almost every visitor to the Vatican State goes first to St. Peter's Square (Piazza S. Pietro), which is one of Bernini's finest creations; the French novelist Stendhal called it "the art of perfection." In 1656, when Bernini was commissioned by Alexander VII to give the square in front of St. Peter's worthy form, he found a large rectangular court, most of which was still unpaved. Leading to the neighboring district of Borgo, it was unadorned except for a fountain and the Egyptian obelisk that Domenico

Fontana had erected in 1586. Both had to be taken into account in the plans. Similarly, the pilgrims still had to be able to look straight at the balcony from which the pope still gives his blessing *urbi et orbi* (to the city and world) to this day.

Bernini designed a masterpiece consisting of two conjoined open spaces. The first (the Piazza Obliqua) is in the shape of an ellipse formed by covered colonnades consisting of four rows of huge Doric columns; these colonnades open out like huge embracing arms symbolizing the Mother Church. There is a wide opening in the center through which motor vehicles can pass and two narrower openings for pedestrians.

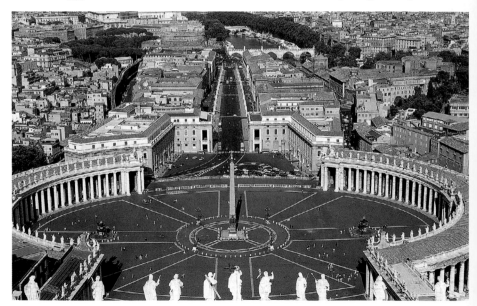

Aedicules mark the center of the two semicircles and the transitions to the adjoining wings. White strips of stone set into the paving direct one's gaze to the center of the square, where the obelisk is mounted on the backs of four bronze lions. Traditionally, this obelisk is meant to represent the link between antiquity and Christianity, for the ashes of Caesar are supposed to rest at its foot and a relic of the Holy Cross to be hidden in its tip. At both sides are two high fountains with huge granite basins, to the right and left of which the two focal points of the ellipse are marked with discs of marble. Seen from these points the rows of four columns in the colonnades look like a single row. The second main space, the Piazza Retta immediately in front of St. Peter's, forms a trapezoid that grows wider towards St. Peter's, thus optically lessening the huge breadth of the façade. The building on the right contains the entrance to the Apostolic Palace, which leads to the Scala Regia, the ceremonial flight of steps designed by Bernini.

The Coat of Arms of Alexander VII on the Colonnade

The Piazza is like a festive stage on which the pope celebrates Pontifical Mass at the major church festivals. A host of statues – in total one hundred and forty saints, martyrs, popes, and founders of religious orders – welcome the pilgrims from the balustrade of the colonnades, which are 17 m (56 feet) wide. His coat of arms and inscriptions are reminiscent of Pope Alexander VII who commissioned the masterly ensemble.

St. Peter's
(S. Pietro in Vaticano)

The cathedral of St. Peter is not only the biggest of all Roman Catholic churches, as the Mother Church of the Catholic community it is the most famous and most visited church in the world. The present building is a Renaissance and Baroque structure, but this was built over an earlier structure that the Emperor Constantine had erected (from about A.D. 319) over the grave of the Apostle St. Peter as his memorial. The choice of this site and the inclusion of the grave in the church not only necessitated orientating the building westward, it also involved filling in the old necropolis and erecting high supporting walls to create a broad platform to act as a foundation. On this platform was built a basilica consisting of a central nave and four aisles, richly adorned with mosaics, frescoes and memorials, and with a large colonnaded atrium before it. Often restored and altered, Constantine's building (known as Old St. Peter's) survived until the beginning of the 16th century. During the exile of the popes in Avignon (1309–1377), the building had deteriorated and much of its magnificence and grandeur were lost. The desire for a Mother Church of appropriate size and grandeur, together with the removal of the papal residence to the Vatican, gave rise to the first plans for a new building and under Nicholas V (pontificate 1447–1455); work started on a new choir and transept, but soon had to be abandoned because of a lack of money. It was Pope Julius II (pontificate 1503–1513) who finally decided to pull down Old St. Peter's, and on April 18, 1506 commissioned Bramante to design a new one. Bramante's designs were for a centrally planned building, with a dome placed at the center of a Greek cross (a cross with arms of equal length). This form corresponded to the ideals of the Renaissance and took up the idea of an antique mausoleum. But well over a century was to pass before the main body of St. Peter's was completed in its present form, with many celebrated architects being involved in the development. Bramante was followed as architect of St. Peter's by Raphael, Fra Giocondo, Giuliano da Sangallo, Baldassare Peruzzi, and Antonio da Sangallo before Pope Paul III (pontificate 1534–1549) entrusted the direction of the work to Michelangelo in 1546. Michelangelo's interest lay above all in the grandiose dome, the huge drum of which was completed by his death in 1564; Vignola, Pirro Ligorio, and Giacomo della Porta continued his work. But changes in the liturgy introduced by the Council

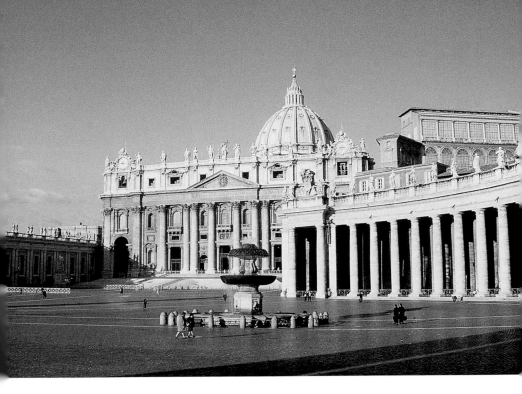

of Trent made yet more changes necessary under Pope Paul V (pontificate 1605–1621). He commissioned Carlo Maderno to extend the existing centrally planned building eastwards by adding a nave, creating a Latin cross; he completed the celebrated façade in 1614. Pope Urban VIII dedicated the new church on November 18, 1626, exactly 1300 years to the day after the first basilica had been dedicated. In 1629 Bernini, who was now the principal architect of St. Peter's, began to construct bell towers on the façade, but building had to stop when one of the towers collapsed as a result of a weakness in the structure of the façade. Thirty years later Bernini was to redesign St. Peter's Square and change aspects of Michelangelo's imposing dome, finally blending the whole into a uniform ensemble. The work on St. Peter's cathedral was finished in the 18th century, when the sacristy was added on the south side under the direction of Pope Pius VI (pontificate 1775–1799).

St. Peter's

Arnolfo di Cambio, Bronze statue of St. Peter, p. 483

Gianlorenzo Bernini, Tomb of Pope Urban VIII, p. 482

Gianlorenzo Bernini, Altar Baldachin and Catedra Petri, p. 480

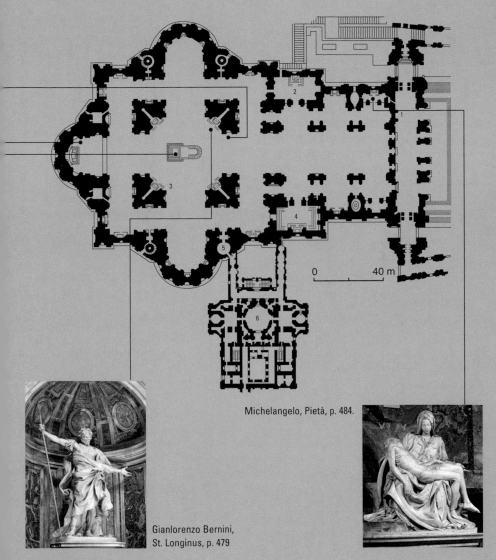

2

1

3

4

5

0 40 m

6

Gianlorenzo Bernini,
St. Longinus, p. 479

Michelangelo, Pietà, p. 484.

St. Peter's **471**

The Interior of Old St. Peter's, 16th Century, S. Martino ai Monti

Fresco

Nothing has remained of Constantine's 4th-century building, but it can be almost completely reconstructed from archaeological finds, old depictions, and descriptions by medieval pilgrims. As with all the early Christian churches, here too the antique model of the Roman civic basilica was followed: a rectangular hall divided into a nave and aisles offered sufficient room for a large congregation, while the ceremonies at the altar could be performed in the apse at the end of the nave, visible to all. So Old

St. Peter's was a basilica with a nave and four aisles; it had large extended transepts, an apse at the western end, and a great atrium at the eastern end. A 16th-century fresco in S. Martino ai Monti gives us some idea of the original appearance of the interior and the construction of the wooden roof. However, it tells us nothing of the rich paintings and sculptures inside. The columns of the high nave bore an architrave, above which was a two-story wall subdivided by pilasters, with windows in the clerestory, while the windows in the lower side aisles were linked together by blind arcades.

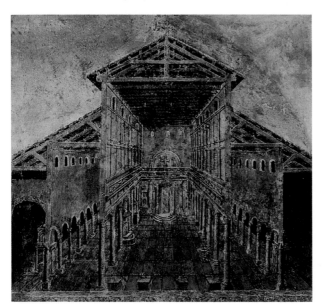

The Dome

The dome of St. Peter's is visible from all over the city, dominating its skyline. With a diameter of about 42 m (138 feet) it is slightly smaller than the dome of the Pantheon, but because it has a height of 132.5 m (435 feet) it is much more imposing. The design derives from Michelangelo, who took over the direction of the building in 1546 at the age of 72. He was not to live to see the dome completed, but thanks to his plans and a wooden model his successor, Giacomo della Porta,

was able to complete his work with only slight modifications. In essence, the dome of St. Peter's follows the model of Brunelleschi's famous dome on Florence Cathedral, and was designed to create an imposing effect. It consists of an inner structural shell and an outer dome which rises from a mighty drum and is crowned with an elegant lantern. The drum is subdivided by twin Corinthian columns and a great molded entablature; it also has windows with alternating triangular and segmented gables. The outer shell of the dome has windows and great external ribs that also perform a structural function, as they take the weight of the vault to the buttresses hidden behind the drum's double columns. Unlike Michelangelo's design, the completed dome is not semi-

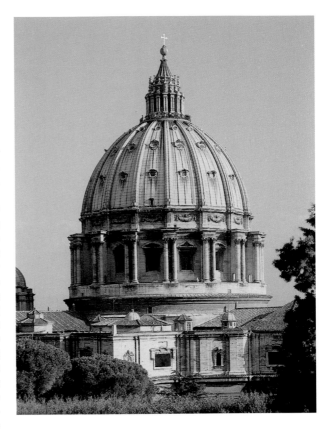

circular but peaked, as Giacomo della Porta narrowed it towards the top, creating a dynamic upward thrust. It culminates in the lantern, where window slits inserted between twin columns let light flood into the interior. When the keystone of the dome was set in 1590, an incomparable masterpiece was created that is still one of the miracles of Western architecture.

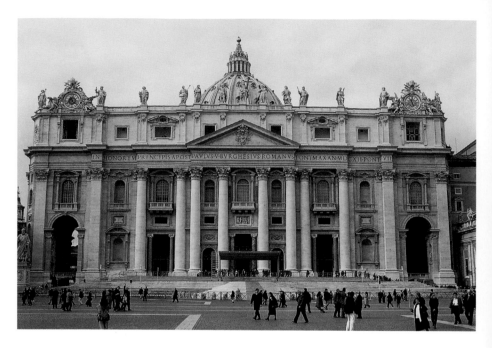

The Façade

Giant pilasters link the lower and upper stories that, with a high attic, divide the unusually broad façade of St. Peter's. Pope Paul V (pontificate 1605–1621) entrusted the design to the architect Carlo Maderno at the beginning of the 17th century. Alternating rectangular and round doorways in the portico open onto St. Peter's Square, their rhythm being taken up by the windows of the upper story. The central window of the main façade is emphasized by a triangular pediment; this window opens onto the balcony from which the pope gives his blessing *urbi et orbi* (to the city and the world). It is also from this balcony that the name of the newly elected pope is announced by the dean of the College of Cardinals, and that the names of those who are pronounced blessed and canonized are read. The triangular pediment projects from the central axis of the fenestrated attic. Monumental statues of Christ and the Apostles (without Peter) crown the façade; the two clocks on the ends were added by the architect Valadier in the 19th century.

The Portico, Antonio Filarete (ca. 1400–ca. 1469), Bronze Door, 1433–1445
Bronze, enameled in parts, 630 × 358 cm

Passing through the five large portals of the façade visitors reach the inside of the broad vestibule. Here they can see the equestrian statues of Charlemagne (by Agostino Cornacchini, ca. 1730) and the Emperor Constantine (by Bernini, 1670), and also, above the central portal, fragments of the famous mosaic by Giotto from Old St. Peter's, the *Navicella*, showing the storm on the Lake of Galilee. Five bronze doors lead into the interior of the church; the right-hand door is the Porta Santa, the Holy Door, which is opened only in Holy Years. The central portal contains a double bronze door that the Florentine sculptor Antonio Filarete made for the old church between 1433 and 1445. The front is divided into six large relief panels. At the top we see Christ and the Virgin Mary; beneath them St. Peter (with Eugene IV kneeling before him to receive the keys of the Kingdom of Heaven) and St. Paul; and in the lower sections the martyrdom of the two Apostles. The panels are divided by narrow relief bands showing historical events from the pope's pontificate; they are framed by acanthus leaves intertwined with scenes from ancient mythology. The other three bronze doors were made by 20th century artists; the most impressive is the one on the extreme left, the Porta della Morte, made by the Italian sculptor Giacomo Manzù in 1964.

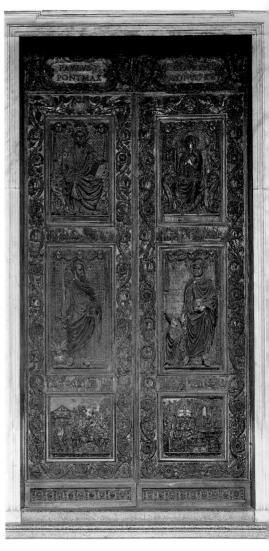

The Interior

Despite its huge dimensions, the interior of St. Peter's does not look gigantic. This is due to the balanced proportions of the design and the harmonious adornments, above all the uniform Renaissance and Baroque decoration. When designing the nave, Carlo Maderno largely adopted Michelangelo's directions for the crossing beneath the dome, and so four great arcades separate the wide nave from the narrow side aisles, with giant Corinthian pilasters being attached to vast piers. Above the arcades windows are cut into the barrel vault, which is decorated with richly gilded coffers. Bernini was responsible for designing the multi-colored marble panels and the medallions with the portraits of the popes, while the statues of the founders of orders located in the niches in the pillars have been set here gradually since the 18th century.

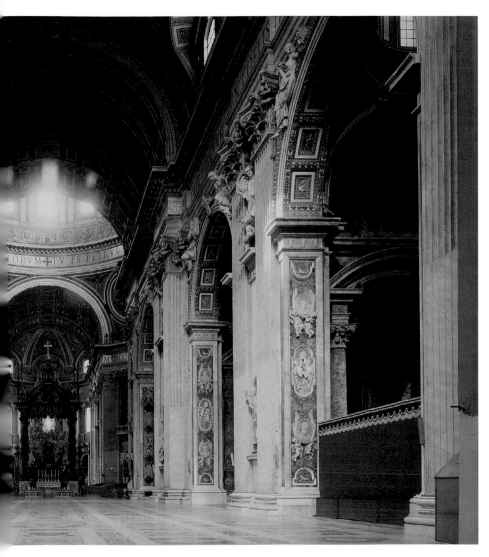

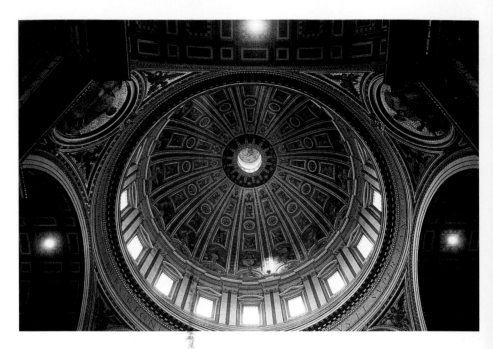

View into the Dome

Four hexagonal pillars 24 m (79 feet) in diameter bear the weight of the dome that spans the crossing of St. Peter's, the place where the tomb of St. Peter is situated. Sixteen windows in the drum and the same number in the lantern flood the space with light. The words in the mosaic inscription round the lower edge of the dome read: TU ES PETRUS ET SUPER HANC PETRAM AEDIFICABO ECCLE-SIAM MEAM ET TIBI DABO CLAVES REGNI CAELORUM (Thou art Peter and upon this rock I will build my church; and I will give unto thee the keys of the Kingdom of Heaven). Mosaics on a gold ground taken from drawings by Cavalier d'Arpino (1568–1640) cover the entire dome and represent the Kingdom of Heaven. Right at the top in the lantern we can see depictions of God the Father, beneath Him angels, Christ and Mary surrounded by the Apostles, saints, and popes. In the lunettes are the busts of the leading Church Doctors, while the pendentives are decorated with four tondi featuring larger-than-lifesize mosaics of the four evangelists.

**Gianlorenzo Bernini,
St. Longinus, 1630–1639**
Marble, h 440 cm

The round niches in the huge piers bearing the weight of the dome are occupied by four monumental statues of saints 5 m (16 feet) high. Dating from the 17th century, they relate to the Passion of Christ. One is St. Veronica with her veil (by Francesco Mocchi); another is the mother of Emperor Constantine, St. Helen, who is said to have brought the Cross of Christ from the Holy Land to Rome (by Andrea Bolgi); St. Longinus, the Roman soldier who pierced Christ's side with his lance (by Gianlorenzo Bernini); and the Apostle Andrew, who was crucified like Christ (by François Duquesnoy). The loggias above contain their relics, which are displayed on Holy Days. These include the veil of St. Veronica, a highly venerated relic that always draws great crowds.

According to legend, Veronica handed Christ her veil when He was on the way to Golgotha, to wipe the blood and sweat from His face. When Christ gave it back to her, His features were imprinted in the cloth. Veronica brought it to Rome and used it to cure the emperor of leprosy. Ever since, this icon has made an overwhelming impression on pilgrims, for in Rome they could see during their lifetime what others could only see in heaven – the very features of Christ.

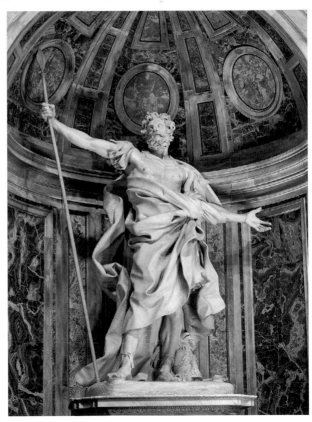

Gianlorenzo Bernini, Altar Baldachin, 1624–1633
Bronze and gold, 29 m

For the papal altar above the tomb of St. Peter, Bernini created a technical and artistic masterpiece for Urban VIII Barberini. It is a high baldachin of gilded bronze. From marble plinths, displaying the coat of arms of the pope, rise four twisted columns bearing the baldachin with a globe and a cross. After earlier unsatisfactory and provisional arrangements, this design, with its exuberant Baroque energy and movement, was deemed to be a fitting solution for the great domed space at the heart of St. Peter's. In order for it to be cast, the pope ordered the bronze facing to be taken from the roof of the portico of the Pantheon and melted down, earning him the mocking comment from the people of Rome: "What the barbarians failed to do, the Barberini have managed."

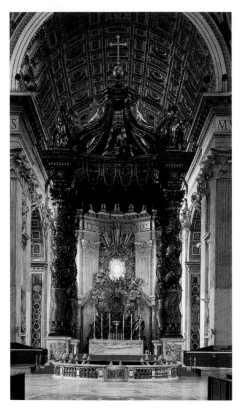

Gianlorenzo Bernini, Cathedra Petri, 1656–1666
Bronze, polychrome marble, gilded stucco,
h ca. 20 m

Bernini created this bronze and marble sculpture in the apse of St. Peter's for Pope Alexander VII; it contains the most precious relic in the church, the Cathedra Petri, "throne of St. Peter" (in reality a wooden throne on which Charles the Bold was crowned emperor in 875). It is shaped like a bronze armchair held high by the four Fathers of the Church. At the top are putti with the papal insignia and a nimbus of angels framed in rays of gilded bronze. This encloses an oval alabaster window with a stained-glass image of a dove, the symbol of the Holy Spirit; natural light flooding through this creates a spectacular effect. The Cathedra Petri glorifies the office of pope, for here the throne of the representative of God appears as the link between heaven and earth.

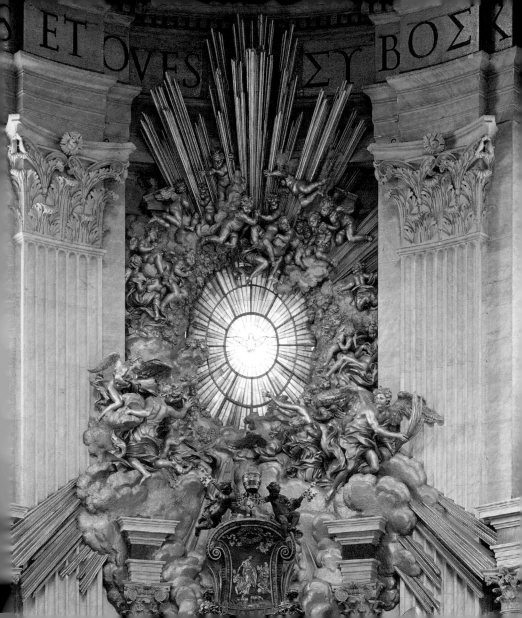

Gianlorenzo Bernini,
Tomb of Urban VIII, 1627–1647
Bronze and marble,
seated figure of the pope, h 250 cm

In the apse of St. Peter's stand two of the twenty-three tombs of popes buried in the

cathedral. In the niche to the right of the Catedra Petri is the tomb of Urban VIII pontificate (1623–1644). When designing this, Bernini had to take stylistic account of the tomb of Paul III pontificate (1534–1549) opposite (completed in 1575). This explains the pyramidal structure, with the pope enthroned high above the tomb, and also the use of a variety of materials. Unlike Guglielmo della Porta's portrait of Paul III as a benevolent old man dispensing blessing, with the allegories of Wisdom and Justice at his feet, Bernini's Pope Urban VIII appears as a strong and self-confident ruler wearing the papal tiara. Bernini enlivened his figure with the triumphal gesture of the raised right hand, giving the blessing *urbi et orbi*. The compositional counterweight is the huge boss on the papal throne adorned with the symbol of the Barberini family, bees. The allegories of Love and Justice are leaning on the sarcophagus, while Death, a winged skeleton, is attaching to the tomb an inscription bearing the pope's name.

**Arnolfo di Cambio
(ca. 1245–1302),
Bronze Statue of St. Peter,
13th Century**
Bronze, h 180 cm

On the right-hand side of the nave, a figure of St. Peter seated on a throne is set before the pillar of St. Longinus. This is a 13th-century work generally ascribed to Arnolfo di Cambio. The two keys of heaven are in his left hand, while his right is raised in blessing in the ancient Greek manner, with two fingers outstretched in acknowledgement of the dual nature of Christ, divine and human, while the other three fingers are together as a sign of the Trinity. It is an established ritual for every pilgrim on his or her way to the tomb of St. Peter to pay homage to the age-old statue of St. Peter by kissing the outstretched foot of the statue, or touching it with a hand. On great Holy Days, particularly on the feasts of the two Apostles

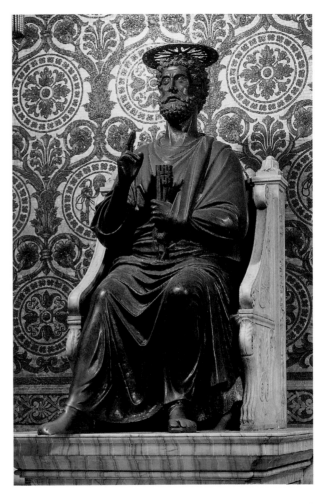

Peter and Paul, it has long been the custom to robe the statue in costly raiments. When the pontiff enters the church and kisses the foot of the statue, it really appears as if the bronze St. Peter is actually blessing his living successor.

**Michelangelo Buonarotti,
Pietà, 1499–1500**
Marble, 174 x 69 cm

In the first chapel in the right-hand aisle stands the famous Pietà by Michelangelo. It is one of his earliest works in Rome and since an attack was made on it in 1972 it has been protected by bullet-proof glass. The ribbon running diagonally across the Virgin Mary's breast bears Michelangelo's only signature: MICHAEL. ANGELUS. BONAROTUS. FLORENT. FACIEBA(T) – "Michael Angelus Buonarotus of Florence made this!" Originally intended for the tomb of the French Cardinal Jean Bilhères de Lagraulas in Old St. Peter's, it was brought to St. Peter's in around 1519. In its present position, the viewer has a slightly distorted impression of it because it is rather high. The superb handling of the marble and the perfect harmony of the composition draw all eyes. Michelangelo's achievement in blending into a harmonious composition the upright figure of Mary and the largely horizontal figure of Christ, stretched across her lap, is unsurpassed. Her head bent and her expression somber, Mary, who is depicted in ideal youthful beauty, sits holding the lifeless body of her son, which fits almost completely into the contours of her abundant robes. Though derived from the North European pietà (a depiction of Mary grieving over the body of Christ), Michelangelo's Pietà

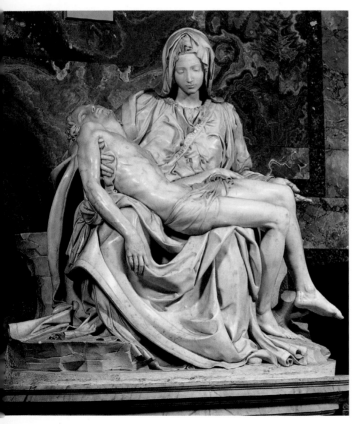

dispenses with the cruel realism typical of this genre in favor of an idealized vision. Michelangelo understood the youthfulness of Mary – to which many critics have objected – as an expression of her incorruptible purity. This masterpiece is all the more powerful precisely because it successfully combines death and youth, grief and beauty.

Antonio Pollaiuolo (ca. 1431–1498),
Tomb of Pope Innocent VIII, 1498
Bronze, 549 x 216 cm

One of the masterpieces of Italian Quattrocento sculpture, the bronze tomb of Innocent VIII stands on an attached pillar in the left aisle of St. Peter's. It was created by Antonio Pollaiuolo in 1498 for a wall niche, and it is the only tomb of a pope to be transferred from the Old St. Peter's to the new. For the first time a pope is shown not only recumbent on a sarcophagus (below) but also as an earthly ruler seated on the papal throne, framed by reliefs showing the cardinal virtues, his right hand raised in blessing. In his left hand he holds the relic of the holy lance of St. Longinus, with which Christ's side is said to have been pierced. Innocent VIII received the lance in 1492 as a personal gift from the Turkish Sultan Bajazet II.

**Museo del Tesoro di S. Pietro,
Sarcophagus of Junius Bassus,
4th Century A.D.**
Carrara marble, 142 x 234 cm

Adjacent to the sacristy is the treasury, where major items of the church's treasure are displayed. One of the most celebrated pieces is the sarcophagus hewn from a single block of marble, in which, according to the inscription, Junius Bassus is buried. He died in 359 at the age of forty-two as a *neophytus*, a new convert. The sarcophagus is one of the most interesting items of

Christian archaeology both because of its high quality and also because of its intriguing iconographic. It is decorated with scenes from the Old and New Testaments set in two zones one above the other and separated with columns. In the center of the upper zone Christ is shown enthroned as the Ruler of the World; He is youthful and clean-shaven, and seated between Peter, to whom He is handing the laws, and Paul. He has his feet on the arching sky that the pagan god Caelus has spread over himself. To the left are the Sacrifice of Abraham and the Capture of Peter, and on

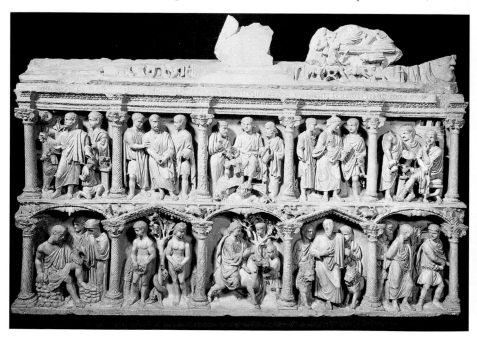

the right Jesus standing before Pilate. In the lower zone, from left to right, are Job, the Fall from Grace, Jesus' entry into Jerusalem, Daniel in the Lions' Den, and the Arrest of the Apostle Paul.

Museo del Tesoro di S. Pietro, Antonio Pollaiuolo (ca. 1431–1498), Tomb of Sixtus IV, End 15th Century
Bronze, 302 x 166 cm

The bronze tomb of Pope Sixtus IV (pontificate 1471–1484) came from the choir of Old St. Peter's. It dates from the end of the 15th century and is one of the first works by the Florentine sculptor Antonio Pollaiuolo in Rome. It is a realistic depiction of the deceased pope lying in state, every inch the energetic and powerful prince of the church even in death. His head resting on a brocade cushion, Sixtus IV is wearing full pontifical robes. An inscription at his feet recalls the key dates in his life and his great achievements, for the Sistine Chapel bears his name, and he played a major part in the urban renovation of Rome. The effigy is enriched by an extensive range of images. The reliefs at the pope's sides are the personification of the virtues (on the right side Hope, Moderation, and Justice; on the left side Faith, Courage, and Wisdom), while the ten panels on the concave sides of the memorial slab are adorned with personifications of the liberal arts.

The Vatican Palace
(Palazzo Apostolico Vaticano)

Over the last five centuries the Vatican Palace has grown into a complex of long corridors, with roughly 11,500 rooms and about twenty courts. Even in the Middle Ages, when the popes still resided in the Lateran Palace, there were papal residential quarters beside St. Peter's. One of the first, built by Pope Symmachus (pontificate 498–514), was replaced with a new palace by Pope Eugenius III (pontificate 1145–1153); then Innocent III (pontificate 1198–1216) extended and strengthened it,

turning it into what was essentially a fortress. Only the tower of this building remains in one corner of the Cortile del Papagallo, which forms the core of the Vatican Palace.

When Gregory XI found the Lateran Palace almost derelict on his return from exile in Avignon (1377), the Vatican was declared the official residence of the popes. Various restorations, extensions, and fortifications were carried out periodically until under Nicholas V (pontificate 1447–1455) a program of systematic rebuilding began. Nicholas had the Cortile del Papagallo built and had his private chapel, the Cappella Niccolina in Inncocent III's tower, deco-

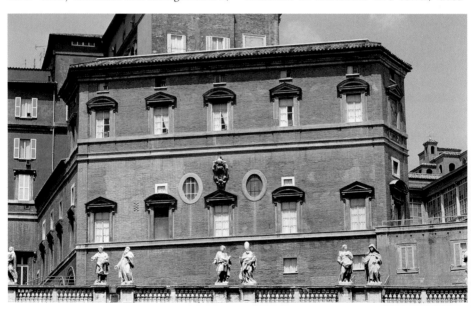

rated by Fra Angelico. Under Sixtus IV (pontificate 1471–1484) the Sistine Chapel was built and under Alexander VI (pontificate 1492–1503) the Appartamento Borgia and the Borgia Tower were added as a new residential wing for the pope; the *passetto* (a covered passageway leading from St. Peter's to the Castel Sant'Angelo) was also built. Innocent VIII (pontificate 1484–1492) had already had the Palazzo del Belvedere laid out on the highest point of the Vatican Hill, and under Julius II (pontificate 1503–1513) Bramante linked this with the older palace buildings through the wide Cortile del Belvedere. Julius commissioned Michelangelo to paint the Sistine Chapel and had Bramante start on the loggias facing the present Cortile di San Damaso. They were decorated by Raphael under Leo X (pontificate 1513–1521). Paul III (pontificate 1534–1549) entrusted the decoration of the Sala Regia and the building of the Cappella Paolina to Antonio da Sangallo the Younger; the chapel was painted with frescoes by Michelangelo. Under Pius V (pontificate 1566–1572) and Sixtus V (pontificate 1585–1590), Domenico Fontana added a wing beside the colonnades of St. Peter's Square, a wing that still contains the pope's private apartments. The same architect also built the library wing, which bisects the Cortile del Belvedere, and created a second court, the Cortile della Pigna.

Since this extensive work carried out during the Renaissance, only a few alterations have been made to the Vatican Palace. Except for the monumental Scala Regia,

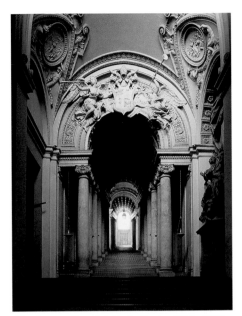

Gianlorenzo Bernini, Scala Regia, 1663–1666, The Vatican Palace, Rome

which Urban VIII (pontificate 1623–1644) commissioned from Bernini, most of the later building work related to enlarging the museums. Raffaele Stern built the Braccio Nuovo under Pius VII (pontificate 1800–1823); Pius XI (pontificate 1922–1939) had the Pinacoteca (the painting gallery) and the monumental entrance to the Vatican Museums built; and John XXIII (pontificate 1958–1963) commissioned a new wing. In half a millenium a complex of buildings evolved that, historically and artistically, is now unique.

Fortiter et Fideliter – the Swiss Guard

by Jürgen Sorges

The papal *guardia svizzera*, the Swiss Guard, came into being on January 21, 1506, when Pope Julius II (pontificate 1503–1513), who was as astute as he was warlike, started recruiting mercenaries in the German-speaking cantons of Switzerland. The pope, who was regarded as economical to the point of being parsimonious, had a war chest that was full to bursting. And it needed to be, for the newly acquired guardsmen from the Swiss Alps were then the most expensive – and the best – mercenaries of the time. Even then, their most striking characteristic was their imposing size compared with rival Mediterranean mercenaries; moreover, there was their fierce fighting spirit, which was made all the more effective by strict self-discipline. The Swiss soldiers were regarded as particularly loyal – as long as the money flowed and they were given hearty and regular meals, with plenty of meat. Unlike the Spanish or Italian halberdiers, who were fed only vegetables and paid in copper coin, the Swiss, and later the German mercenaries, could obtain agreements in writing for shiploads of pickled and dried meat and for pay in the more durable silver coin. As a consequence, not every ruler could afford to maintain and pay the expensive Swiss soldiers, a potentially decisive advantage in the warfare of the period.

The Swiss Guard still have to meet the criteria that were laid down for entry in the 16th century: they must have at least the minimum height of 1.75 meters (just under 6 feet), be under thirty, and have completed their military service in Switzerland. The corps is now limited to one hundred men: seventy halberdiers, twenty-three sergeants, four officers, two *tamburi* (drummers), and a commander holding the rank of colonel. Wearing their distinctive Renaissance uniform, and sporting huge halberds, they all share the work, which mainly consists of guarding the entrances to the Vatican.

The motto of the Swiss Guard, inscribed proudly on their banner, is *Fortiter et fideliter*: With Strength and Loyalty. Every year, on the morning of May 6, the motto acquires a particular significance, for then the corps holds a parade on the Cortile di San Damaso in the Apostolic Palace to recall May 6, 1527, the day Rome was plundered by Habsburg mercenaries; it was only the heavy price paid in blood by the Swiss Guard – one hundred and forty-seven papal guards were killed – that enabled Pope Clement VII to escape into the Castel Sant'Angelo. A memorial before their barracks in the Vatican recalls the black day, and on May 6, each year the corps renew their oath of loyalty. The ceremony includes raising three fingers of their right hand as a symbol of the Divine Trinity. At the same time the left hand touches the guards' blue, yellow, and red banner, which bears a white cross and the insignias of the commander, of Pope Julius II, who founded the Swiss Guard, and of the

current pontiff. It is not known for certain whether the magnificent brightly colored uniforms worn for this occasion were really designed by Michelangelo, but they certainly ensure that the Swiss Guard are one the most photographed sights in the Vatican. Whenever the guard is being changed, or when dignitaries are arriving, out come the cameras and camcorders. Sometimes a few privileged visitors may even see "shoulders presented," a distinctive greeting reserved for cardinals. Today the main duty of the Swiss Guard is to watch over the three entrances to the Vatican: the Arco delle Campane, the Portone di Bronzo, and the Porta Sant'Anna. However the *Guarda robba*, who check the clothing of people entering St. Peter's – for shoulders must be covered and shorts and mini skirts are not allowed – are not Swiss Guards.

Otherwise the Swiss Guard only drew attention during the time of "inner emigration" for the popes, from the destruction of the Church State in 1871 up to the signing of the Lateran Treaties with Benito Mussolini in 1929, when they had to guard the frontiers of the Vatican State.

On May 4, 1998 a scandal hit the Swiss Guard. Colonel Alois Esterman (aged 44) had just been appointed as the new commander when he was gunned down by a junior officer, Cédric Tournay. Tournay shot Esterman and his wife, Gladys Romero, and then is said to have turned the gun on himself. Despite the official verdict of "double murder motivated by jealousy with ensuing suicide," many questions raised by this "thriller in the Vatican" are still unanswered.

The Swiss Guard have certainly put the event behind them and in the Holy Year 2000 they stood at the Holy Door of St. Peter's as well, visibly ready for the third Christian millennium.

The Swiss Guard renew their oath of loyalty and present their colors on May 6 each year, when new recruits are sworn in.

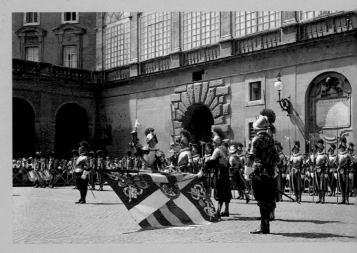

The Vatican Museums (Musei Vaticani)

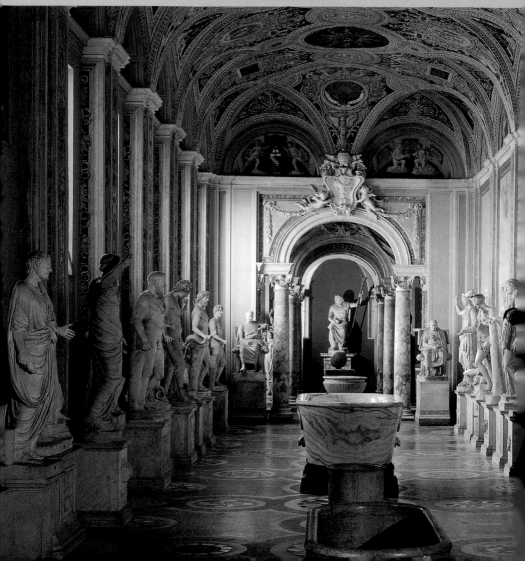

"I get lost in these Vatican Museums, with their eleven thousand rooms and eighteen thousand windows – masterpieces standing alone and silent!" (Chateaubriand)

Visitors to the Vatican Museums have before them one of the finest art collections in the world. It was built up over centuries through the artistic, dynastic and religious ambitions of the popes and has now grown into a museum complex of unrivalled scope and importance. Housed in sections of the huge Vatican Palace and also in wings built specially for the purpose, the Vatican Museums not only display major works of art from every century, they also reflect the ideas and ideals that gave birth to the museums. Furthermore, They give access to the Sistine Chapel, which is one of the most important parts of the papal palace, historically and artistically.

The founder of the museums was Pope Julius II (pontificate 1503–1513), who had the court (cortile) of the Belvedere Palace redesigned by Bramante in order to display antique sculptures. It contained the finest and most celebrated antique statues then excavated, including the Apollo Belvedere, the Laocoön, and

Galleria delle Statue, Vatican Museums

the Belvedere Torso. The Cortile del Belvedere was the first open-air archaeological museum to be opened and for centuries it was the main attraction for every visitor or artist who came to Rome eager to gain an understanding of classical antiquity. Under Pope Julius II and his successors the most famous artists of the day, such as Michelangelo, Leonardo da Vinci, and Raphael came to the papal court to decorate rooms in the palace. In the course of time other antiquities, contemporary works of art and other important objects were placed there. In the 18th century elsewhere other collections of antiquities and works of art were being turned into public museums and work therefore started on cataloging the collections in the Vatican and making them accessible to the public.

Spiral staircase in the Vatican Museums

The Vatican Museums

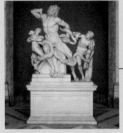

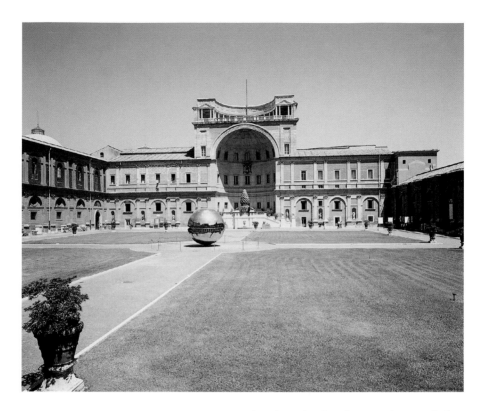

Cortile della Pigna

In front of the Museo Gregoriano Egizio, which was opened by Pope Gregory XVI (pontificate 1831–1846) in 1839 in response to the growing interest in Egyptian culture, there lies the Cortile della Pigna with its famous Nicchione, a monumental three-story niche executed by Pirro Ligorio. The court is named after a huge bronze pine cone (*la pigna*) which was brought here from the atrium of Old St. Peter's when that church was pulled down. It adorns Michelangelo's double staircase that leads up to the Nicchione. The pine cone is thought to have originated from a shrine of the Egyptian goddess Isis, in whose cult it is a symbol of immortality.

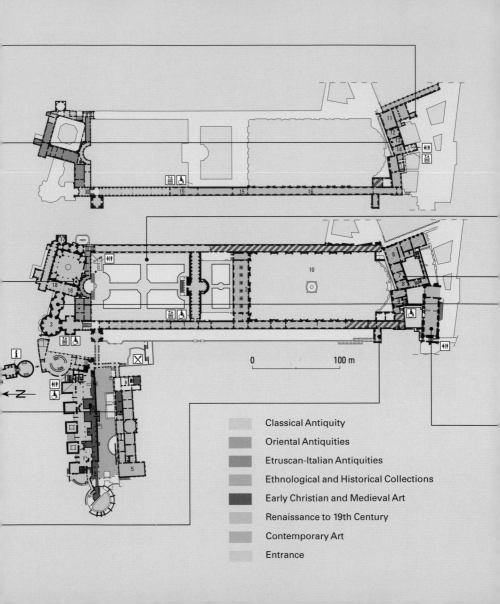

0 100 m

Classical Antiquity

Oriental Antiquities

Etruscan-Italian Antiquities

Ethnological and Historical Collections

Early Christian and Medieval Art

Renaissance to 19th Century

Contemporary Art

Entrance

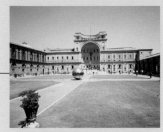

Cortile della Pigna, p. 498

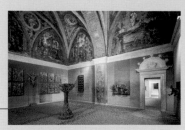

Sala dei Santi, Appartamento Borgia, p. 514

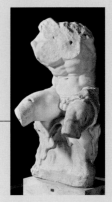

Belvedere Torso,
Sala delle Muse,
p. 504

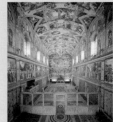

Sistine Chapel, p. 520

Innocent III 1198–1216 Lotario dei Conti di Segni	**Honorius III** 1216–1227 Cencio Savelli	**Gregory IX** 1227–1241 Ugolino dei Conti di Segni	**Boniface VIII** 1294–1303 Benedetto Castani	**Clement V** 1305–1314 Bertrand de Goth
Urban VI 1378–1389 Bartolomeo Prignano	**Gregory XII** 1406–1415 Angelo Correr	**Martin V** 1417–1431 Oddone Colonna	**Nicholas V** 1447–1455 Tommaso Parentucelli	**Julius II** 1503–1513 Giuliano della Rovere
Leo X 1513–1521 Giovanni de Medici	**Clement VII** 1523–1534 Giulio de Medici	**Paul III** 1534–1549 Alessandro Farnese	**Paul IV** 1555–1559 Giovanni Pietro Caraffa	**Pius IV** 1559–1565 Giovanni Angelo de Medici
Pius V 1566–1572 Antonio Michael Ghisleri	**Sixtus V** 1585–1590 Felice Peretti	**Clement VIII** 1592–1605 Ippolito Aldobrandini	**Paul V** 1605–1621 Camillo Borghese	**Urban VIII** 1623–1644 Maffeo Barberini
Innocent X 1644–1655 Giovanni Battista Pamphilj	**Alexander VII** 1655–1667 Fabio Chigi	**Innocent XI** 1676–1689 Benedetto Odescalchi	**Innocent XIII** 1721–1724 Michelangelo dei Conti	**Clement XII** 1730–1740 Lorenzo Corsini
Pius VI 1775–1799 Giovanni Angelo Braschi	**Pius VII** 1800–1823 Barnaba Gregorio Chiaramonti	**Pius IX** 1846–1878 Giovanni Maria Mastai-Ferretti	**John XXIII** 1958–1963 Angelo Giuseppe Roncalli	**John Paul II** 1978–2005 Karol Wojtyla

Museo Pio-Clementino

**Gabinetto del Apoxyomenos,
The Apoxyomenos of Lysippus,
Roman Copy of a Greek
Original, ca. 330/320 B.C.**
Yellow marble, h 205 cm

The Museo Pio-Clementino houses a unique collection of antique sculptures. One of the finest pieces is the only good Roman marble copy of a bronze master-piece by the Greek sculptor Lysippus (ca. 330/320 B.C.): the Apoxyomenos (The Scraper). It reflects a new image of the Olympic victor that emerged in the 4th century B.C. This is not a radiant, idealized hero, but an athlete exhausted by the effort to win. His weary eyes look into the distance as he cleans off the stadium dust: his right arm is out-stretched as he uses the *strigilis* (metal scraper) in his left to clean himself.

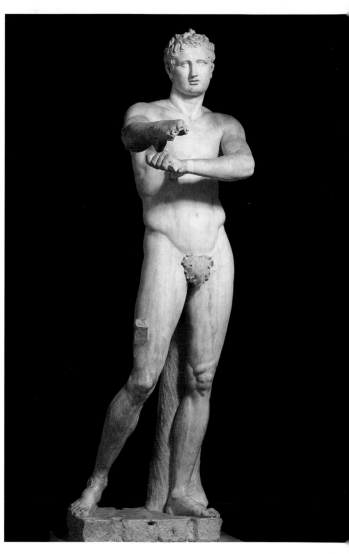

Cortile Ottagono

Apollo Belvedere, Roman Copy of a Greek Original of the 4th Century B.C.
Marble, h 224 cm

In the Cortile Ottagono stands one of the most famous sculptures in the history of

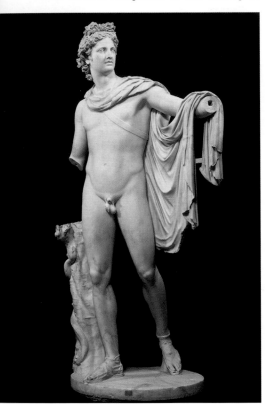

Western art; it was placed there by Julius II. Apollo treads lightly, gazing into the distance; his left arm is outstretched, with a *chlamys* (shoulder cloak) draped over it, and his right arm is lowered. To the 18th-century art theorist Winckelmann, the Apollo Belvedere represented "the supreme ideal of art among all the works of antiquity." Artists in every century have sculptured copies of it, drawn and engraved it; its impact has been enormous. But the reconstruction and dating of the statue are still matters of dispute. It was not until 1924 that the authorities removed the additions that the sculptor Montorsoli had undertaken on the instructions of Clement VII; he had added a left hand with a bow and a lower right arm and hand reaching outward and resting on a high tree stump. Many scholars and archaeologists believe the right hand held an arrow or a laurel twig, making this a dual image of Apollo as the god both of healing and of revenge. For a long time the statue was regarded as a Roman copy of a bronze original from the 4th century B.C. by the Athenian sculptor Leochares, and only in recent times have doubts been raised about this attribution. A close analysis of the right hand, the quiver, the *chlamys*, and the sandals, as well as stylistic comparisons with other sculptures of the 4th century B.C., suggest that this is an eclectic work dating from the late Hellenistic period.

Antonio Canova, Perseus, 1797–1801
Marble, h 228 cm

The influence of the Apollo Belvedere and of Winckelmann's enthusiastic descriptions of this classical sculpture are evident in Antonio Canova's statue of Perseus (1797–1801). Here the sculptor has clearly aimed to give a three-dimensional form to the ideas of the concept of ideal beauty formulated by Winckelmann. He has also taken up a theme that had until then only rarely been depicted in sculpture. Unlike the famous Perseus by Benvenuto Cellini of 1545–1554 in the Loggia dei Lanzi in Florence, who is holding up the deathly head of Medusa to the viewer pensively, Canova's hero stands confident and triumphant, his gaze fixed on the head. He seems indeed to be the "real" Perseus of antiquity, as though he had been turned to stone by looking at the head of Medusa.

Canova could not know that only a short time later his work would replace the work that had until then been praised as the supreme achievement of Greek art. For when the Apollo Belvedere was taken to Paris during Napoleon's plundering of Rome, the papal authorities decided to purchase Canova's work. His dream of standing beside the sculptors of antiquity had literally come true.

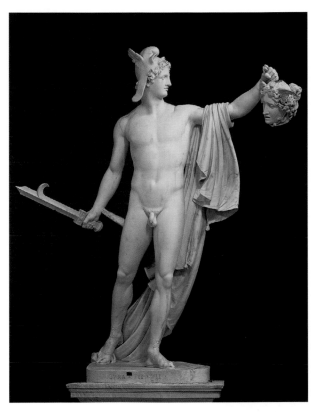

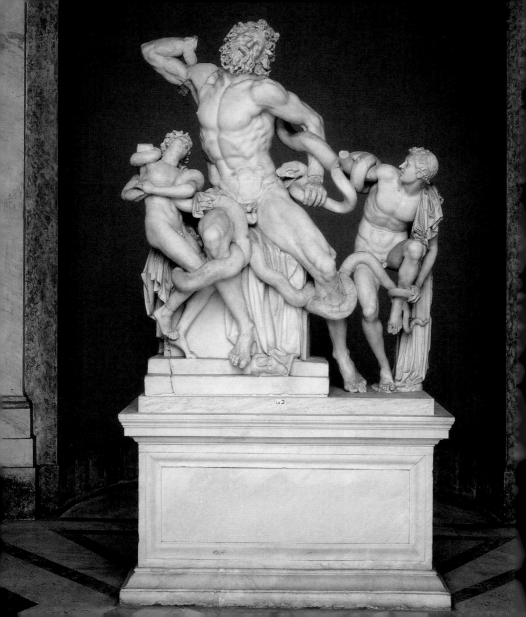

Laocoön, Roman Copy of a Greek Original, 2nd Century B.C.
White marble, h 242 cm

The famous Laocoön group was found in 1506 in the Domus Aurea (Emperor Nero's palace complex). It is celebrated for the sculptor's perfect handling of the marble and his ability to capture so forcefully the stages of human suffering in the fight against death. It depicts the terrible struggle of the Trojan priest Laocoön and his two sons against the two serpents that are crushing them to death. The Greek goddess Athena sent the serpents to punish Laocoön and his sons after the priest had warned his fellow countrymen not to trust the Trojan Horse. The myth had symbolic significance for the Romans, as only Aeneas heeded the warning and fled to Italy, where he founded Rome. In the early imperial age the myth was particularly relevant, for Emperor Augustus used the supposed Trojan descent of the Julian dynasty to justify his claim to power. Modern scholars regard the group as a copy, made for Tiberius in the early imperial age, of a Greek bronze dating from the middle of the 2nd century B.C.

Galleria delle Statue

Ariadne Sleeping, Roman Copy of a Greek Original, Mid-2nd Century B.C.
Yellow marble, h 161.5 cm, l 195 cm

This recumbent figure is a representation of Ariadne after Theseus has deserted her. She has fallen asleep on a rock on the island of Naxos; soon Dionysos will arrive and take her as his wife. The figure's pose is a complex one, for we see her from the side, with her legs crossed and her head resting on one arm. Her robe falls in opulent folds, emphasizing her pose. It is presumed that this is a copy of an original Greek bronze dating from the middle of the 2nd century B.C.

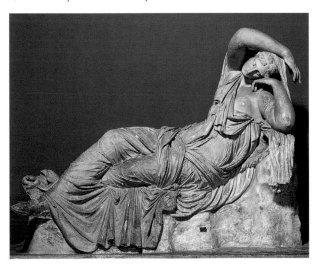

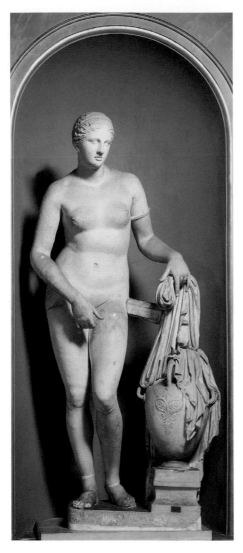

Gabinetto delle Maschere

Aphrodite of Knidos, Roman Copy of a Greek Original, ca. 340 B.C.
White marble, h 204 cm

In the tower-like projection of the Belvedere Palace stands one of the best copies of the Aphrodite originally carved by the Greek sculptor Praxiteles about 340 B.C. This figure, which was already famous in the literature of classical antiquity, stood in the shrine at Knidos. Ready to enter the bath, Aphrodite has laid her robe over the *hydria*, a water jug; her eyes gaze dreamily into the distance. A cult statue, for the first time in antiquity here the goddess of love appears naked, and is quiet and undisturbed in her divinity, as if no one could see her and she herself was aware of no one.

Sala delle Muse

Belvedere Torso, 1st Century B.C.
Yellow marble, h 159 cm

"I am myself inclined to regard this fragment as the finest I have ever seen." The German poet Goethe was only one of many who admired the Belvedere Torso as a timeless work of art. Scarcely any other fragment of classical antiquity has so worked on the imagination of artists and art lovers as this marble fragment of a

muscular man seated on a rock. And it is probable that no other figure has been of such significance in Western art. Artists from Michelangelo to Picasso have studied it and been inspired by it. Indeed, Michelangelo is said to have come to Belvedere in his old age, when he was almost blind, in order to feel the beauty of the statue once more with his hands. According to the signature on the front of the rock, the Athenian sculptor Apollonios, who lived in Rome in the 1st century B.C., was the creator of the statue, of which only the thighs and torso, leaning forward and slightly turning, have survived today. Winckelmann compared it with "a mighty oak, that has been cut down and stripped of its twigs and branches, so that only the trunk has remained." Ever since the Renaissance artists and archaeologists have tried to solve the puzzle presented by the work. In view of the animal pelt spread over the rock, some have believed the figure to represent Hercules, others a mythical boxer from the Argonaut saga. Still others see the late Hellenistic sculpture as a depiction of Philoctetes, the hero who, on his way to Troy, suffered a snake bite that turned into a wound that refused to heal. It smelled so abominable that his Greek companions set him down on the island of Lemnos, where he was to spend many years in isolation.

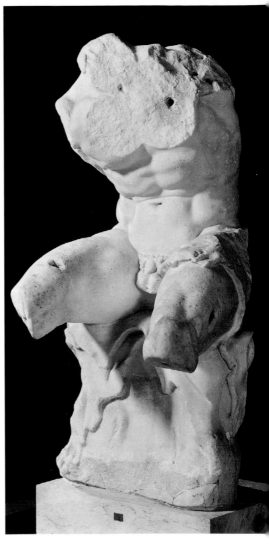

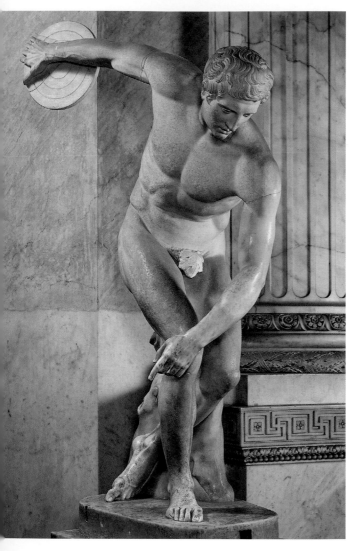

Sala della Biga

The Discus Thrower of Myron, Roman Copy of a Greek Original, Mid-5th Century B.C.
Parian marble, h 133 cm

In a vaulted room that is named after an antique two-horse triumphal chariot, stands a copy of the bronze discus thrower by the Attic sculptor Myron from the mid-5th century B.C. The copy dates from the time of Emperor Hadrian (reigned 117–138). The head is a modern addition – and is wrongly set – but the work is one of the peaks of the early classical movement. The sculptor could hardly have chosen a more expressive moment to depict a man throwing the discus. The athlete is shown at the moment just before the throw, his face concentrated; in the next instant he will spin around and hurtle the discus. His bent back, the movement of his arms and the position of his feet, indeed every muscle, reveal the tension of his body.

Stanze di Raffaello

When Pope Julius II (pontificate 1503–1513) moved into the papal apartments on the first floor of the Appartamento Borgia after his election as pontiff he took a strong dislike to the frescoes by Pinturicchio – largely because the face of his hated predecessor, Pope Alexander VI, met his gaze wherever he looked. So in 1507 he decided to move up to the second floor and have these rooms redecorated. At the end of 1508 he summoned Raphael to Rome, along with several other artists, and in 1509 they commenced working on the Stanza della Segnatura, Pope Julius II's study and private library. After the success of Raphael's first fresco *The School of Athens*, he was entrusted with the entire project.

Stanza della Segnatura,
Raphael,
Philosophy, 1509–1511
Fresco, dia 180 cm

In accordance with the traditional program for the decoration of libraries, the four walls each represent one faculty of knowledge as it was classified at the time: theology, philosophy, law, and poetry. Their personifications appear in four large tondi on the ceiling, while the rectangular paintings on the walls illustrate scenes depicting the most celebrated figures in each of these areas of knowledge. In this decorative scheme Raphael has not merely depicted the individual elements independently; he has created a thematic program in which the paintings on the walls and those on the ceiling are subtly interrelated.

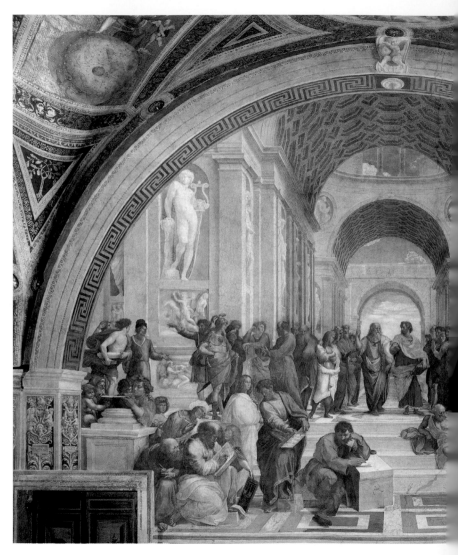

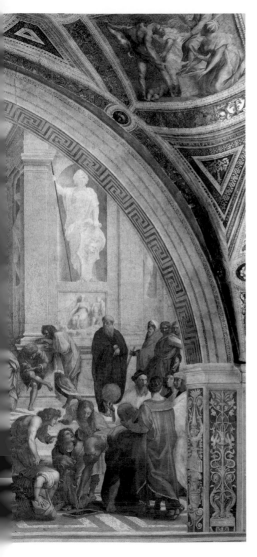

**Stanza della Segnatura, Raphael,
The School of Athens, 1509–1511**
Fresco, length at base 770 cm

For Philosophy, Raphael chose an antique setting with the most celebrated philosophers disputing in small groups as if in a school of philosophy. In the center are the leading philosophers of antiquity, Plato and Aristotle, deep in discussion. Under his arm Plato is carrying his book *Timaeus*, in which he reflects on the origin of the cosmos and its creator; Aristotle has his *Ethics* in his hand, the treatise on correct human behavior. Plato is pointing up with one finger, to symbolize the source of inspiration from above in the realm of ideas, while Aristotle is pointing down to the earth, the place from which all natural sciences arise. On the steps before them lies Diogenes, the cynic who despised all material goods and the lifestyle associated with them. On Plato's left is his teacher, Socrates, who is counting four on his fingers to represent the four steps (like the four leading up from the hall below) that have to be ascended in order to participate in the philosophical discussion: geometry, astronomy, arithmetic, and three-dimensional geometry. These branches of knowledge are symbolized in the other figures. On the far right Raphael himself, standing beside a pillar with his friend, the painter Sodoma, is looking out of the picture.

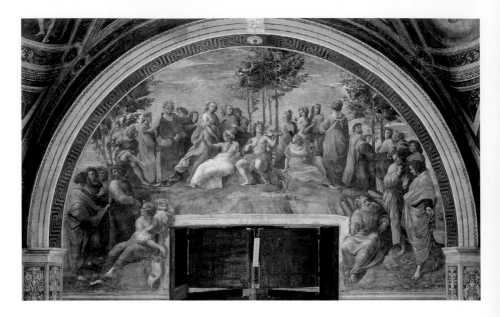

Stanza della Segnatura,
Raphael,
Parnassus, 1509–1511
Fresco, length at base 670 cm

To represent Poetry, Raphael chose to show Apollo making music on Mount Parnassus, surrounded by the nine Muses and celebrated poets of antiquity and of Raphael's own day. Among them blind Homer is recognizable in the group on the left, to his left is Dante, on the right presumably Virgil, and in the left foreground Sappho. Mount Parnassus was dedicated to the arts, as was the Vatican Hill, on which, in antiquity, stood a shrine to Apollo, the god of music and poetry. The window at the base of the fresco underlines this connection, for it gives a view of the Cortile del Belvedere, the courtyard that Julius II commissioned Bramante to redesign to display antique sculptures. These included *Ariadne Sleeping*, which Raphael chose as the model for the Muse on Apollo's left. Raphael also makes reference to the celebratory work of contemporary poets in his fresco, who were lauding Julius II as a new Apollo and his pontificate as a new golden age of poetry and art.

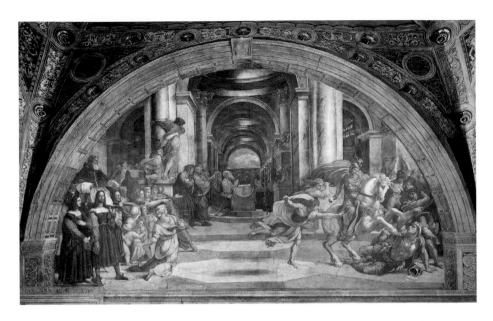

**Stanza d'Eliodoro,
Raphael and Giulio Romano,
The Expulsion of Heliodorus, 1512–1514**
Fresco, length at base 750 cm

For the frescoes in the Stanza d'Eliodoro, Julius II's audience chamber, Raphael evolved a very specific program to express the might of the Church. *The Expulsion of Heliodorus* is intended as a warning to the French, who at that time (1512) had occupied parts of the Papal State. To depict this dramatic event, Raphael chose a narrative form in which consecutive events are shown simultaneously. On the left we see Pope Julius II carried in the papal chair among the spectators, directing his gaze to the High Priest Onias at the altar, who is praying to God to liberate Jerusalem from its occupiers. The scene on the right shows that his prayer has been heard: a heavenly rider in golden armor, together with the youths at his side, are expelling from the temple Heliodorus, who has desecrated this holy place. The perspective of the architecture takes the viewer's gaze straight to the altar in the center of the painting, and so links the two groups in a dynamic but unified composition.

Cappella Niccolina

In one of the oldest parts of the papal palace, Innocent III's tower, is the private chapel named after Pope Nicholas V (pontificate 1447–1455), which Fra Angelico and his assistant Benozzo Gozzoli covered with frescoes in 1448–1449. On the low ceiling are the four evangelists, in the corners eight life-size figures of the Church Fathers. While the *Deposition* on the altar wall is now completely destroyed, the images on the other three walls have survived. Each one is on two levels, with the life of St. Stephen in the lunettes and that of St. Lawrence beneath.

St. Stephen, a Jew who spoke Greek, was called by St. Peter to be one of the first deacons in Jerusalem. He was well versed in the scriptures and disputed fearlessly with the elders of the city. However, his sermons drew the wrath of his opponents, who drove him out of the city and stoned him to death.

Fra Angelico, The Martyrdom of St. Stephen, 1448–1449, fresco, 250 × 420 cm

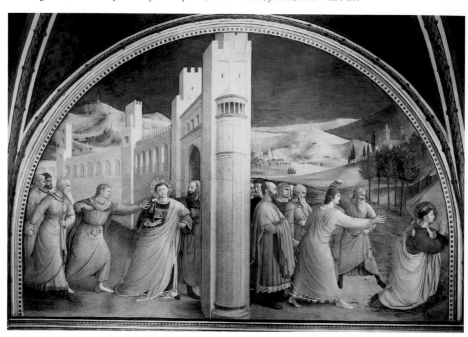

St. Lawrence was entrusted with the Church treasure by Pope Sixtus II during the Roman persecution of Christians; instead of handing it over to the agents of Emperor Valerian, he distributed it to individual Christians and to the poor. In the year 258 he was punished by being burned on a grill.

The parallels in the lives of the two saints are shown in the frescoes in the same sequence: ordination as deacon, distribution of alms to the poor, and a courageous confession of faith resulting in martyrdom. The scenes are intended to underscore the continuity between the early Church in Jerusalem, which St. Peter established, and the early Church in Rome, governed by the popes. The frescoes also contain references to the life of Pope Nicholas V, one of whose major concerns was to restore the former glory of the Eternal City as *caput mundi*, the head of the known world. This is reflected in the magnificent church buildings depicted in the frescoes, and the delicately detailed friezes and capitals of the room's real architecture. The mighty city gates of Jerusalem, for instance, in the lunette showing the stoning of St. Stephen, recall the building of the new city gates in Rome under Nicholas V. This image also depicts a schism in the Jewish community as a reference to the crises and divisions within the Catholic Church.

St. Lawrence was one of his great models, and Fra Angelico painted several portraits of Nicholas V in the figure of his predecessor Sixtus II. In *The Summoning of St. Lawrence*,

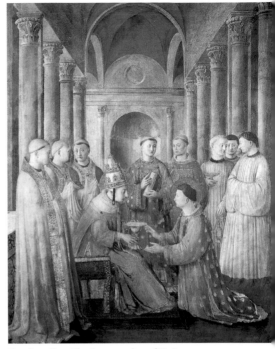

Fra Angelico, The Summoning of St. Lawrence, 1448–1449, fresco, 220 × 185 cm

for example, he is handing a chalice to the young deacon (St. Stephen), while a young priest behind him holds one of the costly books that were entrusted to St. Lawrence for safekeeping.

Appartamento Borgia

The rooms, which are on the first floor of the papal palace, are named after Alexander VI, the Borgia pope (pontificate 1492–1503), who had them decorated by Pinturicchio and his workshop between 1492 and 1495. Among the finest frescoes which Pinturicchio designed (and largely executed himself) are those that are found in the Sala dei Santi, which was used for official purposes.

Sala dei Santi, Bernadino Pinturicchio, The Dispute between St. Catherine of Alexandria and the Emperor Maxentius, 1492–1495
Fresco

While the paintings on the ceiling consist of scenes from Egyptian and Greek mythology alluding to the bull on the Borgia coat of arms, the frescoes in the lunettes show the persecution of Christians by unbelievers and the Christians' eventual triumph. On the wall opposite the windows is a scene from the life of St. Catherine of Alexandria.

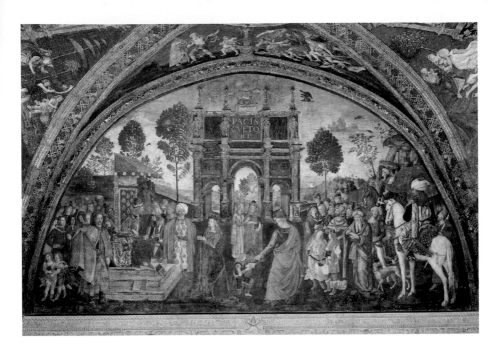

She suffered martyrdom in 307 under Emperor Maxentius after denying the pagan gods at a sacrificial festival held by the emperor. The fresco shows the dispute between the saint and the emperor in an oriental setting, though behind them is the Arch of Constantine. The emperor summoned fifty pagan philosophers to refute the saint, but Catherine succeeded in convincing them that her faith was the true one and so converted them to Christianity. In his fury, Maxentius had them all put to death. Catherine was to be broken on the wheel, but this itself broke, and so she was beheaded. Pinturicchio portrayed numerous contemporaries in this fresco. On the left of the throne, for instance, we see Andreas Palaiologo, a member of the Byzantine ruling dynasty; behind him stand Antonio da Sangallo and the painter himself. The man on a horse on the right edge could be Prince Djem, who was a hostage in the Vatican Palace and also served Pinturicchio as a model for oriental costumes.

The Most Important Popes

Peter (30–67): 64 Persecution of the Christians in Rome under Nero; 67 crucifixion of Peter on the Vatican Hill and his burial in Ager Vaticanus (below).

Callistus I (217–222): Lays great stress on exceptional status of the bishops of Rome and so creates the "idea of the papacy."

Miltiades (311–314): 313 Edict of Milan under Constantine proclaims principle of tolerance and so ensures complete religious freedom for Christians.

Damasus I (366–384): Demands doctrinal authority for the bishops of Rome with reference to their succession to Peter; as a consequence the papacy gradually develops.

Siricius (384–399): 391 Christianity becomes the state religion in the Roman empire and the bishop of Rome is acknowledged as the supreme authority in the Church.

S. Giovanni in Laterano (after 313)
Old St. Peter's (under Silvester I, 3rd century; left)
S. Marco (under Marcus 336)
S. Costanza (1st half of 4th century)
S. Pudenziana, has oldest figurative mosaic in its apse (Siricius)
S. Paolo fuori le Mura (end 4th century)

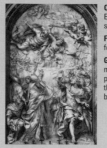

Celestine I (422–432): 431 Council of Ephesus decides that the Virgin Mar should be venerated as the Mother

Felix IV (526–530): 529 Benedictine founded by Benedict of Nursia.

Gregory I, The Great (590–604): The monk to be pope, he founds the sec power of the papacy in Italy by cent the papal properties and so gradual becomes ruler of the City of Rome.

Leo I, The Great (440–461): 445 Emperor Valentinian III recognizes t primacy of the bishops of Rome in the Western world, making Leo I real pope (above).

SS. Cosma e Damiano with a mosaic in the apse (526; above)

S. Sabina with one of the oldest depi the crucifixion of Christ on its woode (Celestine I)
S. Maria Maggiore (Sixtus III, 432–44
S. Stefano Rotondo (Hilarus, 461–468
Simplicius, 468–483)
Mosaic on the triumphal arch in S. L fuori le Mura (Pelagius II, 579–590)

Sergius III (904–911): 910 Benedictine Abbey at Cluny founded; the "time of the immoral popes" begins, as they come under the influence of their mistresses.

John XII (955–964): Otto I, first Holy Roman Emperor, renews the Church State and secures the emperor's right in the election of the pope.

Gregory V (996–999): Appointed first German pope by his cousin, Otto III, and in return crowns Otto emperor (below).

S. Bartolomeo under Benedict VII, 977 (left).

Leo IX (1049–1054): Combats the sale of offices and marriage for priest 1054 first Great Schism in the Church, the final split between the Easte and the Western Churches.

Nicholas II (1059–1061): 1059 Lateran Synod transfers the election of th popes to the cardinals.

Gregory VII (1073–1085): 1075 Formulates the rights of the pope (*Dictat Papae*); forbids lay investiture and the sale of offices and insists on celibacy; start of the investiture conflict with Henry IV, over whether th secular ruler may appoint bishops and abbots; 1077 Rome plundered b Normans; retreat of Henry IV and the pope banished.

Urban II (1088–1099): 1096 First Crusade, which ends with the conquest of Jerusalem (right).

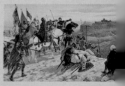

Fresco in the Mary Oratory in S. Pudenziana (1080)
Frescoes with the legend of St. Clement in S. Clemente (11th century; left)

600–800

...hen III (752–757): Allies with the Frankish ... Pepin, who gives the land he conquered to ...Holy See as Pepin's Bequest, thus laying the ...dation of the Church State. Stephen III ...s his claim to be the independent ruler on a ...ed document (the *donatio Constantini*) ...ng that the Emperor Constantine the Great ...already appointed the pope secular and ...esiastical ruler of Rome and the Western ...inces for all time (right).

...rian I (772–795): 774 Lombardy conquered ...harlemagne; Pepin renews his promise to ...a Church state under the protection of the ...ks.

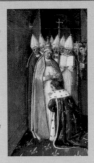

800–900

Leo III (795–816): Crowns Charlemagne emperor in Rome (right).

Paschal I (817–824): 824 *Constitutio Romana*: Emperor Lothar I affirms imperial rights within the Church State.

Leo IV (847–855): Proclaims the pope's sovereignty on earth (*Papa caput totius orbis*) to strengthen his own power and that of the Church against the secular powers.

Nicholas I (858–867): Establishes a steadily stronger position against the Carolingian dynasty, aims to replace the system of national churches with a centralized administration in Rome.

S. Agnese fuori le Mura (Honorius I, 625–638; left)
S. Maria in Cosmedin (Hadrian I)

S. Prassede (Paschal I)
S. Cecilia in Trastevere (Paschal I)
S. Maria in Domenica (Paschal I)
S. Marco (Gregory IV)
Città Leonina (Borgo district cleared and fortified, after 847)
The Ascension of Christ, fresco in the lower church of S. Clemente (Leo IV) (left).

1100–1200

...stus II (1119–1124): 1122 Concordat ...rms between the pope and Henry V ...the investiture conflict; 1123 the ...ateran Council declares the Church ...endent of secular powers.

...ius III (1145–1153): 1146 Republic ...ne proclaimed by Arnold of ...ia, in an uprising against the ...ar powers of the popes.

...an IV (1154–1159): 1155 Arnold of Brescia executed, Frederick I ...ned emperor in Rome (right).

...ent III (1187–1191): 1188 Romans give contractual recognition of the ...as ruler of the city, in return he acknowledges the rights of the ...e.

1200–1300

Honorius III (1216–1227): 1220 Confirmation of the Dominican order founded by St. Dominic (ca. 1170–1221) and 1223 of the rules of the Franciscan order founded by St. Francis of Assisi (1182–1226).

Gregory IX (1127–1241): 1232 Introduction of the Inquisition, entrusted to the Dominican Order.

Celestine IV (1241): First pope elected by the cardinals in conclave, that is, in a closed room.

Innocent III (1198–1216): Takes the power of the pope to its peak. The pope is now regarded as God's appointed ruler, and the secular princes receive their realms as fiefdoms from him (above).

Upper church of S. Clemente (Paschal II, 1099–1118)
SS. Quattro Coronati (Paschal II)
S. Maria in Cosmedin (Callistus II)
S. Maria in Trastevere, portico, campanile and Cosmati work (Innocent II, 1130–1143)
S. Saba (ca. 1150; left)
S. Croce in Gerusalemme (Lucius II, 1144–1145)

Frescoes in S. Giovanni a Porta Latina (early 13th century)
Cloister in S. Paolo fuori le Mura (1205–1241)
S. Lorenzo fuori le Mura (ca. 1220)
Cloister in S. Giovanni in Laterano (1223–1230; left)
Bronze statue of St. Peter in St. Peter's (13th century), S.M. sopra Minerva (from 1280; Martin IV, 1281–1285)

The Most Important Popes

1300–1400

Clement V (1305–1314): 1305 Philipp IV, The Fair, of France enforces the election of Clement V as pope, sealing the dependence of the Curia on France; 1309 the popes move to Avignon.

Gregory XI (1370–1378): 1376 Catharine of Siena (1347–1380) induces the popes to return to Rome.

Urban VI (1378–1389): 1378 Great Schism begins with the election of Clement VII as anti-pope; it is to split Europe into two camps.

Boniface VII (1294–1303): 1300 First Holy Year proclaimed; 1302 papal bull *Unam sanctem,* stating that all, including secular rulers, are subject to the authority of the pope (above).

1400–1500

Gregory XII (1406–1415): Second Reform Council in Constance ends the Great Schism.

Martin V Colonna (1417–1431): Authority of the pope restored within the Church State and the reconstruction of Rome begins.

Nicholas V (1447–1455): With the election of Nicholas V, who summons humanist scholars and artists to Rome, the papacy regains its strong position in the Church (right).

Sixtus IV della Rovere (1471–1484): Art and scholarship begin to flourish under papal patronage; the pope strongly opposes the moral decline caused by nepotism (famil erences) and the sale of offices; 1471 starts to build up an art collec

Alexander VI Borgia (1492–1503): 1500 Holy Year.

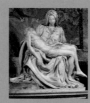

Apse mosaic by Jacopo Torriti in S. Maria Maggiore (1255)
Frescoes in S. Cecilia and S. Maria in Trastevere by Pietro Cavallini (end 13th century; left)
Giotto, Stefaneschi Triptych, Musei Vaticani (1313)

Bronze Door for Old St. Peter's by Anton (1433–1445)
The Castel Sant'Angelo converted (from
Frescoes in the Cappella Niccolina by F (1448–1449)
Palazzo Venezia (from 1455)
S. Maria del Popolo (from 1472)
Sistine Chapel (from 1473)
Palazzo della Cancelleria (1483)
Pietà by Michelangelo in St. Peter's (149

1600–1700

Urban VIII (1623–1644): Supports France in the Thirty Years' War (1618–1648) against the Holy Roman Emperor and Spain; 1631 delivers Galileo Galilei, the astronomer, to the Inquisition.

Alexander VII (1655–1667): 1665 Queen Christina of Sweden moves to Rome and converts to the Roman Catholic faith.

Innocent XI (1676–1689): 1684 "Holy Alliance" of Austria, Poland, and Venice against the Turks under the protection of the pope.

Innocent XII (1691–1700): 1692 papal bull *Romanum decet Pontificem* condemns nepotism.

Innocent X (1644–1655): 1648 Rejects the Peace of Westphalia, which is unfavorable to the Catholic Church (above).

1700–1800

Clement XII (1730–1740): 1734 Establishes Capitoline Museum.

Clement XIV (1769–1774): 1773 Jesuit Order dissolved; 1770–1784 Museo Pio-Clementino established in the Vatican Museums.

Pius VI (1775–1799): 1788 first excavations on the Forum; 1789–1799 the Republic of Rome proclaimed under the impact of the French Revolution; 1798–1801 wars against France, in the course of which the pope is taken prisoner by the French.

Clement XIII (1 1763 Appoints Winckelmann trator of the pa tion of antiquit (above).

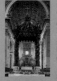

Painting in the Cerasi Chapel in S. Maria del Popolo by Caravaggio (1600–1601)
Altar baldachin in St. Peter's by Bernini (1624–1633; left)
S. Ignazio di Loyola (from 1626)
S. Carlo alle Quattro Fontane by Francesco Borromini (from 1634)
Fresco in the dome of the Chiesa Nuova by Pietro de Cortona (1648–1651)
St. Peter's Square redesigned by Bernini (from 1656)
St. Ignatius Altar in Il Gesù by Andrea Pozzo (1696–1700)

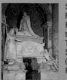

Spanish Steps (1723–1726)
Fontana di Trevi (1732–1762)
Parnassus by Anton Mengs in the Villa Albani (1761)
Tomb of Clement XIII in St. Peter's by Canova (1788–1792; left)
Palazzo Braschi (from 1790)

1500–1550

Popes

…us II della Rovere (1503–1513): Becomes …ing statesman and patron of the arts (right).

…X de Medici (1513–1521): Promotes …ding of St. Peter's with letters of indulgence; …Start of the Reformation with the publication …ther's 95 Theses.

…ent VII de Medici (1523–1534): 1527 Sack of …e by the troops of Emperor Charles V; the …cy loses its position as a major political …er.

…III Farnese (1534–1549): 1534 Society of …s (the Jesuits) founded by Ignatius of Loyola (1491–1556) and …mes the major force in the Catholic Church during the Counter …rmation; 1545–1563 Council of Trent summoned to reform the Catholic …ch.

1550–1600

Popes

Paul IV Carafa (1555–1559): First active reformer; start of the Counter Reformation.

Pius IV de Medici (1559–1565): 1562–1563 3rd session of the Council of Trent establishes Catholic creed and strengthens the position of the pope.

Pius V (1566–1572): strong action against the sale of offices (right).

Gregory XIII (1572–1585): 1582 Introduction of the Gregorian calendar.

Sixtus V (1585–1590): Major builder and conservator of historical monuments.

Clement VIII (1592–1605): 1600 Philosopher Giordano Bruno burned at the stake as a heretic on the Campo dei Fiori.

Art and Architecture

Tempietto (1502)
Tomb of Julius II by Michelangelo (1505–1545)
St. Peter's rebuilt (1506–1626)
Villa Chigi (1507–1511)
Raphael rooms in the Vatican (from 1509)
Palazzo Farnese (from 1514)
The Last Judgment in the Sistine Chapel painted by Michelangelo (1534–1541)

…g fresco in the Sistine …el painted by …elangelo (1508–1512; …).

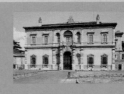

Villa Giulia (from 1550; left)
Dome of St. Peter's (1564–1590)
Il Gesù (from 1568)
Chiesa Nova (1575–1599)
Lateran Palace (after 1585)
Piazza del Popolo (from 1599)
S. Andrea della Valle (from 1591)
Frescoes in the Galleria of the Palazzo Farnese by Annibale Carracci (ca. 1597)

1800–1900

Popes

…II (1800–1823): 1806 Holy Roman Empire comes to …d after 1000 years when Franz II lays down the …al crown; 1808–1811 Rome becomes part of the …h empire and the pope is a prisoner of Napoleon …814; 1814 the Church state reestablished …he Peace of Paris (right).

…X (1846–1878): 1848 Flees from Rome …pressure of the Risorgimento, the …ng nationalist movement; France restores …e of the popes in Rome against opposition …aribaldi; 1854 doctrine of the Immaculate …tion of Mary; 1869–1870 First Vatican Council: …e of the infallibility of the pope; 1870 Italian …enter Rome, end of the Church state; 1871 the pope resists the …ntee Law and withdraws into the Vatican.

PIVS VII

1900–2005

Popes

Pius XI (1922–1939): 1929 Lateran Treaties signed between Mussolini and the pope recognizing the sovereignty of the Church state.

John XXIII (1958–1963): 1962–1965 Second Vatican Council intended to work for the unification of the Christian churches.

Paul VI (1963–1978): The Holy Office renamed the Congregation for the Propagation of the Faith; recognition of the bones found in the marble tomb under St. Peter's as genuine relics of St. Peter.

John Paul II (1978–2005): First pope from outside Italy for more than four hundred years; he traveled widely, visiting Christians all over the world, and took up the dialogue with other faiths; 1981 assassination attempt on him in St. Peter's Square; 2000 Holy Year (above).

Art and Architecture

…Park (early 19th century)
…f Pius VII in St. Peter's by Thorvaldsen (1823; right)
…ent to Giuseppe Garibaldi (ca. 1850)
…teca in the Vatican (1846–1878)
…e Termini (from 1867)
…della Repubblica (1887; Leo XIII 1878–1903)
…di Giustizia (1899–1910)

Foro Italico (1928–1936)
EUR (from 1940; Pius XII 1939–1958)
Palazzo della Civiltà del Lavoro (1938–1943)
Palazzo dello Sport (1960)
Lateran Museum in the Vatican (1958–1963)
Sala delle Udienze Pontificie in the Vatican (1964–1971; right)
Restoration of the Sistine Chapel completed (1994)

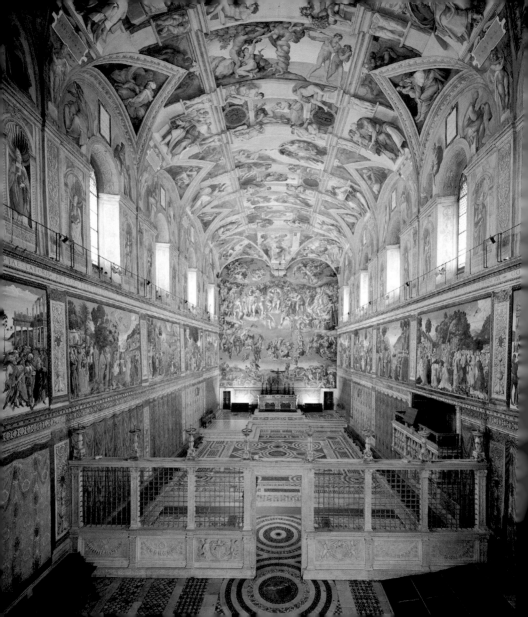

The Sistine Chapel
(Cappella Sistina)

The most famous room in the Vatican Museums is the Sistine Chapel, built by Giovanni de'Dolci in 1475–1481 for Pope Sixtus IV. It is a monumental room measuring 40.9 by 13.4 m (134 by 44 feet) and having a height of 20.7 m (67.9 feet). Six windows are set in each of the long sides. Andrea Bregno created the marble screen that separates the altar area reserved for the clergy from the room for the lay congregation, and the famous choristers' gallery beside it. The floor is decorated with inlay work in multi-colored marble, while the lower part of the walls is traditionally hung with tapestries. Under Sixtus IV the artists Botticelli, Ghirlandaio, Cosimo Roselli, Piero di Cosimo, Perugino, Pinturicchio, Bartolomeo della Gatta, and Luca Signorelli had already painted the walls beneath the windows with frescoes between 1481 and 1485. Divided into simple rectangular fields, the left-hand wall contains scenes from the life of Moses, and the right-hand wall scenes from the story of Christ. The painted niches between the windows contain portraits of popes. But the crowning glory of the decoration is the vaulted ceiling, which Michelangelo painted twenty-five years later for Julius II, and his later fresco *The Last Judgment* on the altar wall, painted for Paul III. These frescoes, the supreme examples of Italian High Renaissance painting, make the Sistine Chapel a major attraction for every visitor to Rome. Nevertheless, the Sistine Chapel is not a museum or gallery; it is part of the active daily life of the Church. It is still used by the pope for private services and it is where the conclave takes place to elect a new pope.

Michelangelo Buonarroti (1475–1564), Ceiling Fresco, 1508–1512
Fresco, 40.23 × 13.30 m

When Julius II entrusted the decoration of the ceiling of the Sistine Chapel to Michelangelo in 1508, the vault was simply painted with a starry sky. Dissatisfied with his original task, namely to depict the twelve Apostles, Michelangelo persuaded the pope to accept a radical change of plan. He created a vast painting in which the real architectural features of the chapel (notably twelve triangular ribs and the lunettes they create) are combined with an elaborate *trompe l'œil* painted architecture. The areas between the lunettes were painted to resemble an attic zone, in the niches of which he could place large seated figures. This scheme gives the impression that the real ribs rise from painted piers that stretch right across the ceiling, creating the nine central panels in which the main scenes are depicted. These scenes show three narratives: *The Creation of the World*, *The Expulsion from the Garden of Eden*, and *The Story of Noah*. The triangular lunettes on both sides contain images of prophets and sibyls

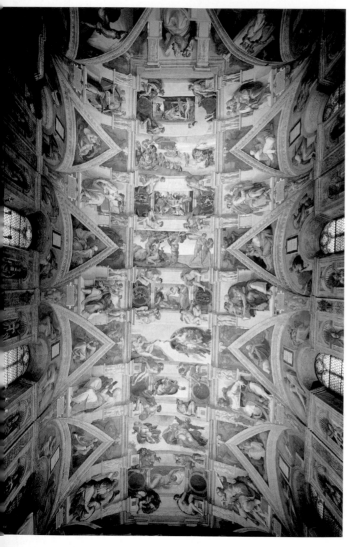

and scenes from the Old Testament. This rhythmic division into large horizontal pictures and smaller flanking scenes gives particular prominence to four major scenes that develop chronologically, beginning at the altar end: *The Separation of Light and Darkness*, *The Creation of Adam*, *The Fall from Grace and the Expulsion from the Garden of Eden* and *The Flood*. The program is arranged in such a way that it can be read from the entrance. Michelangelo painted the seated prophets and sibyls and the *ignudi* (male nudes) on a scale that increases towards the altar end, correspondingly reducing the number of figures in the individual scenes. This gigantic undertaking was completed in only four years' time, and was unveiled on All Saints Day in 1512.

Schematic arrangement of the ceiling decoration

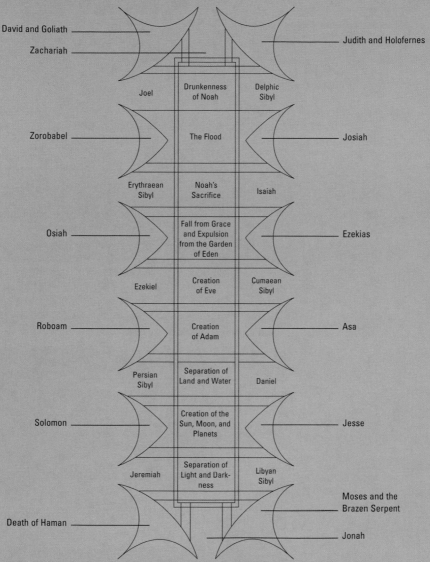

David and Goliath

Zachariah

Judith and Holofernes

Joel

Drunkenness of Noah

Delphic Sibyl

Zorobabel

The Flood

Josiah

Erythraean Sibyl

Noah's Sacrifice

Isaiah

Osiah

Fall from Grace and Expulsion from the Garden of Eden

Ezekias

Ezekiel

Creation of Eve

Cumaean Sibyl

Roboam

Creation of Adam

Asa

Persian Sibyl

Separation of Land and Water

Daniel

Solomon

Creation of the Sun, Moon, and Planets

Jesse

Jeremiah

Separation of Light and Darkness

Libyan Sibyl

Death of Haman

Moses and the Brazen Serpent

Jonah

Michelangelo Buonarroti, Ceiling (detail),
The Creation of Adam
Fresco, 280 × 570 cm

Probably the most famous fresco on the ceiling is *The Creation of Adam*. Michelangelo chose the dramatic moment when Adam is touched by the finger of his Creator and a soul is breathed into him.

Michelangelo Buonarroti, Altar Wall,
The Last Judgment, 1535
Fresco, 13.70 × 12.20 m

In 1535, a long time after the ceiling frescoes, Michelangelo was commissioned by Pope Paul III to paint the altar wall in the Sistine Chapel. While the angels above bear the instruments of Christ's Passion and beneath blow trumpets to announce the Last Judgment, Christ is enthroned amidst a sea of nude figures and surrounded by the Apostles and other saints. His judgment appears so terrible that even the Virgin Mary is turning away. On the left side, the blessed are rising to heaven, while on the right the damned are tumbling into the dark depths where Charon, the ferryman of the Underworld, is waiting to take them over the River Styx to Hades (hell). Michelangelo has placed the dark entrance to the underworld exactly where the gaze of the priest reading mass will fall, as if to strengthen his frightening vision of the Last Judgment; the scene recalls the description of hell in Dante's *Divine Comedy*. Initially the fresco was greeted with admiration, but later people began to object to the many naked forms and Pope Pius IV instructed Girolamo da Fano and Daniele da Volterra (who has entered art history as "the fig leaf painter") to cover the nudity.

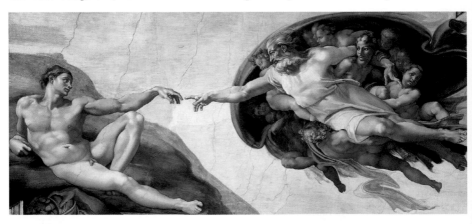

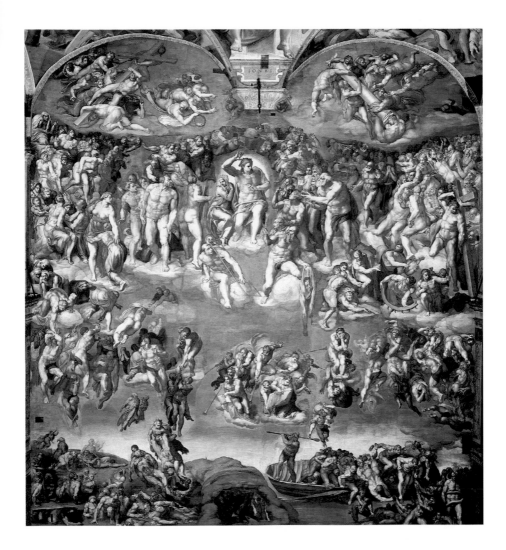

The Renaissance of Color – the Restoration of the Sistine Chapel

"It is like opening a window in a dark room and seeing a panorama flooded with light." That is how Carlo Pietrangeli, former Director General of the Vatican Museums, described the restoration work on the ceiling, the lunettes, and the altar wall in the Sistine Chapel. Indeed the result filled specialists and art lovers alike with amazement. What had until then been referred to as "Michelangelo's dark coloring" and his "monochrome work" was revealed as a brownish-gray patina that had been created over centuries by dust and candle smoke. Once the work was cleaned, light and powerful colors emerged that have allowed scholars now to form a completely different impression of Michelangelo and his way of working. To decorate the chapel he used the technique of *buon fresco*, the application of paint to a plaster ground that was still wet. He chose a broad spectrum of colors – they range from violet, pink, and enamel blue to red ocher and golden brown umber, with bold contrasts of yellow, blue and green, light cinnabar, and lavender gray;

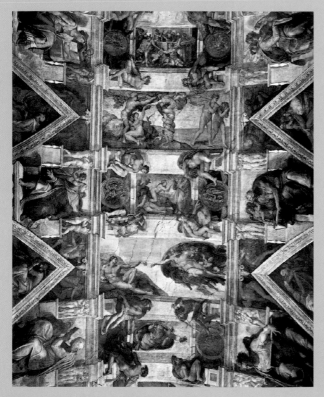

Michelangelo Buonarroti, Ceiling Fresco in the Sistine Chapel 1508–1512, before restoration, The Vatican Museums, Rome

the agitated crowd of naked figures on the altar wall are set against a background of intense blue.

But not everyone was convinced by the glowing colors, and the criticism that accompanied the restoration work right from the start is still being voiced today. The New York Professor James Beck spoke of a "Chernobyl of art history" and "an assassination attempt on Michelangelo," expressing his concern that the "genuine" Michelangelo would be irrevocably lost through the cleaning. But other scholars believe that the bright colors are very credible in view of the Florentine tradition of fresco painting, and clearly prepared the way for the emergence of Mannerism, a movement that was strongly influenced by Michelangelo.

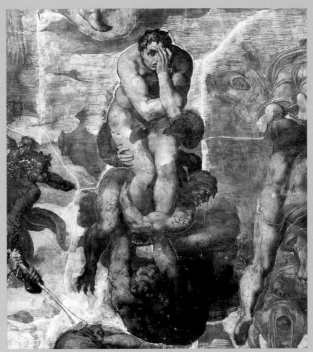

Michelangelo Buonarroti, The Altar Wall in the Sistine Chapel, detail of The Last Judgment, Vatican Museums, Rome

How it all Began

The story of the restoration of the Sistine Chapel is almost as old as the frescoes themselves. Only fifty years after the ceiling was completed, soot from candles and heaters had darkened the colors; rainwater had seeped in, causing cracks and salt encrustations to appear on the frescoes. Pius V (pontificate 1566–1572) was therefore forced to undertake the first repairs, and he entrusted Domenico Carnevali, a painter from Modena, with the work. Even at this date the colors must have been very dirty, for Carnevali often – as became apparent in the most recent examinations – used much darker colors than those of the original. About a hundred and fifty years later, Annibale Mazzuoli undertook

Michelangelo Buonarroti, The Ceiling in the Sistine Chapel, detail showing the Libyan Sibyl, 1511, The Vatican Museums, Rome

The Return of the Colors

Under the direction of Gianluigi Colalucci, chief restorer of the Vatican Museums, work began on Michelangelo's Sistine frescoes in 1980. It was preceded by a detailed analysis to determine the chemical components of the frescoes, so that the cleaning process could first be simulated in the laboratory. The actual restoration work was followed on camera by the Japanese television company that financed most of the project by buying the rights to film and photo reproduction. Thanks to another sponsor, an elaborate computer complex was installed to store the data regarding format, painting technique, the condition of the frescoes, and the progress of the restoration work. It was probably the most elaborate documentation ever made, and it was supplemented by commentaries the restorers recorded on audio tape as they worked.

The actual restoration work consisted of washing down the frescoes with a cleaning fluid specially developed in the Vatican Istituto Centrale del Restauro in the 1970s. The solution was applied twice at intervals of twenty-four hours to the areas that had been painted *al fresco*; this caused the deposits of soot, dirt, and varnish that had accumulated over centuries to swell up so that they could simply be wiped off.

another restoration, attempting to clean the frescoes with a sponge and white wine. He then covered them with a varnish of animal size to cover the salt and freshen up the colors. But all these efforts were of little avail, and after only a short time the colors resumed their dark, yellowed tint; it appeared that there was no way to clean them thoroughly. Only after a successful campaign to clean other 15th-century wall frescoes in the 1960s did restorers dare to touch the Michelangelo frescoes as well.

However, this technique was not suitable for the few areas that had been painted *al secco* (on to dry plaster), which were identified using computer graphics before restoration began. As these areas are much less durable, this form of cleaning would have damaged them irreversibly. Instead, they were fixed first with a solution of acrylic resin, and then cleaned using brushes and organic substances that contained no water. To conserve the magnificent colors that had re-emerged, the restored frescoes were not only covered with a simple glaze as Michelangelo had done: modern aids were installed as well. These include special lamps that ensure lighting conditions that will not damage the work, and a computer-controlled air-conditioning plant to ensure that the humidity and temperature in the chapel are constantly kept at the right level.

After the work on the ceiling and the altar wall was completed, the restoration of the Quattrocento frescoes on the sides walls by Perugino, Botticelli, Ghirlandaio, Roselli, and Signorelli was undertaken. This work was recently completed and now the Sistine Chapel is radiant again in all its former glory.

It is now hoped that the frescoes will keep their glowing colors for a very long time. Giorgio Vasari said of them prophetically: "Truly, this work was and is the shining glory of our art. It has brought so much light and aid to painting that it will illuminate the world that was in darkness for so many centuries."

Michelangelo Buonarroti, The Last Judgment, detail with the Artist's Self-Portrait, 1535, Sistine Chapel, Vatican Museums, Rome

Biblioteca Apostolica Vaticana

Sala delle Nozze Aldobrandini,
The Aldobrandini Wedding, ca. 20 B.C.
Fresco, 205 × 92 cm

When this fresco from the Augustan age was rediscovered on the Esquiline Hill, it was given the name of its first owner, Cardinal Pietro Aldobrandini. It shows the preparations for a wedding. On the bed in the center of the room sits the veiled bride with Venus, the goddess of love; the woman on the left, leaning against a low pillar, is presumably a member of the goddess' retinue; the young man on the step on the right is the bridegroom. On the left edge of the picture a veiled woman can be seen preparing the bridal bath, while two female musicians on the right are striking up a wedding song and another is blowing gently on the fire contained in a bronze dish. The fact that there are differences in the size of the figures, in the modeling, and in the composition is a clear indication that the fresco is not based on a uniform composition. The central group is probably taken from a Greek model of the late 4th century B.C., the *Hieros gamos*, showing the sacred nuptials of Dionysos and Ariadne. The painter then added the groups of figures at the sides and transformed the whole into a Roman wedding ceremony.

Sala delle Nozze Aldobrandini,
The Landscapes of the Odyssey, ca. 50/40 B.C.
Fresco, height of parts 150 cm

Also found on the Esquiline is a wall frieze dating from around 50/40 B.C. It shows scenes from the 10th and 11th books of Homer's epic *The Odyssey* set against wide, impressionistically rendered landscapes. During his many wanderings, Odysseus and his companions came to the land of the Laestrygones, who were cannibals. Under the directions of their king, Antiphates, the Laestrygones immediately attacked and killed those who had come ashore. They hurled great blocks of stone at the Greek ships – as the upper image shows. Odysseus was the only one who was able to escape back to sea and to continue his journey to the island of Aeaea. There he was received in the palace of Circe, the famous sorceress. Unfortunately, the scene showing the transformation of his companions into animals has been lost. The lower picture shows Odysseus setting off for the underworld, where he will question the celebrated seer Tiresias. The following scene shows the suffering of those who were condemned to Hades – the Danaides, Sisyphus, Tityus, and Orion – while the last two scenes, of which only fragments have survived, show the daring voyage past the island of the Sirens and his escape from the cave-dwelling monster Scylla. This frieze is not an original Roman creation; it derives from a late Hellenistic original that was presumably set out in continuous sequence.

The Roman painter, however, used only parts of his model and set them in a painted architecture, so that it gives the impression that the frieze were running out behind the pair of pillars on a high plinth on the wall.

Braccio Nuovo

Doryphoros, Roman Copy of a Greek Original ca. 440 B.C.
Yellow marble, h 211 cm

The Braccio Nuovo, one of the buildings adjacent to the Cortile del Belvedere, was built in the early 19th century by Raffaele Stern; it contains a number of masterworks of antique sculpture. Among the very finest works of classical Greek statuary is the Doryphoros (Man with a Spear) by Polyclitus dating from around 440 B.C., of which only this Roman copy in marble has survived. Often interpreted as a victorious athlete, the statue is more likely to be the youthful hero Achilles. The sculpture is regarded as a model of the rules which Polyclitus set down in his theoretical "canon" for the harmonious balance in sculpture of tension and relaxation, supports and weight, rest and movement. This *contrapposto* is expressed in the contrast between the leg supporting the body's weight and the leg in movement, between the resting arm and the active arm, which appear as opposing but balancing elements. The young man seems to have paused briefly while walking, one side of his body at rest, the other still active. The principle of movement and counter movement, which is sustained right through to the curls of the man's hair, became a model which was used by following generations of sculptors.

Augustus of Primaporta, ca. 20 B.C.
Yellow marble, h 204 cm

The most famous portrait of Emperor Augustus is this statue of him in armor, which was found in the Villa Livia near Primaporta. It is an idealized portrait of a handsome, ageless face and body in the classical mode of Greek art of the 5th century B.C. Presumably it was made for his wife, Livia, after the death of Augustus in A.D. 14, the sculptor copying a bronze honorary statue of him sculptured shortly after 20 B.C. This is suggested by the unique relief decoration on the armor, the central scene of which shows the return of the standard lost by Crassus to the Parthians in 53 B.C., which was regarded as marking the start of the golden Augustan age. This historic event is shown as an integral part of the cosmos, and is accompanied by grieving figures on both sides representing subjugated peoples, or nations forced to pay tribute. Above we see the god of the sky Caelus, his mantle blowing wide; under him the sun god Helios on a chariot; before him are the moon goddess Luna, and Aurora, the goddess of the dawn. Below is the goddess of the earth, Tellus, with a cornucopia full of fruit. On the lower sides we see the patron deities of Augustus – Apollo and Diana – while sphinxes on the shoulder flaps watch over the new age of peace that has dawned.

Pinacoteca Vaticana

Giotto di Bondone (ca. 1266–1337),
The Stefaneschi Triptych, ca. 1313, St. Peter
Tempera on panels; central section 178 × 88 cm,
side panels 168 × 82 cm. Predella: central
section 44 × 85 cm, side panels 44 × 82 cm

Cardinal Jacopo Stefaneschi probably commissioned Giotto to paint the triptych for Old St. Peter's in 1313. It was painted to support the demands made by the Roman cardinals when the papacy returned to Rome after its exile in Avignon. So the main figure in the center is St. Peter, seated on a throne of Cosmati work, bearing in his left hand the keys of his office. On the right side a saint is recommending the hermit Peter of Morrone, whose sanctification Stefaneschi had documented in 1313. The patron himself is in the left foreground, kneeling on a marble floor that is shown in convincing perspective; he is handing St. Peter a model of this very triptych. Stefaneschi is being introduced to St. Peter by the saint to whom his own church was dedicated, St. George. On the side panels are depicted St. Jacob and St. Paul (left) and St. Andrew and St. John (right).

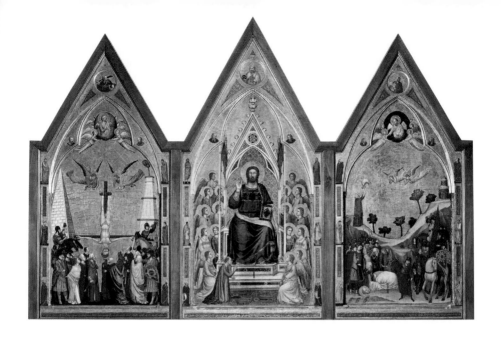

The Stefaneschi Triptych, Christ

The side panels on the reverse show the martyrdom of St. Peter (left) and St. Paul (right), who are the main saints of the church for which the work was intended (Old St. Peter's). In the center Christ is enthroned, His hand raised in blessing. The donor of the altar kneels bareheaded before him. The extremely high format of the panels is unusual, but Giotto has utilized it to create compositions full of tension for the scenes contain a large number of figures. In the scene showing the martyrdom of St. Peter, the inverted cross is set between a pyramid and the *meta Romuli*, the emblem of Rome and the Vatican, with a crowd of soldiers and grieving watchers pressing around it. But in the scene showing the martyrdom of St. Paul, a rocky landscape separates the events on earth from those in heaven. The middle foreground is occupied by the figure of the executioner and the soldiers, while the mourners are gathered around the beheaded figure on the left. Giotto's delicate painting, the strong colors set against a gold ground, the rendering of figures, and a pioneering use of perspective all make the triptych one of the great masterpieces of the 14th century.

Leonardo da Vinci (1452–1519)
St. Jerome in the Wilderness, ca. 1480
Oil on panel, 103 × 75 cm

This panel, dated to around 1480, is a work that Leonardo da Vinci left unfinished, with only the underpainting executed. In contrast to the traditional iconography, it does not show St. Jerome as a learned Father of the Church, in a cardinal's hat and with a book. Instead he is depicted as a clean–shaven and emaciated repentant. Jerome withdrew into the wilderness to make a new translation of the Bible (the Vulgate bible) and to live a frugal, ascetic life. He is depicted sunk in humility before the Cross of Christ, crouching, holding in his right hand a stone with which he is beating his breast. The only reference to his identity is the lion lying before him, a symbol rather than a living animal. Although it is unfinished, the painting is still very compelling, the saint's emaciated body, only lightly painted, standing out dramatically against a dark and fantastical landscape.

Raphael, The Transfiguration, 1520
Oil on panel, 405 × 278 cm

This is Raphael's last painting; he died in 1520 leaving it unfinished. The client, who was Cardinal Giulio de Medici, commissioned the artist to depict the dual nature of Christ, divine and human. Raphael succeeded in handling this complex theme by combining in one picture two narratives that are separate in the Bible. The composition was conceived in such a way that the Transfiguration of Christ Resurrected in the upper part would be visible from a distance to the faithful as they entered the church, while the lower section would be seen only by the priest who was saying Mass. Depicting the story of the healing of a young boy who was insane, the lower section deals with the theme of Jesus as healer, providing release from all pain and suffering. This theme was a reference to the patron (in Italian *Medici* means "doctors").

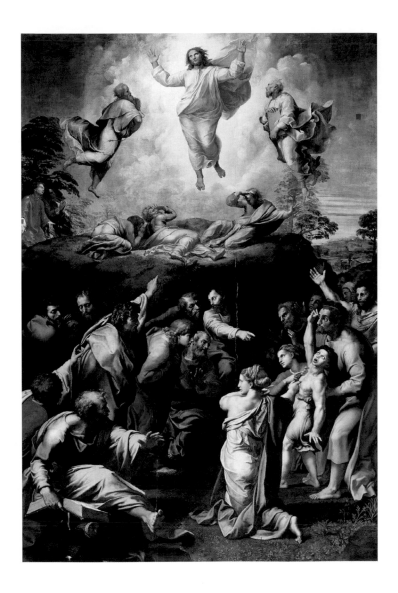

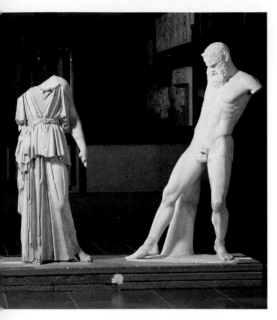

Myron (5th century B.C.) that once stood on the Acropolis in Athens. The original can be reconstructed from the descriptions given by two writers of classical antiquity, Pliny and Pausanias. It showed the goddess Athena, robed in a belted *peplos*, who has cast away the double flute she had invented because her face is distorted when playing it. The goddess is thrusting Marsyas away with a firm gesture as he bends to pick up the instrument from which such wonderful sounds can be drawn. He later learned to play the flute and challenged Apollo to a competition; Apollo punished him for his presumption by having him flayed alive. In the gallery a figure of Athena is displayed beside Marsyas, together with another torso of Marsyas from Castel Gandolfo.

Reconstruction of the Athena-Marsyas Group

Museo Gregoriano Profano

Marsyas, Roman Copy of a Greek Original from the Middle of the 5th Century B.C.
Pentelic marble, h 156 cm

In 1823 a sculptor's workshop was unearthed on the Esquiline; it was found to contain several sculptures, most notably that of a naked bearded man with pointed ears and a horse's tail. He is shown making an unusual dancing step. This marble statue of Marsyas is one of many copies of a famous bronze group by the Attic sculptor

**Niobide Chiaramonti,
Hellenistic Copy of an Original
from the 4th Century B.C.**
Yellow marble, h 176 cm

This statue of a girl moving quickly, her clothes streaming out behind her, was probably found in the Villa Hadriana. It is clear that she is Niobide, as the same figure recurs in the famous Niobide group from the 4th century B.C. in Florence. The statue relates to the myth of Niobe, daughter of Tantalus who, after she had given birth to seven sons and seven daughters, mocked the goddess Latona because she had only produced two children, Apollo and Artemis. To avenge their mother, Apollo and Artemis killed all her children. Niobe turned to stone in grief and was taken to her Lydian homeland and placed there as a rock. The statue in the Vatican, once displayed in the Museo Chiaramonti, depicts Niobide, one of the daughters of Niobe, in flight from the avenging gods. It was probably copied as an individual work in the 2nd century B.C.

A Small Paradise – the Vatican Gardens

by Jürgen Sorges

March 12, 1514. To celebrate the consecration and enthronement of the new pope, Leo X de Medici, King Emanuele of Portugal sent a particularly weighty gift. Moreover, it was very much alive. The Vatican court watched in amazement as an *archibestia* arrived, a primeval beast that had not been seen in Rome since the time of the Caesars. It was a live elephant named Annone after the Carthaginian general Hanno, and from that day on it lived in a stable on the edge of the Vatican Gardens. These gardens adjoined the new cathedral of St. Peter's, that was then under construction, and the new buildings of the Vatican papal palace. The mighty Leonine Wall, built in the 9th century, protected the grounds from the gaze of the curious. But in 1514 there was not much for the curious to see. The greater part of the Vatican Gardens was really a vegetable garden used to supply the papal kitchens. The narrow paths led between vegetable and herb beds and fruit trees.

In time, however, the Vatican Gardens were turned into an extensive park with countless decorative architectural pieces, enticing visitors to stroll and linger. Five centuries earlier the grounds, with their enclosing walls and watchtowers, had no buildings. Only the plane trees and pines of the *bosco*, the wood, that are still impressive today, dominated the scene. In those days it was common to call this the *selva*, the jungle. Hidden in the ground beneath the wild vegetation slumbered the remains of the circuses of Nero and Caligula, the foundations of Roman villas of the 2nd century A.D., and part of the Ager Vaticanus with many early Christian and heathen graves. In the early 16th century the terrain offered ideal conditions, not only for Annone and his keeper, and gradually a complete zoo was built up here amid the cultivated gardens. By 1516 the pope had already received another present, a live Indian rhinoceros. This species was completely unknown in Europe, and the German artist Albrecht Dürer had to use his imagination for a copperplate engraving he made in 1515 that has since become famous.

The jungle behind St. Peter's rapidly became a magic wood. The newly discovered world was regularly shown to courtiers, cardinals, and diplomats from America, Africa, and Asia in theatrical presentations. Artificial stands were built in the Cortile del Belvedere, the biggest inner courtyard in the Vatican Palace, for the spectators to applaud the taming of these utterly foreign creatures. Annone was a spectacular sensation, and he cost the papal court, eager for amusement, a considerable sum in upkeep. The satirist Pietro Aretino calculated that the elephantine eating machine, which he conceded was extremely intelligent, ate 100 ducats a year in food. His keeper, Giambattista Branconi, a confidant of Raphael, bore the prestigious title "elephant tutor." Annone's features can still be seen today in the Vatican

Anonymous, A Jousting Match on March 5, 1565 in the Cortile del Belvedere of the Vatican, Museo di Roma, Rome

Museums, in the corridor between the Stanza d'Eliodoro and Raphael's Stanza della Segnatura – a drawing by Raphael and a painting by Giovanni da Udine.

The veil of mystery surrounding the Vatican Gardens was lifted only at the end of the 20th century. Now visitors, under supervision, can enter the little state to the left of St. Peter's Square by the Piazza Protomartiri Romani every day through the Arco delle Campane. On the immediate left lies the Camposanto Teutonica, the German cemetery, which goes back to the year 799 and the coronation of the Frankish ruler Charlemagne (at Christmas 800). Among the many prominent people buried here is Regiomontanus (Johann Müller), the

Renaissance humanist who translated the *Almagest*, a scientific compendium by the ancient astronomer Ptolemy. The church of S. Maria della Pietà, which is part of the complex, was renovated in 1975 and re-consecrated. Next to it, by the Largo della Sagrestia, is the shell-shaped Aula delle Udienze, which was opened in 1971. It is the papal audience chamber and can hold twelve thousand standing or six thousand three hundred seated. After passing through the ticket office at the Ufficio Tecnico della Fabbrica di San Pietro, the Vatican site office, visitors are inevitably drawn to the magnificent magnolias on the Piazza Marta. All around lie the law courts, the Scuola del Mosaico (a mosaic work-shop with exhibition space), the Ethiopian

A Perspectival View of the Vatican Gardens. This engraving was made for a peep cabinet designed by the Husquier brothers around 1760 in Paris

Seminar, and the Vatican railway station. The great Palazzo del Governatorato on the Piazza del Forno is the seat of the papal civil administration. A great flower pattern before the main door is laid out in the *stemma*, the insignia of the reigning pope.

By the Fontana della Conchiglia is the entrance to the gardens on the Vatican Hill. Countless fountains and waterworks arranged in sequence mark the centuries and their distinctive styles. Crossing the Via dell' Osservatorio, visitors reach a replica of the grotto at Lourdes, a gift to Pope Leo XIII in 1902 that was conse-

crated on March 28, 1905 under Pius X. However, the Neo-gothic concrete tower 60 m (197 feet) high that was originally part of it was pulled down in 1933, as it no longer suited the park landscape architecturally. The Centro Trasmittente Marconi on Viale Pio XI takes one back to the early days of Radio Vatican (Radio Vaticana). The first transmitter was opened here in February 1931 in the presence of Pius XI and the scientist Guglielmo Marconi. The subsequent location, the Palazzo della Radio Vaticana, is opposite the Lourdes grotto. In 1939 the first studios were set up in what was once the summer residence of

Pope Leo XIII, and today two large satellite dishes, each a meter (3.28 feet) across, are evidence of technical progress; the studios were later moved to the Palazzo Pio on the Via della Conciliazione. Inside the building it is worth casting a glance at the ceiling painting by the 19th-century artist Ludwig Seitz showing the starry sky over Rome under the zodiac sign of Leo, a homage to the pope of the period, Leo XIII (pontificate 1878–1903). Immediately next to this building stood the Specola Vaticana from 1906 to 1932, the Vatican's astronomical observatory that was traditionally run by Jesuit priests known as the "sons of Heaven." Previously located in the legendary Tower of the Winds, the Specola is now in the papal summer residence at Castel Gandolfo. The papal helicopter landing-pad is immediately adjacent.

The undisputed highlight of this tour is the visit to the Casina di Pio IV on Viale del Giardino Quadrato. The two oldest buildings in the park, the large and small Casinos in the ensemble, were created in the 16th century by Pirro Ligorio and Giovanni Sallustio Peruzzi, a son of the famous architect Baldassare Peruzzi, under the aegis of Pope Paul IV (pontificate 1555–1559).

Inside, fantastic mosaics, a loggia in the Doric style, opulent figurative and ornamental stucco work, and the frescoes of Federico Barocci make the ensemble a time capsule of mid-16th century art. Since Pius XI (1937) the Pontifica Accademia delle Scienze, the papal Academy of Science, has been located here. Its members now form a particularly prominent group, for they are appointed directly by the pope, and without regard to nationality, gender or religion, and are accorded the title of Excellency.

The jewel of the Vatican Gardens is the Casina di Pio IV on the Viale del Giardino Quadrato

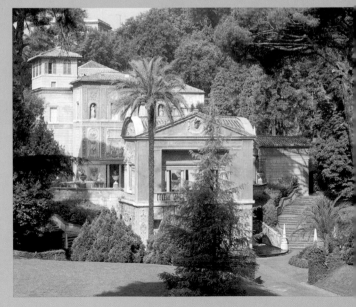

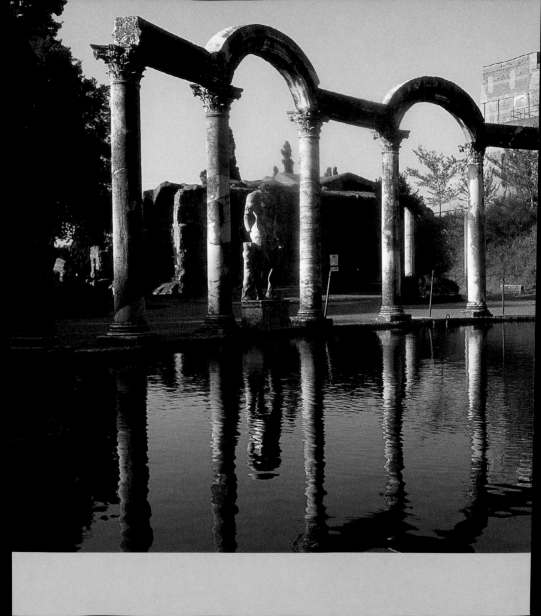

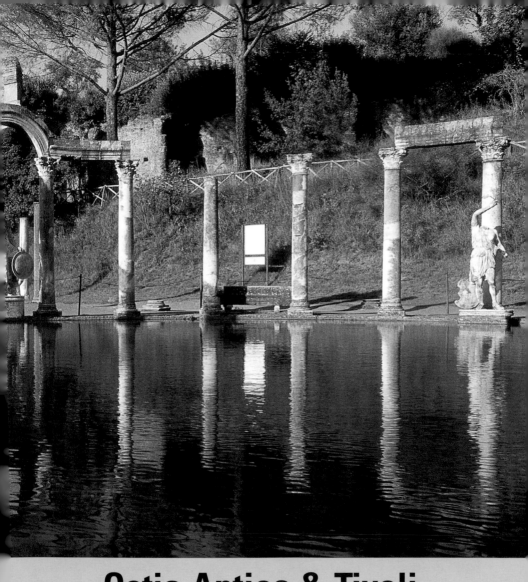

Ostia Antica & Tivoli

Ostia Antica

Nowhere else in the environs of Rome will the visitor gain so full and immediate an idea of the essence and history of an ancient Roman town as amid the ruins of Ostia, Rome's military outpost and main supply port. In the course of centuries the coastline has shifted several miles westwards, but in ancient times Ostia lay directly at the mouth (*ostium*) of the Tiber. According to legend, King Ancus Martius founded the town in the 7th century B.C. on the spot where Aeneas had landed.

Previous double page: the Vale of Canopus, Villa Hadriana, Tivoli

Archaeologists date the oldest building, the *castrum* (fortress), to the late 4th century B.C. It formed the core of the settlement, which rapidly grew into a busy town as Rome's sea trade grew and it became a major naval power. Food imports arrived here, particularly grain, from every corner of the empire; they were stored in *horrea* and then transported by river or along the Via Ostiensis to Rome. After the destruction during the civil wars in the 1st century B.C., Emperor Sulla had the town enclosed in a great wall. In A.D. 42 Claudius began building a new harbor (the Portus Augusti), but this was too small even by the end of the 1st century A.D. A second, larger harbor (the Portus Traiani) was laid out about 2 km (1.2 miles) north of the town

Painting on a tomb in Ostia showing a merchant vessel

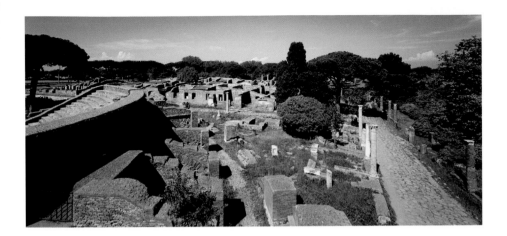

itself by Trajan; it was to help the town expand rapidly, making it a large and densely populated city. At its peak Ostia had around fifty thousand inhabitants, and many shopkeepers, seamen, traders and agents lived here, as did the *procurator annonae*, who was responsible for distributing the grain. The many squares, streets, temples, baths, and other public buildings, together with the large number of fine houses, bear witness to the importance of Ostia in imperial Rome. The buildings were adorned with valuable mosaics, wall paintings, reliefs and sculptures, some of which can still be seen. Only in the late 3rd century did Ostia gradually lose its importance. It had to cede its trade and administrative functions to Portus, which was raised to city status by Constantine. Another setback was the plundering by barbarians. In the 8th century, a malaria epidemic finally caused almost all the inhabitants to leave. Ostia was little more than a ghost town right down to the early 19th century. Then the first systematic excavations began under Pius VII and by 1942 about forty percent of the ancient town had been uncovered. The excavations were resumed in the 1960s, concentrating on the parts still buried. One of the great sensations of recent years was the discovery of an early Christian basilica near to the city wall – the bishop's church donated by Constantine.

Ostia Antica

The ancient city was built on the same plan as other Roman towns, in other words around the crossing of two major thoroughfares, the Decumanus Maximus, running east-west, with the Cardo Maximus, which ran north-south. At the intersection of these two axes lay the political and religious center of every Roman town – the Forum with the temple of the Capitoline Trias and the Curia. To the south, east, and west of this lay residential districts with temples, baths, and other functional buildings. These were laid out like a chessboard in *insulae*, blocks of houses edged by streets. The area of Ostia to the north of the Forum, towards the harbor, contained mainly the great warehouses and offices; this was also where the mercantile center of the city lay, the Piazzale delle Corporazioni (Commercial Square), and the theater.

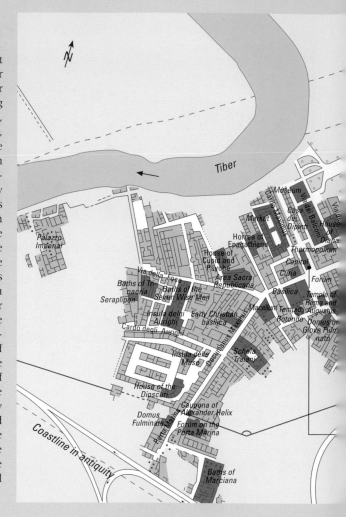

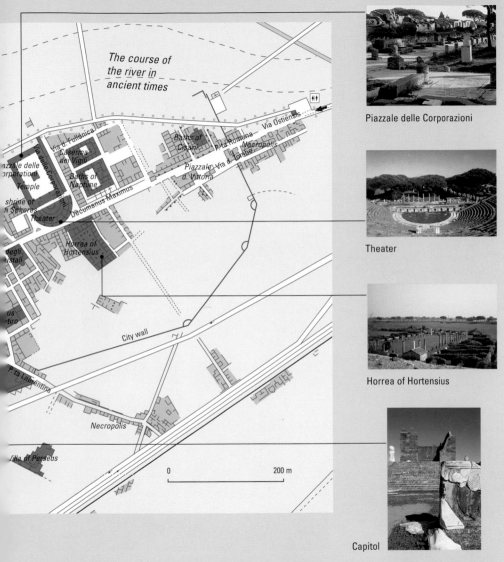

The course of the river in ancient times

Via d. Fullonica

Caserma dei Vigili

Via delle Corporazioni

Piazzale delle Corporazioni

Temple

shrine of h Spheres

Theater

Baths of Neptune

Decumanus Maximus

Baths of Cisari

P.ta Romana

Via Ostiensis

Necropolis

Piazzale d. Vittoria

Via d. Tombe

degli stali

Horrea of Hortensius

us tiro

City wall

P.ta Laurentina

Necropolis

Villa of Perseus

0 200 m

Piazzale delle Corporazioni

Theater

Horrea of Hortensius

Capitol

Tivoli

Villa Hadriana

About 30 km (18.6 miles) northeast of Rome lies Tivoli, which is well worth a visit, mainly to see the Villa Hadriana (Hadrian's Villa) and the Villa d'Este. Known as Tibur in ancient times, this little town was a favorite summer residence of the Roman nobility from the 2nd century B.C. They were enamored of this beautiful site in the Tiburtine Hills between the waterfalls on the River Aniene, and like many prosperous Romans before him, the Emperor Hadrian (ruled 117–138) built a luxurious country estate here. Covering an area of 120 hectares, it was the largest of all the imperial villa complexes. Situated slightly south of the town of Tivoli, the huge complex is distinguished by its great variety of buildings which are set side by side in a broad, sweeping landscape. The construction work took more than ten years to complete, and the emperor kept producing his own ideas and plans, so it is evident that the work was not based on an entirely unified overall design. The impressiveness of the huge villa complex was enhanced by the magnificence of the fittings and decoration, including marble and stucco facing, wall paintings, polychrome floors in *opus sectile*, and numerous sculptures. In late antiquity the villa was allowed to fall into decay and later it was used as a stone quarry, until the interest of collectors and archaeologists was awakened in the late 18th century. Systematic research into the buildings began when the site was taken over by the Italian Government in 1870, and this work is still in progress.

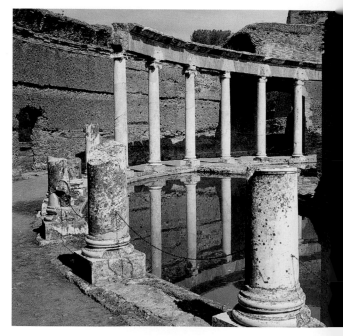

Teatro Marittimo

One of the most unusual buildings in the Villa Hadriana is the rotunda by the library courtyard, erroneously known as the Teatro Marittimo (Maritime Theater). It is a small but complete villa offering all the comforts of Roman living and providing the emperor with a place to which he could withdraw in complete privacy. Shut off from the outside by a high wall, it consisted of a circular artificial island on which a small villa stood (hence its other name, the Villa dell'Isola). Around the island there was a portico which ran between the water and the outer wall.

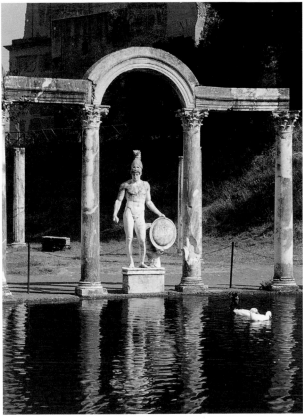

The Vale of Canopus

South of the *thermae* (baths) the view opens on to an artificial vale containing a pool 119 m (390 feet) long; it is a copy of the Vale of Canopus in Ancient Egypt. The northern end is terminated by a semicircular ring of columns with alternating horizontal and curving entablatures. Copies of the most celebrated Greek statues once stood between the columns. The southern end terminates in a great nymphaeum (grotto), an exhedra with decorative waterworks. This building is thought to be a temple to Serapis.

Villa Hadriana

A model at the entrance now gives a good impression of the original appearance of the whole site. As well as official buildings like the imperial palace, utilities, and facilities for the court and guests, subterranean corridors for the staff, baths, nympheums, temples, a barracks, and numerous gardens and fish ponds, the site also included a Greek theater, libraries and a small private villa where the philosopher emperor spent his leisure hours. Then there were the sites and buildings that Hadrian had seen and admired on his long journeys through the empire, and which he had copied here to create his empire "in miniature." An example is the Stoa Poikile in Athens, another the famous Vale of Canopus near Alexandria in Egypt, which were both recreated on the site.

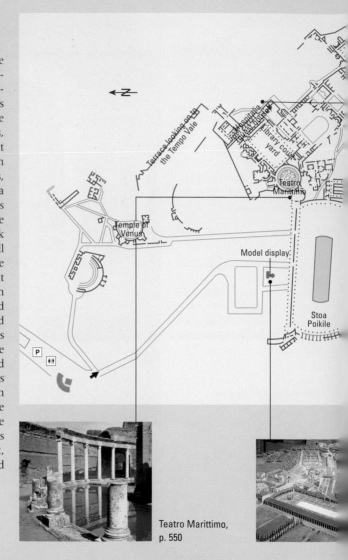

Teatro Marittimo, p. 550

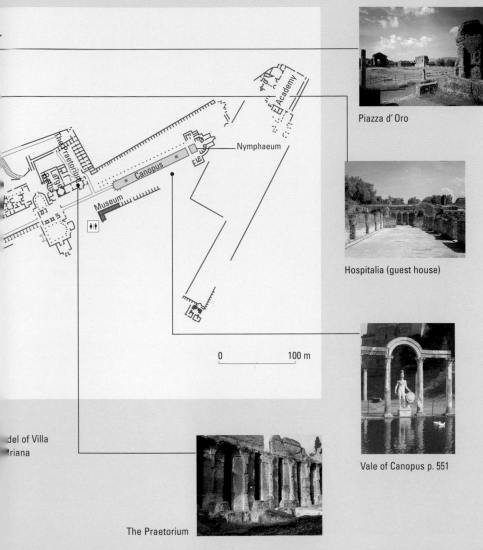

Piazza d' Oro

Hospitalia (guest house)

Nymphaeum

Canopus

The Praetorium

Large
Baths

Museum

Academy

0 100 m

del of Villa
driana

Vale of Canopus p. 551

The Praetorium

Villa d'Este

When Cardinal Ippolito d'Este, who was a passionate collector of works of art, moved into the former Benedictine monastery in Tivoli in 1550, he commissioned Pirro Ligorio to redesign it and make it a residence fit for a cardinal. But the three-story Villa d'Este owes its fame to its magnificent gardens much more than to its Mannerist frescoes, for the gardens are regarded as one of the peaks of European garden art. They stretch from a lower level up five terraces to the villa at the top of the hill, the whole complex structured by a severely geometric system of paths, ramps, and steps that is repeatedly interrupted by fountains, grottoes, and arched walks.

Étienne Dupérac, Overview of the Villa d'Este, 1573, engraving

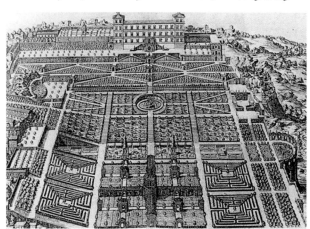

No matter which route the visitors take, the gurgling, splashing and murmuring of the countless fountains and waterworks can be heard. From the loggia one climbs past Bernini's Fontana del Bicchierone to the Rometta (Little Rome), a symbolic depiction of the City of Rome laid out in a semicircle, with its seven hills and the most famous buildings. In its center is the Dea Roma and the She-wolf with Romulus and Remus, while below this is a model of the Tiber Island. This is where the Viale delle Cento Fontane (Path of a Hundred Fountains) starts. It is laid out on three levels with one hundred moss-grown fountains in the form of grotesques, obelisks, ships, and the heraldic eagle of the d'Estes. On the level of the three fishponds stands the Fontana dell'Organo Idraulico (Fountain of the Hydraulic Organ), with the statues of Apollo and Orpheus. The water pressure once played a hydraulic organ. Water power was also used to operate the Fontana della Civetta e degli Uccelli (Owls and Birds Fountain) but unfortunately the song of the bronze birds and screech of owls of can no longer be heard.

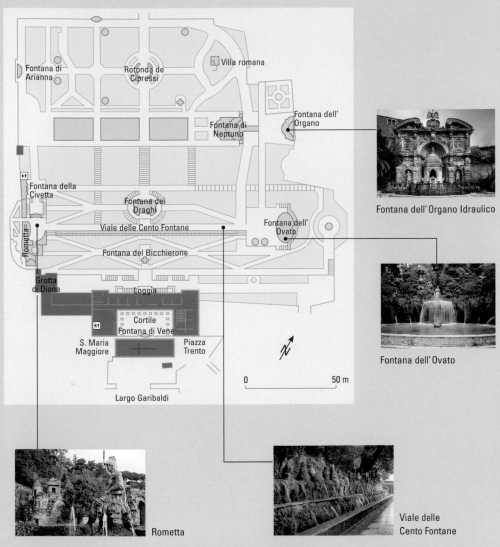

Fontana di
Arianna

Rotonda de
Cipressi

Villa romana

Fontana di
Neptuno

Fontana dell'
Organo

Fontana dell' Organo Idraulico

Fontana della
Civetta

Fontana dei
Draghi

Viale delle Cento Fontane

Fontana dell'
Ovato

Rometta

Fontana del Bicchierone

Grotta
di Diana

Loggia

Fontana dell' Ovato

Cortile
Fontana di Vene

S. Maria
Maggiore

Piazza
Trento

0 50 m

Largo Garibaldi

Rometta

Viale delle
Cento Fontane

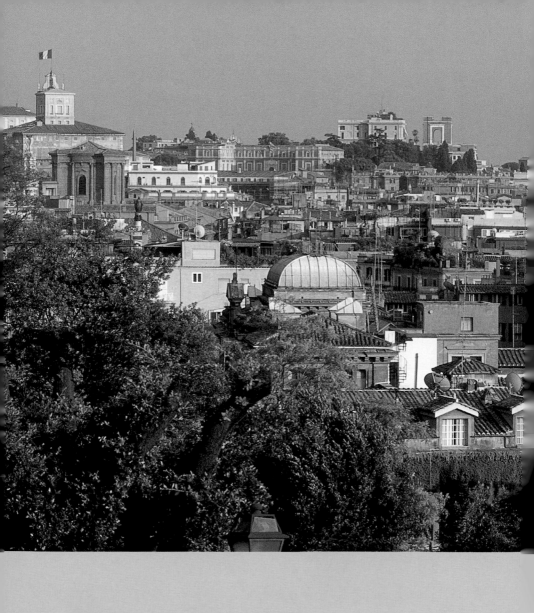

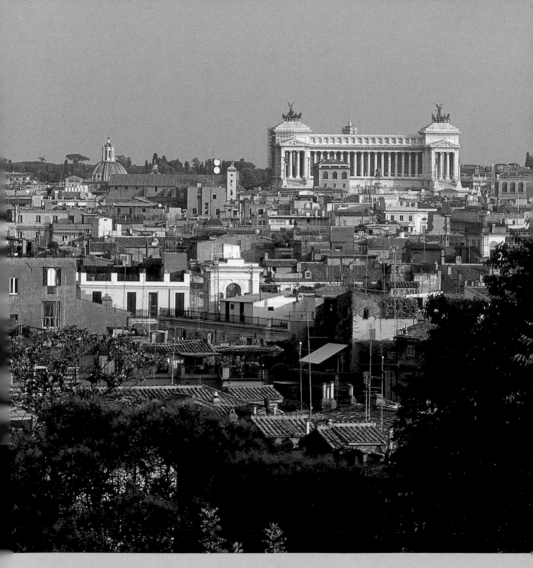

Appendices

Roman Architecture: Classical to Baroque

The Round or Centrally Planned Building

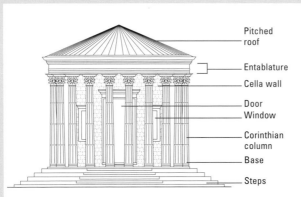

Temple of Hercules Victor, 146–142 B.C., front elevation

Labels (top to bottom):
- Pitched roof
- Entablature
- Cella wall
- Door
- Window
- Corinthian column
- Base
- Steps

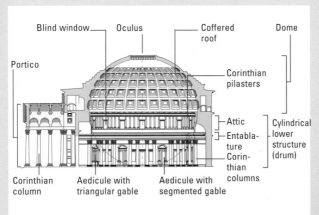

The Pantheon, 118–125 B.C., cross-section

Labels:
- Blind window
- Oculus
- Coffered roof
- Dome
- Portico
- Corinthian pilasters
- Attic
- Entablature
- Corinthian columns
- Cylindrical lower structure (drum)
- Corinthian column
- Aedicule with triangular gable
- Aedicule with segmented gable

Round Temple

With its circular ground plan, the temple of Hercules Victor on the Forum Boarium represents the simplest type of centrally planned building. It takes up the form of the round temple that evolved in Greece in the 4th century B.C., with a ring of twenty Corinthian columns on a shallow flight of steps enclosing the circular, single-story shrine (cella) of the temple. The structure terminates in a pitched roof.

The Pantheon

In the Pantheon the development of the classical centrally planned building reached its peak. Here the architectural effects are concentrated in the interior. Two geometric elements, the cylinder formed by the drum and the semicircle formed by the dome, are combined to form a uniform and perfectly harmonious whole. If the dome were extended to make a sphere it would fit exactly into the drum.

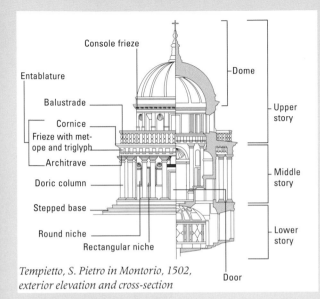

Console frieze

Entablature

Balustrade

Cornice

Frieze with metope and triglyph

Architrave

Doric column

Stepped base

Round niche

Rectangular niche

Dome

Upper story

Middle story

Lower story

Door

*Tempietto, S. Pietro in Montorio, 1502,
exterior elevation and cross-section*

The Tempietto

The classic example of a centrally planned building of the High Renaissance in Rome is the Tempietto by Bramante, with its superb balance of horizontals and verticals. It follows the model of the round temple of antiquity, but while the cylindrical core of the middle story is enclosed in a ring of Doric columns on the antique model, the upper story, which is slightly recessed above the entablature, has a balustrade and is crowned by a semicircular dome.

Baroque Rotunda

Unlike the centrally planned buildings of the Renaissance, the Baroque church of S. Andrea al Quirinale is set on an oval ground plan. The external division by columns has now been moved almost entirely to the interior, where the intricate pattern formed by the oval and rectangular chapels is traced by Corinthian columns. The lantern rising from the dome provides another decorative architectural feature.

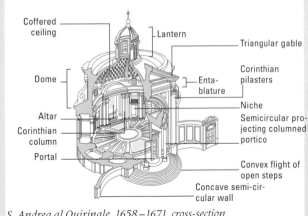

Coffered ceiling

Lantern

Triangular gable

Dome

Entablature

Corinthian pilasters

Altar

Niche

Corinthian column

Semicircular projecting columned portico

Portal

Convex flight of open steps

Concave semi-circular wall

S. Andrea al Quirinale, 1658–1671, cross-section

Façades

The Roman Podium Temple

Set on a rectangular ground plan, the Roman temple had as its main focus an altar at the top of a flight of open steps. The temple consists of a colonnaded hall (containing the shrine) that rises from a high podium. The flight of steps lends emphasis to the front of the temple; the columns at the sides and rear are often half-columns.

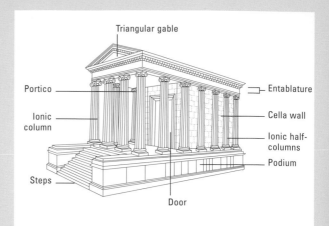

Temple of Portunus, 1st century B.C., view

Roman Triumphal Arch

Triumphal arches, erected in honor of an emperor or general, are free-standing gateways, usually with either one or three openings. Characteristic features are: the columns or half-columns on high pedestals attached to the two frontages and side openings; rich relief work on every available wall space; and a high attic which has a dedicatory inscription and which is crowned by a statue of the person or persons honored (often in a four-horse chariot know as a quadriga).

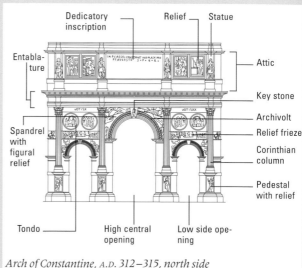

Arch of Constantine, A.D. 312–315, north side

Early Baroque Façade

The façade of the main church of the Jesuits is articulated by Corinthian pilasters, cornices, and niches that reflect the divisions of the interior. The three portals mark the breadth of the nave; behind the unfenestrated outer sections of the façade are the side chapels. The deep entablature that divides the two stories is very striking; it, too, repeats the division into two stories inside. Volutes above the side sections lead the eye up the narrower upper story, which terminates in a large triangular gable. The double gable over the main portal and the central window of the upper story gives strong emphasis to the symmetry of the façade. Il Gesù was a model for many churches in the 16th and 17th centuries.

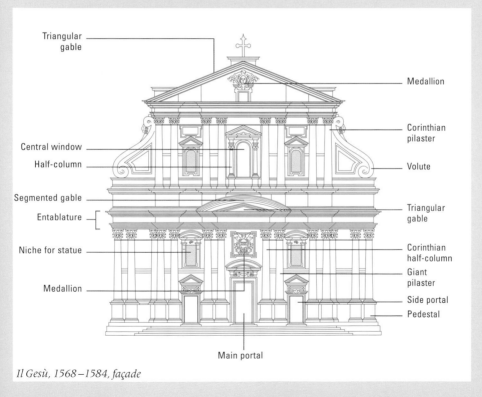

Triangular gable
Medallion
Corinthian pilaster
Central window
Half-column
Volute
Segmented gable
Triangular gable
Entablature
Corinthian half-column
Niche for statue
Giant pilaster
Medallion
Side portal
Pedestal
Main portal

Il Gesù, 1568–1584, façade

Basilica

Roman Basilica

The Maxentius Basilica differs from the traditional Roman basilica: the traditional form consisted of a nave separated from side aisles by rows of columns; the nave was higher than the aisles and its upper wall was pierced by windows. In the Maxentius Basilica, by contrast, the aisles have been replaced by a series of barrel-vaulted rooms, three down each side, which serve as chapels. Apses extend the west wall and the central room on the north side. The cross-rib vaulting over the nave rests on large piers with additional support from the barrel vaulting over the side chapels. The construction is derived from the architecture of the Roman baths. The axial orientation of the Maxentius Basilica, emphasised by the apse in the west, is interrupted by the portico on the south side.

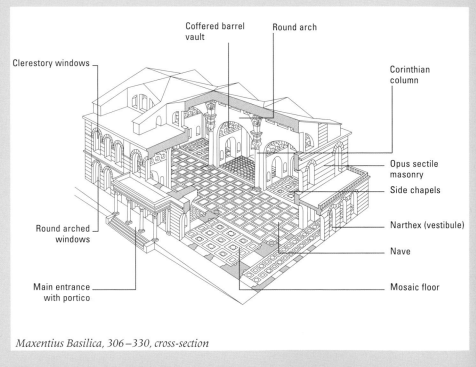

Maxentius Basilica, 306–330, cross-section

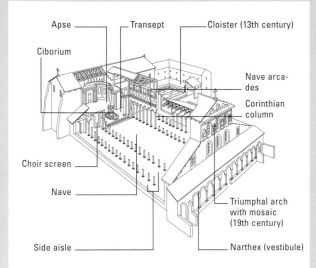

Apse — Transept — Cloister (13th century)

Ciborium

Nave arcades

Corinthian column

Choir screen

Nave

Triumphal arch with mosaic (19th century)

Side aisle

Narthex (vestibule)

S. Paolo fuori le Mura, end 4th century, cross-section

Early Christian Basilica

For the first Christian churches, the form of the Roman basilica (a nave with side aisles and an eastern apse) was adopted. The axial sequence of spaces consists of: the narthex, a rectangular area set across the west front; a vestibule for repentants and those about to be baptized, or sometimes an atrium with a colonnade and a cantharus (a vessel of holy water); a long central nave; and finally an apse, at the eastern end of the nave. In the 4th century a transept was inserted between the apse and the main body of the church.

Baroque Basilica

The form of the Baroque church of S. Andrea della Valle, a long building topped by a dome, evolved from the integration of the rectangular building facing east (basilica) with the round temple. The nave, the broad main body of the church, is like a great hall. Barrel-vaulted, it is intersected by transepts to form a crossing on which the dome sits. The nave ends in a choir and a semicircular apse at the eastern end.

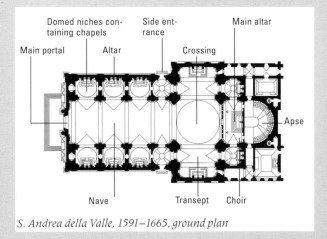

Domed niches containing chapels — Side entrance — Main altar

Main portal — Altar — Crossing

Apse

Nave — Transept — Choir

S. Andrea della Valle, 1591–1665, ground plan

Colosseum, A.D. 72 – 80, façade

Labels on diagram (top to bottom):
- Cornice on roof
- Console
- Corinthian pilaster
- Window
- Entablature
- Denticulation
- Corinthian half-column
- Sculpture
- Entablature
- Ionic half-column
- Balustrade
- Entablature
- Impost or springer
- Doric half-column
- Arcade

Story labels (left side):
- 4th story
- 3rd story
- 2nd story
- 1st story

The Classical Orders

Roman Composite Order

The classical arrangement of half-columns of different orders placed directly above each other appears for the first time on the external façade of the four-story Colosseum. It became the standard form for many generations to come. The lower three stories are divided by arcades, with a half-column set on a high pedestal before each pillar. Sculptures are set into the openings in the arcades on the second and third stories. The Tuscan columns on the first story (a variant of the Doric order) are followed by Ionic columns on the second and Corinthian half-columns on the third story. The fourth story, which is divided by Corinthian pilasters, is in effect the attic story, with a rectangular window in every second section of the wall. About two thirds of the way up between these pilasters there are three consoles to which the vast sunblind that half-covered the Colosseum was attached.

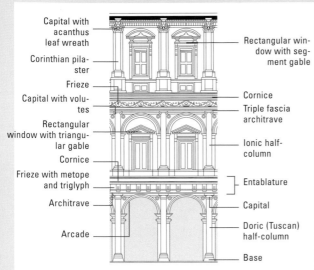

Capital with
acanthus
leaf wreath

Corinthian pila-
ster

Frieze

Capital with volu-
tes

Rectangular
window with triangu-
lar gable

Cornice

Frieze with metope
and triglyph

Architrave

Arcade

Rectangular win-
dow with seg-
ment gable

Cornice

Triple fascia
architrave

Ionic half-
column

Entablature

Capital

Doric (Tuscan)
half-column

Base

Palazzo Farnese, 1514 –end 16th century, façade

Renaissance Composite Order

During the Renaissance the decorative motif of superimposed orders that had evolved in antiquity was taken up again. The façade of the inner courtyard of the Palazzo Farnese is characterized by open arcades on the ground floor, the pillars of which have Doric half-columns before them. A blind arcade with Ionic half-columns repeats this articulation on the middle story, while the third story is articulated by triple Corinthian pilasters.

Giant Order

The giant (or colossal) order, as it is called, was used for the first time in secular Renaissance architecture on the façade of the Palazzo dei Conservatori. Mighty Corinthian pilasters rise through both stories and perform the function of drawing them together optically. The façade design is variegated by the use of different types of window.

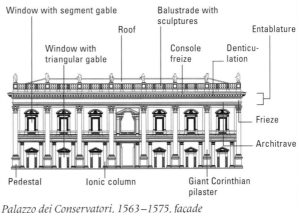

Window with segment gable

Roof

Window with
triangular gable

Balustrade with
sculptures

Entablature

Console
freize

Denticu-
lation

Frieze

Architrave

Pedestal

Ionic column

Giant Corinthian
pilaster

Palazzo dei Conservatori, 1563–1575, façade

Glossary

Aedicule (Latin *aedicula*, "small house or temple"): Two columns, pillars, or pilasters framing a portal, window, or niche and bearing an entablature and a triangular or segmented gable.

Alabastron (Gk.): Small Greek ointment container, originally made of alabaster, later also of clay or bronze; in shape long or spherical with a narrow neck.

Allegory (Greek *allegoria*, from *allegorein*, "to depict differently"): In art history, the representation of concepts or ideas through images, usually in the form of symbols or personifications. During the Renaissance, particularly in Italy, much use was made of mythological allegory based on writings of classical antiquity. Allegory also flourished in Baroque painting, often in a political context, one of the leading exponents being the Flemish artist Peter Paul Rubens (1577–1640).

Altar (Latin *alta ara*, "raised sacrificial table"): In ancient Greece and Rome, the place set aside for cult acts in the holy area in front of a temple, especially the sacrifice of animals or the offering of libations. In the Christian era, the table on which the mass is celebrated. The high altar usually stands in the apse of a church that faces east; smaller altars are frequently set in the side apses or chapels or in the crypt. The artistic decoration of early Christian altars usually consisted of an antependium related to the saint to whom the church was dedicated. Later altars were elaborately decorated. See Altar retable, Antependium.

Altarpiece (Latin *altare* from *altus*, "high," "raised up"): A painting or sculpture used to decorate an altar. In the early Middle Ages, sculptures or work in precious metal were used to adorn altars; later paintings were introduced. An altarpiece can consist of a single work or multiple panels. A *reredos* is an altarpiece that rises from the ground; a *retable* is an altarpiece that stands on the back of the altar, or on a pedestal behind it. See Altar retable, Antependium.

Altar retable (Latin *alta ara*, "raised sacrificial table"

Altar retable: Gothic altarpiece with a central section and two side panels

and *retabulum*, "rear wall"): An artistic work set on (or behind) an altar. In the Middle Ages the retable rested on the back part of the altar table, while in the Renaissance and Baroque eras it stood on a substructure behind the altar. In the Middle Ages the retable consisted initially of goldsmith work or relief sculpture; later, paintings also appeared, either a single picture or several panels. In the Late Gothic period the retable was given an architectural frame and extended with side panels. In the Renaissance and the Baroque it consisted of only a central panel. See Altarpiece.

Ambo (Greek *ambon*, "rise," from *ambainein*, *anabainein*, "to climb"): In early Christian and early medieval churches, a podium raised on several steps with a

reading desk from which biblical texts and sermons were read out; an early form of pulpit. A stone ambo placed before a choir screen was usually enclosed by a balustrade. If a church had two ambos, the northerly one, for the Gospel readings, was often more richly decorated, with two flights of steps and an Easter candlestick. The smaller ambo to the south was called the Epistle ambo. In the 14th century the ambos became part of the rood screen or pulpitum that was inserted between the choir and the nave, or were replaced by a pulpit.

Amphitheater (Greek *amphitheatron*, from *amphi*, "on both sides, all around" and *theatron*, "theater"): In ancient Rome, a form of open air theater on an elliptical ground plan and with rising tiers of seats; often used for animal baiting and combat between gladiators.

Amphora (Lat. *amphora*; Gk. *amphoreus*, "container with a handle on both sides", from *amphi*, "on both sides", and *pherein*, "carry"): Bulbous storage container used by the Greeks, with two handles and up to 3 feet (1 m) in height.

Antependium (Latin *ante*, "before" and *pendere*, "to hang"): Originally, a cloth hanging down in front of the altar table in a costly and richly decorated material, or painted canvas, leather etc. Later, the name for any kind of altar covering or screen, e.g. textile or wood. See Altarpiece.

Antiquity (Latin *antiquus*, "old"): Ancient Greece and Rome. Antiquity begins with the early Greek migration in the second millenium B.C. and ends in the west in A.D. 476 when the Roman emperor Romulus Augustulus was deposed by the Goths (ca. A.D. 475); in the east (Byzantium), antiquity ends in A.D. 529 when the Platonic Academy was closed by Emperor Justinian (reigned 527–565).

Apocalypse (Greek *apokalyptein*, "unveil," "reveal"): The end of the world, notably as described in the Revelation of St. John, the last book in the New Testament. St. John's vivid account of the violent end of world and of the Last Judgment was often used by artists.

Apostle (Greek *apostolos*, "messenger," "advance fighter"): One of the twelve disciples of Jesus selected

Antique masonry: Most frequent types of Roman faced concrete building (top to bottom): opus incertum, opus testaceum, and opus reticulatum

to continue His work and spread the "good news" of the gospels.

Apotheosis (ill. p. 591) (Greek *apotheoun*, "idolize, sublimate"): Deification; the assumption of a mortal into the realm of the divine.

Apse (Latin *apsis*, Greek *hapsis*, "link, round corner, arch"): Generally, a large recess or niche built on a semicircular or polygonal ground plan and vaulted with a half-dome; in both a church and a temple it may contain an altar. An apse vault in the form of a segment of a dome is called a *calotte*. When the apse adjoins the main body of the church or the choir area reserved for the clergy, it is also known as an *exhedra*. Smaller side apses, or apsidioles, are often found along an ambulatory, transept, or side aisles.

Aqueduct (Latin *aquaeductus*, "water pipes," from *aqua*, "water" and *ducere*, "to lead"): An artificial channel for carrying water, especially in the form of a bridge. In the imperial age in Roman aqueducts were built as arched bridges; many examples have survived to this day.

Arabesque (Fr. *arabesque*, "Arabic ornamentation"; It. *arabesco*, "Arabic"): Decoration consisting of leaves and vines that is very similar to plant models. It has been known since Hellenistic art and in classical times was used to decorate pilasters and friezes. It was once more used on a larger scale during the Italian Early Renaissance, thus gaining entrance to later periods in Western art.

Arcade (Latin *arcus*, "bow," i.e. hunting weapon): A row of arches carried on columns or piers.

Arch: In architecture, a curved structure that carries a downward thrust to two supports (e.g. walls, pillars, or columns). The simplest form is round, though a wide range of curving shapes have also developed. The highest point of the arch, known as the crown or apex, contains the *keystone*. The keystone, which is often wedge-shaped and frequently distinguished by color or size, is the last stone of the arch to be set in place. The rise of an arch is the vertical distance between the crown and the *springing line* or *impost* (projecting member from which an arch springs). The inner curve of

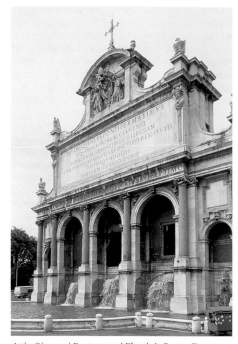

Attic: Giovanni Fontana and Flaminio Ponzo, Fontana Acqua Paola, 1610–1612, Gianicolo, Rome

the arch is called the *intrados*, and the *extrados* is the upper or outer curve of the arch.

Architrave (Greek *archein*, "start," "control" and Latin *trabus*, "beam"): The horizontal beam or block that rests on supports such as columns and that bears the weight of the upper structure. The lowest member of an entablature.

Archivolt (It. *archivolto*, "front arch"; Gk. *archein*, "begin, rule" and Lat. *volutus*, "rolled, twisted"): A continuous decorative moulding framing the face of an arch, which can be viewed as a semi-circular architrave (main beam carrying the weight of the

building above) leaning on a jamb (vertical surface of a wall opening).

A secco (Italian *secco*, "dry"): Fresco painting in which paint is applied to dry plaster, in contrast to "true fresco" painting on wet plaster. It is less durable than true fresco painting. See Fresco.

Atrium (Latin) : An open central courtyard, especially of a Roman house; a court in front of a church, usually one surrounded by a colonnade.

Attic (Latin *atticus*): In classical architecture, a low story above the entablature; the attic was used again in Renaissance and Baroque architecture, becoming a half-story with windows. There is a distinctive attic on St. Peter's in Rome.

Babylonian Captivity: Period 1309–1377 when the papacy, then under French domination, was in Avignon in France. The end of the Babylonian Captivity marked the beginning of the second Great Schism. See Schism

Balcony (Italian *balcona*): A projection from the façade of the upper story of a building. Generally not roofed, they are enclosed by a parapet, railing or balustrade. Balconies can also be built inside a building, for instance in great halls and theaters. As well as providing a practical function, a balcony can also be an architectural feature, serving to articulate a façade.

Baldachin, baldacchino (Italian *baldacchino*): The fabric cover held above a throne or bed; a canopy supported on poles and carried in a procession; in architecture, a permanent, elaborately decorated canopy of wood or stone above a throne, an altar, catafalque, pulpit, or statue. The name derives from the costly silks interwoven with gold thread from Baghdad (Italian *baldacco*), from which the first canopies in Italy were made.

Balustrade (Italian *balustrata*): A stone railing formed of a row of balusters (posts) supporting a continuous coping, used particularly in the Renaissance and the Baroque to edge flights of steps, balconies, terraces, and roofs.

Baptistery (Latin, Greek *baptisterion*, "bathing place," "swimming pool"): A church or chapel for baptisms; an independent, generally octagonal building on a central ground plan (see Centrally planned building) often standing to the west of an episcopal church and dedicated to St. John the Baptist.

Baroque (Portuguese *barucca*, "strangely shaped pearl"): Epoch in European art between Mannerism and the Rococo (ca. 1590–ca. 1725) and characterized by a wide range of stylistic developments. In painting, for example, the classicism of the Carracci is found beside the realistic depictions of Caravaggio. Initially, the term Baroque simply meant "not in good taste, extravagant"; it was in France in the 18th century that it came to be used for art, namely art that was counter to Neo-classical taste. The general features of Baroque art are exuberant, highly expressive movement; the elimination of the borders between architecture, sculpture and painting and their unification in a total work of art; the creation of illusionistic effects (*trompe l'œil* painting); and a concentration on intense and dramatic effects. Baroque art developed first in Italy as a return to certain stylistic features of the High Renaissance. The building of the church of Il Gesù in Rome marked the start of Baroque church architecture. Closely related with the work of the Catholic Church during the Counter-Reformation, Baroque art became an important instrument for the spread of both the true doctrine and political absolutism. As well as religious and mythological themes, allegories played an important role (illustrating abstract ideas and terms). Despite these developments, genre scenes and landscape painting also evolved in this period.

Barrel vault: A roof structure constructed as a continuous semicircle. See Vault

Base (Greek "step," "walk," "basis," then "the ground trodden," from *bainein*, "to walk"): In architecture, the extended, generally profiled foot of a column or pillar designed to spread the weight being supported over a larger area; the base acts as a transition from ground to plinth. In sculpture, the stand of a pedestal or statue.

Base (Vulgar Latin *bassus*, "low"): In architecture, the projecting foot of a column, pedestal, or building.

Basilica (Greek *basilike stoa*, "royal hall"): In antiquity,

a building consisting of a roofed hall divided by aisles and used as a market or a court of law; later, a church built to the same design.

In Christian architecture, a basilica is usually a church building facing east, with a nave and two or four side aisles; the side aisles are lower than the nave, and the upper walls of the nave contain rows of windows. The eastern end of the nave often ends in an apse. The walls dividing the nave and aisles are open arcades supported by columns or pillars. Since the 4th century, the basilica has been the dominant form of large church building in the Western world, but the ground plan has often been altered. In some churches built in the reign of Emperor Constantine (306–337), for example, the side aisles were extended to form an ambulatory around the round end of the nave (ambulatory basilica). In the 4th century a transept was inserted between the nave and the apse, creating the dominant form of church building for coming centuries (the cruciform basilica). Many early Christian basilicas have a courtyard at their western end (an atrium) and a vestibule or narthex; in the Middle Ages towers and a western front were added.

Bay: A regular structural division of a building, especially a church. In classical buildings a bay may be marked by columns; in Gothic churches, a bay is the area below a vault.

Bishop (Greek *episkopos*, "supervisor"): A high dignitary of the Church. In the early Christian era, a bishop was the head of a congregation and later, as the successor to the Apostles, the church-appointed head of a diocese or parish. A bishop has the authority to teach and to perform priestly and pastoral duties. In time, bishops became distinguished by their miter (bishop's hat), staff (crozier), and golden ring.

Blind ornament: A blind architectural motif that is added to a building for the purpose of decoration and creating structure, but does not support the structure in any way; examples are blind windows and blind arcades.

Bull (Latin *bulla*, "capsule"): Originally a special form of metal seal on documents; later a papal edict.

Bust (French *buste*, Italian *busto*): Generally a sculptured portrait on a plinth showing only the head, shoulders and the upper chest.

Buttressing: Arch and pillar which, in addition to the walls, carry the pressure of the vault and weight of the roof on the outside of the building.

Byzantine art: The art of (or influenced by) the Byzantine Empire, a period that started ca. A.D. 330, when Constantinople (formerly Byzantium, now Istanbul) became the capital of the Roman Empire, and ended in 1453, when Constatinople fell to the Ottoman Turks. Byzantine art evolved from Hellenistic and late Roman art, and was influenced by Eastern art. Based on the strict observance of fixed artistic and theological rules, it is characterized by highly stylized forms and an unworldly sublimity and solemn spirituality. Gradually a freer observation of nature is also apparent, especially in the late phase. Byzantine art repeatedly inspired Western art.

Calotte (French, "little cap"): In architecture, a segment of a sphere smaller than the radius, e.g. the dome over a niche.

Campanile (from Italian *campana*, "bell"): The freestanding bell tower of a church.

Capital (Latin *capitulum*, "small head"): The top of a column or pillar, acting as a transition between the support (shaft) and the load. A variety of types developed, classified according to their form and decoration. See Capitals, types of.

Capital, types of: In the course of time many different forms of capital developed. Most important are those used since Ancient Greek times: the Doric, the Ionic, and the Corinthian. In Ancient Rome the composite capital appears, combining the Ionic and the Corinthian form. In the early Middle Ages these four basic types were only used for imperial buildings in the Carolingian, Ottonian, and the Salian empires, while other forms evolved beside them, including the geometric, cushion, and block capitals. Figural capitals with carvings of people, animals, plants and rich ornamentation also developed, especially during the Gothic period, to be displaced in turn by the revival of the antique types in the Renaissance.

Columbarium: Columbario di Vigna Codini II, ca. the birth of Christ, Via Appia, Rome

Carthusian Order (Latin *Ordo Cartusiensis*): Catholic order of hermits founded in 1084 by Bruno of Cologne (1032–1101) near Grenoble, France. The order combines life as a hermit with service to the community. In the 14th and 15th centuries new Carthusian monasteries (consisting of individual houses) were established, often leaning towards late medieval mysticism, the *devotio moderna* (modern devotion, or new piety), and humanism, the striving for a genuine humanity.

Caryatids (Greek *karyatides*): In architecture, robed female figures acting as columns supporting an entablature. Typically they wear baskets on their heads, or cushion-shaped headdresses, as devices for spreading the load the column has to bear. The term probably derives from girls, especially the temple dancers, from the Greek town of Carya near Sparta, who during the Persian Wars (500–479 B.C.) were taken into slavery by the Persians.

Catacombs (Late Latin *catacumbae*, presumably Greek kata, "low" and *kymbe*, "basin" or "hollow"): Originally, the name of a hollow near the church of S. Sebastiano in Rome, where the subterranean cemetery, used by Christians since the 4th century, was known as the *coemeterium ad catacumbas* in the Middle Ages. The term was applied later to all the subterranean Early Christian and Jewish burial places in Rome and its environs. Catacombs consist of a system of passages hewn out of natural stone, with several rows of box-shaped wall graves hollowed out of the walls, one above the other.

Cathedral (Med. Lat. *ecclesia cathedralis*, "church belonging to the cathedra [bishop's throne]"; Gk. *cathedra*, "bishop's throne"), term used to denote a bishop's church.

Centrally planned building: A building in which all the parts are related to a central area, as opposed to an axial plan (e.g. the basilica). Centrally planned buildings can be circular, elliptical, square, or rectangular, and are often domed. In antiquity the term initially only referred to small round temples and tombs (*tholos*), but the form found its finest expression in the huge Pantheon in Rome. In early Christian times the type occurs less frequently and was generally reserved for baptisteries and mausoleums. As an architectural form it reached its supreme artistic and ideological expression during the Renaissance and the Baroque.

Century (Latin *centuria*, "a group of a hundred [people]"): In Ancient Rome, a basic unit of citizens for elections and army service; also a division in the army. The system was introduced by King Servius Tullius (6th century B.C.), with five classes being established on the basis of financial status. In the army the *centuriae* were the hundred-strong subdivisions of a legion, which was led by a *centurion*, a captain of subaltern rank.

Chapel (Middle Latin *cappella*, "small cape"): A small, separate place for worship and prayer in a church; a small church without parish privileges and built for a particular purpose, such as baptism or burials. The term derives from the name of a small sanctuary in Sainte-Chapelle in Paris, where the

Division of the Roman Empire (395)

End of the Western
Roman Empire (476)

Invasion by the
Langobards (568)

Gregory I
(590–604)
esta-
blishes
the
secular
power of
the pope in
Rome

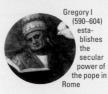

Charlemagne
crowned Holy
Roman Emperor
(December 25, 800)

Pepin's Donation
(754)

Rome conquered by the Western Goths
(410) and the Vandals (455)

Rome plundered by the Saracens

400	500	600	700	800

Mosaic on the Triumphal
arch in S. Lorenzo fuori le
Mura (579–590)

Apse mosaic in S. Agnese
fuori le Mura (7th C.)

Madonna della Clemenza,
S. Maria in
Trastevere
(early 8th C.)

Apse mosaic in
S. Prassede (9th C

Mosaics in the nave of
S. Maria Maggiore (5. C.)

S. Maria Maggiore (432–440)

S. Stefano Rotondo (ca. 440)

S. Sabina (422–432)

S. Agnese fuori le
Mura (625–638)

S. Marco (827–844

Old St. Peter's
(from 319)

S. Paolo
fuori le
Mura
(end 4th C.)

S. Costanza rebuilt
(late 5th C.)

S. Maria in Cosmedin
(8th C.)

S. Prassede rebuilt (817

Sarcophagus of Junius Bassus,
St. Peter's Treasury (4th C.)

Wooden Door, S.
Sabina (5th C.)

Tombstone (8th C.)
reused as a choir
screen, S. Maria in
Cosmedin

Cruciform reliquary for
I, Museo Sacro
(

Ivory Diptych
Museums, B
Apostolica Vaticana

St. Jerome, Vulgate
(383–405)

Gregory the Great,
Antiphonary
(Gregorian chant)
(590–604)

Start of the
Iconoclastic
Controversy when
Leo III, Emperor of
Byzantium, bans the
creation of images
(726)

Aelius Donatus (4th C.),
Ars grammatica

Ausonius (311–393), Mosella

Boethius (480–542), De
consolatione philosophiae

Magnus Cassiodorus (490–583),
Chronicon

History

Conquest of Carthage (146 B.C.)
Start of the Civil Wars (88 B.C.)

Battle of Actium (31 B.C.)
Augustus (27 B.C.–A.D. 14)

Period of the Soldier Emperors (235–305)

Introduction of tetrarchy under Diocletian (284–305)

Constantine the Great (324–337)
Edict of Tolerance issued in Milan (313)

Roman Empire reaches its greatest extent under Trajan (98–117)

Constantinople becomes capital of the Christian Empire (330)

Murder of Julius Caesar (44 B.C.)

200	0	100	200	300

Painting

Fresco of Apollo, Palatino Museum (ca. 30 B.C.)
Aldobrandini Wedding, Vatican Museums (ca. 20 B.C.)

Ceiling painting from the Domus Transitoria, Palatino Museum (mid-1st C. A.D.)

Doves mosaic from the Villa Hadriana in the Capitoline Museum (117–138)

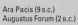

Apse mosaic in S. Pudenziana (ca. 385)

Architecture

Temple of Hercules Victor (end 2nd C. B.C.)

Ara Pacis (9 B.C.)
Augustus Forum (2 B.C.)

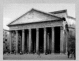

Aurelian Wall (from 270)
Baths of Diocletian (298–306)

Maxentius Basilica (306–310)
Arch of Constantine (312)
S. Giovanni in Laterano (after 313)

Pantheon (118–125)

Mausoleum of Augustus (29 B.C.)

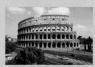

Colosseum (72–80)

Trajan Forum and Trajan's Column (107–113)

Arch of Septimius Severus (203)

Sculpture

Laocoön Group (mid-2nd C. B.C.), Vatican Museums

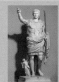

Augustus of Primaporta, Vatican Museums (20 B.C.)

Reliefs on Trajan's Column (107–113)

Decennial Plinth (303)

Seated boxer (mid-1st C. B.C.), Planetario

Equestrian statue of Marcus Aurelius (180/193)

Reliefs on the Arco degli Argentari (204)

Literature & Scholarship

Cato the Elder (234–149 B.C.), Origines
Vitruvius, De Architectura (ca. 25 B.C.)
Asinius Pollio (76 B.C.–A.D. 4) establishes the first public library in Rome
Pliny the Elder, Naturalis historiae (77)

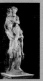

Tacitus, Historiae and Annales (ca. 110)

Plutarch, Vitae parallelae (ca. 114)

Suetonius (70–130), De vita Caesarum

First Latin translation of the Bible ("Itala," 195)

Dio Cassius (154–229), Romaike Historia

Virgil (70–19 B.C.) Aeneid

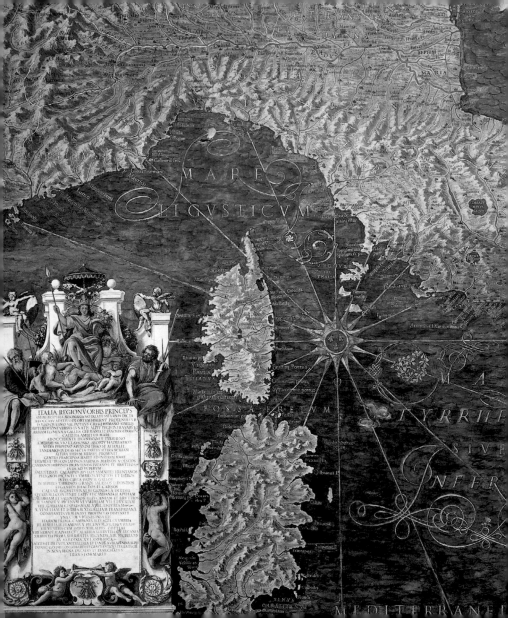

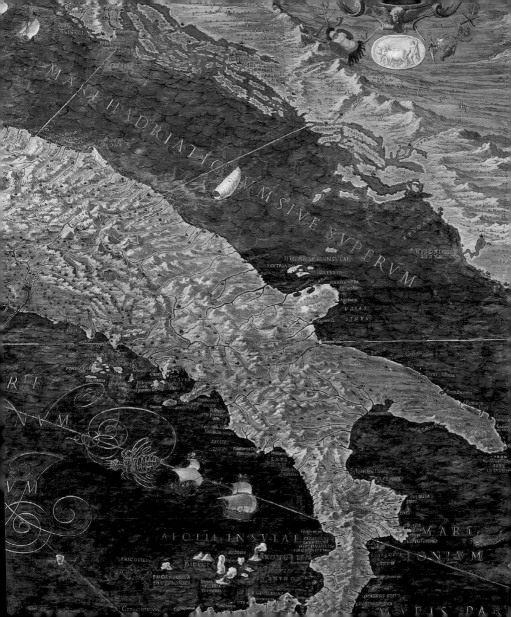

Philosopher Giordano Bruno burned at the stake as a heretic (1600)

Christina of Sweden moves to Rome (1655)

Napoleon's troops take Rome (1798)

Mussolini becomes Minister President (1922)

Lateran Treaties (1929)

Italy enters the Second World War (1940)

Italy becomes a republic after a referendum (1946)

Treaties of Rome establish the European Community (1957)

Year 2000 a Holy Year

Rome conquered by the troops of the Kingdom of Italy (1870)

Rome made the capital of Italy (1871)

1600 1700 1800 1900 2000

Pietro da Cortona, Triumph of Divine Providence, Palazzo Barberini (1633–1639)

Caravaggio, Conversion of St. Paul, S. Maria del Popolo (1600–1601)

Giuseppe Chiari, St. Clement in Glory, S. Clemente (1715–1716)

Giulio Aristide Sartori0, Gorgon and the Heroes, Galleria Nazionale d'Arte Moderna (1899)

Renato Guttuso, Crucifixion, Galleria Nazionale d'Arte Moderna (1941)

The restoration of the Sistine Chapel completed (1994)

Palazzo Barberini (1628–1633)

S. Ivo alla Sapienza (1642–1660)

Spanish Steps (1723–1726)

Palazzo Braschi (from 1790)

S. Paolo fuori le Mura rebuilt (from 1823)

Stazione Termini (from 1867)

Palazzo di Giustizia (1899–1910)

National monument to Victor Emmanuel II (1885–1911)

EUR (from 1942)
Palazzo dello Sport (1960)
Vatican Museums (1958–1963)

Fountain of the Four Rivers (1647)

St. Peter's Square (from 1656)

Fontana di Trevi (1732–1762)

Piazza della Repubblica (1887)

Gianlorenzo Bernini, Apollo and Daphne, Borghese Museum (1622–1625)
Gianlorenzo Bernini, St. Peter's (1656–1666)

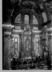

Andrea Pozzo, St. Ignatius altar, Il Gesù (1696–1700)

Antonio Canova, Tomb of Clement XIII, St. Peter's (1788–1792)

Antonio Canova, Paolina Borghese as Venus, Borghese Museum (1804–1808)

Bertel Thorvaldsen, Tomb of Pius VII, St. Peter's (1823)

Giacomo Manzù, Portrait of Francesca Blanc, Vatican Museum

Angelo Binancini, The Story of St. Paul, Vatican Museums (20th C.)

Queen Christina of Sweden donates a literary academy (originally the Accademia Arcadia, 1674)

Winckelmann, History of the Art of Antiquity (1764)

Goethe in Rome (1786–1788)

Filippo Tommaso Marinetti, Futurist Manifesto (1909)

Luigi Pirandello establishes the Teatro d'Arte in Rome (1925)

Carlo Levi, Christ Stopped at Eboli (1945)

Vittorio de Sica, Stazione Termini, Rome (1953)
Federico Fellini, La Dolce Vita (1959)

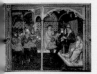

Start of the Investiture Conflict (1075)

Norman invasion (1084)

Concordat of Worms ends the Investiture Conflict (1122)

Republic proclaimed by Arnold of Brescia (1143/44)

First Holy Year (1300)

Papacy moved to Avignon (1309–1377)

Unsuccessful coup d'etat by Cola di Rienzo (1347)

Great Schism in Western Church (1377–1417)

1500 Holy Year

Sack of Rome (1527)

Council of Trent (1545–1563)

1000 1200 1300 1400 1500

Frescoes in S. Clemente, lower church (11th C.)

apse mosaic S. Clemente (12th C.)

Pietro Cavallini, The Last Judgment, S. Cecilia in Trastevere (end 13th C.)

Jacopo Torriti, The Crowning of Mary, S. Maria Maggiore (1292–1295)

Giotto, Stefaneschi-Triptych (ca. 1313)

Fra Angelico, Frescoes in the Cappella Niccolina, Vatican Museums (1448–1449)

Michelangelo, Frescoes in the Sistine Chapel, Vatican Museums (1508–1512)

Raphael, The School of Athens, Vatican Museums (1509–1511)

upper church of S. Clemente (1099–1118)

S. Maria in Trastevere (1130–1143)

Cloister, S. Giovanni in Laterano (1223–1230)

S. Lorenzo fuori le Mura rebuilt (1216–1227)

S. Maria sopra Minerva (from 1280)

Campanile, S. Maria Maggiore (ca. 1377)

Palazzo Venezia (from 1455)

S. Maria del Popolo (from 1472)

Palazzo della Cancelleria (from 1483)

St. Peter's rebuilt (1506–1626)

Tempietto (1502)

Palazzo Farnese (ca. 1514)

Palazzo Spada (1550)

Il Gesù (1568–1584)

Arnolfo di Cambio, Altar ciborium, S. Paolo fuori le Mura (1285)

Statue of St. Peter, St. Peter's (13th C.)

urachios by Chios, Portal, Paolo fuori le Mura (ca. 1070)

Giovanni da Cosma, Tomb of Cardinal Garcia Gudiel, S. Maria Maggiore (1299–1303)

Antonio Pollaiuolo, Tomb of Sixtus IV, St. Peter's, Treasury (end 15th C.)

Antonio Filarete, Bronzetür, S. Pietro (1433–1445)

Michelangelo, Pietà, St. Peter's (1499–1500)

Michelangelo, Tomb of Julius II, S. Pietro in Vincoli (1505–1545)

Dante Alighieri, Divina commedia (1307–1321)

Pope Gregory IX bans the study of Aristotle's writings on the natural sciences (1241)

Founding of Rome University (1303)

Pope Nicholas V establishes the Vatican Library (1447)

Sixtus IV establishes the Capitoline Museum (1471)

Leon Battista Alberti, De re aedificatoria (1452)

Ignatius Loyola establishes the Collegium Romanum (1551)

The Accademia di San Luca established (1577)

Laocoön Group discovered (1506)

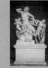

mantle of St. Martin of Tours (316/7–397) had been kept since the 7th century.

Chevet or apse: The eastern side of a church's choir (reserved for clerics), which consists of a wall recess and semidome.

Choir (Latin *chorus* and Greek *choros*, "formation dance," "group of dancers and singers"): Generally, a raised and separated area inside a church reserved for the clergy for the purpose of prayer or choral singing. Since the early Middle Ages the term has been used to refer to the eastern extension of the nave beyond the crossing (the intersection of the nave and the transept), including the apse, which often concludes the nave.

Choir gallery or **cantoria** (Italian *cantoria*): A gallery set aside for singers, usually in a church but occasionally in Renaissance palaces. From the 13th century they were built to separate the choir of lay singers from the choir formed by the clergy. Initially preferred on the long sides of the church, they were later moved to above the western entrance in continental churches, where they were often integrated with the organ gallery. In Italy this change took place in the 16th century.

Choir screen (Latin *chorus* and Greek *choros*, "formation dance," "group of dancers and singers"), also chancel screen: A wall, screen or balustrade that separates the choir, which is reserved for the clergy for prayer or choral singing, from the nave, where the congregation gather. These screens are often richly ornamented.

Church Fathers (Latin *patres ecclesiae*): Church teachers and leading theologians in early Christian times. The four Church Fathers of the Roman Church, all saints, were Ambrose (ca. 340–397), Augustine (ca. 354–430), Jerome (ca. 340/47–420), and Gregory the Great (ca. 540–604).

Ciborium (ill. p. 597) (Latin And Greek *kiborion*, "beaker," "container"): A free-standing canopy over an altar, supported by four columns; a covered receptacle in which the Eucharist is kept.

Cinquecento (Italian "five hundred"): In art history, the term for the 16th century.

Circus (Latin "racing track"): In ancient Rome, a race track consisting of a long rectangular arena with one semicircular end containing a gate (*porta triumphalis*) through which the victorious chariots would leave the arena. At the other end were the starting stalls for the chariots (*carceras*) beside the entrance gates (*porta pompae*) with a tower (*oppidum*) beside each one. The arena was divided down the center by a low narrow wall (*spina*) adorned with statues, trophies, and obelisks. There were also seven moveable egg shapes (*ova*) and seven dolphins (*delphines*) to count the rounds the drivers had raced. In front of these counters stood three round columns on semicircular plinths (*metae*) to mark the point where the drivers had to turn their chariots. The spectators sat on tiered rows of seats along the long sides and at the semicircular end.

Clerestory (Middle English "clear" and "story"): The upper part of the walls of the nave, choir and transepts of a church, rising above the roofs of the aisles and pierced with windows to allow light to enter a church.

Cloister: In a monastery, an arched walkway around an interior square courtyard, usually located on the south side of the monastery. The main rooms of the monastery were often situated around the cloister according to fixed rules.

Codex (Latin "block of wood"): Originally, a wooden tablet consisting of panels fastened together and used for writing. Later the term was used for individual sheets of parchment bound together. It is also used for a collection of writings and laws, and for unwritten, generally accepted rules.

Coffering: In architecture, an ornamental system consisting of deep panels recessed into a vault, arch, or ceiling. One of the finest surviving coffered ceilings is in the Pantheon in Rome.

Column: A circular pillar used as a load bearing support in a building. The basic elements are: a base

(foot), a tall shaft (central section), and capital (head). They are often classified according to the classical orders of architecture. Though usually free-standing, columns can also be "attached," like half-columns, only half of which project from a wall or pillar. See Orders of architecture, classical; Pillar

Colonnade (Old French *colonne*): A row of columns carrying either an entablature or a series of arches.

Columbarium (ill. p. 597; Latin "dovecote"): In large Roman and early Christian burial monuments from the end of the republic to the late 2nd century A.D., niches containing urns of ashes. In modern usage, columbarium refers to the monument itself. The burial monuments were simply decorated chambers or ring-shaped structures built around a central pillar and barrel vaulted. They had small round or rectangular niches set close to each other. In the 2nd century A.D., rectangular niches were often constructed as aedicules with gables or shell-shaped tops. Each niche could hold two urns, on which the name of the deceased was inscribed. In front of the chamber was an enclosed space where funerals took place.

Conclave (Latin "room that can be locked"): The terms for the closed chamber where the cardinals gather to elect the new pope; thus also the assembly of cardinals who elect a pope.

Confessio (Latin "confession"): A written or spoken confession of faith; a confession to a priest, or an admission of guilt; but also used to denote the resting place of a martyr or saint. In this case, the confessio is the vestibule of a martyr's tomb that lies beneath an altar. It later developed into the crypt. Confessios are known in basilicas, notably that of St. Peter in St. Peter's cathedral.

Congregation (Latin *congregatio*, "social gathering"): In the early Christian Church, a community following simple rules, unlike the orders of monks; also designates the association of several monasteries living according to the same order. Congregations of cardinals are the administrative departments of the papal administration (see Curia).

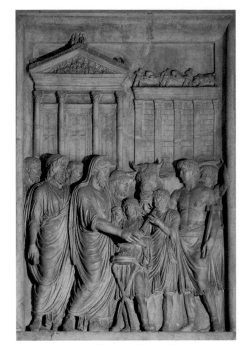

Genius: Marcus Aurelius Sacrificing before the Capitol Temple, relief from an arched monument to Marcus Aurelius, probably A.D. 176. In the left foreground beside the emperor is the Genius Senatus

Console (French *console*, "corbel," "underlay," from Latin *solidus*, "solid"): A stone or bracket projecting from a wall, generally profiled or carved and serving as support for an arch, a cornice, balcony, or statue. A corbel.

Contrapposto (ill. p. 585) (from Latin *contrapositus*, "opposite," from *ponere*, "to set"): In figure sculpture, an asymmetrical standing pose in which the counter movements of the body are brought into balance. The weight falls on one leg, so that the hip on that side projects, the torso moving in the opposite direction to

balance the body. The principle of *contrapposto*, which brought both greater naturalness and dynamism to sculpture, is though to have been developed by the classical Greek sculptor Polyclitus. It played a leading role in the development of Renaissance, Mannerist, and Baroque sculpture.

Corinthian column: A classical column consisting of a richly profiled base and a slender fluted shaft (the flutes separated by fillets), a capital, and an abacus (top plate). The capital and abacus are adorned with acanthus leaf decoration (large leaves like thistles, with jagged edges and a rolled tip). Corinthian columns are part of the classical order of architecture.

Cornice: A horizontal strip protruding from a wall that articulates the horizontal sections of a building.

Cosmati: Term for a number of artists and families of craftsmen who worked in Rome and Latium from about 1150 until into the 14th century. The name derives from the Christian name Cosma, which occurs frequently in these families. The Cosmati created costly decorations in the form of inlay work in marble, porphyry, glass, and gold paste on the model of antique forms and oriental patterns. They made floor mosaics and decorative pieces for churches, such as pulpits, choir screens, bishops' thrones, altars, tabernacles, tombs and porticos.

Council of Trent (1545–1563): A Roman Catholic council convened by the Holy Roman Emperor Charles V (reigned 1519–1556), to restore the unity of Christian faith after the Reformation. However, the Council led to an even sharper distinction between Catholic doctrine and that of the leading Reformation thinkers, Luther, Calvin, and Zwingli. Representatives of the Catholic Church made "weeding out heresy" a point on the agenda, whereupon the Protestants refused to participate and the religious and political split in Europe deepened. Playing an important role in the Counter-Reformation, the Council of Trent led to increased support for the arts in Catholic countries.

Counter-Reformation: A term introduced in the 19th century by the German historian Leopold von Ranke for the period immediately after the Reformation. It

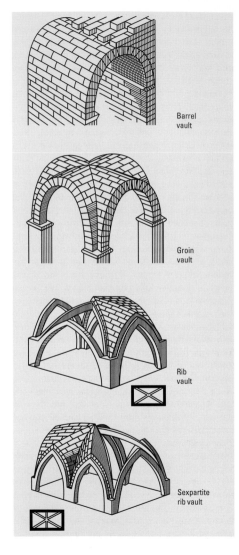

Barrel vault

Groin vault

Rib vault

Sexpartite rib vault

describes the attempts by the Catholic Church to regain its full authority and win back ground lost to the Protestants. Towards the end of the 16th century Maximilian I of Bavaria and Ferdinand of Steiermark (the future Emperor Ferdinand II of Austria, known as the "Devourer of Protestants") were the leaders of the counter-reformation. This reached its peak in the Thirty Years War (1618–1648), which was ended by the Peace of Westphalia in 1648. During the counter-reformation, artistic styles and themes were reappraised to counteract the growing secularization of Church art.

Crenellation, battlement: As part of the fortification of a building, a parapet (wall) with a series of gaps from which missiles can be fired. Later, a decorative feature.

Crossing: In a church, the intersection of the nave and transept, usually surmounted by a dome or tower.

Crucifix (Lat. *crux*, *croce*, "cross", and *fixus*, "fixed"): Sculptural or painted representation of the crucified Christ.

Crypt (Latin *crypta*, Greek *krypte*, "covered walk," "vault"): Subterranean shrine, chapel, or burial chamber, generally beneath the choir of a church.

Curia (Latin "association of men," "senate," "town hall"): In Ancient Rome, the method of dividing Roman men, women and children into thirty associations for religious celebrations. Later, the place where the Senate met, i.e. the Curia Julia on the Forum Romanum. In ecclesiastical practice the term Curia is used mainly for the central papal administration (the Roman Curia), consisting of the secretary of state's office and nine subgroups headed by cardinal prefects.

Dioscuri, the (Greek *dios*, genitive from *Zeus* and *kuros*, "boy," "son"): In Greek mythology, the inseparable twins Castor and Polydeukes (Roman Castor and Pollux), sons of Zeus and Leda and the brothers of Helen and Clytemnestra. The Romans particularly revered them as aids in battle and in distress at sea.

Dogma (Greek *dokeuein*, "believe" and Greek/Latin *dogma*, "opinion, doctrine"): An article of faith in the

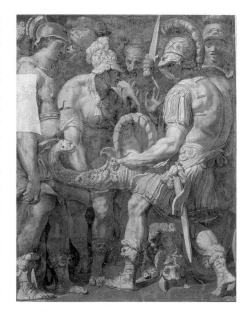

Grisaille: Annibale Carracci, Ceiling painting showing Apollo and Marsyas, 1597, Galleria Farnese, Rome

Catholic Church pronounced by the pope and having absolute validity. For the Orthodox Church only the pronouncements of the first seven councils (325–787) are dogmas. The Protestant Church, by contrast, has only doctrine that must be taught.

Dome: An evenly curved vault, often a half sphere, which sits on a circular, polygonal, or square ground plan. The transition from the square ground plan to the circular dome plan can be made in various ways: 1. With a sail dome, where the base of the dome circumscribes the square; 2. With pendentives, where the lower sections of what would be a sail dome are cut off horizontally and the circular area thus created is set on curving spandrels known as pendentives; 3. With a hemispherical dome, which is like the sail dome and

Hoplites: "Proto-Corinthian" vase decoration, Chigi Pot, 650–640 B.C., Villa Giulia, Rome

used when the area to be domed is smaller than the square ground plan.

Dominican order (Latin *Ordo Fratrum Praedicatorum*, "order of preaching brethren"): A mendicant order founded by St. Dominic (1170–1221) in Toulouse in 1216, dedicated to spreading and defending the faith through preaching and teaching. In 1232 the Dominicans were charged by the pope to hold the Inquisition, the Church tribunal to examine cases of heresy.

Doric column: In classical architecture, a stout column that has: a fluted shaft that swells in the middle and that has no base; an unadorned capital consisting of incised rings (*anuli*); and, between the capital and the load, a cushion (*echinus*) and a square *abacus* (plate). Doric columns are part of the classical order of architecture.

Drum (Old High German, *trumba*): A cylindrical or polygonal wall, sometimes pierced by windows, supporting a dome.

Early Christian art: The art and architecture created between the 3rd and 6th centuries for the Christian church in Italy and the western Mediterranean. The theme of the paintings and mosaics is usually salvation through Christ, and it is expressed in symbols such as the peacock and the fish (both representing Christ), and also in scenes from the Old and New Testaments. Early Christian building began in the 4th century with the Church of the Holy Sepulchre in Jerusalem (326) and in Rome with S. Giovanni in Laterano (313–317). Early Christian art also includes ivory work, reliefs on sarcophaguses, and illustrated manuscripts.

Eclecticism (from Greek *eklegein*, "select"): A term used in art and architecture, generally with a negative implication, for the adoption of older styles. An example is 19th-century Gothic Revival.

Engaged: In architecture, a vertical element (e.g. a column or pier) that is attached to or partly buried in a wall.

Entablature: In classical architecture, the upper horizontal part of an order of columns, consisting of the architrave (the main slab bearing the load of the superstructure), the frieze (a horizontal decoration on the wall), and the cornice (the projecting strip of wall below the roof).

Ephebe (Gk. *ephebos*, "youth"): In classical Greece a young man between the ages of 18 and 20 who was fit for military service.

Evangelist (Greek *evaggelistes*, "bringer of good news," Latin *evangelista*): In the early Church, initially a term for those accompanying the Apostles; from the 3rd century, the four authors of the Gospels: Matthew, Mark, Luke and John.

Evangelists' symbols (Greek *evaggelistes*, "bringer of good news," Latin *evangelista*): Winged creatures symbolizing the authors of the four Gospels: for Matthew a man or angel, for Mark a lion, for Luke a bull, and for John an eagle. These symbols may also be shown in a single figure, the tetramorph. Taken together, they are also a symbol of Christ, who embodies the unity of the gospels. The Evangelists' symbols derive from the vision of God by the Old Testament prophet Ezekiel (1:4) and the Revelation of St. John (4:6). In the fine arts they have been known since the 4th century.

Exhedra (Greek, "outdoor seat," "concealed seat"): In classical architecture (e.g. in a Greek gymnasium), a semicircular or rectangular niche with a bench at the end of a colonnade. In church architecture, the apse at the end of the choir, or any semi-circular niche.

Fluting (Middle English *flowte*, Old French *fleute*): Vertical concave grooves along the shaft of a column, pillar or pilaster. These may adjoin and have sharp edges or be separated by flat strips (fillets).

Forum (Latin "marketplace"): The public square in a Roman town or settlement originally serving as a marketplace and forming the center of political and administrative life.

Fresco (from the Italian *fresco*, "fresh"): A wall painting executed on wet plaster, i.e. painted *al fresco*. The paint reacts chemically with the plaster and cannot be removed when dry; unlike painting on dry plaster (*a secco* painting), it will not peel off. As the plaster dries very quickly, only small sections can be painted in one day, and these are known as *giornate*, i.e. literally "day."

Frieze (Medieval Latin *frisium*, "fringe," "tip"): A horizontal decoration on a wall running in a long strip of relief work or painted images, serving to articulate or enliven a wall surface.

Frontispiece (Fr. *Frontispice*, "front side [of a building], title page"; Med. Lat. *frontispicium*; from Lat. *frons*, "front", and *spicere*, "look"): Triangular pediment above the central protruding façade bay of a building, and also above doors and windows.

Gable: The flat end section of a pitched roof, often triangular; a similarly shaped architectural feature above doors, windows, or niches. The flat triangular and arched gables of antiquity were copied in the Renaissance and the Baroque and, as in the classical originals, broken or molded at the top; in other words the central part is left open or projects to a greater or lesser extent. The tympanum (field of the gable) was often decorated.

Gallery: An upper floor or elevated tier within a large room, often built in churches to create room for a larger congregation or to separate certain groups (e.g. women, or members of the court). In rectangular churches they are usually raised on free-standing supports; in a centrally planned church they are situated above the ambulatory; and in a basilica, above the side aisles. They rarely appear at the western end or in a transept.

Garments, Greek: The basic form of dress for men and women was the *chiton*, a short or long robe, worn with or without sleeves; it was made of wool and belted round the waist. Women could wear the *peplos* over this, a long sleeveless garment pinned on the shoulders and kept closed with a belt. Both men and women wore the *himation* as the top garment, a large rectangular piece of woolen cloth draped over the left shoulder, taken round in front under the right arm, and then thrown over the left shoulder or left lower arm. The *chlamys*, which was made of thicker material, was the cloak for travelers and soldiers; it was thrown around the shoulders and held with a buckle.

Garments, Roman: The main item of clothing for both sexes was the *tunica*, which was closely related to the Greek *chiton*. Women gathered it under the breasts and round the waist. Free-born male Roman citizens wore the *toga* as a top garment. This was made of a delicate woolen material and cut in the shape of a segment of a circle. It was draped according to a fixed rule: the left shoulder had to be covered and the right arm left free. Men could wear a *pallium* over the tunic, women a *palla*, both of which were the same as the Greek *himation*. In Roman times clothing was a sign of class. As well as different types of shoes, a purple border on the lower edge of the toga and a broad purple strip (*clavus*) proclaimed the wearer to be a senator, while the Roman knight's tunic was adorned with a narrower purple band.

Gem (Latin and Italian *gemma*, "bud," "jewel"), also known as **intaglio** (Italian "Incised"): A precious or semiprecious stone or shell with an image cut into the surface, in contrast to the relief on a cameo.

Genius (ill. p. 579) (Latin "protective spirit"): In Roman religion, a protective spirit. Often depicted as a bearded youth, usually with naked chest, bearing a cornucopia on his left arm and a sacrificial vessel in his right hand.

Individual groups had their own *genius*, like the Senate (*genius senatus*), places (*genius loci*), and the state (*genius populi Romani*).

Gens (Latin pl. *gentes*, "large family," more rare "people" of a nation): In Roman usage, originally a large association of people based on a common stock; clan. The *gens* acquired political significance mainly in early Roman times (9th to 6th centuries B.C.); by the late republic (1st century B.C.) it was synonymous with *familia* (family). Membership of a *gens* was reflected in names, e.g. Caius Julius Caesar came from the Julian *gens*.

Glory (Lat. *gloria*, "fame, splendor, heavenly magnificence") or gloriole: Light painted as emanating from God the Father, Christ, the Holy Spirit, Mary or a saint and surrounding the entire body.

Gothic (Italian *gotico*, "barbaric, not classical"): The style of European art and architecture during the Middle Ages, following Romanesque and preceding the Renaissance. Originating in northern France about 1150, the Gothic style gradually spread to England, Spain, Germany and Italy. In Italy Gothic art came to an end as early as 1400, while elsewhere it continued until the 16th century. The cathedral is the crowning achievement of Gothic architecture, its distinctive features being the pointed arch (rather than the Romanesque round arch), the ribbed vault, large windows, and exterior flying buttresses. In Italy, where architecture was strongly influenced by the architecture of classical antiquity, Gothic was far less successful than in northern Europe and Spain.

Graffito (Italian from *graffiare*, "to scratch"), sometimes sgraffito: A decorative technique (on pottery and walls) in which a design is scratched through one layer of paint or plaster to reveal a contrasting color below. Graffito was a favorite form of façade decoration in the Baroque and Renaissance eras because it is highly resistant to weathering. Numerous façades in Rome had graffito decoration, but only a few remnants have survived.

Grand Tour: Largely during the 18th century, an extended tour of the Continent undertaken by young men to broaden their education. The main destination was Italy, and Rome in particular, the attractions being the art and architecture of ancient Rome and of the Renaissance. The Grand Tour played an important role in encouraging an interest in classical and Renaissance art.

Greek cross: A cross with four arms of equal length. The preferred ground plan for Byzantine churches.

Grisaille (ill. p. 581) (from French *gris*, "gray" and *grisailler*, "to paint in gray"): Monochrome painting in which only gray or brown tones are used. Because of its strong tonal contrasts, it is particularly suitable for depicting images meant to resemble sculpture.

Groin vault (Middle English *grynde*): The right-angled intersection of two barrel vaults of the same size (forming a semicircular or segmented ceiling). If the joins are ribbed it is known as a ribbed vault.

Grotesque (from Italian *grottesco*, "wild," "fantastic"): A form of decoration used in the Hellenistic period in Greece and Ancient Rome consisting of fantastical plants and animal ornamentation. The name was coined in the 16th century when decorations of this type were discovered in the subterranean rooms (Italian *grotte*) of the Domus Aurea, Nero's palace complex in Rome.

Hades: Greek god of the underworld, son of Kronos and Rhea, the husband of Persephone; also known to the Romans as Pluto. Hades divided the rule of the world with his brothers Zeus (sky and land) and Poseidon (sea), and was assigned the underworld. As a sign of his sovereignty, Hades bears a scepter and keys; he is accompanied by the three-headed monster, Cerberus, the guardian of the underworld. Later, the name Hades came to be used for the underworld itself.

Hagiography (from Greek *hagios*, "sacred" and *graphein*, "to write"): The study of the lives of saints and the blessed. Hagiography developed mainly in the Middle Ages from folk tales about martyrs and saints. One of the most important collections of legends was the *Legenda aurea* (Golden Legend) compiled by bishop Jacobus Voragine (1228/30–1298/99).

Hellenism (Greek *hellenismos*, "speaking Greek"): In antiquity, a term for the Greek language and culture; in

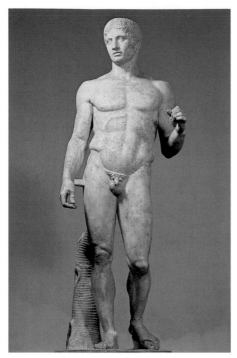

Contraposto: Polyclitus, Doryphoros, ca. 440 B.C., Roman copy made around the birth of Christ, Museo Nazionale, Naples

modern scholarship, a term used by historians for the period in Greek culture from the death of Alexander the Great (323 B.C.) to the death of Emperor Augustus (A.D. 14). Characteristic of Hellenism were the dynastic monarchies in Egypt and Asia Minor that emerged from the empire of Alexander (the Ptolomaic, the Seleucid, the Antigonid and smaller realms like Pergamum), each with a strong army, court and bureaucracy, while the city states of the Greek motherland lapsed into political insignificance. Independent schools of art developed around the powerful royal courts, creating new styles that were to be a determinant influence on the art of the Roman conquerors of these regions later. Free of the rules of the classical age, Hellenistic art developed more expressive and emotional forms.

Heresy (from Greek *hairesis*, "the chosen one," "an attitude of mind"): In antiquity, the choice of a certain creed; in Christianity, a belief deviating from orthodox Christian faith or the prevailing doctrine. Also called heterodoxy.

Hoplites (ill. p. 582) (Greek *hoplon*, "shield"): Heavily armed infantry of the ancient Greek city states from the 7th century B.C. They wore a helmet and body armor and carried a large shield, a sword, and a spear. Only men with full citizenship who were financially in a position to purchase their own armor and weapons could enlist with the Hoplites. Their battle order was a closed formation known as the phalanx (Greek "line of battle").

Iconography (from Greek *eikon*, "picture" and *graphein*, "write" or "describe"): The study of the symbolism employed in the visual arts, particularly in Christian art; originally, the study of classical portraits.

Inquisition (from Latin *inquisitio*, "examination," "research"): Tribunal set up by the Catholic Church in the Middle Ages to combat heretics; from 1231 papal inquisitors were appointed (usually Dominicans and Franciscans). The Inquisition was made a papal institution by Pope Gregory IX (pontificate 1227–1241).

Intarsia (from Italian *intarsiare*, "to apply inlaid work," Arabic *tarsi*, "lay," "place"): Inlay work in wood, ivory, mother-of-pearl, tortoise-shell, or metal. The designs are either carved into a surface and then filled, or made of tiny pieces fitted together and glued on to the surface.

Investiture (Latin *investire*, "to robe"): In the Roman Catholic Church, the last stage of the process by which the pope appoints someone to a Church office, e.g. bishop or abbot.

Investiture Conflict: A struggle between the papacy and the Holy Roman emperors between 1075 and 1122 over the right to appoint bishops and abbots, who had been appointed by the secular rulers since the 9th century. Pope Gregory VII (pontificate 1073–1085) unleashed the

conflict by forbidding lay investiture. Emperor Henry IV (reigned 1056–1106), who felt his imperial rights were infringed, countered by dismissing the pope, and so was in turn excommunicated by Pope Gregory. The investiture conflict was ended in 1122 by the Concordat of Worms between Henry V and Callistus II, when the king renounced the right to appoint bishops, though his right to be present at the canonical selection of a bishop was acknowledged. The investiture conflict also affected England and France, but very much less than Germany.

Ionic column: A classical column having a richly profiled base, a slender fluted shaft, a capital adorned with volutes (spiral scrolling ornaments), and an abacus (top plate). Ionic columns are part of the classical order of architecture.

Islam (Arab. *islam*, "state of grace, surrender to the will of God"): Monotheistic religion founded by the prophet Muhammed in the 7th century.

Jesus, Society of (Latin *Societas Jesu*), or Jesuits: Roman Catholic religious order founded between 1534 and 1539 by St. Ignatius of Loyola (1491–1556) to combat heresy. The Jesuits aimed to renew the authority of the Church and counteract the Reformation. Through their missionary work, education and teaching, and also through their writings and scholarship, they exercised a powerful influence, particularly in education.

Lantern (Latin *laterna*, Greek *lamptera*, "light," "lamp"): In architecture, slender and upright structures, round or polygonal in plan, on top of a dome or vault; pierced by openings or windows, their purpose is to allow light into a building.

Lararium (ill. p. 586) (Latin From *lar*, "protective divinity"): Shrine for the household gods in a Roman dwelling; the main place of the daily religious ceremonies. They are often richly decorated.

Latin Cross (Latin *crux*): A cross in which the upright member is longer than the arms. The most frequent form of ground plan in Western churches.

Latins: Inhabitants of the plain of Latium. In the 5th century B.C. the Latin cities formed an alliance to defend themselves against the invading Aequi and Volsci

tribes. The conflict over leadership of the alliance sparked off the Latin War (340–338 B.C.), in which most of the Latin cities fought against Rome. Nevertheless, Roman military might proved superior. The Latin cities and their inhabitants were incorporated into Rome, and the Roman area grew to about 6,100 square km (2,355 square miles). The victory made Rome the major power on the Italian peninsula.

Latrine (Latin *latrina*, from *lavare*, "to wash"): Public convenience in ancient Rome consisting of rows of

Lararium: House of Menander, Pompeii, reconstruction by P. Connolly

toilet seats. Roman latrines were often adorned with marble and wall paintings, and anyone could use them for a small charge.

Loggia (Italian): Open roofed walk supported by columns or pillars; a columned hall.

Lunette (French "little moon"): A semicircular space framed by a vault or arch (such as those over a door or window) usually elaborately decorated.

Mannerism (French *manière*, "manner," Latin *manuarius*, "pertaining to the hands"): A period in art between the Renaissance and the Baroque, from ca. 1530 to 1620. Mannerist art deviates from the harmonious ideal forms, proportions, and compositions of the Renaissance. In painting, scenes become more dramatic and intense, the human body being greatly elongated and depicted in positions that are anatomically impossible. The compositions are exaggeratedly complicated, light is handled very theatrically and irrationally, and the coloring moves away from the strict adherence to local color.

Masonry, antique: (ill. p. 567) Masonry made of stone or brick and held together with mortared rubble or concrete. The Romans used a variety of techniques (*opera*). The earliest was *opus incertum*, in which the concrete was poured down between two masonry walls consisting of small irregularly shaped stones that were of more or less the same size. From the late 2nd century B.C. *opus reticulatum* was used; this consisted of stones cut into pyramidal shape and with their flat, square sides forming a network of diamonds on the surface of the wall. In the Augustan age and later, in particular in the time of Trajan and Hadrian, the *opus mixtum* was popular. Here layers of small natural stones alternated with bricks. From the time of Nero, the Romans used *opus testaceum*, which consisted of fired bricks. The use of concrete poured behind a frontage of stone made the construction of domes and vaults possible.

Mausoleum (Greek *maussolleion*): A monumental and stately tomb. The term derives from the *mausolleion*, the tomb of Prince Mausolos of Caria in Halikarnassus from ca. 350 B.C., which in antiquity was regarded as one of the Seven Wonders of the World. A columned hall rose from a base with several steps and a high substructure decorated with reliefs. The pyramidal roof was crowned with a quadriga.

Medallion (French *médaillon*, "large medal"): Large, round metal disc engraved with a portrait, device, or inscription.

Minaret (Arab.): Turret of a mosque with a platform from which a muezzin calls the faithful to prayer five times a day.

Mithras: Ancient Iranian sun god. The myth of the slaying of the bull (representing the moon) by Mithras (the sun) was the feature of this Hellenistic mystery religion, which spread to Rome and reached the Roman provinces through the army. From the 2nd century A.D. the worship of Mithras was one of the most important cults in the Roman empire, and numerous shrines (Mithraea, sing. Mithraeum) were built. Most of these were long underground chambers with benches down each side; more rarely they were artificial grottoes. Cult rites were depicted on the walls and floor; the cult image on the rear narrow wall showed Mithras slaying a sacrificial bull.

Monochrome (Greek *monos*, "alone," "single" and *chroma*, "color"): A painting executed in only one color, in contrast to a polychrome image painted with several colors.

Monolith (Greek *monos* and *lithos*, "stone"): In architecture, a part of a building consisting of a single stone (mainly a column or pillar); in sculpture a monumental creation out of a single block of stone (an obelisk, a monumental statue etc.).

Mosaic (Latin *musaicum*, *musivum*, Greek *mousa*, "muse," "art," "artistic activity"): An art form in which pictures or designs are built up by setting small pieces of colored stone, ceramic, or glass in mortar. It was extensively used in ancient Rome, especially to decorate floors, and later became popular for wall and vault decorations in medieval Byzantine and Italian churches, especially in Rome and Ravenna in the 5th and 6th centuries A.D. During the early Renaissance it was largely replaced by fresco as a form of wall decoration.

Opus sectile: Section of a wall, 4th century A.D., Ostia Museum

Narthex (Greek *narthex*, "box"): In architecture, a portico or lobby at the front door of an early Christian church or basilica.

Nave (Latin *navis*, "ship"): In a church with a clearly identifiable longitudinal ground plan (as opposed to a centrally planned church), the open central section extending from the west entrance to the crossing. The nave is usually flanked by aisles, from which it is separated by rows of columns or pillars. The side aisles are generally lower than the nave, and so windows may be inserted in the section of the nave wall above the aisles (the clerestory). See Basilica

Necropolis (Greek *nekros*, "deceased" and *polis*, "town," Spanish *necrópolis*): Burial ground outside the city walls in antiquity and the early Christian era.

Neo-Classicism (Latin *classicus*, "exemplary," "of the first rank"): A style in European art and architecture from the mid 18th century until the end of the 19th century. Based as it was on the use of ancient Greek and Roman models and motifs, its development was greatly influenced by the excavations at Pompeii and Herculaneum, and by the theories of the German art historian Johann Joachim Winckelmann (1717–1768). Intellectually and politically it was closely linked to the Enlightenment rejection of what was seen as the aristocratic frivolity of Rococo, the style of the Ancien Régime. Among Neo-classicism's leading figures were the French painter Jacques-Louis David (1744–1825), the German painter Anton Raffael Mengs (1728–1729), and the Italian sculptor Antonio Canova (1757–1822).

Nepotism (Latin *nepos*, "grandson," "nephew"): The practise of favoring members of one's own family in awarding offices and honors. Often used to refer to the papal appointments of family members, especially sons.

Niche (French *niche*): A semicircular, rectangular or polygonal recess in a wall or pier, commonly used for statues.

Nimbus (Latin "cloud"): In art, the bright disc, halo, or triangle placed behind the head of a holy person. It was used this way in Oriental, Classical, and Indian religious art, and was adopted by Christian artists in the 4th century.

Obelisk (Latin *obeliscus* and Greek *obeliskos*, "skewer for frying food"): Square pillar of stone, narrowing at the top to form a small pyramid. Originating in ancient Egypt, where they were a cult symbol of Ra, the sun god, since the Renaissance obelisks have usually been used as memorials.

Opus sectile: (ill. p. 588) Wall facing or floor covering consisting of small marble pieces arranged in geometric patterns or other forms.

Orans, orant (Latin "praying"): In early Christian art, a figure shown with hands outstretched in prayer.

Oratorians (Latin *orare*, "to pray," "to talk"): Members of an oratory, especially the order founded by St. Philip Neri (1515–1595) in Rome.

Oratory (Latin *orare* "pray," "talk"): Small room or chapel reserved for private prayer, especially as part of a larger church building or complex. A church belonging to the Oratorian Order founded by St. Philip Neri. See Oratorians

Orders of architecture, classical: A clearly defined architectural system in antiquity in which the column,

capital, architrave (that bears the weight of the super-structure), and cornice (horizontal projecting strip of wall) are all in harmony in terms both of proportion and decoration.

The earliest, the Doric order, is the simplest, with a sturdy column and a plain capital. The Ionic order has a slenderer column, a more elaborate base, and a capital formed by a pair of spiral scrolls (volutes). The Corinthian order is the most ornate, having a very slender column and a capital formed of ornately carved leaves (acanthus). Greek architecture used the Doric, Ionic and Corinthian orders; Roman architecture used these three forms together with variations, notably the Tuscan order, which incorporates Doric elements, and the Composite order, which combines the Ionic and the Corinthian.

Palazzo (Italian, "palace"): Large, richly decorated residence; an Italian city mansion or palace. The name derives ultimately from the monumental imperial buildings on the Palatine in Rome.

Palladion (from Greek *pallas*, "girl," Latin *palladium*): A small wooden cult image of the goddess Pallas Athene showing her with shield and raised spear. Most famous in Antiquity was the Palladion of Troy, which was believed to have fallen from heaven. The fate of the city of Troy depended on the statue, and so there are various myths of its theft by Odysseus and Diomedes. According to the Roman version, the Palladion was saved by Aeneas and taken to Rome, where it was preserved in the temple of Vesta. Later the protective divinity of any city, whose loss would render the city defenseless, was called its Palladion.

Panel (Fr. *panneau*, "panel"): Recessed wooden plate used to fill in the gap between the mouldings and frames of paneling.

Patriarchal basilica (Latin *basilica major*): Since the 17th century, the designation of a basilica directly under the authority of the pope. A patriarchal basilica is endowed with special privileges, and contains a papal altar and a papal throne. The patriarchal basilicas in Rome are the Lateran basilica, St. Peter's, S. Paolo fuori le Mura, and S. Maria Maggiore. Attendance at all the patriarchal basilicas may under certain conditions give absolution; in Holy Years the Holy Door (Latin *Porta Sancta*) in all the patriarchal basilicas is opened.

Patrician (Latin *patricius*, "descendant of the head of a Roman noble family"): Roman nobility by birth. Under the Etruscan kings the patricians owned most of the land and they achieved numerous privileges through their family ties and a network of political alliances. They played a major part in the downfall of the Etruscan kings in the early 5th century B.C. and seized power (start of the Roman Republic). During the class wars (ca. 470–300 B.C.) they had to defend their privileged

Personification: Gianlorenzo Bernini, The Ganges, from the Four Rivers Fountain, 1651, Piazza Navona, Rome

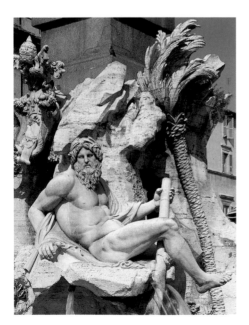

position against the plebs, and when the plebs achieved political equality towards the end of the 4th century B.C. a new socially mixed elite evolved, the "nobility." As time went on the power of the patricians declined. From the time of Emperor Augustus (reigned 27 B.C.–A.D. 14) a growing number of members of the "nobility" were raised to patrician status, and this finally eliminated its character as nobility "by birth." See Plebs

Pedestal (Latin *pes*, "foot"): The support for a pillar, column, or statue.

Pediment: The classical flat triangular or segmental arch pediments were imitated during the Renaissance, Baroque and Neoclassical periods and, as in the originals, can be broken or have a cornice running through it; in other words the central part can be missing or projecting to a greater or lesser extent. The tympanum (area within the pediment) can be decorated.

Pendentive (Latin, *pendere*, "to hang"): A curving and concave triangular section of vaulting linking a dome to the square base on which it rests. See Dome

Personification (Latin *persona* and *facere*, "to make or do"): The use of a person to represent or symbolize a quality, virtue etc.; a form of allegory.

Perspective (Medieval Latin *ars perspectiva*, "the science of optics"): The depiction of three-dimensional objects on a two-dimensional surface. As far as possible the objects and figures are rendered as the human eye sees (i.e. objects get smaller as they recede). The most important form of perspective in the Renaissance was linear perspective (first formulated by the architect Brunelleschi in the early 15th century), in which the real or suggested lines of objects con-verge on a vanishing point on the horizon. Since the Italian Renaissance, perspective has generally been interpreted as the way the individual sees the world. Since the 19th century the use of perspective in the composition of paintings has been losing its binding authority.

Pietà (Latin *[Maria Santissima della] Pietà*, "most holy Mary of pity"): A depiction of the Virgin Mary with the crucified body of Jesus across her lap. Developing in Germany in the 14th century, the Pietà became a familiar part of Renaissance religious imagery. One of the best-known examples is Michelangelo's Pietà in St. Peter's, Rome.

Pilaster (Italian *pilastro*, from Latin *pila*, "pillar"): Rectangular attached pillar that generally projects only slightly from the wall, with a base (foot), shaft (central section), and capital (head). The shaft is often fluted, that is, decorated with vertical channels. It is usually a decorative rather than structural feature.

Pilgrim church: The churches pilgrims had to visit during visits to Rome; they contained particularly important tombs or holy relics. Pope Boniface VIII (pontificate 1294–1303) granted pilgrims who visited all seven of these churches full absolution from all their sins in the Holy Year 1300. The seven pilgrimage churches in Rome are: St. Peter's; S. Giovanni in Laterano; S. Maria Maggiore; S. Paolo fuori le Mura; S. Croce in Gerusalemme; S. Sebastiano fuori le Mura; and S. Lorenzo fuori le Mura.

Pillar (from Latin *pila*): A vertical support with a round, square, rectangular, or polygonal cross-section. It usually consists of a base (foot), shaft (central part) and capital (head). Depending on the position and function pillars may be free-standing, attached to a wall (engaged), or forming a buttress (a pillar attached to the wall outside a building to take the thrust from the roof and vault). The shaft of the round pillar is straight, unlike that of the column, which swells and then tapers towards the top. See Column

Plebs (Latin, "crowd," "lower classes"): The class of Romans outside the nobility, mostly farmers but including traders and shopkeepers. During the class wars (ca. 470–300 B.C.) the plebs organized their own political institutions and were finally able to achieve a large degree of legal security and political equality with the patricians. The representatives of the plebs (tribunes of the people) were recognized by the patricians as holding an office of state in 287 B.C. After that date, the word "plebs" was used to describe all classes below the senators and knights. See Patrician

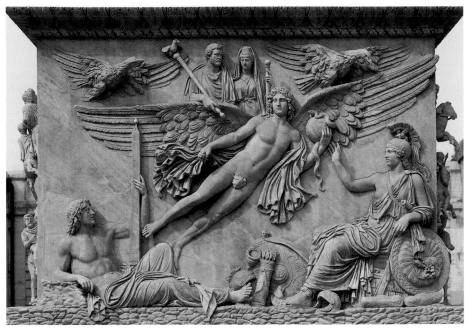

Bas-relief on the Antoninus Pius Column, Apotheosis of the Emperor and his Wife Faustina, ca. A.D. 161, Vatican Museums, Cortile delle Corazze, Rome

Podium temple (Lat. *podium*; from Gk. *podion*, "step, step-like rise"; and Lat. *templum*, "holy place"): In Etruscan and Roman architecture a temple with a front on a high base (podium) entered by way of a broad staircase at the front.

Pomerium (Latin): Sacred border of a city (imaginary rather than physical). It was marked at the corners by *cippi*, border markers in wood or stone bearing an inscription. Inside the pomerium, no burials could take place and no weapons could be carried.

Pontifex Maximus (Latin "supreme builder of bridges"): In ancient Rome, the supreme priest. The *pontifices* formed a college of priests who constituted the ultimate authority on all religious questions. Originally there were three priests in the college, but under Sulla and Caesar the number rose to 15 and then 16. Under the direction of the Pontifex Maximus the priests watched over observance of the calendar of Holy Days and religious rites generally. From the 5th century the pope was also called Pontifex Maximus.

Pontificate (Latin *pontificatus*, "the office of supreme priest"): The period in office of a bishop or pope.

Portal (Medieval Latin *portale*, "vestibule"): The entrance to a large or important building, especially a church. The model for the western portal is the Roman triumphal arch (a free-standing gateway in honor of a general).

Portico (Latin *porticus*, "colonnade," "hall"): Projecting open structure supported by columns or pillars at the front of a building. Frequently gabled.

Predella (Italian "kneeling-stool"): The base of an altar retable or a winged altarpiece; in some cases holding relics (revered objects or mortal remains of a saint). Often decorated with pictorial representations. See Altarpiece

Putto (Italian "little boy," Latin *putus*, "boy"): A small naked boy (with or without wings) invented in the Italian Renaissance from Gothic images of child angels and modeled on the cupids of antiquity.

Quadriga (Latin *quattuor*, "four" and *iugum*, "yoke"): In ancient Rome, a two-wheeled war or triumphal chariot pulled by a team of four horses. Used as decoration on top of buildings, such as triumphal arches, since the 4th century B.C.

Quattrocento (Italian "four hundred"): In art history, the 15th century.

Reformation (Latin *reformatio*, "change," "renewal"): 16th-century movement that began as a search for reform within the Roman Catholic Church and led subsequently to the establishment of Protestantism. This split in Western Christendom had profound political consequences, with the whole of Europe dividing into opposed and often hostile camps. Among the Reformation's leading figures were Jan Huss (ca. 1370–1415), Martin Luther (1483–1546), and John Calvin (1509–1564). In Catholic countries patronage of art remained with the Church and courts; in many Protestant countries patronage was increasingly in the hands of the middle classes and new subjects for art were developed to replace the religious imagery that was seen as idolatrous. The Catholic response to the Reformation was the Counter-Reformation. See Counter-Reformation

Relic (Latin *reliquiae*, "remains," "what is left behind"): Part of the body of a saint or object from a saint's possession that is revered as holy.

Relief (Latin *relevare*, "lift," "raise"): A sculptural work in which the design projects from the flat surface. There are three basic forms: low relief (*bas-relief, basso rilievo*), in which figures project less than half their depth from the background; medium relief (*mezzo rilievo*), in which figures are seen half round; and high relief (*alto rilievo*), in which figures are almost detached from their background.

Renaissance (French, from Italian *rinascimento*, "rebirth"): Cultural epoch originating in Italy and lasting from the late 14th or early 15th century until the 16th century. The later period from about 1530 to 1600 is also called Mannerism. The term *rinascità* was coined by the artist and art historian Giorgio Vasari (1511–1574) in 1550; Vasari meant it to refer to progress beyond medieval art. The culture of the Renaissance was primarily established by visual artists, scholars, philosophers, and writers. They were inspired by humanism, which aimed for a new image of humanity, the world and nature and took antiquity as its model. The Renaissance evolved the concept of the *uomo universale*, the person of universal learning and all-round intellectual and physical capacity. The visual arts emerged from their status as crafts, and with their new independence artists found that their social status had risen too. The arts and sciences were closely tied and influenced each other, for example in the discovery of mathematical perspective and increasing anatomical knowledge. Renaissance architecture took its bearings from the theories of Vitruvius (ca. 84 B.C.) and adopted classical features; its major achievements were in palace and church architecture, and centrally planned buildings were characteristic of the Renaissance.

Restauratio Romae (Latin): The restoration of Rome undertaken by Pope Julius II and Leo X at the beginning of the 16th century. The work involved new buildings and programs of restoration, together with commissions for paintings and sculptures, and helped to make Rome one of the most important art centers of the High Renaissance.

Retable (Fr. *retable*; Lat. *retabulum*, "rear wall") or **altar-piece**: Sculptural or painted altar decoration usually mounted behind the altar or over its rear wall. It can consist of a single work of art or several panels.

Reticulated vault: Late Gothic vault form in which the

ribs (weight-bearing sections of the ribs (weight-bearing sections of the roof) form a network disguising the division of the bays.

Rib: An arch supporting a vault; a projecting band or molding to strengthen the joints, edges or intersections in a vault; often profiled.

Rib vault: The intersection of two barrel vaults (semicircular and segmental arch roofs) of equal size at right angles. The intersections are called ribs.

Risorgimentao (Italian "resurrection"): The political movement (from 1815 to 1870) that sought to unify Italy (which was then a collection of states controlled by foreign powers). In the struggle over the future structure of Italy, the monarchy (the King of Piedmont-Sardinia, who became Victor Emanuel II of Italy) supported by the Liberal Conservatives was successful when the nation state was formed (1859/61), defeating the left-wing liberal Republican Democratic Action party under Giuseppe Mazzini and Giuseppe Garibaldi.

Rococo: A style of design, painting, and architecture dominating the 18th century, often considered the last stage of the Baroque. Developing in the Paris townhouses of the French aristocracy at the turn of the 18th century, Rococo was elegant and ornately decorative, its mood light-hearted, and witty. Louis XV furniture, richly decorated with organic forms, is a typical product. Leading exponents of the Rococo style included the French painters Antoine Watteau (1684–1721) and Jean-Honoré Fragonard (1732–1806), and the German architect Johann Balthasar Neumann (1687–1753). Rococo gave way to Neo-classicism.

Romanesque (Latin *romanus*, "Roman"): Style of architecture in the early Middle Ages that adopted the formal repertoire of Roman architecture (the round arch, groin vault, the pillar). Romanesque architecture often exhibits a sculptural interplay of cylindrical and cubic forms. Romanesque dates from the end of the 8th century to the 12th century, i.e. in the period immediately before the Gothic era. In every country national characteristics and stylistic features developed; the greatest examples of Continental Romanesque are in Burgundy, Normandy, Northern Italy and Tuscany, mainly churches, cathedrals and abbeys. British Romanesque architecture is often referred to as Norman.

Roman house, elements of: (ill. p. 596) The most familiar form of Roman house, a house built around an atrium, was adopted from Etruscan architecture; it was generally a single story building accessible from the street. A *vestibulum* (hall) led into the atrium, or court, around which were the other rooms, including the *cubicula* (bedroom), *triclinium* (dining room), the *tablinum* (reception room for the master of the house), and the utility rooms. In the middle of atrium was an *impluvium* (sunken basin) to collect rainwater and take it into an underground cistern. Through the dining room or in some cases an *ala* (corridor) one reached the *hortus* (garden). From the 2nd century B.C. the atrium-house was extended by replacing the garden with one or several garden courts surrounded by *peristyles* (columns) with subsidiary rooms and adding a second story. This was the *domus* (Latin "house"), a town house for one family.

The ground floor of the multi-story tenement blocks (Latin *insulae*) generally contained shops with a mezzanine floor above for their stores. The upper floors contained apartments of various sizes, often with a communal toilet.

The villa (Latin "country house or estate") was the summer residence of the wealthy. It was larger than the basic atrium house, and in the course of time various types developed, depending on the position, the use and requirements of the owner. See Villa

Rustication (Latin *rustica*, from *rusticus*, "rural," "peasant-like"): Masonry consisting of large blocks whose faces are rough hewn so as to contrast with dressed ashlar (finished stone). Often used on Roman palaces to create a sense of robustness.

Sack of Rome (Italian *Sacco di Roma*): The plundering of Rome by the Protestant mercenaries employed by Emperor Charles V (reigned 1519–1556). They occupied the city from May 6, 1527 to February 17, 1528. The Pope

was held prisoner, thousands were killed, and churches and palaces badly damaged.

Sarcophagus (Greek *sarcophagus*, "flesh eater"): A coffin or tomb, made of stone, wood or terracotta, and sometimes (especially among the Greeks and Romans) carved with inscriptions and reliefs.

Schism (Greek "split"): Any major split within the Christian community. There have been two "great schisms:" the schism between the Eastern and Western Churches (traditionally dated to 1054); and the split in the Western Church 1378–1417, when there were two lines of papal succession, one in Rome and one (of the so-called antipopes) in Avignon in France. This Great Schism was preceded by the so-called Babylonian Captivity, when the papacy resided in Avignon. See Babylonian Captivity

Segmented gable: In architecture, a gable terminated by the segment of an arch. The flat segment gable was adopted from antiquity and copied in Renaissance, Baroque, and Neo-classical architecture; as in antiquity, the arch could also be broken, and was usually molded. The form appears frequently to decorate a portal or window. See Gable

Senate: The most powerful political body in the Roman Republic, evolved from the council of nobles under the Etruscan kings. The Senate had the right to participate in almost every political issue, including foreign policy and fiscal administration. The *ordo senatorius*, the members of the senate and their families, were the highest level in society, and senators wore distinctive signs of their rank, notably red shoes and a broad purple band on their tunic. Under Emperor Augustus (reigned 27 B.C.–A.D. 14) the Senate lost some of its powers to the imperial bureaucracy.

Severe (or austere) style (from German *strenger Stil*): Term introduced by the German poet Johann Wolfgang von Goethe to describe the period in Greek classical art from ca. 480–460/450 B.C. when the archaic forms, in which sculpture was stiffly statuesque and concentrated on the vertical axis, gradually changed to a balance of rest and movement, load and relaxation (see

Contrapposto). Instead of the smile on archaic faces, the sculptures of the Severe style often have rather hard, closed features; the forms are heavy, a weightiness that was to disappear in the idealization of the high classical period.

Sibyl (Greek *sibylla*, "prophetess"): A wise woman in classical antiquity who could foretell the future. According to Christian legend, several of the sibyls foretold the birth, passion, and resurrection of Christ. Originally, in antiquity, there was only one sibyl; the number later increased to ten. In the early Christian era the number rose to twelve, analogous to the twelve prophets in the Old Testament. The sibyls are depicted in Michelangelo's frescoes on the Sistine Ceiling.

Smalts (Italian *smalto*, "molten glass"): A preparation of silica, potash and oxide of cobalt to create a blue pigment used to color the glazes for ceramics and porcelain.

Spandrel (Middle English *spaundrell*): The triangular space between one side of the outer curve of an arch and a ceiling or rectangular frame (e.g. a door frame). The triangular space between two arches of an arcade.

Spolia (Latin *spolium*, "spoils," "booty" and *spoliare*, "plunder," "rob"): Parts of a building reused in other buildings or art works at a later period. In Rome, a good deal of early Christian architecture made extensive use of *spolia*.

Stucco (Italian "plaster"): A protective coat of coarse plaster applied to external walls; sculpted plaster decorations, usually interior. During the Renaissance stucco decorative work, often employing classical motifs, achieved a high degree of artistry.

Tabernacle (Latin *tabernaculum*, "small tent or hut"): In architecture, a decorative canopy consisting of columns and a pointed roof placed over statues, e.g. on Gothic buttresses; a structure on supports over an altar; a shrine where the dedicated host is kept.

Temple (Latin *templum*, "separate room for the augurs to observe the flight of birds," then "holy place, temple"): A non-Christian religious building, the main form of cult building in ancient Greece and Rome. The

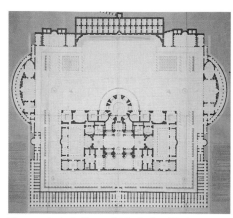

Thermae: From I. Gismondi, The Baths of Trajan, A.D. 109, Rome

core of all temples is the windowless inner sanctuary, called in Greek *naos* and in Latin *cella*. Unlike Christian churches, temples were not used by the congregation; they housed a cult image (usually the statue of a god) and were visited only by priests. The sacrifices were performed at the altar in front of the temple. At a very early age various types of temples evolved in Greek architecture and are named according to the manner in which the cella is enclosed: with a vestibule (*pronaos*); with a room at the rear (*opisthodom*); or set within a colonnade. The oldest type of Roman temple derives from the Etruscan podium temple. It stands on a raised base and the front is strongly emphasized with a flight of steps and a deep portico (it was here that sacrifices were usually performed).

Thermae (Greek *thermos*, "warmth," "warm spring"): Public bath house in ancient Rome. The main rooms in the *thermae* were: the *caldarium* (hot water bath); the *tepidarium* (warm water bath); the *frigidarium* (cold water bath); and the *natatio* (swimming pool). Beside these were the changing rooms (*apodyteriae*); a steam bath (*laconicum*); massage rooms (*unctuariae*); and rooms for leisure pursuits and sports facilities (*palaestrae*). Many of the great baths in imperial Rome were set in a park containing nymphaea, libraries, and rooms for music or lectures. The water was brought on aqueducts and stored in great cisterns. The baths were heated by hot air circulated from heating chambers or through channels (hypocausts) under the floors.

Tiara, papal (Greek and Latin "headband," "turban"): The pope's high domed hat adorned with three coronets. Also known as the *trigenium* (Latin "triple crown").

Titular church (Latin *titulus*, "heading," "name"): The name known in the 3rd century A.D. and usual from the 4th for a Roman (parish) church within the Aurelian Wall of Rome. Rooms in private houses used for religious services (and referred to by the name of the owner of the house) were called *tituli* and the priests active there in an official capacity were *cardinales*; this later evolved into the office and title of cardinal. Today every cardinal is appointed to a titular church in Church law, and the church is recognizable by his coat of arms and those of the reigning pope on its façade.

Tondo (Italian "sphere," "round plate," from Latin *rotundus*, "round"): A circular painting or relief.

Torso (Italian "rump"): Originally, an antique statue left unfinished, or of which only part has survived. Since the 16th century torsos have been created as works of art, and the sculptor has deliberately refrained from executing the head or arms. The most famous and important antique model is the Belvedere Torso in the Vatican Museums.

Transept: A section of a church running at right angles to the main body of the church and added to create more room for the clergy and the altars. In the early Christian basilicas the transept usually concludes the church building. In Romanesque churches it is often followed by the choir, which has the optical effect of lengthening the nave (and thereby forming a cross). Such a structure is referred to as a transept only if its ceiling or vault is at the same height as that in the nave.

Triclinium (Latin): The dining room in a Roman house; in a monastery, the refectory for pilgrims.

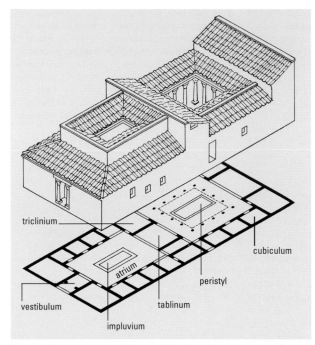

Roman atrium-style house with a peristyle (schematic representation from models in Pompeii)

triclinium

cubiculum

atrium

peristyl

vestibulum

tablinum

impluvium

Trinity (Latin *trinitas*, "triple unity"): In the Christian faith, the triple identity of God, God the Father, God the Son, and God the Holy Ghost.

Triptych (Greek triptukhos, "three-tiered," "triple," from *tri*, "three" and *ptyche, ptyx*, "fold"): A painting in three sections, usually an altarpiece, consisting of a central panel and two outer panels (wings). In many medieval triptychs the two outer wings were hinged so that they could be closed over the center panel. Early triptychs were often portable.

Triumphal arch (Latin *triumphus*, "victory procession"): Since the 2nd century B.C. in Rome, a free-standing gateway with openings, built in honor of a general or emperor. In early Christian basilicas, the arch between the nave and the apse, often bearing a mosaic decoration; the form also influenced the development of the western portals of a church.

Triumvirate (Latin *triumviri / tresviri*, "three men"): Joint rule by three men. An alliance of three political leaders in Rome in the 1st century B.C. formed for a particular purpose, namely to perform a task of state or achieve a common objective. The most important triumvirates were those of Pompey, Crassus, and Caesar (60 B.C.); and Antony, Lepidus, and Octavian (who was later the Emperor Augustus) (43 B.C.) Originally triumvirates were a college of magistrates exercising police and supervisory functions in the Roman Republic.

Trompe l'œil painting (French "deceives the eye"): Painting which, through various naturalistic devices, creates the illusion that the objects depicted are actually there in front of the viewer. Dating from classical times, *trompe l'œil* was revived in the 15th century.

Varnish (French *vernis*, "lacquer" or "glaze," Medieval Latin *veronix*): A transparent protective coat applied to a finished oil painting to protect it, generally consisting of a solution of soft resins in refined turpentine oil.

Vault: (ill. p. 580) Any roof or ceiling whose structure is based on the arch. Abutments (walls or pillars) beneath the vault bear the downward thrust.

There are a wide range of forms, including: the barrel (or tunnel) vault, formed by a continuous semicircular arch; the groin vault, formed when two barrel vaults

intersect; and the rib vault, consisting of a framework of diagonal ribs supporting interlocking arches, and the sexpartite, formed by several cells. The development of the various forms was of great structural and aesthetic importance in the development of church architecture during the Middle Ages.

Venus: Roman goddess of Spring and gardens, closely connected with the concept of grace and charm; later equated with the Greek goddess of love, Aphrodite.

Vestal Virgins (from Latin "goddess of fire"): Four (later six) Roman priestesses of the goddess Vesta who had to guard the holy "fire of state" in the round temple on the Forum Romanum under the supervision of the Pontifex Maximus. The fire was believed to have come from Troy and was never allowed to go out. The Vestal Virgins dwelt in the Atrium Vestae next to the temple and were bound to remain virgins for thirty years upon pain of being buried alive or thrown from the Tarpeian Rock on the Capitol if they transgressed. The Vestal Virgins were highly regarded in Roman society and were often consulted on political matters.

Vestibule (Latin *vestibulum*, "forecourt"): A porch in front of a building, in front of the entrance to a house in ancient Rome.

Victoria (Latin "victory"): Roman goddess of victory; the personification of victory; the victorious power of the people of Rome and the patron divinity of the Roman Empire. The goddess was depicted as a virginal maiden, like the Greek goddess Nike, winged and generally wearing the crown of victory.

Villa (ill. p. 596) (Latin "country house," "estate"): Originally, a dwelling in the country. A new creation in Roman architecture, the villa evolved from the 2nd century B.C. as the counterpart of the atrium-style town house. In the course of time different types evolved, depending on the geographical position, specific use (many were working farms), and requirements of the owner (imperial villas). The idea of the villa was taken up again in the Italian Renaissance in the 15th century and architectural theorists and architects, like Leon Battista Alberti (1404-1472), Andrea Palladio (1508-1580), and

Vincenzo Scamozzi (1552-1616) went back to sources in ancient Rome (Vitruvius and Pliny the Younger) and evolved ideal designs. The villa was seen as a retreat and a place of relaxation. See Roman house, elements of.

Volute (Latin *voluta*, "snail," "rolled element"): In architecture, a spiral-shaped and rolled ornamentation. Especially used on capitals, particularly the Ionic column, and gables, and to link vertical and horizontal parts of the building.

Ciborium: Arnolfo di Cambio, S. Cecilia in Trastevere, 1293, Rome

Biographies

Agrippa (Marcus Vipsanius Agrippa. 64/63 B.C. Dalmatia–12 B.C. Campagna). Agrippa was a provincial administrator and an able military commander, who supported Octavian in his struggle for power; his greatest success came at the naval battle of Actium in 31 B.C., which secured Octavian's victory over Mark Antony. He became Augustus' most important partner in the emperor's comprehensive program of reforms. As Roman aedile, and later as consul, he built aqueducts, canals and public baths and commissioned the first pantheon.

Alberti, Leon Battista (1404 Genoa or Venice–1472 Rome). An architect and art theorist, Alberti embodied the Renaissance ideal of the *uomo universale*, or "universal man," the humanist scholar who was accomplished in a broad range of fields. From 1432–1434 he lived in Rome, and later in Florence, Bologna, Mantua, and Ferrara where he also worked as an architect. From 1443 he was largely domiciled in Rome where he concentrated on the study of the city's classical legacy, the results of which appeared in his work *Descriptio urbis Roma* (Description of Rome). He

Matteo de'Pasti, Medallion portrait of Leon Battista Alberti, ca. 1438, Museo Nazionale del Bargello, Florence

became the closest assistant to Pope Nicholas V, advising him on numerous architectural projects such as the redesigning of S. Stefano Rotondo and the new plans for the Vatican. In 1452 in Rome he completed his main theoretical work *De re aedificatoria libri decem* (Ten Books on Architecture), the first great architectural treatise of the modern era.

Algardi, Alessandro (1598 Bologna–1654 Rome). In the mid-17th century Algardi was one of Rome's leading sculptors. He trained at Ludovico Caracci's Academy of Painting and Drawing in Bologna, and under the less renowned sculptor Giulio Cesare Conventi. From 1625 he worked in Rome. With the accession of Innocent X (pontificate 1644–1655) Bernini's popularity began to wane and he was superseded by Algardi. As the representative of a type of classicism that reacted against the expressive style of the Baroque, Algardi was strongly influenced by the art of antiquity, as can be seen in the painterly quality of his sculptures.

Angelico, Fra (ill. p. 604) (ca. 1395 Vicchio di Mugello near Florence–1455 Rome). Real name Guido di Pietro, also known as Beato Angelico. A leading painter in the period between the late Gothic and early Renaissance. After training as an artist he entered the Dominican monastery in Fiesole under the name of Fra Giovanni da Fiesole. In 1436 both he and the convent moved to S. Marco in Florence. In 1447/48 and again in 1452 he worked for the papal court in Rome as well as undertaking commissions in Orvieto. Influenced by Gentile da Fabriano and Lorenzo Ghiberti, Fra Angelico took up the new Renaissance forms in his frescoes and panel paintings to develop a unique style, charac-

terized by light colors, elegant forms, and balanced compositions.

Apollodoros of Damascus (A.D. 65 Damascus–125 Rome). One of the greatest architects of the Roman Empire. As official architect to Emperor Trajan (reigned 98–117) he was responsible for the most prestigious construction projects of the day. He retained this position in the first years of Hadrian's reign but fell into disfavor when he is said to have criticized the emperor's designs for a temple. His reputation rests mainly on his fusion of Hellenistic and Oriental styles of architecture with Romano-Italian forms.

Apollonios (1st century B.C.). Greek sculptor who worked in Rome. Mainly known for the Belvedere Torso – the sculpture is signed on the pedestal – which was highly praised by Winckelmann. Apollonios worked in an eclectic fashion and sought to create new forms by combining older styles.

Aquinas, St. Thomas (1225 Roccasecca near Monte Cassino–1274 Fossanuova). Theologian and philosopher, the most distinguished exponent of scholasticism. Against the wishes of his parents, he entered the Dominican order and studied theology in Cologne and Paris. Aquinas created a synthesis of Christianity and the Aristotelian world view, which had been rediscovered in the Middle Ages. In his two *Summae* he systematized the theological and philosophical knowledge of his age (*Summa theologica, Summa contra gentiles*). According to Aquinas faith and knowledge were united in their common orientation toward God.

Aristotle (384–322 B.C.). Greek philosopher; a pupil of Plato's for 20 years, Aristotle was called by King Philip II to Macedonia in 342 B.C. to teach his son, Alexander the Great. In 335 B.C. he founded the Lykeion (the origin of the word *lyceum*) in Athens, which was also known as the Peripatetic School from Aristotle's habit of walking through the arbors (Greek *peripatoi*) of the institution as he taught. His work covers all the fields of classical knowledge: philosophy, metaphysics, logic, ethics and politics, rhetoric and poetry, biology, zoology, and medicine. Aristotle established the basis for these disciplines as well as their scientific methodology.

Baciccia, Giovanni Battista (1639 Genoa–1709 Rome). His real name was Giovanni Battista Gaulli. After an apprenticeship in Genoa he went to Rome either in 1653 or 1656 where he studied the works of Raphael and, especially, those of Pietro da Cortona. He soon became the favorite of the sculptor and architect Giovanni Lorenzo Bernini. From 1662 he was a member of the Accademia di S. Luca and was named its director in 1674. Baciccia became known for his frescoes and portraits. A warm coloration, skillful handling of light and dramatic shortening of perspective allowed him to achieve an idiosyncratic and dynamic style which influenced both the frescoes of the Roman Baroque as well as later artistic movements.

Bernini, Gianlorenzo (1598 Naples–1680 Rome). The most influential of the great masters of the Baroque in Rome. From 1606 he worked in Rome as a sculptor. His reputation was established by his free-standing

Gianlorenzo Bernini, Self-portrait as a Young Man, 1623, Galleria Borghese, Rome

sculptural groups based on biblical or mythological themes as well as his Roman fountains commissioned by a series of popes and cardinals from 1615/16. In the second half of his life his architectural work began to dominate and he was considered a rival to Borromini. Between 1624 and 1670 Bernini directed the rebuilding and decoration of St. Peter's. In 1665 he was invited to France by Louis XIV to design additions to the Louvre; the work was, however, never carried out. Bernini's work is characterized by his brilliant handling of marble, an impressive use of light, and his theatrical manipulation of space. Other features include the disciplined power and proportionality of his buildings, and the symbiotic unity of architecture and sculpture.

Francesco Borromini, Self-portrait, 1667, San Carlo alle Quattro Fontane, Rome

Bernini, Pietro (1562 Sesto/Florence–1629 Rome). Father and teacher of Gianlorenzo Bernini, Pietro was trained as a sculptor in Florence and worked at various times in both Rome and Naples. Towards the end of his creative life he assisted Gianlorenzo in his son's studio. Technically brilliant but lacking in originality, his work combined the Mannerist elements with those of the Quattrocento.

Borghese, Scipione Caffarelli (1576–1633). The nephew of Camillo Borghese, who was elected Pope Paul V in 1605, he later became Cardinal Scipione Borghese. Scipione came from a Sienese noble family who settled in Rome in the 16th century, and it was there that he lavished most of his fortune on the construction and restoration of churches and palaces. He was also patron of the sculptor and architect Gianlorenzo Bernini, and between 1613–1616 he had the Villa Borghese built on the Pincio in Rome, where he founded his famous collection of art.

Borromini, Francesco (1599 Bissone/ Lake Lugano–1667 Rome). A Swiss-Italian architect and sculptor who, along with Bernini, was the main exponent of the High Baroque in Rome. He began his career as a colleague of Maderno and Bernini while working on St. Peter's. Borromini received his first big commission in 1632 when he was appointed architect of the Sapienza, the city's university. His major work is considered the church of S. Ivo alla Sapienza, completed in 1660. His architecture is characterized by an avoidance of straight lines in favor of curving façades, broken pediments, and an innovative way of combining interior spaces.

Botticelli, Sandro (1445 Florence–1510 Florence). Real name Alessandro di Mariano Filipepi, the artist Botticelli worked largely in his native city. After first training as a goldsmith he was later apprenticed to the painter Fra Filippo Lippi in the 1460s. He was particularly influenced by Pollaiuolo and Andrea del Verrocchio – later by Ghirlandaio and Perugino – inspired by the circle of humanists around his chief patron, Lorenzo de'Medici (1469–1492). Botticelli's allegory of spring, the *Birth of Venus*, represented a classicizing ideal steeped in

Neo-Platonism, its figures are elegant and otherwordly. About 1482 he received a commission from the Vatican for three large frescoes in the Sistine Chapel. After Botticelli's return to Florence his art took a new turn under the influence of the religious leader Savonarola (1452–1498), and he began to express a more profound religious spirituality.

Bramante (1444 Fermignano near Urbino–1514 Rome). Real name, Donato d'Angelo or Donato de Urbino. Known mainly as the founder of Italian High Renaissance architecture, Bramante was also an accomplished painter, a profession for which he originally trained (possibly in the studios of northern Italian artists). It seems likely that he was introduced to architecture by Luciano Laurana at the court of Urbino in the 1460s. From 1476 he worked in Milan first as a painter for Duke Sforza but also as an architect, creating major buildings such as the S. Maria della Grazie. In 1499 Bramante went to Rome where he entered the service of Pope Julius II (pontificate 1503–1513) in 1503 and he soon rose to become the architect of St. Peter's. Bramante succeeded in developing a new interpretation of classical styles that powerfully expressed an ideal of harmony and clarity.

Bruno, Giordano (1548 Nola–1600 Rome). A Dominican, and one of the leading scientific thinkers of the Renaissance. He further elaborated the teachings of Copernicus, according to which the sun stood at the center of the solar system, by declaring the universe to be infinite. God, he claimed, was another name for the laws that governed the universe. It was for this pantheistic doctrine, according to which God and the universe were one, that Bruno was put on trial in Italy as a heretic. In 1593 he was imprisoned, and in 1600 was burned at the stake in Rome.

Cambio, Arnolfo (ca. 1240/45 Colle Val d'Elsa–1302 Florence). Apprenticed to Nicolò Pisano, he became one of his teacher's greatest successors as a sculptor and architect. Arnolfo worked in both Rome and Florence, and the Renaissance artist and art historian Vasari was generous in his praise of him as an architectural innovator. Documentary evidence of his work

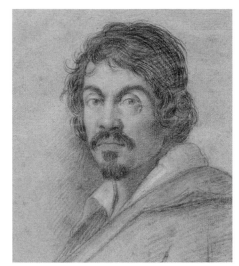

Ottavio Leoni, Portrait of Caravaggio (from life?), Biblioteca Marucelliana, Florence

exists only for the cathedral in Florence and the full extent of his architectural work remains unclear. Arnolfo's significance today is due partly to his signed sculptural work, which is characterized by the use of antique forms and imposing scale.

Canova, Antonio (1757 Possagno/Treviso–1822 Venice). Apprenticed at 11 to the sculptor Giuseppe Torretti, he later studied at the Venetian academy of art. With the profits from his first sales in Venice he financed a trip to Rome, and visited the most recent excavations in the cities around Mount Vesuvius. His encounter with antique sculpture was to leave a lasting mark on his work and inspired him to settle in Rome. In 1783/84 he was awarded a commission to execute several papal tombs; in 1800 he became a member of the Accademia di S. Luca, and in 1802 Pope Pius VII appointed him Superintendent of Antiquities. Canova reclassified the Vatican's antique collections and ordered further

School of Giotto di Bondone, Portrait of Dante, ca. 1320, Museo Nazionale del Bargello, Florence

excavations. He also created numerous copies of sculptures in and around Rome, which had been plundered by Napoleon, an achievement that brought him wide acclaim. In 1814 he succeeded in winning back many of these confiscated art treasures. Antonio Canova is considered the greatest sculptor of the 19th century. His smoothly finished marble figures, strongly influenced by antiquity, are both coolly dignified and sensuous at the same time; today they are considered to represent the undisputed pinnacle of Neo-classicism.

Caravaggio (ill. p. 601) (1571 Milan?–1610 Porto Ercole). Real name Michelangelo Merisi. Caravaggio was apprenticed to Simone Peterzano in Milan from 1584 to 1588 and then worked in the town of Caravaggio near Bergamo. In about 1592 he went to Rome where he worked in several studios and soon found favor at the papal court. In the years around 1604 he was imprisoned several times for brawling and spent the last years of his life on the run from the authorities. His work is marked by the extraordinary realism of his figures, brilliantly defined objects, and a dramatic use of chiaroscuro. Rejected by his contemporaries, Caravaggio had an enormous influence on later artists both north and south of the Alps.

Carracci, Agostino (1557 Bologna–1602 Parma). Older brother of Annibale Carracci, Agostino's major contribution was as a theorist. He trained and later worked mainly in the studio of his cousin, Ludovico Carracci. He was also heavily involved in the Accademia dei Desiderosi (Academy of the Aspiring) in Bologna which broke with late Mannerist tendencies and became the departure point for Baroque painting. After sojourns in Parma and Venice he followed his brother Annibale to Rome in 1597, before finally settling in Parma again in 1600. Apart from his murals and ceiling paintings, Carracci also worked on a number of easel paintings as well as being an accomplished engraver.

Carracci, Annibale (1560 Bologna–1609 Rome). One of a family of artists, Annibale first worked together with his brother Agostino in the studio of their cousin Ludovico Carracci, to whom he was probably apprentice. Around 1585 he helped found the Accademia dei Desiderosi (Academy of the Aspiring) in Bologna and later the Accademia degli Incamminati (Academy of the Progressives) in Rome where he settled in 1594 and where he later painted the galleries of the Palazzo Farnese. Correggio was an important influence on his early work, but later he came under the spell of Raphael. He combined these new impulses with a close study of nature to achieve a clear, harmonious and immediate style of painting that served to idealize beauty. A rival of Caravaggio's, Carracci was Rome's leading painter at a time when art was turning away from Mannerism and

back to the traditions of classical antiquity and the High Renaissance.

Cavallini, Pietro (ca. 1240/50 Rome–ca. 1330/40 Rome). One of the few painters and mosaic artists known by name who practised a typically Roman style in the last quarter of the 13th century; their style was characterized by a combination of classical and Byzantine influences. In contrast with work produced in Tuscany, much Roman art from this period has been lost and Vasari's legend that Cavallini was a pupil of his junior, Giotto, was long accepted as true. It is in fact probable that Giotto was indebted to the older Cavallini.

Charlemagne (ill. p. 607) (A.D. 742–814 Aachen). Considered the founder of a unified Christendom. King of the Franks from 768, he was crowned Holy Roman Emperor by Pope Leo III on Christmas Day 800 in Rome. Between 772 and 800 he subdued the Saxons. Charlemagne was a patron of the arts and sciences (the so-called Carolingian Renaissance), and gathered the most prominent scholars of his day at his court such as the Anglo-Saxon poet and theologian, Alcuin; the Lombard monk, Paulus Diaconus; and the Frankish poet, Einhard, who later wrote Charlemagne's biography.

Christine of Sweden (1626 Stockholm–1689 Rome). Daughter of the Swedish king, Gustav Adolf II, she ruled after his death in 1632 first under a regent, and then independently from 1644. A patron of the arts and sciences, she surrounded herself at court with a circle of scholars that included the philosopher and mathematician René Descartes. She abdicated in 1654 and converted to Catholicism in 1655, living mainly in Rome until her death.

Cicero (Marcus Tullius Cicero. 106 B.C. Arpinum–43 B.C. near Formiae). The greatest Roman orator and rhetorician. His writings still attract interest today and their style is seen as exemplary. Educated in Rome, he entered Roman political life and achieved a prominent position in the Senate. As the self-styled savior of the Roman Republic, he was opposed to the dictator Julius Caesar, whose assassination led to Cicero's own execution after Rome's new masters began to persecute their political opponents.

Cola di Rienzo (1313 Rome–1354 Rome). Politician of the late Middle Ages. He was seen as a leading example of an Italian patriotism through which Rome attempted to regain her importance as a center of the empire and of the Christian faith. In 1347 he sought to introduce a new form of government on the model of classical, adopting elements from both the Roman Republic and Empire. He also planned to federate the Italian cities within the context of Roman citizenship. Supported by the

Domenichino, Self-portrait, 1631, Landesmuseum Darmstadt

populace, which elected him Roman tribune, Cola di Rienzo governed the city for several months before a group of influential nobles expelled him from Rome in the winter of 1347.

Cortona, Pietro da (1596 Cortona–1669 Rome). One of the most prominent architects and painters of the Baroque in Rome. A pupil of the painter Andrea Commodi, he followed his teacher to Rome in 1612 and there continued his training in the studio of Baccio Ciarpi. His combination of Baroque classicism and Venetian color is virtually unique. His major contribution lies in his highly illusionistic ceiling paintings that are magnificent combinations of various artistic effects. Cortona was a favorite of the Sacchetti family but the Barberinis and Pope Urban VIII (pontificate 1623–1644) were also important patrons.

Dante (ill. p. 602) (Dante Alighieri. 1265 Florence–1321 Ravenna). His chief work, *Divina Commedia* (*Divine Comedy*), is the founding work of Italian literature and Dante is universally considered the country's national poet. Born into a noble family, he devoted himself to philosophy and theology and was active in the political life of his native city. In 1301 he was banished for life from Florence by papal decree and he spent his remaining years in Paris, Bologna, and Padua, as well as at the princely courts of Verona and Ravenna. The *Divina Commedia*, which is an allegorical depiction of the path taken by a sinful soul to eternal salvation, had an enormous influence on Renaissance artists such as Signorelli, Michelangelo, and Raphael.

Domenichino (ill. p. 603) (1581 Bologna–1641 Naples). Real name Domenico Zampieri. One of the most important artists to follow in the footsteps of the Carracci. He first served an apprenticeship in the studio of Ludovico Carracci and in 1602 worked with Annibale Carracci in Rome. Influenced by the Carracci brothers as well as by Correggio, Raphael, and Caravaggio, he developed a unique style typified by classical clarity and monumental forms. After Annibale Carracci's death, Domenichino became one of the leading figures in Bolognese landscape painting. He worked in Rome until 1630, except for the years 1617 to 1620, when he was based in Bologna; he then went to Naples, where he worked until his death. His frescoes and panel paintings deal with religious and mythological themes.

Farnese, Alessandro (1468–1549), later Pope Paul III (pontificate 1534–1549). Born into a family of Italian nobles he began the intellectual renewal of the Catholic Counter-Reformation with the Council of Trent (1545–1563) and he led the Church out of its crisis. He was also a leading patron of the arts; he continued the building of St. Peter's, commissioned *The Last Judgment* fresco from Michelangelo for the Sistine

Luca Signorelli, Portrait of Fra Angelico (detail), 1499–1504, Cathedral, Capella di S. Brizio, Orvieto

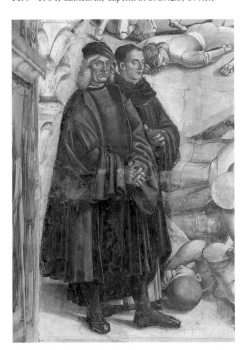

Chapel, and ordered the construction of a series of important buildings in Rome. Alessandro Farnese established the power and wealth of his family, which rose to become one of Italy's greatest dynasties.

Filarete, Antonio (ca. 1400 Florence–ca. 1469 Rome). Real name Antonio di Pietro Averlino, he took up the name Filarete (Friend of Virtue) later in life. From 1433 he worked as a sculptor in Rome. He was called to the court of Duke Sforza in Milan as an architect in 1451. His *Trattato di archittetura* (Treatise on Architecture), the first Italian book on architecture illustrated by the writer's own drawings, was published in 1465 with a dedication to this duke. This work, which proposes an ideal city based on classical models, has survived in several copies and is one of the key works in the theory of Renaissance art and architecture.

Fontana, Carlo (1634 Brusata/Tessin–1714 Rome). Studied architecture under Giovanni Maria Bolino and Pietro da Cortona. In the 1660s he worked continuously on architectural projects with Bernini. The breadth of his activities means he is numbered amongst Rome's leading architects; his influence was widely disseminated by his many pupils. North of the Alps, his style was adopted by Fischer von Erlach.

Fontana, Domenico (1543 Melide/Lake Lugano–1607 Naples). One of the most famous of a group of Roman architects in the late 16th century who made a name for themselves with technical innovations in their planning and direction of large construction projects. He is considered the main exponent of the early Baroque style that was influenced by the work of Michelangelo. His most important creative phase coincided with the papacy of Sixtus V.

Galilei, Alessandro (1691 Florence–1736 Rome). One of the leading Italian architects of the early 18th century. His work represented a reaction against the Baroque and prepared the way for Neo-classicism. He trained at the academy in Florence and then spent five years in London, where he was influenced by the theorist Anthony Ashley Cooper, who called for a return to classical Greek forms. From 1720 he worked in Florence and

Domenico Indono, Portrait of Garibaldi, 1876, Museo del Risorgimento, Rome

Rome where he created the façade of S. Giovanni in Laterano (1732–1735), now considered one of the high points of the Roman late Baroque. Galilei's buildings are particularly impressive for their clear, functional forms.

Garibaldi, Giuseppe (1807 Nice–1882 Caprera). Crucial figure in the unification of Italy, particularly as the leader of a group of irregulars known as the Red Shirts. His military invasion of Sicily and capture of Palermo and Naples in 1860 spelled the end for Austrian rule in Italy. After plebiscites were held in various parts of Italy, Garibaldi resigned the dictatorial powers granted him in favor of King Vittoria Emanuele II, though he remained closely connected to the Risorgimento.

Ghirlandaio, Domenico (1449 Florence–1494 Florence). Real name Domenico di Tommaso Bigordi. One of the leading fresco painters of the early Renaissance in

Jacopino del Conte, Portrait of Ignatius of Loyola, 1556, General Curia of the Society of Jesus, Office of the General, Rome

Florence. After completing an apprenticeship as a goldsmith he was taught by Alesso Baldovinetti. His chief influences were Netherlandish art and the art of classical antiquity, and the works of Andrea del Castagno, Lippi, and Andrea del Verrocchio. Ghirlandaio developed a style which emphasizes sharp contours and which is marked by a strong sense of the three-dimensional. His crowd scenes are masterfully arranged and some of his scenes mark the beginning of genre painting. Michelangelo was trained in Ghirlandaio's studio.

Giotto di Bondone (ca. 1267 Colle di Vespignano near Florence–1337 Florence). One of the defining artists of Western culture, Giotto made a decisive contribution to the development of painting. As a painter and architect,

Giotto was probably acquainted with Cimabue and may have been his pupil. After 1292 he worked in Assisi and then in Rome, Padua, Naples, Milan and Florence where he was appointed cathedral architect in 1334. Giotto rediscovered both the three-dimensionality and monumentality of the human figure, and he invented a new formal and narrative language to depict biblical events that broke with Byzantine traditions. His robed figures are shown acting in landscapes and interior spaces; these sensitive portrayals of human emotions make the depicted events appear utterly lifelike.

Guercino, Il (1591 Cento near Bologna–1666 Bologna). Real name Giovanni Francesco Barbieri. Il Guercino was one of the leading exponents of the Bolognese school, he trained from 1607 with a local painter and traveled in about 1618 to Venice and Florence. From around 1622 he was employed by Pope Gregory XV (pontificate 1621–1623) in Rome, but thereafter withdrew from the world to work in his hometown. In 1642 he succeeded Guido Reni as director of the Academy in Bologna. Il Guercino, "the squint-eyed," was mainly influenced by Ludovico Carracci and Bartolomeo Schedoni. His earlier work was characterized by fresh, dynamic compositions and dramatic chiaroscuro. Later, he worked in cooler colors to achieve an expressive, idealized Neo-classical style.

Hertz, Henriette (1846–1913). German art collector and patron. In 1904 she was given the Palazzo Zuccari in Rome as a present, and she used the building to house her important private library on Roman and Italian art history, the Biblioteca Hertziana, and also for her collection of work by the Italian masters. Her house became a meeting place for scholars and artists. Hertz bequeathed the Palazzo, together with its library, to the Kaiser-Wilhelm-Gesellschaft (today's Max Planck Institute). Her collection of paintings was given to the Italian State.

Holbein, Hans the Younger (ca. 1497 Augsburg–1543 London). One of the greatest German portraitists of his age. He trained under his father and then worked mainly in Basel, where he was received into the Gild of

Painters in 1519, winning numerous commissions. In around 1527 he traveled for the first time to London, where he settled in 1532. From 1536 he worked exclusively on portraits, mainly of nobles at the royal court and of Hanseatic merchants working in London. Holbein's early work was still strongly influenced by the late Gothic but his encounter with Italian art gradually brought about a change to a more lucid and simpler expression. His entire oeuvre is marked by a sense of cool objectivity and precise attention to detail.

Homer Greek poet (ca. 800 B.C.) who probably lived on the Ionian coast of Asia Minor. The great epics *The Iliad* and *The Odyssey*, which are attributed to him mark the beginnings of Western literature. Human emotions are at the center of his works, such as Achilles' pride and boldness in the Trojan War, and Odysseus's courage and homesickness during his ten-year odyssey. Little is known of Homer's life but he is known in legend as "the blind singer."

Julius Caesar (Gaius Julius Caesar. 100 B.C. Rome–44 B.C. Rome). Leading statesman during Rome's transition from a republic to an empire. His skillful political tactics and military successes in the civil war enabled him to become virtual dictator of Rome. The Senate, politically weakened, conspired to have him removed and Julius Caesar fell victim to an assassination plot. It proved too late to reverse his political and social reforms, however, and the principle of dictatorship became firmly established in Rome.

Landini, Taddeo (ca. 1550 Florence–1596 Rome). Sculptor and architect in Rome under Popes Gregory XIII, Sixtus V, and Clement VIII. His chief work, the Fontana delle Tartarughe – named after the stone turtles at its base – was created together with Giacomo della Porta. As an architect he mainly worked on engineering and renovation projects.

Lanfranco, Giovanni (1582 Parma–1647 Rome). A prominent painter of the Roman Baroque during the 1620s, he received his first lessons from Agostino Carracci in Parma. After his teacher's death in 1602, he continued his studies under Annibale Carracci in Rome. Heavily

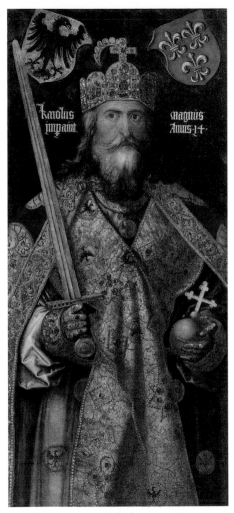

Albrecht Dürer, Portrait of Charlemagne, 1512, Germanisches Nationalmuseum, Nürnberg

influenced by Correggio, he is best known for the illusionism of his wall and ceiling paintings. From 1634 he spent most of his time in Naples working on monumental commissions.

Leochares (active in the 4th century B.C.). Various classical sources praise Leochares for his skill as a sculptor. Several of these descriptions bear a resemblance to copies of statues in Rome, which provide at least an impression of his art. His work seems to have been characterized by slim proportions and dynamism in the overall form. The style of the famous Apollo Belvedere can therefore be associated with Leochares.

Leonardo da Vinci (1452 Vinci near Empoli–1519 Cloux near Amboise, France). One of the great geniuses of Western art. From around 1468 he was engaged as an apprentice in Andrea del Verrocchio's studio, where he continued to work after qualifying in 1477. From 1482/83 until 1499 he was in the service of Duke Ludovico il Moro in Milan. After various sojourns in Mantua, Venice, and Florence he returned to Milan in 1506. In 1513 he went to Rome before traveling to France in 1516 at the request of King Francis I. Leonardo worked as a painter, sculptor, architect, and engineer. In the course of his career he concentrated increasingly on studies of the natural sciences and artistic technique. He was the first to embody the Renaissance ideal of the universally educated man (*uomo universale*) who could work in a variety of disciplines. His masterful compositions and innovative treatment of color meant that he had a great influence on succeeding generations of painters.

Ligorio, Pirro (ca. 1510 Naples–1583 Ferrara). Architect, painter and archaeologist. He arrived in Rome in 1534 and in 1549 entered the service of Cardinal Ippolito d'Este of Ferrara, who commissioned him with planning a villa in Tivoli. At the same time he worked for Pope Paul IV (pontificate 1555–1559), and later his successor, Pius IV (pontificate 1559–1565). In 1568 he was called by Duke Alfonso II d'Este to Ferrara. Ligorio's work had a profound effect on the design of Renaissance gardens. He published his archaeological reconstructions of antique Rome in his book *Libri dell'antichità di Roma*.

Lippi, Filippino (ca. 1457 Prato–1504 Florence). Son and pupil of Fra Filippo Lippi. After the death of his father, he completed his training with Sandro Botticelli in Florence. The chief influences on Lippi's early work were his teacher, as well as the Netherlands artist Rogier van der Weyden, who was widely known south of the Alps. Along with Botticelli, Filippino Lippi is the greatest Florentine painter during the transition from the Early to the High Renaissance. His legacy includes large altarpieces, as well as allegories and portraits, and he established a considerable reputation as a fresco painter: from 1489–92 he decorated the Cappella Caraffa in S. Maria sopra Minerva in Rome. Numerous autograph drawings by Lippi have survived.

Loyola, Ignatius of (ill. p. 606) (1491 Loyola–1556 Rome). Founder of the Jesuit Order and a leading figure in reforming the Catholic Church. He underwent a profound spiritual experience while recovering from wounds received in the French and Habsburg battle for Pamplona in 1520. He later lived as a hermit in Catalonia, where he received the divine inspiration described in his book *Spiritual Exercises*. Studied theology in Alcalá, Salamanca, and Paris. In 1540 his Society of Jesus (the Jesuits) was recognized by Pope Paul III. The order was later charged with leading the Counter-Reformation.

Lysippus (ca. 370–300 B.C.). Greek sculptor at the court of Alexander the Great. Although he probably produced a large number of pieces, none of his original sculptures have survived. Literary descriptions of his work and his style, however, can be associated with a number of copies in Rome, and these convey at least an impression of his art.

Maderno, Carlo (1555/56 Capolago/Lake Lugano–1629 Rome). One of Rome's most prominent architects during the first third of the 17th century. From 1576 he worked with his uncle Domenico Fontana on papal commissions and in 1594 Maderno took over the family business. From 1603 he was made supervisor of the building work on St. Peter's, which included responsibility for the building of the nave. His personal contribution is often

difficult to determine as he often worked together with other architects; he was also frequently involved only at the inception or completion of projects.

Maderno, Stefano (ca. 1576 Bissone near Lugano–1636 Rome). Lombard sculptor and restorer who worked in Rome; he is reputed to have been a brother of Carlo Maderno. Amongst his numerous figures of saints – which were later influenced by Bernini – the most prominent are his sculptures in St. Cecilia (1599) and in the Cappella Paolina in S. Maria Maggiore (1608) in Rome. There is evidence of Stefano Maderno having worked on the Vatican and the Quirinale between 1615 and 1622.

Marcus Antonius (Mark Antony, 82–30 B.C.). Roman statesman. Fought on Caesar's side in the civil war against Pompey (49 B.C.) and allied himself with Octavian in their battles with Caesar's assassins. He participated in the formation of the second triumvirate with Octavian and Lepidus (43 B.C.) and married the Egyptian queen Cleopatra (36 B.C.). Rivalry within the triumvirate finally led to the naval battle of Actium (31 B.C.), in which his forces were defeated by Octavian. When Octavian landed in Egypt the following year, both Mark Antony and Cleopatra committed suicide.

Michelangelo Buonarroti (1475 Caprese, Tuscany–1564 Rome). Real name Michelangiolo di Ludovio di Lionardo di Buonarroti Simoni. One of the defining figures in Western art history. He received his training under Ghirlandaio and, around 1490, from the sculptor Bertoldo di Giovanni. His greatest influences at this time included Giotto, Masaccio, and the sculptor Donatello. Michelangelo was inspired to study antique sculpture and humanist philosophy by the artists around his patron, Lorenzo de'Medici. During a sojourn in Rome from 1496 to 1501 he devoted himself to sculpture, painting his first pictures after his return to Florence. In 1505 he was called to the papal court in Rome where he worked until 1520, and again from 1534. His main project while in Rome was the painting of the Sistine Chapel; in 1535 he was appointed the pope's chief architect, sculptor, and painter. Breaking free from the traditional view of man, Michelangelo's painting developed new possibilities of expression and his figures featured a

Daniele da Volterra, Bust of Michelangelo, ca. 1565, Museo Nazionale del Bargello, Florence

psychological intensity and physical three–dimensionality unknown until that time.

Mussolini, Benito (1883 Predappio–1945 Giulino de Mezzegra). Founded and led a political movement which became known as the Fascists for their use of the ancient Roman symbol of a bundle of rods (Latin *fascis*). After the March on Rome in 1922, a dramatic show of power, he was able to gain supreme power in Italy. The totalitarian dictatorship of the Il Duce (the leader) initially notched up domestic and foreign policy successes but Italy's entry into the war in 1940 as an ally of Hitler meant that the regime came under increasing pressure. Mussolini fled under the protection of Hitler to a rump state on the shores of Lake Como, where he was later captured and executed by partisans.

Myron of Eleutherai (active ca. 470–440 B.C.). Worked mainly as a sculptor in Athens and, along with Phidias

*Pietro Perugino, Self-portrait, ca. 1500, Uffizi,
Florence*

and Polyclitus, is praised in classical sources for his skill. His dynamic compositions occupy a special place in Classical sculpture most of which feature figures at rest. Myron had no direct successors and it was not until the advent of Hellenism that his influence began to be felt. His best known work is the celebrated *Discus Thrower*, which exists in a number of copies.

Nervi, Pier Luigi (1891 Sondrio–1979 Rome). Internationally renowned Italian architect and engineer. A leading figure in modern architecture, along with Le Corbusier and Mies van der Rohe. Studied and worked in Bologna before founding a partnership in Rome with Nebbiosi (1923–1932) and later Bartolia, before working with his three sons under his own name from 1960. His main architectural achievement was his combination of functional elements with abstract sculptural forms. In the early 1940s he invented *ferro-cimento*, a fine ferrous cement mixture which, because of its lightness and stability, was suitable for his building methods.

Ovid (Publius Ovidius Naso 43 B.C.–A.D. 17). Roman Poet. Ovid's early works were devoted to the art of love (*Amores, Epistulae Heroidum, Ars amatoria*), but he later turned his attention to narrative poetry. In the fifteen books of his *Metamorphoses* he retold Hellenistic and Roman myths, from the origin of the universe to the death of Julius Caesar. Since the Renaissance they have served as a popular source of mythological narrative and imagery. The Emperor Augustus banned Ovid's works from libraries and banished the poet to the Black Sea. Since the 12th century Ovid, along with Virgil, has been acknowledged as the greatest Roman poet.

Perugino, Pietro (ca. 1448 Città della Pieve near Perugia –1523 Fontignano). Real name Pietro di Cristoforo Vannucci. A chief exponent of the Umbrian school, Perugino helped to pave the way for the High Renaissance. He was probably trained in Perugia and was a member of the Gild of Painters in Florence from 1472, where he may have been a pupil of Andrea del Verrocchio and Piero della Francesca. Influenced by these artists, Perugino experimented with new methods in the depiction of space and form as well as in balancing the surface of a picture with its depth. In so doing he achieved lucid, harmonious and self-sufficient compositions with a soft, unified coloring. Perugino was active in Umbria, Venice, and in Tuscany; he worked on several occasions for the Vatican between 1478 and 1492, and thereafter was mainly employed in Florence. Raphael was trained in his studio.

Piero di Cosimo (1462 Florence–1521 Florence). Real name Piero di Lorenzo. He was apprenticed in Florence to Cosimo Rosselli, whose first name he adopted. In 1481–82 he worked with Rossellini on the frescoes in the Sistine Chapel in Rome but most of his subsequent creative work was carried out in Florence. His style echoes that of Filippino Lippi, Domenico Ghirlandaio, the early

work of Leonardo da Vinci, and Hugo van der Goes. He combined these diverse influences into a set of lyrical and dramatic elements that often have a grotesque and fantastic effect.

Pinturicchio (ca. 1454 Perugia–1513 Siena). Real name Bernadino di Betto Biagio, Pinturicchio was probably trained in the studio of Fiorenzo di Lorenzo. He was also strongly influenced by Perugino, whom he helped paint the Sistine Chapel from 1481–1483. Apart from Perugia and Rome, Pinturicchio also worked in Orvieto, Spoleto, Spello, and Siena, where he lived from 1502. He was mainly a painter of frescoes but his legacy also includes religious history paintings and portraits. In his day he was one of the most sought after painters for decorating palaces. He cultivated a graceful, often genre-like narrative style with a decorative effect that was generally free of dynamic or dramatic elements. His coloring is intensely luminous. Pinturicchio was one of the first painters in the Italian Renaissance to introduce the grotesque ornamentation of classical antiquity into his work.

Piombo, Sebastiano del (ca. 1485 Venice–1547 Rome). Real name Sebastian Luciani, known as Viniziano. Apprenticed at first to Giovanni Bellini and later to Giorgione in Venice, whose painting exercised a decisive influence on him. In 1511 he went to Rome where he decorated the Villa Farnese with frescoes. Apart from a year spent in Venice in 1528–1529, Sebastiano remained in Rome until the end of his life. It was there in 1531 that he was given the honorable title of Protector of the Seal at the Curia – the *officio del Piombo*– which is the origin of his name. Sebastiano del Piombo mainly executed large altar panels for Roman churches, but he was also employed as a portrait painter. Raphael and Michelangelo were the most important influences on his work, which is marked by monumentality and a vigorous formal language.

Piranesi, Giovanni Battista (1720 Mogliano/Mestre–1778 Rome). The greatest innovations of Piranesi were in the field of copperplate engraving but he also worked as an architect, archaeologist, and art theorist. In 1740 he went to Rome, where he learned his trade as an

Sarcophagus of Plotinus (detail), ca. 270, Vatican Museum, Museo Gregoriano Profano, Rome

engraver. Piranesi's large-scale *vedutà* (views) depict Rome with its ancient and Baroque monuments, though they are combined in a fantastic rather than realistic way. These so-called capriccios are accompanied by notes and archaeological observations. His knowledge of antiquity was displayed in his four volume work *Le antichità Romane*, published in 1756, which propagated the notion of the superiority of Roman over Greek architecture. Of Piranesi's architectural designs only one, the Roman church of S. Maria del Priorato, was completed.

Plato (427–347 B.C.). A pupil of Socrates, the Greek philosopher Plato spent 12 years abroad after his teacher's death (including a period with the mathematician Euclid) before founding the most famous philosophical school in antiquity, the Academy, in Athens in 387. His work was recorded in the form of written dialogue. The focus of his thought is the distinction between the changeable material world accessible to our senses and the unchanging original ideas, or "forms," of things. Plato's doctrine of the ideal state (*politeia*) forms the basis of the numerous political and philosophical utopias in Western thought.

Plotinus (ca. 205 Lyconpolis?–270 near Minturae). Founder of the philosophical school of Neo-Platonism. Educated in Alexandria, he settled in Rome, where he became the first teacher of Platonic philosophy,

becoming particularly popular in the circles of the nobility. The works of Plotinus were enormously influential on the early Church Fathers and their effects can still be detected in the German Idealism of the 18th century.

Pompey (Gnaeus Pompeius Magnus, 106–48 B.C.). Roman general. He had his first military successes as a 17 year old at the side of his father Gnaeus Pompeius Strabo, and he later followed this up with victories over Gaius Marius in Africa and Sicily (84 B.C.); the quelling of the slave rebellion (70 B.C.); as well as a victory over the Mediterranean pirates (67 B.C.). He contributed to the expansion of the Roman Empire with victories over Mithridates in Asia Minor (66 B.C.); the defeat of the Armenian king, Tigranes; and the conquest of Syria (64 B.C.). Together with Julius Caesar and Crassus, Pompey formed the first triumvirate (60 B.C.) but was politically and militarily defeated by Julius Caesar at the Battle of Pharsalos (48 B.C.) and he was murdered on September 28, 48 B.C. while fleeing to Egypt.

Porta, Giacomo della (1532 Porlezza–1602 Rome). One of the most prominent Roman architects of the last quarter of the 16th century. He was responsible for completing several large projects begun by others. After the deaths of Michelangelo and Vignola, he was awarded a number of important commissions and also worked on the new St. Peter's, where he completed Michelangelo's dome.

Porta, Giovanni Giacomo della (ca. 1485 Porlezza–1555 Genoa). Sculptor and architect whose work is documented in Genoa from 1513, but who was also active in Milan. There is evidence that he worked together with his son Guglielmo, whom Vasari confused with Giovanni's nephew Guglielmo del Piombo.

Pozzo, Andrea (1642 Trento–1709 Vienna). He entered a Jesuit novitiate in Milan as a lay brother in 1665, and from 1676–1678 he decorated the Jesuit church of S. Francesco in Mondovi. On the recommendation of Carlo Marattas, he was called to Rome by the Jesuit general Padre Oliva at the end of 1681. There he began work on painting the monumental ceiling of the Jesuit church of S. Ignazio at the start of the 1690s. From 1703 the artist

Andrea Pozzo, Self-portrait, after 1685, Uffizi, Florence

worked in Vienna, where he painted the vault of the university church; he also executed the ceiling frescoes in the Liechtenstein Palace that feature the deeds of Hercules. Pozzo worked as a painter, architect and art theorist. His treatise *Prospettiva de pittori e architetti* appeared in 1693 in Rome.

Rainaldi, Carlo (1611 Rome–1691 Rome). Worked as an architect on several large projects in Rome. He was trained by his father, Girolamo, who worked in northern Italy. He often collaborated with other architects, and frequently only began or completed a particular project; this means that there are few structures which allow Rainaldi's own style to be seen as a unified whole.

Raphael (1483 Urbino–1520 Rome). Real name, Raffaello Santi. Received his first artistic training from his father, the painter and poet Giovanni Santi. Around 1500 he entered the studio of Pietro Perugino in Perugia. In 1504 he went to Florence, where he studied contemporary as well as older painting. In 1508 Raphael was called to

Rome by Pope Julius II. From 1509 he worked on frescoes for the *stanza* (main rooms) in the Vatican. In 1514, after the death of Bramante, he was appointed architect at St. Peter's. In 1515 he was awarded the office of Conservator of Roman Antiquities. Raphael is considered one of the greatest painters of the High Renaissance. His altar panels, Madonnas, and portraits as well as his large, thematically complex murals are characterized by formal clarity and a profound but natural expressiveness. His work had a great influence on succeeding generations of artists.

Reni, Guido (1575 Calvenzano near Bologna–1642 Bologna). Received his artistic training from the Dutch painter Denis Calvaert in Bologna in the years around 1584; both teacher and pupil later worked together in a studio cooperative. Around 1595 Reni joined the Academy of the Carracci in Bologna, and from 1600 onwards he lived mainly in Rome. From 1614 onwards he is recorded as being permanently in Bologna, where he remained – with the exception of brief periods in Ravenna (1620), Naples (1622), and Rome (1627) – until the end of his life. After the death of Annibale Carracci in 1609, Guido Reni became the undisputed master of the Bolognese Baroque. He painted frescoes, altar panels, mythological history pictures as well as portraits.

Ricci, Sebastiano (1659 Belluno–1734 Venice). As a youth Ricci went to Venice, where he trained with Sebastiano Mazzoni and Federico Cervelli. From the late 1670s he worked with Giovanni Giuseppe dal Sole in Bologna. Enjoying the patronage of Duke Ranuccio II Farnese, Ricci was awarded numerous commissions in Piacenza and also in Rome, where he spent several years. In 1694 he moved to Florence, and in 1696–1698 he worked in Milan where he probably met his fellow painter, Magnasco. Ricci was then mainly employed in Venice, though he also spent long periods in Vienna (1701–1703), Florence (1706–1707), and London (1712–1716). The work of this leading Venetian Rococo painter is marked by its animated, decoratively illusionist forms and bright palette.

Romano, Giulio (ca. 1499 Rome–1546 Mantua). Real name Giulio Pippi. Apprenticed to Raphael, he became his teacher's greatest pupil and preferred assistant. Until 1524 the young artist, whose influences also included Bramante and Michelangelo, was active in Rome, where one of his chief tasks was to administer Raphael's legacy. He made an important contribution to the completion of the Sala di Constantino in the Vatican Palace, and afterwards became court painter and architect to the Gonzagas in Mantua, where he built and decorated a country house, the Palazzo del Tè, for Duke Federigo Gonzaga between 1525–1535. This was Romano's major work, in which he used his Roman experiences – both in painting and architecture – to develop

Raphael, Self-portrait, ca. 1506, Uffizi, Florence

his own style whose vigorous expressiveness went beyond even Michelangelo's, and in which he made a crucial contribution to development of Mannerism. Giulio Romano was also prominent in popularizing Raphael's Roman style throughout northern Italy.

Rubens, Peter Paul (1577 Siegen–1640 Antwerp). Trained in Antwerp under the painters Tobias Verhaecht, Adam van Noort, and Otto van Veen. In 1598 he was accepted into the Gild of St Luke in his native city. Between 1600–1608 he was in Italy where he became court painter to Vicenzo Gonzaga II, the duke of Mantua, and he traveled to Genoa, Venice, Florence, and Rome. He settled in Antwerp in 1608, remaining in the city despite becoming court painter to the Archduke Albrecht and Isabella in Brussels. From 1628–1630 he traveled in the diplomatic service to the courts of England and Spain. Rubens was the most distinguished Flemish painter of the Baroque era. His large oeuvre includes religious and mythological history paintings, monumental cycles for ceiling frescoes and murals, portraits, and landscapes. This work is complemented by a large number of oil sketches and drawings.

Sallust (Gaius Sallustius Crispus, 86–35 B.C.). Roman historian and chronicler of the late Roman Republic. He published histories of the Jugurthine War (*Bellum Iugurthinum*), the Catiline conspiracy (*De Catalinae Coniuratione*), as well as his chief work, the *Historiae*, a history of the years 78 to 67 B.C. Sallust's writings analyzed the origins of political events, though his own view of man and history was consistently pessimistic; he regarded the corruption of the nobility as the reason for the decline of the Roman Republic.

Salvi, Nicola (1697 Rome–1751 Rome). Architect who made a name for himself with a number of individual works such as the Fontana di Trevi in Rome. Trained as a craftsman under Antonio Canevari. Salvi's work is characterized by his knowledge of Baroque and Renaissance buildings, as well as his close study of Vitruvius' treatise *De architectura* (On Architecture).

Salviati (1510 Florence–1563 Rome). Real name Francesco de'Rossi. Trained in Florence with G. Bugiardini, Bandinelli and later, in 1529, with Andrea del Sarto. From 1531 he worked in Rome for Cardinal Salviati, whose name he adopted. After a period in Florence from 1544–1548 he returned to Rome where he remained – with the exception of a year spent in France from 1554–1555 – until the end of his life. Salviati is one of the most eminent representatives of Florentine and Roman Mannerism. His diverse output includes frescoes, altar panels, and portraits, as well as designs for tapestries and stage decorations.

Sansovino, Andrea (ca. 1460 Monte Sansovino–1529 Monte Sansovino). As a sculptor and architect, Sansovino was a prominent exponent of Florentine art in the late 15th century, even though he generally worked outside that city. Trained in Florence, he was accepted into the gild of the *maestri di pietra*, the stonemasons, in 1491. In the same year he was sent by Lorenzo de'Medici, at the request of King John II, to Portugal, where he remained with occasional interruptions until 1500. From 1505 to 1513 Pope Julius II employed him in Rome. In his later years he worked in Loreto, Rome, and Sansovino.

Sappho (ca. 600 B.C., Mytilene/Lesbos). Greek poet and leading female poet of antiquity, she was head of a circle of women and girls in Mytilene. When the aristocrats were banished from that city, she was temporarily exiled to Sicily. She wrote love and marriage poems for the young women in her charge, as well as hymns to the gods in a unique verse form (the Sapphic ode, a four-line poem with its own metrical pattern).

Seneca (Lucius Annaeus Seneca. 4 B.C. Córdoba–A.D. 65 near Rome). One of the greatest Roman philosophers and tragedians. At an early age Seneca went to Rome, where he received an education in rhetoric and philosophy. He pursued a political career and was responsible for the education of Nero, who later became emperor (54–68). After Nero's accession to power he became co-administrator of the Empire, which achieved a brief flowering under his direction. After falling into disfavor he took his own life in A.D. 65, on the orders of Nero.

Bust of Seneca, ca. 50/60, Rubens House, Antwerp

Socrates (469–399 B.C., Athens). Considered the founder of Classical philosophy: all previous philosophers such as Thales and Pythagoras became known as the pre-Socratics. His famous saying "I know that I know nothing" marked a turning away from the Sophists, who declared man the measure of all things. For Socrates, knowledge and a virtuous life were one and the same thing: knowledge of what is good and right leads man to behave accordingly. His teachings, which he never wrote down himself, are known from the work of his pupil Plato.

Sodoma (ca. 1477 Vercelli–1549 Siena). Real name Giovanni Antonio Bazzi. Born in a small town in Piedmont, he was apprenticed to the local painter Giovanni Martino Spanzotti between 1490 and 1497. In 1500 the Spanocchi banking dynasty used their influence to send the young artist to Siena. In 1508 Sodoma was called to Rome to paint the Stanza della Segnatura in the Vatican, but he was unable to progress beyond the work's early stages. He had a second sojourn in Rome in 1512, when he designed the famous Alexander fresco in the Villa Farnese for Agostino Chigi. After 1515 he was chiefly active in Siena, though in his later years he also worked in Volterra (1539–1540), Pisa (1540–1543), Lucca (1545), and Piombino.

Suetonius (Gaius Suetonius Tranquillus, ca. A.D. 69–140). Biographer who enjoyed the support of the writer Pliny the Younger. Under Hadrian he was the director of the imperial Roman libraries and archives, as well as adviser to the emperor in cultural matters. His biographical collection *De viris illustribus* (Lives of Famous Men) has done much to influence today's perception of Rome's most distinguished poets and thinkers. *De vita Caesarium* (Lives of the Ceasars) describes the life and work of the Roman emperors from Caesar to Domitian.

Tacitus (Publius Cornelius Tacitus, A.D. 55/56 Patavium? –ca. 118 probably in the Province of Asia). Last of the great Roman historians. As well as several minor literary works, he wrote *Historiae* and *Annales*, which describe the political and moral decay of the Roman Empire under the monarchy. His systematic methods greatly influenced succeeding generations of historians.

Thorvaldsen, Bertel (1768/70 Copenhagen–1844 Copenhagen). Danish sculptor who worked mainly in Rome. After studying at the Academy in Copenhagen, he went to Rome on a scholarship to study antiquities and remained in the city. His rapid success enabled him to work with a large studio and complete commissions from throughout Europe. The leading exponent of a complete Neo-classical style, he made numerous portraits in addition to working on subjects from classical antiquity. In contrast to the work of Canova, which was strongly inspired by Hellenism, Thorvaldsen's sculptures convey an impression of calm and tranquility.

Titian (1488/1490 Pieve di Cadore–1576 Venice). Real name Tiziano Vecellio. The most celebrated Venetian painter of the Cinquecento. The date of his birth is uncertain, and little is known of his early years; it is thought that his teachers may have been the Venetian mosaic artists Sebastiano Zuccato as well as Giovanni and

Gentile Bellini. In 1508–1509, together with Giorgione, Titian executed the frescoes of the Fondaco dei Tedeschi in Venice and in 1510–1511 there followed the frescoes in the Scuola del Santo in Padua. From 1515 he worked for a number of employers including the powerful Este, Gonzaga, Farnese, and Rovere families, as well as King Francis I of France. In 1533 he was appointed court painter to Emperor Charles V and received the Order of the Golden Fleece. He was employed by Pope Paul III in 1545–1546. In his later years, Titian worked almost exclusively at the Spanish court in the service of King Philip II.

Vasari, Giorgio (1511 Arezzo–1574 Florence). Painter, architect, and art historian. He began his broad humanist education with the glass painter Guillaume de Marcillat in Arezzo and continued his apprenticeship from 1524 in Florence with Andrea del Sarto and Baccio Bandinelli, among others. In 1531/1532 Cardinal Ippolito de'Medici called him to Rome, where he was based for the next several years and where he studied the works of Raphael, Peruzzi, and above all Michelangelo, with whom he formed a close bond. In 1546 Vasari painted a cycle of frescoes for Alessandro Farnese in the Palazzo della Cancelleria featuring the deeds of Pope Paul III. After several fruitless attempts to win commissions from the newly elected Pope Julius III (pontificate 1550–1555), he returned to Florence for good. On his many travels Vasari studied Italian art from antiquity to his own time and he owes his extraordinary fame mainly to his *Vite de'piu eccellenti pittore, scultore e architetti* (Lives of the most Excellent Painters, Sculptors, and Architects) which first appeared in 1550, and was followed by a revised second edition in 1568: it is considered to be the leading reference work on Italian art history.

Velázquez, Diego Rodríguez de Silva y (1599 Seville–1660 Madrid). Trained with Francisco Herrera the Elder and later, from 1613–1617, with Francisco Pacheco in Seville. In 1622 and 1623 he undertook his first journeys to Madrid in the company of Pacheco, and on the second occasion succeeded in attracting the attention of King Philip IV, who appointed him court painter. In 1627 his meteoric rise at court began, which finally reached its peak in 1652, when he was made Chamberlain of the Royal Palace. In 1628 Velázquez met Peter Paul Rubens in Madrid. From 1629–1631 and again from 1649–1651 he traveled to Italy where he purchased Renaissance and classical art for the Spanish royal house. It was in Rome in 1650 that Velázquez became a member of the Accademia di San Luca. In 1658 he was made a Knight of the Order of St. James on the recommendation of the Spanish king. Velázquez worked in all genres of painting and is considered the leading Spanish painter of the 17th century.

Virgil (Publius Vergilius Maro, 70–19 B.C.). Roman poet who enjoyed the patronage of Emperor Augustus.

Giorgio Vasari, Self-portrait (not dated), Uffizi, Florence

Virgil's chief works include the four books of the *Georgica*, a didactic poem on agriculture, wine and fruit growing as well as cattle breeding and bee-keeping; and the ten pastoral idylls of the *Bucolica*. His national epic, *Aeneid*, which he was encouraged to write by Augustus, relates the prehistory of Rome in a series of twelve books. Virgil's epic style is indebted to Homer. His work idealizes rural life and constructs an ancient, heroic origin for the Roman people.

Verschaffelt, Peter Anton von (1710 Ghent–1793 Mannheim). Known as Pietro il Fiammingo in Italy, where he worked as a sculptor and architect. Received his first training in Ghent and afterwards worked in Paris in order to continue his education at the Royal Academy. In 1737 he went to Rome where he received a number of prominent commissions, and in 1752 he was called to Mannheim by the Elector Theodor von der Pfalz to work as court sculptor.

Vignola, Giacomo (1507 Vignola/Modena–1573 Rome) One of the most famous Roman architects from the mid-16th century. He began his career in Bologna but in 1549 moved permanently to Rome, where he soon entered papal service. At the same time he worked on important commissions for the Farnese family. His chief work is the Jesuit church of Il Gesù, which set the pattern for Baroque church architecture in Rome. As a theorist, Vignola made a name for himself with his illustrated treatise of 1562, *Regola delli cinque ordini d'architettura* (The Five Order of Architecture), which was read throughout Europe.

Vitruvius (active 1st century B.C.). Roman architect and theorist. Vitruvius has had an enormous influence as a result of his ten volume work *De architectura* (On Architecture), which is the only treatise on architecture to have survived from antiquity; the oldest copies of which date from the Carolingian era. It was not until its rediscovery in the Renaissance that the text became regarded as once again relevant because it provided architects with a valuable source of classical forms and techniques. Vitruvius' text also forms the basis for Alberti's *De re aedificatoria libri decem* (Ten Books on Architecture) of 1452.

Vittorio Emanuele II (1820 Turin–1878 Rome). The first King of Italy elected by the Italian parliament (reigned 1861–1878). Son of King Charles Albert of Piedmont and Sardinia, he was crowned by the newly constituted parliament after the victories won by Garibaldi's troops in 1861. He ruled with strict adherence to the new constitution. During his reign Italy was unified and Rome became the country's new capital in 1870.

Winckelmann, Johann Joachim (1717 Stendal–1768 Trieste). Considered to be the founder of modern archaeology and art history. In his essay *Thoughts on the Imitation of Greek Works in the Art of Painting and Sculpture* (1755) he postulated a return to classical antiquity and provided a manifesto for the emerging Neo-classical movement in Germany. Winkelmann praised the "noble simplicity" and "tranquil grandeur" of classical art as an expression of a lost age. His *History of the Art of Antiquity* (1764–1768) is characterized by a virtually unique developmental history of antique art. Instead of concentrating on individual artists Winckelmann wrote a stylistic history that took into account the social and cultural conditions under which art was produced.

Zuccari, Federico (1540–42 Sant'Angelo in Vado–1609 Ancona). Late Mannerist painter. In 1555 he went to Rome where he first worked under the supervision of his brother Taddeo, and was employed on various papal commissions. From 1564 his work took him to a number of other locations: he was employed in several Italian cities as well as in the Netherlands, Spain and England. His *Idea de'pittori, scultori ed architetti* (The Idea of Painters, Sculptors, and Architects) of 1608 marked him out as one of Mannerism's leading theorists.

Zuccari, Taddeo (1529 Sant'Angelo in Vado–1566 Rome). Trained initially under his father Ottaviano, before continuing with his education in Rome. He was greatly impressed by the work of the High Renaissance, and his work clearly shows that he was influenced by Michelangelo. His success is evident by the commissions that he completed in the service of the pope as well as for the Farnese family.

Further Reading

Andreae, Bernard: *The Art of Rome*, H. N. Abrams, New York 1978

Balsdon, J. P. V. D.: *Life and Leisure in Ancient Rome*, Bodley Head, New York 1969

Brendel, Otto: *Prologomena to the study of Roman Art*, Yale University Press, New Haven,1979

Böethius, Axel: *The Golden House of Nero: Some Aspects of Roman Architecture*, University of Michigen Press, Ann Arbor 1960

Bowen, Elizabeth: *A Time in Rome*, Penguin 1989

Brentano, R.: *Rome Before Avignon*, Basic Books, New York 1974

Claridge, Amanda: *Rome: An Oxford Archaeological Guide* Oxford Archaeological Guides, Oxford University Press, Oxford1998

Cellini, Benvenuto: *The Autobiography of Benvenuto Cellini* (tr. George Bull), Penguin Harmondsworth 1956

Chastel, A.: *The Sack of Rome, 1527*, Princeton University Press, Princeton 1983

Coarelli, Filippo: Rome: *Monuments of Civilization*, Cassell, London 1973

Coffin, D.R.: *The Villa in the Life of Renaissance Rome*, Princeton University Press, Princeton 1979

D'Ambra, Eve: *Art and Identity in the Roman World*, Weidenfeld and Nicolson, London 1998

D'Amico, J.F.: *Renaissance Humanism in Papal Rome*, John Hopkins University Press, Baltimore/London 1983

David, Penelope; *Death and the Emperor: Roman Funerary Monuments, from Augustus to Marcus Aurelius*, CUP, Cambridge 2000

Delaine, Janet: The Baths of Caracalla, A study in the design, construction, and economics of large-scale building projects in Imperial Rome, *Journal of Roman Archaeology*, Portsmouth, Rhode Island 1996

Dudley, D.R.: *Urbs Roma: A Sourcebook of Classical Texts on the City and its Monuments*, Phaidon, London 1967

Elsner, J.R.: *Imperial Rome and Christian Triumph: The Art of the Roman Empire AD 100–450*, Oxford University Press, Oxford 1998

Freedberg, S.J.: *Painting in Italy 1500–1600*, Yale University Press, New Haven 1993

Garrett, Fagan: *Bathing in Public in the Roman World*, University of Michigan, 1999

Gazda, Elaine: *Roman art in the private sphere: new perspectives on the architecture and decor of the domus, villa and insula*, University of Michigan Press, 1991

Geller, Ruth: *Jewish Rome: A Pictorial History of 2000 Years*, Rome 1983

Gibbon, Edward: *The History of the Rise and Fall of the Roman Empire*, Penguin, Harmondsworth 1985

Gombrich, Ernst: *The Story of Art*, Phaidon Press, London 1995

Graves, Robert: *I, Claudius: From the Autobiography of Tiberius Claudius*, Barker, New York 1934

Hebblethwaite, Peter: *In the Vatican*, Sidgwick and Jackson, London 1986

Henig, Martin: *A Handbook of Roman Art*, Oxford, Phaidon Press, 1983

Heintze, Helga von: *Roman Art*, Herbert, London 1990

Hibbard, H.: *Michelangelo*, Harper and Ron, New York 1974

Hibbert, Christopher: *Rome, the Biography of a City*, Viking, London 1985

Hopkins, Keith: *A world full of Gods: Romans, Jews and early Christians in the Roman Empire*, Weidenfeld and Nicolson, London 1999

James, Henry: *Italian Hours*, Barrie and Jenkins, New York 1989

Jardine, Lisa: *Worldly Goods: A New History of the Renaissance*, Papermac, London 1996

Jones, R. and N. Penny: *Raphael*, Yale University Press, New Haven/London 1983

Kahn, Robert: *City Secrets Rome*, Rome, Little Bookworm, 2000

Krautheimer, Richard: *Rome, Profile of a City, 312–1308*, Princeton University Press, Princeton 1980

Llewellyn, P.I.: *Rome in the Dark Ages*, Faber, London 1971

Luff, S. G. A.: *The Christian's Guide to Rome*, London: Burns and Oates, New York 1967

MacDonald, W.L.: *The Architecture of the Roman Empire: An Introductory Study*, Yale University Press, New Haven/London 1965

Mack Smith, Denis: *Mussolini*, Weidenfeld and Nicolson, London 1981

Mariano, Laura (ed.): *The Museums of Rome*, Rome 1987

Masson, Georgina: *The Companion Guide to Rome* (Companion Guides), University of Rochester Press, Woodbridge 1998

McKay, A.G.: *Houses, Villas and Palaces in The Roman World*, Johns Hopkins University Press, Baltimore, 1998

McNally, Sheila: *The Architectural Ornament of Diocletian's Palace at Split*, Tempus Reparatum, Oxford, 1996

Mitchell, B.: *Rome in the High Renaissance: The Age of Leo X*, University of Oklahoma Press, Norman, 1973

Morton, H.V.: *A Traveller in Rome*, Methuen, London/New York 1957

Nash, E.: *Pictorial Dictionary of Ancient Rome*, Thames and Hudson, New York 1968

O'Grady, Desmond: *Rome Reshaped: Jubilees 1300–2000*, Harper Collins, New York 1999

Paoli, Ugo Enrico: *Rome: Its People, Life and Customs*, Longmans, New York 1964

Partridge, Loren: *The Renaissance in Rome*, Weidenfeld and Nicolson, London 1996

Pietrangeli, C. and others: *The Sistine Chapel: The Art, the History, and the Restoration*, Muller, Blond and White, New York 1986

Pomeroy, Sarah B.: *Goddesses, Whores, Wives, and Slaves: Women in Classical Antiquity*, Schocken Books, New York 1975

Ramage, Nancy H. and Andrew Ramage: *Roman Art: from Romulus to Constantine*, Noyes Press, New York 1991

Sear, Frank: *Roman Architecture*, Batsford Academic and Educational, London 1982

Sharp, Mary: *A Traveller's Guide to the Churches of Rome*, Evelyn, London 1967

Staccioli, R.A.: *Ancient Rome, Monuments Past and Present*, Getty Trust Publication, 2000

Stendhal: *A Roman Journal* (tr.), Orion Press, London 1989

Stinger, C.L.: *The Renaissance in Rome*, Indiana University Press, Bloomington 1985

Strong, Donald: *Roman Art*, Yale University Press, Harmondsworth 1981

Suetonius: *The Twelve Caesars: An Illustrated Edition*, Penguin, Harmondsworth 1993

Tames, Richard: *Garibaldi and the Risorgimento*, Jackdaw Publications, London 1970

Thorpe, Martin: *Roman Architecture*, Bristol Classical Press, London 1995

Varriano, John: *Rome, a Literary Companion*, J Murray, London 1991

Vasari, Giorgio: *Lives of the Artists* (tr. George Ball), Penguin, London 1965

Wall, Bernard: *A City and a World: A Roman Sketchbook*, New York 1962

Ward-Perkins, John B.: *Roman Architecture*, H. N. Abrams, New York 1977

Weiss, Roberto: *The Renaissance Discovery of Classical Antiquity*, Blackwell, Oxford 1963

Wheeler, Mortimer: *Roman Art and Architecture*, Thames and Hudson, London 1985

Wittkower, R.: *Art and Architecture in Italy: 1660–1750*, Penguin, Harmondsworth 1958

Yourcenar, Marguerite: *The Memoirs of Hadrian*, New English Library, London 1955

Zanker, Paul: *The Power of Images in the Age of Augustus*, University of Michigan Press, Michigan 1990

Index of People

Main entries are indicated in bold

Acknowledgment of Sources

P. 68, 71 and 72 based on a model from: Hermann Kinder/Werner Hilgemann: The Penguin Atlas of World History © 1974 Penguin Books Ltd., London.
P. 83 and 97 based on a model from: Filippo Coarelli. Rom: Ein archäologischer Führer, Verlag Herder, Freiburg. 4th edition 1989.
P. 558 and 560 based on a model from: Herbert Pothorn, Das große Buch der Baustile, 1997 Cormoran in the Südwest Verlag GmbH & Co KG, Munich.

Index of Places and works

Main entries are in bold; works of art and architecture described in the text are italicized.

Photo and Map Credits

The majority of the pictures come from Scala Group S.p.A. in Florence. The publisher made every effort up to the time of publication to contact the copyright holders of the images in this book. Private and institutional text or image copyright holders who may not have been contacted are hereby requested to contact the publisher.

KEY: l = left; r = right; c = center; t = top; b = bottom; 2.f.t. = 2nd from top; 2.f.b. = 2nd from bottom

© AP, Frankfurt/M. (452; M.Ravagli 455).© AKG, Berlin (10, 11, 17, 45, 60 Sec.3 Pic.2, 61 Sec.5 Pic.1/2, 65, 73, 104, 111, 112, 113, 132, 135 r., 175, 182, 183, 192, 194, 266, 268, 269, 276, 286, 287, 288, 289, 291, 295, 316 l., 316 r., 317, 321, 332, 343, 345, 366, 369, 377, 378, 392, 400, 433, 434, 435, 460, 461, 462, 463, 516 Sec.3 Pic.2, 519 Sec.1 Pic.1 542, 549 t., 573 Sec.1 Pic. 2, 574 Sec.1 Pic.2, 575 Sec.1 Pic.3/4, 576 Sec.5 Pic.1, 606; Erich Lessing 105, 135 l., 136 c., 147, 268, 269, 318, 342, 367, 398, 401, 403, 419, 573 c.: W. Forman 110, 134 r., 331; H. Heine 195; G. Lachmuth 421; Schütze/Rodemann 276; J. Sorges 73); © Archivi Alinari, Florence (74 b., 86 t., 95, 131 b., 408, 516 Sec.1 Pic.1/2), © Archivio Fotografico dei Musei Capitolini, Rome (57; M.T. Natale 58 t.r., 59 t.l.), © Archivio Magnus, Fagagna (226, 293, 574 Sec. 4 Pic. 3; M. Listri 107, 432; P. Marton 155; Magliani 576 Sec. 2 Pic. 2), © Bayer. Verw. D. Staatl. Schlösser. Gärten u. Seen, Munich (61 Sec.2 Pic. 1), © Bibliothèque Nationale, Paris (19, 60, Sec.3 Pic.1, 574 Sec.5, Pic.1), © Bidarchiv Foto Marburg (61 Sec.3, Pic.1), © BPK, Berlin (60 Sec.5 Pic.3, 61 Sec.1 Pic.4, 344; J.P. Anders 347), © Bridgeman Art Library, London (193; Lauros-Giraudon 133, 517 Sec.1 Pic.1, 573 Sec.5 Pic.2, 574 Sec.5 Pic.1, 575 Sec.5 Pic.1), © Cinetext, Frankfurt/M. (255, 576 Sec.5 Pic.3), © Martin Claßen, Cologne (555), © C.M.Dixon, Canterbury (546), © Peter Connolly, Lincolnshire (69, 101, 121, 124, 146, 189, 567, 586), © dpa, Frankfurt/M. (453, 519 Sec.3 Pic.2), © DTV, Munich (68, 71, 72), © ENSBA, Paris (39, 93, 138/9, 271, 393, 595), © Jeannette Fentroß, Cologne (24/25, 26), © Das Fotoarchiv, Essen/T. Mayer 55 t.l., 478), © The Fotomas Index, London (573 b.r.), © Peter Frese, Munich (75/76, 128/9), © Sonia Halliday Photographs, Buckinghamshire (19), © Claus Hansmann, Munich (446 r., 448), © Markus Hilbich, Berlin (197, 516 Sec.3 Pic. 1), © ICCD, Rome (383 t., 388), © Andrea Jemolo, Rome (8, 40 t., 41 l., 43, 46, 48, 49, 52, 54 t.l., 55 t.r., 58 t.l., 58 b., 63 Sec.2 Pic.1, 63 Sec. 4 Pic.2, 74 c., 75 r., 76 l., 77, 89, 92, 96, 98, 128 t., 134 l., 134 c., 136 l., 137, 142, 152 t.l., 154 b.r., 158, 163, 168, 170, 178, 180, 181, 188, 190, 197, 198, 199, 202 t., 203 t.r. and b., 204, 208, 210, 217 t.l., 224, 227, 229, 236 c., 245, 249, 264, 273, 281, 284 b., 292, 296 t.r., 298 t., 300 t.l., 300 t.r., 301 r., 302, 304, 305, 306, 308, 309, 311, 322, 324 b., 325 r., 338, 340, 349 c., 352, 354, 358, 360 b.l., 362, 372, 374, 380, 396, 411, 412, 416 b.l., 417 r., 426, 428, 431, 437, 444, 446 l., 451, 454, 516 Sec.2 Pic. 2, 517 Sec.1 Pic.2, 517 Sec.2 Pic.1, 547, 552 r., 553 t., 553 2. f.t., 573 Sec.3 Pic. 2, 573 Sec.4 Pic. 1, 574 Sec.2 Pic.1/2/5, 574 Sec.3 Pic.4/5, 574 Sec.4 Pic.2, 576 Sec.1 Pic.1, 589), © K & B News Photo, Florence (574 Sec.5 Pic.1), © Andreas Koch, Vienna (294, 379, 414, 449), © KÖNEMANN in der Tandem Verlag GmbH, Königswinter/A. Bednorz (251, 254), © Kunsthistorisches Museum, Vienna (223); © Laif, Cologne, (F. Zanettini 7 b.,16, 36/37, 108 t.,123, 126, 148, 162, 191, 360, 364, 391, 413, 415, 458, 466, 544/5, 549 2. f.t., 549 b., 556/7; Celentano 184), © Landesmuseum Trier/T. Zühmer (60 Sec.5 Pic.1), © Lotos-Film, Kaufbeuren (389), © Araldo de Luca, Rome (60, Sec.1 Pic.3, 62 Sec.1 Pic.2, 62 Sec.4 Pic.2, 70), © Luftbild Klammet&Aberl. Ohlstadt (456/7), © Musei Vaticani, Rome (494 t.r., 495 b.l., 512, 520, 575 Sec.2 Pic.4;A. Bracchetti/P.Zigrossi 522, 524, 525, 528, 529), © Michael Neumeister, Munich (61 Sec.3 Pic.2, 381), © G. Dagli Orti, Paris (103, 517 Sec.3 Pic.1, 519 Sec. 1 Pic.2, 575 Sec.1 Pic.1), © Andreas Post, Münster (61 Sec.1 Pic.3, 63 Sec.2 Pic.2, 106, 128 b., 139 t., 143 t., 164, 323, 355, 365 r., 467, 468/9, 472, 549 2.f.b., 550, 551, 552 l., 553 b.r.), © Pubbli Aer Foto, Milan (256 t.r., 270), © RMN, Paris (459; H. Lewandowski 368), © Roger-Viollet, Paris (127), © Rolli Arts, Essen (14/15, 29, 32, 33, 54/55, 58/59, 79 t., 83, 97, 118/119, 203, 209, 219, 241, 246/247, 267, 301 t., 303 t., 314, 333, 349, 373, 399, 420, 471, 495, 497, 523, 548/49, 552/53, 558, 559, 560, 561, 562, 563, 564, 565, 566, 580, 596), © SIME S. Vendemiano (2, 38, 62 Sec.5 Pic.1, 63 Sec.1 Pic.1, 64, 86 t., 87), © Soprintendenza Archaeologica di Roma (118 b., 119 t.r.,. 275, 278, 279), © Jürgen Sorges, Berlin (385), © Henri Stierlin, Genf (60 Sec.1 Pic.1, 61 Sec.2 Pic.2, 216 b.r., 218), © Studio für Landkartentechnik, Norderstedt (30/31, 187, 217, 237, 257, 297, 325, 361, 382/383, 396/397, 417, 446, 465), © Topham Picturepoint, Edenbridge (576 Sec. 1 Pic. 3), © Alessandro Vasari, Rome (122), © Joachim Willeitner, Munich (63 Sec.1 Pic.3)

626

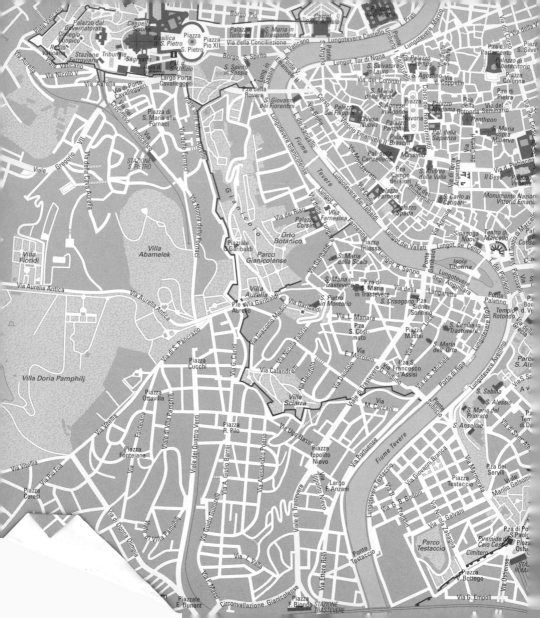